POP ART

THE DOCUMENTS OF TWENTIETH-CENTURY ART

General Editor, Jack Flam
Founding Editor, Robert Motherwell

Other titles in the series available from University of California Press:

POP ART

A Critical History

edited by

STEVEN HENRY MADOFF

UNIVERSITY OF CALIFORNIA PRESS

Berkeley Los Angeles London

The publisher gratefully acknowledges the contribution provided by the Art Book Endowment Fund of the Associates of the University of California Press, which is supported by a major gift from the Ahmanson Foundation.

University of California Press
Berkeley, California

University of California Press, Ltd.
London, England

Library of Congress Cataloging-in-Publication Data

Pop art : critical history / edited by Steven Henry Madoff.
 p. cm. – (The documents of twentieth century art)
 Includes index.
 ISBN 978-0-520-21243-5 (pbk. : alk. paper)
 1. Pop art – United States. 2. Art, Modern – 20th century –
United States. I. Madoff, Steven Henry. II. Series.
N6512.5.P6P63 1997
709'.73'09045-dc21 97-2587
 CIP

Printed in the United States of America

16 15 14 13 12 11 10 09 08
10 9 8 7 6 5 4

The paper used in this publication meets the minimum requirements of ANSI/ NISO Z39.48-1992 (R 1997) (*Permanence of Paper*). ♾

CONTENTS

3 FOCUS: THE MAJOR ARTISTS

ROY LICHTENSTEIN

CLAES OLDENBURG

LIST OF ILLUSTRATIONS

ACKNOWLEDGMENTS

I would like to thank Jack Flam, editor of the series The Documents of Twentieth-Century Art, for inviting me to edit this volume. Artists continue to be influenced by Pop art, museums continue to curate exhibitions concerning Pop and Pop artists, and collectors continue to follow the work closely. It seemed to me essential that an anthology of contemporaneous writings on Pop should be done.

Charlene Woodcock, my editor at the University of California Press, has been enormously patient during this volume's creation.

The librarians at the Museum of Modern Art's library and the art library at the New York Public Library have been wonderful resources. Research done by Alexandra Muse on the chronology at the end of the volume was crucial. The work done by Kara Olsen and Eleanor Hughes, who provided invaluable research help at the end of this project, was also of enormous importance.

Most important of all – and here words pale – thanks to Pamela. This book is for her.

S. H. M.

WHAM! BLAM! HOW POP ART STORMED THE HIGH-ART CITADEL AND WHAT THE CRITICS SAID

Steven Henry Madoff

The image slyly disturbs, and yet it is brightly vacuous. *Marilyn (Three Times)*. The hair is a molded mound of brass, the lips smeared with red. The eyes, weighted with two technicolor slabs of makeup, a parody of makeup, have the opiated look of someone who has stared too long into the camera's flash, who no longer sees anything but the packaged good she has become. The portrait in the picture is multiplied (here by three, by six in a similar silkscreen job, by a hundred in another) so that we may learn one thing above all else: that the painting's author, Andy Warhol, knows she is a packaged good – pumped-up, electric-hued, and hollow – and adores what she is. He wants to be every bit like her and, even more so, like the world that made her.

Warhol is in his studio (the Factory, he calls it), emulating that world, that glittering engine of the fabulous and the jaded, which, like his picture, offers up a star who fabricates feelings for a living, but whose own feelings get hidden inside the package, get lost in the repeated, endless manufacture. He likes what he sees. He states as much in an oft-quoted remark meant to announce his distance from Jackson Pollock's proclamation, "I am nature." Flatly, Warhol says, "I want to be a machine." There is irony here and a willing blankness. There is something vapid, but also something oracular. He only wants to be what Marilyn already is, what America clearly wants her to be in the year of her death, the year he paints the picture. It is 1962.

———

With the explosive unburdening of the 1960s, as the Eisenhower-and-McCarthy years fell away at light speed, a new kind of art happened. It didn't bow before Abstract Expressionism, which had brought America its great cultural victory after the Second World War. This new art was not held back by the monklike asceticism, the purity of feeling so brilliantly presented by Newman and Rothko. It wasn't fazed by the pictures of Pollock and de Kooning, all densely packed and psychologically charged.

In fact, this new art did not seem to advertise anything in the least bit worried. The art was extroverted. It projected an air of intoxication; a sense that here in New York, in the rising elation of the Kennedy years (and in the nostalgia for that elation after the president's assassination), a world of plain and sharply colored objects, of Brillo boxes and billboards, spelled out the youthful buoyancy of America's unchecked global climb. It announced that here in the metropolis of great fame, in the capital of art and of commerce, too, was not only a jazzed-up bounty of vital subject matter but a ready-made way of visualizing things just waiting to be grasped.

This new work, it turned out, took more than a little from the abstract art it kicked over. That was part of what made it tick – and it ticked loudly, riotously, wonderfully to some, shockingly to others. It ticked with the energy of the suddenly discovered. And what made it tick most jarringly of all was that the populace, looked down upon from the high citadel of the art world's sense of its own singularity, took up this new vision with satisfaction, at times with ebullience. Here was what the people had suspected all along, that they *could* understand vanguard art if it were not so opaque, so willfully unrecognizable. The world that people knew, that they worked in and looked at every day, was the subject of the most contemporary painting and sculpture again.

The character of this art shared with television a cool sense of distance matched only by overt sentimentality. That should come as no surprise. In an art that gleefully espoused the importance of the packaged good, that the exterior life of things was far more interesting than the interior, true sentiment gave way easily to sentimentality – emotions, identity, landscapes, everyday objects, and scenes of war all presented as highgloss, no-stain products. Television was not the only popular source that put a gloss on the world and made it so palatable, so light. Comic strips offered a still simpler flattening of things. In the strips, Lichtenstein and Warhol, and other artists as well, found a lively graphic style and a formality of feeling that somehow always ended with an exclamation point: an anti-solemnity that was right for the times.

The leaching away of emotions and the projection of an enormous energy onto the antic figure of Mickey Mouse, onto sprightly beach balls and blown-up ice cream cones, was at once a statement of innocence retaken and a provocation. This new work's mixture of comic-strip goofiness, gargantuanism, and exposé spoke of an impulse that a certain kind of radical art of the 19th and 20th centuries had already hinted at, from Edouard Manet's brazen *Olympia* to John Sloan's denizens of lower-class New York: a grating realism meant to be impolite, to be inclusive of parts of society deemed outré or fallen, and so to push the limits of what art could show.

Yet unlike that earlier work, which was met with initial outrage, the new art had the clever strategy to impose on its realism nothing more fallen or impolite than what culture already was. If the esthetes who had embraced Abstract Expressionism were inflamed, others were not. Here was a realism that thrust itself knowingly in the face of a society that liked its garishness larger than life; a society ineluctably drawn to cartoon romance and tabloid scandal, to that particular species of glamour – in parts lurid, sexual, and tragic – that was embodied by Elvis and Marilyn and Jackie. Pop, as this new kind of art came to be called, was a diminutive of the word "popular." It was not a technical term, a bit of off-putting art-historical jargon meant to exclude. And like pop music, beneath its raucous or laughing or shimmering surfaces, its craft was sophisticated. Its beat was calculated. It swung.

What Pop took from the canvases of Pollock and Rothko was their physical size, their all-over patterns and repeated images. But bigness meant something different to Lichtenstein and Oldenburg and Warhol. Exchanging world-weary spirituality for smiling (or smirking) worldliness, the Pop artists went at bigness in their canvases as the expression of a society enjoying its imperial swagger on a transcontinental scale. Bigness in Pop pictures reflected America's self-delighted astonishment in what seemed a never-ending pile of freshly minted goods sprawling across the planet. What this translated into, in Rosenquist's billboard-inspired collages of Pepsodent-gleaming teeth and fighter jets, in Warhol's acid images of colossal flowers, cows, and electric chairs, was finally a very different purity of feeling from Rothko & Company's. It was a feeling of pure ambiguity, an ambivalence that the war-generation Abstract Expressionists could never allow themselves. It was the luxurious pleasure of facile unconcern: the ability to look into the conscience of America's commercial culture, find the glint of shiny metal no more than an inch thick, and mirror it brilliantly.

For the writers of the day, the new sensibility was in turns bewildering, affronting, thrilling, and an opportunity. There were many critics, among them Hilton Kramer and John Canaday, who found in Pop a decline. Expecting moral urgency, they confronted an art that freely traded soul-searching for what appeared to be a genre of social anthropology. Here, in their eyes, was little more than trivial subject matter, hymns to bubble-

headed excess. They followed the pronouncement of Clement Greenberg, Abstract Expressionism's master spokesman, judging that nothing technically interesting happened in this new work: the Pop artists retreated from formal innovation.

Still, this old guard of opinion was opposed by an array of critics who argued that something fundamental had changed in culture. The Pop artists were both reflecting and defining that change. Lawrence Alloway, who coined the term "Pop"; Thomas Hess, an influential editor at *Art News;* Gene Swenson, that magazine's most ardent champion of the movement; the brilliant young critic Barbara Rose; and, later, the (then) West Coast painter and writer Peter Plagens all saw in Pop art a new freedom, a savvy analysis of the new society, a cheekiness, and true invention.

There were still others – such men as Sidney Tillim and Max Kozloff – who lived between these camps, who were as much appalled as intrigued by, in Kozloff's phrase, the "new vulgarians." And yet it was this ability to appall, this candy-colored vulgarity that drew the corps of writers that made Pop's name with the public. In hindsight, it is easy to say that the popular press naturally had an easier time with Pop. Its subject matter and social chic were no difficulty at all for writers who were used to the journalistic bread-and-butter of covering fashion, music, and the year's auto styles.

What the writers in *Time* and *Newsweek* saw and passed on to the American public was a bauble of leisure that had all the charm of college boys stuffing themselves into phone booths to see how many would fit. After the eminent gravity of Abstract Expressionism, these journalists wrote about the giddiness and cool displayed in the oversize images of Lichtenstein's golf ball and Robert Indiana's jaunty "LOVE." This was a story the press could deliver with the same wonderment that drove their coverage of the Beatles: harmless, fun-loving, sometimes silly, but smart all the way to the bank.

What was publicized and debated was driven in turn by a rising power nexus in the art world of new collectors and such art dealers as Leo Castelli, Virginia Dwan, and Sidney Janis. The critics could say what they wished, but for this instantly formed firmament of collectors, most famously represented by Robert Scull, the New York taxi baron, the new art was similar indeed to their new money. It was not involved with the past. It was involved with climbing a fresh ladder into the social heavens. The work was about what these men could get straight away: products and power with a bold gleam. This doesn't mean that staring at a Warhol double car crash, or even at a mammoth hamburger by Oldenburg, didn't raise questions about the industrial complex and its dire plethora of waste. But Pop put this new world in a light of hyperbole that made the right kind of sense to these collectors and their huge ambitions, offering equal amounts of levity, indifference to what had come before, and candid, unembarrassed voyeurism.

The combination of wealth, influential dealers, and the epic outpouring of words from writers of every stripe contributed to the ostentatious success of these artists among the widest audience that any avant-garde movement in the visual arts has experienced at its inception (matched only in the 1980s, whose money-fueled Neo-Expressionist art stars could not have existed without the advent of Pop). The postwar artists' community of spirit, once replaced by the '60s' collective attention to style among the middle class and nouveau riche alike, now gave way to marketing in full heat. The dealers had a new art on their hands that collectors wanted. The newspapers, weeklies, and glossies had a new subject. The rapid sales, the clever write-ups in *Life* and *Vogue*, the titillation of Warhol's seedy glamour, along with the fervent demolition and defense of the movement among serious critics, all led to Pop's ascent.

This new community, lofted by its embraceable subject matter, galvanized culture

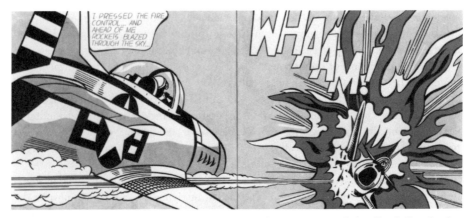

Roy Lichtenstein, Whaam!, *oil and magna on canvas, two panels, 68 × 83 inches each, 1963. Tate Gallery, London*

beyond those small precincts of the art world that paid obeisance to the shibboleths of Formalism and the Universal Soul. The Pop artists – whose techniques and esthetics settled quickly – hit the Zeitgeist dead on. Theirs was the same flare as mod fashion's. History, for their moment, was not the operative issue. History had shown its compulsion to repeat in the traumatic war of the last generation, then slept it off in the '50s. No, the historical impulse was specifically not essential. The issue was the *un*-history of a very contemporary world: a process of leaning impulsively into the present. So much of this art, for all its suggestion of high energy, has an airlessness about it that is the condition of this single-minded focus. The still life of the un-historical? A profusion of objects meant to last only as long as it takes to spend or consume them. Thus, a Warhol roll of bills; Lichtenstein's rounds of ammunition fired from a blazing warplane; a mountainous slice of cake by Oldenburg; Wesselmann's impossibly pink nude stepping from a bath into the viewers' arms; or, in Warhol again, a flood of images of death – an obsession with death in which life is the presumed consumable and time no longer matters, time is spent.

————

There is a pointed irony that emerges from this notion of Pop's paean to the un-historical in the light of making this anthology. An anthology is a consequence of the general human yearning to capture and classify the past, to construct a history. And while the forward-looking Pop artists and the culture of their day wanted nothing more than to see their father figures shrink to specks in the rear-view mirror, it is inescapable that Pop arose as a response to the art that directly preceded it. To formulate what critical documents best record the era of Pop and to bracket those documents between dates that presumably open and terminate its era is an act of historical imagination. So there is an inevitable, ironic pull between the artists' ambitions and the anthologist's duty that underlies the project of this book.

Yet to construct this history was straightforward enough. It begins with critical writings of the 1950s and early '60s that set the stage for American Pop. A number of these writings focus on the British investigation of popular culture that gave rise to British Pop art as it came into being in the early '50s under the aegis of the Independent Group. This marginal congregation of the like-minded and intellectually curious included the architects Alison and Peter Smithson, the writers Lawrence Alloway and Reyner Banham, and

the artists Richard Hamilton and Eduardo Paolozzi. They looked out at the drear of '50s London and shuddered. They found their art world blinkered, driven back into its own past, unwilling to address what the postwar world order meant to the creation of art in that place at that time.

The theory, art, and criticism that the IG put forward is entirely influenced by the melancholy of England's social state and a desire to compensate for the material duress of their postwar scene. The ideas and imaginative works they made embraced the notion of a new culture built upon the promises of science, the fantasies of comics and science fiction, and the gleam of new products – many from America.

It is crucial to read, as a backdrop to American Pop, what the British thought and did. It is equally crucial to note that the sources and effects of the two arts are substantially different. While British Pop emerges from England's wartime devastation and its social ramifications, American Pop artists were never forced to deal with that landscape and its meanings. Warhol, Lichtenstein, and Rosenquist started with the sheen of their own land-scape at the optimistic center of the globe. When you compare the works of these two movements, two things are striking. First, the size of British works is typically small; still tied to the European easel tradition. Second, and more telling, there is nothing defensive in the works of American Pop. Its invention is not a declaration of reconstruction or es-cape, of *elsewhere*, as it was for the British. No, its invention declares arrival – a cool-eyed assurance, crisp and aggressive, laying claim to the *here* of America's productive powers.

These sorts of differences point in a larger way to the rationale for this anthology as it is. While it was tempting to consider a far broader collection of writings that covered Ger-man and French, Italian and Scandinavian, and South American strains of Pop art, it fi-nally seemed not only impractical but removed from the primary intention of the Docu-ments of Twentieth Century Art series, which focuses on the central activities of an art historical movement. There is a definite fascination in looking out from the promontory of retrospective time on these international artists to see the ways in which they adapted Pop, mixed it with their own cultures' pasts, then moved on to something else. Yet that would be another book; one that might be of real curiosity to scholars and connoisseurs. It would be about artists (with the exception of the British) who derived their Pop inflec-tions largely from the American style. You see this in the Germans Gerhard Richter's and Sigmar Polke's period of Capitalist Realism, for example. And there is a decisive account in Bruce Altshuler's "Pop Triumphant: A New Realism" – the second part of which is ex-cerpted in this anthology – about the punctured reaction of the French *Nouveau Real-istes*, who realized that the Americans' art out-scandalized their own in sheer intensity when they first exhibited together in New York at the Sidney Janis Gallery.

The focus of this volume remains on the American exposition of the style as it flow-ered in this soil and gained its central historical prominence. And that is why the first section of the book is not only about the British background but about the American as well. While the American Pop artists did indeed borrow scale and an interest in all-over patterns from the Abstract Expressionists, Pop subject matter didn't rise *ex nihilo* with the new dawn of the '60s. Jasper Johns, Robert Rauschenberg, and Larry Rivers each had broken the abstract mold and were drawn to the play and ambiguity of common objects: of news photos and clothes hangers, of brightly painted cigar box labels rendered with knowing Ab-Ex drips. Their art was both linchpin and lever, offering a link to that earlier generation, but doing so with a droll energy, a lightness that gave the Pop artists license, lifting them away from the heavy influence of Pollock and Rothko.

The anthology's plan follows logically from predecessors to the general phenomenon of the movement itself. A chronological arrangement of voices speaks to and over one another; voices calling back and forth and repeating the names of pictures, artists, dealers, collectors, exhibitions, and the arguments of other writers. As Pop was an art that targeted contemporary society head on and garnered its authority as much from public attention as from critical praise, the writings gathered here are meant to capture the gamut of printed notice; to encounter the movement's social as well as critical reception. In this light, it's as revealing to read pieces like *Life*'s introduction to Roy Lichtenstein, "Is He the Worst Artist in the U.S.?" and the *Sunday Herald Tribune*'s glitterati-spotting in "Superpop or a Night at the Factory," as it is to follow the art-historical insights of where the speech balloons in Lichtenstein's pictures come from or whether Rosenquist's murals add anything meaningful to the history of history painting.

Through all of these writings, whether reviews or journalistic takes on the scene or art historical musings, a granular sense of a particular time makes its texture felt: Hilton Kramer biting off the words of Leo Steinberg in exasperation at the Museum of Modern Art's Pop symposium in 1962; Oldenburg's funky, astonishing "Store" on East Second Street; Rosenquist at lunch in his paper suit; Norman Mailer among the new bohemians at a Warhol sideshow of flesh and fauna; the observations of critics who saw so much in their first glimpses of this art, which they captured with such names as "Neo-Dada," "New Sign Painting," and, loveliest of all, Sidney Tillim's phrase, "New American Dream" painting.

After poring over hundreds of articles and catalogues for this book, one aspect of Pop art's life became particularly notable. For all the diversity of opinions, the vast historical body of writings on Pop makes one thing clear: the roster of artists generally considered members of the Pop camp barely included the mention of women. While history marks the '60s as the era of liberation, you would hardly know it from the case study of Pop. Marisol is the *single* woman whose works were exhibited frequently in Pop shows. And even then writers on her work more often questioned, ignored, or denied her label as a Pop artist, insisting instead on her significance as a sculptor of singular sensibility whose art is far more intimate, drawn with warmth to the pleasures and humor of social community, and whose artistic roots (evident in her predilections) are Latin American, not American. Women critics fared a little better in number – Barbara Rose, Dore Ashton, Ellen Johnson, Lucy Lippard, Grace Glueck, Vivien Raynor – but none of their writings, or their male counterparts', reveal a woman among the Pop artists who has been forgotten.

What the writers wrote was, to a great extent, about a four-headed goliath named Lichtenstein-Oldenburg-Rosenquist-Warhol. They are the central figures and the focus of the book's third section. Some readers are going to disagree with this. Some readers will argue that Jim Dine and Tom Wesselmann in particular have been downgraded, pushed off into the subsequent section about artists who participated in Pop but were not as essential to its definition. Both Dine and Wesselmann, along with the others in that section, compel consideration. Yet for all of their accomplishments, to my mind their art is less incisive. Their bodies of work do not have the uniquely attractive and rebarbative force of Pop's four masters, who variously shaped the movement's blunt insight that commerce had so deeply transformed the landscape of American culture that it had formed a new landscape ready for a new art. And it is their complicated tone of ambivalence – brightly innocent on the one hand and excessive (suggesting heartlessness, indifference, or moral corruption) on the other – that is so difficult and galvanizing. Dine and Wesselmann have some of this, but there is an undertow lacking. Dine's debt to Johns and Wes-

selmann's to Matisse soften the original edginess of Pop that described *Homo Americanus* as empty and happy, hungry for a mound of disposable pleasures.

In fact, there are other artists whose works were at one point in the fold of Pop, yet who are not included here at all – Billy Al Bengston, Stephen Durkee, Joe Goode, Red Grooms, Phillip Hefferton, and Robert Watts among them. Why are they absent? There is the essential objective reason of lack of space. And there is the altogether personal view, after going through so much material on the subject, that their Pop-period works did not alter the shape of the movement or claim the defining moment in their own careers.

Perhaps the most painful exclusions are Marisol and Richard Artschwager. She because of her significance as the woman most often included in Pop exhibitions – though, again, never entirely thought of in Pop terms. Artschwager because of his extraordinarily elusive yet fertile relation to Pop. Seen in many of the early Pop group shows, his sculptures done in Formica appear at first to be sendups of furniture, more chair effigies and table effigies than functional objects. They have the tongue-in-cheek smartness of vintage Pop, yet they are far more cooled out, more abstract and difficult to place within the sphere of the movement's magnified energy. Indeed, his work has as much to do with the esthetic of Minimalism as it does with Pop art, and it is just this tantalizing, shifting character that draws him into any rarified discussion of Pop but does not let him sit comfortably there. And this, I suppose, he shares with Marisol.

Two sections wrap up the volume, each offering a different kind of historical perspective. The penultimate section collects several representative essays that look back on Pop from the distance of a few years or many. Whether it is Robert Hughes's lacerating revision of the Warhol legend or Lynne Cooke's measured exposition of the relations of British and American Pop, these pieces provide social and historical contexts that the writers who were the movement's witnesses couldn't have apprehended. And they point to the fact that Pop continues to have its spectral hold on our culture's imagination.

While American Pop is now considered historic enough to fetch awesome prices at auction – consider the figure of about $15 million paid in 1996 by New York's Museum of Modern Art for a Warhol image of Campbell's soup cans – the sensibility of Pop permeates our society. An essay not included in this anthology, Michiko Kakutani's "The United States of Andy," published in the magazine of the Sunday *New York Times*, November 17, 1996, claims that Warhol's lasting lesson that art is all about commerce and packaging has been "picked up willy-nilly by successive generations of artists and artistes. . . . 'Access Hollywood,' the Jacqueline Onassis auction, Dennis Rodman's book, *Planet Hollywood*, Calvin Klein ads and the new 'Brady Bunch' movies are all post-Warholian phenomena, just as Cindy Sherman's photographs and Damien Hirst's dead cows are post-Warholian art."

Many of the names mentioned in Kakutani's essay, and the essay itself, will fade into history soon enough – adding to Warhol's most famous maxim, "In the future everyone will be world-famous for fifteen minutes," the bracing finale: and fifteen minutes only. But what is equally bracing is the testimony that these artists and artistes lend to the ongoing phenomenon. Perhaps instead of speaking of Pop's permeating sensibility, it is better to say that the commercial sensibility that inspired Pop art has come to grip our culture ever more deeply. Pop has simply continued to be a compelling emblem of that fact and has inspired new expressions of it in turn. Certainly, commercial culture's strategy of planned obsolescence becomes an irony in the light of Pop art's longevity and bears on the need, or at least the usefulness, of this anthology.

In fact, another sense of irony related to the perspective of history touches this volume's closing section, its chronology of exhibitions. While the whole shape of Pop rolls out in the chronology's retrospective form of a historical ledger, reading through it is a matter of instants, month after month, lived through, however whimsically, one at a time. The sense of history is momentarily lost. At least in one interpretation of Pop, that is how these artworks were meant to live.

From LARRY RIVERS: "WHY I PAINT AS I DO"

Frank O'Hara

Larry Rivers lives in a house in Greenwich Village on a street crowded with bars and cof-feehouses behind the New York University Law School building. Formerly inhabited by a scene designer, the studio is two stories high with walls of brick, whitewashed many years ago and now covered with the city's patina of warm gray. In the daytime the light pours in from three skylights, but at night it is a vast, dim place, lit by seven naked light bulbs hanging high up near the ceiling. At night the studio looks very much like the set for Samuel Beckett's *Endgame;* it's hard to believe you can find out anything about the out-side world without using a ladder; the windows are way up.

Part of the house is divided into two floors, duplex style, the upper floor with a little balcony overlooking the studio. On these two semifloors the artist lives with his youngest son, Steven, thirteen years old. (His older son, a painter too, lives not far away in his own cold-water studio.) The other member of the Rivers household is a friendly, frantic shep-herd dog named Amy who is perpetually hungry and lunges up and down the stairs in a delirium of affection for all comers.

On one of the studio's huge walls is stapled a 10 by 15 foot canvas, in preparation for the start of the artist's projected new work *ME.* On the opposite wall a female figure in welded steel has been attached several feet off the floor – the sculpture which appears in two of his paintings, *Second Avenue* and *Second Avenue with THE.* It was made in 1957 in Southampton, Long Island, where the Riverses lived for four years. Another wall has the huge *Journey* of 1956, a painting which looks small in the space of the studio; lurking un-der a nearby potted plant is a plaster commercial figure of Psyche or Aphrodite which Rivers rescued from a night club; she is holding an orange light bulb in her uplifted hand and Rivers uses her as a night light.

I have known Larry Rivers since 1950, when he had just returned from Europe. It was at a cocktail party we met, as one always meets people in New York, and waving at the crowd he said, "After all it's life we're interested in, not art." A couple of weeks later when I visited his studio for the first time, with its big splashy canvases and the begin-nings of full-scale female nudes in plaster hanging from pipe-and-flange armatures, he said with no air of contradiction or remembrance, "After all it's *art* we're interested in, not life." His main interest was obviously in the immediate situation. And so it seems to have remained. . . .

O'HARA: The famous *George Washington Crossing the Delaware* was painted soon after your return from Europe, wasn't it? Was it influenced in any way by what was going on in New York art circles?

RIVERS: Luckily for me I didn't give a crap about what was going on at the time

Excerpt, *Art Chronicles, 1954–1966* (New York: George Braziller, 1975), 106–20

The fine artist is often unaware that his patron, or more often his patron's wife who leafs through the magazines, is living in a different visual world from his own. The pop art of today, the equivalent of the Dutch fruit and flower arrangement, the pictures of second rank of all Renaissance schools, and the plates that first presented to the public the Wonder of the Machine Age and the New Territories, is to be found in today's glossies – bound up with the throw-away object.

As far as architecture is concerned, the influence on mass standards and mass aspirations of advertising is now infinitely stronger than the pace setting of *avant-garde* architects, and it is taking over the functions of social reformers and politicians. Already the mass production industries have revolutionized half the house – kitchen, bathroom, utility room, and garage – without the intervention of the architect, and the curtain wall and the modular prefabricated building are causing us to revise our attitude to the relationship between architect and industrial production.

By fine-art standards the modular prefabricated building, which of its nature can only approximate the ideal shape for which it is intended, must be a bad building. Yet, generally speaking, the schools and garages which have been built with systems or prefabrication lick the pants off the fine-art architects operating in the same field. They are especially successful in their modesty. The ease with which they fit into the built hierarchy of a community.

By the same standards the curtain wall too cannot be successful. With this system the building is wrapped round with a screen whose dimensions are unrelated to its form and organization. But the best postwar office block in London is one which is virtually all curtain wall. As this building has no other quality apart from its curtain wall, how is it that it puts to shame other office buildings which have been elaborately worked over by respected architects and by the Royal Fine Arts Commission?

To the architects of the twenties, "Japan" was the Japanese house of prints and paintings, the house with its roof off, the plane bound together by thin black lines. (To quote Gropius, "the whole country looks like one gigantic basic design course.") In the thirties Japan meant gardens, the garden entering the house, the tokonoma.

For us it would be the objects on the beaches, the piece of paper blowing about the street, the throw-away object and the pop-package.

For today we collect ads.

Ordinary life is receiving powerful impulses from a new source. Where thirty years ago architects found in the field of the popular arts techniques and formal stimuli, today we are being edged out of our traditional role by the new phenomenon of the popular arts – advertising.

Mass-production advertising is establishing our whole pattern of life – principles, morals, aims, aspirations, and standard of living. We must somehow get the measure of this intervention if we are to match its powerful and exciting impulses with our own.

lustrations, advertisements, slick and pulp fiction, comics, Tin Pan Alley music, tap-dancing, Hollywood movies, etc." All these activities to Greenberg and the minority he speaks for are "ersatz culture . . . destined for those who are insensible to the value of *genuine* culture . . . Kitsch, using for raw material the debased and academic simulacra of *genuine* culture welcomes and cultivates this insensibility" (my italics). Greenberg insists that "all kitsch is academic," but only some of it is, such as Cecil B. De Mille-type historical epics which use nineteenth-century history-picture material. In fact, stylistically, technically, and iconographically the mass arts are anti-academic. Topicality and a rapid rate of change are not academic in any usual sense of the word, which means a system that is static, rigid, self-perpetuating. Sensitiveness to the variables of our life and economy enable the mass arts to accompany the changes in our life far more closely than the fine arts which are a repository of time-binding values.

The popular arts of our industrial civilization are geared to technical changes which occur, not gradually, but violently and experimentally. The rise of the electronics era in communications challenged the cinema. In reaction to the small TV screen, movie makers spread sideways (CinemaScope) and back into space (Vista Vision). All the regular film critics opposed the new array of shapes, but all have been accepted by the audiences. Technical change as dramatized novelty (usually spurred by economic necessity) is characteristic not only of the cinema but of all the mass arts. Colour TV, the improvements in colour printing (particularly in American magazines), the new range of paper back books; all are part of the constant technical improvements in the channels of mass communication.

An important factor in communication in the mass arts is high redundancy. TV plays, radio serials, entertainers, tend to resemble each other (though there are important and clearly visible differences for the expert consumer). You can go into the movies at any point, leave your seat, eat an ice-cream, and still follow the action on the screen pretty well. The repetitive and overlapping structure of modern entertainment works in two ways: (1) it permits marginal attention to suffice for those spectators who like to talk, neck, parade; (2) it satisfies, for the absorbed spectator, the desire for intense participation which leads to a careful discrimination of nuances in the action. There is in popular art a continuum from data to fantasy. Fantasy resides in, to sample a few examples, film stars, perfume ads, beauty and the beast situations, terrible deaths, sexy women. This is the aspect of popular art which is most easily accepted by art minorities who see it as a vital substratum of the folk, as something primitive. This notion has a history since Herder in the eighteenth century, who emphasized national folk arts in opposition to international classicism. Now, however, mass-produced folk art is international: Kim Novak, *Galaxy Science Fiction,* Mickey Spillane, are available wherever you go in the West. However, fantasy is always given a keen topical edge; the sexy model is shaped by datable fashion as well as by timeless lust. Thus, the mass arts orient the consumer in current styles, even when they seem purely, timelessly erotic and fantastic. The mass media give perpetual lessons in assimilation, instruction in role-taking, the use of new objects, the definition of changing relationships, as David Riesman has pointed out. A clear example of this may be taken from science fiction. Cybernetics, a new word to many people until 1956, was made the basis of stories in *Astounding Science Fiction* in 1950. SF aids the assimilation of the mounting technical facts of this century in which, as John W. Campbell, the editor of *Astounding,* put it, "A man learns a pattern of behavior – and in five years it doesn't work." Popular art, as a whole, offers imagery and plots to control the changes in the world; everything in our culture that changes is the material of the popular arts.

THE ARTS AND THE MASS MEDIA

Lawrence Alloway

In *Architectural Design* last December there was a discussion of "the problem that faces the architect to-day – democracy face to face with hugeness – mass society, mass housing, universal mobility." The architect is not the only kind of person in this position; everybody who works for the public in a creative capacity is face to face with the many-headed monster. There are heads and to spare.

Before 1800 the population of Europe was an estimated 180 million; by 1900 this figure had risen to 460 million. The increase of population and the industrial revolution that paced it have, as everybody knows, changed the world. In the arts, however, traditional ideas have persisted, to limit the definition of later developments. As Ortega pointed out in *The Revolt of the Masses:* "the masses are to-day exercising functions in social life which coincide with those which hitherto seemed reserved to minorities." As a result the élite, accustomed to set æsthetic standards, has found that it no longer possesses the power to dominate all aspects of art. It is in this situation that we need to consider the arts of the mass media. It is impossible to see them clearly within a code of æsthetics associated with minorities with pastoral and upperclass ideas because mass art is urban and democratic.

It is no good giving a literary critic modern science fiction to review, no good sending the theatre critic to the movies, and no good asking the music critic for an opinion on Elvis Presley. Here is an example of what happens to critics who approach mass art with minority assumptions. John Wain, after listing some of the spectacular characters in P. C. Wren's *Beau Geste* observes: "It sounds rich. But in fact – as the practised reader could easily foresee . . . it is not rich. Books with this kind of subject matter seldom are. They are lifeless, petrified by the inert conventions of the adventure yarn." In fact, the practised reader is the one who understands the conventions of the work he is reading. From outside all Wain can see are inert conventions; from inside the view is better and from inside the conventions appear as the containers of constantly shifting values and interests.

The Western movie, for example, often quoted as timeless and ritualistic, has since the end of World War II been highly flexible. There have been cycles of psychological Westerns (complicated characters, both the heroes and the villains), anthropological Westerns (attentive to Indian rights and rites), weapon Westerns (Colt revolvers and repeating Winchesters as analogues of the present armament race). The protagonist has changed greatly, too: the typical hero of the American depression who married the boss's daughter and so entered the bright archaic world of the gentleman has vanished. The ideal of the gentleman has expired, too, and with it evening dress which is no longer part of the typical hero-garb.

If justice is to be done to the mass arts which are, after all, one of the most remarkable and characteristic achievements of industrial society, some of the common objections to them need to be faced. A summary of the opposition to mass popular art is in *Avant Garde and Kitsch* (*Partisan Review,* 1939, *Horizon,* 1940), by Clement Greenberg, an art critic and a good one, but fatally prejudiced when he leaves modern fine art. By kitsch he means "popular, commercial art and literature, with their chromeotypes, magazine covers, il-

Architectural Design & Construction, February 1958: 84–85

Mass produced
Young (aimed at youth)
Witty
Sexy
Gimmicky
Glamorous
Big business

This is just a beginning. Perhaps the first part of our task is the analysis of Pop Art and the production of a table. I find I am not yet sure about the "sincerity" of Pop Art. It is not a characteristic of all but it is of some – at least, a pseudo-sincerity is. Maybe we have to subdivide Pop Art into its various categories and decide into which category each of the subdivisions of our project fits. What do you think?

Yours,

(The letter was unanswered but I used the suggestion made in it as the theoretical basis for a painting called Hommage à Chrysler Corp., *the first product of a slowly contrived programme. R.H.)*

LETTER TO PETER AND ALISON SMITHSON

Richard Hamilton

16th January 1957

Dear Peter and Alison,

I have been thinking about our conversation of the other evening and thought that it might be a good idea to get something on paper, as much to sort it out for myself as to put a point of view to you.

There have been a number of manifestations in the post-war years in London which I would select as important and which have a bearing on what I take to be an objective:

Parallel of Life and Art
(investigation into an imagery of general value)

Man, Machine and Motion
(investigation into a particular technological imagery)
Reyner Banham's research on automobile styling
Ad image research (Paolozzi, Smithson, McHale)
Independent Group discussion on Pop Art-Fine Art relationship
House of the Future
(conversion of Pop Art attitudes in industrial design to scale of domestic architecture)

This is Tomorrow
Group 2 presentation of Pop Art and perception material attempted impersonal treatment. Group 6 presentation of human needs in terms of a strong personal idiom.

Looking at this list it is clear that the Pop Art/Technology background emerges as the important feature.

The disadvantage (as well as the great virtue) of the TIT show was its incoherence and obscurity of language.

My view is that another show should be as highly disciplined and unified in conception as this one was chaotic. Is it possible that the participants could relinquish their existing personal solutions and try to bring about some new formal conception complying with a strict, mutually agreed programme?

Suppose we were to start with the objective of providing a unique solution to the specific requirement of a domestic environment e.g. some kind of shelter, some kind of equipment, some kind of art. This solution could then be formulated and rated on the basis of compliance with a table of characteristics of Pop Art.

Pop Art is:
Popular (designed for a mass audience)
Transient (short-term solution)
Expendable (easily-forgotten)
Low cost

Collected Words 1953–1982, London 1982

Critics of the mass media often complain of the hostility towards intellectuals and the lack of respect for art expressed there, but, as I have tried to show, the feeling is mutual. Why should the mass media turn the other cheek? What worries intellectuals is the fact that the mass arts spread; they encroach on the high ground. For example, into architecture itself as Edmund Burke Feldman wrote in *Arts and Architecture* last October: "Shelter, which began as a necessity, has become an industry and now, with its refinements, is a popular art." This, as Feldman points out, has been brought about by "a democratization of taste, a spread of knowledge about non-material developments, and a shift of authority about manners and morals from the few to the many." West Coast domestic architecture has become a symbol of a style of living as well as an example of architecture pure and simple; this has occurred not through the agency of architects but through the association of stylish interiors with leisure and the good life, mainly in mass circulation magazines for women and young marrieds.

The definition of culture is changing as a result of the pressure of the great audience, which is no longer new but experienced in the consumption of its arts. Therefore, it is no longer sufficient to define culture solely as something that a minority guards for the few and the future (though such art is uniquely valuable and as precious as ever). Our definition of culture is being stretched beyond the fine art limits imposed on it by Renaissance theory, and refers now, increasingly, to the whole complex of human activities. Within this definition, rejection of the mass produced arts is not, as critics think, a defence of culture but an attack on it. The new role for the academic is keeper of the flame; the new role for the fine arts is to be one of the possible forms of communication in an expanding framework that also includes the mass arts.

MIXED MEDIUMS FOR A SOFT REVOLUTION

Thomas B. Hess

A lively, in places a brilliant exhibition, titled "New Mediums – New Forms," at the Jackson Gallery [June 6–24], informally poses one of the most interesting questions that concerns modern art 1960. It assembles free-standing works and reliefs made of sponge, wood pegs, tacks, a smashed fender, folded paper, ping-pong balls, playing cards, spikes, a stuffed chicken, a cut-out bird, tar, garter-belts, coffee-grounds, a railroad tie, styrofoam, polyesters, corrugate, pillows, an electro-magnet – rubbish and valuables, "garlic and sapphires in the mud . . ." Chronologically the start is ancestral objects by Arp, Schwitters, Calder (but where is St. Marcel?); there are established artists whose works here seem brimming with dignity – Cornell, Dubuffet, Mallary, Zogbaum; there are the latest "sensations" from just below Tenth Street and the far-out colonies of the Coast and Continent. Quality is as varied as materials. Bare-foot crypto-Bohemian farce and art-student efforts elbow their ways through works of severe insight and hard-won originality.

Previewing the exhibition in a spare room (that looked like *Citizen Kane* directed by a Collyer Brother) hardly afforded the opportunity for leisurely observation. But the jumble made the issue of the show even clearer: a great many artists today seem dissatisfied with the basic limits of Art, not for esthetic reasons, but for social ones. There is a kind of protest in many of these works, but it is not against the values of middle-class society as were the Dada manifestations. Rather the new protest is in favor of society – or for People in general – and against the invisible, crystal-hard barriers that an oil-on-canvas or a sculptured-sculpture place between the witness and the finished object. It is as if many of these artists were trying to reach out from their works to give the spectator's hand a good shake or nudge him in the ribs. You are invited to touch and move things, open hinged boxes, switch playing cards around, to rearrange "compositions": be a participant – *homo ludens* – in a game with art. The only rule kept is that there must be at least two people in each game – artist and onlooker. One gets the feeling that many of these works could die of loneliness. Thus it follows, it seems to me, that the human (i.e. ethical) quality of the audience will directly affect and modify the esthetic quality of the work. Art becomes an event and its audience's response is a function of art's equation – indeed it is the X which the artist wants to keep unknown and, in so doing, gambles his work on each pair of eyes and hands with which it collides. To over-simplify: such a work might be handsome and amusing among a group of artists and disgusting and boring at a chi-chi private viewing – depending on who is in attendance.

Not all the works in the exhibition, of course, break with that ambiguous *stasis* which has been the strength and the purity of the fine arts since long before its definition by Aristotle and which will endure until generations from now. Cornell and Mallary, for example, by the perfection itself of their craft and vision (you must look closely at the parts to see the logic of their unities), re-establish a "distance," a remoteness of art. This separation, magic quality of scale, exists in the lush imagination that is behind Rauschenberg's "combine" and Zogbaum's throne for a boulder. It is present, elsewhere, too. But an attack on the aristocracy of art by and with art is the main point of the exhibition –

Art News, Summer 1960: 45, 62

although "attack" is too aggressive a noun for the witty, ingratiating social activity to which so many of these works are dedicated. Is there, perhaps, a new collective dive into sociology, into the streets, to the crowded sidewalks where barricades have become only romantic souvenirs? A soft Revolution? It is a subject to which this writer hopes to return in a more extended observation.

JASPER JOHNS

Robert Rosenblum

The situation of the younger American artist is a particularly difficult one. If he follows too closely the directions established by the "Old Masters" of that movement inaccurately but persistently described as Abstract Expressionism or Action Painting, he runs the risk of producing only minor embellishments of their major themes. As an alternate approach, he may reconsider the question of a painting's reference to those prosaic realities banished from the Abstract Expressionist universe. Like many younger artists, Jasper Johns has chosen the latter course, yet unlike them, he has avoided the usually tepid compromise between a revolutionary vocabulary of vehement, molten brushwork and the traditional iconography of still lifes, landscapes, or figures. Instead, Johns has extended the fundamental premises rather than the superficial techniques of Abstract Expressionism to the domain of commonplace objects. Just as Pollock, Kline, or Rothko reduced their art to the most primary sensuous facts – an athletic tangle of paint, a jagged black scrawl, a tinted and glowing rectangle – so, too, does Johns reduce his art to rockbottom statements of fact. The facts he chooses to paint, however, are derived from a non-esthetic environment and are presented in a manner that is as startlingly original as it is disarmingly simple and logical.

Consider his paintings of the American flag. Suddenly, the familiar fact of red, white, and blue stars and stripes is wrenched from its everyday context and forced to function within the rarified confines of a picture frame. There it stands before us in all its virginity, an American flag accurately copied by hand, except that it now exists as a work of art rather than a symbol of nationalism. In so disrupting conventional practical and esthetic responses, Johns first astonishes the spectator and then obliges him to examine for the first time the visual qualities of a humdrum object he had never before paused to look at. With unerring logic, Johns can then use this rudimentary image as an esthetic phenomenon to be explored as Cézanne might study an apple or Michelangelo the human form. But if this artistic procedure of reinterpreting an external reality is essentially a traditional one, the variations on Johns' chosen theme seem no less extraordinary than its first pristine statement.

To our amazement, the American flag can become a monumental ghost of itself, recognizable in its tidy geometric patterns, but now enlarged to heroic size and totally covered with a chalky white that recalls the painted clapboards of New England houses. No less remarkable, this canvas-flag can be restored to its original colours, but unexpectedly con-

Art International, September 1960: 75-77

sidered as a palpable object in space from which two smaller canvas-flags project as in a stepped pyramid. Or in another variation, the flag, instead of being tripled outward into space, can be doubled vertically, coloured an arid slate-gray, and painted with erratic and nervous brushstrokes that threaten the dissolution of those once immutable geometries of five-pointed stars and parallel stripes.

If we expect to salute flags, we expect to shoot at targets. Johns, however, would have us realize that targets, like flags, can be the objects of esthetic contemplation and variation. The elementary patterns of concentric circles, as recreated by Johns in a monochromatic green or white target are to be stared at, not aimed at, and offer the awesome simplicity of irreducible colour and shape that presumes the experience of masters like Rothko, Still, and Newman. Again, as with the flags, this symbolic and visual monad can be transformed and elaborated. Such is the case in another target, whose circles are painted in different colours and whose upper border is complicated by a morbid exhibition of plaster body fragments. Or then, there is a target drawing in which, as in the double gray flags, the impetuous movement of the pencil disintegrates the circular perfection of the theme. Johns' capacity to rediscover the magic of the most fundamental images is nowhere better seen than in his paintings of letters and numbers. In "Gray Alphabets" he makes us realize that the time-worn sequence of A to Z conveys a lucid intellectual and visual order that has the uncomplicated beauty and fascination of the first page of a children's primer. Similarly, the "Gray Numbers" presents another chart, whose inevitable numerical patterns are visually translated into that ascetic geometric clarity so pervasive in Johns' work. At times, Johns even paints single numbers, as in "Figure One," in which the most primary of arithmetical commonplaces is unveiled as a shape of monumental order and a symbol of archetypal mystery. Such works look as though they might have been uncovered in the office of a printer who so loved the appearance and strange meaning of his type that he could not commit it to practical use.

If the almost hypnotic power of most of Johns' work is in part the result of his disconcerting insistence that we look at things we never looked at before, it is equally dependent upon his pictorial gifts. In general, he establishes a spare and taut equilibrium of few visual elements whose immediate sensuous impact is as compelling as the intellectual jolt of monumental flags and targets in picture frames; and his colours have a comparable clarity and boldness. Nor should his fastidious technique be overlooked. Most often he works with a finely nuanced encaustic whose richly textured surface not only alleviates the Puritanical leanness of his pictures, but emphasizes the somewhat poignant fact that they are loved, handmade transcriptions of unloved, machine-made images. Although Johns has devoted most of his young career to the manipulation of target, flag, number, and letter themes, he has also made many other discoveries. There are, for example, the chilly expanse of mottled gray geometries that becomes a tombstone for the Victorian poet whose name seems to be carved at its base; and the small open book, transformed from reality to art by the process of painting, and therefore concealing, the print on its page, and by fixing its mundane form in a position of heraldic symmetry within a framed box. And no less inquisitive about the interplay between art and reality are the "Drawing with Hooks," an intellectual and visual speculation on the curious mutations of two- and three-dimensional illusions when a canvas with two projecting hooks is viewed from both the front and the side; and the more recent "Thermometer," in which painted calibrations, fixed by the artist's brush, permit us to read on a real thermometer those fluid variations of temperature determined by nature rather than by art.

It remains to be said that Johns' adventurous inquiries into the relationship between

art and reality have often been equated with Dada, but such facile categorizing needs considerable refining. To be sure, Johns is indebted to Duchamp (if hardly to other, more orthodox Dadaists), whose unbalancing assaults on preconceptions were often materialized in terms of a comparably scrupulous craftsmanship, yet he is far more closely related to the American Abstract Expressionists. For if he has added the new dimension of prosaic reality to their more idealized realm, he has nevertheless discovered, thanks to them, that in the mid-20th century, the simplest visual statements can also be the richest.

From AFTER ABSTRACT EXPRESSIONISM

Clement Greenberg

The crux of the matter of the aftermath of Abstract Expressionism has, in any case, little to do with influence in itself. Where artists divide in the last resort is where safe taste leaves off. And this is as true in what begins to look like the aftermath of Abstract Expressionism as it ever was. The painters who follow Newman, Rothko, or Still, individually or collectively, are as safe by now in their taste as they would be following de Kooning or Gorky or Kline. And I have the impression, anyhow, that some of those who have chosen to do the first, and not the second, have done so because they feel frustrated, merely frustrated, by the going versions of Abstract Expressionism in New York.

This applies even more, I feel, to those other artists in this country who have now gone in for "Neo-Dada" (I except Johns), or construction-collage, or ironic comments on the banalities of the industrial environment. Least of all have *they* broken with safe taste. Whatever novel objects they represent or insert in their works, not one of them has taken a chance with colour or design that the Cubists or Abstract Expressionists did not take before them (what happens when a real chance is taken with colour can be seen from the shocked distaste that the "pure" painting of Jules Olitski elicits among New York artists). Nor has any one of them, whether he harpoons stuffed whales to plane surfaces, or fills water-closet bowls with diamonds, yet dared to arrange these things outside the directional lines of the "all-over" Cubist grid. The results have in every case a conventional and Cubist prettiness that hardly entitles them to be discussed under the heading "After Abstract Expressionism." Nor can those artists, either, be discussed under this heading whose contribution consists in depicting plucked chickens instead of dead pheasants, or coffee cans or pieces of pastry instead of flowers in vases. Not that I do not find the clear and straightforward academic handling of their pictures refreshing after the turgidities of Abstract Expressionism; yet the effect is only momentary, since novelty, as distinct from originality, has no staying power.

Excerpt, *Art International*, October 1962: 24–32

POP ART AND AFTER

Jasia Reichardt

In England the interest in "pop art," as it has been called during the past year, has been quite unprecedented. In view of the fact that its exponents are very young, i.e. in their early twenties, the general enthusiasm for their work has been something of an event. To-day when we speak of "pop art," we don't think of the original meaning implied when the term was first invented nearly ten years ago.

Contrary to general belief, pop art did not come from the U.S.A., it was born in England. Lawrence Alloway first coined the phrase "pop art" in 1954, and his exact definition of what it meant was very different from the meaning ascribed to it now. When Alloway spoke of "pop art" he meant: advertisements in glossy magazines, posters outside cinemas, leaflets, pamphlets, all give-away literature forcefully communicating a single message. He meant, in fact, the whole paraphernalia of public art – art made by the few for the many, not for its own sake but for the sake of what seems to be naively speaking, an ulterior motive. Thus, pop art accompanied one during breakfast, on the way to work, during one's leisure hours and it infiltrated its way into one's dreams, forcibly and inevitably. Had Alloway, instead of using the term "pop art" coined another phrase, say, "visual pop kicks," or "mass pop samples," the controversy which involves the use of the word "art" with veneration for traditional meaning, instead of assigning to it a completely new significance, the current revival of figurative painting in England would have been called something else. Perhaps it would have been called "big city folk art."

In 1952 in London, a group of young artists, writers and architects used to meet at the Institute of Contemporary Arts for discussions and lectures. In order to stress their affiliation with the avant garde, and with history in the making rather than with that already set down in books, they called themselves the Independent Group. Among them were Peter Reyner Banham, Richard Hamilton, Lawrence Alloway, Eduardo Paolozzi, William Turnbull, Nigel Henderson, Sandy Wilson, Edward Wright, Toni del Renzio, John McHale, Theo Crosby, Alison and Peter Smithson, John Voelcke, Jim Stirling, and others. The subjects discussed by the group included philosophy, science, and later, cybernetics, information theory, communications, mass media, fashion, "pop" music and industrial design. The first convenor of the group, 1952/53, was Reyner Banham. In 1954 Alloway and McHale became joint convenors, and by 1955 the talks included such subjects as violence in the cinema, by Alloway, and American automobile styling, by Reyner Banham; ensuing discussions took place in 1952, when Eduardo Paolozzi showed what he then called "found images," projected on a screen. The "found images" consisted mostly of advertising material which, when isolated and enlarged, seemed to acquire a new meaning and a new significance. Later the architect Peter Smithson also organised a similar evening using publicity material. The first exhibition to make use of this sort of subject matter took place in 1953 at the Institute of Contemporary Arts under the title "Parallel of Life and Art," and was organised by Paolozzi and Smithson.

The preoccupation of the group with mass media was a socially significant sign. A new sort of respectability descended on such lightweight and intellectually undemanding material as science fiction and cowboy movies. The very notion of culture changed before

Art International, February 1963: 42–47

one's eyes, and time hitherto afforded for the discussion of a "Western." The unlimited communication assailing one in the form of radio, television, reading matter, had forced its way into one's consciousness and could not be ignored. In 1955, John McHale went to the U.S.A. and when he came back some months later he brought with him a trunk full of glossy magazines: *Esquire*, *Mad*, *Playboy*, etc. These provided much material for discussion. At the time the group looked to America as the source of a new and unexpected inspiration, as a romantic land with an up-to-date culture, a hotbed of new sensibility in art.

One person on whom the glossy American literature made a tremendous impact was Richard Hamilton, who later became the initiator of "pop art" in England. Hamilton's definition of pop art was rather different from Alloway's. Whereas Alloway did not envisage pop art as fine art at all, nor as anything that called upon one's really creative instincts. Hamilton used the term to describe the sort of source material the artist was drawing on in making his *own* imagery, which was creative in every sense of the word.

The first piece of work in pop art idiom (according to Hamilton's definition) was shown in 1956 at the Whitechapel Art Gallery in London in an exhibition called "This is Tomorrow." The exhibition set out to show the possibilities of collaboration between an architect, a painter and a sculptor in making a visually meaningful environment. The exhibition included twelve sections designed and prepared by twelve different teams which included three or four people each. It was an attempt to draw the viewer into a work of art as an environment, rather than to show him an *objet de virtu* on the mantelpiece. The exhibition aimed at destroying the notion that art is precious and sacrosanct, and set out to present it as a space in which the viewer becomes involved and implicated. Accompanied by complicated and longwinded statements, pronouncements, and all the other items that traditionally go with the making of manifestos, the exhibition made its point that art was an integral part of life. As an art event, "This is Tomorrow" was a real shot in the arm, but the stand which was long remembered as the most extraordinary and strange was designed by Richard Hamilton, John McHale, and John Voelcke (architect). Hamilton wrote in the catalogue: "We resist the kind of activity which is primarily concerned with the creation of style. We reject the notion that 'tomorrow' can be expressed through the presentation of rigid formal concepts. Tomorrow can only extend the range of the present body of visual experience. What is needed is not a definition of meaningful imagery but the development of our perceptive potentialities to accept and utilise the continual enrichment of visual material."

Hamilton contributed a pop art collage of which a very large photostatted version dominated the entrance to the exhibition. The items in the collage included cut-outs of glamour girls, a strip cartoon, tape recorder, vacuum cleaner, tinned food, television, advertisements, furniture, and a muscle-man in the centre holding an object in the shape of a lolly-pop with "pop" written on it in large letters.

Courbet said a hundred years ago that "an artist must concern himself with his own time." When Hamilton on January 16th, 1957 wrote down a definition of what pop art is and what it can contain, he was following Courbet's dictum. Hamilton wrote: pop art is –

popular (designed for a mass audience)
transient (short term solution)
expendable (easily forgotten)
low cost
mass produced
young (aimed at youth)

witty
sexy
gimmicky
glamorous
big business

In his own work Hamilton combined the formal clichés of glamour anthology (be it feminine, masculine, appertaining to a city or a motorbike) with abstract considerations of pictorial structure. Typical of his early and recent work is that nothing happens in his painting-collages without a clearly defined reason or a discernible source. For instance, if one may wonder about the significance of a row of dotted lines appearing in the picture – it is certain that their presence is not incidental or of a purely pictorial function, but that they had appeared in some other form in an advertisement or a poster from which some other section of the painting had originated. In a strange sort of way one could assign to Hamilton the function of an editor who collects material and quotations and later transforms them into something else, without ever forgetting their original source or function. Basically all his elements, however disparate they may seem, are related at source. His paintings have always been characterised by exactitude and precision, and the only ambiguity from advertising and publicity material to Hamilton's paintings is never explicit.

One might ask: what has Chrysler Corporation to do with an artist living and working in London who has, moreover, never been to the States? When Hamilton painted his *Hommage à Chrysler Corp.*, which was, in fact, his second pop art painting, he had simply made a statement about the presence of new demi-gods that the post-war generation of artists had elected. If Hamilton was living in Yugoslavia he might have painted an homage to Ford. However, living in England where Ford is a common commodity, he chose as the subject for his homage a car manufacturing corporation that epitomised the ethos of a country he had never visited. He was painting an imaginary representation of something that was essentially an unknown quantity and that carried the romantic associations of a materialistic heaven.

In 1960, at the annual Young Contemporaries exhibition held in London – which contains the work of art students submitted from the whole of Great Britain – a group of young painters who were at that time students at the Royal College of Art showed a number of works which included allusions to pop art imagery. Their preoccupation with figuration was a violent departure from the abstract tendencies of the generation immediately before them. The three most important influences evident in the work of these young artists were R. B. Kitaj (an older student at the Royal College who was preoccupied with historical and social events as sources for his imagery), Richard Hamilton, and Peter Blake (an ex-College student who had created a personal, romantic art form in which he incorporated Victorian valentines, dolls, mementos of the music hall and likenesses of popular vocalists). The group of young painters asserted their position firmly within one year, and at the end of 1961 their work created a considerable amount of interest in the John Moores Liverpool biennial. The "pop art" title was bandied about in connection with these young painters, although it soon became quite clear that they resented it. Among those working in this new figurative idiom who had so quickly distinguished themselves were: Derek Boshier, David Hockney, Brian Wright, Anna Teasdale, Allen Jones, Peter Phillips, Howard Hodgkin, Norman Toynton, Pauline Boty, John Bostead, and others.

There are several reasons why the title pop art is a misnomer when applied to them

collectively. First of all, their social consciousness is fairly dormant – that is, with the exception of Boshier – and if they incorporate such pop art elements into their work as advertisements, pin-ups, targets, toothpaste, bikinis, motorbikes and newspapers, their treatment of these elements is almost purely romantic. Yet, to present these artists collectively as the new English romantic movement would be equally erroneous, for the name does not take into account the spirit of whimsy with which so much of the work is imbued. In a recent exhibition in which six of the above mentioned painters took part at the Grabowski Gallery, their statements (which appeared in the catalogue) clearly indicated that the paintings were based on personal experiences translated in a very obvious and direct way. The intellectual process which transposes events into symbols, metaphors, or geometry is totally absent. Instead, the emotional response to environment takes over, magnifying those elements which have had the greatest impact on the artist, and ignoring others which, incidentally, may have a greater universal significance. A modern fable has emerged which has been endorsed by these young artists. A myth in which the real princess is not discovered as in Andersen's tale by her sensitivity to a dried pea that was placed under the tenth mattress, but by her ability to answer the question why one should use toothpaste brand A rather than brand B, without actually believing in her reply. Glamour, advertising, a certain amount of cynicism, are all public commodities which have been turned into private dreams and fantasies.

In one sense, one could refer to the work produced by these artists as urban folk art. And indeed the essential quality of folk art is often persistent, but whereas folk art is made by the many for the many, the elements of pop art (such as publicity material) are made for mass consumption by the few. The artist too is a consumer. The consumer of brand goods as well as of easily obtained and cheap entertainment, which allow him to enter into the spirit of the time without involving such issues as politics, economics, social problems, and religion. With the exception of Boshier, who has painted very few pictures that did not bear references to the space race, the others have solely made use of entertainment-industry topics, or of such pedestrian articles as playing cards, newspapers, disc sleeves, games, etc., which are then imbued with that particular spirit of irreverence characteristic of all these paintings.

Derek Boshier with his rainbows, pin ball machines, guns, and little pink figures inevitably turning into inanimate objects and shapes, has been concerned more with the social significance of events, and for this reason his work is concerned with rather more serious issues than that of the others. Anna Teasdale in her fragmented paintings with references to an industrial city life has quoted visual images from reality, which like pieces of jig-saw puzzle fit into a routine of somebody's life. In her subject matter she comes closest to the preoccupation with social realism of painters like John Bratby and Jack Smith some six years ago. Peter Philips has taken the whole gamut of the colours and symbols of the fair; from its pot-luck and brashness he has created fantasies that are now rather distant from the themes which first inspired them. Howard Hodgkin has presented modern man with Victorian pomposity. He has made a melodrama out of nothing, conveying the ridicule of a man who despite the number of layers of clothing he wears is always naked inside and always vulnerable. Specialising in the literary translation of imaginary events which are usually triggered off by some personal escapade is David Hockney, who has already had a considerable amount of success in London. His paintings have the irresistibility of allusions to passion in the form of small tokens and shared secrets. Nothing very dangerous, but just sufficiently naughty for the viewer to get the feeling of conspiracy. Hockney's special kind of whimsy presents the fears and hopes that most people

have but lack either the language or the coherence to voice. With a certain amount of self-indulgence, Hockney has touched our sensibilities with strange accuracy. Allen Jones's allusions to real events are very tenuous. In the painting entitled *The Battle of Hastings* he makes reference, through symbols, to a state of tension. The title refers simply to the preoccupation of his students at the time he was painting the picture with that particular historical event. In his *Bikini Baby* the process of fragmentation has left only a suggestion of what might or could have happened to the theme. This is a good example of literary theme being lost through the process of pictorial presentation. Norman Toynton has translated such symbolic events as *The Temptation of St. Anthony* into purely personal and subjective experiences. Often the events in the story are presented simultaneously within one canvas and occasionally supplemented by written comments. Brian Wright's paintings have contained rather more cryptic references to outside happenings. One of his best works was based on the theme of a recurrent nightmare in which two elements, a flower and a rock, became the symbols of menace.

What is interesting about these young artists, who lack neither courage nor eloquence, is that they say neither No nor Yes to the world. They don't accept things as they are, they make fun of them, they make use of them out of context, but they don't rebel against anything. They have made use of every scrap of information, news, emotion, publicity, bad luck, etc., that comes their way. Like hungry animals they have swallowed the world wholesale, and quickly forgetting its meaning they continue to lead their own lives and to play their own games.

This art must be taken at its face value, because a search for deeper meaning would be fruitless at the moment. So far, the contribution of these artists is a sly irony, well-aimed whimsy, and some individual talent. The new figuration movement which has captured the public eye to such an extent is still in the embryo stage. Only the next ten years will tell whether something exceptional can emerge from art under this much used and misused heading, pop art.

From ROBERT RAUSCHENBERG

Alan R. Solomon

In the past several years the course of American painting has taken a dramatic new turn, so that for the second time since the end of the war important new developments in contemporary art have centered in New York, rather than in Europe. These innovations reach far beyond the familiar alterations of stylistic position which occur in every new generation, since they include a number of diverse new styles; instead, they have to do with a basic readjustment of all of the artist's attitudes toward his forms, his content, and his materials. As a result, we are presently experiencing the most radical alteration in modern art since the invention of cubism.

To some observers these changes seem old hat, but the seriousness, the importance and the scope of these new developments cannot be denied, despite the discomfort they stimulate. If the new abstract painting recalls the hard-edge geometric development out of cubism, it still differs significantly from the painting which preceded it in the thirties and forties. In the same way, the apparent relationship of the "New Realists" or "Pop Artists" to Dada has gravely misled many people, so that the distinction and the importance of these artists has not been fully understood.

What then is the character of this new art? In the first place, both the new abstract painters and the new "figurative" painters share a profoundly altered concept of the psychological meaning of the painting or sculpture, in which a calculated measure of ambiguity and a persistent involvement in the deeper, inexplicable currents of feeling now shape the content of the work of art. For the former group, this means that the abstract vocabulary of shapes and colors generates a new insistent space and an equivocal formal tension which provoke enormously complex and compelling responses in the beholder, on terms distantly removed from the rational statement and the formal logic of abstract painting after Mondrian. If there is a paradox in this painting it is that ambiguities persist in the meaning despite the continuing clarity and purity of forms and colors, which differ in no essential way from earlier abstract painting.

None of these painters has altered the traditional attitudes toward materials and forms in art, which remain hierarchically pure. By contrast, the second group of artists has rejected wholly the idea that one kind of materials or another is more or less appropriate to the work of art. Indeed, they cannot any longer really be called painters, since the old distinctions between painting and sculpture have broken down to the extent that artists like Rauschenberg have had to devise new terms to describe the objects they make; in his case he calls his combinations of painting, collage and construction "combines." Furthermore, these artists have also set aside traditional esthetic values with respect to subject matter, and they have doubled back to a whole new range of previously reprehensible or even despicable subjects and images, which earlier had only been encountered in commercial art and other vulgar sources.

For this second group of artists, the involvement in psychological ambiguity attributed to the abstract painters above is extended to include both the content of the work of art and the very fabric of the object itself. For them a whole new world of expression has

Excerpt, exhibition catalogue, *Robert Rauschenberg;* The Jewish Museum, New York, March–May 1963

thus been opened out, and this extraordinary expansion of possibilities accounts for the force and vitality of the new movement which has burst upon us in such an uncanny and, for some people, frightening way. The positive commitment of these artists to the exploration of a new order of materials, images and relationships, operating on a direct and non-rational level, together with their pervasive sense of humor, distinctly weighted on the dark side, have led many people, as I have already suggested, to confuse them with the earlier Dada group. Yet their connection with Dada is far less important than the differences between the new artists and the Dadaists.

The issue of the acceptability of the common objects, advertising art, refuse, news photographs or cartoons as elements of a work of art seems to raise the Dada ghost of anti-art anew, but the esthetic and social climate in which the new art is produced differs substantially from that of 60 years ago. The apparently negative attitude of the Dada group toward art and society actually grew out of a deep sense of esthetic and political frustration. The new artists operate, by contrast, in complete esthetic freedom, and politically they have disengaged themselves totally. By way of explanation one might say that both the art battles and the historical battles have been fought for them by their predecessors, but whatever the explanation, the result seems to be that this new generation is wholly engaged in life and the process of art, in a direct, intense and optimistic way, without commitment to any of the familiar existing institutions. How did this come about? Apart from the larger historical considerations, two artists have played a major part in pointing the way for the new group. One of these, Jasper Johns, has had a great deal to do with the way younger artists are looking with new insight at both the abstract world of forms and the familiar world of the most banal objects. The other, Robert Rauschenberg, perhaps more than anyone else was responsible for reopening the broad question of esthetic appropriateness which has been discussed above. At the same time, Rauschenberg stands as the major link between the new art and the preceding generation of abstract expressionists, as well as with the more remote roots of the contemporary style in certain aspects of Picasso's Cubism of 1912-14.

The mature work of Rauschenberg which is illustrated in this exhibition spans a scant decade, from 1954 to the present. Despite the changes in style in this period, the body of his work consistently shows an involvement in an idea which he states clearly in the beginning and subsequently develops and enriches. His combines depend on the tension between freely manipulated oil paint, close to the expressionist style of de Kooning, and real objects, almost invariably "found" materials of great variety and in a relative state of decay. His painted surfaces, brightly colored and thickly applied (either squeezed from the tube or laid on in broad fluid passages which are scumbled or permitted to drip generously down the surface of the canvas), excite our visual and tactile senses, in the great tradition of twentieth century expressionism. The common source for both Rauschenberg and the generation of de Kooning is, of course, the bravura style of Picasso. The objects which Rauschenberg attaches to his canvases are either fragments of paper, cloth, wood or metal, usually rectangular and flatly applied, so that they refer to the surface, or a miscellany of three-dimensional objects, positively articulated, and often placed outside the frame of the canvas. Particularly in the earlier work, these are usually "strong" objects, with a high degree of associative value, like stuffed birds, pillows, or Coke bottles. Once again, the precedent for these objects turns out to be not Dada, but the constructions made by Picasso in 1912 and later, and, subsequently, the *objets trouvés* of Duchamp.

The basis of Rauschenberg's position lies extraordinarily close to the esthetic of Picasso, especially in the sense that both are involved in the tension between the illusion-

ism of paint and the impinging presence of fragments of reality. Both exploit the ambiguities of reading and meaning which such juxtapositions induce, and both are caught up in the sheer visual delight of the contrasts of texture and color which such a range of materials permits. Both Picasso and Rauschenberg deliberately choose weathered objects, pieces of wood, for example, which have been crudely cut, accidentally broken, stained, painted and weathered, so that their patinas become rich and unpredictable. They show the accidental effects of uses long forgotten, such as old nails or nail holes, or attached fragments of unidentifiable materials.

Except where he uses such complete objects as birds or photographs, Rauschenberg, like Picasso, carefully selects fragments which tend to suppress the true identity of the objects, so that he only permits fragments of words, for instance, to appear, with the result that letters become elements of the design, asserting their strong shapes and referring to the surface. In other words, they function as components of an enriched visual vocabulary which enlarges the range of pictorial opportunities open to the artist to a significant degree.

Many other artists have taken advantage of the visual possibilities suggested by Picasso's collage techniques, either in terms of the formal embellishments they permit, as in the case of Schwitters, or in terms of the ichnographical potential of specific images, as in the case of Max Ernst. In this sense, when Rauschenberg has been called a Neo-Dadaist, he is usually compared with Schwitters. Not only do his compositions have a cubist feeling in their tendency to dispose geometric shapes irregularly (a clear reflection of his relationship to Picasso and subsequent geometric abstraction), but they also depend, like those of Schwitters, on bits of familiar paper, refuse and nonsense fragments of words. Yet Rauschenberg's position is not really like Schwitters' or any other artist's, despite these superficial similarities. Schwitters' train tickets, or buttons, or bits of cloth, apart from the questions raised by their accidental origin (after Picasso) and apart from whatever private nostalgic meaning they may have, induce virtually no associative or emotive connotations. They do not call to our minds any situations or conditions which might evoke any pattern of interrelated responses in us. They simply tell us that in spite of their origins they function esthetically, and it is the most important quality they have in common with Rauschenberg's work.

The objects used by Rauschenberg have a high associative potential, because they are so powerful visually, because they are so manifestly decadent, or perhaps because they have been intensified by the artist in such a way that they become tawdry or repulsive and therefore provocative. The setting of such images side by side might at first glance seem to be the result of an anecdotal intention; this possibility appears to be even clearer in situations like that in *Canyon*, for example, where we find a color photograph of the Statue of Liberty, and where we can read words like "LABOR" and "ASOCIAL." However, it is not true that the combines are intended to be anagrammatic statements of ideas, as it were, which we are expected to puzzle out and which will reveal their meaning to us if we succeed in fitting the pieces properly. There are no secret messages in Rauschenberg, no program of social or political discontent transmitted in code, no hidden rhetorical commentary on the larger meaning of Life or Art, no private symbolism available only to the initiate. The enigmatic confrontations which he poses for us seem to demand explanation, and they force us to examine them more closely, to search for the key, to *look*. Their real meaning is contained in this simple fact, since the more we look, the more we are faced with complexities of meaning. In this way the paintings constantly renew themselves; their real virtue lies in their multiplicity, and Rauschenberg's images have been

chosen to maintain that condition of pictorial and psychological tension to which I have already referred. Resolution would destroy this tension, and the elements chosen never admit the possibility of logical interpretation or elucidation, either in themselves or in relation to the things with which they have been combined.

To take a specific example, the angora goat surrounded by a tire in *Monogram* is without a doubt one of the most extraordinary images of the century. Its "rightness" and clarity cannot be denied, and yet the goat absolutely defies any kind of rational explanation; it has no meaning, in the conventional sense. Yet there is a certain justness in the illogical association of the two elements which makes the object eminently satisfying to us, on a purely intuitive and utterly inexplicable plane. Rauschenberg seems uncommonly attuned to such possibilities and his great talent lies in his special sensibility to the evocative potential of his images which, despite their extravagance, never at any time become strained, obvious or trivial. The risk of overstatement in a piece like *Monogram* is one before which Rauschenberg never falters.

Indeed, Rauschenberg in all of his work is a kind of esthetic tightropewalker, easing his way along with a solid sense of balance above the pitfalls of ugliness, vulgarity or slickness. The sureness of his performance depends on taking chances; his absolute tact and his impeccable taste are concealed beneath the facility and the abandon of the performance. For those who are not aware of the distance he works above the net, his virtuosity can be confused with clumsiness. The casual, off-hand way in which he appears to work might suggest indifference and awkwardness, so that for them his boldness becomes affront. He might seem to depend too much on the bizarre encounter and the happy accident, on excessive statements and out-landish propositions. However, a more careful look at his intentions and at his way of working makes the absolute refinement of his position clear enough.

Perhaps the easiest way to demonstrate the mixture of deliberation and meticulous organization with planned accidental effects and slapdash execution is to compare the two versions of *Factum,* 1957 (not in the exhibition), which are virtually identical in shape, size and detail. The same elements of collage appear in both, while the smears and drips of paint almost coincide, granting the unpredictable and uncontrollable flow of the paint. Obviously Rauschenberg made the pair of paintings partly out of an awareness of this particular problem raised by his work, at the same time that he wanted to demonstrate the contrast between the exact equality of the mechanical collage elements and the minor variations in the painted passages, where each accident somehow establishes its own appropriateness. This kind of subtle idea, understated and ironic, always underlies Rauschenberg's solutions of the problem of the work of art, and it is through his constant re-examination of the inevitable paradox posed by the painting that Rauschenberg (along with Jasper Johns) has made his most important contribution to the progress of art and to the new generation. . . .

At any rate, when we turn to the meaning of Rauschenberg's art, the ambiguity and indeterminacy which are the conditions of his style make each combine a kind of unanswerable question, or series of questions, about art or experience, unanswerable because they are stated with such complexity, because they are formulated in terms which cannot be reduced to words, and because their purpose remains for them to be unanswered. Rauschenberg has said, "Painting relates to both art and life. Neither can be made. (I try to act in that gap between the two.)" The literal degree to which this is true should not be underestimated, and it becomes quite impossible to talk about Rauschenberg's art without discussing it in relation to the way it got made (his life).

In the first place, the unfamiliar and disquieted viewer might ask what motives apart from sheer perversity could account for hand-painted neckties attached to the canvas, bedding hung on the wall and smeared with paint, the ladder dividing a canvas in two, or the pair of real electric fans blowing at the canvas. Yet each of these situations with varying degrees of intensity raises questions about the quality of experience and the mechanics of the esthetic experience, about life (what is "real"?), and about art (what is "real"?). Is our response to the crass landscape painted on a necktie more "real" than our direct and tactile reaction to the smeared and dripping paint next to it? Is the abstract space of the paint less "real" than the illusionistic landscape on the necktie?

What is the difference between bedding on a bed (life) and bedding on a wall (art)? How are our responses to the familiar and comfortable altered by the introduction of ominous and enigmatic associations? The thousand comforts of a patchwork counterpane (grandma, home, childhood, order) give way to the horror (joy?) of corruption (enrichment?) by paint (blood?), producing Exhibit A, an arena of violence (what crimes, what unconscious feelings, what essential disorder?). And yet the question which is asked remains the same: Does not the work of art transcend life (reality) at the same time that its fabric is life? Is not the final meaning larger than violence and larger than comfort? Finally, perhaps the most important question Rauschenberg asks us: What is beauty, and where is it to be found? The answer, if there is one, must be: In life-art, despite any previous hierarchal ordering of materials or meaning. Rauschenberg's art is neither pejorative, nor a celebration of corruption. It is the highest and most affirmative statement of the quality and dignity of direct human experience, of the value of the least and most degraded object in the environment, of the potential for enrichment of the most hum-drum and deplorable conditions of our existence through a special way of looking, feeling, and questioning. Rauschenberg is a kind of transcendental *voyeur* (in the truest sense of Rimbaud and all modern artists after him) creating his own canon of beauty and thereby opening up a whole new world of esthetic experience for us.

The questions Rauschenberg asks about the work of art attack the fundamental basis of its physical nature. He refuses to allow the painting to remain a discrete rectangle, for example. He makes holes in it, through which the wall behind becomes an active force, providing a colored area of shadow as a result of the *Magician's* trick. He attaches a chair to the painting, a "real" object which has been activated by paint applied to it just as it is applied to the canvas, at the same time that the chair, by resting on the floor, relates the painting to its environment. In a similar way, a ladder divides the canvas into two unequal rectangles. They enclose a void, and yet they have no separate existence without the void and the ladder. Is the painting an object hanging on the wall or standing on the floor? How do we "use" the ladder? To what may we climb on it? Many of the objects used by Rauschenberg raise questions about their conventional functions in this way which their presence is not intended to answer. Neither should we consider them as symbols, in the sense that Miro introduces such objects into his pictures. Rauschenberg presents these objects to us as interrogatory confrontations which demand the answer that they are simply themselves, facts offered to us without prejudice except for his assertion of their appropriateness in these unfamiliar contexts.

In *Pantomime* a pair of identical old fans which actually work blow up clouds of paint, one dark, the other light, eddying against one another and literally seeming to move, since the canvas bellies against the currents of air. Here both the traditional physical inertness of the painting and the suggestion of expressive movement in paint have been called into question. Abstract masses of pigment imply movement in space through their

plasticity and through the cursive flow of the brush strokes, but the optical effect of actual movement here underscores the immutably fixed condition of solidified paint. This inherent paradox is one to which Rauschenberg returns frequently. He does so not only as part of his questioning process, but also because he likes the idea that his paintings may have a degree of independent existence after they have left his hand, so that they may continue to modify themselves predictably or unpredictably. In *Black Market* (not in the exhibition) Rauschenberg has arranged for the viewer to add or remove objects from the combine, with the result that the picture changes after each encounter as a consequence of conditions absolutely beyond the control of the artist.

Rauschenberg was also probably the first artist to explore the possibilities of adding sound to a painting; the three radios in *Broadcast* when tuned produce a collage of sound exactly parallel to the visual conditions operating in the painting itself, so that fragments of "real" sound (commercials, news, rock and roll music) play against abstract sounds (truck ignition and neon static, dirty controls in the radios). These ideas have widely influenced the new generation of artists, as well as some of Rauschenberg's contemporaries, so that Tinguely's constructions with radios, Dine's showers from which a spray of paint descends, and Wesselman's interiors with real television sets have become almost commonplace.

In his turn, Rauschenberg has often been compared with Duchamp, whose paradoxical turn of mind he frequently recalls. The fact is that Rauschenberg was not particularly conscious of Duchamp until quite late, until his own position had been for the most part defined. It has become increasingly difficult in recent years to determine very precisely how influences operate on artists because the modern press transmits ideas so rapidly and extensively that a photograph in a picture magazine may have a profound effect on a painter. Much has been made of the influence of Duchamp on artists like Rauschenberg and Johns, or the younger group. Even though the work of Duchamp had been accessible in the museums and galleries throughout the fifties, actually the publication of the American edition of Robert Lebel's book on Duchamp in 1959 seems to have stimulated a considerable amount of interest in his work: Rauschenberg did not make his *Trophy II,* which is dedicated to Duchamp, until 1960–61; he also acquired the replica of Duchamp's *Bottle Dryer* which he owns at this same time. Consciously or unconsciously, Rauschenberg reveals a true community of spirit with Duchamp, and he has found in him reinforcement and reassurance for his own position. . . .

From MONTH IN REVIEW: NEW YORK EXHIBITIONS

Sidney Tillim

In the gay town of Lepingville I bought her four books of comics, a box of candy, a box of sanitary pads, two cokes, a manicure set, a travel clock with a luminous dial, a ring with real topaz, a tennis racket, roller skates with white high shoes, field glasses, a portable radio set, chewing gum, a transparent rain coat, sunglasses, some more garments – swooners, shorts, all kinds of summer frocks.

<div align="right">Vladimir Nabokov, in Lolita</div>

QUESTION: Subject:

ANSWER: [in part] . . . The TILT of all those millions of Pin Ball Machines and Juke Boxes in all those hundreds of thousands of grubby bars and roadside cafes, alternate spiritual Homes of the American; and star-studded Take All, well-established American ethic in all realms – spiritual, economic, political, social, sexual and cultural. Full Stop.

QUESTION: What in your ancestry, nationality or background do you consider relevant to an understanding of your art?

ANSWER: Only that I am American. Only that I am of my generation, too young for regional realism, surrealism, magic realism and abstract expressionism and too old to return to the figure . . . I propose to be an American painter, not an internationalist speaking some glib visual Esperanto; possibly I intend to be a Yankee. (Cuba or no Cuba.)

<div align="right">Replies by Robert Indiana, painter,
to questions put by the Museum of Modern Art,
which last year acquired Indiana's The American Dream</div>

Rising to the challenges of continual change, American art has been a running accompaniment to the nation's history. For change and progress are the stuff of life, especially in America. And life itself, especially in America, is the heart and soul of painting.

<div align="right">Alexander Eliot, in 300 Years of American Painting</div>

It is both a tribute to and a criticism of the perverse genius of the "beatniks" that they have been able to exploit Walt Whitman as if he were Alfred Jarry. But it helps to explain why America's rediscovery of America, a preoccupation with our own past which overtook us during the 1950s (climaxing I think in the election of President Kennedy, who, as a writer and a devotee of touch football plus proof-positive wealth, reconciles the internal conflicts of the all but discredited American Dream, since renamed the National Purpose),

Excerpt, *Arts Magazine*, February 1962: 34-37, © Sidney Tillim

has been slow in revealing itself in modern American art for what it really is. For now we can find in a new generation of artists increasing evidence that not only is the American Dream not dead, but that it is also avant-garde. Obviously this is not the dream of the Founding Fathers, plucked from the deep freeze of history. It is an exalted but ambivalent hot rod version of it, substituting philosophy for polity, yet trying at the same time to "existentialize" the American experience. It is in his search for (an) experience that this new artist has come via a long route back to America as a new kind of primitivism. In mass man and his artifacts, his cigarettes and beer cans and the library of refuse scattered along the highways of the land with their signs, supermarkets and drive-in motels the New American Dreamer – let us call him – finds the content that at once refreshes his visual experience and opens paths beyond the seemingly exhausted alternatives of abstraction – *without returning to the "figure."* The New American Dreamer sees this new America, however, much like a foreigner. It has the same nearly morbid fascination for him as it does for Nabokov's Old World *émigré,* Humbert Humbert, who is secretly thrilled by the inventory of anesthetic items he has purchased for his "ultraviolet darling," Lolita. This "foreign" perspective in turn emphasizes the dreamer's link with the avant-garde traditions of Europe. He has never known, or at least never tried to know, art in any spirit but that of disaffiliation – the tradition of Bohemia. But where the disgusted European intellectual sees only the Indian – or the Negro – as the transcendent symbol of America's regenerative powers (the habit of condescension is hard to shake, even if you are nauseated by Europe; Sartre saw the prairies beginning at the outskirts of New York), the ostensibly disaffiliated American has discovered Mass Man, a sort of Paul Bunyan made over by the Industrial Revolution. He is mediocre, but he is honest – or at least *himself.* What's more, he has no *taste.* At any rate, the effect is the same as if the dreamer had slipped back into the (old) American Dream, blocking out his nostalgic sentimentality (for what else is it, really?) by taking refuge in his tradition of disaffiliation. In Robert Indiana's statement, for instance, the prodigal's return is concealed in the radical but pat language of protest.

I think that much of what has been called neo-Dadaism is but a form of this new dream, representing a subversive form of reconciliation with society on the one hand, with subject matter on the other, or at least indicating a repressed desire for both. The New American Dreamers are, in fact, realists of a sort, whose techniques have been wrongly interpreted, whose motives have been misunderstood, whose art has been simultaneously over and underrated, frequently by themselves. It is only because it is, aesthetically, an extension of avant-garde premises that it has received the lion's share of attention at the expense of a broad front of reaction which includes both the rhetorical provincialism and unabashed hero worship of the likes of Alexander Eliot, and all that is implied by the "new realism." At bottom the New American Dreamers remain sophisticates, as aware of style as their patrons (new dreamers produce new patrons). For these patrons, the adoption of traditional *kitsch* by the modern artist provides a vindication of the *original* American Dream.

It is hard to establish the charter membership of this phenomenon, but certainly Jasper Johns is somewhere near the top of the list, if not at the beginning, even if he has only brought a rare refinement to what was implicit in some of the cruder combines of Robert Rauschenberg. Though I have only read about them, the "happenings" (a sort of ultimate psychodrama theater in the round) put on by Allan Kaprow and his friends strike me as expressions of a longing for a childlike sense of participation in a total social experience – which is merely a corollary of the innocence projected by the very phrase

"The American Dream." And soon we shall be seeing more of artists like Indiana, James Rosenquist, Roy Lichtenstein and Peter Saul (Frumkin Gallery, January 9–February 4), portraitists of the banal, of the billboard, the automobile and the comic strip. (See also my review in this issue of Larry Rivers' new work.) If all this is merely neo-Dadaism, then the parent form itself has all this time been interpreted wrongly, probably to be consistent with the view of Western culture entertained by intellectuals and critics of a liberal – or even further Left – persuasion.

So much said, I have to and I willingly admit that – to me – the New American Dream in art is not entirely suspect. Given the development of art since the original avant-garde, I do not necessarily find it unnatural for one to be torn between a tradition of disaffiliation and a desire to reform. What I find suspect is work that does not transcend its own rationalizations such as Indiana's painting which lets the subject do the work of the imagination. Jasper Johns's sculpture, especially, does transcend these rationalizations. I also consider it highly revealing that Kaprow (for instance), an especially noisy American Dreamer, launched until recently his love-hate assaults on the squares from the Halls of Ivy, specifically, Rutgers University, where he taught. Similarly, I suspect that the sympathy I felt for Claes Oldenburg's *The Store* when I visited his studio, which had once really been a store, will at least partially evaporate when *The Store's* contents are shown at Green Gallery in the near future.

Oldenburg is the proprietor of the Ray Gun Manufacturing Co., a pseudonymous front for a talent (one I respect) which has so far conceived Ray Gun Comics, Ray Gun Mottoes, Ray Gun Theater and once even instigated a campaign to change the name of New York City to Ray Gun. (His participation in and creation of "happenings" only demonstrate to me that he too is, on occasion, a victim of the pressures of perpetual avant-gardism.) In May, 1960, Oldenburg installed within the now defunct Reuben Gallery a microcosmic city, built of cardboard, papier-mâché and stuffed burlap. If *The Store*, which opened and ran for the entire month of December (in co-operation with the Green Gallery), came closer to obviously embracing that which it presumably deplored, it was partly because Oldenburg no longer depends on Dubuffet for what was both aesthetically and sociologically misleading. Dubuffet's basal and reflexive sophistication contradicted Oldenburg's very real infatuation with the tawdriness of specifically American *kitsch*. *The Store* captured that and more.

It was the very simulacrum of the ultimate in American variety stores, a combination of neighborhood free enterprise and Sears and Roebuck. Its inventory included candy bars and wedding gowns, pastries and men's suits, bread, corsets, bacon and eggs, sandwiches, *cards* (*typique!*) of bow ties, carrots, a corsage and an airmail letter. Oldenburg had even had printed up for himself a business card and, not incidentally, had the posters announcing the event printed in Spanish Harlem by a man who improvises magnificent circus-type primitive typographical layouts. But the clothes were unwearable and the food inedible because they were all made of plaster and chicken wire and coated with dripping enamels – bright, gaudy, festive, vulgar, lugubrious, sloppy. *The Store* was a substitute for the real thing. Indeed, if its aggravated humor finally settled within an aura of faint melancholy – possibly my own – it was because it was all so hopelessly nostalgic. For each item and finally *The Store* itself embodied a special emotion, one which had compared the way things were (have Mary Janes gone up?) with the way things are, and found the latter a possibly appalling inevitability. Only a kind of mockery could make it all desirable again. Meanwhile the avant-garde would still receive the indigent.

It was a pleasure, and then it became disturbing, and I fell into the critic's habit – or

was it the consumer's? – of examining individual items. I began, in other words, to draw away from the experience via the aesthetic outlet that had been so carefully provided. I found the candy sticks too unformed, mere varied blobs of plaster and color. The wedding gown on a cadaverous mannikin was more lumpish than *lumpen,* undecided as to how serious it should be as sculpture. The pastries were especially attractive, and the air-mail letter I craved as I might a bit of eighteenth-century porcelain which I saw here in its demotic transformation. (The melting pot, of course!) Oldenburg made no effort to reproduce each item faithfully. The likenesses varied, for on the principle of caricature the color and tactile properties of each object were exaggerated, though usually natural scale was retained. But the degree to which Oldenburg caught the memorial character of the real thing, the way he invoked, for instance, the *feel* of an air-mail letter largely through color, the gelatinous and crumbly texture of a pastry, the ready-to-wear but ready-to-shrink visage of a mail-order shirt, the way, in other words, he evoked the *attitudes* invested in these material things, and even defined their class (no higher than middle), was really quite overwhelming.

Still, one must find a form for these things, and sometimes Oldenburg is seduced by his technique, permitting it and the subject, that is, its shock value, to take over – at which time the forms become unnecessarily gross and the perfection of approximation is lost as the paint drips back into the tradition of the new. In the end, *The Store* was more than the sum of its many wonderful parts. It epitomized, artistically, an unconscious effort to draw everyday America into art which is desperate for substance and communicable experience, yet is unable to surrender the aestheticism it believes it is thus shedding. It also is something of an answer to Coolidge's simplistic notion that "the business of America is business," but in its crazy mixed-up way doesn't know whether to laugh or cry. And it will be suspended over this chasm of indecision as long as it regards the banality of the American experience as a form of primitivism – and as kicks – rather than what it is – America itself, take it or leave it. . . .

"POP" CULTURE, METAPHYSICAL DISGUST, AND THE NEW VULGARIANS

Max Kozloff

Among labels which catch on and hold their place in the art world, but which were never deemed adequate to begin with, the term "Neo-Dada" is a lowly one. Before the "Neo" had even been defined properly, a number of painters have laughed it into obsolescence, even while they thrive on the absurdities and confusions which gave it birth. The city has been playing uneasy host to a group of such artists having first shows this winter – artists who come on calm and clean but iconoclastic. Naturally they would be among the first to disclaim that they form a group. And indeed, since they were spread out and unknown to each other, this would seem to be historically true, as it is stylistically obvious. The very fact, however, that they form a grass roots movement gives authenticity to their common concern with the problems of the commercial image, popular culture, and metaphysical disgust. Upon these themes, too, they superimpose an inquiry into the nature of the creative act, and the existence of the work as object and / or vision.

Particularly controversial was the show of Jim Dine at the Martha Jackson Gallery. Yet no one has remarked clearly enough that one of his most provocative gestures was to *return* to easel painting, not reject it. Having started his career with his celebrated "happenings" – that is, theatrical events created within a totally invented environment, Dine found himself at the farthest edge of that development (1950's) which sought to break into the spectator's space. How significant, therefore, to see him next not only embrace the durability of paint, but to engage particularly in those issues which finally allow a considered judgment of his work: the bringing to bear of insights from a completely separate métier into the pictorial context. Physical vestiges of the stage still remain, to be sure, in a platform supporting a black derby, or certain stage-set colours, but only to be translated into a different language. Similarly, Roy Lichtenstein (Castelli) and Robert Watts (Grand Central Moderns) come to painting originally from engineering, James Rosenquist (Green), from billboard work, and Peter Saul (Frumkin) might just as well be a refugee from the funnies. Yet, however varied their previous experience, the point is that they inject something of its mentality into art, which act is a sign of their conservatism as much as it is a token of their ambition. It is almost unnecessary to add that they mostly consider themselves to be interested in form, and that they compose and execute in no manner contrary to their more conventional colleagues.

Hence, to explain the shock with which they burst into your consciousness, you cannot accuse them either of using outrageous materials or of abusing the time honored rectangle of pigment. (With the exception of Oldenburg and Watts.) Rather, they operate by a metaphor which they know very well would be quite ridiculous for us to accept: that their work is not what it assumes itself to be – the actual thing, or something terribly close to it. Here I find myself disagreeing with Lawrence Alloway, à propos Dine, when he insists that "the object is present as literally and emphatically as possible." Such literalness would be too crass, even for artists who are rather complete vulgarians in other respects. In the same way, Dine does not show mystery to be unavoidable, as Alloway suggests, but that recognition of fraud is inevitable. Lichtenstein, Rosenquist, and Saul may set up

Art International, March 1962: 35-36

an illusion, but only so that they may finally *undeceive* the viewer. I suspect they accomplish this on two levels.

The first is by taking advantage of the proximity of abstract painting. These artists have a field day with the modern eye that has educated itself agonisingly to see no associations whatsoever in the physical presence of the painting. Now, suddenly, blatantly familiar images from reality ram themselves home, but, as distinct from those in merely representational or story painters, so magnified as to require reinterpretation all over again. (Oldenburg, Dine, Lichtenstein, Rosenquist.) Furthermore, the colours are not those of the real objects, but illustrative of them – those hues we pass by without self-reproach in catalogues and comic strips, but which seem much more nastily arbitrary in the new works than the completely arbitrary chromatics of abstract art. (Dine most successfully evolves a whole new palette from this idea, while Peter Saul's colours have a remarkable bathroom vitality.) In addition, an artist like Lichtenstein turns the whole abstract-representational argument inside out by demonstrating that the recognizable is not necessarily communicative at all, and that it is just as difficult to abide the known, as it once was to take the unknown seriously. Here is a pretty slap in the face of both philistines and cognoscenti alike.

The second twist is more fantastic. With Rosenquist, for example, the entire concept of the artist creating an image from his inner, or the outer, world is reversed. Instead, in his *I used to have a '50,* not merely do the images appear precreated, but the artist expects us, rather than himself, to contribute the imaginative values. He poses as the agent, not the author of the work. In Lichtenstein, this even goes so far as to produce canvases which are great simulated copies of tabloid engraving, reproduced down to the enlarged dots of the ink screens. Echoes of Surrealism are contained in this self-effacement which is nevertheless so ostentatious. One recalls Dali and his concept of the dream postcard, and even Blake, who considered himself merely God's secretary transcribing a heavenly vision. In any event, if the metaphor may be purposely obscured in the two artists just mentioned, or embarrassingly strained as in Oldenburg, there can be no doubt that all of them want the spectator eventually to triumph over it, and to recognize a special irony in their mock disguises – the responsibility behind the irresponsibility.

This brings us to the question: to just what extent are their themes altered by these kinds of vision? Peter Saul, after all, depicts grafitti which are careful re-evocations – in oil paint – of the careless. He is a great homogenizer of imagery, and tosses together emblems of the supermarket, latrine, and comic books, none of which, and here is the rub, would occasion a second glance if they weren't painted with an irritating excellence and organized so interestingly. Dine is even more shamelessly sensual as he gives us his meaningless illustrations, his ties and coats, which are not even symbols. (If there is a general rule underlying the new iconography it is that there is no focus, no selectiveness about it. Anything goes, just as anything goes on the street.) With Oldenburg, Lichtenstein, and Rosenquist, not to speak of Robert Indiana, the spectator's nose is practically rubbed into the whole pointless cajolery of our hardsell, sign dominated culture. (A recent painting by Joan Jacobs, *Ripe U.S.A.,* has the same effect, although her general interests are elsewhere.) Oldenburg may even be said to comment on the visual indigestibility of our environment by his inedible plaster and enamel cakes and pies. And Robert Watts flippantly insults the trivia of day to day living by modifying a U.S. Postage stamp machine so that it issues faintly pornographic stamps. With the exception of the latter, who is too much of a chameleon to classify, the new artists fall into two camps: the charmers and uncharmers. The trouble with the former is to determine whether the seductive surfaces are incidental to the coarse imagery, or vice versa; and with the latter, whether one

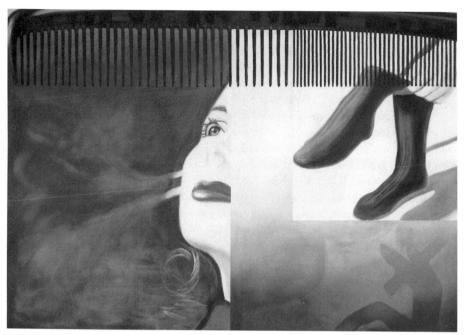

James Rosenquist, The Light That Won't Fail I, *oil on canvas, 71 ³/₄ × 96 ¹/₄ inches, 1961. Hirshhorn Museum and Sculpture Garden, Smithsonian Institution, Washington, D.C. Photograph by Lee Stalsworth.* © *1997 James Rosenquist / Licensed by VAGA, New York, NY.*

derives any pleasure from knowing that others, too, have felt the tormenting and biting quality of the American urban scape. But the probability of discovering their overall attitude to American experience is obstructed by their speaking farcically in tongues, as if, somehow, we were the witnesses of a demonic Pentecost of hipsters. Thus, Dine and Rosenquist and Lichtenstein address us as if we were children, and they, condescending adults, while Oldenburg and Saul pretend to be the children to our elders. The elaborate sarcasm of these projections confuses and mystifies their total handling of the problem of disgust – for no one knows whether there are essentially pictorial reasons for the new form, whether it is, perhaps, a dialogue with Pirandello (or Ionesco) now transposed to the realm of visual art, or whether, finally, they are in subversive collusion with Americana, while pleading the cause of loyalty to high art and a new beauty.

Yet, concerning that which is artistically new in this work, there is surprisingly little to say. On one hand, you have the injection of merchandising and "direct mail" techniques into art, a phenomenon much more sinister than the corresponding influence of de Stijl and the Bauhaus upon store fronts and display windows several years ago. And on the other, these curious and rather desperate impersonations, of which I spoke. For the rest, particularly the aspect of metaphor, there is a distinguished pedigree which may be worth commenting upon, for a moment. When Rosenquist paints a metallic scoop of ice cream, or Dine a flesh coloured tie, for instance, they are pulling down magical curtains over identity which Magritte had been "photographing" all during the fifties. And when Lichtenstein edges a contour, he follows in the footsteps of Stuart Davis, Richard Lindner, and Léger, who stands paternally over the whole mechanization of line, as well as the metallic shadow occasionally to be seen in Rosenquist. Then too, Oldenburg's plaster food is related to Picasso's famous charaded edible, *The Glass of Absinthe,* but where the

Picasso had a real spoon under the wooden sugar, the American attacks the same problem less humorously. I would also mention, in the more immediate surroundings, affinities the new artists have with Jasper Johns (who should be sulking over all this), Louise Nevelson, Cy Twombly, and Arman.

With all their more or less good company, however, there is a moral dilemma implicit in these latest vulgarities which is completely lacking in, say, their great precursor, Davis. It would be erroneous, for example, to imagine them quite as dedicated to pictorial self-sufficiency, to sheer energy of form and composition, as he. On the contrary, they depend too much on the repulsiveness of their imagery, so that artists as naturally desirous of recognition as they are, "hardsell" the public by means only of hardsell. Oldenburg has even cleverly fronted these activities with a "store," where you can buy his disagreeable pastries at "slightly inflationary prices." (One good way to starve.) Hence, there is a curious, frank admission of chicanery among them, that does not necessarily succeed in becoming honest. Nor are they any the more decent crooks with respect to the central idea – kitsch. Are we supposed to regard our popular signboard culture with greater fondness or insight now that we have Rosenquist? Or is he exhorting us to revile it, that is, to do what has come naturally to every sane and sensitive person in this country for years. If the first, the intent is pathological, and if the second dull. The truth is, the art galleries are being invaded by the pin-headed and contemptible style of gum chewers, bobby soxers, and worse, delinquents. Not only can't I get romantic about this, I see as little reason to find it appealing as I would an hour of rock and roll into which has been inserted a few notes of modern music. Only works of the most exquisite wittiness, such as a few I saw at the Dine, Watts, and Saul shows, escape the debacle. But I fear very much for their authors in the future. In the meantime, save us from the "uncharmers," or permutations thereof, the Rosensteins or Oldenquists to come!

From LOS ANGELES LETTER

Jules Langsner

This critic finds himself in the unfamiliar (and vaguely uneasy) position of being cantankerously at odds with a serious effort to fashion a new mode of vision in the pictorial arts. That effort is the attempt to invest commonplace objects with a hitherto unsuspected significance, usually in painting with a straightforward presentation, on a magnified scale, of things characteristic of our machine way of life. To be sure, this tendency, variously described as *New Social Realism, Common Object Painting,* and *Commonism*, currently is receiving the endorsement of the more zealous enthusiasts of "Pop" Culture as well as the shrill acclaim of the more chic circles of the art world. The latter group can be dismissed out-of-hand. Artists, unlike politicians, cannot be held accountable for their fanatical supporters. On the other hand, the partisanship of certain reputable critics and curators cannot be waved aside with cavalier insouciance. Something is going on worth notice, whatever judgement one finally renders.

The Pasadena Art Museum's current exhibition – *New Paintings of Common Objects* – has brought this emerging tendency into sharp focus, including, as it does, works by such members of the school as Jim Dine, Roy Lichtenstein, Andy Warhol, Edward Ruscha, Robert Dowd, Phillip Hefferton, Joe Goode, and Wayne Thiebaud, the last five of whom are Californians. A can of *Campbell Soup* by Andy Warhol, or a *Travel Check* by Dowd, initially rivets the viewer's attention by the simple expedient of removing the mundane object from its ordinary surroundings and enormously increasing its scale. The initial shock, however, wears off in a matter of seconds, leaving one as bored with the painting as with the object it presents. It is not the ordinariness of the object that induces boredom. After all, a loaf of bread and a jug of wine by Chardin are equally banal. The lack of interest generated by these works resides in the poverty of visual invention. It is not the eye that is engaged but rather the play of ideas this genre generates whether one is looking at the work or not. Indeed, it's not necessary to see the pictures at all in order to embellish psychological and metaphysical notions to one's heart's content. The paintings are made to order for "word people." They make excellent conversation pieces for dinner parties and graduate courses in esthetics.

It becomes quickly apparent at Pasadena that the Common Object painters are split with regard to literalness of presentation. It seems there are painterly commonists and meticulous copyists. Thus Warhol and Lichtenstein adhere strictly to accuracy of reproduction, while Dowd, Hefferton, and Thiebaud use the common object as a point of departure for painterly treatment. A hot dog or slice of cream pie by Thiebaud bursts with juicy pigment, a succulence that brings out the properties of paint more than it does the food he is obsessed with. The travel checks by Dowd, and the five and twenty dollar bills by Hefferton, are not presented straight, but positioned on a pictorial surface, often consisting of stars and stripes of the American flag. Both artists blur the insignia, letters, numbers and faces on the financial certificates with which enthralled, thereby adding a pictorial interest otherwise absent in their work.

The celebration of common objects particular to our mechanized civilization represents a Jean-Jacques Rousseau primitivism in reverse. The impulse is the same, merely

Excerpt, *Art International*, September 1962: 49

turned around, so that revulsion with the technological age has prompted the advocates of the genre to delight in what the custodians of culture are supposed to despise as ordinary and unworthy of attention. Instead of the happy care-free Noble Savage in a state of nature, the artist turns to despised objects in his everday surroundings. Unhappily, while the motive sprung for the effort is commendable, the works resulting from the impulse are insufficient esthetically. So far as this viewer is concerned, unless the eye is engaged in a kind of sight experience that cannot be delegated to some other order of being, the enterprise may have significance, but not as painting or sculpture. . . .

THE NEW AMERICAN "SIGN PAINTERS"

G. R. Swenson

A golden hand with a pointing finger (applied in gold leaf to a piece of now broken glass) hangs on a wall in Stephen Durkee's studio. It was once a sign of commerce and direction; now the hand, slightly etched and reworked by its owner, points nowhere and is a sign with a life of its own. The shining hand tells us more about its owner and his attitudes toward the world than about its original context.

This kind of sign has recently appeared in the paintings of a number of younger artists. Words, trade marks, commercial symbols and fragments of billboards are molded and fused into visual statements organized by the personality of the artist; they cannot be understood through formulas or some conventional pattern of visual grammar one or more remove from experience. The artists have shared – for the last few years, at least – a common interest in the ubiquitous products of their artisanal cousins, the painters of commercial signs and designers of advertising copy.

Like all artists who are unwilling to imitate, these painters force a re-examination of the nature of painting and its changing relation to the world. James Dine and Robert Indiana are proving that, as Rauschenberg puts it, "there is no poor subject." Roy Lichtenstein, James Rosenquist and Andrew Warhol are proving you can have recognizable references (so-called images) without regressing to earlier fashions. Richard Smith and Stephen Durkee, with their striking individuality and their formal sensitivity, bring diversity and depth to the newest phase of the continuing revolution that characterizes painting in the twentieth century.

The content of their work is direct. It points to objects that are commonplace. Their techniques are without ceremony or pretence. Ordinary objects which prick our associative faculties, along with a technique almost shocking in its simplicity, create the tone of this new painting. At the same time, although composed of fragments which may derive from Wall Street and Madison Avenue, the subject of these works, to use a phrase of George Heard Hamilton, "is not what the world looks like, but what we mean to each other."

Both James Dine and Robert Indiana regularly introduce words into their paintings. In a painting dominated by two necktie shapes, Dine prints the word "TIE" twice. On a

Art News, September 1962: 44–47

strip that looks like a riveted metal plate, Indiana stencils the words "THE AMERICAN REAPING COMPANY." Like words on signboards they insist on our attention. They are not subordinated to the composition as in a Cubist collage, nor are they used as a psychological pun as in some Surrealist painting (for example, when an image of a pipe bears the inscription, "this is not a pipe").

The visual references in the works of Dine and Indiana are readily and easily recognized. Dine sews buttons down the center of a canvas that is painted in the pattern of a heavy overcoat. He puts twelve cloth neckties into one picture, covers it all with green paint and calls it *Twelve Ties in a Landscape.* Indiana makes more subtle and oblique references. In *The American Dream,* the circle with highway numbers stenciled on it is the same yellow and black as stop signs; the double row of triangles in *The Great Reap* suggests the cutting edge of a mowing machine. He uses words to conjure unlikely presences. *The American Gas Works*, a black, yellow and white painting with those words stenciled in it, conjures a metaphorical meter-reader; the incongruity of his imaginary presence is heightened by the decorative elegance of "hard edge" visual variations of the theme. The words and numbers stenciled into the painting tighten the composition and, like arrows, indicate the direction the eye should travel. The meter-clocks lack hands, but the painting is kept from fantasy by the vigor of its color, the straightforwardness of the composition and the tension between a beautiful appearance and incongruous subject matter. Dine's concern with the abstract nature of the anatomy and its coverings is bold and questioning; Indiana's concern with unsuspected artistic juxtapositions is subtle and concrete.

There is something impudent in these works, something so simple-minded and obvious as to be unexpected. We find Dine mocking the meanings we conventionally invest in words and images. Both the word and the image in his work may refer to something well-known, like hair; in combining the two Dine has changed them both and revealed our arbitrary ideas of them. The image is merely an illusion we read into the work; yet it would also be an illusion to believe that we see only black, brown and flesh-colored oil paints squeezed out of a tube. The printed word seems superfluous; even in terms of pure composition the dotted "I" between "HA" and "R" is somewhat irrelevant. The redundant word underscores both the liveliness of objects and the deadness of definitions. The word and image have been willfully related until they – and our ideas of them – seem naked and slightly obscene. Repetition has blurred their commonness.

Both Dine and Indiana come from the Midwest: twenty-seven years old, Dine was born and raised in Ohio; Indiana, six years older, was born and raised in Indiana and Illinois. Both now live and work in New York; they are aware of each other's work, but disclaim mutual influences.

Dine even dissociates his present work from the "Happenings" he himself was doing merely a year or two ago [see A.N., May '61]. The sculpture of one of his associates in the "Happenings," Claes Oldenburg, can be (and has been) superficially linked to Dine's work; but Oldenburg's papier-mâché pastries deal – as one of their major interests – with the difference between illusion and reality. That difference is largely irrelevant to Dine's work; Dine takes for granted that the way in which each of us knows the world is "reality" to us and "illusion" to anyone who disagrees with us.

Indiana, if he admits influences at all, prefers to associate his work with that of his friends Ellsworth Kelly and Jack Youngerman. His present style seems to have grown out of an interest in an old circular copper stencil he found when he moved into his loft; he liked the shapes of the lettering and their purely formal possibilities. When he finally

used the stencil, however, the resulting words and even statements were not simply forms and their meanings not simply spice in an abstract composition; they were used by him to express concrete, vivid meanings – to convey the substance of an esthetic idea on which his forms then commented.

Roy Lichtenstein, James Rosenquist and Andrew Warhol have all had actual experience with commercial art. Thirty-nine-year-old Lichtenstein, a native of New York who now lives and teaches in New Jersey, had brief experience with industrial design and display work while living in Ohio. Several years ago he did some experiments using comic book designs as the formal basis for Abstract-Expressionist painting; in his recent work he has straightforwardly used the colors, stencils and Ben-Day dots of the comic strips as basic elements in his style.

Lichtenstein places a large face of a girl in one of his pictures; the girl may be pure although we cannot be sure, especially since the words "It's . . . It's not an ENGAGE-MENT RING, is it?" are written in the balloon next to her. To the left of the girl is a smaller man; size is the principal indication of space in these paintings. Partly because they are stenciled, the outlines do not contain mass or volumes, the space between them is as vacant as that between the wires of a mobile. The dots seem to waver like molecules; because of the regularity and the amount of white space between them, however, the screen of dots (by convention a solid in the comic strips) suggests merely a transparent plane. The picture is a stringent but amusing exposure of visual as well as social habits.

Although Lichtenstein attempts to make his color seem mass-produced, the objects he reproduces (for example, a kitchen range or a baked potato) seem neatly chosen and carefully arranged; they are not merely symbols of a type, just as his people are not merely symbols of general human traits. He is sometimes forced to vary the color he uses for the dots to make them seem the same "mass-produced" color as his solid areas; his paintings force us to find something important, amusing or inflated in a cliché, in an ordinary event or in tabloid heroism.

James Rosenquist, born in North Dakota in 1933, learned some of his present techniques while painting twenty-foot-high faces of mothers and other All-Americans on Times Square. As a commercial billboard painter he had to try to see the images he painted with his mind's eye, asking himself how they looked three blocks behind him. The size and familiarity of the objects in his paintings at the present time, and the explosive force with which they are presented, seem to place us between the picture and the position from which its fragments were meant to be seen; the space of the picture comes forward to surround us.

Rosenquist uses recognizable fragments of our environment as echoes. The radiator grill of an automobile, canned spaghetti and two people kissing have ready associations and everyday references, although they are likely to have been dulled through commercial familiarity; by combining them in *I Love You with My Ford* Rosenquist has pointed up the death of our senses which has made these three things equally indifferent and anonymous.

The painting is also concerned with how love is made. The upper section, an obsolescent '49 Ford, comments on things which change (car models), or persist (making love in cars). The progressive enlargement of scale in the three sections parallels the increasing intimacy and loss of identity in the sexual act. The artist changes his palette from grisaille to a vivid orange in the lower section. Like the interlocking forms which tie the left and right panels together visually, every aspect is ultimately seen for its importance to the whole. It is not simply rebellion when Rosenquist says, "I want to avoid the romantic

quality of paint." He speaks in the tradition of anti-Romantic Realist Courbet (not anti-Romantic Classicist Ingres), objecting to imitated moods and rarified atmospheres (not to the ignoring of rules).

Andrew Warhol was born in Philadelphia in 1931 and now lives in New York; until recently, he depended entirely on commercial shoe designs and advertising layouts for a living. Partially in reaction to the artificial neatness of the commercial designs, he often used to make a drip or blot in the painting he did for his own interest; he made those "accidents," however, seem quite painterly – they had a beauty often found in the intentional "carelessness" of some New York School painting. In one painting of an old can of Campbell's soup, the texture of the weathered tin surface behind the tattered label has a quality of lofty elegance. In a black-and-white painting of an enormous Coke bottle done early in 1961, nervous scratches are made in an enclosed area and a "mistake" is corrected with some handsome white paint brushwork. A recent black Coke bottle has none of those references to art; the painted bottle is larger and a trademark to its right runs off the right-hand side of the picture as if the 6-foot-high canvas were not large enough. The older picture provided a setting and its own scalar referents; the sense of a disproportionately increased scale in the later work results from the bottle being related to the familiar object we often hold in our hand rather than to the size of the stretchers on which the canvas is tacked. Our awareness is not so much of a Coca-Cola billboard as of the shrunken size of the world we occupy; an image from a sign, never intended to be so consciously seen in focus, is stripped of its original signification. Far from symbolizing a civilization, the image loses even its ability to symbolize a product. It signifies a specific common object; the shape, size and color of its presentation characterize an attitude toward objects to which we seldom pay conscious attention, but which make up the preconceptions of our everyday visual experience.

Art of the recent past not only provides a perspective on our environment; it is part of that environment, and one of especially intimate appeal to the artist. The formal debt of Richard Smith and Stephen Durkee to Newman and Rothko is clear; the significance of their adaptation is the radically different tone they bring to their work. Scale seems to be their closest link with the works of the two older painters; certain images which they use, however, relate to things outside the picture and produce a scale more analogous to that of Lichtenstein, Warhol and Rosenquist. Abstract painting often suggests specific moods, sometimes even objects; in a picture such as Franz Kline's *Shenandoah,* a landscape may be suggested by a few abstract brushstrokes. In a Smith painting (as in an Indiana), an image (or word) transforms the work's abstract elements into comments on the concreteness of the image (or the word); in a Durkee, as in a Dine, specific objects are drawn as explicitly as possible, yet it is not their concreteness but their abstract qualities which are most striking.

Durkee may simply copy markings from the back of a truck, or refer to a lion from a circus poster with a few sketchy lines, or paint consecutive numbers in such a manner as to suggest the passage of time. One of his most impressive qualities is his attention to detail – the delicacy of his expression and the distinctions which it implies. Two acrobats hang from a trapeze which has no visible support in one of his pictures. Their physical posture and their proportions are so stiff and stylized that one might suppose Durkee had based them on an old advertisement or a cut-out (actually they were suggested by two broken wooden dolls he used in a construction); they also have delicately varied outlines and shadows – as if the artist had been unable to rid himself of sympathy for his subject and intended to give them an inner quality deserving of our sympathy. (Durkee once

hired a commercial sign painter when he wanted perfect slickness and its quality of utter indifference towards the subject-matter.) The parable of one man depending on another might seem tired or commonplace without these details to give it intensity and vibrancy.

The distinctions he makes in *Flowers* are less subtle, but he maintains a similar tension between dubbed-in morality and intense concern. The three images are signs for three definite objects, although they may also be seen as symbols for the human, the mechanical and the natural. The relationship of each object to us (how we know and use it) is implied as well: the eye is closest and most abstract, the spokes of the bicycle wheels look like flowers, the natural object is known only through words. The various kinds and degrees of tension between image, scale and abstraction produce a sense of the vividness and complexity to be discovered in our examination of visual cliché.

Durkee was born near New York in 1938 and has lived in the city most of his life. Last year one of his neighbors in lower Manhattan was a thirty-year-old Englishman, Richard Smith, who has since returned to London. Both had their first one-man shows in New York in 1961.

Smith's *Billboard*, for the most part an orange surface varied only in the texture of the paint, has eight relatively small green rectangles around the top edge and along the sides with a strip of red across the bottom; with a few lines, Smith changes the red to bricks and transforms the entire tone of the painting. The unusual simplicity of the "billboard" image and its remarkable consistency with a beautiful solid-color expanse are both refreshing and unaffected. *McCall's,* the magazine that capitalized on the word "togetherness," is also the name of Smith's painting of a giant red, white and green heart. The heart shape is in part simply a device, no more concerned with its traditional meaning than the magazine's advertising campaign was concerned with human relations. Unlike the advertisements, the heart does to some degree revive old meanings while making its comment upon modern society; most of all, however, it moves us by the splendid beauty of its color and form. This beauty has the same irrelevance to the picture's subject and the same importance to the picture's comment that Christianity has to any good Baroque crucifixion. Like Lichtenstein, Rosenquist and Warhol, Smith focuses on exhausted symbols and brings them to life with an exploded scale; the comment and tone of the picture are most effective not because they pretend to be universally truthful but because they are genuine and present concerns of the artist.

Does the work of these painters constitute a "movement"? One observer who believes that it does has dubbed it "commonism"; a few of the artists find that label unobjectionable if not very illuminating. As we have observed, many similarities can be found in their work. Nevertheless Richard Smith's most recent painting, for example, is quite different from the two works discussed above and probably should *not* be called "sign painting" – even though, as Lawrence Alloway observed, it continues to show "approximations to marquee scale . . . combined with the soft-focus and dazzle of slick magazine color photography." Artists exhibiting such vigor and imagination as these are not likely to be confined by any idea or label for long.

The seven young painters described here revitalize our sense of the contemporary world. They point quite coolly to things close at hand with surprising and usually delightful results. A nineteenth-century landscape painter once said that Manet's *Fifer* looked like a tailor's signboard. To this Zola responded, "I agree with him, if by that he means that . . . the simplification effected by the artist's clear and accurate vision produces a canvas quite light, charming in its grace and naïveté and acutely real."

ON THE THEME OF THE EXHIBITION

Sidney Janis

Reaction and change in the continuity of art have never before undergone the rapid nor unpredictable succession of metamorphoses as they have in the twentieth century.

Cubism, Surrealism, Dadaism and later Abstract Expressionism, to name only a few, were each in turn ardent dissents from existing creative art forms and frequently before these forms were even accepted. The originality of each succeeding movement, challenged or maligned as it was, ultimately found its recognition.

Today's Factual artist, and the work of these artists make up the present exhibition, belong to a new generation (age average about 30) whose reaction to Abstract Expressionism is still another manifestation in the evolution of art. As the Abstract Expressionist became the world recognized painter of the 50s, the new Factual artist (referred to as the *Pop Artist* in England, the *Polymaterialist* in Italy, and here as in France, as the *New Realist*) may already have proved to be the pacemaker of the 60s.

City bred, the New Realist is a kind of urban folk artist. Living in New York, Paris, London, Rome, Stockholm, he finds his inspiration in urban culture. He is attracted to abundant everyday ideas and facts which he gathers, for example, from the street, the store counter, the amusement arcade or the home. Rediscovered by the artist and lifted out of its commonplace milieu, the daily object, unembellished and without "artistic" pretensions is revealed and intensified and becomes through the awareness it evokes a new esthetic experience. In the unplanned transformation the ordinary become extraordinary, the common, uncommon, a transposition in which the spirit of the common object becomes the common subject for these artists. Thus, the traditional artist-invented work of art now is supplanted unceremoniously by a true product of mass culture, the *Readymade.* Artists working in this direction form the central theme of the exhibition.

Also dead center to the idea of the exhibition is work colored by other qualities in mass media. The billboard, magazine, comic strip, daily newspaper, very directly have been the inspiration of a variety of facts and ideas introduced by the new generation.

Repetition, another inevitable consequence of his environment, plays a role as well in the artist's choice. *Accumulations,* objects painted or gathered in great quantities are leitmotifs, concentrated and accentuated by the New Realist. The multiplication of mass-produced objects into great accumulations imparts to the viewer a highly intensified visual experience.

These are the categories upon which the exhibition concentrates. To avoid confusion, peripheral, or closely related works of quality, but whose techniques are less factual than they are poetic or expressionist, have been omitted as outside the scope of the exhibition. In this sense, the paintings of Rivers and Rauschenberg come to mind. Johns, an established Factualist, also is, unfortunately, not included. To remain within the idea of the exhibition, the important directions of *Collage* and *Assemblage* are omitted. In line with this, the inventive walls of the pioneer Louise Nevelson, varied assemblages by Dubuffet; automobile compressions by César, assembled sculptures by Chamberlain and by Stankiewicz and work by Conner; Del Pezzo; Frazier; Marisol, among others, have not been included. Because of limitation of space, many artists working in the direction of

Exhibition catalogue, *The New Realists*, October 1962

New Realism, to name a few, Brecht; Filliou; Getz; Henderikse; Hockney; Kaprow; Kien-holz; St. Phalle; Watts; Westermann; are not represented in the present showing.

Since no attempt here has been made of an historical survey of the object in twentieth century Art, the pioneer, Cornell and the precursors, Picasso, Schwitters, Duchamp, Man Ray, together with others, have been exempt.

Because of its connotation, the label Neo-Dada sometimes applied to the new work, needs clarification, for while the Dadaist then and the New Realist now, have certain common ground, aims of each are in fact quite polar. Dada artists, disillusioned by the war, set out to destroy art; that despite negation and pessimism a new art-form came into being is beside the point, but none the less, a windfall we now gratefully accept. Still, the Dadaist in attitude and intent was violently anti-art; the present day Factualist eschewing pessimism is, on the contrary, intrigued and stimulated – even delighted – by the environment out of which he enthusiastically creates fresh and vigorous works of art. In this context, the angry young men of 1918, and the cool young men of today, are diametrically opposed.

But in the sense that the basic vocabulary of creative ideas survives, the long angry silence of Dada has ended, reborn with the healthy cry of a new generation. Duchamp, most prophetic of the Dada painters, whose sense of irony and indifference saved him from involvement with contemporary vitriolic controversy, himself has become, in recent years, most influential and encouraging to Factual artists everywhere. Duchamp's *Readymades* of 1914 remain today art works of vision and of particular significance and inspiration to the New Realist.

ART: AVANT-GARDE REVOLT

Brian O'Doherty

It's mad, mad, wonderfully mad. It's also (at different times) glad, bad and sad, and it may be a fad. But it's welcome. It is called "New Realists," and it opens today at 4 P.M. in the Sidney Janis Gallery at 15 East 57th Street.

The occasion is a rearguard action by the advance guard against mass culture – the mass culture that pushes the individual below the line into the lowest common denominator. In fact, it might be called an artful attempt to enrich spiritual poverty.

Included are advertisements, cutouts, garden tools, a lawnmower, newspapers, toothy Madison Avenue smiles, a refrigerator, cosmetics, plaster pastries – almost everything to assuage all appetites and nothing that you wouldn't see if you watched television commercials from 7 A.M. to 3 A.M.

All these defenseless objects are isolated, surrounded, manipulated in attempts to divert them from their everyday function to esthetic ends. Here form follows malfunction.

To turn these numb and blunted weapons of industry back on their source, the exhibitors (the word "artist" would require redefinition for use here) make use of the standard ploys of an educated minority against a majority they indulgently despise – wit, satire, irony, parody, all the divisions of humor. The exhibitors have a great advantage: the target is known to them and to their audience. The target is so big that it's hard to miss.

The general tone is zippingly humorous, audaciously brash, making use of the industrial products of conformity in order to nonconform. Behind this satiric attack on Madison Avenue there stands the injured shadow of the Common Man, sadly using after-shave lotion and brushing his teeth after every meal.

Although the standard vocabulary of such antique art movements as surrealism and dada is used, the intent is entirely different; a fresh wind is blowing across the vast billboard wasteland, and anarchy is out.

In Mr. Janis's definition of the "new realist" art, the touchstone is the "daily object" so manipulated that esthetic emotion is allowed to replace functional usage.

Although he does not keep strictly to his own definition (anyway it doesn't seem necessary to establish rigid cut-off points here) he has provided what must be the year's most entertaining show. "Entertaining" is the right word, for the show does not often transcend visual social comment: a sort of red, blue and yellow journalism.

This is one of the most interesting developments in the galleries, for it marks the entrance of artists into social criticism with ephemeral works that can be thrown away when circumstance has changed enough to remove their relevance. America has been a pioneer in throwaway cups and saucers, milk containers and tablecloths. Now it is a pioneer in throwaway art.

It might be added here that the catalogue articles take this development very seriously. "Pop" art, a very good name, becomes "new realism." Since the very essence of the movement is compounded of lightness, irreverence and wit, it would be ridiculous to take it with deep philosophical seriousness. This would perform the nice trick of making mass culture esoteric.

Not all the show is lightweight, just as not all the show is American. There is good

work from Britain and the Continent. But the clever things hook the eye. A dancing board shows the steps of a foxtrot. A rack of supermarket supplies is carefully compartmented. A la billboard hoardings, there is a vast, painted eye. There's also the old package trick: a package bound up with cord, with the permanent promise of unopened goods. There are papier-mâché pastries. All these are smart one-shot rockets that have no second stage.

What is welcome is a higher sense of esthetic responsibility among a few whose work has been turning up this year. Andy Warhol (despite his "Fox Trot"); Jim Dine, who goes past banality to produce some strange, seriously disturbing pieces, including a dislocating bathroom board with mirror, toothbrush and soap dish; Tom Wesselmann, who parodies bright advertisements until they become slightly cuckoo; and of course Wayne Thiebaud.

There is also excellent work by foreign artists, but it is more traditional in style. The main interest is the American satire of America's mass market. This is new.

The find of the exhibition is George Segal. His white life-size figures set up in hollow tableaus are as memorable and upsetting as stumbling into a ghost town dusted with fallout.

With this show, "pop" art is officially here. It is, of course, founded on the premise that mass culture is bad, an expression of spiritual poverty. So perhaps this is the old story of the avant-garde given the opportunity to seize on the bourgeois again, this time through its packaged products. Or, more amusingly, things may have reversed themselves, and now it may be the bourgeois that shocks the avant-garde.

THE NEW PAINTING OF COMMON OBJECTS

John Coplans

An exhibition assembled by Walter Hopps at the Pasadena Art Museum, with the following dramatis personae:

OUT OF NEW YORK: *Roy Lichtenstein*, age 42, previously an abstract expressionist living in New Jersey. First one man show of new work, Leo Castelli Gallery, New York, fall 1961.

James Dine, age 35, major figure in "Happenings" in New York ("Car Crash," Rubin Gallery, 1960). One man exhibition, Martha Jackson Gallery, fall 1961.

Andy Warhol, age 38, for several years a very successful commercial artist for top Manhattan fashion magazines, who, without exhibiting or even being thought of as a serious artist, developed new work over past two years in almost total seclusion.

OUT OF DETROIT: *Philip Hefferton*, age 29, sometime jazz trombonist and serious artist previously working in an abstract expressionist style.

Robert Dowd, age 28, a serious artist also previously working in an abstract expressionist style.

OUT OF OKLAHOMA CITY: *Edward Ruscha*, age 24, and *Joseph Goode*, age 25. In student exhibitions at the Chouinard Art Institute in Los Angeles their first adventures into their current work were received with ridicule and clamorous agitation. An ugly point was reached when an enraged faculty member burned a work of Ruscha, when hung on the Institute walls. Ruscha makes a livelihood in the field of commercial art, which he abhors, while Goode works at the Chouinard Institute doing odd jobs.

OUT OF NORTHERN CALIFORNIA: *Wayne Thiebaud*, age 42, assistant professor of art, University of California at Davis.

Practically every movement in the last thirty years has had a strong theoretical basis. Mondrian dealt with the glorious world of pure form, a metaphysical vision of architectonic space, Ernst and Dali with the vista of psychosexual imagery, abstract expressionism with the vista of surface light and color of actuality, in exchange for the actuality of paint (but with a certain duality of tension between the two factors rather than a complete overthrow). Given these preoccupations, with certain exceptions, a whole visual environment was being ignored. The lack of an empirical base and direct perceptual contact with the everyday world had serious consequences, leading to an inevitable trivialization of form and content. Without the knowledge of the theoretics of Yves Klein's art, for example, it is impossible to decode his paintings.

Neither philosophical newness nor modernism of metaphysics has ever necessarily led to the deepest art. The intuitive understanding of this position differentiates to a great degree the American artist from his European counterpart and the result has been an art of direct response to life rather than to "problems." The proverbial dumbness of most younger artists on the West Coast, for example, is a reflection not only of their deep understanding of the lie of the evolution of progress, but also an affirmation of the basis of both Jazz and Beat poetry, that art springs directly from life, with all its anguish.

Man, having engineered a society to an undreamed of state of mass production, now labors solely in order to consume with the same ferocity as he produces. He is constantly,

Artforum, November 1962: 26-29, © John Coplans

and with enormous pressure, subjected to visual effects conditioning him to selling and consumption, that is, message carrying, to inform and to induce him to act. This new art of Common Objects springs from the lashback of these visual effects and has nothing to do with any form of descriptive realism. Lichtenstein's painting of a hand holding a hairspray tells you nothing about a hairspray, any more than one of Cézanne's apples tells you about an apple: both are formal devices, but with an important difference. Cézanne's apple is mute, but Lichtenstein's hairspray carries a moral judgment. Lichtenstein's blownup image of the artwork of the ad brings out a true and most pointed flavor of the situation. The vulgarity of the image itself is shocking in the way the howl of the Beat poets is, in comparison, for example, to the cultured cantos of Robert Graves.

The sense of crisis precipitated in Lichtenstein's painting is totally missing in Thiebaud's paint act; Thiebaud's art is a coincidence: he lacks the guts and the total commitment of the others in this group. Lichtenstein's painting is deliberate, outrageous and daring. Thiebaud begs the issue. The anguish of the situation is not well enough reflected; he titillates rather than creates a distillation that can either lead to or bare the heart of the issues. Thiebaud is both clever and flippant rather than deeply perceptive, a polite slap instead of a murderous wound.

James Dine, somewhat like Frank Stella, uses the stylistic device of a series system, as in mathematics, but this device should not be confused with architectonic balance. He paints in series, eight separate but contiguous panels, on each panel a nearly, but not quite, flattened-out tit. He implies a comic paradise – an acre of tits. "I am surrounded by all good things," but at the same time there is highlighted the desperate and horrible depersonalization of contemporary American women (remember Magritte's imagery?). Although linked to surreal imagery, the format of his work probably derives from the problem of time sequences in his Happenings. But Jasper Johns' work (see chronology) is probably the focal point to which many ideas can be hooked. Even if a somewhat shaky terminus, every one "got through" via his insight. Dine paints something he likes to look at (tits and rainbows in this exhibition). His realistic rainbows are not an abstraction – he writes "rainbow" on them. Of all these painters, Dine, because of his complex and sophisticated background, is the most esoteric and does not fit too happily in the exhibition title.

Warhol, with his now famous Campbell soup images, refers to his work as a kind of portraiture. His images can be read as a pun on people, how much alike they are, how all that changes is the name. His S & H Green Stamp painting reminds us of a hive of grey flannel clerks, all identically clothed, all working for a pay check, to be spent on identical goods in identical supermarts to get identical stamps to redeem them for identical goods to be put in identical homes and be shared with stereotyped wives.

The isolated and lonely figure is thematic in American literature and constantly reoccurs, but here is a totally different approach from a humble nobody, a young unknown American painter named Goode, who has painted two of the loneliest paintings imaginable. They represent a totally new and radically different approach to the quest for identity. Each canvas rests on a squat white platform; the painted surface of the canvas, almost monochromatic, is slightly anthropomorphised into motion, but quite blurred and formless. On the platform, immediately in front of the painting, stands a milk bottle, covered completely with paint of a single flat hue, only the shape reminding us of a milk bottle. The nearest parallel would be the work of Cornell, because he is completely outside the logical mainstream of art, with a personal poetic logic, more poetic than logical.

He sets a standard in the use of concrete objects not to be surpassed, creating a whole new sense and logic of structure in our time. Goode has absorbed this new sense and uses it to create two most powerful, deeply moving and mysterious paintings.

Both Dowd and Hefferton paint American banknotes and seem to chronologically antedate Larry Rivers. In any event whether they do or not is unimportant, because their performance puts Rivers in the shade. Both painters have a high degree of painterly quality of paint, use loose color over color, dragged and dry-edge brush marks, impasto and drips, a heritage from the whole gamut of abstract expressionist painting technique. Hefferton uses his money as a device to make some excellent and imaginative portraits of Lincoln and Jackson and in one case substitutes a family portrait. But his handling of the portraits is so fine that he induces a freak love for these stereotyped heroes. Both these artists have a fixation on Lincoln. Dowd's Lincoln has a brash funereal quality. All his paintings have a high degree of paint sophistication, using blurring as a formal device almost as if his art does not depend on a precise environment. His typography on the notes is also used to create almost dada word puns.

Ruscha's art reminds us of the visual humor of Mondrian's "Broadway Boogie Woogie," but he is impressive for his creation of a totally new visual landscape. On the upper half of his paintings, almost like a heading, is the name of a product, Spam, Sunmaid (raisins) and Fisk (tires) while on the lower half is an image of the product. But he combines a beautiful use of typography with an exquisite sense of placing and extraordinary color to upset our whole aesthetic balance.

CHRONOLOGY: THE COMMON OBJECT AND ART

1890 Eugene Atget photographs the banal urban image.

1916 Impact in New York of the friendship of Duchamp, Man Ray and Joseph Stella. Both Stella and Man Ray produce collages and assemblages of ready-mades.

1920s Arthur Dove produces unique collage/assemblage work.

 Steiglitz photographs of the banal urban image.

1930s Joseph Cornell begins to use commonplace concrete objects themselves in a complex symbolism.

 Walker Evans, one of a whole wave of American photographers of commonplace, cheap and mass-produced man-made imagery.

 Frederick Somer's photographs.

1940s Wallace Berman's precise pop culture drawings with startling irrational imagery, specific portraits of the pop and jazz heroes, in precisely rendered common technique.

 William Copley, the painter, links to his sophisticated knowledge of European surrealism a banal American imagery.

 Kurt Schwitters, in 1947 makes a number of collages, notably one from the Phantom and Prince Valiant comic strips, of a sexy blonde being reached for by a bunch of assorted men for his New York show at Rose Fried Gallery. Schwitters dies a week before his opening, and the exhibition is cancelled.

 Von Dutch Holland, itinerant custom coach craftsman of the Southern California hot rod world, conceives and executes the striping motif of hot rod dec-

oration; deliberately corny science fiction images of bug eyed monsters with ray guns driving hot rods, with puns, politicians' heads, etc., inset in cartoon bubbles. (See hot rod magazines from 1947 to date.)

Moholy Nagy dies in 1946; students at the Institute of Design turn away from Bauhaus concepts of design and typography and return to common everyday American sources for ideas. Notably Aaron Siskind, Robert Nickel, Harry Callahan, photographers, and H. C. Westerman, an assemblage and construction artist.

Judson Crews' random sliced slick magazine images with poetry.

1950s Hassel Smith's objects and collages as photographed by Bern Porter.

In 1951 exhibition of "Common Art Accumulations" at the Place Bar, San Francisco, by Hassel Smith and others. (Complete American flag iconography.)

In 1952 Wally Hedrick, displaced Los Angeles artist, feeds banal and ironic reflections into his paintings and junk metal sculptures.

Eduardo Paolozzi, in London, shows "found images" from advertising material projected onto a screen. First public exhibition of this subject matter at the London Institute of Contemporary Arts under the title "Parallel of Life and Art."

Robert Rauschenberg, Jasper Johns and Ray Johnson working on the New York scene. Johnson pioneers the use of the cheapest graphic techniques and images in his approach to graphic art.

In 1954 Lawrence Alloway coins the phrase "pop art" and defines it, which later Richard Hamilton redefined to today's usage. Hamilton makes huge blowup of "pop art" collage for the 1956 "This is Tomorrow" exhibition at London Whitechapel Art Gallery.

In San Francisco, J. de Feo in 1954, Fred Martin in 1954, Robert La Vine in 1954, Joan Brown in 1955, Roy de Forest in 1957 and Richard Kegwin create constructions, assemblages, drawings and paintings.

In Southern California, Ed Kienholz in 1954 makes constructions and assemblage objects; at the same time Billy Al Bengston makes paintings, drawings and collage objects (wind-up cookies, etc.). John Reed makes paintings, drawings and sculptures of World War II fighter planes and George Herms in 1958 makes assemblages. A number of important artists such as Bruce Conner come in on the tail end of the Fifties.

In Italy, the Galeria Schwartz in Milan exhibits "pop artists" such as Enrico Baj who collages pop images with textiles.

In England a whole movement of pop painters develops in the late Fifties.

KITSCH INTO "ART": THE NEW REALISM

Gilbert Sorrentino

INTRODUCTION

In this paper, I propose to discuss the New Realism and its place in the painting of today. That is, where it comes from, the outer forces which seem to be behind it, the "necessity" for artists to indulge in it, the validity, if any, that it possesses. I do not believe that it has any validity, or, to make myself clear, I believe that it possesses a validity in much the same way that competent commercial painting possesses it. I propose, also, that the commercial aspects, that is, the *money value* of this painting, are as "real" as the commercial aspects of "poster" painting; however, the New Realism has cloaked itself in the more "respectable" mantle of Art, or, better, "shock" or "ironic" or "Americana-as-it-really-is-underneath-all-our-pretended-happiness" Art. As such, in the minds of many people, it stands as a sort of brave and defiant neo-Dada. This would be fairly amusing, if it were not for the fact that many of the people who think of it as a valid method were not in high places *in* the art world. As everyone must know, this neo-Dadaistic tendency on the part of the New Realism is at best, rather displaced. Dada was a very conscious movement to disturb the opinions of the bourgeoisie, it was very consciously anti-art, or more exactly, it was against the idea of "art" that the bourgeoisie held. As such it was exceptionally successful as wrecker; that was its purpose. With the New Realism, however, we have before us the phenomenon of the bourgeois buyer purchasing *soi-disant* "anti-bourgeois" paintings from galleries, under the influence of favorable reviews.[1] This would not *be* a phenomenon if everyone involved in this were aware that it *is* bourgeois "taste" controlling all this flurry. Instead, everyone involved is apparently convinced that he is in the vanguard of the furthest advanced guard. It is as if Dada never existed, and now that it does, it is beloved of those it supposedly is meant to shock. To this point, Edward Sapir, in a paper on *Fashion,* says: "A specific fashion is utterly unintelligible if lifted out of its place in a sequence of forms." I do not feel that the word "fashion" here negates my argument. On the contrary, if Dada is admitted to be a fashion – and it certainly must be admitted to be such (a fashion, perhaps not intended for the "consumer" but for the "producer") – then the New Realism, *as* neo-Dada, may be validly considered to be the same, or, better, may be considered to be a *truer* fashion, since it is executed with the conspicuous desire to be accepted by the new "art-loving" middle-class, as something "revolutionary."

As long as I have brought up the concept of Fashion, I would here like to insert the idea of the theory of "obsolescence" which is all the rage now in the market and motivational research divisions of large companies and their advertising agencies. Briefly stated, this is a theory which maintains that a product, if old, is *naturally* inferior to one which is new. Manufacturers are obsessed with the modern fetish of Progress as being always *good.* The new product is *better* than the old: none can tell you why, nor, as a matter of fact, no one who is inflamed with this concept of Progress – in all areas of human experience, *including* art, can tell you why. The idea of Progress has assumed a *natural* excellence. It is considered good in much the same way as well-cooked food is good. The outcome of all this is the warped idea that the new is, *by right,* better than the old. In art,

Kulchur, Winter 1962: 10–23

it takes the form of the contemporary mode being an *improvement* over that mode in favor yesterday. This is, of course, bunk. No one that I know of now believes that urban, civilized man is more "advanced" than his primitive forebear: what has happened is that he has discovered and used things that were not necessary or even desirable for the latter. This does not make him *better* unless one believes in the concept of Progress as a God. In his *Speculations,* T. E. Hulme says: "In November 1829, a tragic date for those who see with regret the establishment of a lasting and devastating stupidity, Goethe – in answer to Eckermann's remark that human thought and action seemed to repeat itself, going round in a circle – said: '*No, it is not a circle, it is a spiral.*' You disguise the wheel by making it run up an inclined plane; it then becomes 'Progress,' which is the modern substitute for religion."

This concept of Progress as being an absolute, a natural good, has unfortunately asserted itself not only in those segments of modern life which obviously stand to profit by it, e.g., manufacturing and politicking, but in the arts themselves, particularly the plastic arts. The literary arts have weathered the deluge of rubbish grouped together under the general classification, "beat" writing, which was, and is, in its final floundering, a degree (not a *kind*) of neo-romanticism. The plastic arts are now wallowing in the slop, and will probably wallow much longer, since it is another "accepted" fact that for an artist's work to be shown in a gallery or museum implies "excellence." This idiot thinking has never infected the literary world, at least, not in the same explicit way that it has infected the world of the plastic arts. No one in his right mind considers Harold Robbins, for instance, a good writer, merely because he has succeeded in publishing *The Carpetbaggers.* It is a bad book, bound and distributed in the same manner as good books, but still a bad book, and Robbins is a bad writer. Nor are dozens of bad painters made good if they are shown in dozens of "reputable" galleries; those galleries show them because they think that they can find, or make, a *market* for the junk they show. It is a hard fact that a gallery is essentially a *store* that *sells* things, and if the gallery doesn't think that a certain commodity will sell, it will not handle that commodity. At the present time, galleries are selling the New Realism because the New Realism is in vogue, and its practitioners are, consciously or not, part of the selling game. What I propose to do in the succeeding sections of this paper is to examine the New Realism, and to suggest that it is, even if an art of "inevitability," a poor art, distinguished by sterile facility, cynicism, and middle-class opportunism. I also wish to suggest that this New Realism has no chance at excellence, since it is not, to start, a legitimate art. Before going on to the first section, I want to make clear, however, that I am not "defending" all abstract painting: I also wish to make clear, though, that I consider abstract painting a *valid form of painting,* where the values of good and bad may be applied. These values have no meaning when applied to work which, in itself, has no value, unless one wishes to concede that this ketchup bottle is "better" than this cupcake.

I

Before I come to a more detailed examination of the New Realism, I want to quote rather extensively from an essay entitled *Modern Art,* written in 1914 by T. E. Hulme. It was this essay, the discovery of it, that first led me to think out these remarks on the New Realism. Hulme got most of the ideas from a German aesthetician named Worringer, and used these ideas to make his own thinking, on the art being produced in England at the time, clearer. I have used these views, twice-removed, to be sure, to try to make my thinking clearer. They are remarkable ideas, and I cannot seem to find in them any flaw or omission which makes them invalid for my purposes. Let me quote from the essay.

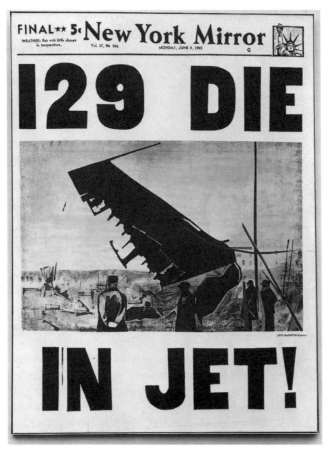

Andy Warhol, 129 Die in Jet (Plane Crash), *synthetic polymer paint on canvas, 8′ 4″ × 6′, 1962. Museum Ludwig, Cologne.*

Take first the art which is most natural to us. What tendency is behind this, what need is it designed to satisfy?

This art as contrasted with geometrical art can be broadly described as naturalism or realism – using these words in their widest sense and entirely excluding the mere imitation of nature. The source of the pleasure felt by the spectator before the products of art of this kind is a feeling of increased vitality, a process which the German writers on aesthetics call empathy (Einfühlung). This process is perhaps a little too complicated for me to describe it shortly here, but putting the matter in general terms, we can say that any work of art we find beautiful is an objectification of our own pleasure in activity, and our own vitality. The worth of a line or form consists in the value of the life it contains for us. Putting the matter more simply we may say that in this art there is always a feeling of liking for, and pleasure in, the forms and movements to be found in nature. It is obvious therefore that this art can only occur in a people whose relation to outside nature is such that it admits of this feeling of pleasure in its contemplation.

Turn now to geometrical art. It most obviously exhibits no delight in nature and no striving after vitality.[2] Its forms are always what can be described as stiff and lifeless. The dead form of a pyramid and the suppression of life in a Byzantine mo-

saic show that behind these arts there must have been an impulse, the direct opposite of that which finds satisfaction in the naturalism of Greek and Renaissance art.

This is what Worringer calls the *tendency to abstraction*.

What is the nature of this tendency? What is the condition of mind of the people whose art is governed by it?

It can be described most generally as a feeling of separation in the face of outside nature.

Now, let us distill these remarks into two generally useful precepts which we may articulate as follows:

1. Naturalistic art occurs when the society takes pleasure in the natural reproduction of nature's forms, when it feels *at one* with nature.

2. An abstract art (or a tendency toward abstraction) occurs when the society feels removed from the nature surrounding it, when it feels either fearful or contemptuous of nature.[3]

Let me make clear one thing concerning these two precepts: I conclude that Hulme meant, by nature, not only the forms and growths and manifestations of nature, but the entire *attitude* of the world in which any given society is forced to live.

The general art movement today, in the United States, and, I suppose, from what I know of it, in the rest of the western world, is that form or school of painting which is called abstract-expressionism. I think I will call it abstraction and be done with it. However, abstract painting has always had its enemies, people who see in it what they wisely condemn as "sterility," or, better yet, a disavowal of humanism. Did it never occur to these people that abstract painters paint that way because that is how they feel as artists *in* this world? They paint that way because they are *not* humanists. My point, of course, is Hulme's point: that is, the world in which we live today is certainly, in no way that I can imagine, friendly or at one with any human being living in it, let alone the artist. The "tendency to abstraction" which Hulme saw occurring before his eyes in England prior to the First World War has culminated in the American painting of the last 20 years or so. That is not to say that the "realistic" or "naturalistic" painter has ceased to exist. It is simply that the great majority of painters seem to feel more at home, more as if they are doing work which has some real meaning for them as painters, as abstractionists.

It must be obvious that what I am trying to get at here is the role of the New Realism as it pertains to these two general categories. I am not going to ram through the idea that painters today should paint abstractly. I want to make it perfectly clear only that the great body of legitimate work being done *is* abstract, and the reasons for its being abstract may be found in the lucid statement of Hulme's concerning abstraction and the kind of world in which it manifests itself.

Now, what of the New Realism, and what is it doing here? It is neither abstract painting, nor is it naturalistic painting in terms of a depiction of the outer world of natural forms. What it is, is a depiction of certain things in this outer world which have heretofore found their objectification in that form of art which may be called *kitsch,* or mass art. It is a "reality" made clear to us by these New Realists, but the reality is one which, long ago, was prostituted and warped by the mass taste and the mass media; a *specious* reality, much like the reality of "poster" art. In terms of the absolute, actually, some of the *commercial* products from which the New Realism constructs its art are, ironically enough, more pleasing, even aesthetically, than the *art* products. In this case, I think of Lichtenstein and the comic strips he paints. However, the New Realist adherent would probably

tell me that Lichtenstein's purpose in this "super" comic-painting is to show up the shallowness and vapidity of American life, although a good comic strip is anything but shallow and vapid. On the other hand he might maintain that this is neo-Dada, although it wouldn't shock your aunt from Peoria. A third defense, let us call it the romantic defense, would be that this painting is a kind of apotheosis of the "simplicity" of the true American *zeitgeist.* A romantic and sentimental view, at best; or perhaps we may call it the "innocence" approach. I feel that this third defense is the one which might be used most frequently by our imaginary adherent, although the first may also be used quite often. I will not discuss the second defense here, since it must be clear by now that the New Realism, whatever else it may be, is *not* neo-Dada. I would here like to show that our imaginary adherent is not so imaginary by quoting from two different reviewers on two New Realists, Wayne Thiebaud and Billy Bengston. The first painter is praised for Reason One, let's call it the "indictment" defense; the second for Reason Two, or the *zeitgeist* defense. Here is Brian O'Doherty on Wayne Thiebaud: ". . . Triple-tier sandwiches, hot dogs, pies, cupcakes, melons, chocolate, meringues, fruit cups, salads, layer cakes, all placed in orderly rows, as regimented as the people who eat them. A similarly insistent feat in poetry would make Mr. Thiebaud the Walt Whitman of the delicatessen . . . For Mr. Thiebaud is the wordless poet of the banal . . . The entirely deadpan air with which he does it can be interpreted, if one wishes, as a comment on the comfortable desolation of much American life, as seen through the stomach." Aside from the patent stupidity of comparing Whitman's "cataloguing" with Thiebaud's, we have here what we might call the classic example of the "indictment" defense. It is a defense, or a critique, which is at its very best, subjective, and hence, utterly romantic. But before continuing, here is Irving Sandler on the same painter. "These still-lifes are simultaneously attempts at 'realism' and ironic take-offs on bright, banal and unpalatable confectionery advertisements."

So we see that both Mr. Sandler and Mr. O'Doherty have sagely agreed that this delicatessen display is an indictment of the soft and sloppy, well-fed American and the "materialistic" culture he inhabits. These are incredibly dull reviews, lazily conceived and thought out, and would delude only those who refuse to reflect on anything. Both reviewers blithely jump into the pictures shown and make their crass judgments, or as Hulme would say, they *permeate the pictures with their own activity.*

Now let me move to Mr. Sandler's review of Billy Bengston: "He sprays and paints his pictures, . . . with shiny automobile enamel, thus providing them with an 'American' look. In the exact center of each of his works, Bengston has painted a top sergeant's stripes, symbols for the American hero. To make this content completely obvious, he gives his pictures such titles as 'Billy the Kid,' 'Earp,' 'Red Ryder,' and 'Hollywood Calling.'"

This is what I have referred to above as the *zeitgeist* defense. In a sense, it is more absurd than the other, since it implies that the disparate materials used to make a work of art are to be considered suggestive *in themselves* of movements, customs and intellectualizations quite apart from the whole work. This sort of thing died with the end of analytical cubism (at least it is hoped). No one of any intelligence thinks that the use of automobile enamel, sergeant's stripes, and "Americana" titles *makes* a thing American. No artist of any value uses materials in that way. If Mr. Bengston were to use oils, leave out the sergeant's stripes and the titles, would his paintings be then *less* "American"? Or just what *would* they be without the surface gimmicks? To this point, Hulme again, in *Modern Art.* "It may be said that an artist is using mechanical lines because he lives in an environment of machinery. In a landscape you would use softer and more organic lines. This seems to me to be using the materialist explanation of the origin of an art which has

been generally rejected. Take the analogous case of the influence of raw material on art. The nature of material is never without a certain influence. If they had not been able to use granite, the Egyptians would probably not have carved in the way they did. *But then the material did not produce the style.* If Egypt had been inhabited by people of Greek race, the fact that the material was granite would not have made them produce anything like Egyptian sculpture. *The technical qualities of a material can thus never create a style.* A feeling for form of a certain kind must always be the source of an art. *All that can be said of the forms suggested by the technical qualities of the material is that they must not contradict this intended form.*[4] They can only be used when the inclination and taste to which they are appropriate already exist. So, though steel is not the material of the new art, but only its environment, we can, it seems to me, legitimately speak of it exercising the kind of influence that the use of granite did on Egyptian art, no more and no less." (all italics mine)

Before I talk about what I earlier called the "innocence" approach, as being one intimately connected with the *zeitgeist* idea of art, I would like to go off the track of the New Realism, as it exists in painting, to talk about the assemblagists for a moment, and how they relate to the above remarks by Hulme. As far as I am concerned, one of the finest *sculptors* in America today is John Chamberlain. Mr. Chamberlain uses, as materials for his works, scrap metals almost exclusively. However, none of the works (the metals are mostly from wrecked cars) suggest "death on the highway," "speed," "violence of American life," etc. In a color spread in LIFE on Mr. Chamberlain some months ago, however, the writer of the article implied that these things were what Mr. Chamberlain meant to depict in his use of scrap. In the same article they showed a color picture of a wrecked car and its reflection in the water, or some such arty nonsense, and remarked on the great similarities between this and Mr. Chamberlain's sculptures. To cap this overwhelming stupidity, they quoted Mr. Chamberlain at the end of the article as saying that he used scrap metal because there was an automobile graveyard near his studio and the metal was not only cheap and workable, but it was already *colored,* a fact that interested him greatly – I seem to recall also that he spoke of Michelangelo having a marble quarry near his studio, and hence, that particular material was easy for *him* to come by. In other words, Mr. Chamberlain briefly said exactly what T. E. Hulme said years ago concerning the nature and use of materials. LIFE, however, apparently either did not see the discrepancy between Chamberlain's remarks and their own, or else, as is usual with them, showed their utter contempt for their readers' ability to think. The point I want to make is, again, that Chamberlain is a sculptor, *not* an assemblagist, although many of these latter have aped him. Unfortunately they have simply used the same *materials* he uses. What is produced is very different. One does not see, *nor is one supposed to see,* a fender *as* fender in Chamberlain's sculptures; the fender becomes part of the work and contributes to its *wholeness.* It is not the *putting together of things,* which still remain *things put together,* it is true sculpture. Against this we have the ludicrous example of the sculptor I read of who merely throws a whole car into a crusher and displays it. In between these extremes of art and charlatanry, or, to be charitable, caprice, we have the assemblagists.

Locke, the rationalist, says of Wit, that it lies "most in the assemblage of ideas, and putting those together with quickness and variety wherein can be found any resemblance or congruity, thereby to make up pleasant pictures, and agreeable visions to the fancy." On the other hand he placed Judgment, which, he said, consists "in separating carefully, one from the other, ideas wherein can be found the least differences, thereby to avoid being misled by similitude, and by affinity to take one thing for another . . . " The irony here, of course, lies in the fact that for Locke, *Wit equalled Art,* which he rejected as

trivia, and against which he placed the rational, "sober," conception of Judgment. It is the voice of the Philistine. Everyone knows by now what happened. The romantics stared into the heavens, wept and moaned over the fact that Art was the orphan of the age, and, in their work, did nothing about it except to make Locke seem correct. Locke may not have known what Art was, but neither did the heart-sore romantics. It took some 150 years to clear the garbage away, and now we seem to be shoveling it back again – of course, in the name of Art, and the "Contemporary."

II

If one were to tell a friend who recently returned from, let's imagine, the South Pole, that a large group of the recent exhibitions in New York showed cupcakes, salads, billboards, window shades, comic strips, sergeant-stripes, ketchup bottles, pies, and the like, and if that friend were not convulsed in helpless laughter, he might ask you who the innocents were, or what the innocent "revival" was all about. For this patent "innocence" of the New Realism is, indeed, a revival of a kind of cult which flourished after the First War in art circles, and which was led, in part, by Gertrude Stein. Its repercussions are still with us, and I would like to quote from Wyndham Lewis, in *Time and Western Man* (1927), to make clear that this phenomenon was indeed so at *that* time, and that it certainly is not new. From there, I will try to work in the concept of the market for the New Realism, and who comprises it. The quote follows: "I suppose there is no one who has not noticed, passim and without attentiveness, perhaps, in a hundred different forms, the prevalence of what now amounts to a cult of childhood, and of *The Child.* This irresponsible, Peterpannish psychology is the key to the Utopia[5] of the 'revolutionary' Rich; the people, namely, who have taken over, have degraded, and are enjoying the fruits of revolutionary scientific innovation – far from its creative ardours, cynically scornful of its idealisms, but creating out of its ferments, which they have pillaged, a breathless Milennium." And again: "Romance and scholarship plus advertisement, take the place of really new creative effort. Some quite ridiculous piece of the mildest 'daring' in the world, or the tamest 'experiment,' is advertised as *an outrage.* And as an outrage it is accepted, on the word of the advertiser; though there is nothing there to disturb the pulse of a rabbit, and no more invention than is required to spell a word in an unusual way, or to paint a bird with a monkey's tail." At the risk of over-quoting, I must insist on being allowed this remark, also by Lewis, almost 30 years later, in a book entitled *The Demon Of Progress In The Arts.* "Extremism is symptomatic of a vacuum – a time in which there is no rationale for visual expression." By "extremism" here, Lewis is referring to extreme abstraction, that is, the art of the "New Real" as it was then (1955) manifested in Europe. The interesting points here are two:

1. The fact that the use of the term *New Real* as exemplified by the European painting of perhaps ten years ago is directly juxtaposed to the use of the term *New Realism* as exemplified by current American painting. Everything is different except the words, the "magic" word, "New," being the key to the entire world of fad and fashion in art.

2. Lewis's quote strengthens and corroborates Hulme's ideas on "naturalism" and "the tendency to abstraction" as outlined earlier in this paper. Lewis, being a humanist, or let me say, a Greek humanist (a classicist in the Hellenic tradition), looks, in his book, for a return to "naturalistic" painting, as against what he termed the "absurdities" and "sterilities" of the *New Real.*

Now we come to what may seem an impasse. In the New Realism we see displayed a turning away from abstract painting towards a naturalism, however narrow. However, it

is *not* the naturalism which Lewis looked for, nor is it the naturalism which Hulme spoke of as "a feeling of liking for, and pleasure in, the forms and movements to be found in nature." No one can seriously maintain that he takes pleasure in the "forms and movements" of a cupcake, unless he is a genuine *naif,* which brings us, by devious route, back to Lewis's child cult and its absurd Utopianism, the "breathless Millennium."

Now I come to what is the major point of this paper, and that is: why the New Realism? Now that it is under way and "accepted" by the snobbish "avant-garde" and the idiot fringe of "art-lovers" swarming around it, it is difficult to separate the desires of the painters, the demands of the market, the vagaries of gallery owners, and the snobbism, fear of being "dated," and gullibility of the *nouveau-riche* collector. Added to this, of course, are the slothful and careless writings of the established reviewers. So we have an intricate net of which the mesh is made of snobbism, status, "progress," and carelessness, and the cord which ties it up, to continue the analogy, is money. But how did it start?

Let us formulate several basic ideas, which, though they are platitudes, are necessary to the development of this argument.

1. Abstract painting, in America, over the last 15 or 20 years, has been led by painters who were dissatisfied with painting both as it was given to them by the cubists and neo-cubists, and by the naturalistic painters, most of whom painted what may loosely be called "social" paintings.

2. It was during the misery of the Second World War, and the days that followed it (still with us, of course), that is, during a time when all the members of "civilized" societies, including, of course, the artist, were not *at one* with nature in any way, when the world was a place to be feared, or avoided, that American painting's "tendency to abstraction" went all the way in that direction to *total* abstraction.

3. American abstract painting has been (despite the tongue-clucking of critics like John Canaday, who is simply a bourgeois humanist) the *most* valid painting for our time, in terms of the artist's relationship to his world. I want to make clear that this does not mean that representational painting is bad. It is, simply, not as *valid* for us as abstract painting in much the same way as the sonnet is no longer a *valid* form for the contemporary poet. It is, basically, that the contemporary poet does not even consider it.

4. Brilliant work, in any art form, brought to perfection, and perhaps exhausted by the artist, puts that artist's disciples in a terribly straitened position. They must either copy him, *revert* to an earlier form, or invent a different form. The only other alternative, in a fairly sane and not overly-avaricious society, is for the younger artist, or disciple, to work on a certain *aspect* or aspects of his master's work, and bring *that* to a flowering. This last is what has usually happened over the years, in all the arts. It is very difficult for the young artist to do this however, when he is under constant pressure from a lunatic market to do something "new" and "progressive." It becomes even more difficult when that lunatic market spends freely on, and lauds even *more* freely, the "new" and "progressive." Lewis speaks of the painter in this situation as "a figurine in a ballet, advancing . . . with a score of men exactly like himself, in a studied rush."

Out of these basic ideas, we can extract at least one cause of the phenomenon called the New Realism, which is, briefly stated: the manner and/or style of painting which has come to be called the New Realism has come about because the disciples of the masters of abstract painting have not had a chance to develop certain, let us call them peripheral and interstitial, ideas in these masters' works because of the constant pressure upon them by a market for something "new" and "advanced" with which to titillate the snobbish middle-class; a middle-class which originally damned the early work of the abstrac-

tionists and which cannot now "socially" *afford* to commit the same Philistine error. This syndrome is completed by the critics who damn that which is bad or academic in the more recent abstract painting, but who will not look at, or cannot *see,* that which is good. The whole thing is complicated by the cries for a "return to the Figure."

Now let us examine the worth of this New Realism as art.

<div align="center">III</div>

Alright, we have the abstract painter whose work I have called most valid for our time, granted the fact that our time is one of a "feeling of separation" from outside nature and the natural world. We also have the naturalistic painter, who still finds that the forms of nature, and the world in general, have a rapport with him as a man and as an artist. I will call him the humanist painter, as against the abstract painter, whom I shall term the anti-humanist, or as Hulme will have it, the "religious" painter – one who believes in *absolute* ideals. To this point, Philip Guston has said of his painting: "You don't care how you appear; you have given that up." What matters is *what* appears, not how *you* appear. Or as Olson has said in *Projective Verse:* "Objectism is the getting rid of the lyrical interference of the individual as ego, of the 'subject' and his soul, that peculiar presumption by which western man has interposed himself between what he is as a creature of nature (with certain instructions to carry out) and those other creations of nature which we may, with no derogation, call objects."

So, we have the humanist painter and the anti-humanist painter. One depicts, let us say, the sky, the sea, still-lifes, etc. The other makes paintings which are either pure abstraction, like Pollock's, or tend to abstraction very strongly, like de Kooning's *Woman* paintings. The only other area left open is the area of what we might call "social" painting, which is "humanistic" according to the above definitions, but which carries a heavy, and usually obvious message, sometimes poignant, sometimes satiric, sometimes bitter.

Let us assume for a moment, in spite of the pragmatic solidity of the existence of the New Realism, that these three areas of painting, which actually fall into the two familiar major groupings, are the only ways that an artist can paint; as a matter of fact, they are the only ways in which artists have always painted. Impinging on these two ways of painting, we got Dada; we have already given the historical and aesthetic reasons for this movement, and determined that the New Realism is *not* neo-Dada. To repeat: Dada had a conscious, non-aesthetic (or anti-aesthetic) *raison d'etre,* it was directed toward a specific group, or group opinion, for the purposes of shock as a *final cause.* Neo-Dada may be *labelled* so, but *as such,* it has no worth, since the *final cause* finds no fulfillment – in short, it is an art directed against a group opinion *which does not exist.*

Now, we have the solid fact of the New Realism before us. It is most certainly not neo-Dada; it is most certainly not abstraction; it does not tend *to* abstraction, but, rather, tends *away* from it. Then what is it? Is it "social" painting? But where is the message in it, unless it is what O'Doherty and Sandler seem to think is an "indictment" of our soft society, or a reflection of our *zeitgeist?* But here we get into the subjective-critique system which may be compared to the filling of a bag labelled *sugar* with the critic's salt. The dreary fact is that the only "indictment" of our society inherent in the New Realism is the fact of its *being.*

It seems, then, that we are left with the fact that the New Realism is naturalistic painting. And just here is where it fails, here is where it reveals itself to be a form of painting which has not a particular, *real* value to the painter or the viewer, since what it depicts in the world are those things which are most gross, most used, most *owned* by everyone. A

culture, however decayed, may not be legitimately defined by its crudest and grossest elements, unless those elements are deeply and specifically a *cause* of the culture's decay. The packaged food, ill-baked cakes, comic strips, etc., are not in any way *causes* of the tawdry and vulgar in America, but they *are* the *effects*.

To carefully select certain areas of American experience, and to single out specific *effects* indigenous to these areas; then to make of these narrow effects an "art" seems to be the *modus operandi* of the New Realists. At its worst, it is one-of-a-kind *kitsch*, and its display is loosely akin to showing an Eskimo a *papier-mâché* model of an igloo and telling him that it, in some way he will never comprehend (since he is not "sophisticated" or "progressive"), "represents" or "indicts" his barren world and his customs. At its best, it is an art of the narrowest provincialism, an art in which the painter has tried to make a taken-for-granted *manufacture* of our times, or a form of *kitsch* which is one of a million like itself, into a representation of the entire *zeitgeist*. To be completely uncharitable, it is an art which sells you the comic strips or the hamburger for several thousands of dollars – and, laughably, succeeds. The most ridiculous aspect of it is that it is most at home with those people whom it is "attacking."

I don't presume to say that this is bad *painting*. I have heard men who are much more aware of the problems of painting than I am say that certain of these New Realists are technically proficient, if not excellent. The more's, of course, the pity. To squander a talent for painting on such a narrow, fashionable "aesthetic" seems a violent denial of one's self as an artist. I do say, however, that it is bad *art*. Instead of a search for a way of revealing the forms of a world (or of the painter's mind), either friendly or hostile, this art has become a frenzied rout in which the critic-dealer-buyer triumvirate lead the pack, waving fistfuls of dollars. This month the fashion will be cupcakes or automobile enamelling, next month geranium plants or bathroom tiles. The "art-loving" bourgeoisie will fearfully accept it, LIFE will talk nonsense about a *vital, harsh art, singularly American,* and painters of intelligence will hear themselves referred to as "not avant-garde enough."

I will not, of course, predict the span of life that this New Realism will have, but I will say that I am sure it will die, in fact, it will probably do itself to death as soon as something more "progressive" and "advanced" becomes the fashion. Unfortunately, as Olson says of "subjectivism," we will all be "caught in its dying."

NOTES

1. In his weekly art column in the *New York Post*, Irving Sandler said recently: "Contemporary New Realism has a satiric edge which relates it to Dadaism, and to the attempt of the Dadaists to undermine conventional, moral and artistic values." And one may add, undermine all values *except* those of the monied buyer of paintings. He can be duped, but *never* shocked.
2. By "vital," Hulme did not mean the opposite of "uninteresting," or "weak." He meant the word as specifically referring to life and living things.
3. It will be objected that cave paintings have been discovered which are naturalistic, and that cave dwellers made them in the face of a hostile world. However, cave dwellers seem to have been *at one* with that world; they were hunters functioning within it, much the same as the animals they hunted. Also, these paintings were not "art," *per se*, but performed a magical function. A third point may be made, which is that many of the cave paintings, of different periods perhaps, were completely un-natural, the animals depicted with grotesque masks, etc.
4. To make a literary analogy we have Creeley's: "Form is never more than an extension of content." In other words, one does not squeeze the content into a ready-made form, nor *impose* a form upon an "available" content.
5. Georges Sorel, in his *Reflections On Violence*, equates *Utopists* with *reactionaries* – as did Marx, also. A shocking discovery for many "progressive" people.

DADA, THEN AND NOW

Barbara Rose

Therefore it is not difficult to predict a great future for Dada. Dada will experience a
golden age, but in another form than the one imagined by the Paris Dadaists.
<div align="right">Richard Hülsenbeck, Dada Lives!, 1936</div>

We will be speaking here only of the American art that has been called neo-Dada. The dif-
ficulty in finding an appropriate name for this group of artists is illustrated by the title
given by the Pasadena Art Museum to its recent exhibition of Dine, Dowd, Goode, Hef-
ferton, Lichtenstein, Roscher, Thiebaud and Warhol. The show was finally called "New
Paintings of the Common Object," a conservative but more accurate title than the mis-
leading "neo-Dada," a term invented by an unsympathetic critic to derogate the works in
question.

"Dada est mort, vive Dada," wrote Max Ernst in 1921. No one today will claim that Dada,
as it captured the imagination of Europe's most daring young men after the first World
War, is still a vital art style. Yet the term has been resurrected to describe the work of
some younger American artists. In addition to Robert Rauschenberg and Jasper Johns,
such disparate talents as Jim Dine, Claes Oldenburg, Allan Kaprow, Tom Wesselmann
and Robert Whitman, among others, have been tagged "neo-Dada." So have the artists
known as the sign painters, the pop artists or, more recently, the new realists, who include
Robert Indiana, James Rosenquist, Roy Lichtenstein, Andy Warhol and Wayne Thiebaud.
 Neo-Dada may be a misleading label, but by now it is obvious there exists a group of
artists who have chosen the middle way out of Abstract Expressionism (the path between
a kind of simplified abstract image and new figure painting). This season enough of their
efforts have been exhibited in galleries and museums for us to begin to consider who they
are, where they come from, what they have in common and how and if they are indeed
"neo-Dada."
 Almost half a century, a depression, a world war and the subsequent polarization of
East and West, separates the madcap Dadaists of Paris and Berlin from their American
descendants. What once seemed vanguard invention is now merely over-reproduced
cliché. Anti-art, anti-war, anti-materialism, Dada, the art of the politically and socially
engaged, apparently has little in common with the cool detached art it is supposed to
have spawned. We shall see in fact the new Dada owes little to European Dada, save an in-
terest in the *collage* technique of Schwitters and in the ready-mades of Duchamp. The
term "neo-Dada" unfortunately is charged with associations, often causing us to misun-
derstand the objectives of the new art through the reading-in of what we know about past
Dada: One popular misconception is that new Dada is an art of protest; another is that it
is anti-art.
 Although it is certainly debatable whether the Dadaists succeeded in creating anti-
art, they at least pretended to want to. Zealously and quasi-religiously they set about to
destroy old art, whose traditional forms they thought must be rendered impotent before
new ones could be created. They felt bound and impaired by convention and taboo in a

Art International, January 1963: 23–28

way that today's artist, liberated by the total victory of the Surrealists over subject matter and of the "action painters" over technique, can hardly understand.

Not only is neo-Dada *not* anti-art, it is very seriously pro-art. The only reason for saying, as one art historian did, that Rauschenberg's work is never "pretty," is that pretty is pejorative when we mean beautiful. Today's artist, in his attempt to elevate and transform the ordinary and the banal into art, is constantly composing and arranging, often in the most self-conscious fashion. What is characteristic of all new Dada works, from Johns' exquisitely brushed targets to Whitman's rubbish heaps, is a preoccupation with formal relationships. Neo-Dadaists, far from being anarchic, are the first to acknowledge that the artist's task is to order.

In matters of technique, the neo-Dada artists are – as is anyone painting today – the inheritors of Abstract Expressionism. The way Johns, Rauschenberg, Dine apply paint, the way Oldenburg's drips run, even the way the sign painters fill in broad areas, depends on the technical innovations of Abstract Expressionism. To Abstract Expressionism they owe also the size of their pictures, and the sometimes vast spaces of emptiness. Dadaists of the 'twenties were essentially cabinet painters: most were happy to work on a scale that to artists living in the country of the Rockies and the New Jersey turnpike seems insignificant.

With the treble freedoms of means of expression, media and subject matter, the post-Abstract Expressionist artist no longer fears the tyranny of the masterpiece. The *Mona Lisa* is no more enemy than Rembrandt, whose paintings Duchamp once suggested be used as ironing boards.

If the masterpiece is no longer enemy, neither is the machine (nor is it god or hero, but closer to brother, as we see it taking on more and more human characteristics, thus reversing Ortega's prophecy). Conventional morality, which the Dadaists sought to undermine, is tacitly understood, despite the daily protestations of Mary Worth and daytime TV, to have ceased to exist. The *bourgeoisie,* that formerly worthy adversary, is the shock-proof patron of the new art.

In Ezra Pound's time, the experimenters hated "Kulchur"; today's artist, like the American intellectual in general, views with mixed horror and fascination the popular culture which surrounds him. The enemy may once have been the Classics, now the threat is classic comics. In the face of the vulgarization and mass diffusion of what was once the highest level of culture, artists have resorted to the lowest for inspiration. Since Jasper Johns first transformed Alley Oop into a work of art, comic strips have enjoyed the place as models formerly held by Michelangelo's cartoons. The success of Roy Lichtenstein, creator of the billboardsize cartoon, has prompted others to work in the same direction. And which of us, able to recite the myths of Captain Marvel and Wonder Woman as unfalteringly as Homer sang of the gods, can fail to experience the shock of recognition upon seeing Mel Ramos' lurid, grinning Joker, or Oyvind Fahlstrom's Bat-Man (as viewed through the eyes of Gorky and Matta)?

As the line between art and advertising becomes obscured, so the two tend to invade each other's domain for inspiration. The result is what the detractors of abstract painting have clamored for: the image has returned to painting, but in a form they never imagined. It has come back via the TV, magazines, highway billboards, supermarkets and comic books, and not by way of Salon painting or socialist realism. This has proved a disappointment for some and a *cause célèbre* for others.

Thus, when we look for the common denominator which unites the new Dada artists, we find it is a dedication to the image, the recognizable object as we encounter it in

everyday experience. By this definition, painters like Stephen Durkee and Dick Smith, who alter or do not refer to the image at all, are not neo-Dada, and to describe them as such is to misunderstand their work, as it is to misconstrue the sculpture of Chamberlain and Stankiewicz, who use the *material* but not the images of the real world.

Objective and factual in their means, though their ends may be poetic or evocative, the neo-Dadaists expropriate from the world around them commonplace items – forks, hangers, umbrellas, furniture, old clothes and rubbish. Sometimes instead of borrowing, they completely recreate these objects, as when Andy Warhol paints a soup can or Claes Oldenburg makes a plaster cupcake. What is important is that no matter how they combine, remake or transform the objects of the real world, these objects retain that property which relates them to life and everyday experience.

Neo-Dada art, for the most part, is being produced by the generation, now aged 25 to 40, that achieved maturity in affluent post-War America. Variously this generation has been called "beat," "silent" and "uncommitted." Its attitudes are very unlike those of the generation that created Abstract Expressionism: These latter were literally men of "action" who fought in the War and lived through the Depression. They had a sense of personal freedom and of the efficacy of the individual will. Many were immigrants or sons of immigrants, who still felt more part of than at odds with Europe.

In contrast, the generation of the neo-Dadaists is native born. The young artist's problem is coming to terms with America; in Fitzgerald's words, he is "face to face for the last time in history with something commensurate to his capacity for wonder." Sidney Tillim (in a review of Oldenburg's store: *ARTS*, Feb., 1962) was the first to correctly identify the subject matter of new Dada as the American Dream. Rosenquist's billboard fantasies, Lichtenstein's cartoons, Robert Indiana's pinball machines, Wesselmann's nostalgic collages, Rauschenberg's coke bottles and Johns' American flags and maps illustrate a longing for and recognize the betrayal of that unobtainable dream.

This generation is in love with the American Dream they see commercialized, exploited and fading before their very eyes ("the orgiastic future that year by year recedes before us"). Their formative years were spent in a very different fashion from those of the generation that invented Abstract Expressionism. The action painters, growing up in the heady atmosphere of Henry Miller's Paris, the idealistic togetherness of the W.P.A., and the early days of the Art Student's League, developed the active, dynamic way of looking at life reflected in their paintings; but younger artists, experiencing the war years as children and adolescents, learned to accept in a dispassionate manner what would outrage and inflame a generation that had known something else. Playing a passive role from the start in the events that shaped our world, they are passive, acquiescing and accepting still. Every generation to some extent feels itself the inheritor of a world not of its making, but this feeling usually engenders protest. In this case, however, the futility of protest and the early acceptance of the horrible, the atrocious and the insane as objective facts of life led rather to detachment and non-participation. Thus it is ludicrous to think of a new Dada artist painting Ban the Bomb posters, as Grosz once illustrated the anti-war pamphlet, *Nie Wieder Krieg*. Artists are no longer political, nor is art a vehicle for propaganda. The neo-Dadaist, though he uses the content of life, stands apart from it – amused, detached. Through his attitude toward what we take for granted, he puts an even greater distance between us and it.

If the artist is no longer actor or participator, but detached spectator who reports, in an uneditorialized fashion, on what he sees, then his desire to express his individual will, to assert himself in some way, even if capricious or arbitrary, is so much the greater. To

the question "Why is this – this goat's head, this rubber tire – Art?" the artist answers, "Because I tell you it is." (When Robert Rauschenberg was asked to do a portrait of Iris Clert, the Parisian art dealer, he complied by sending a telegram which read, "This is a portrait of Iris Clert if I say so.")

Sometimes an artist exercises his will by choosing not to be understood; then, using his own private vocabulary of images, he creates works described as "personal," a word often used by critics when they do not or cannot understand what the artist has in mind.

Artists exercise their will as well by isolating an object from its context, as Duchamp did with his ready-mades, thus forcing the viewer to see it new and to re-evaluate its meaning in the new context. By relentlessly focussing the attention of the spectator, the new Dada artist requires him to think again about what he is seeing. While we paper our dining alcoves with Toulouse-Lautrec wallpaper, this is not bad training.

Unlike Duchamp, who merely selected an object from the outside world and set his stamp on it, today's artist seeks more often to recreate the object from scratch in his own terms, making appearance resemble reality only to that degree which causes us to reflect on just what the reality is. Thus Johns' cast and painted beer cans duplicate the real ones, but in a more perfect form, and Oldenburg's inedible pastries lead us back to a redefinition of what real pastries are like.

Sometimes the artist feels he must *tell* us what we are seeing (so blind and witless have we become that we need help), even though it is often something so familiar as to be contemptible. Jim Dine labels his ties and apples and rainbows and Jasper Johns solemnly stencils in the words "red," "yellow" and "blue" over those colors, so that we may know what they are. They are asking: Do you know what you are seeing, do you *really* know? Oldenburg, when he changes the scale of familiar objects, making a foam rubber ice cream cone the size of a car, adds an additional dimension of ambiguity. Feeling a little like Alice after she has swallowed the contents of the bottle marked "drink me," we begin to wonder *where* we are.

Although the new Dada artist does not protest his environment, he is as acutely aware of it as writers once were. He is constantly reporting on and referring to it. Thus he reflects the temporariness of our wildly fluctuating surroundings by making things which look as if they will not last. Flimsiness and perishability are inherent qualities of Whitman's constructions and Kaprow's environments. The Happenings are assembled, transpire and then are gone (unless they are recorded, as some have been, on film). Objects made of materials like chicken wire, plaster and cardboard are, unlike the tombs of the Pharaohs, not intended for the ages; they must be enjoyed on the spot for they may not last much longer. Impermanence is a fact of our existence; a building we see today may not be there tomorrow.

Time is approached again from the angle of the frozen moment, the allusion (analogous to John O'Hara's fictional use of the hit tune to fix the year) is to something that smacks unmistakably of today: a newspaper clipping of a public figure, a headline, a postmark. The obsession with the "contemporary" (any object wrenched from, and unmistakably marked by today) may represent the artist's desire to take hold of a reliability which moves too fast to be apprehended by ordinary means. It is as if the artist senses the present so quickly becoming the past that he already feels a nostalgia for it. When Rauschenberg snatches from today's paper (already yesterday's) the grinning head of Ike, his intention is not caricature or satire, but the effect of the "time capsule" buried at the 1939 World's Fair for posterity to unearth, which contained bits and pieces of everyday life as it was lived then and as it is, incidentally, no longer lived now.

For Rauschenberg, speed and change are especially important. More successfully than the Futurists perhaps he has indicated velocity, the speed of change. In his transfer rubbings, where the rapidity of the gesture is recorded, what is expressed is not so much movement (which is what the Futurists tried to capture by a series of simultaneous images), as velocity, in images that remain static behind a blur. Larry Rivers, too, gives us this blur in series of images that emulate the action of the movie camera as it pans from scene to scene.

New Dada, like the Dada of Max Ernst and Picabia, is interested in the irrational, the seemingly unrelated which, when juxtaposed, takes on new meaning. In the 'twenties the discoveries of Freud and Jung were uppermost in the minds of the Dadaists as they sought to involve the subconscious of the viewer, sometimes in spite of himself. The source of the irrational element in new Dada, however, is rather the existential concept of the "absurd" than the workings of the subconscious. Thus they equate the trivial with the essential, elevating the ridiculous to the level of the sublime. (Thiebaud paints a slice of cake with much the same care and craftsmanship that once went into a Crucifixion or a Madonna.) The sign painters are in reality icon painters, if we consider the figures in our pantheon to be empty coke bottles and soup cans.

There are references in new Dada as well to problems of "existence." A used quality is characteristic of many of the objects the artist now chooses to work with; they have the air of a previous existence and the effluvia of life still clings to them. The nausea Sartre's hero feels when he suddenly becomes physically aware of the mortality of the flesh, his consequent disgust toward his own flesh and its processes accounts for our revulsion at Lucas Samara's gift-boxed fingernails and "breakfasts" of rusty steel wool and bent, grimy silverware. Oldenburg's bedside still-life of the contents of a trouser pocket dumped on a chair has the truth of the voyeur's vision. George Segal's life-size plaster mummies sitting at their dressing tables painting their plaster fingernails are a page from our own Book of the Dead.

In Oldenburg's most recent work (the "store" and the last show at the Green Gallery) there is another implicit theme, understood although never referred to directly: The *leit-motif* is money. The stuffed and painted sailcloth jockey-shorts, the plaster shirts, the overgrown hamburger are all for sale in a dual sense, which is part of their ironic effect.

Money, the real goal of the American Dream, as Fitzgerald so accurately defined it in *The Great Gatsby,* is a great problem for the young artists because, for the first time in America, they are making it. (A number of painters, including Larry Rivers, Andy Warhol and the Detroit artists Dowd and Hefferton are making it in a more specific sense by painting soft pastel French franc and crisp American two dollar bills.) The status of the American artist has radically changed and the artist, once scorned and starved in this country, is now the darling of the White House and the fashion magazines.

A certain amount of guilt is attached to the money the artist receives because it is both the symbol and product of what he simultaneously loves and hates – American material-ism. It would be attractive to simplify the situation by saying the artist no longer protests in the old ways, but that he is protesting something else. The case unfortunately is more complicated than simple, unequivocal protest against the materialism of America. Often the nature of the aggressive, hostile content of new Dada has more to do with the artist's personal relationship with the patron, who today is as frequently collecting artists as art. Thus the ironic edge to works made of rags, scraps, dirty odds and ends – the dis-cards of any poor neighborhood – which the artist forces the collector to take home and install in his immaculate white living room. It is as if, having so totally sanitized and ster-

ilized our lives, we need to bring a little dirt back into it, to convince ourselves we are still alive.

Today the artist knows exactly whom he is painting for; he is as sure of his audience as he is sure that he does not share its values. This is where new Dada most closely resembles old Dada, in its antagonism toward the bourgeoisie. However, the artist can no longer hope to shock or alienate the very group who purchase his work as rapidly as he can turn it out. So he embraces what he probably hates the most, exalting into icons the consumer products (what Rilke called the "life-decoys from America"). The soup cans, the money, the movies stars, the Good Humors (in your choice of six delicious artificial flavors), the beer cans, are the altarpieces of our religion. The artist, after a century of abstaining from painting the saints, once again turns to religious subjects. The store, as Oldenburg knows, is the temple of money.

The attitude of worship is as common to new Dada as the attitude of negation was to the Dada of the past. Thus new Dada does not protest the contemporary reality in the old sense, but embraces it with the irony of determination. Unlike Moses, who destroyed the Golden Calf, the artist today, sensing the inadequacy of protest, multiplies the idols and joins in the ceremony.

To view a moment historically is to kill it. As soon as Abstract Expressionism was taught as a seminar in the graduate schools, the end was in sight. However, let us, now that we have seen what new Dada is and what it means, look (without homicidal intent) to its development in America. That European Dada did not bear root in America, and that the American experience was not describable in Dada terms, is illustrated by the fate of the Dadaists who came to settle in this country: Duchamp, still the revered pontiff of the avant-garde, paints no more; Grosz, the fervent "Propagandada" experienced a breakdown in America and returned to Germany to spend his last days: Hülsenbeck, credited with bringing Dada from Zürich to Berlin, is a psychiatrist in New York. That brief Dada flowering which took place after the Armory Show was essentially a transplant, and everything related to it could as easily have taken place in Paris or Berlin.

We must therefore try to find an American and not a European source for new Dada. Strangely enough, the two leading American Dadaists of the older generation, Joseph Cornell and George Ortman, had little effect on the development of Dada in this country. The fact is, American new Dada has its source outside the visual arts.

Although we may perceive two distinct trends: the elegant, painterly achievement of Rauschenberg, Rivers, Johns and Dine, and the rag-and-bone-shop art of the Environments and Happenings, they have a common origin. It is in the ideas and experiments of the avant-garde composer, John Cage.

Cage, although familiar with the work of the European Dadaists, evolved theories about music that were very original, very American and very adaptable to the visual arts. Younger artists came into contact with these revolutionary ideas through articles he published and lectures he delivered at Black Mountain College and at the New School in New York. Although it is doubtful if the artists here mentioned would agree, it is Cage, the musician, who has come closest to stating in so many words the common aesthetic of new Dada. In *Silence,* his recently published lectures and papers, we find the seeds of many, if not all, new Dada concepts – the use of the ordinary and the commonplace, the familiar and the banal in art, the consecration of the unique, unrepeatable moment, the juxtaposition of anomalies. Part of his text for *45' for a Speaker* could serve as the motto for new Dada:

. . . Our poetry now
is the realization
that we possess nothing.
Anything therefore
is a delight
(since we do not possess it) . . .

Tracing new Dada's genesis to Cage, we point to his organization in 1952 at Black Mountain College of an "event" involving works by Rauschenberg, the dancing of Merce Cunningham and films and slides. (Since then Rauschenberg has at various times collaborated with Merce Cunningham, Jasper Johns, Niki de Saint-Phalle and Jean Tinguely in producing such "events.")

Although Cage's ideas were germane, their application to the visual arts was the invention of Rauschenberg, Johns and Kaprow. The three, though their works vary enormously, have in common that they introduce into art the stuff of life. Rauschenberg shares with Cage an interest in chance and co-incidence – chance in that he uses what he happens to find (there is no fixed or preconceived idea to begin with, as Cage points out in a most useful essay on Rauschenberg) and co-incidence in the duplication of images (the two Eisenhower combines, duplicated to the last detail are a good example).

Johns, whose effects are more calculated and clearly conceptualized before they are executed, shares with Cage a debt to Zen. Much of his imagery which critics have found obscure or unintelligible – the doors which open to nowhere, the sinister hands and heads, especially the targets (a crucial Zen motif) – has the absurd logic and suspended irony of the Zen *koan,* the riddle without an answer. Kaprow's debt to Cage is clearest of all. His environments, which incorporate, without distinction or precedence, objects from the outside world, are parallel to Cage's use of noise as a factor in musical composition. (At one point Cage asks if the sound of a truck in the street is less musical than the sound of a truck in a music school. Kaprow, in a sense, is continually asking this question.) In Cage's remarks about the theater are the first hints of what the Happenings will be.

John Cage was one of the first to understand the deadness of Europe, and to try to find some way out of it. New Dada, which relies heavily on his ideas, is a peculiarly and often chauvinistically American solution to the problem of where we go from here. We can probably pinpoint its beginnings in the 1951 publication of what is now the most thumbed book in art school libraries, Robert Motherwell's anthology, *Dada Painters and Poets,* which first gave wide circulation in this country to the words and works of the Dadaists. It is interesting to remark that American artists are now ready to adapt Dada to their own ends, as they were not in 1936, when the Museum of Modern Art held a large exhibition of Dada and Surrealist art. It was in the 'fifties, then, that new Dada got its start.

Duchamp, who exhibited in 1952, '53, '56, and '59 at the Sidney Janis Gallery, has been a constant source of interest for younger artists, who view him as something like the patron saint of the movement. (It is fitting that Janis, who showed Dada art in New York throughout the 'fifties, should now exhibit new Dada works.) Allan Kaprow's environments were first seen at the Hansa Gallery in 1957 and were an important step in the development of the Happenings, although Red Grooms is usually credited with organizing the first theatrical performance resembling a Happening. (Kaprow has set the record straight for future historians in a detailed history of the Happenings.)

In 1958 Rauschenberg and Johns held their first one-man shows at the Leo Castelli

Gallery; included were such now historic pieces as Rauschenberg's bed and Johns' colored targets. Since then new Dada works have turned up in galleries, museums and private collections all over America and Europe.

We have seen that American new Dada is not European Dada. It borrows certain techniques from the latter, but its attitudes and content are vastly different. Unlike European Dada, it seeks neither to criticize, to satirize nor to scandalize. It does not affirm, like socialist realism, or protest, like Expressionism; it suspends judgment in a passive, detached fashion. Having none of the cult-religion aspect of Dada, it is against nothing and for art. Perhaps its goals are most clearly articulated by Cage, in the introduction to a performance given in 1956 by Merce Cunningham:

> The novelty of our work derives therefore from our having moved away from simply
> private human concerns towards the world of nature and society of which all of us are
> a part. Our intention is . . . simply to wake up to the very life we're living . . .

Here he speaks only for himself and Merce Cunningham, but he could speak as well for the generation of new Dadaists, who, turning from the inner world of Abstract Expressionism, look outside, and make art of what they see.

What they see is America, its glitter, its vulgarity, its carnival-like excitement and constantly changing face. By transforming the commonplace and the ordinary into the poetic or the arresting, they force us to look freshly, to correct our corrupted vision.

But is this art serious? Yes, insofar as it is at all possible to be serious now. By investing the trivial with importance, it mirrors our dislocated sense of values. Apolitical and unprogrammatic, new Dada is not without humor, but its humor is what Duchamp called the "irony of despair."

Do we inflate its meaning, as Oldenburg himself blows up a hamburger to Brobdingnagian proportion? No, not when we realize, no matter how attached we are to the old ways, Munch's *Scream* is no longer the valid expression of anguish in our time. It is as outmoded as the clichés the new Dadaists serve up to us; and perhaps these artists, giving us back in the form of art the sights and sounds of everyday experience, are creating an iconography as serious, as profoundly disturbing as the infernal tortures of Bosch's *Millenium.*

from its beginnings, has suffered from the humiliating predicament of having to deal with a class of objects – namely, works of art – which were far more interesting than anything that might be said about them. With the coming of pop art, this humiliation has at last been abated. It has, to all appearances, been triumphantly overcome. The relation of the critic to his material has been significantly reversed, and critics are now free to confront a class of objects, which, while still works of art more or less, are art only by default, only because they are nothing else, but about which almost anything critics say will engage the mind more fully and affect the emotions more subtly than the objects whose meaning they are ostensibly elucidating.

Pop art is, indeed, a kind of emancipation proclamation for the art critic, and while I hesitate to labor the point unduly, it may just conceivably be possible that *some,* though surely not all, of the interest this movement has generated among critics – and among museums, too, and museum symposia – is traceable to the sense they have of being placed by this new development in a more advantageous position vis-à-vis the work of art than they have heretofore enjoyed.

Why is it the case, as I emphatically believe it to be, that this work is interesting for what is said *about* it rather than for what it, intrinsically, is? Primarily, I think, because it is so preponderantly contextual in its mode of address and in its aesthetic existence; so crucially dependent upon cultural logistics outside itself for its main expressive force. It neither creates new forms nor gives us new ways of perceiving the visual materials out of which it is made; it takes the one from the precedents of abstract art and the other from the precedents of window display and advertising design. It adopts and adapts received ideas and received goods in both spheres – form and content – synthesizing nothing new, no new visual fact of aesthetic meaning, in the process. The critic Sidney Tillim, in writing about Oldenburg's last exhibition, said: " . . . at no time in Oldenburg's work was there ever a possibility for form to have a destiny"; and to this correct observation I would myself add: There was neither the possibility of content having a destiny, for the brute visual facts of the popular culture all around us, and upon which Oldenburg was drawing, had already endowed this material with a destiny that only a formal and psychological and social imagination of the greatest power and magnitude could hope to compete with and render artistically meaningful.

Pop art derives its small, feeble victories from the juxtaposition of two clichés: a cliché of form superimposed on a cliché of image. And it is its failure to do anything more than this that makes it so beguiling to talk about and write about – that makes pop art the conversation piece *par excellence* – for it requires talk to complete itself. Only talk can effect the act of imaginative synthesis which the art itself fails to effect.

Why, then, are we so interested in it just now, so interested in the art and in the talk?

In answering this more general question, it seems to me imperative to grasp the relation of this development to the current popularity of abstract painting, and particularly abstract painting which has been so extreme (whatever its other achievements may be) in denuding art of complex visual incident. This poverty of visual incident in abstract painting has given rise to practically every new development of the last couple of years; happenings, pop art, figure painting, monster-making, kinetic art – all have in common, whatever their differences, the desire to restore to complex and recognizable experience its former hegemony over pure aestheticism. And it is as part of this desire that the taste for pop art must be understood – again, I emphasize, a contextual meaning rather than an intrinsic, creative one.

Pop art carries out a moderately successful charade – but a charade only – of the two

For the first time in this century there is a class of American collectors that patronizes its advanced artists. The American artist has an audience, and there exists a machinery, dealers, critics, museums, collectors, to keep things moving and keep people on their toes. Yet there persists a nostalgia for the good old days when the artist was alienated, misunderstood, unpatronized. The new situation is different. People *do* buy art. In this sense too there is no longer, or at least not at the moment, such a thing as an avant-garde. Avant-garde must be defined in terms of audience, and here we have an audience more than ready to stay with the artist. One even gets the idea that shock has become so ingrained that the dealer, critic and collector want and expect it.

The general public has not become appreciably more aware of good painting, but the audience for advanced art, partly because of the influence of the Museum of Modern Art, is considerably wider than it has ever been in this country.

Through our writers and art historians we have become very conscious of the sequence of movements, of action and reaction. The clichés and tools of art writing have become so familiar that we can recognize a movement literally before it fully happens. About a year and a half ago I saw the work of Wesselmann, Warhol, Rosenquist and Lichtenstein in their studios. They were working independently, unaware of each other, but with a common source of imagery. Within a year and a half they have had shows, been dubbed a movement, and we are here discussing them at a symposium. This is instant art history, art history made so aware of itself that it leaps to get ahead of art.

The great body of imagery from which the pop artists draw may be said to be a common body, but the style and decisions of each are unmistakable. The choice of color, composition, the brush stroke, the hardness of edge, all these are personal no matter how close to anonymity the artist may aspire in his desire to emulate the material of his inspiration, the anonymous mass media. The pop artists remain individual, recognizable and separate. The new art draws on everyday objects and images. They are isolated from their ordinary context, and typified and intensified. What we are left with is a heightened awareness of the object and image, *and* of the context from which they have been ripped, that is, our environment. If we look for attitudes of approval or disapproval of our culture in this art, of satire or glorification of our society, we are oversimplifying. Surely there is more than satire in Hogarth, the Longhis, Daumier, Toulouse-Lautrec. There is a satirical aspect in much of this art, but it is only that, one aspect.

Pop art is immediately contemporary. We have not yet assimilated its new visual content and style. The question at hand is not whether it is great art; this question is not answerable, or even interesting, just now. I think the point is *not* to make an immediate ultimate evaluation, but to admit the possibility that this subject matter and these techniques are and can be the legitimate subject matter and technique of art. And the point is too to realize that pop art did not fall from the heavens fully developed. It is an expression of contemporary sensibility aware of contemporary environment and growing naturally out of the art of the recent past.

HILTON KRAMER

Perhaps I should begin my remarks on the phenomenon of pop art, neo-Dada, New Realism, or whatever we finally agree to call it, on a positive note (since there will be much to say in the negative) and admit straightaway that I do believe it represents a significant historical breakthrough, as we say, in one – but only one – respect. It represents something new, not so much in the history of art as in the history of art criticism, for criticism,

and even exportable to Europe, for we have carefully prepared and reconstructed Europe in our own image since 1945 so that two kinds of American imagery, Kline, Pollock and de Kooning on the one hand, and the pop artists on the other, are becoming comprehensible abroad.

Both Clement Greenberg and Harold Rosenberg have written that increasingly in the twentieth century, art has carried on a dialogue with itself, art leads to art, and with internal sequence. This is true still, even with the external references pop art makes to the observed world. The best and most developed post–Abstract Expressionist painting is the big single-image painting, which comes in part out of Barney Newman's work – I am thinking of Ellsworth Kelly, Kenneth Noland, Ray Parker and Frank Stella, among others – and surely this painting is reflected in the work of Lichtenstein, Warhol and Rosenquist. Each of these painters inflates his compulsive image. The aesthetic permission to project their immense pop images derives in part from a keen awareness of the most advanced contemporary art. And thus pop art can be seen to make sense and have a place in the wider movement of recent art.

I have heard it said that pop art is not art, and this by a museum curator. My feeling is that it is the artist who defines the limit of art, not the critic or the curator. It is perhaps necessary for the art historian, who deals with closed issues, to have a definition of art. It is dangerous for the critic of contemporary art to have such a definition. Just so there is no unsuitable subject for art. Marcel Duchamp and Jasper Johns have taught us that it is the artist who decides what is art, and they have been convincing philosophically and aesthetically.

Pop art is a new two-dimensional landscape painting, the artist responding specifically to his visual environment. The artist is looking around again and painting what he sees. And it is interesting that this art does not look like the new humanism some critics were so eagerly hoping for. It points up again the fact that responsible critics should not predict, and they should not goad the artist into a direction that criticism would feel more comfortable with. The critic's highest goal must be to stay alert and sensitive to what the artist is doing, not to tell him what he should be doing.

We live in an urban society, ceaselessly exposed to mass media. Our primary visual data are for the most part secondhand. Is it not then logical that art be made out of what we see? Has it not been true in the past? There is an Ogden Nash quatrain that I feel is apposite:

> I think that I shall never see
> A billboard lovely as a tree
> Perhaps unless the billboards fall
> I'll never see a tree at all.

Well, the billboards haven't fallen, and we can no longer paint trees with great contemporary relevance. So we paint billboards.

A proof I have heard that pop art cannot be serious is that it has been accepted so readily. As everyone knows, the argument goes, great art is ignored for years. We must examine this prejudice. Why are we mistrustful of an art *because* it is readily acceptable? It is because we are still working with myths developed in the years of alienation.

The heroism of the New York School has been to break through and win acceptance for the high and serious purpose of American painting. There is now a community of collectors, critics, art dealers and museum people, a rather large community, that has been educated and rehearsed to the point that there is no longer any shock in art.

A SYMPOSIUM ON POP ART

Peter Selz, Henry Geldzahler, Hilton Kramer,
Dore Ashton, Leo Steinberg, Stanley Kunitz

As interest in pop art has spread quickly not only from 77th Street to 57th Street but indeed from coast to coast, the Department of Painting and Sculpture Exhibitions at the Museum of Modern Art thought it might be enlightening to organize a panel discussion on the subject. I therefore invited five distinguished critics to participate in a symposium on December 13, 1962. These participants were selected for their different points of view as well as for their past contributions to American art criticism.

We chose the term "pop art" because it seems to describe the phenomenon better than a name like New Realism, which has also been applied to such divergent forms as Germany's Neue Sachlichkeit of the twenties and France's Réalités Nouvelles of the forties. The term neo-Dada was rejected because it was originally coined in the pejorative and because the work in question bears only superficial resemblance to Dada, which, it will be remembered, was a revolutionary movement primarily intended to change life itself.

The panel was not expected to come up with a definition of pop art at this stage, but rather to present prepared papers and to engage in a lively discussion. I introduced the evening by presenting a number of slides, including photographs of window displays and billboards taken by Russell Lee for the Farm Security Administration in the thirties; these, although they were documentary in purpose, are similar to some of the new work when presented in this context. Limiting myself only to American practitioners of this art, I showed slides of relevant work by Robert Rauschenberg and Jasper Johns, by the so-called sign painters Roy Lichtenstein, Robert Indiana, James Rosenquist, Andy Warhol and Wayne Thiebaud, by those as diverse as Claes Oldenburg, Peter Saul, James Dine and Tom Wesselman, as well as by artists whose sculptures and assemblages are only iconographically related to pop art: H.C. Westermann, Edward Kienholz, Niki de St. Phalle and Marisol.

The papers and the ensuing discussion among the panel members are presented in the following pages. The discussion from the floor concluding the evening could not be taped and has therefore been omitted.

Peter Selz

HENRY GELDZAHLER

It is always a simple matter to read inevitability back into events after they have happened, but from this vantage point it seems that the phenomenon of pop art was inevitable. The popular press, especially and most typically *Life* magazine, the movie close-up, black and white, technicolor and wide screen, the billboard extravaganzas, and finally the introduction, through television, of this blatant appeal to our eye into the home – all this has made available to our society, and thus to the artist, an imagery so pervasive, persistent and compulsive that it had to be noticed. After the heroic years of Abstract Expressionism a younger generation of artists is working in a new American regionalism, but this time, because of the mass media, the regionalism is nationwide,

Arts, April 1963: 35-45

kinds of significance we are particularly suckers for at the present moment: the Real and the Historical. Pop art seems to be about the real world, yet it appears to its audience to be sanctified by tradition, the tradition of Dada. Which is to say, it makes itself dependent upon something outside art for its expressive meaning, and at the same time makes itself dependent upon the myths of art history for its aesthetic integrity. In my opinion, both appeals are fraudulent.

But pop art does, of course, have its connections with art history. Behind its pretensions looms the legendary presence of the most overrated figure in modern art: Mr. Marcel Duchamp. It is Duchamp's celebrated silence, his disavowal, his abandonment of art, which has here – in pop art – been invaded, colonized and exploited. For this was never a real silence. Among the majority of men who produced no art, and experienced little or none, Duchamp's disavowal was devoid of all meaning. Only in a milieu in which art was still created, worried over, and found to be problematical as well as significant and necessary, could Duchamp's silence assume the status of a relevant myth. And just so, it is only in the context of a school of painting which has radically deprived art of significant visual events that pop art has a meaning. Place it in any other visual context and it fades into insignificance, as remote from our needs as the décor in last year's Fifth Avenue windows.

Duchamp's myth does carry a moral for pop art. If his silence means anything – and it surely means much less than has been made of it – its meaning is more biographical than historical. At a certain point in Duchamp's development as an artist, the experience and objects of modern life defeated his ability to cope with them. This is not an uncommon development in the life of an artist, but Duchamp was perhaps the first to turn his aesthetic impotence into a myth of superior powers. His ready-mades were simply the prologue to the silence that followed. It was *not* Duchamp, but artists like Mondrian (in his "Boogie-Woogie" paintings) and Stuart Davis (in his paintings of New York) and David Smith (in the very way he used factory materials) who told us what it felt like to live in this particular civilization at this particular moment in history.

Pop art does not tell us what it feels like to be living through the present moment of civilization – it is merely part of the evidence of that civilization. Its social effect is simply to reconcile us to a world of commodities, banalities and vulgarities – which is to say, an effect indistinguishable from advertising art. This is a reconciliation that must – now more than ever – be refused, if art – and life itself – is to be defended against the dishonesties of contrived public symbols and pretentious commerce.

DORE ASHTON

When Lawrence Alloway first discussed pop art he explained that it was based "on the acceptance of mass-produced objects just because they are what is around." The throwaway materials of cities as they collect in drawers, closets and empty lots are used, he said, so that "their original identity is solidly kept." For Alloway it was essential that the "original status" of junk be maintained. He bared the naturalistic bias of pop art when he insisted that "assemblages of such material come at the spectator as bits of life, bits of the city."

The urgent quest for unadorned or common reality, which is the avowed basis of pop art, was again asserted by Alloway two years after. In an introduction to Jim Dine's catalogue he flatly poses pop art as an antidote to idealism: he suggests that aesthetic tradition tends to discount the reality of subject matter, stressing art's formality "which can be made a metaphor of an ideal order."

And here is the crux of the matter: the contemporary artist, weary and perplexed by

the ambiguities of idealism (as in Abstract Expressionism, for instance), decides to banish metaphor. Metaphor is necessarily a complicating device, one which insists on the play of more than one element in order to effect an image. The pop artist wants no such elaborate and oblique obligation. He is engaged in an elementary game of naming things – one at a time.

Perhaps the movement can be seen as an exacerbated reaction to the Romantic movement, so long ascendant in modern art history, in which artists were prepared to endure an existence among things that have no name.

Or perhaps pop art is a defensive movement against overwhelming Romantic isolation. Baudelaire said that the exclusive passion of art is a canker which devours everything else. Perhaps this generation is fearful of being devoured – fearful of life itself.

The impatient longing to reduce reality to the solid simple object which resists everything – interpretation, incorporation, juxtaposition, transformation – appears again and again in modern art history. But it is always delusive. The artist who believes that he can maintain the "original status" of an object deludes himself. The character of the human imagination is expansive and allegorical. You cannot "think" an object for more than an instant without the mind's shifting. Objects have always been no more than cues to the vagabond imagination. Not an overcoat, not a bottle dryer, not a Coca-Cola bottle can resist the onslaught of the imagination. Metaphor is as natural to the imagination as saliva to the tongue.

The attitude of the pop artist is diffident. He doesn't aspire to interpret or re-present, but only to present. He very often cedes his authority to chance – either as he produces his object, or as it is exposed to the audience which is expected to complete his process. The recent pop artist is the first artist in history to let the world into his creative compound without protest.

A few brief history notes: Apollinaire said Picasso used authentic objects which were "impregnated with humanity" – in other words, he used them metaphorically. When Duchamp exhibited his urinal he was careful to insist that it was significant because he, Duchamp, had chosen it. Schwitters wrote that "every artist must be allowed to mold a picture with nothing but blotting paper, provided he is capable of molding a picture."

But by the time pop art appears, the artist as master image-maker is no longer assertive. He gladly allows Chance to mold his picture, and is praised for it, as when John Cage praises Rauschenberg because he makes no pretense at aesthetic selection. There is a ring of Surrealism and Lautréamont in Cage's observation that between Rauschenberg and what he picks up is the quality of an encounter – but not the metaphorical encounter of sewing machine and umbrella – only a chance encounter in the continuum of random sensation he calls life.

In the emphasis on randomness and chance, on the virtual object divested of associations, on the audience as participant, and in his rebellion against metaphor, the pop artist generally begs the question of reality. He refuses to take the responsibility of his choices. He is not the only one. Alain Robbe-Grillet, commenting on his filmscript *Last Year at Marienbad,* parallels him when he says that the spectator can do with it what he likes; he, the author, had nothing decisive in mind.

The contemporary aesthetic, as exemplified by many pop artists and certain literary and musical figures, implies a voluntary diminution of choices. The artist is expected to cede to the choice of vulgar reality; to present it in unmitigated form. Conventionally, choice and decision are the essence of a work of art, but the new tendency reduces the number and quality of decisions to a minimum. To the extent that interest in objects and

their assemblage in non-metaphorical terms signifies a reduction of individual choices, pop art is a significant sociological phenomenon, a mirror of our society. To the extent that it shuns metaphor, or any deep analysis of complex relations, it is an impoverished genre and an imperfect instrument of art.

Far from being an art of social protest, it is an art of capitulation. The nightmare of poet Henri Michaux, who imagines himself surrounded by hostile objects pressing in on him and seeking to displace his "I," to annihilate his individuality by "finding their center in his imagination," has become a reality for many would-be artists. The profusion of things is an overwhelming fact that they have unfortunately learned to live with.

I can see the movement as cathartic – art protecting itself from art. But catharsis is by no means an adequate response to the conundrum of contemporary life.

LEO STEINBERG

I have put down three questions: First: Is it art? Second: If it is – if pop art is a new way in art – what are its defining characteristics? And Third: Given its general characteristics (if definable), how in any particular case do you tell the good art from the bad? Since I have only seven minutes, if I can't answer these questions, I can at least complicate them.

The question "Is it art?" is regularly asked of pop art, and that's one of the best things about it, to be provoking this question. Because it's one that ought to be asked more or less constantly for the simple reason that it tends to be constantly repressed. We get used to a certain look, and before long we say, "Sure it's art; it looks like a De Kooning, doesn't it?" This is what we might have said five years ago, after growing accustomed to the New York School look. Whereas ten years earlier, an Abstract Expressionist painting, looking quite unlike anything that looked like art, provoked serious doubts as to what it was.

Now I think the point of reformulating this question time and again is to remind us that if there is a general principle involved in what makes a work of art, we have yet to establish it. And I mean specifically this: Do we decide that something is art because it exhibits certain general characteristics? Or because of the way we respond to it? In other words, exactly what is it that the artist creates?

Victor Hugo, after reading *Les Fleurs du Mal,* wrote to Baudelaire and in five words summed up a system of aesthetics: "You create a new shudder." This implies that what the artist creates is essentially a new kind of spectator response. The artist does not simply make a thing, an artifact, or in the case of Baudelaire, a poem with its own beat and structure of evocation and image. What he creates is a provocation, a particular, unique and perhaps novel relation with reader or viewer.

Does pop art then create anything new – a new shudder – or not? The criticism of pop art is that it fails to do it. We are told that much of it is pre-figured in Dada, or in Surrealism, or worse still, that it simply arrests what advertisements and window displays throw at us every hour. In other words, there is not sufficient transformation or selection within pop art to constitute anything new.

This I cannot accept because I think there is nothing new under the sun except only man's focus of attention. Something that's always been around suddenly moves into the center of vision. What was peripheral becomes central, and that's what's new. And therefore it really doesn't help the discussion of any artistic experience to point out that you can find antecedents for every feature of it. And so I still think it justified to apply to pop art the remark that Victor Hugo applied to Baudelaire: it creates a new shudder.

Just what is it that's new about it? I will limit myself to my own experience; it involves

Roy Lichtenstein, who paints what appear to be mere blow-ups of comic-book illustrations. When I first saw these paintings, I did not like them, and I don't like them now. But I saw in them a new approach to an old problem, that of relating the artist to the bourgeois, the square, the Philistine or pretentious hipster. We remember that twentieth-century art came in with the self-conscious slogan *Epater le bourgeois:* to outrage or needle the bourgeois, keep him as uncomfortable and worried as possible. This program lasted roughly through the 1930's, when it was pursued chiefly by the Surrealists. The heroic years of Abstract Expressionism in New York after the Second World War brought another approach, an approach so organic that it was hardly formulated; it simply ignored the bourgeois. The feeling was, "They don't want us, we don't want them." The artists developed a thoroughgoing camaraderie: "We know what we're doing, the rest of the world never will. We'll continue to paint for each other." This surely was a radically different phase in the relationship of artist and middle class.

And when I saw these pictures by Lichtenstein, I had the sensation of entering immediately upon a third phase in twentieth-century painting. The idea seemed to be to out-bourgeois the bourgeois, to move in on him, unseat him, play his role with a vengeance – as if Lichtenstein were saying, "You think you like the funnies. Wait till you see how I like the funnies!"

I think it has something to do with God and idolatry, God being understood as the object of man's absolute worship. (I know no other way of defining the word.) Wherever people worship respectably, there is rivalry among worshippers to show who worships the most. Where the object of worship is disreputable, we pretend that our respect for it is very casual or a matter of mere necessity. And now Lichtenstein and certain others treat mass-produced popular culture as Duccio would treat the Madonna, Turner the Sea, Picasso the Art of Painting – that is to say, like an absolute good. Something like this is now going on, I think; the artists are moving in, naïvely or mockingly, each in his way, an uninvited priesthood for an unacknowledged, long-practiced cult. And this may be why, as Mr. Geldzahler was able to tell us, several pop artists were working along the same lines for years, though in ignorance of one another.

Whether their productions are works of art I am not prepared to say at this point. But that they are part of the history of art, of its social and psychological history, is beyond question. And if I say that I am not prepared to tell whether they are art or not, what I mean is that I cannot yet see the art for the subject. When I tell you, as I told Mr. Lichtenstein, that I don't like his paintings, I am merely confessing that in his work the subject matter exists for me so intensely that I have been unable to get through to whatever painterly qualities there may be.

This leads me to the second question I had wanted to touch upon. We have here one characteristic of pop art as a movement or style: to have pushed subject matter to such prominence that formal or aesthetic considerations are temporarily masked out. Our eyes will have to grow accustomed again to a new presence in art: the presence of subject matter absolutely at one with the form.

One thing I'm sure of: critics who attack pop art for discarding all aesthetic considerations talk too fast. They forget that artists always play peekaboo. Sometimes – and I am now thinking of all the history of painting – sometimes they play with latent symbolism, at other times they disguise their concern with pure form. Today, for some reason, these pop artists want the awareness of form to recede behind the pretense of subject matter alone, and this creates a genuine difficulty. Why they assign this new role to subject matter, after almost a century of formalist indoctrination, is not easy to say.

I see that some critics of pop art denounce it as a case of insufferable condescension. Several writers regard it as ineffectual satire (I myself see almost nothing satirical in pop art). Others think it's simple conformity with middle-class values. And there is always the possibility that the choice of pop subjects is artistically determined; that the variegated ready-made, pictorial elements he now uses furnish the artist with new richness of incident both in surface and depth, while allowing him not to worry about "the integrity of the picture plane." For since the elements employed in the picture are known and seen to be flat (being posters, cartoons, ads, etc.), the overall flatness of the picture-as-object is taken care of, and the artist, confronting new problems galore, faces one old problem the fewer. But it is obviously impossible to declare whether pop art represents conformity with middle-class values, social satire, effective or otherwise, or again a completely asocial exploration of new, or newly intriguing, formal means. It is impossible to give one answer because we are not dealing with one artist. We are asked to deal with many. And so far, there has been no attempt around this table to differentiate between them. And the fact that there has been no such differentiation encourages me to say something here which, I hope, won't sound too pedagogical.

There are two ways of treating an exhibition experience, especially one like the recent pop-art show at Sidney Janis'. One way consists of the following steps: First: Walk around the show, noting the common features. Second: Describe these features in one or more generalizations. Third: Evaluate your abstracted generalizations and, if you find them wanting, condemn the whole movement.

The other way begins in the same manner. Walking around, you observe this and that, passing by all the works that do nothing to you. Then, if any one work seems at all effective, open up at once and explore it as far as you can. Lastly, ponder and evaluate your reaction to this single work; and this, strangely enough, also yields a first generalization: If this one work in the show produced a valid experience, e.g., a new shudder, then the whole movement is justified by its proven ability to produce a valid work. The generalization emerges from the more intense experience of the particular. This is another way of doing it, and I prefer it, not only because I enjoy thinking about one work at a time, but also because the artists we are discussing share no common intention.

I am sorry to see that my time is up, so that I cannot comment on my question 3.

STANLEY KUNITZ

Confronting this sudden and rather staggering proliferation of "pop art" in our midst, I am tempted to echo the exclamation of the French artist Paul Delaroche when in 1839 he saw a daguerreotype for the first time: "From today," he said, "painting is dead." If I resist the temptation – and I do – it is not because I am afraid of sticking my neck out, for fear I may be proven wrong, but simply because I have every confidence that art is too tough a bird to die of either shame or indigestion. It has outlived even worse disasters. Of course, M. Delaroche was not completely mistaken: something did die after the invention of photography, namely M. Delaroche, together with his brand of bad academicism. The more I reflect on the subject, the more I am convinced that if we are ever to get an ideal history of art, it will have to be written by a master of comedy.

How does one explain the overnight apotheosis not of a single lonely artist but of a whole regiment wearing the colors of pop art, for whom the galleries and the museums immediately open their doors, and the collectors their pocketbooks? The best analogy I can think of is a blitz campaign in advertising, the object of which is to saturate the

market with the name and presence – even the subliminal presence – of a commodity. "Repetition is reputation," said one of the great tycoons of American industry. The real artists in this affair, I submit, are the promoters, who have made a new kind of assemblage out of the assorted and not necessarily related works of dozens of painters and sculptors, to which they have given the collective title (substitute brand-name) "pop art," or the "new realism." I wish I had time to discuss the significance of style in art as the signature of a culture, but I must be content with merely noting that history has become subject to such an acceleration of tempo that the life-span of a style, which used to be measured in centuries, has been reduced first to generations, and more recently to decades. Some of the vibration, I am sure, of American art has its source in the speed of our transit; but I am not persuaded that anything is to be gained by treating art as though it were almost exclusively a commodity, pliant to the whims of the market place and subject to the same principle of planned obsolescence as is inherent in the rest of our economy. I seriously doubt that we really need an annual change of model. And what of the role of the Museum in this development? Much as I love this place, I must confess that I wonder a bit about the ultimate consequences of such a rapacious historicity, such an indefatigable search for novelty. I find it disturbing that in concept and function a museum of art, traditionally a conservator of values, should grow closer and closer to an industrial museum, such as the one opened and operated by the Ford Motor Co., which was designed as a showcase for every model of a Ford car manufactured since the founding of the company. The art-establishment, as a whole, seems to be in such a hurry to get on the bandwagon these days that sometimes it gets there too soon and has to build the contraption before it can jump on it. Of course it is a peculiar kind of stupidity to regard any change of style as a form of subversion; but it is an equally peculiar kind of folly to greet every new twist of style as a revelation. We have in our time invented a new kind of tyranny, which is the tyranny of the avant-garde.

Anyone who has ever written on art must know that it is impossible to prove in words that a given work of art is either good or bad. In the end the art-object must stand as its own witness. Nevertheless I want to try to indicate, in a few paragraphs, why my response to pop art, or, let me say, to most of what passes as pop art, is largely negative. We have had the supreme fortune of a great art in this century, and a substantial part of that greatness originated and flowered here in this country. For the past dozen years in particular I have rejoiced in the companionship of an art that at its best, regardless of the modalities of style, I have felt to be notable for its courage and self-reliance; its self-awareness, sprung between psyche and medium; its rich spontaneity of nervous energy; the pitch and range of its sensibility; and the simultaneous sense that it has often given me of a wild act of assertion combined with a metaphysical entrapment in the infrangible web of space-time. An art of beginnings, misdirections, rejections, becomings, existences, solitudes, rages, transformations.

The archetypal pop artist, who is nobody apart from the brute reality of his milieu, will have nothing to do with the intense subjectivity of what he calls "a painterly aesthetic" – a phrase that is intended to ring like an abusive epithet. He has no interest whatsoever in converting existential feeling into unique gesture. The world of pop art is a clean, well-lighted place where we can see a deliberately tidy arrangement of the most anonymous traces of collective man, presented to us as though they were things in themselves, now that they have been detached from our Western karma, the cycle of manufacture and consumption. The pop artist assiduously refrains from divulging his feelings while he is set-

ting up his store. Perhaps he has had a hard day at the supermarket which is our world, but he is as reticent about his private responses as a newscaster on a network station. Perhaps he is saying that it is futile to attempt a new creation, given the facts of our situation, but we can only guess at that. All that we know is that he has limited himself to a re-arrangement of familiar counters. In so doing he unwittingly demonstrates what Coleridge defined as the difference between fancy and the imagination. This is an art not of transformation but of transposition.

If the pop artist is concerned with creating anything, it is with the creation of an effect. Consider, for example, the celebrated rows of Campbell's Soup labels. We can scarcely be expected to have any interest in the painting itself. Indeed, it is difficult to think of it as painting at all, since, apparently, the serial image has been mechanically reproduced with the aid of a stencil. If I insist, however, on classifying it as a painting, I am constrained to describe it as a kind of literary painting, since the effect for which it was created depends entirely on my recognition of an implied pair of references: first, to the pre-existent supermarket from which the labels are borrowed; and, second, to the pre-existent paintings from whose painterly aesthetic this composition departs. There is no value and, to give modesty its due, no pretension of value in the painting, *per se,* unless we read the footnotes, as it were, and get the drift of the allusions.

Ever since the Enlightenment, the arts have been the vehicle for conveying much of the mystery and disorder, the transcendental yearnings, that the Church had been able to contain before it became rationalized. Consequently the modern arts have found their analogue in religious ritual and action, in the communion that predicates the sharing of a deeply felt experience. The enemy has been consistently identified as bourgeois society and bourgeois values. Pop art rejects the impulse towards communion; most of its signs and slogans and stratagems come straight out of the citadel of bourgeois society, the communications stronghold where the images and desires of mass man are produced, usually in plastic.

Condemning an aesthetic of process, the pop artist proposes to purify the muddied stream of art by displaying objects in isolation, the banal items of our day refurbished, made real, by their separation from the continuum. What a quixotic enterprise! Even a seventh-grade science textbook informs us that objects are the least solid of our certainties. Heisenberg, who demonstrated that the very act of observation changes the phenomenon to be observed, quietly asserts – without feeling the need for an exclamation point: "Modern physics, in the final analysis, has already discredited the concept of the truly real." Probing the universe, man finds everywhere himself. In the words of another Nobel Prize physicist, Niels Bohr: "We are both spectators and actors in the great drama of existence." When Sartre brought the full weight of his philosophical intelligence to bear on this theme in an early novel, he significantly entitled his book *Nausea.* The theme is still being pursued by some of the best creative minds of France, notably by the writers and film-makers of the so-called *nouvelle vague.*

Pop art, in conclusion, seems to me to be neither serious nor funny enough to serve as more than a nine days' wonder. It brings to mind a recent Stanford Research Institute study on the contemporary boom in American culture – a study that is as amazing as it is, unintentionally, depressing. No doubt some of you will be even more depressed than I at the disclosure that there are as many painters in this country as hunters. Altogether some fifty million Americans are currently being stimulated to "do it yourself" in the practice of the sundry arts. One major explanation of this tidal wave is the growing availability of

"instant success" products, such as chord attachments for pianos and automatic light meters for cameras. "These devices," concludes the study, "come close to making a pro out of a dubber."

DISCUSSION

SELZ: I have a number of questions here which I would like the panel to discuss, questions I had prepared before . . . but before doing so, or perhaps instead of doing so, I will just take the place of the moderator and open it right up to you people.

GELDZAHLER: I'd like to ask Mr. Kunitz a question. I'd like to ask Mr. Kunitz what he feels the role of the Museum of Modern Art, or the art magazines and so on is, if it's not to record and to present to the public what is going on in the contemporary art world. If pop art is being done in New York City, if the Museum of Modern Art is involved in the hurly-burly, in the course of twentieth-century art and its most current manifestations as it has been since 1929 when it was founded, how could it possibly ignore something like this?

KUNITZ: I don't think for a moment that the Museum should ignore what's going on, especially a museum of *modern* art. But there are obviously principles of selectivity and of timing that enter into any active choice. I do have a feeling that in this terrible effort to get everything even *before it happens,* something strange happens to the landscape of art in our time.

GELDZAHLER: Then you feel modern art becomes modern in time but not right away?

KUNITZ: Well, the old debate of the difference between contemporary and modern is, I think, an exhausted one, and I don't want to get into that at this moment, but obviously I do believe in a principle of value.

KRAMER: May I ask Mr. Geldzahler a question on that? Do you then conceive the role of the Museum to be like that of a kind of three-dimensional tape recorder, giving us back what is currently being seen a few blocks away?

GELDZAHLER: I will agree that there has been some confusion in recent years between the galleries and the Museum of Modern Art. The Ad Reinhardt retrospective was given at the Section 11, the big Dickinson show was at the Graham Gallery, not at one of the museums where it should be, the "Sixteen Americans" was here, the "35 Painters under 35," or whatever it was – a lot of whom didn't have galleries – was at the Whitney, and as far as that goes, I would agree. But my feeling is that I pointed out the fact that this all happened terribly quickly (instant art history, etc.), but it is a fact that it has been considered and seen as a movement, and that the Museum of Modern Art with its dedication to contemporary art was made aware of it immediately, and couldn't ignore it. I just feel it was a compelling issue, and had to be engaged.

KUNITZ: But if the motto becomes "Make it new," and not only "Make it new," but "Make it new fast," and if obviously the role of the Museum is, as you see it, to introduce the *new,* then the sure way of being admitted to the Museum is to make it new faster than anybody else. And this becomes, it seems to me, a merry-go-round.

STEINBERG: There is no shortage in the world today of museums, even museums dedicated to modern art (I'm thinking, for instance, of the Tate Gallery in London), which make a practice of waiting until quality can be sifted. The Tate Gallery now is trying to raise I don't know how many hundreds of thousands of dollars to buy a Matisse. (They're very short on Matisse. They missed out on him.) And I would like to remind everybody here of a remark of Mr. Alfred Barr's, who is Director of Museum Collections, and I

quoted it once before from this platform because I've always admired it for its straightforward intelligence and humility and understanding of the nature and difficulties of contemporary art. Mr. Barr apparently said that if one choice in ten that we make now turns out to be valid in retrospect, we will have done very well indeed. It is very difficult, if you think of art-buying in the last hundred years, to find anyone who would have scored that well, and perhaps the Museum is buying a thousand percent to get its eventual hundred. I think that the words that Mr. Kunitz used and *repeated,* that the Museum is trying to get there before it happens, I think these are amusing words, but I don't understand what they are supposed to mean. They are not getting there before the pictures are painted, and they are clearly reacting to paintings that have been made, so what are you trying to say when you say "before it happens"?

KRAMER: May I make a comment on that, because I think, Leo, that you are completely ignoring the role that the Museum plays in *creating* history as well as *reflecting* it. It is its responsibility as a factor determining the course of what art is created, that people are objecting to.

GELDZAHLER: It is too late for the Museum of Modern Art to step out of history. It is very much involved in the action and reaction of contemporary history.

STEINBERG: Hilton, in answer to this I would say that of course the Museum has a role to play in making history, but fortunately this is a pluralistic society, and there is a balance of power. The Museum is not alone. The Museum had very hard days when it was fighting against God knows everything, from artists picketing on the street to Senators in Congress. And now that the opposition from Congress is hardly to be expected any more, the Museum has very tough competition from other museums that have arisen in New York.

KRAMER: Not really.

STEINBERG: Well, it certainly is a competition that will grow, but if the competition is not tough enough, then it's because Mr. Selz, Mr. Seitz, Mr. Barr, Mr. D'Harnoncourt, and the others, are faster or more intuitive or more perceptive . . . [cut off]

KUNITZ: But you really aren't answering the question.

STEINBERG: No, I am answering the question because I think that *Art News* and ARTS, and other museums, and the Metropolitan, they all share, quite equally, or potentially equally, in power play.

KRAMER: No. I don't think that's the case, and the difference is measurable.

STEINBERG: You cannot simply accuse a man of exercising power because he buys a certain art and this has an effect upon the market.

KRAMER: Oh yes you can! Of course you can!

GELDZAHLER: Mr. Kramer, how does he correct the situation? Does the Museum of Modern Art step out for five years and hold its breath? I don't understand.

KRAMER: Yes, I see nothing wrong with that. Maybe even *ten* years.

ASHTON: Hilton, why is this whole discussion focusing on the word "competition"? I always thought that art was beyond the notion of competition. If this is a discussion of a genre of art, why don't we keep it within that limit?

SELZ: I think maybe we ought to get back to some of the more basic issues. There is one question that I'd like to ask. It has something to do with one of the things Dore raised, that I'd like to bring out. I think most of us always felt that one of the absolute necessities for anything to be a work of art, was the aesthetic distance between the art and the experience. Now, if an aesthetic distance is necessary for a work of art, is an aesthetic experience possible when we are confronted with something which is almost the object itself? Without any distance, or with a real minimum of distance, which is, I think, one of

the problems we are confronted with in looking at this art. The old story of the person witnessing an accident on the highway not having an aesthetic experience comparable to tragedy. Where does the problem of the metaphor come in? There is a distinction to be drawn, I think, in the slides I showed, between some of the art, where the object is presented almost directly, say like in a comic strip by Lichtenstein, and in some of the others where there is a much greater transformation taking place. But what happens really where there is this minimum of transformation? Now Leo said that we don't know yet, that the form is hidden to some extent behind the subject, which is obviously apparent. Yet as critics, I think it is our absolute duty to know this difference and to be able to say yes or no. And my question to any one of you people is: Where is the aesthetic distance? Where does the problem of the metaphor come in with some of these objects?

GELDZAHLER: I would like to say that the means of contemporary art, the ways in which most contemporary art at any point is projecting and creating its magic, are mysterious, and the extent to which they are mysterious, incomprehensible, the extent of the difficulty we have in talking about it, is the extent to which the contemporary vibration, the immediacy, is felt. And when I said at the end of my talk, "I don't know if it is great art or not, we are not going to evaluate it ultimately tonight," and when Leo Steinberg said that the subject matter is so strong that the actual formal means seem to be disguised or behind, we are so confronted by the object, therefore not being used to it for so many years. I think that all this ties into Peter's question that the exact aesthetic distance is difficult to measure at this point.

STEINBERG: I think that aesthetic distance is in any case a nineteenth-century concept, and I do not unhesitatingly subscribe to it as an essential, as a *measurable* essential, of experience. One develops aesthetic distance from works that attain the *look* of art, the patina of art. The objection to an art like Caravaggio, like Courbet, any sort of real, raw, tough, realistic breakthrough in the history of art – the objection to it is always that it ceases to be art. Poussin would say, in the name of art, about Caravaggio, that he had been born to destroy painting. The whole of painting can be felt – after the initial blast of something like Caravaggism – can be felt to recoil, to defend art against the incursion of too much reality. It closes itself off the way a cell would against a foreign body. And what happens always is that aesthetic distance seems to have been destroyed. But not for us who look at it with the distance of time, because this aesthetic distance has been created. Just as aesthetic distance will exist for us for any kind of fashion the moment it is more than twenty or thirty years old.

SELZ: But when we look back does it become a work of art?

STEINBERG: Well, this is exactly when I say that this is premature. When I said about Lichtenstein's paintings that I do not like them as *paintings,* what I meant to say was that I do not feel competent to judge them as paintings, because the pressure of subject matter is so intense. This was not intended as a negative judgment upon them, but as a confession of inability on my part. But as a rider to this, I would say I suspect anyone who claims to know, now, that it is not serious painting.

KRAMER: I find a serious discrepancy in the discussion here. Dr. Selz asked a fairly sophisticated aesthetic question about pop art as art, and Mr. Steinberg, who avers that he doesn't *know* whether it is art or not, answers it in a very complicated way on the assumption that it *is.* Now, do you think it's art, or not? And, are you in the habit of applying aesthetic criteria and aesthetic categories to a discussion of data or matter that you have not yet determined to have an aesthetic character?

STEINBERG: I think the question is legitimate, and I am very glad it was raised. When

I said before that the questions about the art status of a work that is presented to us, depend not merely on analysis of certain inherent characteristics, but may also depend on the nature of the spectator's response, this would imply that before I can answer the question "Is this a work of art or not?" I want to have all the data in. Now the picture itself is part of the data, obviously. The rest of the data will be my reaction to it, the full experience of it. And this means that I must be interested in the kind of reaction a work elicits. Not every work elicits a reaction from me, obviously. And I know for instance, in reading – I have a certain advantage here over Mr. Kramer because I have his article that he wrote in *The Nation.* And the article is, as everything Mr. Kramer writes, exceedingly intelligent. I disagree with about 90 percent of it. But I disagree with the method. And the method is evident, for instance, when he begins to describe the show at the Janis Gallery. He says: "It is full of things to talk about. There is a small refrigerator whose door opens to the sound of a fire siren. There is an old-fashioned lawn mower joined to a painting on canvas. There are collections of old sabers and discarded eye-glasses under glass. There are even paintings, like you know, with paint on canvas, of pies and sandwiches and canned soup . . . " and it goes on listing these things. Now, at no point is there any indication that Mr. Kramer submitted to any one of these objects singly. Mr. Kramer is the person I have in mind who makes a general rapid survey and is interested in the generalization about the common features. This is a valid way of doing it. It is not the only way of doing it, and it is one that I suspect for my own purposes, because it will never yield an answer to the question whether an individual work is art or not. Now for myself, I feel pretty certain that a good many of the exhibits in the Janis show were not art.

KRAMER: How do you know that?

STEINBERG: This is entirely a matter of . . . [cut off]

KRAMER: And if they aren't art, what are they?

STEINBERG: Perhaps I should modify this. They are art in so far as things produced in the art classes in schools, from first grade up, are art, because they are art classes. In so far as work done in the art department of the layout department, where the art editor lays things out on a magazine – in so far as this is art, this is perhaps the kind of thing that some of the followers of pop art will also produce. Therefore, if I say, offhand, that I suspect that they are not art, they may be only that kind of thing.

KRAMER: A *low* form of art.

STEINBERG: A low form of art – yes, or I think for instance . . . [cut off]

KRAMER: But not exactly *non*-art.

STEINBERG: What is non-art?

KRAMER: Well, that's what I'm asking you, because you are the only member of this panel who has declared himself as being uncertain as to whether these objects are art objects. And if they're not art objects, you must have another category that you place them in. Is it experience, or intellectualism?

STEINBERG: Well, they could be attempts to create art objects, which misfire, couldn't they?

KRAMER: Yes – *"failed"* art.

STEINBERG: Yes

KRAMER: Still art.

SELZ: May I bring up another point? A point that has been discussed comparatively little on this panel. We picked the term pop art. We might have called it New Realism as they did in the Sidney Janis Gallery, or New Dada. And this New Dada thing interests me.

What is the relationship (I think this is something worth exploring) between this and Dadaism? Dada, as we know, was essentially a conscious movement by writers and artists against the spirit of conformity and the *bourgeoisie*. Now this neo-Dada is to some extent – well, we heard Mr. Geldzahler say that the alienation was over, that everything is nice now, and using very much of a Madison Avenue term, he says it's nice because it "keeps things moving." Now if this art is as closely related to advertising and the whole campaign of Madison Avenue that we are so familiar with, as some people say it is, what is its relation to Dada?

GELDZAHLER: The difference between the beginning and the end of the question was a little complicated.

SELZ: Let's try to discuss for a minute its relationship to Dada.

GELDZAHLER: Leaving out Madison Avenue or bringing Madison Avenue in?

KUNITZ: Briefly, obviously, one finds sources of pop art in Dada, and I think the term New Dada has a degree of relevance. Certainly if you think of Schwitters' *Merzbilder* – there's a great relationship there. And then the *objets trouvés* and so forth. But it seems to me that the profound difference is that Dada was essentially a revolutionary movement. It was a movement that had great social passion behind it. It was a form of outrage. And it was launched against the very bourgeois society which the Dadaists felt were responsible for the First World War. It was launched as an *attack* upon them. Now the New Dada instead *embraces,* in a sense, the bourgeois symbols. And is without passion.

STEINBERG: I want to use a technique of Professor Ernst Gombrich, who never gives a lecture without quoting a *New Yorker* cartoon. One of my favorite *New Yorker* cartoons, and one that I think was really prophetic in showing that a new pathway for our admiration was being grooved. This was a cartoon showing an exasperated wife who exclaims to her husband, "Why do you always have to be a non-conformist like everybody else?" Just about that time there was a show of nineteenth-century French drawings mounted in New York, and the artists who were not the well-known revolutionaries of French official art history were labeled as "non-dissenters." I was immensely impressed with this term – this is an invention of real genius – the non-dissenters. Because after being educated as we have been, all of us, in this century, to read the history of art as just one damn rebel after another, and that's all there is, see – the succession of Delacroix, and then it's Courbet, and then it's Manet, and then it's Cézanne, and then it's Picasso – suddenly we find that there is an alternative mode of conduct, the *non-dissenter.* This is terrific, you see, and this suddenly becomes an avenue of extraordinary novelty and originality. You don't always have to be a non-conformist like everybody else. So my answer to Mr. Kunitz is simply this: Sure, Dada was revolutionary. Every art movement we have known for a hundred years was revolutionary. And it may be that the extraordinary novelty and the shock and the dismay and the disdain that is felt over this movement is that it doesn't *seem revolutionary* like every other.

GELDZAHLER: The great excitement and so on of Dada was its anti-formal nature after the great formal revolutions of Cubism, etc., and the break of sequence with the First World War. Dada was an anti-formal excitement. Pop art is definitely a formal art. It's an art of decisions and choices of composition. And I think Mr. Selz has downgraded the extent to which, for instance, Roy Lichtenstein changes the comic strip he's working from and the painting that's finished. I've seen the comic strip, I've seen the painting, the colors . . . [cut off]

ASHTON: What do you need, a magnifying glass? [laughter]

GELDZAHLER: You don't need a magnifying glass, Dore. All you need is a pair of eyes, and an open, willing spirit, and a soul, and a . . . [cut off by laughter]

KRAMER: I think that the question of the relationship of pop art to Dada has really not been taken seriously. It should be. But I think if it's going to be taken seriously, Dada itself has to be looked at in a way that nobody has really been willing to look at it for a long time. And that is that Dada was revolutionary *only* in its ideology, not in its aesthetics. You cannot say that Schwitters broke with Cubism. That's an absurdity. Cubism provided the entire syntax for everything he did. And so, if you're going to compare pop art with Dada, you would have to be very clear about what you're talking about, whether its avowed social ideology or its actual plastic accomplishments. They do not coincide by any means.

POP ART AT THE GUGGENHEIM

Barbara Rose

In the midst of the teapot tempest "pop art" has created in New York this season, Lawrence Alloway, Curator of the Guggenheim Museum, has organized a modest, unassuming, historically-minded show he modestly calls "Six Painters and the Object." The paintings, by such now celebrated object painters as Rauschenberg, Johns, Lichtenstein, Dine, Rosenquist and Warhol, seem almost to be seeking sanctuary on the Guggenheim's hallowed ground from the sensational press which pursues them. The thoroughly documented catalog, in listing instances in which artists have been inspired by *motifs* from popular sources in the past, relates pop art to older painting in a misleading way. In the past, when an artist like Courbet or van Gogh appropriated material from popular culture, it was with the intent of reaching a larger public – in fact of producing a kind of elevated popular art. Pop art in America had no such intention; it was made for the same exclusive and limited public as abstract art. That it has filtered down to the mass public, mostly by way of the mass media, and that it does have popular appeal, is irony to the third power. The public loves it because it is intelligible in everyday terms; the *cognoscenti* resent it and fail to see it as abstract art for virtually the same reason, although it uses the conventions of abstract rather than representational art.

The works have been selected with care. One bay, enough space to show five or six paintings, is devoted to each painter. By excluding lesser "pop artists," Alloway has assembled a much handsomer and more substantial show than the one currently on view in Washington. In general, he has chosen paintings that give a fair idea of each painter's variety and range. The only exception I would take to the selection is to wonder why no recent works by Jasper Johns were included. On the one hand his five paintings, including the famous *Green Target* and *White Flag,* are perhaps the strongest single body of work in the show, but on the other, one suspects Johns was the only artist not to be represented with a recent work because it is a fashionable position to assume only his early work counts.

For me, the Guggenheim exhibition brought out more clearly than ever the distance that separates Johns and Rauschenberg from the so-called "pop artists," in whose company they increasingly find themselves. I think it is not as inappropriate to talk of them in the same breath as it is to associate them with "pop art," which has a lot to do with them, but with which they have nothing to do. They are like the inventors of the signs of a language they do not speak. I haven't seen their earlier work side by side since the "Sixteen Americans" show in 1959, and the juxtaposition suggests that what they share – and what sets them apart from other artists – is a unique relationship to abstract expressionism.

The earliest, and possibly the best painting in the show, is Rauschenberg's extravagant, complex and highly-charged painting with *collage* elements of 1953-54. When this painting was done, fewer choices were open to the young painter of original mind who would not dog de Kooning's footsteps, as most of the other talented younger painters were doing. At that time the technique of abstract expressionism was not as exhausted as its content. By 1955, when Johns did *Tango* and the large *Green Target,* the situation in New York was something like that in Florence in 1520, when all the problems posed by

Art International, May 1963: 20-22

High Renaissance painting had been solved, but lip-service was still being paid to the outworn vocabulary. Both 1520 and 1955 were "crisis" moments; what makes Johns' and Rauschenberg's paintings of the middle fifties so interesting are precisely the marks of stress, pressure and conscious reaction to the precarious artistic situation of the moment. Around 1955, both painters – although Rauschenberg is working with multiple elements and Johns with a single image like a target or a flag – are covering over the whole surface. The works are densely-packed, solid looking, with an intensity that burns cold in Johns and hot in Rauschenberg. This reacting against and to the vital issues at a critical juncture comes across in the paintings in the sense of their being compact and condensed, determined and unyielding.

The paintings of Rauschenberg and Johns show so much intelligence we must assume the choice to cling to the modes of abstract expressionism after its creative heyday was not made in the dark, as one suspects it was in the case of de Kooning's followers. That Rauschenberg is acutely aware of the ironies of his situation is clear in his duplicated "action paintings" *Factum I* and *Factum II,* in which he proves the lie of abstract expressionist spontaneity by accurately reproducing every drip and splatter. In Johns' case, Michael Fried's statement that the later paintings "mock, not in venom but in loving sadness, the mannerisms of abstract expressionism," seems to me entirely correct.

Recently, both artists have opened up their paintings, and have in general relaxed their attack and loosened their brush-work. However, having opted in this direction, they proceed in their respective ways, better equiped to amuse, entertain or reward us aesthetically than the second-generation abstract expressionists who are their peers, and with whom they have far more in common than with "pop art."

For Rauschenberg, this means constantly pushing himself. His dynamism consists, I think, in the destruction of his own incredible facility and virtuosity through the conscious pursuit of the ugly or the inartistic. We understand this destructive quality as we understand the late pastels of Degas, in which Degas sought to efface the beauty of his own line by making the contours scribbled and broken. The seemingly inexhaustible inventiveness of Rauschenberg's imagination appears, in its restless ambition, to want to swallow the world.

Jasper Johns seems to me in love with his paintings. And the more he loves them, the better they are. Only a lover could lavish the kind of care and consideration Johns gives the surfaces of his paintings. Four of the paintings in the show are encaustic on newspaper; Johns revives the ancient technique of wax-painting in a way that again calls attention to the surface, which is both veined and suave, almost like skin over membrane, rather than harsh and rough like the surfaces of the abstract expressionists (or for that matter, Rauschenberg's surfaces). Where Rauschenberg expresses himself in gesture, Johns prefers the delicacy of touch. *False Start,* an oil painting of 1959, is characteristic of the direction of Johns' most recent works, but does not incorporate objects as many of them do. These 1959 paintings of bursts of the primary colors over which are stenciled "red," "yellow" and "blue" are Johns' poorest efforts; I can't understand why this painting rather than any number of works from the sixties, which are better, is included. In such an historically oriented show, the impression given is that Jasper Johns died in 1959, while Jim Dine lived on to continue his great tradition.

Jim Dine appears to strive for a heavy-handed freshness, as if to make a virtue of his own clumsiness. If he could do this, it would be fine, but instead he seems capable only of cartooning his own ideas. I found him in all ways the least of the artists represented.

Lichtenstein is a case in point of Leo Steinberg's observation (made at the Museum of

Modern Art's pop art symposium) that: "we have here one characteristic of pop art as a movement or a style; to have pushed subject matter to such prominence that formal or aesthetic considerations are temporarily masked out." Before discussing the relevance of this statement to Lichtenstein's work, I wish to disagree with the assumption that pop art is an *art style*. It is not; these artists are linked only through subject matter, not through stylistic similarities. This makes it possible to talk of the iconography or attitudes of pop art, but not of pop art as an art style, as one would speak of Baroque or Cubism. In fact, Rauschenberg and Johns belong to abstract expressionism (with Jim Dine a variation on their themes), Rosenquist is a billboard Surrealist who marries Magritte's paint handling to *collage* space, and Lichtenstein is a hard-edge painter, whose two-dimensional surface patterns and crisp outlines derive as much from Kelly as from comic strips. Only Andy Warhol has actually offered anything new in terms of technique, by adapting the commercial and purely mechanical process of silk screen to the purposes of painting on canvas. As for whether formal or aesthetic considerations are being temporarily "masked out," we must decide whether the subject matter of pop art is in fact strong enough to momentarily arrest the apprehension of formal relationships. This does seem true in Lichtenstein's case. I find his images offensive; I am annoyed to have to see in a gallery what I'm forced to look at in the supermarket. I go to the gallery to get away from the supermarket, not to repeat the experience. Of course the point is, the experience is not the same, since Lichtenstein is creating a strong, highly-formalized surface pattern which belongs to art and not to advertising. Why he chooses to dissociate image from pattern is another question. Simply put, I think it is because art itself is now suspect, and that Lichtenstein is saying, as Norman Mailer says, "Do not understand me too quickly."

The Guggenheim exhibition seems to answer the question of whether "pop art" is art. I am willing to say that if it is in the Guggenheim, it is art. But art of what calibre? The range in quality from Rauschenberg's early combine-painting to Jim Dine's *Coat* is almost too great to be bridged by merely setting them side by side. Museums are a center of authority in our culture; if the museum believes these are equally art, what choice has a public which lives in awe of authority but to think so too?

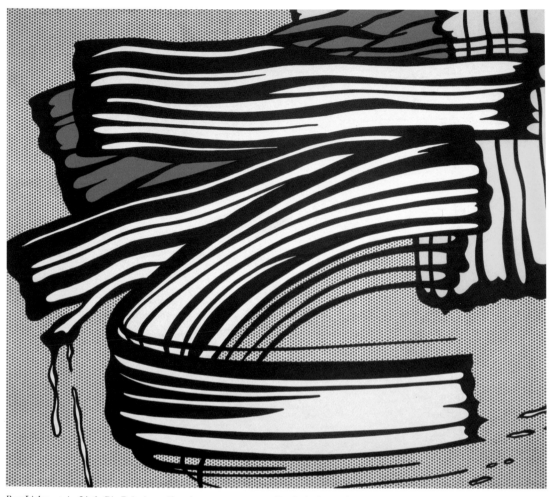

Roy Lichtenstein, Little Big Painting, *oil and magna on canvas, 68 × 80 inches, 1965.*
Collection of Whitney Museum of American Art, New York. Photograph by Robert E. Mates Studio, New Jersey.

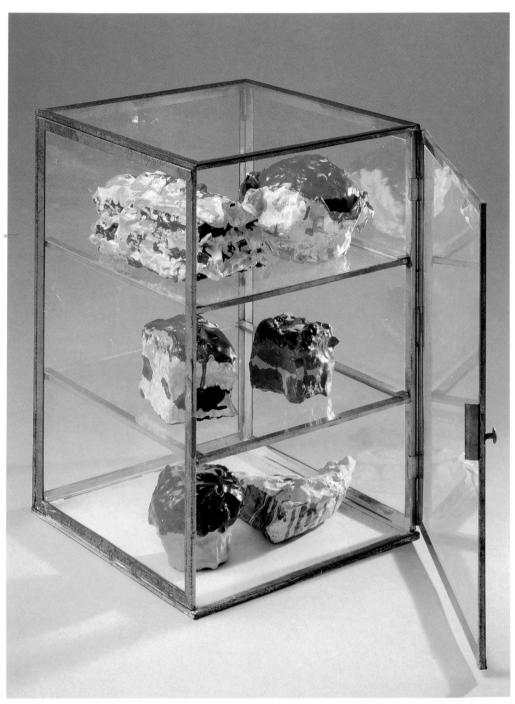

Claes Oldenburg, Pastry Case, I, *enamel paint on nine plaster sculptures in glass showcase, 20¾ × 30⅛ ×14¾ inches, 1961–62. Museum of Modern Art, New York. The Sidney and Harriet Janis Collection.*

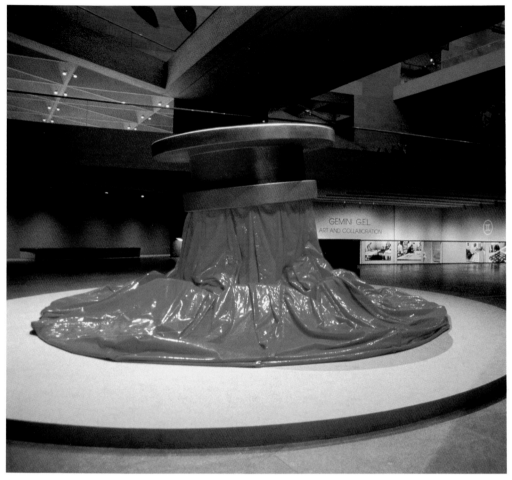

Claes Oldenburg, Giant Icebag, *vinyl, hydraulic mechanism, wood, 84–192 inches × 144–180 inches, 1969.*
Los Angeles County Museum of Art.

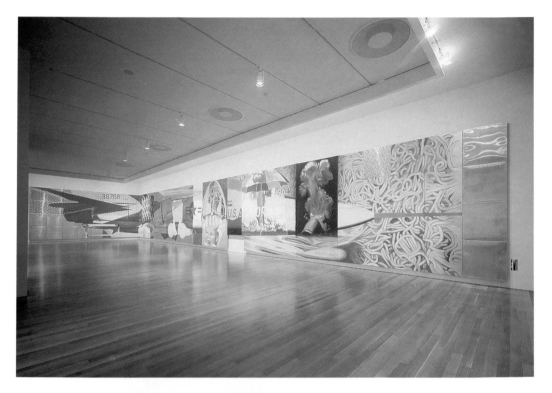

Above: James Rosenquist, F-111, oil on canvas with aluminum, 10 feet × 86 feet, 1964–65. The Museum of Modern Art, New York.

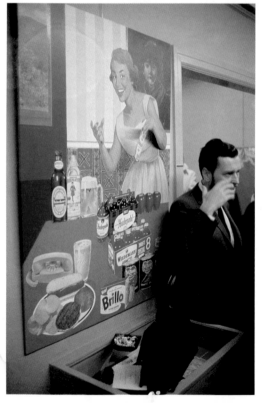

Left: Opening of the New Realists exhibition at the Sidney Janis Gallery, New York, October 31, 1962, with critic Leo Steinberg standing in front of Tom Wesselmann's Still Life #17. Photograph by Robert McElroy.

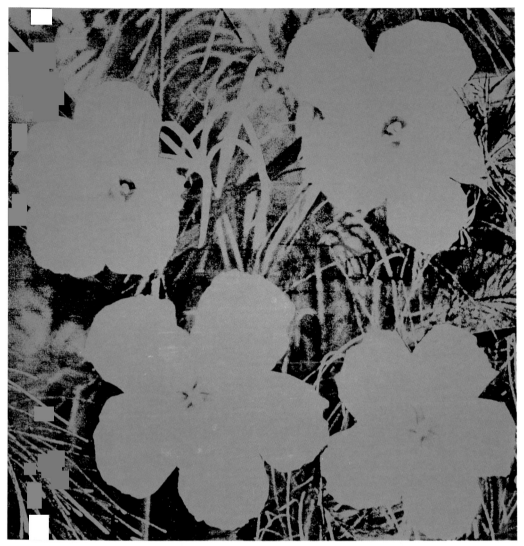

Andy Warhol, Flowers, *acrylic and silk-screen enamel on canvas, 9 feet, 7 1/2 inches × 9 feet, 7 1/2 inches, 1967. Museum of Contemporary Art, San Diego. Photographer: Philipp Scholz Ritterman.*

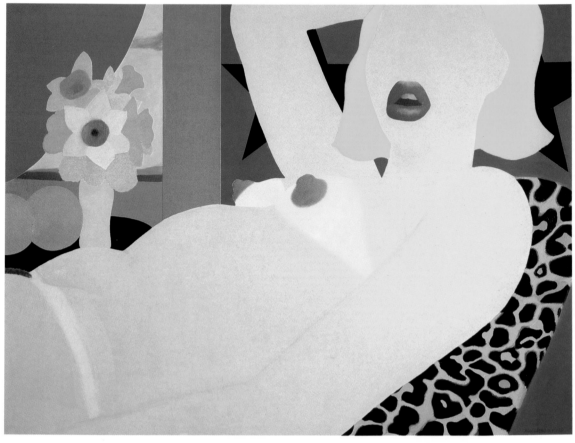

Tom Wesselmann, Great American Nude #57, *synthetic polymer on composition board, 48 × 65 inches, 1964. Collection of Whitney Museum of American Art, New York.*

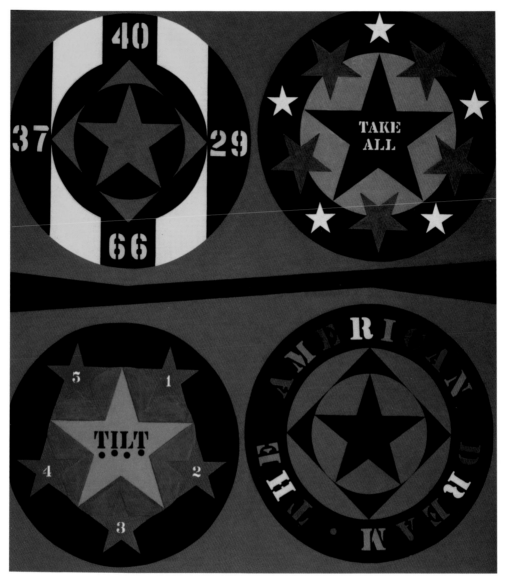

Robert Indiana, The American Dream I, *oil on canvas, 6 feet × 60⅛ inches, 1961.*
The Museum of Modern Art, New York. Larry Aldrich Foundation Fund.

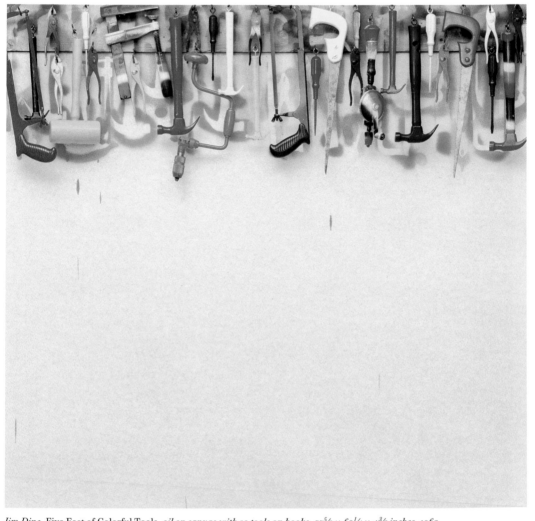

Jim Dine, Five Feet of Colorful Tools, *oil on canvas with 32 tools on hooks, 55⅝ × 60¼ × 4⅜ inches, 1962. The Museum of Modern Art, New York. The Sidney and Harriet Janis Collection.*

THE FLACCID ART

Peter Selz

Ten years ago painting in America was largely dominated by Abstract Expressionism. To-day there is a wider range of possibility in both style and subject matter. The older Abstract Expressionists are doing some of their finest work and Rothko has just completed a series of impressive murals for Harvard University. But, in addition, the Hard Edge painters are successfully synthesizing Mondrian and the New York School; a group of painters from Washington, Morris Louis and Kenneth Noland among them, have achieved new images by staining their canvases with simple shapes of decorative color; a rising generation of figure painters – Diebenkorn, Golub, and Oliveira – depict the ruined and isolated human beings of a disaffected society. Also the detritus of our culture is being re-assembled with often stunning and mordantly amusing results by the "junk artists." But the trend which has been most widely publicized and discussed during the past year is Pop Art.

Artists who make use of images and articles from popular culture – H.C. Westermann, Edward Kienholz, Marisol, Tinguely – are not necessarily practitioners of Pop Art. Westermann's metaphorical statements about the violent and ambiguous quality of contemporary life, Kienholz's incisively bitter social satire, or Marisol's sophisticated and humorous primitivism, the highly inventive constructions of Jean Tinguely, which have electrified and motorized our esthetic concepts, all differ significantly from Pop Art works. It is true that Pop Artists owe a great debt to Rauschenberg, but his Combine Paintings transform ordinary objects by fusing them provocatively with Abstract Expressionism.

The Pop Artists, some of whom came out of the advertising world, some out of the world of painting, stand apart as a group in that they not only take their subject matter from mass-production sources in our culture – magazines, billboards, comic strips, television – but they frequently employ commercial techniques as well: the airbrush, silk-screen reproductions, imitated benday screens. Sometimes, as in pictures by Dine and Wesselmann, actual objects are incorporated in the manner of collage. There is no theoretical reason why such popular imagery, or even the use of commercial art processes, should not produce works of real interest and value. After fifty years of abstract art, nobody could propose an academic hierarchy of subject matter; after fifty years of brilliant invention in collage and assemblage, nobody would be justified in suggesting that any technique is taboo. The reason these works leave us thoroughly dissatisfied lies not in their means but in their end: most of them have nothing at all to say. Though they incorporate many forms and techniques of the New York School (there is a particular debt to de Kooning's women) and the Hard Edge painters, these forms have been emptied of their content and nothing has been added except superficial narrative interest. People who ought to know better have compared Pop Art to the work of Chardin, because it depicts actual objects among familiar surroundings: an eighteenth-century still life, a twentieth-century billboard – why not? Leo Steinberg in the Museum of Modern Art's symposium on Pop Art goes so far as to suggest parallels to the realism of Caravaggio and Courbet. But Chardin, Caravaggio and Courbet created worlds of their own in which the reality of the subject was transformed into an esthetic experience. The interpretation or

Partisan Review, Summer 1963: 313-16. Reprinted by permission.

transformation of reality achieved by the Pop Artist, insofar as it exists at all, is limp and unconvincing. It is this want of imagination, this passive acceptance of things as they are that make these pictures so unsatisfactory at second or third look. They are hardly worth the kind of contemplation a real work of art demands. If comparisons are in order, one might more appropriately be made to the sentimental realism of nineteenth-century painters like Meissonier, Decamps, or Rosa Bonheur – all exceedingly popular and high-priced in their day.

When I was a teacher in the 1950's, during and after the McCarthy period, the prevailing attitude among students was one of apathy and dull acceptance. We often wondered what sort of art would later be produced by these young men and women, who preferred saying, "Great, man!" to "Why?" or possibly even, "No!" Now that the generation of the Fifties has come of age, it is not really surprising to see that some of its members have chosen to paint the world just as they are told to see it, on its own terms. Far from protesting the banal and chauvinistic manifestations of our popular culture, the Pop painters positively wallow in them. "Great, man!"

In the symposium on Pop Art at the Museum of Modern Art, Henry Geldzahler, an enthusiastic supporter of the trend, clarified both the attitudes of these artists and the reason for their prompt acceptance by the art world when he said, "The American artist has an audience, and there exists a machinery – dealers, critics, museums, collectors – to keep things moving. . . . Yet there persists a nostalgia for the good old days when the artist was alienated, misunderstood, unpatronized."

But I doubt that nostalgia is at issue here. What we have instead is a school of artists who propose to show us just how nice everything is after all. A critical examination of ourselves and the world we inhabit is no longer hip: let us, rather, rejoice in the Great American Dream. The striking abundance of food offered us by this art is suggestive. Pies, ice cream sodas, coke, hamburgers, roast beef, canned soups – often triple life size – would seem to cater to infantile personalities capable only of ingesting, not of digesting nor of interpreting. Moreover, the blatant Americanism of the subject matter – packaged foods, flags, juke boxes, slot machines, Sunday comics, mammiferous nudes – may be seen as a willful regression to parochial sources just when American painting had at last entered the mainstream of world art.

Only in the Pop Artist's choice of subject matter is there an implicit taking of sides. Essentially he plays it cool. He makes no commitments; for a commitment in either love or anger might mean risking something. Aline Saarinen in the April issue of *Vogue* (such magazines are an important part of the machinery that creates art-fashion) aptly says of Warhol: "He seems to love everything and love it equally. . . . I suspect that he feels not love but complacency and that he sees not with pleasure or disgust but with acquiescence."

What is so objectionable about Pop Art is this extraordinary relaxation of effort, which implies further a profound cowardice. It is the limpness and fearfulness of people who cannot come to grips with the times they live in. The Abstract Expressionists dedicated their lives to art and made a point of doing so. And who could have been more committed than Caravaggio, Chardin, and Courbet? But the Pop painters, because of their lack of stance, their lack of involvement, are producing works that strike the uninfatuated viewer as slick, effete, and chic. They share with all academic art – including, by the way, Nazi and Soviet art – the refusal to question their complacent acquiescence to the values of the culture. And most ironic of all is the fact that this art of abject conformity, this extension of Madison Avenue, is presented as *avant garde.*

In his brief introduction to the catalog of the Recent Acquisitions for Brandeis University, Sam Hunter suggests that Pop Art uses many of the compositional devices of the "purer expressions of our times." Indeed it does. It uses them in the same manner that a Hollywood movie vulgarized and banalized the teachings of Freud, or, at best, as Truman Capote has popularized and sensationalized Faulkner. It is what Dwight Macdonald calls "Midcult," the exploitation of the discoveries of the *avant garde*. "It is a more dangerous opponent to High Culture than Academicism," he says, "because it incorporates so much of the *avant garde*." This, I believe, exactly describes the relation of Pop Art to the tradition of modern art.

What we are dealing with then is an art that is easy to assimilate – much too easy; that requires neither sensibility nor intellectual effort on the part of either artist or audience; that has no more personal idiom than rock and roll music or the standard mystery story or soap opera. It is as easy to consume as it is to produce and, better yet, is easy to market, because it is loud, it is clean, and you can be fashionable and at the same time know what you're looking at. Eager collectors, shrewd dealers, clever publicists, and jazzy museum curators, fearful of being left with the rear guard, have introduced the great American device of obsolescence into the art world. For one thing, many of these objects simply won't last physically, but – more important – they will soon be old-fashioned because "styling" has been substituted for style, and promotion has taken the place of conviction. Like all synthetic art, when its market collapses it will collapse for good.

For this is not a folk art, grown from below, but *Kitsch,* manufactured from above and given all the publicity Madison Avenue dealers have at their disposal. The creator of such objects is not permitted to mature as an artist, for he has allowed himself to be thrust into a role he previously rejected (though it paid well it was demeaning), i.e., that of the designer of tail fins for General Motors. Allan Kaprow, the author of environments and happenings, prophesies that art dealers may indeed turn into art directors, and he actually looks forward to this development with relish.

It has been suggested of Pop Art that "something good may come of it – just give it time." I am not a prophet, but as an historian I must point out that earlier movements of this century – Cubism, Constructivism, Dada, Surrealism, Abstract Expressionism – produced much of their best work at the outset. It is possible that artists of conviction and ability may use some of the imagery of Pop Art in genuine works of art. Some have already done so. But that is a different question.

ANTI-SENSIBILITY PAINTING

Ivan C. Karp

The American urban landscape is fantastically ugly. Detroit is a fine example. The packaged horror of the super shopping center inspires at its worst (or best) a degree of revulsion instructive to the open eye. All others flee to Venice.

The Common Image Artist observes the landscape with its accoutrements and provokes a consummately generous view of a generally monstrous spectacle. His philosophy is that all things are beautiful, but some things are more beautiful than others. What is "more" beautiful is imbued with the glorious nimbus of revelation. This is his subject. At its best Common Image Art violates various established sentiments of the artist. By rendering visible the despicable without sensibility, it sets aside the precept that the means may justify the subject. The poetry is invisible. It is the fact of the picture itself which is the poetry. There is no starting pictorial apparatus employed to seduce the eye. The forms are locked into place and the colors are bright. The design is simple, almost simple minded. But the simplemindedness is vicious. It grates against the nerves.

The greatest art is unfriendly to begin with. Common Image Art is downright hostile. Its characters and objects are unabashedly egotistical and self-reliant. They do not invite contemplation. The style is happily retrograde and thrillingly insensitive (a curious advance). Red, Yellow, and Blue have been seen before for all they are worth. In Common Image Art they are seen once again. It is too much to endure, like a steel fist pressing in the face.

The formulations of the commercial artist are deeply antagonistic to the fine arts. In his manipulations of significant form the tricky, commercial conventions accrue. These conventions are a despoilation of inspired invention. But they are, in the distillations of profound observations, a fecund fund for insight into the style that represents an epoch. In Common Image Painting a particular and certainly peculiar moment in time is perfectly revealed in a strangely timeless mode by encompassing the conventions of commercial and cartoon imagery. Thus it engages the total panorama of visible evidence. The worthy subject is struck down once and for all. Nothing that is seen is too base to look at, as every form and space is suddenly interconnected. The merciless matchbook is lying in a vernal meadow, beside a brook near a frozen custard stand and funny papers on the chair in a house full of paintings by Inness.

Why Common Image Painting is remarkable at this time is because it proceeds from the artist's ecstasy of vision. The best of recent abstract painting, the works of Louis, Noland, Kelly, result from a total inward turning, a blindness to the spectacle, and in that they are excessively effete, refined, and genteel. Noland's recent show in New York was elegant and lean; the grandeur was missing. The vortex and target are, like the suspension bridge, infallible as form. But Noland's targets have crossed all their rivers. The paintings of Louis are not a civilization. For all the exquisite tonalites, expansiveness, and scale, the works are timorous and kindly. Art without fierceness is only restful. It never agitates or beckons. Even Claude is fierce. When the painter eschews the experience of wonderment at the spectacle he becomes a nervous pattern maker. Kelly's paintings are a grandiose rearrangement of small, neat discoveries which derive from the

inward turning against the pain and pleasure of the spectacle. Abstract Art at the moment is onanistic, an art of special effects. The artist uses his vision after the picture is made. The paintings of Pollock, Kline, and de Kooning begin with astonishment at something outside the self; they are of the phenomena and the energy of the environment. European art is tired because the landscape and spectacle are depleted of interest for the painter.

Common Image Painting, in extracting, amplifying, and re-poising the conventions of the commercial arts, reveals the psychological and stylistic temperament of an age before it is visible. Nostalgia becomes instantaneous. Lichtenstein paints popular subjects of the forties and fifties which is, as an age, still invisible without Lichtenstein. The "Yellow Girl" is timeless in her horror. In her conceit and vacuity she is hateful forever. In "No Nox," the Gas Station Attendant is a symbol of himself, vile in his uninvolved stupidity. He is created of hard, cold lines that do not derive from abstraction; a severe classicism, no sensitivity, no poetics, no mush. Rosenquist depicts the Gothic of the Thirties in vomity tones and brilliant, cruel compositions. The toast is stale and the smile is not for us. Although he manifests a certain artfulness that is akin to surrealism, the distance of his subjects from the viewer sustains the nice, cold, signboard clarity. Wesselman's subjects are the present moment in commercial art. At his best he is bright and brutal, like the aluminum jackets of cheap skyscrapers. The juxtapositions are crucial. He has proven with a subtle maneuver that the immense vulgarity of advertising color and form, separated from their natural habitat, is sufficient to reveal its hidden charms. The giant economy size can of Del Monte asparagus is a glory unto itself. The plastic corn with butter induces nausea and trembling. These objects are ghastly and wonderful at once, too horrible for words, a fearful joy. Warhol's art is that of innocent wonderment. When he avoids lyricism his repetitions achieve a grave simplicity. The "Electric Chair" painting in silver is an apogee of violence. It has no literary content. (The "Silence" sign insists.) The vertical zone on the right is numb and reflective, an abstraction of the image on the left.

Sensitivity is a bore. Common Image Painting is an art of calm, profound observation and humorous wonderment without sensibility. It does not criticize. It only records. The attitude of the Common Image painter is whimsical and slightly ironical. The environment is overwhelming, and thus he observes it. He must maintain the sense of the monumentally bizarre without surrealism or else he will defeat his art, just as Abstract Expressionism was winded by lyricism. The Abstract painters are obliged to locate the timeless symbols from their environment before they can conceive a revolutionary vitality akin to Common Image Art. The purging of poetic sensations in painting for an aggressive classicism marks the end of Impressionist oozings. For all the perversities, horrors, and doomist regalia in the excellent private works of Lindner, Samaras, Bontecou, and Conner, the American artists are inclined to bold affirmations. Rauschenberg's art is the ideal symptom of these high spirits. He is a prince of imagination, that critical ingredient, and bountiful source of inspiration. Common Image Painting is an affirmation of the pleasure of seeing, and although it was supposed to have expired at five o'clock on a Friday a long time ago, it will surely continue until a petty academy vetoes its puissance. Already it is a monument and possibly a bridge to a splendid new Romanticism.

THE NEW ART

Alan R. Solomon

From the moment when it became plain in the late forties that the first significant American style had crystallized in abstract expressionism, a certain unhappy majority began to look forward to the day when its discomfort at the absence from art of references to external reality would be mollified by a return to figuration in painting and sculpture. For this group the abandonment of the human figure and its environment reflected a failure with respect to "humanism," and they were unwilling to acknowledge the opportunity presented by the new attitude for the artist to create a new world of form and space, existing apart from all previous experience of the tangible external world, and creating its own special logic as well as its own unique excitement.

The appeal to humanism had built into it an implied moral hierarchy of ideas deriving from the whole classical tradition which has been a model for our society and which takes as its point of departure the anthropomorphism of the Greeks.

From time to time, those who take comfort in the presence of humans in art have found momentary hope in the prospect of the emergence of new images of man. However, contemporary man sees himself in his art not as an idealized god-like figure, in the manner of the classical tradition, but as a disrupted, contorted victim of the modern cataclysm, torn by forces of a magnitude beyond his comprehension, a grim figure, full of despair and anguish, entirely without hope. The "new image" is a monster, the product of irradiated esthetic genes. The basis of classical humanism was the spirit of man and its accommodation to the world, not the simple physical presence of his "human" person; figuration alone has not succeeded in restoring to art a meaningful sense of the value of man's existence and of his unique personality. Those of us who have looked for a way out of what we have regarded as the dilemma of abstraction through a new figurative art have therefore been faced with frustration heaped upon frustration.

Those of us for whom abstract art had not presented a dilemma, but for whom abstract expressionism seemed to have run its course, now find ourselves confronted by an ironic turn of events. In the first place, a vigorous new kind of geometric abstraction has quietly gathered force during the past few years. In the second place, and much less quietly, a new figurative art has come to public attention during the past few months. Unfortunately, the new art offers no solace at all to the advocates of figuration, who had something quite different in mind.

While the public has received the new abstraction with relative indifference so far, the new figurative art, or, as it is called, "New Realism," "Pop Art," "Neo-Dada," etc., has provoked a response of extraordinary intensity, stimulating extremes of unabashed delight or renewed anguish. Like all vital new movements in the modern period (impressionism, cubism, fauvism) it has quickly been assigned a pejorative title – or string of titles, in this case – by the unsympathetic critics, who add to the confusion by emphasizing the wrong attributes of the style. On the other hand, among the "advanced" observers and collectors of contemporary art, the new artists have enjoyed a spectacular success in a relatively short period of time, and their work has been sought out even before it reached the up-town galleries during the last two seasons.

Art International, September 1963: 37–41

The new art stirs such polar responses because it seems to make an active frontal assault on all of our established esthetic conventions at every level of form and subject matter. Yet the problem is really ours and not the artists; they have no aggressive or doctrinaire intention and, in fact, they present their new faces to us with a certain blandness and indirection. At the same time, their work is pitched at a high emotive level (for reasons which will be explained later) without any accretion of reference to complex abstract ideas; they appeal directly to the senses in what one might describe as a visceral rather than an intellectual way. In other words, these artists speak to our feelings rather than to our minds and they have no *programmatic* philosophical intent. Still, they speak so clearly from the contemporary spirit that their art, as much as it varies from individual to individual, shows a remarkable degree of philosophical consistency.

It is not difficult to understand the extremes of feeling stirred by the new art. In the past, with few exceptions we have attached a special importance to art, separating it clearly from the rest of the world and the rest of experience, viewing it as an activity of man comparable in importance to his most highly regarded institutions, in a distinct moral sense.

This habit of separating one kind of activity *and its attributes* from others which are demeaned by the wear and tear of the practical details of human existence had brought us to a position in which we attached "moral value" to objects depending on their uses as well as their properties. For a long time (until the sixteenth century) objects of utility or common familiarity did not enjoy sufficient moral value to justify their use as subjects for art by themselves, and it was really not until the nineteenth century that artists actually enjoyed the freedom to make such choices without reference to external consideration of hierarchy (an historical painting was "better" than a portrait which was "better" than landscape, which was "better" than a still life, etc.). Even so, as free as the artist may have seemed in such matters even up to the mid-twentieth century, his repertory of objects included, for example, food and culinary implements, but not tools or plumbing, books and musical instruments, but not comic strips and radios. Even within acceptable categories like food definite distinctions were made, so that bread, meat, game, fruit, vegetables, fish or wine as they come from the market might be used, but not hamburgers, hot dogs, candy bars, pies or Seven-Up. It does not suffice to answer that the latter were not available fifty years ago or their contemporary equivalents appeared in art. In 1913 the cubists exercised a precise, self-conscious restraint in their choice of still life objects not only in continuing acknowledgment of the traditional attitude toward such choices, but also because they wished to avoid the introduction into the cubist still life of associations which would detract from the emphasis on formal issues. They chose objects from the studio-cafe environment, but only those which connote pleasurable, unexacting activities like eating, drinking, smoking, playing cards, music, painting, and so on. The Bass bottle or the bunch of grapes in a Braque still life have a very different function from the coke bottle or chocolate cream pie in the work of the new artists, where the latter have become highly charged emotive devices. The cubists selected things which were familiar, intimate and comfortable, so that they could set a diffuse iconographical tone for the painting. The new artists select things which are familiar, public and often disquieting.

Why is this so? To put it as simply as possible, because the new artists have brought their own sensibilities and their deepest feelings to bear on a range of distasteful, stupid, vulgar, assertive and ugly manifestations of the worst side of our society. Instead of rejecting the deplorable and grotesque products of the modern commercial industrial world – the world of the hard sell and all it implies, the world of bright color and loud

noise too brash for nuance, of cheap and tawdry sentiment aimed at fourteen-year-old intelligences, of images so generalized for the mass audience of millions that they have lost all real human identity – instead of rejecting the incredible proliferation of *kitsch* which provides the visual environment and probably most of the esthetic experience for 99% of Americans, these new artists have turned with relish and excitement to what those of us who know better regard as the wasteland of television commercials, comic strips, hot dog stands, billboards, junk yards, hamburger joints, used car lots, juke boxes, slot machines and supermarkets. They have done so not in a spirit of contempt or social criticism or self-conscious snobbery, but out of an affirmative and unqualified commitment to the present circumstance and to a fantastic new wonderland, or, more properly, Disneyland, which asserts the conscious triumph of man's inner resources of feeling over the material rational world, to a degree perhaps not possible since the middle ages.

We cannot help but be anxious or cynical about the activities of these artists in the face of what we know to be "true" about Disneyland as a source of esthetic meaning. We suspect them of deliberate provocation in the manner of the Dadaists, that is to say of political intention, so that they might seem to be nihilists at the very least, or subversives at best, or even worse, we fear that they might be "putting us on," asking us to take seriously activities which we know to be frivolous and valueless. Yet in retrospect the way in which the present group emerged has not only an air of undeniable consistency but also a distinct flavor of historical inevitability. This new style could neither have been encouraged nor prevented, nor could it have been contrived; it has followed an organic course which makes it an absolute product of its time. Perhaps the most remarkable features of the new art are the rapidity and the spontaneity with which it developed from the assumptions of several artists at the same moment in a variety of different places. Almost all of the key figures in the group gravitated to New York, where their styles were established and they had become conscious of one another long before even the informed art public was significantly aware of their activities.

Writing history always becomes a process of oversimplification, and it is extremely difficult in this case to pinpoint the precise way in which the new group arrived at its own position. We can speak of a certain prevailing climate, refer to the fact that most of these artists were too young to serve in the war, grew up in the time of The Bomb, have inherited a set of esthetic predilections, and so on. We can certainly make a number of accurate observations about them, as artists and as the younger generation. For example, they have matured in an environment in which the path of the artist has been made smoother than it was for the generation which suffered through the depression and the war decades. They have enjoyed not only a sympathetic milieu in which art has flourished, but they have also arrived at financial security with extraordinary speed; the importance of this cannot be denied; it has spared them much of the bitterness of their predecessors.

For whatever historical reasons, the new artists are detached politically (they have not shared the political experience of the older generation), and indeed they are disengaged from all institutional associations. At the same time that they are withdrawn from causes (social manifestations), they are deeply committed to the individual experience and one's identity with the environment (by contrast with the Dada group, whose sense of estrangement led them away from participation). This involvement has an unquestionably optimistic and affirmative basis as well as a distinctly existential cast, and it has a good deal to do with the tone set in their work, as we shall see. At the same time, the new artists are not intellectuals, by and large, and they have no interest in enunciated philosophical or esthetic tendencies.

They share, then, an intense passion for direct experience, for unqualified participation in the richness of our immediate world, whatever it may have become, for better or worse. For them this means a kind of total acceptance; they reject nothing except all of our previous esthetic canons. Since we regard our institutions as rationally derived and morally valid, this makes the artist seem antirational and reprehensible. It should be understood, of course, that the issue of morality raised here is an esthetic issue and not personal or social. Despite whatever impressions their work may stimulate, these artists are not bohemians or "beatniks"; they have not rebelled against conventional social standards or modes of behaviour.

The non-sense aspect of their work results from the unfamiliarity of their juxtapositions of ideas, which depend on intuitions and associations somewhat removed from customary habits of looking and feeling. In much the same way, the new theater, which searches for a deeper psychological reality and which shares a good deal in common with the new artists, has been called "absurd"; its absurdity lies simply in its rejection of the familiar modes of reality which have governed the theater much longer than they have the plastic arts.

In referring to the unfamiliarity of the artists' associations, I come back to what is perhaps their essential quality, their unwillingness to accept anything (an object, say) at face value, in the light of its possibility for enrichment and elaboration. Such an attitude is not unique in the contemporary world; it might be regarded both as a product of modern scientific skepticism and at the same time as a reaction to the modern scientific habit of precise determination of phenomena. It may well be that the new artists could best be described as "hip" in the sense that they are incapable of outrage, in the sense that they cannot generate conventional responses to established virtues, and in this sense that they are sharply attuned to the bizarre, the grotesque and, for that matter, the splendor contained in the contemporary American scene.

I have said that these artists are not bohemians; most of them are familiar middle-class types, but their detachment from their own society becomes a necessary condition to their work. As outsiders they see us with a clarity that throws our appurtenances into proper focus. Like Vladimir Nabokov, they are tourists from another country, with resources and a spirit of curiosity which permit them to observe Disneyland with delight and amazement.

The point of view of the new artists depends on two basic ideas which were transmitted to them by a pair of older (in a stylistic sense) members of the group, Robert Rauschenberg and Jasper Johns. A statement by Rauschenberg which has by now become quite familiar implicitly contains the first of these ideas:

"Painting relates to both art and life. Neither can be made. (I try to act in the gap between the two.)"

Rauschenberg, along with the sculptor Richard Stankiewicz, was one of the first artists of this generation to take up again ideas which had originated fifty years earlier in the objects made or "found" by Picasso, Duchamp and various members of the Dada group. Rauschenberg's statement, however, suggests a much more acute consciousness of the possibility of breaking down the distinction between the artist and his life on the one hand, and the thing made on the other. Earlier I discussed the philosophical issues involved here in some detail. In Rauschenberg's view, the work of art has stopped being an illusory world, or a fragment of such a world, surrounded by a frame which cuts it off irrevocably from the real world. Now, the entrance into the picture of objects from outside – not as intruders but as integral components – breaks down the distinction be-

tween a shirt collar, say, as an article of clothing and the same thing as an emotive pictorial device. In other words, we begin to operate here in an indeterminate area somewhere between art and life, in such a way that the potential of enrichment of life as art merges inseparably with the possibility of making the work of art an experience to be enormously more directly felt than the previous nature of paintings and sculpture had ever permitted. Rauschenberg wants the work of art to be *life,* not an esthetic encounter depending in part on an intellectual process.

Without a doubt, this is an exciting and suggestive idea, one of those concepts which may not be startlingly new, but which, stated positively in appropriate circumstances, can trigger activity in other artists.

Allan Kaprow, as much as any one, helped to elaborate this idea. An art historian as well as an artist, Kaprow has brought to the new art a sense of its historical and philosophical contexts. It seems to me that an article written by Kaprow, ostensibly an homage to Jackson Pollock, should be regarded as the manifesto of the new art. ("The Legacy of Jackson Pollock," *Art News*, Oct. 1958, pp. 24 ff.)

Kaprow says in it that

Pollock . . . left us at the point where we must become preoccupied with and even dazzled by the space and objects of our everyday life . . . Not satisfied with the suggestion through paint of our other senses, we shall utilize the specific substances of sight, sound, movement, people, odors, touch. Objects of every sort are materials for the new art: paint, chairs, food, electric and neon lights, smoke, water, old socks, a dog, movies, a thousand other things which will be discovered by the present generation of artists. Not only will these bold creators show us, as if for the first time, the world we have always had about us but ignored but they will disclose entirely unheard of happenings and events, found in garbage cans, police files, hotel lobbies, seen in store windows and on the streets, and sensed in dreams and horrible accidents.

The young artist of today need no longer say I am a painter . . . He is simply an "artist." All of life will be open to him . . . out of nothing he will devise the extraordinary . . . People will be delighted or horrified, critics will be confused or amused, but these, I am sure will be the alchemies of the 1960s.

Elaboration of the idea of interpretation of art and the external world brought Kaprow from painting to the construction of "environments" in which he experimented with the articulation and complication of space in various ways, with lights, with three-dimensional sound, etc. Kaprow's interest in such possibilities had also been stimulated in another way. John Cage, whom Rauschenberg had met in the early fifties, was already deeply committed to the whole range of formal innovations and unprecedented mixtures of sights and sounds, especially in his collaborations with Rauschenberg and Merce Cunningham, which have continued to the present. Cage's freshness of vision, his delight in the accidental and unpredictable and his total avoidance of qualitative judgments have more than a little to do with Zen, and his interest in all of these questions has carried over into the new movement. His friendship with both Rauschenberg and Johns has resulted in a high degree of interaction among the three, and one cannot really separate these factors clearly from the rest of the process.

Cage's "performances" were presented to assembled audiences, as Kaprow's environments were not. The new artists' desire to communicate more directly suggests closer

participation with the audience; as a result, Kaprow and several other artists – most notably Red Grooms, Robert Whitman, Dine, Oldenburg and Lucas Samaras – spontaneously began to elaborate a new kind of theater unlike any seen before, but perhaps recalling certain Dada performances. The formal freedom, the fluid spatial situation, the direct involvement of the audience (who got wet, fed, hit, over-heated, caressed, fanned, berated, gassed, spangled, deafened, kicked, moved, blinded, splattered and entangled) and the spontaneity of the situation were so remote from conventional theater that a new name was required for these performances. They were called "happenings," a name which conveys the immediacy, the intensity of the present moment, the sense of individual participation and the unpredictable accidents which keep the audience at a high pitch of involvement. These events, which usually last five or ten minutes, happen *now*. Unlike ordinary theater, where every moment is predetermined, the happenings depend for their intensity on the audience's awareness that the conditions of the performance approach those of life, heightened in a special way by the creativity of the artist, but experienced without the sense of outcome which can be anticipated within the rigid forms of comedy or tragedy. The happenings differ from theater in another important respect; they depend not on the interplay of personalities, not human conflict or even dialogue, but on "conversations" between people and objects, or between objects alone. The actors are only participants, and the objects often surpass them in scale, importance, variety of traits and violence of behaviour.

If the happenings seem preoccupied with objects, it is no accident; the artists who have been involved have worked interchangeably between making objects and devising happenings. Some, like Dine, have now abandoned the performances, which appear to have been a necessary interlude in the whole process of exploration of the relation between people and things.

This contemporary absorption in the identity of objects and their emotive potential originated not only in the work of Rauschenberg but also in the paintings of Jasper Johns. Earlier I spoke of two basic considerations in the new art, the first being the new awareness of the mutuality of art and life. The second brings us back to the object and its new "personality." Without a doubt, Johns' flags and targets from the mid-fifties reopened this whole issue as much as anything else, since the subsequent preoccupation with popular images and sub-esthetic objects in one way or another refers to his initial assumptions (or non-assumptions).

When Johns made an American flag the subject of a painting, he invited a substantial list of questions about both the image and the way he painted it. The flag is the kind of image so frequently exposed that we have literally become blind to it. In the context of the painting, we ask ourselves whether we have really ever looked at it; a moment of hesitation follows about whether the artist is really serious or not (the banality of the new images always raises this question). We might then wonder whether it is even legal to paint a flag. Short of obscenity, it is hard to think of a situation which could be more unsettling to us than the conflicts presented by this image.

Furthermore, when we really *look* at the flag, it becomes a curious obtuse image, apart from its emotive impact. A strong, simple design of rectangles and stars produces no recessive effects, so that its flatness puts us off at the same time that the strong contrasts and vibrations make such distinct visual demands. The repetitive character of the design verges on monotony, but we simply cannot isolate such factors from our compelling identification with the image, which means so many different things to each of us.

In the face of the flatness and purity of the rectangles and stars, without any modulation

of tone or softening of edge, when Johns imposes on the image his own painterly handling, a new tension results, bringing us back to the basic problem of the relation between the picture and the real object. As I have said, Johns raises quite a number of questions.

Once one has looked at the flag this way (there are few more familiar images), one has to look anew at everything, including the Father of Our Country, the Mona Lisa, coke bottles, money, stamps, comic strips and billboards. However, simply putting these objects in the painting is not the whole story for these artists, and Johns' tension between the anonymity of the execution of the real object and his own performance suggests to them exploration of the style of billboards, advertising art, comic strips, etc. Upon examination, these too reveal unimagined mysteries of form, eccentricities of style, and a strange accumulation of images lurking where we never think to look for them. We discover that we are indeed blind and that we can be taught a new way to see.

Despite the differences in their styles, these artists share a common desire to intensify our perception of the image and to alter it in some way which complicates its effect. They may do this by augmenting the scale (Lichtenstein, Warhol) or by exaggerating or complicating the form, color or texture of objects (Oldenburg, Dine and Rosenquist). Since the objects chosen in one sense must be banal, the new artists have been accused of nostalgia for childish things, an effect which is enhanced by the simple-minded blandness with which they present their objects to us. But they purposefully appeal to our tastes for the simple things, recalling the spirit but not the facts of the child's appetite, for very much the same reasons that an earlier generation of painters turned to child art in search of the directness and intensity of the child's perceptions. The ways in which these artists have made objects function ambiguously and indeterminately recall an earlier time in man's history when spirits hid in every pot, bedevilling objects, making them move or break, even killing and curing. We are reminded here of Picasso's (from whom much of this comes) willingness to believe that paintings might one day again perform miracles.

For the new artists, objects do indeed possess mysterious powers and attributes, strange new kinds of beauty, sexuality even.

The grounds on which these new artists come to us could not be simpler, stronger or offered in better faith. They want us to share with them their pleasure and excitement at feeling and being, in an unquestioning and optimistic way. Their concern for the quality of experience and for the human condition reflects an optimism absolutely at odds with that distrust which any appeal to our intuition and to our deeper currents of feeling seems always to provoke in us. Are we perhaps afraid to let down our guard, to let life become art? The problem seems to touch upon the security of our most cherished values. The contemporary artist is leading us through an esthetic revolution with enormous ramifications in the post-Freudian world in which our fundamental ideas of art, beauty, the nature of experience, and the function of objects all must be reconsidered in substantially new terms. This is not a minor aberration, an interlude which will pass with a change in taste. These new artists may only be pointing the way to us, but we are entering a new world where the old art can no longer function, any more than the old technology can. The new art may not provide the answers, but it is surely asking questions the consequences of which we cannot evade.

POP ART, USA

John Coplans

"Pop Art, USA," the first exhibition to attempt a collective look at the movement in this country, was presented at the Oakland Art Museum during September, 1963. The following essay, by John Coplans, who organized the show, was prepared as the catalog essay for the exhibition.

Although this exhibition is the first to attempt a collective look in considerable depth at Pop Art (as well as those artists who now appear as harbingers of this new art), it has been preceded by a series of important museum exhibitions within the last year that have examined various aspects of this heterogeneous activity:

September 1962	"The New Painting of Common Objects" organized by Walter Hopps at the Pasadena Art Museum.
March 1963	"Six Painters and the Object" organized by Lawrence Alloway at the Solomon R. Guggenheim Museum.
April 1963	"Popular Art" organized by Mr. and Mrs. C. Buckwalter at the Nelson Gallery of the Atkins Museum, Kansas City.
April 1963	"Pop goes the Easel" organized by Douglas McAgy at the Contemporary Art Museum, Houston.
April 1963	"The Popular Image Exhibition" organized by Alice Denney at the Washington Gallery of Modern Art.
July 1963	"Six More" organized by Lawrence Alloway at the Los Angeles County Museum (mainly a repeat of the Pasadena Exhibition) and shown with the traveling version of "Six Painters and the Object."

Abstract Expressionism, the first brilliant flowering of a distinctly American sensibility in painting, is a movement in which the prime innovators and the most important artists are largely based in New York. Another characteristic is that, without exception, all the early work of the painters in that movement can be seen as a direct confrontation of, and struggle with, the dominating influences of European painting. In contrast, the current phenomenon of what for the time being is broadly labeled Pop Art reveals a complete shift of emphasis in both geographical location and subject matter. The first body of work that has emerged from this new movement is widely dispersed between the two coasts – this simultaneous eruption is an important factor neglected by all the organizers of the previous exhibitions, with the exception of Pasadena's "New Painting of Common Objects." It points up several aspects of the new art that have received little consideration in the past. The curious phenomenon, particularly in these times of easy communication, of a group of artists widely separated geographically, who, without knowing, for the most part, of the existence of the others, appear at roughly the same time with images startlingly different from those which dominated American painting for two decades and yet strikingly similar to each other's work, points to the workings of a logic within the problems of American painting itself rather than to the logic of dealers and pressure groups. If the logic of abstract expressionism was hammered out in fiery quarrels in Greenwich

Artforum, October 1963: 27–30, © John Coplans

Village bars by the most intensely speculative group of painters America has yet produced, the logic of this new art, by a quite different, but equally valid process, forced itself on artists geographically isolated from one another and yet faced with the same crisis.

The subject matter most common to Pop Art is for the most part drawn from those aspects of American life which have traditionally been a source of dismay to American intellectuals, and a source of that glib derision of "American culture" so common among Europeans: the comic strip, mass-media advertising, and Hollywood. Some critics argue that the employment of this subject matter places the artists in the morally indefensible position of complacent – if not joyous – acceptance of the worst aspects of American life. Others, however, insist upon finding a negative moral judgment implicit in the work. The artists, for the most part, remain silent, or, worse, perversely make public statements feeding the fury of the party they consider more absurd. For of course neither position approaches the real problems of this new art or searches the nature of the crisis which has brought it forth. That crisis is essentially the same crisis the abstract expressionist painters faced, and solved so brilliantly in their own way: the problem of bringing forth a distinctly American painting, divorced from the stylistic influences and esthetic concerns of a tradition of European art which has lain like a frigid wife in the bed of American art since the Armory show. (And why hasn't anyone seen the re-creation of the Armory show as the greatest irony possible in the light of this new American painting?) If, during the last decade, Abstract Expressionism has been thought of – at least in this country – as finally having solved the problem of the creation of a distinctly American art, here is a whole new generation who have engendered widespread confusion by thinking otherwise. Seen from this point of view the painters of the soup can, the dollar bill, the comic strip, have in common not some moral attitude toward their subject matter that some say is positive and others say is negative, but a series of painting devices which derive their force in good measure from the fact that they have virtually no association with a European tradition. The point is so utterly plain that one is astonished at how often it has been missed. For these artists, the abstract expressionist concern with gesture, with the expressive possibilities of sheer materials is out – all Expressionistic concerns (and Impressionistic ones as well) abstract or otherwise – are out. A sophisticated concern with compositional techniques, formal analysis or drawing, is also out, and, indeed, Lichtenstein will depart from his usual comic strip paintings to lampoon a famous Picasso cubist painting, or a well-known art book's diagramming of the composition of an important Cézanne.

A further challenge to this new direction in art is that of shallowness. This condemnation is based upon the principle that transformation must occur in order to differentiate an art image from a similar image in the real world. Certain artists within the broad category of the movement, it is claimed, in particular Warhol and Lichtenstein, fail to effect such a transformation, and if they do, it is so minute as to be of relatively no importance. The very essence of this new art lies precisely in its complete break from a whole tradition of European esthetics. This is accomplished by the particular choice of subject matter which is put into a new fine art context. This is the transformation.

While it would seem neither to damn nor to approve the material of its inspiration – indeed appear totally disinterested in the moral problems it raises – Pop Art does take subtle and incisive advantage of deeply rooted cultural meanings and demonstrates how for the artist the seemingly common and vulgar everyday images, messages and artifacts of a mass communicating and consuming society can give rise to the deepest metaphysi-

cal speculations. Warhol's rigid, simple, mass produced and standardized symmetry is only a point of departure behind which lies an assertive individuality, despite his non-committal painting technique. Hefferton's deliberate and highly disciplined suppression of the decorative quality of paint by substituting a non-esthetic and primitive handling is also totally personal and at the same time his images insidiously recall a host of associations concerning "political expediency." Lichtenstein's flattened, blown up and arrested images from the comics subtly pose real issues of the crisis of identity. In contrast to these three, Goode in his highly ambiguous milk bottle paintings employs a rich sensuous quality of paint. Oldenberg's painted plaster edibles parody the anxious violent type of caricature and expressive use of color that has marked so much of modern art since Van Gogh, but which has now become an inexpressive formal device and cliché in academic circles. If some of these images are dead-pan, an underlying violence seeps through as in Ruscha's calculated word images. Blosum's cool and detached simply painted monotone image of twenty-five minutes ticking away on a parking meter may appear indifferent to the tortured quality of life, the subject matter of the human condition painters, but it is in fact loaded with suppressed anxiety.

What at first sight appears to be a rather restricted movement employing a narrow range of imagery is in fact enormously rich in the variety of artists it encompasses. At the same time this is not meant to imply that there are no sharp qualitative differences among these artists as in those of any other movement. What is of intense interest, however, is that these artists are looking at and using the most thoroughly and massively projected images of our time – images so looked at that they have become accepted, overlooked and unseen – as a raw material for art.

The emergence of this new art forces the re-evaluation of those artists in the past who have seemed merely eccentric or whose imagery and direction seemed peripheral to the course of American painting since World War II. Obviously Stuart Davis and Gerald Murphy, both considerably influenced by Leger, anticipate certain aspects of Pop Art in imagery and technique – Davis for his use of blown up sign fragments and references to popular culture and jazz, Murphy for his billboard style and American vulgarism.

A more recent forerunner activity than that of Davis and Murphy spanned the last fifteen years in various cities. In Paris was the American expatriate William Copley, a post surrealist with images full of cheese-cake eroticism, patriotic folklore and sophisticated vulgarism. In New York were Larry Rivers with an imagery derived from American folklore and contemporary popular sources, but without the radical innovation of technique that would separate his work from abstract expressionism, and Ray Johnson, a pioneer in the use of the cheapest graphic techniques. In San Francisco Wally Hedrick traced ironic reflections onto radios, television cabinets and refrigerators, and Jess Collins "rewrote" the action and content of comic strips by collaging within existing printed images. Another curious figure is Von Dutch Holland, the Southern Californian hot rod striper, a genuinely popular artist whose eccentric imagery and high craft technique combined with a visionary attitude was admired by younger artists. The two key and most significant artists who are usually included within the Pop category are Jasper Johns and Robert Rauschenberg, but they should rather be regarded as direct precursors who provided the momentum, concentrated insights and focus of ideas that triggered the broad breakthrough of this new art, Rauschenberg for his concern with art as a direct confrontation of life, transforming his environment into art in a strange compelling new way and Johns for the potent questions he raised on the discontinuous quality of symbols. Billy Al

Bengston appears to be one of the first artists to have recognized exactly what Johns and Rauschenberg were opening up; from 1959 on he completed a broad spectrum of work within the new idiom, but his more recent penumbral, hard-surfaced optical images are more concerned with a heightened awareness of the strange beauty and perfection of materials and have little to do with Pop Art.

POP AND PUBLIC

Thomas B. Hess

Pop artists, the only group of recent painters that approves its nickname, remain an issue. This is despite the spate of words and reproductions that have been spent on their promotion and defamation by epigoni, dealers, curators (pro and con – the new-type curator, bored by conservation, dreams of making the scene) and other vested interests.

The books must be kept open on this most successful of Neo-Isms, not only because it is a mere three years old (a similar lapse of time was amply sufficient to bankrupt the "New West Coast Figure Painting" and the "Chicago 'Monster' School") – but also the Pop artists themselves have kept strangely mute about aims, about their sense of identification and identity, attitudes towards subject matter and content, techniques and style. No accurate phrases have been shaken loose from their images. To establish a documentary basis for discussion, the first part of a two-part series of interviews with Pop painters is published in this number of ARTNEWS.

Meanwhile the phenomenon continues hyperactive. New surveys of Pop Art are at the Oakland and University of Michigan museums; a Toronto gallery has finished plans for its anthology; the Guggenheim Museum announces a series of Sunday lectures to focus on this subject. All sorts of other institutions are getting into the act – including the New York State Building at the World's Fair.

In last Summer's ARTNEWS, an attempt was made at a sociological comment on Pop Art. It was pointed out that a new, over-eager audience of communicators, museum officials and collectors, all of whom want to be in on the artists' undress-rehearsals, identifies itself with vanguard styles. And from their craving for modish discoveries, they produced the "phony crisis" in American art by claiming that all the issues posed by Abstract-Expressionism have been resolved, that it is finished as a living idiom; the Action Painters have had it. The new is Pop, and only the new deserves the fare. Their vulgar audience-reaction, it was noted, may harm the younger artists they push, by obscuring the nature of the real crisis which every painter must face in our society if he is to find his identity.

The misunderstanding of the crucial role which the audience plays in Pop Art has confused most commentators, including Erle Loran who, in an article in the September issue of ARTNEWS, attacked the vapid praise a number of critics have lavished on the Pop painters. "Transformation," Loran noted, "is the miracle invoked by the vanguard audience to establish an esthetic for Pop." And he proved that, if you accept the Pop critics'

Art News, November 1963: 23 ff.

terms, no transformation exists. But on the Pop artists' terms, there *is* a transformation, which both Loran and the vanguard audience, equally stuck in formalist analyses, fail to see. It has nothing to do with pictorial details or with changes of scale (most Pop Art has no scale). It is a theatrical and, in a sense, political action. It takes place when a "copied" textbook diagram or Campbell Soup advertisement or pastiche of billboards is framed and hung in a museum or gallery or collector's duplex.

Anyone who looks at a Pop Art exhibition senses the strange, often amusing switch of contexts and the tensions set up between the referent and the relatum (to use the language of freshman Logic) – for example, the billboard on the noisy parkway and its simulacrum in the hushed museum, or the soup ad in *Life* magazine and the painted soup ad in drawing-room life over a modern mantelpiece. It is something like the feeling you get from the "alienation effect" of Brecht's theater, in which the actor simultaneously plays his role and remains himself, where the stage set must be a specific place and still a recognizable bit of theatrical canvas, and the music does not lull you into the mood of the play, but alerts you to pay attention outside it. For Brecht, the alienation effect was a dialectical tool with which to educate the public. The edge of his irony cut in one direction (if never in one way).

In Pop Art, both ends of the ironic simile are kept in optimistic balance. Thus the painting of a soup ad comments on a detail of ugly Americana, but also implies that ugly Americana is very beautiful, too. The Brechtean dialectic has been dissolved in a glow of ambiguous satisfaction (isn't it great how automobile wrecks are horrible!). Pop Art is political in that it keeps urging the belief that everything is pretty rosy; even our ignominy, the electric chair, gets a quaint cosmetic look.

The presence of a big audience is essential to complete a theatrical transformation. It is impossible to conceive of a Pop painting being produced until some plans are laid for its exhibition. Without its public reaction, the art object remains a fragment. (Thus neither Rauschenberg nor Johns fits the category.) Here Pop relates directly to Happenings. And the quality of a Happening is seriously affected by the quality of its audience. What was a poetic transaction among a group of artists and poets in a converted loft, for example, will be a repulsive demonstration of snobbery when it is moved into a consumers' milieu. And this suggests that the vanguard audience, as it embraces Pop Art, not only hides from the artist the true nature of his crisis, but can infect the art with its own demoralization.

If the only transformation that takes place in Pop Art is theatrical (i.e., non-pictorial), is it Art?

Today, the sole requirement of a work of art is intent; what the artist says, goes. But after accepting his declaration that whatever he wants to label art is art, we can still discuss the entry and illuminate our responses to it by examining the quality of its connections with other art.

All great modern painting develops in a father-to-son descent. Art does not proceed by revolutions and reactions to the past, but by passionate emulation (Matisse's devotion to Cézanne comes to mind, Renoir's for Delacroix, Gorky's for Picasso). Pop Art developed with clockwork logic from the assumptions of Abstract-Expressionism (i.e., Art can be Anything), but the quality of its connections to the older generations is artificial and eclectic. Influences are picked with the nonchalance of punching a button on a jukebox.

Great painters are chosen by their ancestors. Their commitments to history have the strength of the inevitable. Pop artists pick up a background as if they were gourmets of ideas. They make a trivial contact with the past.

In its cool attitude towards tradition, Pop Art reminds us of a unique and wrongly

overlooked episode in art history: the immensely successful French Salon painting that dominated the official art world from about 1860 until the turn of the century.

Like Pop Art, Salon painting is a function of a new audience's demands. The artists reverse the historical formula of creation. It used to be:

GOD — to — ARTIST — to — PUBLIC

(for the Romantics, instead of God, read Inspiration; for the Realists, read Spirit of History; for the moderns, read Subconscious or Libido).

In Pop and Salon art, the energy runs from the audience to the painter to the seat of form-making. (Is it possible, if unlikely, that Salon and Pop artists revert to the medieval Christian role of the Artist-as-Saint, modestly avoiding the Renaissance concept of Artist-as-Hero? When they keep "cool," should we infer "abnegation"?)

Both Pop and Salon artists work against, and by opposition stimulate, the strongest, most vital pictorial traditions of their time. Constantly distracted from the content of their art by the psychological implications of its subject matter, Pop and Salon artists memorialize the everyday, middle-class moment and underline its suggestions of fetishism or sado-masochistic behavior. They have a fondness for jokes, visual (trompe-l'oeil, parody, multiple images) and verbal (caricature, puns, intriguing titles). They are sentimental about the contemporary past – the good old 1830s or 1930s – and about popular chauvinism (Napoleonic legends for the Salon; the Great American Scene for Pop artists).

Both rely heavily on public acceptance of their subject matter. It is significant that there is no Pop Art in Paris. For a Frenchman, modern industrial design (a Coke bottle, a comic strip, a movie star) is still an exotic novelty, charged with romance and mystery. In Italy, where Americanization has met with less resistance from native customers, Pop is beginning to flourish. And in Southern California where the whole landscape is magnificently "pop" (a restaurant is shaped like a giant potato; freeways offer such inventive signs as "SMORSGABURGER"), the idiom has a power which makes the young East Coast pioneers seem a bit bookish (British Pop not only looks bookish, but as if made by librarians). Who will care about Lichtenstein's poignant 1935 ice-cream-soda glass when he can have a neoplastic surfboard? While Andy Warhol listens to rock-and-roll in New York, Billy "Al" Bengston goes motorcycle racing in a Los Angeles suburb near Muscle Beach. The future of Pop Art seems drawn to an irresistible mingling with the inspired faddism of Hollywood.

The problems of its immediate past and happy present, however, remain a challenge to criticism.

From WHAT IS POP ART? PART I

Interviews by G. R. Swenson

*Pop Art painters recently have received massive publicity. Their work has been praised
and explained by a small army of curators, promoters and critics, but the artists them-
selves have stayed cool and tight-lipped. This is especially surprising as most American
painters are characteristically voluble. For example, anybody who wanted to know what
Franz Kline was up to in 1950, or Willem de Kooning or Barnett Newman, could drop by
the "Artists' Club" of the favored bars and cafeterias to hear painters define their posi-
tions with vivid recklessness.*

*To keep the record straight and to balance the often inaccurate claims from the par-
tisans and enemies of Pop Art,* Art News *has elicited comment from eight leading "mem-
bers" of this new "school." Four appear on these pages; interviews with the other artists —
Jasper Johns, Oldenburg, Rosenquist and Wesselmann, will appear in a forthcoming
issue.*

ANDY WARHOL

Someone said that Brecht wanted everybody to think alike. I want everybody to think
alike. But Brecht wanted to do it through Communism, in a way. Russia is doing it under
government. It's happening here all by itself without being under a strict government; so
if it's working without trying, why can't it work without being Communist? Everybody
looks alike and acts alike, and we're getting more and more that way.

I think everybody should be a machine.

I think everybody should like everybody.

Is that what Pop Art is all about?

Yes. It's liking things.

And liking things is like being a machine?

Yes, because you do the same thing every time. You do it over and over again.

And you approve of that?

Yes, because it's all fantasy. It's hard to be creative and it's also hard not to think what
you do is creative or hard not to be called creative because everybody is always talking
about that and individuality. Everybody's always being creative. And it's so funny when
you say things aren't, like the shoe I would draw for an advertisement was called a "cre-
ation" but the drawing of it was not. But I guess I believe in both ways. All these people
who aren't very good should be really good. Everybody is too good now, really. Like, how
many actors are there? There are millions of actors. They're all pretty good. And how
many painters are there? Millions of painters and all pretty good. How can you say one
style is better than another? You ought to be able to be an Abstract-Expressionist next
week, or a Pop artist, or a realist, without feeling you've given up something. I think the
artists who aren't very good should become like everybody else so that people would like
things that aren't very good. It's already happening. All you have to do is read the mag-
azines and the catalogues. It's this style or that style, this or that image of man – but

Art News, November 1963: 24–27 ff.

that really doesn't make any difference. Some artists get left out that way, and why should they?

Is Pop Art a fad?

Yes, it's a fad, but I don't see what difference it makes. I just heard a rumor that G. quit working, that she's given up art altogether. And everyone is saying how awful it is that A. gave up his style and is doing it in a different way. I don't think so at all. If an artist can't do any more, then he should just quit; and an artist ought to be able to change his style without feeling bad. I heard that Lichtenstein said he might not be painting comic strips a year or two from now – I think that would be so great, to be able to change styles. And I think that's what's going to happen, that's going to be the whole new scene. That's probably one reason I'm using silk screens now. I think somebody should be able to do all my paintings for me. I haven't been able to make every image clear and simple and the same as the first one. I think it would be so great if more people took up silk screens so that no one would know whether my picture was mine or somebody else's.

It would turn art history upside down?

Yes.

Is that your aim?

No. The reason I'm painting this way is that I want to be a machine, and I feel that whatever I do and do machine-like is what I want to do.

Was commercial art more machine-like?

No, it wasn't. I was getting paid for it, and did anything they told me to do. If they told me to draw a shoe, I'd do it, and if they told me to correct it, I would – I'd do anything they told me to do, correct it and do it right. I'd have to invent and now I don't; after all that "correction," those commercial drawings would have feelings, they would have a style. The attitude of those who hired me had feeling or something to it; they knew what they wanted, they insisted; sometimes they got very emotional. The process of doing work in commercial art was machine-like, but the attitude had feeling to it.

Why did you start painting soup cans?

Because I used to drink it. I used to have the same lunch every day, for twenty years, I guess, the same thing over and over again. Someone said my life has dominated me; I liked that idea. I used to want to live at the Waldorf Towers and have soup and sandwich, like that scene in the restaurant in *Naked Lunch* . . .

We went to see *Dr. No* at Forty-second Street. It's a fantastic movie, so cool. We walked outside and somebody threw a cherry bomb right in front of us, in this big crowd. And there was blood, I saw blood on people and all over. I felt like I was bleeding all over. I saw in the paper last week that there are more people throwing them – it's just part of the scene – and hurting people. My show in Paris is going to be called "Death in America." I'll show the electric-chair pictures and the dogs in Birmingham and car wrecks and some suicide pictures.

Why did you start these "Death" pictures?

I believe in it. Did you see the *Enquirer* this week? It had "The Wreck that Made Cops Cry" – a head cut in half, the arms and hands just lying there. It's sick, but I'm sure it happens all the time. I've met a lot of cops recently. They take pictures of everything, only it's almost impossible to get pictures from them.

When did you start with the "Death" series?

I guess it was the big plane crash picture, the front page of a newspaper: 129 DIE. I was also painting the *Marilyns*. I realized that everything I was doing must have been

Death. It was Christmas or Labor Day – a holiday – and every time you turned on the radio they said something like, "4 million are going to die." That started it. But when you see a gruesome picture over and over again, it doesn't really have any effect.

But you're still doing "Elizabeth Taylor" pictures.

I started those a long time ago, when she was so sick and everybody said she was going to die. Now I'm doing them all over, putting bright colors on her lips and eyes.

My next series will be pornographic pictures. They will look blank; when you turn on the black lights, then you see them – big breasts and . . . If a cop came in, you could just flick out the lights or turn on the regular lights – how could you say that was pornography? But I'm still just practicing with these yet. Segal did a sculpture of two people making love, but he cut it all up, I guess because he thought it was too pornographic to be art. Actually it was very beautiful, perhaps a little too good, or he may feel a little protective about art. When you read Genêt you get all hot, and that makes some people say this is not art. The thing I like about it is that it makes you forget about style and that sort of thing; style isn't really important.

Is "Pop" a bad name?

The name sounds so awful. Dada must have something to do with Pop – it's so funny, the names are really synonyms. Does anyone know what they're supposed to mean or have to do with, those names? Johns and Rauschenberg – Neo-Dada for all these years, and everyone calling them derivative and unable to transform the things they use – are now called progenitors of Pop. It's funny the way things change. I think John Cage has been very influential, and Merce Cunningham, too, maybe. Did you see that article in the *Hudson Review* [*The End of the Renaissance?,* Summer, 1963]? It was about Cage and that whole crowd, but with a lot of big words like radical empircism and teleology. Who knows? Maybe Jap and Bob were Neo-Dada and aren't any more. History books are being rewritten all the time. It doesn't matter what you do. Everybody just goes on thinking the same thing, and every year it gets more and more alike. Those who talk about individuality the most are the ones who most object to deviation, and in a few years it may be the other way around. Some day everybody will think just what they want to think, and then everybody will probably be thinking alike; that seems to be what is happening.

ROBERT INDIANA

What is Pop?

Pop is everything art hasn't been for the last two decades. It is basically a U-turn back to a representational visual communication, moving at a break-away speed in several sharp late models. It is an abrupt return to Father after an abstract 15-year exploration of the Womb. Pop is a re-enlistment in the world. It is shuck the Bomb. It is the American Dream, optimistic, generous and naïve . . .

It springs newborn out of a boredom with the finality and over-saturation of Abstract-Expressionism which, by its own esthetic logic, is the END of art, the glorious pinnacle of the long pyramidal creative process. Stifled by this rarefied atmosphere, some young painters turn back to some less exalted things like Coca-Cola, ice-cream sodas, big hamburgers, super-markets and "EAT" signs. They are eye-hungry; they pop . . .

Pure Pop culls its techniques from all the present-day communicative processes: it is Wesselman's TV set and food ad, Warhol's newspaper and silkscreen, Lichtenstein's comic and Ben Day, it is my road signs. It is straight-to-the-point, severely blunt, with as

little "artistic" transformation and delectation as possible. The self-conscious brush stroke and the even more self-conscious drip are not central to its generation. Impasto is visual indigestion.

Are you Pop?

Pop is either hard-core or hard-edge. I am hard-edge Pop.

Will Pop bury Abstract-Expressionism?

No. If A–E dies, the abstractionists will bury themselves under the weight of their own success and acceptance; they are battlers and the battle is won; they are theoreticians and their theories are respected in the staidest institutions; they seem by nature to be teachers and inseminators and their students and followers are legion around the world; they are inundated by their own fecundity. They need birth control.

Will Pop replace Abstract-Expressionism?

In the eternal What-Is-New-in-American-Painting shows, yes; in the latest acquisitions of the avant-garde collectors, yes; in the American Home, no. Once the hurdle of its non-objectivity is overcome, A–E is prone to be as decorative as French Impressionism. There is a harshness and matter-of-factness to Pop that doesn't exactly make it the interior decorator's Indispensable Right Hand.

Is Pop here to stay?

Give it ten years perhaps; if it matches A–E's 15 or 20, it will be doing well in these accelerated days of mass-medium circulation. In twenty years it must face 1984.

Is Pop esthetic suicide?

Possibly for those Popsters who were once believing A-Eers, who abandoned the Temple for the street; since I was never an acolyte, no blood is lost. Obviously esthetic "A" passes on and esthetic "B" is born. Pity more that massive body of erudite criticism that falls prostrate in its verbiage.

Is Pop death?

Yes, death to smuggery and the Preconceived-Notion-of-What-Art-Is diehards. More to the heart of the question, yes, Pop does admit Death in inevitable dialogue as Art has not for some centuries; it is willing to face the reality of its own and life's mortality. Art is really alive only for its own time; that eternally-vital proposition is the bookman's delusion. Warhol's auto-death transfixes us; DIE is equal to EAT.

Is Pop easy art?

Yes, as opposed to one eminent critic's dictum that great art must necessarily be difficult art. Pop is Instant Art . . . Its comprehension can be as immediate as a Crucifixion. Its appeal may be as broad as its range; it is the wide-screen of the Late Show. It is not the Latin of the hierarchy, it is vulgar.

Is Pop complacent?

Yes, to the extent that Pop is not burdened with that self-consciousness of A–E, which writhes tortuously in its anxiety over whether or not it has fulfilled Monet's Water-Lily-Quest-for-Absolute/Ambiguous-Form-of-Tomorrow theory; it walks young for the moment without the weight of four thousand years of art history on its shoulders, though the grey brains in high places are well arrayed and hot for the Kill.

Is Pop cynical?

Pop does tend to convey the artist's superb intuition that modern man, with his loss of identity, submersion in mass culture, beset by mass destruction, is man's greatest problem, and that Art, Pop or otherwise, hardly provides the Solution – some optimistic, glowing, harmonious, humanitarian, plastically perfect Lost Chord of Life.

Is Pop pre-sold?

Maybe so. It isn't the Popster's fault that the A-Eers fought and won the bloody Battle of the Public-Press-Pantheon; they did it superbly and now there is an art-accepting public and a body of collectors and institutions that are willing to take risks lest they make another Artistic-Over-sight-of-the-Century. This situation is mutually advantageous and perilous alike to all painters, Popsters and non-Popsters. The new sign of the Art Scene is BEWARE – Thin Ice. Some sun-dazed Californians have already plunged recklessly through.

Is Pop the new morality?

Probably. It is libertine, free and easy with the old forms, contemptuous of its elders' rigid rules.

Is Pop love?

Pop is love in that it accepts all . . . all the meaner aspects of life, which, for various esthetic and moral considerations, other schools of painting have rejected or ignored. Everything is possible in Pop. Pop is still pro-art, but surely not art for art's sake. Nor is it any Neo-Dada anti-art manifestation: its participants are not intellectual, social and artistic malcontents with furrowed brows and fur-lined skulls.

Is Pop America?

Yes. America is very much at the core of every Pop work. British Pop, the first-born, came about due to the influence of America. The generating issue is Americasm [sic], that phenomenon that is sweeping every continent. French Pop is only slightly Frenchified; Asiatic Pop is sure to come (remember Hong Kong). The pattern will not be far from the Coke, the Car, the Hamburger, the Jukebox. It is the American Myth. For this is the best of all possible worlds.

ROY LICHTENSTEIN

What is Pop Art?

I don't know – the use of commercial art as subject matter in painting, I suppose. It was hard to get a painting that was despicable enough so that no one would hang it – everybody was hanging everything. It was almost acceptable to hang a dripping paint rag, everybody was accustomed to this. The one thing everyone hated was commercial art; apparently they didn't hate that enough either.

Is Pop Art despicable?

That doesn't sound so good, does it? Well, it *is* an involvement with what I think to be the most brazen and threatening characteristics of our culture, things we hate, but which are also powerful in their impingement on us. I think art since Cézanne has become extremely romantic and unrealistic, feeding on art; it is utopian. It has had less and less to do with the world, it looks inward – neo-Zen and all that. This is not so much a criticism as an obvious observation. Outside is the world; it's there. Pop Art looks out into the world; it appears to accept its environment, which is not good or bad, but different – another state of mind.

'How can you like exploitation?' 'How can you like the complete mechanization of work? How can you like bad art?' I have to answer that I accept it as being there, in the world.

Are you anti-experimental?

I think so, and anti-contemplative, anti-nuance, anti-getting-away-from-the-tyranny-

of-the-rectangle, anti-movement-and-light, anti-mystery, anti-paint-quality, anti-Zen, and anti all of those brilliant ideas of preceding movements which everyone understands so thoroughly.

We like to think of industrialization as being despicable. I don't really know what to make of it. There's something terribly brittle about it. I suppose I would still prefer to sit under a tree with a picnic basket rather than under a gas pump, but signs and comic strips are interesting as subject matter. There are certain things that are usable, forceful and vital about commercial art. We're using those things – but we're not really advocating stupidity, international teenagerism and terrorism.

Where did your ideas about art begin?

The ideas of Professor Hoyt Sherman [at Ohio State University] on perception were my earliest important influence and still affect my ideas of visual unity.

Perception?

Yes. Organized perception is what art is all about.

He taught you "how to look"?

Yes. He taught me how to go about learning how to look.

At what?

At what, doesn't have anything to do with it. It is a process. It has nothing to do with any external form the painting takes, it has to do with a way of building a unified pattern of seeing . . . In Abstract-Expressionism the paintings symbolize the idea of ground-directedness as opposed to object-directedness. You put something down, react to it, put something else down, and the painting itself becomes a symbol of this. The difference is that rather than symbolize this ground-directedness I do an object-directed appearing thing. There is humor here. The work is still ground-directed; the fact that it's an eyebrow or an almost direct copy of something is unimportant. The ground-directedness is in the painter's mind and not immediately apparent in the painting. Pop Art makes the statement that ground-directedness is not a quality that the painting has because of what it looks like . . . This tension between apparent object-directed products and actual ground-directed processes is an important strength of Pop Art.

Antagonistic critics say that Pop Art does not transform its models. Does it?

Transformation is a strange word to use. It implies that art transforms. It doesn't, it just plain forms. Artists have never worked with the model – just with the painting. What you're really saying is that an artist like Cézanne transforms what we think the painting ought to look like into something he thinks it ought to look like. He's working with paint, not nature; he's making a painting, he's forming. I think my work is different from comic strips – but I wouldn't call it transformation; I don't think that whatever is meant by it is important to art. What I do is form, whereas the comic strip is not formed in the sense I'm using the word; the comics have shapes but there has been no effort to make them intensely unified. The purpose is different, one intends to depict and I intend to unify. And my work is actually different from comic strips in that every mark is really in a different place, however slight the difference seems to some. The difference is often not great, but it is crucial. People also consider my work to be anti-art in the same way they consider it pure depiction, "not transformed." I don't feel it is anti-art.

There is no neat way of telling whether a work of art is composed or not; we're too comfortable with ideas that art is the battleground for interaction, that with more and more experience you become more able to compose. It's true, everybody accepts that; it's just that the idea no longer has any power.

Abstract-Expressionism has had an almost universal influence on the arts. Will Pop Art?

I don't know. I doubt it. It seems too particular – too much the expression of a few personalities. Pop might be a difficult starting point for a painter. He would have great difficulty in making these brittle images yield to compositional purposes . . . Interaction between painter and painting is not the total commitment of Pop, but it is still a major concern – though concealed and strained.

Do you think that an idea in painting – whether it be "interaction" or the use of commercial art – gets progressively less powerful with time?

It seems to work that way. Cubist and Action Painting ideas, although originally formidable and still an influence, are less crucial to us now. Some individual artists, though – Stuart Davis, for example – seem to get better and better.

A curator at the Modern Museum has called Pop Art fascistic and militaristic.

The heroes depicted in comic books are fascist types, but I don't take them seriously in these paintings – maybe there is a point in not taking them seriously, a political point. I use them for purely formal reasons, and that's not what those heroes were invented for . . . Pop Art has very immediate and of-the-moment meanings which will vanish – that kind of thing is ephemeral – and Pop takes advantage of this "meaning," which is not supposed to last, to divert you from its formal content. I think the formal statement in my work will become clearer in time. Superficially, Pop seems to be all subject matter, whereas Abstract-Expressionism, for example, seems to be all esthetic . . .

I paint directly – then it's said to be an exact copy, and not art, probably because there's no perspective or shading. It doesn't look like a painting *of* something, it looks like the thing itself. Instead of looking like a painting *of* a billboard – the way a Reginald Marsh would look – Pop Art seems to be the actual thing. It is an intensification, a stylistic intensification of the excitement which the subject matter has for me; but the style is, as you said, cool. One of the things a cartoon does is to express violent emotion and passion in a completely mechanical and removed style. To express this thing in a painterly style would dilute it; the techniques I use are not commercial, they only appear to be commercial – and the ways of seeing and composing and unifying are different and have different ends.

Is Pop Art American?

Everybody has called Pop Art "American" painting, but it's actually industrial painting. America was hit by industrialism and capitalism harder and sooner and its values seem more askew . . . I think the meaning of my work is that it's industrial, it's what all the world will soon become. Europe will be the same way, soon, so it won't be American; it will be universal.

JIM DINE

What is your attitude to Pop Art?

I don't feel very pure that in that respect. I don't deal exclusively with the popular image. I'm more concerned with it as a part of my landscape. I'm sure everyone has always been aware of that landscape, the artistic landscape, the artist's vocabulary, the artist's dictionary.

Does that apply to the Abstract-Expressionists?

I would think so – they have eyes, don't they? I think it's the same landscape only interpreted through another generation's eyes. I don't believe there was a sharp break and

this is replacing Abstract-Expressionism. I believe this is the natural course of things. I don't think it is exclusive or that the best painting is being done as a movement . . . Pop Art is only one facet of my work. More than popular images I'm interested in personal images, in making paintings about my studio, my experience as a painter, about painting itself, about color charts, the palette, about elements of the realistic landscape – but used differently.

The content of a Pollock or a de Kooning is concerned with paint, paint quality, color. Does this tie you to them in theory?

I tie myself to Abstract-Expressionism like fathers and sons. As for your question, no. No, I'm talking about paint, paint quality, color charts and those things objectively, as objects. I work with the vocabulary that I've picked up along the way, the vocabulary of paint application, but also the vocabulary of images. One doesn't have to be so strict – to say, "Let's make it like a palette," and that's it . . . It always felt right to use objects, to talk about that familiarity in the paintings, even before I started painting them, to recognize billboards, the beauty of that stuff. It's not a unique idea – Walker Evans photographed them in 1929. It's just that the landscape around you starts closing in and you've got to stand up to it.

Your paintings look out and still make a statement about art?

Yes, but a statement about art the way someone else talks about new Detroit cars, objectively, as another kind of thing, a subject.

Not as both subject matter and content?

No.

Abstract-Expressionism tended to look in?

Yes.

Is this the difference between your work and theirs?

I don't know what the difference is. Certainly Abstract-Expressionism influenced me, particularly Motherwell. I think he's continually growing and making problems. His paintings meant a lot to me, especially *Pancho Villa Dead or Alive* and the *Je t'aime* paintings, although it now seems a bit strange to write it in French. Still, the climate Motherwell has to live in is rarer and he has to do that for his style, the idea of style, this hothouse flower – but really that's all frivolities compared to the real structures he sets up.

Style as a conscious striving for individuality?

I suppose so. I'm only interested in style, as content at least, if it makes the picture work. That's a terrible trap – for people to want to *have style*. If you've got style, that means you've only got one way to go, I figure; but if you've got art, if you've got it in your hands going for you, style is only an element you need to use every once in a while. The thing that really pulls a painting out is you, if you are strong, if it's your idea you're wanting to say – then there's no need to worry about style.

Do you feel related to Dada?

Not so much, although I never saw any reason to laugh at that stuff. It seemed the most natural thing in the world to have that furlined teacup.

It wasn't anti-art?

No, not at all. I thought it was just a beautiful object; it wasn't anti-art at all. Some of my friends used to say I was square because I was interested in art. Jan van Eyck and Rogier van der Weyden are great favorites of mine. I'm interested in the particular way they manipulate space. With Northern painting there's more than just seeing it . . . And I love the eccentricity of Edward Hopper, the way he puts skies in. For me he's more exciting than Magritte as a Surrealist. He is also like a Pop artist – gas stations and Sunday

mornings and rundown streets, without making it Social Realism . . . It seems to me that those who like Hopper would be involved with Pop somehow. Or those who like Arthur Dove – those paintings of sounds, fog horns, the circle ideas that were meant to be other things. There's a real awareness of things, an outward awareness . . .

Actually I'm interested in the problem and not in solutions. I think there are certain Pop artists who are interested mainly in solutions. I paint about the problems of how to make a picture work, the problems of seeing, of making people aware without handing it to them on a silver platter. The viewer goes to it and is held back slightly from being able to get the whole picture; he has to work a little to deal with the problems – old artistic problems, that particular mystery that goes on in painting.

You once said that your audience tends to concentrate too much on the subject matter in your work.

They can't get past it? Well, that's their tough luck. I was talking about the big audience. The smaller audience gets through it and lives with it and deals with it, just like things coming up all day – in a shooting gallery, you know, things keep popping up to shoot at. And some guys can't shoot, that's all; they can only stand there with a gun in their hands. I'm interested in shooting and knocking them all down – seeing everything . . . But the statement about bridging the gap between art and life is, I think, a very nice metaphor or image, if that's what you'd call it, but I don't believe it. Everybody's using it now. I think it misleads. It's like the magic step, like – "Oh, that's beautiful, it bridges art and life." Well, that's not so. If you can make it in life – and I don't say that's easy to do – then you can make it with art; but even then that's just like saying if you make it with life then you can make it as a race-car driver. That's assuming art and life can be the same thing, those two poles. I make art. Other people make other things. There's art and there's life. I think life comes to art but if the object is used, then people say the object is used to bridge that gap – it's crazy. The object is used to make art, just like paint is used to make art.

Does Pop Art serve a social function? Is it a comment?

There are only a handful of people who seem to understand what I'm doing, so I'm certainly not changing the world. People confuse this social business with Pop Art – that it's a comment. Well, if it's art, who cares if it's a comment. If you write some fantastically obscene thing on a wall, that may be an even better comment, but I'm not sure *that's* art. I'm involved with formal elements. You've got to be; I can't help it. But any work of art, if it's successful, is also going to be a comment on what it's about. I'm working on a series of palettes right now. I put down the palette first, then within that palette I can do anything – clouds can roll through it, people can walk over it, I can put a hammer in the middle of it . . . Every time I do something, the whole thing becomes richer; it is another thing added to the landscape. But once I've done something, I'm no longer interested in it as a problem. It just becomes another facet of my work. I'm interested in striving to do something tougher.

From WHAT IS POP ART? PART II

Interviews by G. R. Swenson

This is the second part of a two-part series of interviews with painters who have recently come into international prominence. Their new kinds of subject matter and attitudes have been labeled "Pop Art" — a phrase picked up in England from the commercial jazz world and recently promulgated in America by establishments as different as those of The New York Times *and the Guggenheim Museum. Complex genealogies have been proposed — Jasper Johns is a precursor of Pop; Stephen Durkee is a legatee, etc. But our interest is not in such artificial categories, but in the artists themselves and what they have to say, individually, about their work and their careers. In the November issue, G.R. Swenson interviewed Jim Dine, Robert Indiana, Roy Lichtenstein and Andy Warhol. This completes the first published documentation on a group of artists who — as they keep repeating in their statements — have been as misinterpreted by over-eager publicists as they have been by a handful of disapproving critics.*

TOM WESSELMANN

What is Pop Art?

I dislike labels in general and Pop in particular, especially because it over-emphasizes the material used. There does seem to be a tendency to use similar materials and images, but the different ways they are used denies any kind of group intention.

When I first came to painting there was only de Kooning – that was what I wanted to be, with all its self-dramatization. But it didn't work for me. I did one sort of non-objective collage that I liked, but when I tried to do it again I had a kind of artistic nervous breakdown. I didn't know where I was. I couldn't stand the insecurity and frustration involved in trying to come to grips with something that just wasn't right, that wasn't me at any rate.

Have you banished the brushstroke from your work?

I'm painting now more than I used to because I'm working so big; there's a shortage of collage material. So brushstrokes can occur, but they are often present as a collage element; for example, in one big still-life I just did there's a tablecloth section painted as if it were a fragment from an Abstract-Expressionist painting inserted into my picture. I use de Kooning's brush knowing it is his brush.

One thing I like about collage is that you can use anything, which gives you that kind of variety; it sets up reverberations in a picture from one kind of reality to another. I don't attach any kind of value to brushstrokes, I just use them as another thing from the world of existence. My first interest is the painting which is the whole, final product. I'm interested in assembling a situation resembling painting, rather than painting; I like the use of painting because it has a constant resemblance to painting.

What is the purpose of juxtaposing different kinds of representations?

If there was any single aspect of my work that excited me, it was that possibility – not just the differences between what they were, but the aura each had with it. They each had such a fulfilled reality; the reverberations seemed a way of making the picture more

Excerpt, *Art News*, February 1964: 40–41 ff.

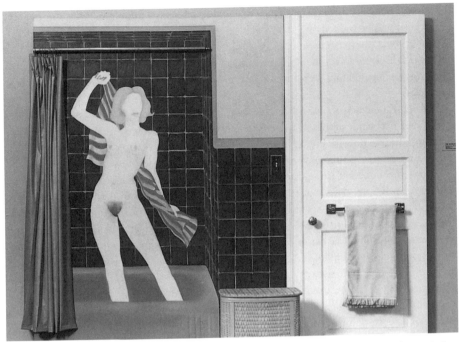

Tom Wesselmann, Bathtub Collage #3, *oil on canvas, enamel on wood, and assemblage, 84 × 106¼ × 20 inches, 1963. Museum Ludwig, Cologne. © 1997 Tom Wesselmann / Licensed by VAGA, New York, NY.*

intense. A painted pack of cigarettes next to a painted apple wasn't enough for me. They are both the same kind of thing. But if one is from a cigarette ad and the other a painted apple, they are two different realities and they trade on each other; lots of things – bright strong colors, the qualities of materials, images from art history or advertising – trade on each other. This kind of relationship helps establish a momentum throughout the picture – all the elements are in some way very intense. Therefore throughout the picture all the elements compete with each other. At first glance, my pictures seem well-behaved, as if – that is a still-life, O.K. But these things have such crazy gives and takes that I feel they get really very wild.

What does esthetics mean to you and your work?

Esthetics is very important to me, but it doesn't deal with beauty or ugliness – they aren't values in painting for me, they're beside the point. Painting relates to both beauty and ugliness. Neither can be made. (I try to work in the gap between the two.) I've been thinking about that, as you can see. Perhaps "intensity" would be a better emphasis. I always liked Marsicano's quote – from *Art News* – "Truth can be defined as the intensity with which a picture forces one to participate in its illusion."

Some of the worst things I've read about Pop Art have come from its admirers. They begin to sound like some nostalgia cult – they really worship Marilyn Monroe or Coca-Cola. The importance people attach to things the artist uses is irrelevant. My use of elements from advertising came about gradually. One day I used a tiny bottle picture on a table in one of my little nude collages. It was a logical extension of what I was doing. I use a billboard picture because it is a real, special representation of something, not because it is from a billboard. Advertising images excite me mainly because of what I can make from them. Also I use real objects because I need to use objects, not because objects need

to be used. But the objects remain part of a painting because I don't make environments. My rug is not to be walked on.

Is Pop Art a counter-revolution?

I don't think so. As for me, I got my subject matter from Hans Memling (I started with "Portrait Collages") and de Kooning gave me content and motivation. My work evolves from that.

What influences have you felt in your work from, say, Dada?

When I first came across it, I respected it and thought it was pretty good; but it didn't have anything to do with me. As my work began to evolve I realized – not consciously, it was like a surprise – that maybe it had something to do with my work.

It was the same with Rauschenberg. When I saw his painting with the radios in it I thought it was fine, O.K., but it had no effect on me. It ceased to exist for me except in Rauschenberg's world. Much later I got interested in the addition of movement to painting, so a part of the painting was attached to a motor. An interest in using light and sound followed – I put in a television. But not only for the television image – who cares about television images? – but because I cared about the dimension it gave to painting, something that moved, and gave off light and sound. I used a radio and when I did I felt as if I were the first who'd ever used a radio. It's not that I think of that as an accomplishment – it's just that Rauschenberg didn't seem an immediate factor in it. He was, of course; his use of objects in paintings made it somehow legitimate; but I used a radio for my own reasons . . .

I've been painting more, lately, in these big works. I'm more and more aware of how audacious the act of painting is. One of the reasons I got started making collages was that I lacked involvement with the thing I was painting; I didn't have enough interest in a rose to paint it. Some of this, I think, comes from the painting of the 'fifties – I mean, for a painter the love of flowers was gone. I don't love roses or bottles or anything like that enough to want to sit down and paint them lovingly and patiently. Now with these big pictures, well, there aren't enough billboards around and I have to paint a bowl – and I don't have any feelings about bowls or how a bowl should be. I only know I have to have a bowl in that painting. Here, in this picture I'm working on, I made this plain blue bowl and then I realized it had to have something on it. I had to invent a bowl and – god! – I couldn't believe how audacious it was. And it's threatening too – painting something without any conviction about what it should be.

Do you mean that collage materials permit you to use an image and still be neutral toward the object represented?

I think painting is essentially the same as it has always been. It confuses me that people expect Pop Art to make a comment or say that its adherents merely accept their environment. I've viewed most of the paintings I've loved – Mondrians, Matisses, Pollocks – as being rather dead-pan in that sense. All painting is fact, and that is enough; the paintings are charged with their very presence. The situation, physical ideas, physical presence – I feel that is the comment.

JAMES ROSENQUIST

I think critics are hot blooded. They don't take very much time to analyze what's in the painting . . .

O.K., the critics can say [that Pop artists accept the mechanization of the soul]. I think it's very enlightening that *if* we do, we realize it instead of protesting too much. It

hasn't been my reason. I have some reasons for using commercial images that these people probably haven't thought about. If I use anonymous images – it's true my images have not been hot blooded images – they've been anonymous images of recent history. In 1960 and 1961 I painted the front of a 1950 Ford. I felt it was an anonymous image. I wasn't angry about that, and it wasn't a nostalgic image either. Just an image. I use images from old magazines – when I say old, I mean 1945 to 1955 – a time we haven't started to ferret out as history yet. If it was the front end of a new car there would be people who would be passionate about it, and the front end of an old car might make some people nostalgic. The images are like no-images. There is a freedom there. If it were abstract, people might make it into something. If you paint Franco-American spaghetti, they won't make a crucifixion out of it, and also who could be nostalgic about canned spaghetti? They'll bring their reactions but, probably, they won't have as many irrelevant ones . . .

The images are now, already, on the canvas and the time I painted it is on the canvas. That will always be seen. That time span, people will look at it and say, "why did he paint a '50 Ford in 1960, why didn't he paint a '60 Ford?" That relationship is one of the important things we have as painters. The immediacy may be lost in a hundred years, but don't forget that by that time it will be like collecting a stamp; this thing might have ivy growing around it. If it bothers to stand up – I don't know – it will belong to a stamp collector, it will have nostalgia then. But still that time reference will mean something . . .

I have a feeling, as soon as I do something, or as I do something, nature comes along and lays some dust on it. There's a relationship between nature – nature's nature – and time, the day and the hour and the minute. If you do an iron sculpture, in time it becomes rusty, it gains a patina and that patina can only get to be beautiful. A painter searches for a brutality that hasn't been assimilated by nature. I believe there is a heavy hand of nature on the artist. My studio floor could be, some people would say that is part of me and part of my painting because that is the way I arranged it, the way things are. But it's not, because it's an accidental arrangement; it *is* nature, like flowers or other things . . .

[Paint and paint quality] are natural things before you touch them, before they're arranged. As time goes by the brutality of what art is, the idea of what art can be, changes; different feelings about things become at home, become accepted, natural . . . [Brutality is] a new vision or method to express something, its value geared right to the present time . . .

When I was a student, I explored paint quality. Then I started working, doing commercial painting and I got all of the paint quality I ever wanted. I had paint running down my armpits. I kept looking at everything I was doing – a wall, a gasoline tank, I kept looking to see what happened, looking at a rusty surface, at the nature, at changing color. I've seen a lot of different ways paint takes form and what it does, and what excited me and what didn't. After some Abstract-Expressionist painting I did then, I felt I had to slice through all that, because I had a lot of residue, things I didn't want. I thought that I would be a stronger painter if I made most of my decisions before I approached the canvas; that way I hoped for a vision that would be more simple and direct. I don't know what the rules for Abstract-Expressionism are, but I think one is that you make a connection with the canvas and then you discover; that's what you paint – and eliminate what you don't want. I felt my canvases were jammed with stuff I didn't want . . .

I'm amazed and excited and fascinated about the way things are thrust at us, the way this invisible screen that's a couple of feet in front of our mind and our senses is attacked by radio and television and visual communications, through things larger than life, the

impact of things thrown at us, at such a speed and with such a force that painting and the attitudes toward painting and communication through doing a painting now seem very old-fashioned . . .

I think we have a free society, and the action that goes on in this free society allows encroachments, as a commercial society. So I geared myself, like an advertiser or a large company, to this visual inflation – in commercial advertising which is one of the foundations of our society. I'm living in it, and it has such impact and excitement in its means of imagery. Painting is probably more exciting than advertising – so why shouldn't it be done with that power and gusto, with that impact. I see very few paintings with the impact that I've felt, that I feel and try to do in my work . . . My metaphor, if that is what you can call it, is my relation to the power of commercial advertising which is in turn related to our free society, the visual inflation which accompanies the money that produces box tops and space cadets . . .

When I use a combination of fragments of things, the fragments or objects or real things are caustic to one another, and the title is also caustic to the fragments . . . The images are expendable, and the images are in the painting and therefore the painting is also expendable. I only hope for a colorful shoe-horn to get the person off, to turn him on to his own feelings . . .

The more we explore, the more we dig through, the more we learn the more mystery there is. For instance, how can I justify myself, how can I make my mark, my "X" on the wall in my studio, or in my experience, when somebody is jumping in a rocket ship and exploring outer space? Like, he begins to explore space, the deeper he goes in space the more there is of nature, the more mystery there is. You may make a discovery, but you get to a certain point and that point opens up a whole new area that's never even been touched . . .

I treat the billboard image as it is, so apart from nature. I paint it as a reproduction of other things; I try to get as far away from the nature as possible . . .

An empty canvas is full, as Bob [Rauschenberg] said. Things are always gorgeous and juicy – an empty canvas is – so I put something in to dry it up. Just the canvas and paint – that would be nature. I see all this stuff [pointing to the texture of a canvas] – that's a whole other school of painting. All that very beautiful canvas can be wonderful, but it's another thing. The image – certainly it's juicy, too – but it throws your mind to something else, into art. From having an empty canvas, you have a painted canvas. It may have more action; but the action is like a confrontation, like a blow that cancels out a lot of other stuff, numbing your appreciation for a lot of juicy things. Then, too, somebody will ask, why do I want that image there? I don't want that image, but it's there. To put an image in, or a combination of images, is an attempt to make it at least not nature, cancel it from nature, wrest it away. Look at that fabric, there, the canvas, and the paint – those are like nature . . .

I learned a lot more about painting paint when I painted signs. I painted things from photos and I had quite a bit of freedom in the interpretation, but still, after I did it, it felt cold to me, it felt like I hadn't done it, that it had been done by a machine. The photograph was a machine-produced image. I threw myself at it. I reproduced it as photographically and stark as I could. They're still done the same way; I like to paint them as stark as I can . . .

I thought for a while I would like to use machine-made images, silk-screens, maybe. But by the time I could get them – I have specifics in my mind – it would take longer or

as long, and it would be in a limited size, than if I did them as detached as I could by hand, in the detached method I learned as a commercial painter . . .

When I first started thinking like this, feeling like this, from my outdoor painting, painting commercial advertising, I would bring home colors that I liked, associations that I liked using in my abstract painting, and I would remember specifics by saying this was a dirty bacon tan, this was a yellow T-shirt yellow, this was a Man-Tan suntan orange. I remember these like I was remembering an alphabet, a specific color. So then I started painting Man-Tan orange and – I always remember Franco-American spaghetti orange, I can't forget it – so I felt it as a remembrance of things, like a color chart, like learning an alphabet. Other people talk about painting nothing. You just can't do it. I paint something as detached as I can and as well as I can; then I have one image, that's it. But in a sense the image is expendable; I have to keep the image so that the thing doesn't become an attempt at a grand illusion, an elegance . . .

If I use a lamp or a chair, that isn't the subject, it isn't the subject matter. The relationships may be the subject matter, the relationships of the fragments I do. The content will be something more, gained from the relationships. If I have three things, their relationship will be the subject matter; but the content will, hopefully, be fatter, balloon to more than the subject matter. One thing, though, the subject matter isn't popular images, it isn't that at all.

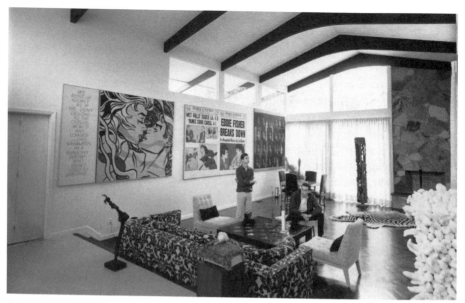

Leon Kraushar home, circa 1964–65. Photograph by Ken Heyman. Two visible paintings: left: Roy Lichtenstein, We Rose Up Slowly, *1964; middle: Andy Warhol,* Daily News, *1962.*

POP ART SELLS ON AND ON — WHY?

John Canaday

The 1963–64 art season in New York, which began on schedule after Labor Day and, on schedule, will soon droop into summer hibernation, definitely belonged to something new called "Pop art."

"Something new" is a description that not everyone would accept. Some of Pop's critics think it is really just something old (commercial art) dusted off and jazzed up, while others think it is just something borrowed (the Dada movement of the nineteen-twenties) without much change. And undeniably, Pop can get pretty blue – in the showbiz sense of designating an off-color gag.

But whatever Pop art is – its patrons and practitioners are still haggling over definitions – it has arrived and gives every sign of staying around at least for a little while. Whether or not Pop is a new art, and whether or not it can last, it has supplied a new bandwagon. And in the art circus as it operates today, that is the final accolade of success.

Four or five years ago, Pop was not much more than a rumor up and down Madison Avenue. About three years ago, during a series of kittenish feints with the established *avant-garde,* it suddenly bared fangs that scared the living daylights out of the most quick-eyed members of a group of artists who until then had felt firmly entrenched as the Latest Thing. A couple of years ago, it demonstrated that even those fangs had been only its baby teeth and during the past season it has had things pretty much its own way.

Pop's list of converts is impressive, at least in numbers. Collectors who used to say

The New York Times Magazine, May 31, 1964: 7 ff.

"It's fine as entertainment, but who could ever live with it?" are now buying it, although from the looks of their apartments they may soon have to move out. Chronically advanced critics, who at first just couldn't see Pop, are making the shift (as quickly as dignity will allow) to a more sympathetic second look, rather than stay behind with their formerly *avant-garde* protégés who have become has-beens overnight. And the two artists who seem most to have anticipated the movement – Robert Rauschenberg, only 39, and Jasper Johns, only 34 – have already been canonized in massive retrospectives as Pop's old masters.

This summer, the American section of the Venice Biennale, which is the established barometer for that combination of sales market and critical market that dictates current esthetic values, is heavily loaded with Pop art.

The New York State pavilion at the World's Fair, potentially the most influential piece of architecture in the place, includes Pop art among the decorative murals and sculpture on the exterior of its theater wing, implying that Pop is as legitimate to our situation as the statues of saints on the exteriors of Gothic cathedrals were to that of our ancestors.

Pop is bulldozing its way through the groves of academe. Teachers teach Pop. Graduate students write theses on the origins and development of Pop. Long, dull seminars headed by venerable professors discuss the esthetics and, for goodness' sake, the history of Pop. On less astral planes, Pop has also got it made. Mass circulation magazines and TV love Pop for its novelty value. The same value brings Pop the largest and most fascinated (if not always the most appreciative) audiences in the galleries along 57th Street and Madison Avenue. And finally, perhaps indicating that the end is already in sight, Pop has replaced abstract expressionism as the thing for easy-come artists to imitate and for easy-go intellectuals to prattle about.

In the smoke from this grass fire, Pop has been called the New Realism, the New Romanticism, the New Social Consciousness, the New Landscape and the New Fantasy – as a beginning. It has also been called, less admiringly, the New Fake and the New Tragedy. What it does is to take the commonest arts, or non-arts, that surround us – comic strips, billboards, magazine advertising, bargain window displays and any other mass-produced vulgarity that this list may suggest – and use them as a point of departure.

The point of departure may be virtually indistinguishable from Pop's point of arrival. "EAT" signs by Robert Indiana, not much different from those that hang outside roadside restaurants except for the price tag, may now be contemplated at leisure in the perfect illumination and sanctified hush of high-class galleries and museums. If it is a lucky day, you may also find a classical rendition of a can of soup by Andy Warhol nearby, or a toothpaste face (seven feet from chin to hairline) by an ex-billboard artist gone legit (or the other way around), James Rosenquist, and some comic-strip characters, true to comic-strip style, but Michelangelesque in dimensions, by Roy Lichenstein.

"Pop" is short for "popular," in the sense of "of the people" or "of the common herd," and by definition Pop is thus opposed to fine art created for the cultivated few. But perversely, and with a perfectly dead pan, the Pop artist addresses his "EAT" signs, soup cans and so on to the most precious echelon of the art-conscious public. As a working definition, we could say that Pop is an art that introduces variations of debased commercial and industrial art into the social, financial and intellectual circles where such art and design have always been regarded with a natural shudder of horror.

As a preliminary explanation of Pop art's vogue, we may say that for this jaded audience, with its insatiable appetite for surprise, Pop is surprising. Its unexpectedness transforms the natural shudder of horror into the artificially induced *frisson* of pleasure that, by one

standard, is the first test of a work of art. But even for an audience of this kind – a fairly limited one that finds its amusements in specialized areas – a vogue of such dimensions is not self-generative. So the compound question remains: Why were any critics interested in Pop in the first place; what induced dealers to take it on, and where did the dealers find the first purchasers to crack a market that seemed cornered by exactly the opposite type of commodity – abstract art?

In all three categories – the writer-promoters, the salesman-distributors and the collector-patrons – a large element of opportunism is mixed with more admirable stimuli. Many a young critic, coming on the scene within the last decade, found himself stuck with the job of sizing up forms of art that had already been staked out by older critics who were in at the birth of such movements as abstract expressionism and had said all there was to say – and a lot more. The appearance of Pop art was equivalent to the discovery of a critical Klondike. New claims could be staked, and new areas mined for interpretation.

Aside from critical opportunism, there is the more creditable fact that art is so much talked and written about today that any hint of a new movement stirs genuine excitement among people whose profession, or avocation, it is to keep an eye on what is going on. The rapid swing from boredom to excitement and back to boredom and then to new excitement may be unhealthy, tending to give disproportionate attention to new movements and also to overfeed them so that they die before they have a chance to develop naturally, but it is a process that explains the extreme receptivity of critics to anything that takes a new turn.

No turn since the early years of this century has been quite as startling as the turn Pop took. For 50 years, the most persistent thread in new art movements has been progressive abstraction, and Pop was the first movement in the direction of literal realism that looked revolutionary rather than reactionary. Pop, as a result, may have been argued pro and con out of all proportion to its potential significance, but the argument nevertheless has established it in the spotlight. And once the spotlight is focused on one part of the stage, the main action goes on there until somebody gets up and shifts the beam again.

Among dealers, who are businessmen, the Klondike analogy is too obvious to need much explanation. When one market is at its peak a good merchant, knowing that it must decline, casts around for a new one. As a businessman, the merchant of contemporary art is in the same position as the clothing merchant. He depends on new styles to keep the customers coming, and his job is to anticipate the new styles, or even to originate them, while keeping his old line moving. It is worth noticing that Pop art, although widely exploited, is being most successfully exploited not by new, adventurous dealers but by well-established galleries who yesterday were pushing yesterday's styles.

More idealistically, a dealer gets satisfaction out of creating a name for an unknown artist. He likes the feeling that he is more than an art broker, that he is a perceptive arbiter of taste. If a critic he respects finds a new product, such as Pop art, worth attention, then the dealer can argue that turning it into a readily available commodity is a cultural, indeed a humanitarian, duty. When he sends up a trial balloon, more critics get interested even if their interest lies in puncturing it. The spotlight is getting focused. More dealers come in, then more critics and so on in a spiral that leads directly to the man who ultimately makes or breaks a movement in the system as set up – the collector, who foots the bill.

Some Pop art is bought just for fun by people who can afford to follow a fad. Many a cocktail party that would otherwise have died a natural death has been saved by a piece of

Pop art hanging on the wall (or lying on the floor, as much of it does). But that Pop has found serious collectors indicates how the nature of art collecting, which for centuries meant the gathering together of rare and beautiful objects, has changed in recent years. Pop is the opposite of rare, and although there may be collectors who are attracted to it for its own lovely self, this is difficult to believe since few collectors are totally blind.

But Pop is a natural for the type of adventurous collector who is eager to be in on the newest thing and is willing to take first crack on the chance that today's questionable item will supply tomorrow's basic collection of early works in a new school. The possibility of increased value is also there for the investment collector, with the cushion of income tax deductions at worst, if the movement begins to die and the stuff is given in time to an amenable museum. But, most important, there are the collectors of modern art who try to build historically complete collections.

For such collections, examples of Pop art are now imperative if the collection is to be comprehensive. For Pop having happened is now history, no matter how curious and lamentable the way of its happening. It is still current history, but if it should die tomorrow it is already part of the story, however brief and flashy its life may prove to be. All esthetic values aside, the fact that Pop can have happened to the extent that it has happened is in itself an ineradicable comment on what the art situation is today.

If Pop is only a novelty, it is as good as dead already. At its present pace, its staying power or its vulnerability to that sinister question, "What next?" should be proved within the next art season or two. The question can be staved off only as long as Pop can keep us wondering about the basic question of its validity as art or answer that question affirmatively. Is there really anything, beneath the novelty, to give it an audience interested in more than vaudeville? Even if it is vaudeville, how long can it find new stunts that keep it from repeating itself too badly? And if it fails as itself, what are its chances of producing sports that, stemming from it, may prove Pop's importance by proving its generative fecundity?

Taking these questions one at a time, we might look first at Pop as the New This and the New That – in some of the terms already listed.

As the New Realism, Pop owes its attraction to its satisfaction of a widespread feeling that it is high time for art to return to some reference to life instead of staying off in a corner and indulging the splatter esthetic that had all but starved out everything else five years ago. But Pop, in abandoning abstraction for a form of realism and declaring itself anti-esthetic in opposition to hyper-estheticism, has hardly taken the course hoped for by a public that still thinks of realism in the terms of the art history books.

Instead of cultivating the good, the true, the beautiful or the socially significant in understandable terms, Pop art has tied its wagon to a curious star, indeed – the bad, the false, the ugly and the socially deplorable, in terms that are all too understandable (although sometimes it is difficult to believe that Pop really means what it seems to be saying).

The New Realism is a rangy term that also applies to any art that, rather than using drawing and painting as its medium, employs actual objects and materials and sticks them together. Pop art does this, too, and visitors to a recent exhibition were offered spiritual elevation in the form of a life-size nude; painted by Tom Wesselmann, in a painted bathroom that included such real accessories as a towel rack with towels, a laundry hamper, a door and a wall telephone rigged up to ring every few minutes.

The reaction of people to Pop as the New Realism parallels the punch line of the old shaggy dog story. A public yearning for an art in which things are recognizable has

greeted various tentative returns toward realism, one after another, with the objection, "Not realistic enough." But faced with Pop's offerings, people cry out, "Oh, no, not *that* realistic!"

A few defenders argue that when you come down to it, Pop isn't really realistic – it just looks that way. Deep down it's just the opposite – romantic. This would have to mean that Pop is a form of soul-searching. The search for beauty in ugliness, pleasure in pain, enlightment through innocence and purification through debauchery have all been methods of romantic exploration from time to time, and it is quite possible to argue that Pop's glorification of the banal, by artists who of course are fully aware of the horrors of banality, is comparable to the romantic hero's taking up with a degraded prostitute in order to find his own salvation.

The trouble with all this is that Pop doesn't give much sign of interest in salvation. Perhaps because of its extreme youth, it seems more interested in just having a good time, although it does amuse itself in some perverse fashions.

The fact remains that some explanation must be found for Pop's decision to occupy itself with all the ugliness, the cheapness and the shoddiness of the most routine aspects of the man-made world that surrounds us. One way out has been to call Pop the New Landscape, since it deals with our omnipresent environment. An early virtue claimed for Pop was that it creates a new awareness of ordinary objects and hence makes for an intensification of experiences to which we have become calloused through exposure.

There is something to this. As the New Landscape, Pop is proving once more that nature imitates art. Where Pop used to look like comic strips or highway restaurant signs, highway restaurant signs and comic strips are now beginning to look like Pop – which is an improvement of sorts.

"But Pop is not interested in externals. It is at the very heart of life," some of its defenders say. "It doesn't present our world as a landscape – it presents it with a New Social Consciousness."

A theory is that Pop art is the artist's solution and through him, ours, to living in the world as it is. All the horrendousness of contemporary life – the mass-produced objects devoid of taste, the degraded images produced serially by the hundreds of thousands – must be not only accepted but embraced. By accepting and even by exaggerating these horrors, we have at least the form of escape involved in the adage, "If you can't lick 'em, join 'em."

But a philosophy of escape through resignation to the inevitable is an odd form of social consciousness, and Pop too frequently suggests horseplay for this interpretation to hold. As a more conventional form of social consciousness, Pop has been called protest by satire, social comment by parody.

Satire and parody, however, can easily drop into fantasy, and here, for one reason or another, Pop plops right over on its reverse side and enters the world of unreality. Pop likes to blow things up to enormous size, which cancels out imitation and realism. A hamburger, an ice cream cone, a tube of toothpaste or a slice of pie, sculptured and realistically colored but executed in a scale of feet for inches, transforms the banal into the grotesque. From here, at hop-skip-and-jump tempo, Pop gets into a no-holds-barred area with a dozen peripheral variations still based on the vulgarity of the motif but transmuting this motif in dozens of ways.

George Segal, classified as a Pop artist but more truly a member of this periphery, is one of the most unnerving artists at work today. His appellation of sculptor brings howls from

more conventional members of the breed, but there is nothing else to call him. Segal's dead-white plaster figures have an uncanny lifelikeness, not entirely explainable by the fact that they are actually a form of casting from life, made by covering live models with plaster-soaked rags that are allowed to harden and are then removed for assembly as hollow dummies. Their eerie reality is made doubly real and infinitely more eerie by their placement in or on actual objects, which is their Pop connection.

Adding a Segal to your collection is like adopting a new member of the family, according to collectors who should know, and a Segal, once acquired, is likely to be given a name for easy reference ("Darling, the maid didn't dust Dave yesterday. Will you ask her to?"). If you own a Segal, you have to find room in your house for, say, a nude plaster woman who sits on her own real honest-to-God bed, all messed up; or a woman who stands in a real bathtub, perpetually shaving her plaster legs; or a bus driver behind the wheel of a real bus; or a group of bus riders on real bus seats; or a man who gives the impression of being ready, at any moment, to crack the plaster film that covers him and reach for the next letter on a full-scale mockup of a theater marquee.

Segal's race of ghosts are partly amusing but largely disturbing, and about equally grotesque and literal. Inhabiting their own little corners of the world, they are examples of an interest that Pop shares with some other *avant-garde* movements – the idea that art should not be dedicated to the production of isolated works but to the creation of an environment. Claes Oldenburg, the Pop chef who created the transmutedburger, has also done an entire bedroom of wee-wawed furniture, complete with lamps, ashtrays and radio, that achieves the impossible by making mass-produced pseudo-modern interior decoration even uglier than it is.

Because of its deadpan and frequently mechanical look, Pop art at its purest can be just about as impersonal as art can get, although each Pop master has his gimmick trademark. But in Pop-related developments, there are hints of more personal, expressive directions in which the movement may eventually discover its true realization. Leading the list is a young woman who uses only her first name professionally, Marisol.

Marisol may offer us, lifesize, an entire jazz band, or a family out for the day in the automobile, or three women, a little girl and a dog out for a walk, executed in a combination of sculpture, squared blocks of wood, life casts, drawing, painting and real articles of clothing, in some of the wittiest and most inventive – what's the word? Concoctions? – being turned out at the moment.

But Marisol differs from straight Pop artists in that she is not looking objectively at the world around us, or even pretending to. She looks into a world of her own, the kind of world that Pop theoretically rejects. But as Pop develops, there are more and more frequent signs that its artists have not so much rejected the inner world as rejected the old paths by which it was explored. The hope for Pop as a significant art movement rather than as a running gag is that it may end by beating out a few such paths, even if it does so in spite of itself.

THE BIENNALE: HOW EVIL IS POP ART?

Tullia Zevi

VENICE

If the Thirty-second Biennale International Art Exhibition in Venice is not "scandalous," why the heated debates, the veto by the highest Catholic authorities, the sudden cancellation of the Italian president's participation in the inauguration?

Every two years the Biennale touches off a chain reaction of moral and aesthetic indignation which its sponsors interpret as a sign of vitality. This year however the controversy is hotter than ever. The exhibition, in the words of its detractors, has turned into a collective "poisoning of the innocent."

What we see documented here is the resumption of the artist's dialogue with everyday reality. One can safely omit the works displayed by the East European socialist countries, and particularly the 46 artists in the USSR pavilion. The smiling smelters, the women carpenters with lilies-of-the-valleys pinned on their robust breasts, the mustachioed Uzbecks who could easily have been painted 40 years ago for the edification of the masses, are again on display. Even the critic of the Italian Communist newspaper *Unitá* had to say that "there does not seem to be news worth underlining in the socialist pavilions."

The show has been derisively called "the Biennale of pop-art," and the fact that American pop-artists are shown prominently – and for the first time under the official patronage of the US government – rather justifies this generalization. However, in the pavilions hidden by the giant lime-trees of the Biennale Gardens, there are other equally interesting manifestations of the contemporary urge for visual objectivity.

Neo-dada, programmed art, group-art, kinetic art – they are all different yet equally valid responses to the call for a new realism, whatever the techniques and materials employed, whether metal, wood, torn posters, discarded objects, synthetic fibers, electricity, magnetism or light; or whoever the artist's guardian angel, whether Kafka or Dale Carnegie; wherever his habitat, whether Hyde Park or Montparnasse, the Village or Madison Avenue.

There is a common root in pop-art and a common motive that impels the converging attacks of cardinals and Communists on the American pavilion and its appendix at the American Consulate. To them it is pop-art *vs.* the soul. Even before the Biennale opened, the patriarch of Venice, Cardinal Urbani, deplored the "moral disorder" revealed by the "disintegration of the human image" and banned the Exhibition for members and clerics of all religious orders. *Osservatore Romano*, the Vatican newspaper, endorsed the patriarch's verdict stressing that most of the works exhibited were "objects having no relationship with art . . . they are grotesque relics, attic junk with the addition of . . . indecent ostentations, offending the moral sensitivity."

Pravda has been equally severe. The critic N. Abalkin called the Biennale a "tragic carnival" and denounced pop art as a new and smuggled form of abstractionism, seeking survival under a false and distorted form of realism. "The public laughs and does not like abstractionism. This does not happen when visitors enter the Soviet pavilion, which

The New Republic, September 19, 1964: 32–34. Reprinted by permission; © 1964,
The New Republic, Inc.

displays the best production inspired by socialist realism. There they find light, quiet, clarity." Another Communist critic wrote, "the entire show is an amusing pastiche of Disneyland and surrealism, of popular art and dada, of comic strips and industrial design. The pop-artists are the eternally clumsy Martin Edens, the eternal American autodidacts."

The bourgeois press has joined the cardinals and Communists. "Who are they?" asked the critic of Turin's *La Stampa:* "Carpenters, blacksmiths, junk-dealers, technicians? Are they geniuses or idiots? Enlightened prophets or impudent crooks? The raw materials chosen among the rubbish of daily necessities is called upon to assume the value of a mystical offering, of a new theology." Pop-artists are "modern savages, psychically close to those redskins who a century ago celebrated their rites wearing crushed top-hats on their heads and sardine cans around their hips . . . they obviously do not represent the intelligentsia of a great progressive country."

Added Milan's *Corriere Della Sera:* "We reject an American art which does not defend the values of the spirit, which does not believe in art, which contributes to the disintegration of the world, which continues to pick up all the European stupidities, the stale materialisms and nullisms." On Rauschenberg: "He probably amuses himself, but his literature is silly, old and boring." As for Jasper Johns, John Chamberlain, Claes Oldenburg, Jim Dine and Frank Stella – "they exhibit contorted and compressed metal, enameled chalk, metal, wood, ghost type-writers and telephones with no poetic novelty, with a frightening mental squalor, but with the illusion and the satisfaction of saying something which will revolutionize the world. If this is America, then America is treason."

From beyond the Alps, after Robert Rauschenberg had been assigned the first prize for painting, came prophetic warnings from French critics: "The Rauschenbergs will proliferate and invade us, they will murder the pictorial idiom with their childish gadgets." And the magazine *Arts* added: "We Europeans are now in the eyes of the Americans nothing but poor backward Negroes, good only for being colonized."

Leading European painters showed no greater tenderness. "Pop-art cannot be judged," stated Giorgio De Chirico, "because it has nothing to do with art." "Every painter does pop-art," said Gianni Dova. "When I take a container, some brushes and place them in a certain order I am doing pop-art. But what counts is painting, not pasting and nailing."

Now for years these same voices had been advocating the burial of informal abstract art. Now that the Biennale has performed the funeral rites, they realize that what is emerging from the ashes is not what they had hoped: a return to the "naturalism" of the good old days, with its green meadows, little pink nudes, galloping horses, dripping sirloins of beef or perhaps fighting partisans and astronauts.

These however are not the only voices. Each day of this torrid summer new visitors come who earnestly try to understand what pop-artists, neo-realists, neo-dadaists, etc. are seeking to express. They hasten to see America's "four germinal" (Louis, Noland, Rauschenberg, Johns) and "four younger" (Chamberlain, Oldenburg, Dine, Stella) artists. The painter Renato Guttuso holds that "American pop-art is the biggest artistic phenomenon of the 20th Century after cubism." Many who find that view exaggerated nonetheless agree that pop-art offers a candid image of the gifts and curses of affluence.

Not the artists, but the glossy catalogue arouses suspicions and misgivings. The exhibition's commissioner, Alan R. Solomon, places a great emphasis on the fact "frequently misunderstood by Europeans and others" that "contemporary American art is based on an accommodation to the domestic environment."

"Rauschenberg," Mr. Solomon says, "operates from a positive and constructive view

of the world. He has no interest in social comment, or satire, or in politics." Johns' purpose too is "neither destructive nor anti-human." Claes Oldenburg is "another of the artists who are evolving a new aesthetic not out of protest," and Dine's "commitment must not be regarded as destructive." All of them "evolve a new aesthetic not out of protest, irony or revolt, but out of an affirmative desire to search the truth of the present reality . . . in response to the wonder and delight of the contemporary American environment."

Looking at Rauschenberg's "combines," with their black seas, their towns sunken in darkness, the vulture above Kennedy's image, his hand out-stretched in an eloquent and accusing gesture, the caged nightingales, the deflated airship, the pillows dangling like ballast, the blotches of blood-red paint, Europeans wonder.

DISSIMULATED POP

Max Kozloff

So many people have been bewildered by Pop art, or have been content to revile it, that its qualities and development have been quite obscured. One knows that the highly centralized Abstract Expressionism, after a vital period, began to choke on its own virtuosity around the middle fifties, and that the ideas which it originated had come to seem quite simply worked out. There appeared a moment ripe for change. We are now witnessing another such moment, but in today's polycentric situation ideas have barely begun to be explored. Never a movement, and never cohesive, but rather a sensibility, Pop art is slowly evaporating, as we are finally beginning to see, into a venturesome and incestuous *mélange* of styles that questions the very mechanics of vision and thought. To be sure, one still meets a strategy of resistance, which thwarts or postpones the perception of content, but now it is gotten up in the new guise of an *entente cordiale* harder and harder to label journalistically. By displacement, or magnification or discontinuity, what we called Pop art is sliding into a larger inquiry of self-concern in which the strictly *kitsch* element fades away, or becomes more transparent.

In fact, because their first line of defense – commercial imagery – is becoming more penetrable (if only through overexposure) various artists are falling back on schemata whose implications are essentially abstract. It would be as irrelevant now to identify Pop art by its subject, as it would current abstraction by a contained formal structure. Acting as conventions which may lock into place some equivocation between object and canvas, or some imbalance of color or illusion that overwhelms the senses, subjects and structure in recent works of art have been subverted by their own self-contradictions. That is, we do not approach the significance of the work by means of its conventions, but rather *through* those conventions, or despite them. As in Oldenburg's vinyl telephones or French fries, the quality of the material is simultaneously denied – in its familiarity – and affirmed by its unexpectedness in its new circumstances. If you cannot distinguish between the conventional and the explorative in such artifacts, it is because the process of displacement keeps them both openended. Under such conditions, in which the identities of the work

The Nation, November 30, 1964: 417-19

of art are refashioned before one's very eyes, social commentary becomes by comparison a trivial by-product.

Magnification has been another catalyst in this aesthetic reaction, though in one sense to aggrandize the scale of things and images is another way of displacing them. By such means, the idea was to make everything in the real world quite out of the ordinary by radically disturbing the size relationships between object and viewer, or at least the context in which they were understood. In Rosenquist and Wesselmann, art has the quality of gigantic still life. But in fact the larger you expand the image, the less does it seem commensurable and objectlike, and the more it takes on the accouterments of an environment. Here, a distinction has to be made between the older and more familiar happenings and environments – which consisted of agglomerations of smallish objects – and a new development which inflates only two or three painted images to such a scale as to insinuate a landscape feeling into the underlying still-life orientation. I am not, of course, speaking about traditional genres, but about modes of visual statement, whose dynamics have much to do with the way we interpret and accommodate works of art to our experience. The point of interest about the superimposition of landscape upon still life in Pop art is not merely that the integrity of signs and objects is diminished, but that such diminution registers a greater quotient of abstraction.

Something of the kind must be said to have taken place in the work of Roy Lichtenstein, whose present show at the Castelli is an eye opener on several points. This perpetrator of snarling pilots, lachrymose girls from *True Romance,* household appliances and six-shooters, all portrayed through the lineaments of elephantine comic strips, has changed his art literally, as well as psychologically, to the transcription of landscape.

To be sure, one sees certain continuities between the old and the new Lichtenstein. The same detached, almost anesthetized psychological tone rules both phases of his work, just as the simulated photoengraving dots and hard outlines of the earlier world have not been abandoned in the later. And, if anything, the change in theme only underscores this artist's fundamentally static conceptual approach, in which ultra-corny motifs (here they are blood-red sunsets and stratified light rays) are played off against his insistence that the fiercely mechanized and amplified components of the style afford new sensations in their own right. Still and all, one cannot shift or rearrange the pressure of previously given conventions as radically as here without affecting content, and Lichtenstein seems poised for some drastically new pictorial embarkation.

When it first came to notice, this art was like a depilatory agent for Abstract Expressionism, expunging brushiness as tonically and painfully as a quick rip of a bandage off human flesh. Now, however, a stubble has come up and Lichtenstein is oddly cultivating it. The tonal passages of his compositions have been gradually accentuated so that the pictures almost come to have a matter and opacity and a tactile variety which they previously lacked. But this impression is misleading, if a glance, say, at his "Impressionist Landscape" is any indication. One seems to be looking here through the physical interference of some back-door screen at a lake vista with distant shore. But the actual landscape is pressed onto the forming dots – is, in fact, indissoluble from them, which makes the canvas ground behind an illimitable blank space. Because one expects some form of illusion in a landscape subject, Lichtenstein's refusal to use his pointillism metaphorically, as would a Neo-Impressionist, for example, catches the spectator short. Here is an instance in which one has to override the pictorial context. Then, too, puzzlement is all the more elicited by the fluctuation of dots (single blue points on white ground or round clusters of blue disks with white holes) which suggests the way photoengraving recon-

stitutes illusionist renditions, but which in this work is merely a neutral spread – flat and surface-affirming.

The Castelli show, therefore, reveals an abrasive moment of tension in the career of Pop art. The demands of light, nuance, atmosphere – which are the properties of land-scape – are put in opposition to the mechanical codes of commercial reproduction en-larged so as to lose a great deal of their specificity. (It is another form of displacement, bracketed by the larger principle of Lichtenstein's art.) If the artist were to go forward, he would lose the intractable, schematic consistency which made his art so uncompro-mising. But he would gain a chromatic and spatial richness that would conceivably be more accessible as a visual experience. If, however, he retains his basically simplistic ar-mature, the opportunities present in landscape will not be availed of and the whole motif will seem increasingly gratuitous or arbitrary. Lichtenstein is not the kind of artist who can make an explicitly ironic foil between form and subject. As can be seen, his is a choice of reformulating conventions: in this case of swinging the focus of attention from con-tour to center, and from rigidity to flexibility.

For myself, the preference is clear. Confronted by those heartless and florid re-cre-ations of comics, those evenly stressed, armor-plated figurations, I have never been able to deny enough of my manipulative will to make them mean anything in human terms. It is not so much that they were without humor or affect, but that they demanded an intel-lectual and emotional submission which, however pliable modern art has made me, were not within reach. In short, Lichtenstein needs viewers who can minimize their ego. (This is, of course, not to deny the cultural fact that literary parallels to Lichtenstein's art, such as the cult of the object in the new French novel, or the "Theatre of the Absurd," make him seem very contemporary.) But now, a tentative loosening-up, in which his previously separate bald reds and yellows and blues are coming together more intimately, suggests a certain kind of *moiré* porosity which will allow the eye to wander and to shape optical re-lations, despite being a little bruised in the process. In his future, one can almost see an interesting harsh refinement.

Something, perhaps, of the opposite impulse is happening to the work of Jim Dine, whose show at the Janis Gallery is concurrent with Lichtenstein's. Dine has never been exactly aligned with the Pop artists, yet it has also not been possible to dissociate him from them too easily. His pastose paintings have always owed a frank debt, or, more likely, have paid outright homage to, Abstract Expressionism – all the while parading themselves in the simulacra of bathroom walls, tool chests, or wardrobes. In his vision, every inch of can-vas has to "be" or mean something other than itself. Considering his sources, such pecca-dilloes have seemed a bit childish, and for this I don't think he has generally been forgiven, either by those who consider his work a belated retention of an outmoded style, or a disrespectful mimicry of a great one. Yet Dine's caricatural relation to action painting had been the most enduring Pop element in his work, in no way less honorable than Lich-tenstein's primitivizing way with comic strips. It has just taken people a little longer to re-alize the subtle idea that brush strokes can be just as deceiving a convention to mask out a concern for the identity of the work of art as billboard or mail-order illustrations. This, at any rate, was the base upon which Dine had ordered his art, up to his recent palette series. But these nostalgic, lushly made gestures have suddenly been over-shadowed in turn by sharply drawn and flatly colored renderings of bathrobes or strange gridded com-positions of colored squares. By this incorporation of vocabulary from present abstraction, Dine in his own manner symptomizes the unmooring of Pop art, even if he is moving to-ward the physical idiom from which Lichtenstein himself is slowly inching away.

Stylistically, then, there is no consensus; but conceptually, one feels a greater rapport among the artists, if only in their chafing agreement to pry apart the causal processes of their art. Dine, for instance, has ventured out on ice as thin as Lichtenstein's by his highly compressive and schematic new imagery which risks being taken for what it seems to be: illustrations from a cut-out book which have been blown up and ornamented with adjacent logs, axes, strings and hooks. He had been much safer, but also more obvious, in his earlier mimetic quotes from a dozen differing visual presentations, ranging from Abstract Expressionism to graffiti to textbook diagrams. Both artists, in fact, had been shameless paraphrasers: an activity which is no longer as literally attractive or as useful as it once was. But Dine, the more excitable and changeable figure, was so much more able to inject a personal, emotional element into his works (e.g., affectionately viewed household objects), that his metaphors could be more farfetched and philosophical. Thus, for example, a razor cuts a swath of paint, a drawing of a clenched hand emerges behind a metal rod standing for a cane (whose real shadow conflicts with a false painted shadow) and painted polka dots (cf., Lichtenstein) are found next to a polka-dotted dress which makes them look like snow flakes falling in the night. In one poetic stroke, Dine shows that natural deductions and visual similarities, when encouraged, are entirely deceiving. Where Lichtenstein switches circuits on only one or two levels, Dine dances over every conceivable simile, evokes ever more fallacious connections, and forces one to judge relations between objects and paint strokes in ways that totally befuddle or reverse the notion of movement and matter in the worlds of art and life.

Not merely because such devices camouflage the rational, but because they are so transparent about it, do they become Dine's equivalent of conventions. No one is more double-faced, casuist, ironic or more normative in all these things than this artist. He is at once a landscape and still-life painter, as well as inseparably spontaneous and mechanistic as a paint handler. In fact, what is most intractable about this wily creature is his refusal to stay at any one point, and his irremediable fusions of opposites.

In his view of 20th-century art – and it extends all the way back to synthetic Cubism – creation is a process of recombining functions and packaging knowledge in ever denser, more economical units. The show at the Janis Gallery, in this respect, is entirely transistorized. Even when Dine has hardened his manner of seeing, as most recently, he is incorrigibly metaphorical. Irate color-field abstraction or optical art enters his work implausibly in the form of a bathrobe or Red Devil color chart. It is typical of him that he tones down a physical belligerence in order to emphasize a conceptual provocation. Sometimes he will even juxtapose two of his highly summarized motifs, as in the color chart through which a ghostly palette form is partially visible. He diminishes his cues, and yet relies all the more strongly on them for recollection.

I can work with all these conflicts, even though I realize that they advertise themselves as snares for credulity, and that they constantly demand ever more information to be legible. As Lichtenstein moves toward sensibility and feeling, Dine approaches a kind of history-laden form of expression. In fact, the symbolical and associational structure of his works (as distinct from their unassuming formal presence) is so complex, that the experience of the overall show is nervous and burdensome as much as it is exhilarating. But, above all, I'll remember this exhibition thankfully for the way it deflates good intentions and teaches in its spirit of mockery that high seriousness is perhaps not all that appropriate as a judge of art. At least, it would be pleasurable to think so.

POP ART EXHIBITED, AND IT'S CRAZY, DAD

Unsigned

"It's crazy . . . it's wild . . . it's just what we need . . . "

These were some spontaneous reactions to the "Pop Art and the American Tradition" exhibition at its opening at the Milwaukee Art Center Thursday night.

"I'm half way through the show and I haven't stopped smiling yet," said one woman. She was looking at a painting of pinball machines.

Below it was a real pinball machine being played by a young man with a long hairdo. The machine went "tilt."

Pop music from a jukebox rocked the gallery as a crowd of about 750 viewers gyrated among the 86 paintings, sculptures and old commercial signs.

INVITATION TO DANCE?

One couple tried to dance, but found little twisting room between a motorcycle and a painted wood sculpture of two dancing couples. A teen age girl saw an old wood carving of Uncle Sam with his hand in the air and thought he was inviting her to dance. Sam continued to grin, but he couldn't do the frug.

Several women were wearing pop dresses. One was white with a huge zipper running down the front; another was blue with a striped belt painted around it; a third was yellow with a big necklace printed on it.

A woman wore a pop necklace made of bottle caps and product labels, including grated cheese, coffee and crackle cereal.

Young viewers in black leather and decked like beatleniks were conspicuous by their presence. But a painting of "The Beatles" produced more smirks than screams. The four familiar figures are faceless.

As they sipped beer and munched monster cookies, viewers admitted doubts about the profundity of many pieces; but most agreed that the display was gay and frolicsome.

In the course of the evening, several women moistened their fingers and tested the heat of the iron in a sculpture of "Ironing Board, Shirt and Iron."

The exhibition consists of paintings and commercial signs dating to the 19th century as well as contemporary pop art, selected by the art center staff to illustrate a long interest among American artists in basing work on popular images.

OUTGROWTH OF ABSTRACTS

Ivan Karp, director of the Castelli galleries, New York city, was lecturer. He said he had seen at least 75 pop art shows, but "this one is the most beautiful and most remarkable exhibition of its kind."

Karp recounted the upsurge of abstract expressionist painting in New York city after World War II and its influence on art throughout the world. He said pop art developed from this.

"Pop art is a direct reversal" of that abstract painting, but it grew from it in "a series of transitional events," Karp asserted.

Milwaukee Journal, April 9, 1965: 6. Reprinted by permission of the *Milwaukee Journal Sentinel*.

He showed color slides illustrating recent changes in pop art. He drew questioning laughs when he suggested that the stylized paintings of commercial images had abstract beauty of their own and were "so bad they are good."

He indicated that people were slow to see this beauty because the images tended to remain despised commercial work, "painfully present everywhere."

POP ART AND NON-POP ART

Robert Rosenblum

So sensitive are the art world's antennae to the symptoms of historical change that, in 1962, when some New York galleries began to exhibit pictures of vulgar subject matter, a new movement, Pop art, was instantly diagnosed and the mindless polemics began. As usual, the art in question was seldom looked at very closely and questions of definition and discrimination were ignored. Instead, things were quickly lumped together into a movement which called for wholesale approval or rejection. Presumably, one had to take sides, and various critics were considered to be either vigorously for or against it. But what was "it"? Considering that "it" was equated with viewpoints as divergent as those of Barry Goldwater and Terry Southern, one suspected that less violent politicking and more temperate thinking and seeing were in order. In fact, the term Pop art soon blanketed a host of artists whose styles, viewpoints, and quality could hardly have been more unlike. When one insisted that names be named, things got foggier. Were Rivers, Rauschenberg, Johns Pop artists? Well, yes and no. And what about Marisol, George Segal, Peter Saul? Well, maybe. But arguments, without names and definitions, continued.

If some common denominator was felt to run through all these artists thoughtlessly bracketed together, it was probably a question of subject matter. But here was an odd turn of aesthetic events. How, after all the formalist experience of our century, could a new kind of art be defined on this basis alone, and didn't this give rise to contradictions? If admirers of de Kooning usually scorned Andy Warhol, hadn't both artists painted Marilyn Monroe? And were Warhol's Coca-Cola bottles really to be mentioned in the same breath as George Segal's or Rauschenberg's? Using iconographical criteria, Pop art produced illogical groupings, but logic never seemed to bother the art-political parties that insisted on condemning or praising Pop art without saying what it was. Writers who could never have paired two 1930's artists of the urban scene, Reginald Marsh and Stuart Davis, because their pictures looked so different, had no trouble pairing new artists who had in common only the fact that, on occasion, they depicted George Washington, dollar bills, or sandwiches.

If Pop art is to mean anything at all, it must have something to do not only with *what* is painted, but also with the *way* it is painted; otherwise, Manet's ale bottles, Van Gogh's flags, and Balla's automobiles would qualify as Pop art. The authentic Pop artist offers a coincidence of style and subject, that is, he represents mass-produced images and objects by using a style which is also based upon the visual vocabulary of mass production. With

Art and Literature, Summer 1965, 80–93

such a criterion, the number of artists properly aligned with the movement dwindles rapidly. Thus, when Rivers and Rauschenberg introduce fictive or real cigarette wrappers and news photos into their canvases, they may be treading upon the imagery of Pop art but in no way touching upon the more fundamental issue of style. Painting as they do with techniques dependent on de Kooning's dedication to virtuoso brushwork and personal facture, they cling to pictorial formulae of the 1950's that are, in fact, largely rejected by the younger artists of the 1960's. Even some of these still offer a hybrid mixture of Pop subject and non-Pop style, as in the case of Peter Saul, who fuses Donald Duck and TV commercials with Gorky; or Wayne Thiebaud, who arranges cafeteria still lifes under a creamy impasto of pastel sweetness derived from Diebenkorn. And in the case of the recent work of Jasper Johns, who may have fathered Pop painting in his early flags and Pop sculpture in his ale cans, there is the curious phenomenon of increasingly wide discrepancy between the geometrically lucid objects represented and the abstract painterly milieu that clouds them.

In terms of definition, and not necessarily of quality, the real Pop artist not only likes the fact of his commonplace objects, but more important, exults in their commonplace look, which is no longer viewed through the blurred, kaleidoscopic lenses of abstract expressionism, but through magnifying glasses of factory precision. When Roy Lichtenstein paints enlarged Ben-Day dots, raw primary colors, and printer's-ink contours inspired by the crassest techniques of commercial illustration, he is exploring a pictorial vocabulary that would efface the handicraft refinements of chromatic nuance, calligraphic brushwork, and swift gesture pursued in the 1950's. When Andy Warhol claims he likes monotony, and proceeds to demonstrate this by painting ten times twenty cans of Campbell's soup, he uses the potential freshness of overt tedium as an assault upon the proven staleness of the de Kooning epigones' inherited compositional complexity. When James Rosenquist becomes infatuated with the color of Franco-American spaghetti or a slick-magazine photograph of a Florida orange, he employs these bilious commercial hues as tonics to the thinning blood of chromatic preciosity among belated admirers of Guston or Rothko. And when Robert Indiana salutes the heraldic symmetry, the cold and evenly-sprayed colors of road signs, he is similarly opposing the academy of second-hand sensibility that inevitably followed the crushing authority of the greatest abstract expressionists.

Thus, artists like Lichtenstein, Warhol, Rosenquist, Indiana, Wesselmann, the recent Oldenburg (but not Rivers, Rauschenberg, Johns, Dine, Thiebaud, Marisol) all share a style that would stem the flow of second-generation adherents to the styles of the American old masters of the 1950's. It is no accident that most pictorial values affirmed by the older generation have been denied by the newer one. A late Romantic imagery referring to remote myth and sublime nature is replaced by machine-made objects from ugly urban environments. Gently stained or shaggily encrusted brushstrokes are negated by an insistence upon hygienic, impersonal surfaces that mimic the commercial techniques in which several Pop artists were, in fact, professionally trained (Rosenquist, as a billboard artist; Warhol, as a fashion illustrator). Structures of shifting, organic vitality are challenged by regularized patterns of predictable, mass-produced symmetry. Colors of unduplicable subtlety are obliterated by the standardized harshness of printer's red, yellow, and blue.

This historical pattern of rejection is familiar. One thinks particularly of the Post-Impressionist generation, when an artist like Seurat controverted Impressionism through an almost mechanized system of brushstrokes, colors, shapes, contours, and expressions, often inspired by such 1880's Pop imagery as fashion plates and posters. In the

case of the 1960's Pop artists, this rebellion against the parental generation carried with it an espousal, both conscious and unconscious, of the grandparental one. In fact, any number of analogies can be made between the style and subject of Pop artists and of those modern masters active between the wars. The purist, machine-oriented shapes and imagery of Léger, Ozenfant, Le Corbusier, and De Stijl are often revived in the current enthusiasm for poster-clean edges, surfaces, and colors (Lichtenstein, for example, provides many parallels to Léger's industrial images of the 1920's and has twice paraphrased Mondrian's black rectilinear armatures and primary hues). More particularly, American art before Abstract Expressionism has begun to strike familiar chords, so that artists like Charles Demuth, Joseph Stella, Stuart Davis, and the newly resuscitated Gerald Murphy all take on new historical contours as predecessors, when considered in the light of the 1960's. (Davis's Cubist Lucky Stripe cigarette wrapper of 1921 suddenly becomes a prototype for Warhol's flattened Campbell's soup can; Stella's *Brooklyn Bridge* and Demuth's *I Saw the Figure Five in Gold* are explicitly restated by Indiana; Niles Spencer's and Ralston Crawford's immaculate cityscapes and highways are re-echoed in Allan d'Arcangelo's windshield views.) Even Edward Hopper, whose 1964 retrospective occurred at a time of maximum receptivity (in 1955, he might have looked merely provincial), has taken on the stature of a major pictorial ancestor. His poignant, American-scene sentiment of the 1930's and 1940's survives not only in those inert, mummified plaster figures of George Segal who suffocate amid the ugliness of coke machines and neon signs, but also in the poker-faced exploitation by anti-sentimental Pop artists of the anaesthetizing blankness and sterility of a commercial America. And the time may soon come, too, when the WPA mural style of the 1930's will look like a respectable grandparent to Rosenquist's public billboard imagery of giant urban fragments.

If the most consistent Pop artists can be located in the heretic position of refusing to believe in those aesthetic values of the 1950's which, with the irony of history, have suddenly become equated with venerable humanist traditions rather than with chimpanzee scrawls, are they, in fact, so singular in their rebellion? The most vigorous abstract art of the last five years has also stood in this relation to the oppressive grandeur of de Kooning, Pollock, Kline, Guston, Rothko, Still, and Newman, and soon the cleavage between Pop art and non-Pop art (solely an iconographical, not a stylistic, distinction) will no longer seem real. So obtrusive was the subject matter of Lichtenstein's or Warhol's first Pop paintings that spectators found it impossible to see the abstract forest for the vulgar trees. Anybody, we heard, could copy a comic strip or a soup can, the implication being that, as in the case of criticism directed against Caravaggio or Courbet, the Pop artist dumbly copied ugly reality without enhancing it by traditional pictorial idealizations. Yet disarming subject matter has a way of receding so rapidly that it becomes well-nigh invisible. When first exhibited, the early flags of Jasper Johns looked like such unadulterated replications of the Stars and Stripes that most spectators dismissed them as jokes of a Dadaist trickster. Today, within a decade of their creation, the same flags look like old-master paintings, with quivering, exquisitely wrought paint surfaces not unlike Guston's, and with formal distinctions that permit us to talk casually about Johns's white flags, grey flags, or flags on orange grounds just as we might talk about Matisse's blue, red, or green still lifes. In the same way, the initially unsettling imagery of Pop art will quickly be dispelled by the numbing effects of iconographical familiarity and ephemeral or enduring pictorial values will become explicit. Then, one hopes, the drastic qualitative differences among Pop artists should become clear even to those polemicists who think all Pop art is either good, bad, or irrelevant.

Already the gulf between Pop and abstract art is far from unbridgeable, and it has become easy to admire simultaneously, without shifting visual or qualitative gears, the finest abstract artists, like Stella and Noland, and the finest Pop artists, like Lichtenstein. The development of some of the Pop artists themselves indicates that this boundary between Pop and abstract art is an illusory one. Thus, Indiana began as a hard-edged abstractionist in the vein of Ellsworth Kelly and Leon Polk Smith. That he then introduced highway words like EAT or USA 66 into his emblematic geometries should not obscure the fact that his pictures are still essentially allied to Kelly and Smith, who, for purposes of art-political argument, would be forced to run on another ticket. And some of the recent landscapes of Lichtenstein, if taken out of context, might even be mistaken for chromatic abstractions or new optical paintings. This party-split between Pop and non-Pop art – the result of argumentative factions and rapid phrase-makers – is no more real than the line one might draw between, say, the abstract work of Léger and Stuart Davis and the work in which their urban subject matter is still clearly legible. Pop imagery may be momentarily fascinating for journalists and would-be cultural historians, but it should not be forgotten that the most inventive Pop artists share with their abstract contemporaries a sensibility to bold magnifications of simple, regularized forms – rows of dots, stripes, chevrons, concentric circles; to taut, brushless surfaces that often reject traditional oil techniques in favor of new industrial media of metallic, plastic, enamel quality; to expansive areas of flat, unmodulated color. In this light, the boundaries between Pop and abstract art keep fading. Al Held's giant paintings recall abstract billboards; Krushenick's blown-up, primary-hued patterns look like image-less comic strips; Dan Flavin's pure constructions of fluorescent light tubes smack of New York subways and shop windows. Art is never as pure or impure as aesthetic categories would make it. Who would want to separate Mondrian's *Broadway Boogie-Woogie* from its urban inspiration? Who would want to ignore the geometric rightness of Hopper's realist wastelands? For the time being, though, we shall go on hearing wearisome defenses of and attacks upon some vague domain called Pop art, a political slogan that can only postpone the responsibility of looking at, defining, and evaluating individual works by individual artists.

FURTHER OBSERVATIONS ON THE POP PHENOMENON

Sidney Tillim

> *David McCallum is utterly self-contained and completely dedicated to his own world. He acts and loves acting, but he also lives and loves living. He has never dissipated himself, never soiled himself with casualness, never deviated from a passionate addiction to his own basic values.*
>
> Jean Kessner, *Photoplay Magazine*, July, 1965

> *Claes Oldenburg has subordinated his entire being to the pursuit of an original, intensely personal vision. His artistic goals are ambitious, and he applies himself to their realization with complete dedication . . . He is the completely inner-directed man. His personality is built on a framework of values and goals that are unaffected by the currents of the world.*
>
> John Rublowsky, *Pop Art*, 1965

Pop Art has upset a lot of people. Those who have taken their commitment to art for granted – painters, critics, patrons, curators and the like – are among its chief critics if for no other reason than that their involvement has been shown up to be the complacent and entrenched force that it had become. The Pop Art audience, as arrogant and as "arriviste" as much of it is, is involved with art in a way that I think no American art public has been involved before. It is concerned less with art, i.e., quality, than with the release of a spirit that has been repressed by its subservience to an idea of culture essentially foreign to its audience. The Pop audience is tired of being educated, tired of merely good art.

What we are experiencing now has gone far beyond the esthetic ramifications of Pop. We are witnessing a parody of innocence that expresses itself as a release from the conventions, values and consciousness of a culture that failed to anticipate the frustrations it was creating in the process of heightening the awareness of its increasingly sophisticated audience. As a result, grown men and women have thrown off the trappings of "respectability," i.e., the serious side of culture, auctioned off their collections of Abstract Expressionism and rolled out the American flag. "This is it! You can't beat the sound, you can't beat the scene! People go to Europe and they're crazy. The whole world is here."[1] This puts the Abstract Expressionist era in the position of parents who are no longer able to communicate and reason with their children.

Everything about Pop, everything connected with Pop seems – and is – exaggerated simply because the release of the frustrated impulses building up in American taste came, as all releases and overreactions do, at once. Revolutions at the outset are never subtle. Pop was successful in effecting this release not simply because it triggered the reaction but because it embodied it, better than, say, hard-edge or color-field painting, which broke radical ground but remained within the formalist camp. People were waiting for a visual Godot, artists like Rauschenberg and Johns were fabricating the tesserae of reaction, and then suddenly it was here, an entirely different if not new mosaic of possibilities. If the American art world then went off its nut, it was consistent with the revolutionary pattern of peasants invading the palace grounds and desecrating the statues. It is regrettable that in the process the troops have felt compelled to string up Europe as a cul-

Artforum, November 1965: 17-19, © Sidney Tillim

tural model, by the heels like Mussolini. Like many modern revolutions, ours is a revolution against the sensibility and authority which educated us. Similarly, its leaders have not been able to contain their revolution.

It is inevitable, then, that certain aspects of the "revolution" should appall some people who, one expects, support it in other respects. "The New York art world is engaged in an endless litany of nationalist self-congratulation," complained Susan Sontag, whose "Notes on Camp" established "camp" as a significant aspect of the contemporary scene. The charge of chauvinism, however, blurs the reality of the actual vitality of American art at this time, a historical fact no matter how, or by whom, it is used. It also ignores the significance of American art having attained a "nationalist" character, regardless of its affiliations with the European, i.e., French, avant-garde of this century.

Indeed, the Pop phenomenon is ironic to the extent that it has carried the day not only at the expense of the European contribution to American modernist art but pretty much at the expense of the art which first aroused American esthetic sensibility to its indigenous potential. But Abstract Expressionism was in fact caught between two drives – its loyalty to the ideas of the European avant-garde and its own aggressive impulses which expressed the impatience of Americans with anything that does not produce immediate practical results. These drives were further complicated by the frustrated idealism carrying over from the Depression. The achievement of a more inimitable character by American art had to be delayed while artists were struggling with their "crisis."

It has, however, been one of the more unfortunate if predictable aspects of the Pop phenomenon that it has been permitted to overshadow thus far, other developments in post-Abstract Expressionist art. In certain respects the situation already resembles, in its intolerance, the protective and pious atmosphere that developed around Abstract Expressionism. That the Pop hierarchy is still dominated by its innovators is another feature in which it resembles the pantheon of what only a few years ago was called The New American Painting.

Still, it is unlikely that Optical art, for instance, would have had the reception in America that it has had, had not Pop Art so effectively brought to a head the growing reaction against painterly abstraction. Optical art received the benefit of the cultural "thaw" precipitated by Pop Art, as evidenced by the fact that some collectors of Pop also took up "Op." This does not contradict the "chauvinistic" side of the Pop phenomenon but is rather an expression of the generosity people can afford when they feel they have come into their own. It also confirms my previously asserted impression that on the part of the audience the issue is not so much artistic quality as a release from certain inhibitions. A lack of discrimination, while dilettantish, is probably natural after years of a visual diet limited to moody Romantic, anti-social documents that anyway quickly reverted to a purely esthetic status. It is also a further measure of the success with which the public has been educated in the acceptance of misunderstood genius. The danger, of which, as I have said, some evidence already exists, is, of course, that the cure may turn out to be worse than the disease. But this has happened before and distinguishes the fellow traveler rather than the committed individual whose abiding vice is, instead, usually snobbishness.

The possibility exists, then, for a backlash to occur in favor of Abstract Expressionism. To many people de Kooning is still the leader. But, ironically, attempts in this direction have only had the effect of even further separating the Abstract Expressionists from the more vital aspects of the scene. I regret to say in these pages that the somewhat compulsive reverence for The New York School expressed by Philip Leider in the September issue of *Artforum* is just the sort of thing that consigns Abstract Expressionism to history

while its surviving artists remain committed to the problems that originally engaged them and while a criticism of them is still barely tolerated. The giants are always lonely precisely because they are made responsible for their admirers' ambitions. Action painting as a movement may be finished, its aura of crisis repudiated, but the artists remain to be dealt with, especially de Kooning, whose difficulties over the past decade recapitulate all of the frustrations which finally found an outlet in Pop Art. Meanwhile, it was an admission that the heroic days of Abstract Expressionism were over when Robert Motherwell exclaimed in an interview with Max Kozloff (*Artforum*, same issue), "How I admire my colleagues!" There was also the clear inference, whatever else may lie behind his compulsive admiration, that the new wave is the creation of sissies and parvenues.

On the other hand, the exploitation of Optical art as an alternative to Pop also has to be considered. John Canaday, in an unqualified rave in the *New York Times*, claimed that "Op" was no less than the art of our time, and "at last." Optical art also reflects the Establishment in other ways. For if "The Responsive Eye," organized by William Seitz at the Museum of Modern Art, was not conceived for the purposes of counteracting the popularity of Pop Art, it did illustrate the difficulty the curatorial Establishment has had in approaching modernist art with anything but an internationalist bias. Anything else would have to be regarded as parochial by an organization whose policies were shaped by events in Europe between 1907 and the 1930s.[2] It wasn't until 1958 that it organized "The New American Painting" and then it was "organized at the request of European institutions," to quote Director René D'Harnoncourt himself. The Museum acknowledged Pop Art principally by a symposium on Dec. 13, 1962, but has attempted no general survey. When it detected a trend to figurative painting, it organized the incredibly feeble "Recent Painting U.S.A.: The Figure" (also in 1962) which managed to reject many of the significant modern realists, and again reflected the museum's obsession with "crisis" esthetics by limiting the exhibition to the figure. Meanwhile, in The Guggenheim International Award of 1964, selected by Curator Lawrence Alloway, Pop Art was represented by Kitaj, an American-born artist living in England, and Oyvind Fahlstrom of Sweden. As I remarked in an article at the time, "Not that Mr. Alloway utterly ignores the palace revolutions of the international style . . . (But) by dispersing the evidence of unrest throughout the world, by assigning, in other words, important parts of the dialogue (between what he described as 'current possibilities') to those least qualified to discuss them, Mr. Alloway has produced a corporation report for stockholders, few of whom will notice that the figures on the balance sheet were juggled."

While Optical art may have recouped some lost prestige for the Museum of Modern Art, and while the Guggenheim has since made some restitution to post-Abstract Expressionist art, Pop was finding support at, of all places, the Jewish Museum. Under the brief and controversial directorship of Alan Solomon (of the new List Pavilion), the museum was transformed from an archaeological and ethnic institution into a force in American art by mounting retrospectives of the works of Robert Rauschenberg and Jasper Johns. Mr. Solomon's aggressive program, however, announced the presence on the scene of "young Turks" who have exploited the Pop phenomenon in the interest of their own struggle with the Establishment.

As I said, everything connected with Pop is exaggerated. This includes the promoted impression that it was violently opposed. But if Pop was not an immediate success in every official circle, it found ready support elsewhere. Even before the Jewish Museum entered the picture, it had already attracted some critical support.[3] Influential dealers like Leo Castelli and Dick Bellamy threw their resources behind it and very quickly one of

the more significant aspects of the Pop phenomenon developed; namely, the role a relative handful of collectors have played in establishing a revolution in taste and style. Pop collectors like Robert Scull and Leon Kraushar advanced the cause of Pop Art through the publicity they received merely by buying it. Today they are almost as well-known as the Pop artists themselves. Not to dismiss outright their beneficent gestures, the fact is that with the aid of Pop Art these new collectors finally caught up with the reaction against provincialism that has inspired modernist American art for most of the century. They have thus joined forces with the new spirit, producing a situation where, in effect, they are virtually competitors with the art and artists they support. Their names now appear alongside those of the artists in newspapers and magazines which recognize in their gregarious passion, albeit with mixed feelings, a clue to both the aspirations and values of The Great Society. Not only have *Life* magazine and *Good Housekeeping* recently devoted several pages to the Sculls and the Kraushars, but a recent book on Pop Art[4] devotes an entire chapter to the new collecting elite. Now incidentally, the new breed collector is also reacting against the pattern in American collecting, which might be called grand eclectic and which covers a period from the Robber Baron days of the Fricks, the Mellons and the Morgans down to those of the no less omnivorous Joe Hirshhorn, who can now be regarded as a transitional figure between the old rich and the new.

However, it has to be considered a sign of the incipient bureaucratization of the Pop phenomenon that it not only has sired a new breed impresario and a baffling range of Ivy League Apollinaires, but has also inspired a hack rhetoric which not only exhumes the Romantic image of the suffering artist but then proceeds to turn him into the great American success story. It was offensive in the early days of the phenomenon, that is, only two or three years ago, to hear Alan Solomon and Henry Geldzahler exaggerate the opposition to Pop Art so that they could defend it, but in John Rublowsky's razz to riches account of Pop Art, secular hagiolatry perfects its vulgar style. Rublowsky tells a tale of simple, stouthearted and poignantly middle class but always "sensitive" men struggling against great odds to express an "uninhibited delight in the extravagant imagery of our world" which, moreover, has been tested "pragmatically." Surrounded by critical hostility and official apathy, they do not waver in their attempts to "see beyond the surface appearance" (of a hamburger or comic strip) to "represent deeply experienced truths about illusion and reality." "Labor and discipline," it seems, pulls them through, as the hero becomes simultaneously a revolutionary and a paragon of the Puritan virtues. Success and international recognition, when they come, do not contradict this image of the artist-as-(Everyman's) tragic hero, for in the popular version of the legend, success, like failure, is equally a testimonial to his superhuman accomplishment. All of which suggests to me that the true hero worshipper is an intellectual transvestite. Rublowsky's panegyrical clichés are accompanied by photographs by Kenneth Heyman of Pop artists at work, at play and as family men. In other words, the book is a package which in word and image resembles nothing so much as a Hollywood fan magazine. The quotes at the front of this article, therefore, require no comment.

It has taken Pop Art four years to achieve the hierarchical eminence which it took Abstract Expressionism about ten. It thus attracted the fellow traveler that much quicker and, given the particular appeal of its imagery, a type of following which would naturally be as adventitiously banal as Pop imagery itself. All revolutions have their ugly aspects; but, in spite of these and despite what I, at least, feel are certain fundamental shortcomings in a basically transitional art, the Pop phenomenon has put the entire history of American art in a new perspective.

1. Pop Art collector Leon Kraushar to *New York Times* reporter Grace Glueck, last June on the occasion of a publisher's party in Andy Warhol's studio to celebrate the publication of *Pop Art*. The party tried to emulate Pop Art itself. A rock and roll combo (The Denims) provided music, hot dogs were served from real pushcarts, and guests had received invitations printed on the back of Campbell's soup labels.

2. In the thirties and forties, the Museum did put on what appears to have been a series of informative exhibitions about American art – folk art, Indian painting, architecture, photography and even George Caleb Bingham. But this only confirms a parochial attitude towards American art which seems to persist to this day. It is only in the last few years that the Abstract Expressionists have been honored. But among the first of these was Mark Tobey, who can hardly be described as typical; and besides, the present series of retrospectives seems curiously belated. In the thirties and forties there may have been some justification for the Museum's intransigence; the new American painting was hardly out of the rough. Not that I think that museums should reflect immediately the changes of taste. On the contrary, premature museum recognition not only seriously distorts the market but hastens the obsolescence of living art. The problem is that the Museum has been ambivalent on the one hand, and aggressive on the other, and has retarded the development of indigenous sensibility by constantly relating art in America to values that over the years have applied less and less to the problems whose issue now simply repudiates what the Museum down deep still thinks is the mainstream.

3. From myself, for instance. My article on Pop Art (*Arts*, Feb., 1962), based largely on Oldenburg's wholly remarkable Store, was the first in this country and actually preceded the formal debut of the movement. As for opposition from critics like Hess, Rosenberg, Greenberg and Kramer, it was hardly of the customary philistine kind. It was rather, an extension of all the ideological disputes that have raged in the New York art world for years. Vanguard art has ultimately profited from these squabbles because they preserved the image of the artist as rebel which appeals both to his – and the popular – imagination. Pop Art's most vocal apologists have not only exploited this image but have frequently seemed to be soliciting opposition as well as support. For without this tradition of dissent, Pop Art would have had to make it on esthetic merit alone. This is something virtually no movement since Cubism has dared to do. My own opinions on Pop, meanwhile, have varied from exhibition to exhibition. I liked the Store when it was set up in Oldenburg's studio, but not the later and cleaned up version at the Green Gallery. Similarly, his furniture failed to transcend its intrinsic banality. But his soft telephones and the like were both terrifying and funny, something banality, which is only terrifying, is not. Lichtenstein did not reach me at all, to put it mildly, until he applied his technique to something besides comic strips. Rosenquist's goals were at first unclear, but he has grown fantastically, though he cannot now change his technique without contradicting himself. Wesselmann's reputation is a complete mystery to me. Warhol is a true iconoclast and a negative genius who confirms, I think, Mr. Greenberg's thesis that "Pop Art amounts to a new episode in the history of taste, but not an authentically new episode in the evolution of contemporary art." Basically, I share Mr. Greenberg's verdict but I place a higher evaluation on Pop Art as an "episode" simply because I believe that a change of taste augurs a more fundamental change in art than Mr. Greenberg would presently allow.

4. "Pop Art," by John Rublowsky. Photographs by Kenneth Heyman. 41 color plates. Basic Books, New York, 1965.

OLDENBURG, LICHTENSTEIN, WARHOL: A DISCUSSION

Bruce Glaser

The following discussion, moderated by Mr. Bruce Glaser, was broadcast over radio station WBAI in New York in June, 1964. The transcript was edited for publication in September–October, 1965.

BRUCE GLASER: Claes, how did you arrive at the kind of image you are involved with now? Did it evolve naturally from the things you were doing just before?

CLAES OLDENBURG: I was doing something that wasn't quite as specific as what I'm doing now. Everything was there, but it was generalized and in the realm of imagination, let's say. And, of course, an artist goes through a period where he develops his "feelers" and then he finds something to attach them to, and then the thing happens that becomes the thing that he wants to be or say.

So I had a lot of ideas about imaginary things and fantasies which I experimented with in drawings, sculptures and paintings, in every conceivable way I could. Through all this I was always attracted to city culture, because that's the only culture I had. Then around 1959, under the influence of the novelist, Celine, and Dubuffet, I started to work with city materials and put my fantasy into specific forms. Then, under the influence of friends like Jim Dine and Roy Lichtenstein and Andy and all these people, the images became even more specific. But I can go back to my earlier work and find a toothpaste tube or a typewriter, or any of the things that appear in my present work, in more generalized forms.

GLASER: You mention that some of the other artists who work with Pop imagery had some effect on you. Yet it is often said by advocates of Pop art that it arose spontaneously and inevitably out of the contemporary milieu without each Pop artist having communication about, or even awareness of, what other Pop artists were doing. Are you suggesting something contrary to this?

OLDENBURG: There is always a lot of communication between artists because the art world is a very small one and you can sense what other people are doing. Besides, America has a traditional interest in pop culture. In Chicago, where I spent a lot of time, people like June Leaf and George Cohen were working very close to a Pop medium in 1952. George Cohen used to go to the dime store and buy all the dolls he could find and other stuff like that. Even though he used them for his own personal image there has always been this tendency.

Also, in California, where I've spent some time, the tradition of getting involved with pop culture goes way back. But I don't think the particular subject matter is as important as the attitude. It's a deeper question than just subject matter.

GLASER: Roy, how did you come upon this imagery?

ROY LICHTENSTEIN: I came upon it through what seems like a series of accidents. But I guess that maybe they weren't completely accidental. Before I was doing this I was doing a kind of Abstract Expressionism, and before that I was doing things that had to do with the American scene. They were more Cubist and I used early American paintings by Remington and Charles Wilson Peale as subject matter.

But I had about a three year period, just preceding this, in which I was doing only ab-

Artforum, February 1966: 20–24

stract work. At that time I began putting hidden comic images into those paintings, such as Mickey Mouse, Donald Duck and Bugs Bunny. At the same time I was drawing little Mickey Mouses and things for my children, and working from bubble gum wrappers, I remember specifically. Then it occurred to me to do one of these bubble gum wrappers, as is, large, just to see what it would look like. Now I think I started out more as an observer than as a painter, but, when I did one, about half way through the painting I got interested in it as a painting. So I started to go back to what I considered serious work because this thing was too strong for me. I began to realize that this was a more powerful thing than I had thought and it had interest.

Now, I can see that this wasn't entirely accidental. I was aware of other things going on. I had seen Claes' work and Jim Dine's at the "New Forms, New Media" show [sic] (Martha Jackson Gallery, 1960), and I knew Johns, and so forth. But when I started the cartoons I don't think that I related them to this, although I can see that the reason I felt them significant was partly because this kind of thing was in the air. There were people involved in it. And I knew Happenings. In fact, I knew Allan Kaprow who was teaching with me at Rutgers. Happenings used more whole and more American subject matter than the Abstract Expressionists used. Although I feel that what I am doing has almost nothing to do with environment, there is a kernel of thought in Happenings that is interesting to me.

GLASER: How did you get involved with Pop imagery, Andy?

ANDY WARHOL: I'm too high right now. Ask somebody else something else.

GLASER: When did you first see Andy's work?

LICHTENSTEIN: I saw Andy's work at Leo Castelli's about the same time I brought mine in, about the spring of 1961. And I hear that Leo had also seen Rosenquist within a few weeks. Of course, I was amazed to see Andy's work because he was doing cartoons of Nancy and Dick Tracy and they were very similar to mine.

GLASER: Many critics of Pop art are antagonistic to your choice of subject, whether it be a comic strip or an advertisement, since they question the possibility of it having any philosophical content. Do you have any particular program or philosophy behind what you do?

OLDENBURG: I don't know, and I shouldn't really talk about Pop art in general, but it seems to me that the subject matter is the least important thing. Pop imagery, as I understand it, if I can sever it from what I do, is a way of getting around a dilemma of painting and yet not painting. It is a way of bringing in an image that you didn't create. It is a way of being impersonal. At least that is the solution that I see, and I am all for clear definitions.

I always felt, for example, that Andy was a purist kind of Pop artist in that sense. I thought that his box show was a very clear statement and I admire clear statements. And yet again, maybe Andy is not a purist in that sense. In art you could turn the question right around and the people that are most impersonal turn out to be the most personal. I mean, Andy keeps saying he is a machine and yet looking at him I can say that I never saw anybody look less like a machine in my life.

I think that the reaction to the painting of the last generation, which is generally believed to have been a highly subjective generation, is impersonality. So one tries to get oneself out of the painting.

GLASER: In connection with this I remember a show of yours at the Judson Street Gallery in 1959 which reflected your interest in Dubuffet, and that work clearly had a very personal touch. Your drawings and objects then were not made in the impersonal way that Roy uses a stencil or Andy a silk-screen.

LICHTENSTEIN: But don't you think we are oversimplifying things? We think the last

generation, the Abstract Expressionists, were trying to reach into their subconscious, and more deeply than ever before, by doing away with subject matter. Probably very few of those people really got into their subconscious in a significant way although I certainly think the movement as a whole is a significant one. When we consider what is called Pop art – although I don't think it is a very good idea to group everybody together and think we are all doing the same thing – we assume these artists are trying to get outside the work. Personally, I feel that in my own work I wanted to look programmed or impersonal but I don't really believe I am being impersonal when I do it. And I don't think you could do this. Cézanne said a lot about having to remove himself from his work. Now this is almost a lack of self-consciousness and one would hardly call Cézanne's work impersonal.

I think we tend to confuse the style of the finished work with the method through which it was done. We say that because a work looks involved, as though interaction is taking place, that significant interaction is really taking place. And when a work does not look involved, we think of it merely as the product of a stencil or as though it were the same comic strip from which it was copied. We are assuming similar things are identical and that the artist was not involved.

But the impersonal look is what I wanted to have. There are also many other qualities I wanted to have as an appearance. For example, I prefer that my work appear so literary that you can't get to it as a work of art. It's not that I'm interested in confounding people but I do this more as a problem for myself. My work looks as if it is thought out beforehand to such a degree that I don't do anything but put the color on. But these are appearances and they are not what I really feel about it. I don't think you can do a work of art and not really be involved in it.

GLASER: You are lessening the significance of appearances but appearances can hardly be dismissed as a reflection of your intentions.

LICHTENSTEIN: But part of the intention of Pop art is to mask its intentions with humor.

GLASER: Another thing; one may say he wants to make a work of art that is not self-conscious and that he doesn't want to give the appearance of a self-conscious work of art, but it doesn't matter whether you use an industrial method or whether you use a method that emphasizes the artist's hand. Whatever the case may be, we assume that if the artist has been working for any length of time he will acquire a certain lack of consciousness in the way he uses that particular method. As a result, consciousness, or the lack of it, becomes less of an issue.

OLDENBURG: I think we are talking of impersonality as style. It's true that every artist has a discipline of impersonality to enable him to become an artist in the first place, and these disciplines are traditional and well known – you know how to place yourself outside the work. But we are talking about making impersonality a style, which is what I think characterizes Pop art, as I understand it, in a pure sense.

I know that Roy does certain things to change his comic strips when he enlarges them, and yet it's a matter of the degree. It's something that the artist of the last generation, or for that matter of the past, would not have contemplated.

LICHTENSTEIN: I think that's true. I didn't invent the image and they wanted to invent the image.

OLDENBURG: That's right. And Andy is the same way with his Brillo boxes. There is a degree of removal from actual boxes and they become an object that is not really a box. In a sense they are an illusion of a box and that places them in the realm of art.

GLASER: Would you say that this particular ambiguity is the unique contribution of Pop art or is it the subject matter?

OLDENBURG: Subject matter is certainly a part of it. You never had commercial art apples, tomato cans or soup cans before. You may have had still life in general, but you never had still life that had been passed through the mass media. Here for the first time is an urban art which does not sentimentalize the urban image but uses it as it is found. That is something unusual. It may be one of the first times that art focuses on the objects that the human being has created or played with, rather than the human being. You have had city scenes in the past but never a focus on the objects the city displays.

GLASER: Is it fair to say that it is only to the subject matter that Pop art owes its distinction from other movements, and that there are relatively few new elements of plastic invention in your work?

LICHTENSTEIN: I don't know, because I don't think one can see things like plastic invention when one is involved.

OLDENBURG: If I didn't think that what I was doing had something to do with enlarging the boundaries of art I wouldn't go on doing it. I think, for example, the reason I have done a soft object is primarily to introduce a new way of pushing space around in a sculpture or painting. And the only reason I have taken up Happenings is because I wanted to experiment with total space or surrounding space. I don't believe that anyone has ever used space before in the way Kaprow and others have been using it in Happenings. There are many ways to interpret a Happening, but one way is to use it as an extension of painting space. I used to paint but I found it too limiting so I gave up the limitations that painting has. Now I go in the other direction and violate the whole idea of painting space.

But the intention behind this is more important. For example, you might ask what is the thing that has made me make cakes and pastries and all those other things. Then I would say that one reason has been to give a concrete statement to my fantasy. In other words, instead of painting it, to make it touchable, to translate the eye into the fingers. That has been the main motive in all my work. That's why I make things soft that are hard and why I treat perspective the way I do, such as with the bedroom set, making an object that is a concrete statement of visual perspective. But I am not terribly interested in whether a thing is an ice cream cone or a pie or anything else. What I am interested in is that the equivalent of my fantasy exists outside of me, and that I can, by imitating the subject, make a different kind of work from what has existed before.

GLASER: What you say is very illuminating. How does this fit in with your intentions, Roy?

LICHTENSTEIN: Well, I don't think I am doing the same thing Claes is doing. I don't feel that my space is anything but traditional, but then I view all space as traditional. I don't dwell on the differences in viewing space in art history. For example, I can see the obvious difference between Renaissance and Cubist painting but I don't think it matters. The illusion of three-dimensional space is not the basic issue in art. Although perspective as a scientific view of nature was the subject matter of Renaissance art, that perspective is still two-dimensional. And I think that what Cubism was about was that it does not make any difference, and they were restating it, making a formal statement about the nature of space, just as Cézanne had made another formal statement about the nature of space. So I would not want to be caught saying that I thought I was involved in some kind of spatial revolution. I am interested in putting a painting together in a traditional but not academic way. In other words, I am restating the idea of space because the form is different from the forms that preceded me.

I think, like Claes, I am interested in objectifying my fantasies and I am interested in the formal problem more than the subject matter. Once I have established what the sub-

ject matter is going to be I am not interested in it anymore, although I want it to come through with the immediate impact of the comics. Probably the formal content of Pop art differs from Cubism and Abstract Expressionism in that it doesn't symbolize what the subject matter is about. It doesn't symbolize its concern with form but rather leaves its subject matter raw.

GLASER: Claes, I want to find out a bit more about the nature of Dubuffet's influence on you which we mentioned before. Your early work seemed to explore the same areas of primitive art and expression of the subconscious that he is interested in.

OLDENBURG: Yes, that's true, but mainly Dubuffet is interesting because of his use of material. In fact, that is one way to view the history of art, in terms of material. For example, because my material is different from paint and canvas, or marble or bronze, it demands different images and it produces different results. To make my paint more concrete, to make it come out, I used plaster under it. When that didn't satisfy me I translated the plaster into vinyl which enabled me to push it around. The fact that I wanted to see something flying in the wind made me make a piece of clothing, or the fact that I wanted to make something flow made me make an ice cream cone.

GLASER: I think it may even be fair to say that Dubuffet's work is one of the main precedents for Pop art insofar as he was interested in banal and discredited images. And as you say, he worked with common or strange materials such as dirt and tar, or butterfly wings, to create his new imagery.

Now, I would like to pick up something else we were talking about before, namely the possible implications of style in regard to Roy's work. I have had the feeling in looking at some of your paintings that they have more affinities with certain current styles of abstract art than with other kinds of Pop art. Your clearer, direct image, with its hard lines and its strong impact relate you to artists such as Al Held, Kenneth Noland or Jack Youngerman. Because of these connections, discounting subject matter, I wondered whether you might be involved in some of the same stylistic explorations they are.

LICHTENSTEIN: Yes, I think my work is different from theirs and no doubt you think so too, but I also think there is a similarity. I am interested in many of these things, such as showing a similarity between cartooning and certain artists. For example, when I do things like explosions they are really kinds of abstractions. I did a composition book in which the background was a bit like Pollock, or Youngerman. Then I also have done the Picasso and Mondrians, which were obviously direct things, but they are quite different in their meaning than the other less obviously related analogies to abstract painting. I like to show analogies in this way in painting and I think of them as abstract painting when I do it. Perhaps that is where the deeper similarity lies, in that once I am involved with the painting I think of it as an abstraction. Half the time they are upside down, anyway, when I work.

WARHOL: Do you do like what Claes does with vinyl ketchup and french-fried potatoes?

LICHTENSTEIN: Yes, it's a part of what you do, to make something that reminds you of something else.

OLDENBURG: This is something I wonder about. I know I make parodies on artists, as with the vinyl ketchup forms which have a lot of resemblance to Arp, but why? I wonder why we want to level these things. Is it part of the humbling process? Maybe it is because I have always been bothered by distinctions – that this is good and this is bad and this is better, and so on. I am especially bothered by the distinction between commercial and fine art, or between fine painting and accidental effects. I think we have made a deliberate attempt to explore this area, along with its comical overtones. But still the motives are not too clear to me as to why I do this.

LICHTENSTEIN: Nor with me either, nor even why I say I do it.

OLDENBURG: I don't want to use this idea as an instrument of ambition or facetiousness or anything like that. I want it to become work. But I am never quite sure why I am doing it.

GLASER: There is a question in my mind as to whether much of the subject matter of Pop art is actually satirical. I have felt so many times that the subject matter and the technique are, indeed, an endorsement of the sources of Pop imagery. It is certainly true that there are some satirical elements in this work, but apparently that doesn't concern you too much. I wonder then, whether you are not saying that you really like this banal imagery.

LICHTENSTEIN: I do like aspects of it.

OLDENBURG: If it was just a satirical thing there wouldn't be any problem. Then we would know why we were doing these things. But making a parody is not the same thing as a satire. Parody in the classical sense is simply a kind of imitation, something like a paraphrase. It is not necessarily making fun of anything, rather it puts the imitated work into a new context. So if I see an Arp and I put that Arp into the form of some ketchup, does that reduce the Arp or does it enlarge the ketchup, or does it make everything equal? I am talking about the form and not about your opinion of the form. The eye reveals the truth that the ketchup looks like an Arp. That's the form the eye sees. You do not have to reach any conclusions about which is better. It is just a matter of form and material.

LICHTENSTEIN: In the parody there is the implication of the perverse and I feel this in my own work even though I don't mean it to be that, because I don't dislike the work that I am parodying. The things that I have apparently parodied I actually admire and I really don't know what the implication of that is.

GLASER: There is an ambiguity here too, part endorsement, part satire.

OLDENBURG: Anyhow there is something very beautiful in putting art back into the present world and breaking down the barriers that have been erected for the appreciation of art. Nevertheless, I would like to say that I have a very high idea of art. I am still romantic about that. This process of humbling it is a testing of the definition of art. You reduce everything to the same level and then see what you get.

LICHTENSTEIN: I am very interested in a thing that seems to happen in the visual arts more than anywhere else. There is the assumption by some people that similar things are identical. If you were to do the same thing in music and play something that sounded like a commercial, it would be very hard to vary it from the commercial or not have it immediately obvious that you are "arting" it somehow, or making it esthetic. Your only alternative would be to play this thing – whatever it is – the simple tune, as is. If you did anything to it, it would immediately be apparent, and this is not true in the visual arts. Maybe this is one reason why this sort of thing has not been done in music. Although it has had parallels in which commercial material is used it is always obviously transformed.

GLASER: You are saying that one of the purposes of the subject matter of Pop art is to confuse the spectator as to whether the advertisement, comic strip or movie magazine photograph is really what it seems to be.

LICHTENSTEIN: This is true. In my own work there is a question about how much has been transformed. You will discover the subjects really are if you study them, but there is always the assumption that they are the same, only bigger.

GLASER: Well, even if there is a transformation, it is slight, and this has given rise to the objection that Pop art has encroached on and plundered the private pleasure of discovering interest in what are ordinarily mistaken as banal subjects. For example, if one privately enjoyed aspects of the comics, today one finds this pleasure made public in the galleries and museums.

LICHTENSTEIN: I am crying.

WARHOL: Comic strips now give credit to the artist. They say "art by." Comic books didn't give credit in the past.

OLDENBURG: It would be interesting to study the effect of this on the average commercial artist who still remains a problem child. He is generally trying to figure out who he is and what he is doing. Maybe this will make them do more crazy things. I don't know.

WARHOL: Commercial artists are richer.

GLASER: That is a difference too. But I am more interested in the problems that come up in regard to your interest in popular imagery. For example, with you Claes, if at one time you saw in this material the possibility of exploring some kind of fantastic world, what you actually have done is to take the world of popular imagery and use it to a point where it is now becoming commonplace in museums and seen and talked about by cultured people, by critics and collectors. Your imagery no longer has any clear relationship to the public that the original popular image had, and the implication of this is that you may, in fact, have abandoned a very vital connection with a very large, but visually naive public.

OLDENBURG: We did not establish that my art had any clear relation to the public in the first place. I think the public has taken it for its own uses just as it takes everything you do for its own uses. You can't legislate how the public is going to take your art.

GLASER: You did say that you were still interested in the idea of high art?

OLDENBURG: I am interested in distinguishing the artist as a creator from certain other people. If I make an image that looks very much like a commercial image I only do it to emphasize my art and the arbitrary act of the artist who can bring it into relief somehow. The original image is no longer functional. None of my things have ever been functional. You can't eat my food. You can't put on my clothes. You can't sit in my chairs.

GLASER: Traditional art is like that too. You can't eat a still life.

OLDENBURG: But they haven't been so physical, nor so close to you so that they looked as if you could eat them, or put them on or sit in them.

WARHOL: But with your bedroom set you can sleep in it.

OLDENBURG: You can sleep in it on my terms. But to get back to the idea of high art, I believe there is such a profession as being an artist and there are rules for this, but it is very hard to arrive at these rules.

GLASER: What is your feeling about the audience that reacts to Pop art? Did you ever think that with such imagery you might be able to reach a larger audience or do you want the same traditional art audience?

LICHTENSTEIN: When you are painting you don't think of the audience but I might have an idea of how an audience would see these paintings. However, I don't think that Pop art is a way of reaching larger groups of people.

GLASER: Some commentators, having noticed the greater popularity and reception of Pop art, have said that this is so because it is representational rather than abstract.

LICHTENSTEIN: I don't think Pop has found any greater acceptance than the work of the generation preceding.

OLDENBURG: There is a sad, ironic element here which almost makes me unhappy. I have done a lot of touring in this country and abroad for Pop shows and Happenings, deliberately, to learn how people feel about this outside of New York. There is a disillusionment that follows. When you come to a town they think you are going to be something like the Ringling Brothers. They expect you to bring coke bottles and eggs and that they are going to eat it and like it, and so on. But then, when they find that you are using different things you begin to grate on them.

WARHOL: Yes, but the wrong people come, I think.

OLDENBURG: But I hate to disillusion anybody, and you find people becoming disillusioned because it turns out to be just the same old thing – Art.

GLASER: Andy, what do you mean by the wrong people coming?

WARHOL: The young people who know about it will be the people who are more intelligent and know about art. But the people who don't know about art would like it better because it is what they know. They just don't think about it. It looks like something they know and see every day.

OLDENBURG: I think it would be great if you had an art that could appeal to everybody.

WARHOL: But the people who really like art don't like the art now, while the people who don't know about art like what we are doing.

GLASER: Then you do believe that the public is more receptive to Pop art than to Abstract Expressionism?

WARHOL: Yes. I think everybody who likes abstract art doesn't like this art and they are all the intelligent and marvelous people. If the Pop artists like abstract art it is because they know about art.

GLASER: The criticism of Pop art has been that it reflects a growing tendency toward neo-conservatism that is apparent in certain areas of American life. On the most superficial level, reference is made to its turning away from abstraction and back to the figure. But on a more serious level, objections are raised about what seems to be the negation of humane qualities which the more liberal segments of our society, rightly or wrongly claim as their special preserve. Superficially, one can point to the fact that you use industrial processes in making your work and deny the presence of the artist's hand. There is also Andy's statement, "I wish I were a machine."

LICHTENSTEIN: This is apolitical. For that matter, how could you hook up abstraction with liberal thinking? Probably most artists may be more liberal politically. But Pop art doesn't deal with politics, although you may interpret some of Andy's paintings, such as those with the police dogs or the electric chairs, as liberal statements.

OLDENBURG: Andy, I would like to know, when you do a painting with a subject matter such as this, how do you feel about it? In the act of setting it up the way you do, doesn't that negate the subject matter? Aren't you after the idea of the object speaking for itself? Do you feel that when you are repeating it the way you do, that you are eliminating yourself as the person extracting a statement from it? When I see you repeat a race riot I am not so sure you have done a race riot. I don't see it as a political statement but rather as an expression of indifference to your subject.

WARHOL: It is indifference.

GLASER: Isn't it significant that you chose that particular photograph rather than a thousand others?

WARHOL: It just caught my eye.

OLDENBURG: You didn't deliberately choose it because it was a "hot" photograph?

WARHOL: No.

OLDENBURG: The choice of these "hot" subjects and the way they are used actually brings the cold attitude more into relief.

GLASER: Perhaps in dealing with feelings in such a way one may be exploring new areas of experience. In that case it would hardly be fair to characterize Pop art as neo-conservative. It might be more worthwhile to consider its liberating quality in that what is being done is completely new.

Special Report: THE STORY OF POP

Peter Benchley

It's a fad, it's a trend, it's a way of life. It's pop. It's a $5,000 Roy Lichtenstein painting of an underwater kiss hanging in a businessman's living room. It's a $1 poster of Mandrake the Magician yelling, "Hang on, Lothar! I'm coming!" taped on a college-dorm wall. It's 30 million viewers dialing "Batman" on ABC every week. It's "Superman" zooming around on the Broadway stage attached to a wire, while the sophisticates in their $12 seats are carried back to childhood. It's a Pow! Bam! commercial for Life Savers on TV and a huge comic-strip billboard for No-Cal glaring down on Times Square. It's lion-maned Baby Jane Holzer in a short-skirted wedding dress. It's the no-bra bra and the no-back dress. It's Andy Warhol's new nightclub, The Plastic Inevitable, where three movies flicker simultaneously and a man lifts barbells to a rock beat.

So what's pop? Harvard's David Riesman ("The Lonely Crowd") declares himself incompetent to define it. Lawrence Alloway, 39, curator of New York's Guggenheim Museum and the man who coined the term "pop," provides the basic definition: "An affectionate way of referring to mass culture, the whole man-made environment. I wanted to remove the snobbishness in art," he explains, "to stress that even an ad could be art – entertainment art – because it was real, it was there." And Britain's Jonathan Miller ("Beyond the Fringe") adds another dimension: "A great way of being new," he says, "is to return to the old."

In short, pop is what's happening. As Newsweek's *Peter Benchley writes about it here, it's anything that is imaginative, nonserious, rebellious, new, or nostalgic; anything, basically, fun.*

Pop started in the big cities – particularly London and New York – and now, just as it is infiltrating the hinterlands, urban esthetes are pronouncing it dead. But never has it been more alive. Changing, yes, but not even moribund. In five years, pop has grown like The Blob, from a label for what appeared to be a minor phase in art history to a mass psyche. It has captivated the Great Society, thrived on its prosperity and exploited its restlessness.

Naturally enough, pop has turned up most insistently in those places where what's new is what sells – the world of art, television, fashion and advertising.

Pop art, for example, turns both creator and collector alike into members of a new pop society. When Andy Warhol sits Ethel Scull (the wife of a New York taxicab fleet owner) in front of an arcade photo machine and snaps away, the result may be art but it also puts Mrs. Scull on the society page along with Mrs. Paley and Mrs. Guest. On TV, "Batman" is a big put-on, one running gag. But next year, "The Green Hornet" (with his faithful chauffeur, Cato) will gobble up another half hour of prime time. After that, perhaps "Wonder Woman." In advertising, the straight hard-sell is being temporarily edged aside by FLASH massages designed to grab. "Oil Man" pushes the advantages of oil heat over gas for the oil companies. "Captain Carbide" pitches Union Carbide. "Superman" sells insurance ("yell help and see how fast your mild-mannered Continental Insurance agent turns into Superman . . . "). In fashion, haute couture has been replaced by "fun" clothes: airline

Newsweek, April 25, 1966: 56–61

stewardesses wear plastic helmets, and Rudi Gernreich's bright new vinyl fashions show up on a full page in that bastion of respectability – Montgomery Ward's new catalogue.

Yet pop is not as new as it seems. Pop art, as it became known in the early '60s, was a descendant of Dadaism during and just after World War I. Dadaism was a rebellion, an attempt to jolt by the use of commonplace objects. Marcel Duchamp found a urinal, signed it R. Mutt, and displayed it. Pop is the further commercialization of Dada. As one pop artist says, "We paint Coke bottles instead of wine bottles."

When pop hit the American scene, the staid art establishment took it as a kick in the head. Lichtenstein was variously called the best new artist of the generation, and, by a *New York Times* art critic, "one of the worst artists in America." Pop art is natural in a prosperous society, argues critic Hilton Kramer: "People want all the prerogatives of education without going to the trouble of being educated." And Jonathan Miller thinks pop is "imposed from an elite. It is not spontaneous expression. It is fabricated, invented, manufactured."

To artists, at least, pop is a serious business. "The expedience of commercial art has given birth to a kind of symbolism," says Lichtenstein, "and we are unifying the symbols. The products and advertising in popular culture show the impingement of this expedience. Why do you think a hill or a tree is more beautiful than a gas pump? It's because you're conditioned to think that way. I am calling attention to the abstract quality of banal images."

But the artists occasionally let banality carry the day. Andy Warhol painted huge Campbell's Soup cans and other *objets,* and now paints his blond hair silver. "Intellectuals still hate pop," he says. "Average people like it. It's easier to understand." Warhol's current show consists of wallpaper decorated with cow heads and silver-painted pillows hanging from the ceilings. To Ivan Karp, director of the Castelli Gallery in New York, where Warhol exhibits, the wallpaper – at $75 a cow – "is an example of repetition in its most vicious form." And the pillows "create a room environment."

The mellifluous Karp has been called "the Sol Hurok of pop art." He is an avid devotee of the form because the artists "transform banal objects. They see beauty in all things." As the chief salesman of the pop-art movement, he assembles properties and promotes them. "It's a very good market," he says. "In 1961, a Warhol or a Lichtenstein ranged from $150 to $500. Now they sell in the $500 to $8,000 class."

Just as pop artists use the crassness of commercialism in their work, so they feel they, too, can become commercial. Warhol, who used to be a commercial artist (illustrating shoes), took an ad in New York's *Village Voice* offering to endorse "clothing AC-DC . . . helium . . . whips . . . anything . . . MONEY!"

"Instead of being a source of disgrace," says critic Kramer, "to be commercial these days is to be fashionable." Warhol has fan clubs, signs autographs, and occasionally joins the jet set that orbits around Jacqueline Kennedy.

The anti-establishment, anti-tradition, anti-formal attitude of pop artists put a dent in the stability of society, but the major crack was made by another pop phenomenon: comic books. Not only is it permissible for adults to read pulp comics, it is a sociological necessity.

"Comics are a tactile experience," says the University of Toronto's Marshall McLuhan, who has become a bit of a pop oracle himself. "The whole culture of North America has gone tactile, iconic. Comics are a highly contoured experience. The words in the balloons aren't just words, they're icons. Comics come at you all at once – wham!"

In Los Angeles, 27-year-old Burt Blum saw a way to turn wham! into cash, and five years ago he began buying old comic books. "No one else in the world has 50,000 comics to sell," he claims. "One collection I bought three years ago for $100 has already netted me $25,000." Who buys them? Everyone. Aerospace engineers and scientists, for example, snap up "Buck Rogers" and "Flash Gordon." His most expensive item is Detective Comics No. 27 (1939), which introduced Batman and Robin.

"Batman" has made pop big business. ABC bought the property from National Periodical Publications last year, and propelled by 58-year-old William Dozier, the twice-weekly TV serial has become the hottest property in Hollywood, with both weekly episodes consistently in the Nielsen top twenty "Everything is deadly serious," Dozier says, explaining its appeal. "One cliché in a TV show is not funny, but ten in one show is funny. Pop culture is wildness, something freewheeling." Still, he says, "I do not want to devote the rest of my life to being the paterfamilias of pop art."

But Dozier's work is regarded so highly that he may not have a choice. The show has already been lauded by the National Safety Council because Batman always reminds Robin to fasten his safety belt. And later this month, Dozier will appear at the University of Pennsylvania's Annenberg School of Communications on a panel with McLuhan, William Jovanovich, president of Harcourt, Brace & World, and anthropologist Dell Hymes to discuss the topic "From Gutenberg to Batman."

Adam West, the straight-faced strong man who plays the big bat, sounds as if he ought to be a panelist, too. " 'Batman' will be considered pop culture in the time continuum of our society," he intones. "Talking in art terms, I guess you could say that I am painting a new fresco. If you twist my arm, I'll say that, I'm the pops of film pop culture." Even if no one twists, he is already considered the top pop. Batman was a write-in candidate for president of the student body at Ohio State University, and the Harvard class of '41 wants to adopt him as the theme for its 25th reunion. Soon, "Batman" will be seen in England (at 6 p.m. and at 11), Japan (as "Battoman") and Australia.

With 30 million people a week being inundated by pop, businessmen quickly jumped on the Batwagon. "This is the biggest thing that's ever happened in licensing," declares Jay Emmett, president of the Licensing Corp. of America, which handles Batman merchandising. So far, 1,000 Batman items have been licensed, including mask-and-cape set (400,000 dozen have been sold at $1 each), bubble bath, jewelry, cutout kits, Batarangs, model Batmobiles, sport jackets ($38), tricycles ($27), bookbinders, pencils, pens, slippers and quilts. More than 1 million Batman posters have been sold, and some buyers have hung them in French provincial living rooms as true pop art. "This fall we'll have a bat-to-school promotion the likes of which you've never seen," says Emmett. Bat-maniacs can look forward to bat-tuxedos for over $50 and a Batman electric guitar for $125. Emmett and Jacob S. Liebowitz, president of National Periodicals, have turned down licenses for Bat guns, cigarettes and wine. Emmett estimates that Americans will eventually spend a total of $600 million on Batfads.

Comics have suddenly bounced back in several forms. The musical "It's a Bird . . . It's a Plane . . . It's Superman" is currently grossing $67,000 a week on Broadway and Captain Marvel is back on movie screens in serials. And "The Great Society Comic Book" – featuring Super LBJ, Captain Marvelous (McNamara), Wonderbird, Gaullefinger, Bobman and Teddy – claims sales of 100,000 copies in less than one week. In the fall, Marvel Comics' "Captain America," "The Hulk," "Thor," "Iron Man" and "Sub-Mariner" will be animated cartoons on local TV stations.

The way to move pop products in a pop society is, naturally, with pop ads, and in the

past year TV and the print media have been saturated with the "Zonk! Pow! Blam!" approach to selling. A leading pop adman is Fred Mogubgub, 38, who claims he took his name from the gub-gub sounds a Lebanese ancestor made while drowning. Among his clients are Ford, Coca-Cola and Life Savers; Mogubgub says he chooses his subject matter from "American objects which stick out from the clichés you get drilled into you in school."

Mogubgub's style is quick, staccato, jump-cut – an assemblage of cartoons and photographs that flash across the screen fast enough to be almost subliminal advertising. He was given the slogan "Have you ever heard anyone say 'no' to a Life Saver?" by the Beech-Nut people and made a pop commercial. A follow-up survey reported that the public recalled it more often than straight ads. "You have to grab them," says an ad-agency vice president. "That pop technique. We have a young audience with whom we have to establish a rapport."

Nowhere is youth recognized as the real aristocracy of pop as much as in fashion. Gwen Randolph, fashion director of *Harper's Bazaar*, believes that 10 to 15 per cent of all current fashion is pop. And the youth market, ages 18 to 25, buys almost all of it – the short skirts, textured stockings, vinyl bathing suits, hats and coats. Different designers claim credit for starting the pop trend, and its origin probably comes from a mixture of four or five styles. British designer Mary Quant ("Little Orphan Annie" dresses) was one of the first to produce simple, way-out designs. Yves St. Laurent likes to think of himself as the creator of the new "nude" look. Courrèges's short skirts and his white boots added to the new look while California's Rudi Gernreich's topless bathing suit in 1964 helped the fad take off.

Gernreich, inventor of the "no-bra bra," has pronounced an obituary of haute couture. "For centuries, haute couture was based on the tastes of the aristocracy," he says. "Now all styles stem from the people, particularly the young." "Pop fashion is a younger way of thinking," says designer John Kloss, 28, whose geometric patterns are sewn together like jigsaw puzzles. But the pronouncements conceal snobbery about pop, a sense of superiority.

But how outrageous can pop get? Among the current season's items are: aluminum wigs, vinyl bangs, vinyl knee decorations, "neon" dresses, huge geometric earrings, and a cotton fabric being developed by Galey and Lord which will be wired for electricity. Presumably a girl can attach light bulbs and turn any part of herself on: a semaphore of sex.

Fashions change so fast that major manufacturers have set up divisions for pop styles. Last fall, Paul Young, 36, a vice president of Puritan Fashions, opened a boutique called Paraphernalia in New York to handle the pop end of the business. By the end of 1967 he expects to gross $50 million from some 30 outlets in the U.S. and Europe. "Pop is happiness," he says. "It's todayness; the feeling we can't afford to wait years for appreciation."

For the first time since the reign of Edward VII, men, too, seem anxious to become dandies in an industrial society. "Men's fashion is becoming more ornate because, as women gather strength, men become rivals in trying to attract them," says Gernreich. On the other hand, it seems that men are all too often trying to look like women. On "The Tonight Show" last week, Britain's John Stephen showed off his "Carnaby Street Look." The first model was a male dressed in a red vinyl vest and bell-bottom hipsters. The audience hooted. Later, the same clothes were brought out, and the audience hooted again. They didn't realize a girl was wearing them.

Is the pop movement, then, neutralizing the genders? While the homosexual effect on fashion is indisputable, it is harder to pin the label on "Batman." It has been tried, how-

ever. In his widely quoted "Seduction of the Innocent," psychiatrist Fredric Wertham concluded: "Only someone ignorant of the fundamentals of psychiatry and of the psychopathology of sex can fail to realize a subtle atmosphere of homoerotism which pervades the adventures of the mature Batman and his young friend Robin . . . It is like a wish dream of two homosexuals living together." Wish fulfillment aside, most critics agree that homosexuality does permeate mass culture via the twilight zone of pop known as camp.

In "Notes on Camp," critic Susan Sontag calls it "the triumph of the epicene style . . . love of the unnatural: of artifice and exaggeration." And in New York's *Village Voice*, a recent article titled "It's a Queer Hand Stoking the Campfire" credits the homosexuals with "guiding the progress of pop art . . . making 'underground' movies, selling cast-iron lamps shaped like roses to schoolteachers, and declaring Gene Kelly–Debbie Reynolds movies . . . breathlessly amusing entertainment."

Another sub-species of pop is the love of trivia. In recent years, knowledge of meaningless trivia ("Name all of Our Gang," "What was the name of Sky King's plane?") provided a smooth tunnel back to the pre-bomb world of the 30s. Now, with the revival of old comic books and old movies, trivia has become a national pastime. Last month, WNEW-TV in New York syndicated an hour-long "National Trivia Test" as a take-off on all the other TV tests; a book of trivial questions was published early this year, and trivia contests have been held on radio stations and college campuses all around the country.

Indeed, classifying culture into its various sub-groups has become a kind of trivia game. Old movies, for example, are not necessarily either trivia or camp. Bogart movies are pure pop nostalgia, and Bogart posters have become pop art in their own right. Bogart is "return-trip" pop: he was once so popular with the middle class that he couldn't be pop. Now he is a cult, a pop cult. The Marx Brothers are "classic" pop because they have *always* been popular with *everybody.* Finally, there is *kitsch,* the conscious appeal to bourgeois sensibility. "Splendor in the Grass" was *kitsch.* So was "Marjorie Morningstar."

From the Bogart hero – visceral, ruthless, virile – evolved the current form of the pop movie, the James Bond superhero. "It is the idea of the stylized person who is invincible and inviolate," says Ivan Karp. "He has no faults, no introspection, no self-realization." He is completely in the pop mainstream of anti-tradition, anti-authority. He lives for now and laughs at himself.

What's happening now is happenings – where music, dancing, movies, everything happens at once and assaults all the senses. They are almost pop, perhaps "min-pop," a term Lawrence Alloway uses for pop appreciated by a minority. Warhol was largely responsible for turning Baby Jane Holzer – in real life, the wealthy wife of wealthy four-square broker Leonard Holzer – into the "pop girl of the year" in 1964. The girl in 1965 was Edie Sedgwick, 22, a tiny blonde with mocha eyes from a very proper California family, who got involved with Warhol because of films and found herself a style-setter. Both are in danger of becoming "out." Baby Jane has been seen singing on NBC's "Hullabaloo," and Edie recently signed a contract to do a film for Bob Dylan's manager. This year's girl? Some say Nico, the 23-year-old German-born model who sings at Warhol's Plastic Inevitable. Warhol himself says it's either Ingrid Superstar (he won't say her last name) or a girl named Mary who, he says, is changing her name to Pfft.

With the Plastic Inevitable, Warhol may make happenings full-scale pop. With The Velvet Underground playing stock rock, plus the fact that Warhol will take the show to Los Angeles, Cincinnati, Minneapolis and London, it seems to be becoming *too* popular. To Alloway, after all, the Mona Lisa is pop "in terms of fame and distribution."

questioned. Four years ago Marshall McLuhan asked that question of himself and answered affirmatively indeed.[11] For him, history is a kind of vast spectator sport in which technological revolutions have already transformed the human psyche over and over again and in which tradition is invariably faulted and novelty always wins the game. Mass culture is by no means aberrant; on the contrary, its media and its methods are benign whereas easel painting and serious poetry are deviant because they have become anachronistic. McLuhan's followers would argue that the success of Pop is just another evidence of the correctness of their conclusions and the appropriateness of their optimism.

On the other hand – even should McLuhan be right – we still must recognize that individual works have qualities surpassing any time or any movement. For instance, the single known work of Praxiteles holds an interest for us that is more than antiquarian. And the paintings of Poussin or Ingres, Picasso, Ernst and Klee far exceed the ambits of the movements they used to signify. The fact is that clumsy Classicist art and mediocre Cubist works are now exempt from serious criticism. So are the monuments to banality produced by obscure Surrealists and by the less adept German Expressionists. In art as in life, one tends to recollect and relish the good while repressing the bad and neglecting the indifferent. Surely, a few artists now committed to Pop will be commemorated as individuals when the movement itself has all gone by. For this reason, if for no other, the question we should ask becomes not what best represents the people but, instead, what represents their best.

NOTES

1. Tom Wesselmann, quoted by G. R. Swenson in "What is Pop Art?," *Art News* (February 1964), p. 41.
2. Malcolm Cowley, *Exile's Return*, 3rd ed. (New York, 1951), pp. 156-157.
3. Correlli Barnett, *The Swordbearers: Supreme Command in the First World War* (New York, 1964) p.5.
4. Eric Partridge, *Dictionary of the Underworld* (London, 1949), p. 100; and Eric Partridge, *A Dictionary of Slang and Unconventional English* (New York, 1956), pp. 122-123.
5. Susan Sontag, "Notes on Camp," *Partisan Review*, XXXI (Fall 1964), pp. 52-53.
6. *Ibid.*, pp. 51-52.
7. See Marion A. Taylor, "Edward Albee and August Strindberg: Some Parallels Between *The Dance of Death* and *Who's Afraid of Virginia Woolf?*," *Papers in English Language and Literature*, I (Winter 1965), pp. 59-71.
8. James Rosenquist, quoted by G. R. Swenson *op. cit.*, p. 41.
9. Larry Bell in a statement made after seeing an Andy Warhol exhibition, September 1953, *Artforum*, III (February 1965), p. 28.
10. Hannah Arendt, *The Origins of Totalitarianism* (New York, 1958), p. 335.
11. See Marshall McLuhan, *The Gutenberg Galaxy* (London, 1962), *passim*.

LONDON COURT FINES A GALLERY FOR "INDECENT" POP-ART DISPLAY

Dana Adams Schmidt

LONDON, Nov. 28 – A London magistrate ruled today that pictures by Jim Dine, the American pop artist, while "individually not indecent, became an indecent exhibition" by reason of their arrangement.

John Aubrey-Fletcher, the Marlborough Street magistrate, fined Robert Hugh Fraser of the Fraser Gallery in Duke Street, £20 with 50 guineas costs (totaling $203) for "willfully exposing to public view an indecent exhibition" under the 1838 Vagrancy Act.

The 21 pictures, which had been seized by Scotland Yard detectives, were arranged, as seen from the window, with male sex organs on the left, female on the right, while a picture on a wall at the back of the gallery represented an act of copulation.

The magistrate's decision turned on this juxtaposition and on the question of whether the pictures could be seen through a large window from the street.

Two detective-sergeants, who made the seizure after the Director of Prosecutions had received a complaint, testified that they could see the pictures clearly, including a four-letter word with an arrow directing attention to one of the pictures.

Peter Weitzman, counsel for the defense, pleaded not guilty and told the court that Mr. Dine was "among the most internationally famous of the younger American artists," and a pioneer in the pop-art movement. Pictures by Mr. Dine hung in the Tate Gallery and the Victoria and Albert Museum in London, he said, and one of the pictures seized had been chosen for showing at a museum in Amsterdam.

After his conviction, Mr. Fraser said he was "very ashamed this should have happened in this country, which I thought had a reputation for liberality." He said he thought it "disgraceful that works of art should be put on the level of pornography that might be seen in a dirty-book shop."

Mr. Fraser said he would not try to show the pictures again, even in a different arrangement. He said he feared that "they would not be judged on their merits, but on the basis of what the prosecution said."

The New York Times, November 29, 1966: 38

PRESENT-DAY STYLES AND READY-MADE CRITICISM

Peter Plagens

> *Black was never a color of Death or Terror for me. I think of it as warm — and gen-*
> *erative. But color is what you choose to make it.*
>
> Clyfford Still

The critical establishment has largely overlooked the formal contribution of Pop; in the
rush to assure that history does not again make a fool of journalism, the impact-innova-
tions (imagery, literary content and the role of the artist) have been proclaimed, and the
underlayers of color, space, structure, scale and surface have been left unattended. *Art
News,* scrupulously fair to Pop news in spite of its editorial bias toward Abstract Expres-
sionism, said in an editorial, *Pop and Public,* that ". . . it [Pop] has nothing to do with
pictorial details or scale (most Pop Art has no scale)."[1] The criticism of Rauschenberg
(who is not, in the strict sense, a Pop artist) and Lichtenstein (who is) stands as examples
for the whole: Rauschenberg is usually seen as a better/worse reincarnation of Dada, his
formal inventions as better/worse means to story-value ends, and Lichtenstein is viewed
through the *philosophical* "why" of his comic-book girls (rather than the *esthetic* "why" of
the hard line, severe shape and metronomic dot).

The Impressionists were hauled in on false charges (decadence); Royal Cortissez saw
an immigration threat in the Armory Show ("Ellis Island art"); the Abstract Expression-
ists were held responsible for any surface with a couple of swatches of Shiva on it being a
painting. Pop, however, was almost instantly accepted, but the criteria – Today's Images
for Today's Times – were just as irrelevant. "Vanguard Audience" notwithstanding, we've
repeated the error of seeing the issue wrongly, rather than misconcluding. Pop contained
new (perhaps not obvious) formal possibilities for painting.

The question of Pop's formalism involves the deepest elements of style and not merely
quickness of fashion or revamping of literature, both of which are periodically desirable
and inevitable. "It is fashion alone that can provide the kindling of actuality needed to
start a fire."[2] The concept of style in painting has changed since the first of the mod-
ernisms; it has, in fact, relocated itself further and further from the specific work. *Le
Grand Jatte* of Seurat is one of the last of the "masterpiece" syndrome – a great/large
work defining the style of a particular painter. (A few pictures, e.g., van der Weyden's *De-
scent from the Cross,* have been able to define whole geographical or chronological
styles.) It is a self-explanatory painting, a culmination of working methods, and the style
is in the physical surface of the painting. Certain early Analytical Cubist works of Picasso
and Braque de-emphasized the totality of the single picture (paintings pointed or devel-
oped toward further paintings); style took a step away from the single picture and nested
in the transitions *between* pictures. In Action Painting style logistically receded to the *act*
of picture-making, into Rosenberg's "arena." The great art-historical phenomenon of
Pop is that it has managed, against a theoretical *cul de sac,* to nudge style back another
notch – to social and esthetic attitudes existing in full form within the artist *before* the
act of picture-making. Warhol's style resides in his *thinking* everybody be like everybody
else, that everybody should be a machine. The premise extends to the formalist edge of

Artforum, December 1966: 36–39

Pop (certain hard-edge, minimal and hybrid works being Imageless Pop; the whole a Greater Pop): Larry Bell's foggy glass boxes are operatives of *a priori* esthetic concepts and contain, in many ways, the more celebrated qualities of party-line Pop – blurring the barriers between art and commerce and industry, austere means, and the absence of "handwriting." A tremendous categorical difference exists between a simplistic non-figurative work painted more or less under the stylistic auspices of Abstract Expressionism (Kenneth Noland, for instance) and, say, Billy Al Bengston. But there is an area where the two form a continuity, a formalist bridge where the real matter of painting seems capable of an alluvial flow of invention, color and form; this, the crux of the matter, will be returned to after we have examined further changes Pop has made in style.

Greater Pop presided at the burial of "handwriting," that specific, detailed (and Romantic) physical trace of the artist's *modus operandi:* it's sometimes called a brushstroke. What has replaced "handwriting" as surface style, in a milieu where products are more separable than ever, is a hypersensitive brand name, "originality." The content of Salvatore Scarpitta's racing cars is unique to the work; anyone else doing straight racing cars is a fool, for the claim has been staked and the racing car is the *de facto* style of Scarpitta. Style and content are at times united within a media extension (Lucas Samaras's room comes to mind), or the whole question is voided by our love affair with the methods, materials, organization and argot of Strangelovian technology: Larry Bell's boxes are not particularly special in content (being formalist) and represent more of a technical *choice;* once the materials are gathered, there is only one way to go about it.

A channel exists, however, between the tenets of Abstract Expressionism and the latent formalist aspects of Pop; this connection has been seen, in part, by a few. Henry Geldzhaler pointed out that Lichtenstein, whose paintings have always seemed directed toward different qualities of line, form and color as formal alternatives to Abstract Expressionism, relates closely to Rothko and Newman in being a painter of big, *single* images.[3] And there is this statement from J. Barry Lord:

> The space which Clyfford Still explored, the space in which McKay's and Rothko's colour-forms found their uneasy position, the reverberating space which Morris Louis colour-streams, the space of paintings without edges in the dimensional world is the space in which our empty, perverted figures must locate.[4]

The formalist differences, then, between Abstract Expressionism and Pop are the differences of adjacent, rather than opposed, qualities; one group supplements, rather than negates, the other.

Emblematic color, a color of equal intensities, abutting planes and total frontality has superseded the depth-charged, plastically intuitive pigment of Hofmann, Guston and de Kooning. Emblematic color, a dissonant abstinence from the lettuce hung out on Cubist trellises, seems to seep chemically through the pores of the canvas, to form a narrow, almost recessionless image. It is enlightening to review Warhol's silk-screen paintings in terms of – say what you will – Mondrian. Hofmann (whose composer was Beethoven – and the epic symphonies at that) stressed "simultaneous contrast," a complex intuitive esthetic of checks and balances, probes and reactions, in short a visual symphony, whose harmonics were based on musical relationships. Warhol (whose music is supplied by the Velvet Underground) made pictures whose brittle, sour *Police Gazette* color echoed an electronic dissonance. Although the comparison may appear semantic, the common denominator is color-space and plasticity.

Where the struggle of Abstract Expressionism involved the paradoxical goal of making "real" depth on an emphatically flat picture plane at the expense of the remaining *trompe-l'oeil,* Pop reintroduced illusionistic imagery to make "real" flatness on a plane with no integrity. While Abstract Expressionism in general managed a sense of overlapping and undercutting, the methods of achieving pictorial space varied: Pollock through action, Brooks through paint skins, Guston through brushmarks, de Kooning through fierce manipulation of planes, and Hofmann through chromatic "push and pull." Pop – deliberately or not – pushed plasticity further by destroying some of this hard-won empire. The picture plane, a flickering, active element since Cézanne, was suffocated with air-tight color. Overlapping – actual and seeming – was modified to an abrupt colliding of planes. An eclectic lithographic offset image formed a need for unnerving color constancy; mechanical greens, yellows, reds, magentas and dark blues projected in similar brightness emitted a frontality beyond that of Abstract Expressionism; a wholly advancing picture plane denied the depth-through-range of previous painting. The application of paint itself went deadpan. Color became less an immediate means (chosen and deposited in an act rich with chance, subtlety and Romanticism) and more a set of conditions (a dispassionate listing of the artist's attitudes toward pictorial revolution and the resiliency of the viewer). But hasn't painting – something of an obsolete term in itself – expanded into multiplanes, source light, sound, sculpture and theater? Perhaps, but the thing will always depend on the puncture and reassembling of the primary picture plane; six or eight surfaces will always depend on one, electric explosions will always depend on quiet canvases, grand psychedelics on natural intimacy. Pop created a new painting space which annotated the Utopian plasticity of Abstract Expressionism, a space which recondensed the spatial limits of painting and heightened the possibilities of the medium.

What this new space is can be described in terms of four characteristics: pre-flattening, archaic symmetry, emblem (mystical sign) and a new scale. Pre-flattening is disassociation from both hole-in-the-wall illusionism and the Romance of an "expanded" picture plane. The surface is flat, shrill, and, above all, arbitrary (a disowning of "natural laws"). Whatever enters a picture (anything is legal) surrenders orthodox abstract esthetics as well as orthodox illusionism; it must be flattened to the brink of destruction, and the whole picture undergoes a similar process. Symmetry can be deadly unless it narrowly misses; the new space avoids both mathematical order and felt, Romantic balances by being, in its not-quite-rightness, archaic. Between bi-symmetry and the Golden Mean lies a path of disharmony, awkwardness – valuable not because of its apparent honesty, but merely because of its narrow, clumsy limits. Beyond pre-flattening and symmetry is scale, an element transformed by the previous two. That Pop has no scale is untenable; on the obvious level of figuration, Rosenquist's demi-billboards are exercises in the development of scale. In formalist terms, the split with Abstract-Expressionist scale (the modular reach of a man's arm, a humanist scale) is inherent in the negation of "handwriting." Images compounded of giant Ben-Day, acidic penetrations of silk-screen, slick, glittering plastic bubbles, frozen couplings of steel and glass are of a technological scale (as small as a miniaturized transistor, as large as a linear reactor) and, given a residue of old associations, a dissonant scale. The emblematic negates passages, depth and connoisseurship; the picture is digested immediately. Brittle color and an intense, shallow space create a simultaneous sign, an emblem. The emblem is not a pre-packaged visual symbol, it is a compactness of state, an unsentimental deployment of means, and a concrete dissonance of total effect.

The color and space of Greater Pop has probed and shifted the space of Abstract Ex-

pressionism; it has not destroyed it or abandoned continuous formalist revolution (which it *has*, according to socio-historical appreciation). What has happened is another step, a strange, angular stride obscured by the easy love-hate titillation of its more superficial aspects. (In the case of Imageless Pop, or minimal art, the obscurity is furnished by the monthly model-change of materials and the self-conscious inertness – an attempt, by self-parody, to eliminate moral responsibility for revolutionary statements.) We are re-examining the gristle of painting: what to do with a surface.

The images we produce are either ritual – derived from socio-political stimuli (one has to be *taught* that Landseer's dogs, Audubon's birds, Dali's madonnas are art) or plastic, visual/emotional results of the application of the poetic means (say, paint). Pop has made us face the persistence of the ritual image, just as Abstract Expressionism re-established the validity of pure plastic creation. A synthesis will come, but it will not mean the superficial overlay of ritual on plastic (or vice versa) or a full-form birth from the head of another technical innovation. It is impossible to say what the choice will be, but it would seem the issue will be one of dissonance against unity, deliberation against spontaneity. There are, admittedly, many conflicts in this format; what was once spontaneous (Pollock's sweep, Hofmann's crisis and Warhol's wishes) can now only be deliberation in the sense of mannerism. What was ostensibly deliberation (Lichtenstein's dots) was in fact spontaneity against the prevailing ways. (Fifteen years of retrospect and/or a decade-and-a-half of imitators reveal an orthodoxy in ripe Abstract Expressionism, and the earlier paintings of Still, Motherwell, Gottlieb, Rothko and Tomlin, in which balance was ignored in the search for new form, begin to interest us more.) Then there is color again. Pop reveals there are no constants allowing a certain color here, another there, to make a picture "right" in accordance with the ebb and flow of a universe. Any color next to another is as good as *any* other color; this leaves the arbitrary the only acceptable working method.

A painting is a pitiable thing, requiring an inordinate amount of care to emit its feeble light in the face of anarchy, but it is, as they say, a candle in the darkness. Our underpinnings of universal plastic harmony have been wrecked by politics (because art is possible only after survival is accomplished; do children suffer in Mondrian's universe?) and we stand vulnerable to anything neat, shiny and secure. But Pop has contributed an alteration of pictorial space which, addressed to the problem of painting, might yield a new plasticity.

NOTES

1. "Pop and Public," *Art News*, November 1963, p. 23.
2. Pierre Schneider, "The Singular Present," *Art News Annual*, 1966, p. 69.
3. "Symposium on Pop Art," *Arts*, Vol. 37, April 1963, p. 37.
4. A. Rockman, "Superman Comes to the Art Gallery," *Canadian Art*, Vol. 21, January 1964, pp. 18–22.

POPULAR CULTURE AND POP ART

Lawrence Alloway

Before it is possible to describe the links between popular culture and Pop Art, we need to define them separately; otherwise any proposed relationship of the two subjects will dissolve amorphously. Recently the term Pop Art has been applied to comic strips and to paintings taken from them; to both commercial and underground movies; to architecture and to fashion. As I shall argue that Pop Art is more than a fashion, more than an expendable movement before Op Art came along and wiped it out, it is necessary to firm up our definitions.

The aesthetics of twentieth-century art, or much of it, derive from the eighteenth-century separation of the arts from one another. Art was defined as, strictly, pure painting, sculpture, architecture, music or poetry and nothing but these five media could be properly classified as fine art. This act of tight discrimination was powerfully reinforced in the succeeding centuries. Nineteenth-century Aestheticism sought the pure centre of each art in isolation from the others and twentieth-century formal theories of art assumed a universal equilibrium that could be reached by optimum arrangements of form and colour. This view of the arts as fundamentally self-referring entities has been, of course, amazingly fruitful, but the continued authority of art as pure visibility, to the exclusion of other kinds of meaning, is now in doubt. No sooner were the arts purified by eighteenth-century definitions than the supporters of pure fine art declared their differences from the popular audience which was not committed to high art. Fielding, Goldsmith and Dr Johnson all recorded their alarm at the taste for realism and sensationalism displayed by the gross new public for novels and plays. Anxieties were expressed about the effects of novels on young ladies which are very like the fears (and fantasies) of parents and teachers in the nineteen-fifties about the effect of horror comics on children and about the effect of violence on TV in the sixties. Connections exist between fine and popular art, but they are not numerous: Hogarth worked for a socially differentiated public, with paintings intended for an affluent and sophisticated audience and prints aimed at a mass audience. Goya drew on English political prints for his execution picture, *May 3, 1808*. Daumier alternated between the directed messages of his political cartoons and the autonomous paintings. Toulouse-Lautrec's posters were pasted on kiosks in the streets of Paris. Despite such individual reconciliations of fine and popular art, of elite artist and public taste, the two taste groups have remained antagonists.

As the popular arts became increasingly mechanized and progressively more abundant, elite resistance hardened correspondingly. Popular culture can be defined as the sum of the arts designed for simultaneous consumption by a numerically large audience. Thus, there is a similarity in distribution and consumption between prints and magazines, movies, records, radio, TV, and industrial and interior design. Popular culture originates in urban centres and is distributed on the basis of mass production. It is not like folk art which, in theory at least, is hand-crafted by the same group by which it will be consumed. The consumption of popular culture is basically a social experience, providing information derived from and contributing to our statistically normal roles in society. It is a network of messages and objects that we share with others.

Studio International, July–August 1969: 17–21

Popular culture is influential as it transmits prompt and extensive news, in visual, verbal and mixed forms, about style changes that will affect the appearance of our environment or about political and military events that will put our accepted morality under new pressures. There is a subtle and pervasive, but only half-described, feedback from the public to the mass media and back to the public in its role as audience. The media have expanded steadily since the eighteenth century, without a break or major diversion. The period after World War II was Edenic for the consumer of popular culture; technical improvements in colour photography in magazines, expansion of scale in the big screens of the cinema, and the successful addition of new media (long-playing records and television). In addition, cross-references between media increased, so that public communication transcended its status of "relaxation" (the old rationalization for reading detective stories) or invisible service (such as providing essential political and national news).

It is necessary to refer to the Canadian Roman Catholic essayist Marshall McLuhan at this point. He celebrates pop culture, in his way, but believes that the arrival of a new medium consigns prior media to obsolescence. It is true that each new channel of communication has its effect on the existing ones, but so far the effect has been cumulative and expansive. The number of possibilities and combinations increases with each new channel, whereas McLuhan assumes a kind of steady state of a number of messages which cannot be exceeded. Consider the relation of movies and TV. At first movies patronized the tiny screen and the low definition image in asides in films; then movies began to compete with TV by expanding into large screens (CinemaScope and Cinerama, for instance) and by using higher definition film stock (for example, VistaVision). (Three-dimensional movies were resurrected but did not get out of the experimental stage.) Today TV shows old movies (more than two years old) continually and in so doing has created a new kind of Film Society audience of TV-trained movie-goers. In addition to making TV films, Hollywood is making sexier and tougher films, leaving the delta of Good Family Entertainment to TV largely. Movies, now, are more diversified and aimed at more specialized audiences, which is not what McLuhan's theory (which would expect the extinction of the movie) requires. After World War II the critical study of pop culture developed in ways that surpassed in sophistication and complexity earlier discussions of the mass media. To Marxists, pop culture was what the bosses doped the people with and to Freudians it was primal fantasy's latest disguise, with a vagina dentata in every crocodile snapping in the cave under the mad doctor's laboratory. The new research was done by American sociologists who treated mass communications objectively, as data with a measurable effect on our own lives. There may be an analogy here with the post-war move among historians away from heroes and dominant figures to the study of crowds. Previously the past had been discussed in terms of generals' decisions, monarchs' reigns and mistresses' fortunes, with the rest of the world serving as an anonymous backing. The practice of treating history as a star system was not really subverted by debunking portraits of the great, à la Lytton Strachey, which preserved, though ironically, the old ratio of hero and crown. The real change came with the study of population and communities. Demography is giving to normal populations something of the legibility of contour that biography confers on individuals. The democratization of history (like the sociological study of mass communications) leads to an increase of complexity in the material to be studied, making it bulge inconveniently beyond the classical scope of inquiry.

In the post-war period an uncoordinated but consistent view of art developed, more in line with history and sociology than with traditional art criticism and aesthetics. In London and New York artists then in their twenties or early thirties revealed a new sensitivity

to the presence of images from mass communications and to objects from mass production assimilable within the work of art. Oyvind Fahlstrom, writing about another artist, Robert Rauschenberg, described the artist as "part of the density of an uncensored continuum that neither begins nor ends with any action of his." Instead of the notion of painting as technically pure, organized as a nest of internal correspondences, Fahlstrom proposed the work of art as a partial sample of the world's continuous relationships. It follows that works demonstrating such principles would involve a change in our concept of artistic unity; art as a rendezvous of objects and images from disparate sources, rather than as an inevitably aligned set-up. The work of art can be considered as a conglomerate, no one part of which need be causally related to other parts; the cluster is enough. Eduardo Paolozzi's work from the early fifties to date has investigated the flow of random forms and the emergence of connectivity within scatter.

Accompanying the view of art as a sample from a continuum is a lack of interest in the idea of the masterpiece, a staple of earlier theories of art. In place of the feeling of awe at a great man's greatest moment, artists and critics became more interested in representative and typical works. The whole life of the man, rather than his record-breaking peak, is what was interesting. Related to this shift of emphasis was a reduction in the high evaluation of permanence. Art was separated from its supposed function as a symbol of eternity, as an enemy of time, and accepted as a product of time and place. Its specificity, its historical identity, was its value, not its timelessness. Parallel to this anti-idealist view of art an aesthetics of expendable art was developed in England in the fifties. Its purpose was to handle the ephemeral popular arts which were no longer, it was speculated, different in kind from the art called "fine."

As popular culture became conspicuous after World War II, as history and sociology studied the neglected mass of the past and the neglected messages of the present, art was being changed, too. It is not, as ultimatistic writers have it, that the emergence of a new style obliterates its predecessors; what happens is that everything changes but the past's continuity with the present is not violated. As an alternative to an aesthetic that isolated visual art from life and from the other arts, there emerged a new willingness to treat our whole culture as if it were art. This attitude opposed the elite, idealist and purist elements in eighteenth- to twentieth-century art theory. It was recognized in London for what it was ten years ago, a move towards an anthropological view of our own society. Anthropologists define culture as all of a society. This is a drastic foreshortening of a very complex issue in anthropology, but to those of us brought up on narrow and reductive theories of art, anthropology offered a formulation about art as more than a treasury of precious items. It was a two-way process: the mass media were entering the work of art and the whole environment was being regarded, reciprocally, by the artists as art, too.

Younger artists in London and New York did not view pop culture as relaxation, but as an on-going part of their lives. They felt no pressure to give up the culture they had grown up in (comics, pop music, movies). Their art was not the consequence of renunciation but of incorporation. Richard Hamilton has referred, accurately, to his work of the period as "built up of quotations." The references are not to the Apollo Belvedere or the Farnese Hercules, but to Charlton Heston as Moses, *The Weapon Shops of Isher,* Vikki Dougan. If these references are now obscure, it doesn't matter any more than the exact identity of the bad poets in Pope's *Dunciad* matter. They can be identified but, in any case, the twentieth-century experience of overlapping and clustered sign-systems is Hamilton's organizing principle, which we can all recognize.

Pop Art is neither abstract nor realistic, though it has contacts in both directions.

Peter Blake and Malcolm Morley, for instance, both British artists, have moved from Pop Art to a photograph-based realism. In New York, on the other hand, an artist like Roy Lichtenstein has been moving in the direction of abstract art, not only by parodistic references to its old-fashioned geometric style, but by the formality of his own arrangements. The core of Pop Art, however, is at neither frontier; it is, essentially, an art about signs and sign-systems. Realism is, to offer a minimal definition, concerned with the artist's perception of objects in space and their translation into iconic, or faithful, signs. However, Pop Art deals with material that already exists as signs: photographs, brand goods, comics, that is to say, with pre-coded material. The subject matter of Pop Art, at one level, is known to the spectator in advance of seeing the use the artist makes of it. Andy Warhol's Campbell soup cans, Roy Lichtenstein's comic strips, are known, either by name, or by type, and their source remains legible in the work of art. What happens when an artist uses a known source in popular culture in his art is rather complex. The subject of the work of art is doubled: if Roy Lichtenstein or Paolozzi uses Mickey Mouse in his work, Mickey is not the sole subject. The original sign-system of which Mickey is a part is also present as subject. The communication system of the twentieth century is, in a special sense, Pop Art's subject. Marilyn Monroe, as used by Andy Warhol and Hamilton, is obviously referred to in both men's art, but in addition, other forms of communication are referred to as well. Warhol uses a photographic image that repeats like a sheet of contact prints and is coloured like the cheapest colour reproduction in a Spanish-language American film magazine. The mechanically produced image of a beautiful woman, known to be dead, is contrasted with the handwritten annotations that deface the image of flesh, in Hamilton's *My Marilyn*.

There has been some doubt and discussion about the extent to which the Pop artist transforms his material. The first point to make is that selecting one thing rather than another is, as Marcel Duchamp established, enough. Beyond this, however, is the problem raised by Lichtenstein who used to say of his paintings derived from comics: "You never really take. Actually you are forming." He wanted to compose, not to narrate, but this is precisely what transformed his source. I showed early comic strip paintings by Lichtenstein to a group of professional comic strip artists who considered them very arty. They thought his work old-fashioned in its flatness. Lichtenstein was transforming after all, though to art critics who did not know what comics looked like, his work appeared at first as only copies. In fact, there was a surreptitious original in the simulated copy. Pop Art is an iconographical art, the sources of which persist through their transformation; there is an interplay of likeness and unlikeness. One way to describe the situation might be to borrow a word from the "military-industrial complex": *commonality,* which refers to equipment that can be used for different purposes. One piece of hardware is common to different operations; similarly a sign or a set of signs can be common to both popular culture and Pop Art. The meaning of a sign is changed by being recontextualized by the artist, but it is not transformed in the sense of being corrected or improved or elaborated out of easy recognition.

The success of Pop Art was not due to any initial cordiality by art critics. On the contrary, art critics in the fifties were in general hostile, and they still are. One reason for this is worth recording because it is shared by Clement Greenberg and Harold Rosenberg, to name the supporters of irreconcilable earlier modernisms. Greenberg with his attachment to the pure colour surface and Rosenberg with his commitment to the process of art, are interested only in art's unique identity. They locate this at different points. Greenberg in the end product and Rosenberg in the process of work, but Pop Art

is not predicated on this quest for uniqueness. On the contrary, Pop Art reveals constantly a belief in the translatability of the work of art. Pop Art proposes a field of exchangeable and repeatable imagery. It is true that every act of communication, including art, has an irreducible uniqueness; it is equally true, that a great deal of any message or structure is translatable and homeomorphic. Cross-media exchanges and the convergence of multiple channels is the area of Pop Art, in opposition to the pursuit of artistic purity.

Thus Pop Art is able to share, on the basis of translatability and commonality, themes from popular culture. An analogue of Pop Art's translatability is the saturation of popular culture with current heroes of consumption, such as the Beatles who are on records and record sleeves, movies, magazines of all kinds, radio, boutiques, who have been widely imitated, although in America a new generation of teeny boppers has already rejected them. Any event today has the potential of spreading through society on a multiplicity of levels, carried by a fat anthology of signs. It is impossible to go into the full extent of the connections between popular culture and Pop Art, but the extent of the situation can be indicated by a few representative cases. Robert Stanley's series of two-tone, black on white, paintings of trees had not been exhibited or written about in art journals when they were featured in *Cheetah,* a smart American teenage magazine. Lichtenstein made a cover for *Newsweek* when the magazine ran a Pop Art survey two years ago and Robert Rauschenberg silk-screened a cover for *Time* on the occasion of a story on *Bonnie and Clyde.* Here, artists who draw on the field of mass communications are themselves contributing to it. Some of the best photographs of Edward Kienholz's environmental sculptures appeared in a girlie magazine *Night and Day* and the *Sergeant Pepper* disc of the Beatles has an elaborate Peter Blake sleeve (the next one is by Richard Hamilton). As art is reproduced in this way it becomes itself pop culture, just as Van Gogh and Picasso, through endless reproduction, have become mass-produced items of popular culture. Van Gogh would have welcomed it because he had the greatest respect for clichés, which he regarded as the authorized expression of mankind, a kind of common property that especially binds us together.

Although the cliché is one of the most powerful resources of pop culture, and although we all consume popular culture in one form or another, there are obstacles to its appreciation. Its pervasiveness has caused it to be taken for granted and all consumers of pop culture are rather specialized. Agatha Christie readers (yes, her books are still in print) are not Ian Fleming's readers who, probably, put down Donald Hamilton (he writes the Matt Helm spy stories), whose readers, in their turn, could not possibly stand the tranquility of Agatha Christie, and so on. However, it is necessary to take one area of pop culture away from its specialists to indicate something of its possible sophistication. The reason for choosing comic books is that the genre is in a flourishing state at present, though the fact has not become a part of general knowledge yet.

In the United States there has been a revival of the costume comic (such heroes as *Batman* and *Superman*), with story lines frequently derived from the paranoid science fiction of pulp magazines of the forties, but updated in a bright baroque style, knowing and confident. There was a time-lag before Mod fashions were accepted in the comics, just as in the movies, but now the traditional story lines run like secret rivers through a hip *mise-en-scène.* (*Wonder Woman,* for example, has just got a nineteen-sixties body and costume, in place of her nineteen-forties model, which looked as if it would stay forever without becoming classic.) In the forties, comic books were sexy but after the Korean war they were cleaned up, though sex heroines may reappear at any minute among the multi-levelled displays of words and images. Italian comic books, the *fumetti,* aimed at adults,

are openly sadistic and sexual but have a far less complex narrative style than American comics aimed at teeny boppers and teenagers. The *fumetti* proceed in a stately and explicit narrative, whereas American comics are intricately structured. A high level of decoding skill is required of the reader-viewer. The best parodies of comics are found in other comics, not only in the celebrated *Mad* but in comic books like *Ecch,* the brawling comedy of which is close to the vernacular style of a group of Chicago painters, *The Hairy Who.* They produce their own comic books, following the layouts of straight comics but swelling into a Rabelaisian inflation of Americana. These random notes make the point, I hope, that the maze of signs in Pop Art is not only the product of artists' sophistication but is present, also, in their source material, which surrounds us, is underfoot.

In New York the first large paintings derived from comic strips were by Andy Warhol in 1960, such as his *Dick Tracy.* The following year Lichtenstein made his first painting of this type, a scene of Mickey Mouse and Donald Duck. Though actually taken from a bubble gum wrapper the style of drawing and the kind of incident resemble comic strips based on Walt Disney's film cartoon characters. Previously Lichtenstein had done Cubist versions of nineteenth-century cowboy paintings and of World War I dog-fights, "the *Hell's Angels* kind of thing," to quote the painter. The contrast of popular subjects (cowboys and Indians, old planes) and their Picasso-esque treatment is certainly proto-Pop. Lichtenstein did not know Warhol's slightly earlier work and was, as I hope this indicates, on a track that led logically to the comics. Early Pop Art, in fact, is peppered with convergences of separate artists on shared subjects. The fact of simultaneous discovery is, I think, a validation of the seriousness of the movement and refutes criticism of Pop Art as a sudden or momentary affair. It would not have developed spontaneously in different places in the fifties, had it not been an authentic response to an historical situation.

The different uses that have been made of comics substantiate the continued independence of the artists after they had become aware of their common interest. Lichtenstein has never used famous figures of the comics, as Warhol took *Dick Tracy* or Mel Ramos took *Batman.* His paintings derive from specific originals, but the reference is always to realistic and anonymous originals. He uses war comics and love comics in preference to named heroes or fantastic comics. Ramos, on the contrary, began a series of *Batman* paintings in 1962, taken directly from Bob Kane's originals (and other artists who draw *Batman*) but rendered in succulent paint. Ramos then switched to painting sex heroines from precode comics and here became engaged in historical research in erotic iconography. (*Mysta of the moon; Glory Forbes, Vigilante; Gale Allen, Girl squadron leader; Futura,* are some of the names.) Then, in the June 1966 *Batman:* "At the Gotham City Museum, Bruce Wayne, Millionaire Sportsman and Playboy (Batman), and his young ward Dick Grayson (Robin), attend a sensational 'Pop' art show." On the walls are full-length, fine art portraits that resemble the paintings of Mel Ramos. Here is a feedback circuit that goes from comics to artist and back to comics.

Linkages between art and pop culture and between one part of pop culture and another are not confined to the comics. In fashion, for example, Yves St Laurent discovered Mondrian through an art book his mother gave him and Courrèges' earlier designs had a science fiction potential realized in the movie *The 10th Victim* and in *Harpers Bazaar* photographs. *Harpers'* space phase influenced two Argentine painters, Delia Cancela and Pablo Mesejean, who built an environment of astronauts and bouquets.

A unifying thread in recent art, present in Pop Art, can be described as process abbreviation. In the past an ambitious painting required a series of steps by the artist, from a conceptual stage, though preliminary sketches to drawing, to underpainting, to glazing

and, maybe, to varnishing. These discrete steps were not experienced in isolation by the artist, of course, but such basically was the sequence of his operations. In one way and another, modern art has abbreviated this process. For instance, Pop artists have used physical objects as part of their work or rendered familiar articles with a high degree of literalness. Though Lichtenstein works in stages himself, he simulates an all-at-once, mechanical look in his hand-done painting. The finished work of art is thus separated from traces of its long involvement in planning and realizing, at least in appearance and sometimes in fact. Warhol's silk screen paintings achieve a hand-done look from the haste and roughness with which the identical images are printed. Photographs, printed or stencilled in the work of art give the most literal definition available in flat signs to the artist. It was the same in the nineteenth century when the Daguerrotype was described as a means "by which objects may be made to delineate themselves."

Where process abbreviation is found in Pop Art it reduces personal nuances of handling by the artist in favour of deadpan or passive images. This deceptive impersonality amounts to a game with anonymity, a minimizing of invention, so that the work is free to support its interconnections with popular culture, and with the shared world of the spectator. Photographs appear as unmediated records of objects and events, as the real world's most iconic sign system. In addition to this property, which Rauschenberg and others have exploited, photographs have a materiality of their own, a kind of visual texture which is generated mechanically but which we read as the skin of reality, of self-delineated rather than of interpreted objects. This zone of gritty immediacy, of artificial accuracies, has been explored by Pop artists as part of their attention to multi-levelled signs. In London the first number of *First* delved into the photographic-texture-as-truth paradox, following up Paolozzi's and Hamilton's photographic research in the fifties. The theme is still viable as is shown by a non-verbal, untitled, anonymous and hand-distributed publication that has just started in New York; its best pictures are straight photographs, highly specific as to subject, but uninterpretable in the absence of cues. Such solidity and mystery, such as we would get if we turned out a stranger's pockets or ransacked an immigrant's only suitcase, is comparable to Pop Art's literalness of objects that resist interpretation.

Perhaps enough has been said to indicate that Pop Art is not the same as popular culture, though it draws from it, and the point may have been made that Pop Art is art. In the ten years since the term began to be used in London in 1957–8, its meaning has shifted in a way that indicates resistance to an anthropological definition of culture. As we saw, the term was, in the first place, part of an expansionist aesthetics, a way of relating art to the environment. In place of an hierarchic aesthetics keyed to define greatness, and to separate high from low art, a continuum was assumed which could accommodate all forms of art, permanent and expendable, personal and collective, autographic and anonymous. From about 1961 to 1964 Pop Art was narrowed to mean paintings that included a reference to a mass medium source. As the term became attached purely to art, its diffusion accelerated.

The Random House Dictionary defines Pop Art as follows:

A style esp. of figurative painting, developed in the US and current in the early 60s, characterized chiefly by magnified forms and images derived from such commercial art genres as comic strips and advertising posters.

In 1965-6 the meaning of the term shifted again, away from the second phase of its use, which is what the dictionary recorded. It was returned to the continuous and non-

exclusive culture which it was originally supposed to cover. The term leaked back to the environment, much as Allan Kaprow's term *Happenings* spread to apply to everything and anything. Both words were taken up by so many people and used so promiscuously that Pop Art was de-aestheticized and re-anthropologized. The dictionary I quoted stressed Pop Art's American-ness. It is true that English Pop artists used to be accused of pro-Americanism, but the nature of their interest can be defined more sharply than that. American pop culture was valued because it was the product of an economy more fully industrialized than Europe's. We looked at the United States as our expected future form, the country at a level of industrialism to which all countries were headed, though at various speeds. This outlook had a mood of optimism that is not in accord with present feelings, but the point remains that Pop Art is the art of industrialism and not of America as such. It is the maximum development of its communications and the proliferation of messages that give America its centrality in pop culture. Its dominance in Pop Art is something else and here we must concede the responsibility is in ourselves.

Pop Art developed independently in England and in America or, more accurately, in London and New York, and its name is British in origin. The artists who contributed to its development in England, Paolozzi and Hamilton especially, are still going strong, working in forms that are cogent extrapolations of their early ideas. They have, however, less company than they had a few years back. A second generation of Pop artists and Pop-affiliated artists came on the scene with the sixties and the best of this group are clearly Richard Smith, Peter Phillips and Peter Blake. English pop culture has prospered (music and clothes) but English Pop Art has not. The painters, aside from the exceptions noted, have not been able to take advantage of getting, for once, an early start. New York, on the other hand, which seemed a bit slow to me compared to London at first, has produced a vast body of work, and so have Los Angeles and Chicago. The reason for the disappointing record in England may, perhaps, be found in the particular character of artists as a group in London.

Here there is almost no professionalism among the artists, by which I mean a level of interpersonal contact which is sustained and open to newcomers. In London no artist seems to know enough other artists; there will be a few others, of his own generation probably, and some of these will probably teach in the same art school with him. The art scene is broken into small groups who have only occasional and suspicious contact with each other. An artist's best audience is other artists who know, from the inside, what he is doing while it is new, and this is the best function of the professional art world in New York. In London, on the other hand, artists work with an audience that is usually too small and either too friendly or too hostile to provide coherent reactions to current work. One needs more than friends and rivals.

What has happened since the late nineteenth century is that many English artists have been terribly short-winded. It is not that they are not talented or intelligent; the trouble is that most are not tough enough to go it alone. The typical pattern for an English artist is early energy followed by prolonged and obscure frustration or by sustained energy but at an idiosyncratic or complacent level. It is the fault of the English artist as audience (its failure to provide feedback) that most of the younger English Pop artists have already disappointed. It seems that they are going the way of the neo-romantic artists of World War II, or of Paul and John Nash, or of Wilson Steer, etc.

POP REAPPRAISED

John Russell

"Pop" has joined the great pejoratives: the insults that no one forgives, like "Cheat!" in a cardroom or "Revisionist!" in the Kremlin. In terms of today's cant, a pop artist is a dated vulgarian, a pop collector is a self-advertising *nouveau riche*, a pop critic is a connoisseur of dead ends and a pop museum director is a man on the way out.

And it's infectious. Finding an artist who will accept the name of "pop" is about as easy as persuading a butcher to put his best filet steak on offer as horsemeat. Pop art has been classed by the opposition as "novelty art" and "gag art," and no one likes to think that his work is a novelty no longer new or a gag that turns every face to stone. Pop art has been written off as a passing fad, a see-through dress with nothing inside it, a campaigner who never got beyond the New Hampshire primaries. Even its supporters would like to rename it, as if "pop" reeked of some distant but ineradicable scandal.

Perhaps scandal did once enter into it? A little bit, undeniably. It is difficult to look at a Brillo box, or at one of Erle Loran's elucidations of Cézanne, or even at a washbasin or a standard hamburger, without remembering what a commotion was made when these things were brought, unaltered and on their own terms, into the domain of "art." But even the most reverberant scandal must one day subside, leaving the cause of it to take its chance in history. That is what has happened to pop art, and it was on this understanding that Suzi Gablik and I were invited by the Arts Council of Great Britain to organize the mammoth pop exhibition which opens on July 3 at the Hayward Gallery in London (and goes on, by the way, until August 30).

The name of pop is as much out of favor in London as anywhere else, and the project of this particular show had lain around the Arts Council's office for some time, with few to praise and none to love it, when suddenly it found a redoubtable champion in the person of John Pope-Hennessy, director of the Victoria and Albert Museum and chairman of the Arts Council's art panel. Though feared primarily as the sternest of censors where Italian painting and sculpture are concerned, Pope-Hennessy has also an imperious curiosity about the art of our own era. In no time at all the invitation was sent out and accepted, and Miss Gablik and I were on the way to New York.

To New York, and not to Paris or Milan or Cologne or Tokyo, because it was our joint decision from the start that only English and American pop should be represented. There is French pop, German pop, Italian pop, Japanese pop; but pop in those countries tends to be rowdy, posturing, imitative, unfocused and self-conscious. Pop is, in our view, an English-speaking affair; all else is inauthentic. Pop art was produced by a defined number of individuals in a particular social and historical situation; it can be imitated in an external way, but if it is put beside genuine pop the imitation will look modish, derivative and unresonant.

Because genuine American pop has almost never been seen in London, and because it has an energy, a single-mindedness and a physical abundance not to be found in the more ambiguous procedures of English pop, the show is predominantly American. American artists outnumber English artists three to one, and the physical predominance of American work is made the more obvious by the very large formats which come naturally to

Art in America, July–August 1969: 78–79

Americans. English pop is domestic in scale; attempts to drag it into a larger arena have not succeeded, whereas physical aggrandizement is fundamental to American pop. The look of the show is, therefore, distinctively American.

This is not, however, to say that it is noisy, aggressive, jokey or sensation-seeking in its intentions. Our aim has been to redefine pop, and to redefine it in terms very different from those usually attached to the name. Pop as we see it is an art, almost, of austerity; an educated art; a necessary art; an art of monumental statement; an affectionate art; even a healing art.

In saying this, I have in mind an ideal visitor. That visitor will know enough of the background of pop to be able to identify the element of risk and adventure within it. But he will also be able to look at James Rosenquist's *F-111,* or at Claes Oldenburg's *Bedroom,* or at Andy Warhol's *100 Soup Cans,* in the same way as the nonspecialist visitor to Abydos looks at the Temple of King Sethos I. He will not, that is to say, be distracted by historical contingencies which are irrelevant to the formal qualities of the work before him. I do not think it an exaggeration to say that a good piece by George Segal has a withdrawn, timeless, unself-conscious quality which calls to mind the Fifth Dynasty *Girl Working at a Mash Tub* in the Cairo Museum, or that when we look at Oldenburg's soft toilet the droop of the material carries us beyond and away from the provocations of the subject matter and into that realm of understanding in which Rembrandt, in his portraits of bodily decay, has so long reigned supreme. This latter analogy caused great offense when I first made it, some years ago in London. But it is as natural for an artist in the late 1960s to be affected by the physical degeneration of mass-produced objects, or by the sight of a lonely woman in a diner, as it was for Constable to be affected by the clouds above his father's millstream. The involvement is akin in kind, and akin in quality, and the initial shock is no greater than it was when Constable's contemporaries were asked to recognize that English landscape does not have the basic tonality of a Cremona violin. If pop provoked, in the early 1960s, it was with provocation of the kind offered by Chardin when he said, in so many words, that for those who knew how to look at it a kitchenmaid's white apron was more beautiful than all Madame de Pompadour's silks and satins.

"An educated art," I said just now. People who dismiss pop art in the belief that it is essentially debasing should look again. Our exhibition is designed to prove that of all the painters who have looked at Matisse's symphonic interiors and wondered how to "go on from there" it is Tom Wesselmann who has done most to carry the tradition forward. There are, of course, Wesselmanns which allude directly to Matisse and quote one or another of the major paintings; but the affinity is climatic as much as iconographical. What looks to the casual eye as if it had been lifted straight from a billboard is the result of an organization as minutely calculated as that of Matisse's *Pink Nude.* Equally, Warhol's multiple portraits relate as much to the iconostases in the Kremlin churches, or to European multiple-head portraits like Gainsborough's *Children of George III,* as they do to photomat pictures. If we look around in the late 1960s for a painting that has the ambitions Courbet had for his *The Studio,* it is not among painstaking naturalistic figure painters that we find it, but in Rosenquist; and it is not only the *F-111* which aims to present Society complete and entire.

The object of all these artists is to rescue for painting some of the functions which it has been losing consistently over the last hundred years. What looked in the early 1960s like the greatest insult that had ever been offered to the notion of fine art will turn out by 1970 to have given new dignity to that notion. Already in the summer of 1965 Robert Rosenblum was pointing out that "the gulf between pop art and abstract art is far from

unbridgeable, and it has become easy to admire, without shifting visual or qualitative gears, the finest abstract artists, like Stella and Noland, and the finest pop artists." And Rosenblum went on to say that "the most inventive pop artists share with their abstract contemporaries a sensibility to bold magnifications of simple, regularized forms . . . to taut, brushless surfaces that often reject traditional oil techniques in favor of new industrial media of metallic, plastic, enamel quality; to expansive areas of flat, unmodulated color." This is a point which we have tried to bring out at the Hayward Gallery.

But if pop art, in stylistic terms, resulted from a wish to rebut the assumptions of abstract expressionism, it had also a democratic, in fact an egalitarian source. The supreme statement of this is to be found in Claes Oldenburg's book "Store Days" – in, to be precise, the long soliloquy which begins on page 39. This is really too good to quote from, too well-judged in its "Leaves of Grass"–like momentum to break into little pieces. But, for the argument, one sentence could be taken out: "I am for an art that embroils itself with the everyday crap & still comes out on top." And, in another part of the book, two short sentences: "Fig/non fig is moronic distinction. The challenge to abstract art must go deeper." It is a matter, all this, of *letting life in* at points where Fine Art had tacked up a sign: "Keep Out." It is a matter of not wincing, not patronizing life, not thinking of art as separate from it; a matter of dis-alienation. Once again, Oldenburg's glorious text for "Store Days" puts the point better than I could hope to do; but perhaps I could add that this kind of pop does seem to me a distinctively American activity, and one not paralleled by English pop. It stands, in other words, for a largeness of embrace, a breadth of acceptance, an openhandedness and openheartedness which have been bred out of European art. This aspect of American pop has been obscured by two subsequent events: first, the collapse of the opposition; second, the shift of stance which has taken more than one of the pioneers into activities which clearly relate to Fine Art. The openness of American pop now seems a normal, healthy reaction to pop's environment; and it has become clear that, far from being a coarse-grained sensation-seeker, Roy Lichtenstein for one is fastidiousness personified. There is also, of course, the fact that American pop in its early days was in part a counterrevolutionary movement, designed to break out from the patterns laid down for art by abstract expressionism. Now that that particular writ no longer runs, the work looks different – not better and not worse, but different – and this is another reason for reconsideration.

Abstract expressionism did, however, do something for American art and American artists that nothing has ever quite done for my own country. It proved that you could have great painting that came about in a spirit, and in a factual context, of complete isolation from the official art world. This happened in Paris before 1914, and it happened in Germany at the same time, but it has never happened in England. English pop never outraged established opinion as American pop did. Nor did it tap, as American pop was to do, sources of unlimited energy in the national life. When Oldenburg makes a giant piece of pie, he does it as an act of physical identification which makes us feel big enough, and well enough, to gobble down that piece of pie and come back for another. English pop is never so direct; its qualities are, rather, those of connoisseurship in a hitherto unexploited field.

This was made clear in documents which predate any comparable statements by pop-makers or pop-mongers in other countries. "But Today We Collect Ads," by Peter and Alison Smithson, of Art in London; as its title indicates, it was a polemical statement by two leading figures in the younger English architecture, and it was the consolidation of discussions which had already been going on for several years. In these discussions Reyner

Banham, Lawrence Alloway, Richard Hamilton, John McHale and Eduardo Paolozzi were participants at one time or another; the discussions were intended to apply to pop culture the same standards of analysis and reasoned evaluation as were applied to fine art. Richard Hamilton defined his own attitude in a letter to the Smithsons, dated January 1957:

Pop art is:
Popular (designed for a mass audience)
Transient (short-term solution)
Expendable (easily forgotten)
Low-cost
Mass-produced
Young (aimed at youth)
Witty
Sexy
Gimmicky
Glamorous
Big Business . . .

English artists at this time did a great deal of talking and writing and in general hashing over the ideal of an alternative culture, a culture which was antithetical to the old-master-oriented fine-art culture of English officialdom. Official English culture still bowed down to Italy, and bowed down to France, and made excuses for England, and rather doubted that America could be said to exist. English pop culture treated movies as Sir Joshua Reynolds had treated Correggio and treated packaging as Gainsborough had treated Rubens – as sources of vitality, forebears whose loins were still fertile, energizers from whom much could be learned. The climate of English pop was talky, sometimes wistful, basically investigatory and deep-dyed with the collector's instinct. It was acted out in argument, but it was not acted out in the work, in a dramatized way, like American pop; American pop gained enormously from being powered in large part by people like Oldenburg and Jim Dine (and, earlier, Robert Rauschenberg) who had an innate theatrical sense and could put on a nonverbal painters' theater which is still talked about, a decade later, for the sureness of its command over an audience. There has never been an English "happening" of any consequence; English pop results, on the contrary, from solitary endeavor. No one could be slower, more conscientious, more profoundly dandified in his way of making a picture than Richard Hamilton. No one could be more bent upon transforming his basic material than Eduardo Paolozzi. No one could bring to pop material a more delicious obliquity than Richard Smith. There just isn't, in English pop, the thrusting, downright, all-or-nothing element characterizing American pop.

But this is not to say that English pop was not just as radical in its relationship to traditional English culture. Anyone who looks up the second edition of Wordsworth's "Lyrical Ballads" (1800), with its polemical preface, will find an attitude very similar to that of the founders of English pop. Coleridge summed up that attitude when he said Wordsworth believed that "the proper diction for poetry consists in a language which actually constitutes the natural conversation of men under the influence of natural feelings." English pop had to contend with an official art world which was still hankering after a modified form of impressionism and would accept abstract painting more readily if it could be presented as a variant of English weather-reporting. It was in this context

that the study of automobile styling, of B-movie iconography, of the latest thing in advertising, took on a revolutionary sense. A tendency to regard the United States as a fairy-land should also be noted as characteristic of early English pop; in the middle 1950s it was still an unusual thing for a young English artist actually to have spent much time in the States. In the 1960s this is, of course, no longer true: Richard Smith and David Hockney and to a lesser extent Allen Jones are impregnated with firsthand experience of the U.S. But English pop is still marked by our national tendency to diversify the load, to render obliquely what others render head-on, and to make allusions in a spirit half of irony, half of detached scholarship.

But what is as true of England as it is of the States is that the best pop artists have shown themselves able to evolve. Twelve years after Hamilton's *Hommage à Chrysler Corp.,* eight years after Richard Smith's first references to cigarette pack and tissue box, eight years after David Hockney's *Alka Seltzer* (*The Most Beautiful Boy in the World*), these painters are getting consistently better and better. Where participation in other movements has often left painters stranded, stagnant, purposeless, a past with pop is still a source of imaginative energy. That energy does not come out in the coarse and blatant forms which legend attributes to pop, but it is there nonetheless: Richard Hamilton's *I'm Dreaming of a White Christmas* began from a still of Bing Crosby, went through many transmutations and ended up as one of the subtlest and most complex statements that have come out of British art since the war. Patrick Caulfield's *Sculpture in a Landscape* speaks for a younger generation of English artists who bring to their work a highly developed sense of pictorial language, together with a good deal of mischief where the uses of that language are concerned. (Another instance of this in the Hayward Gallery show is Clive Baker, whose latest work includes a set of chrome-plated hand grenades, which come in a box from Asprey's, the Tiffany's of London.) In England and the U.S. alike, pop is a movement that never got stuck, a part of history that is still on the jump.

THE ART WORLD: MARILYN MONDRIAN

Harold Rosenberg

Pop Art is thought to be the art of everyday things and banal images – bathroom fix-tures, Dick Tracy – but its essential character consists in redoing works of art. Its scope extends from Warhol's rows of Coca-Cola bottles to supplying the "Mona Lisa" with a mustache. All art is based on earlier art, either consciously or by absorption, but no movement has ever exceeded Pop in alertness to aesthetic cues. Some of the works repro-duced in the just-issued "Pop Art Redefined," by Suzi Gablik and John Russell (Praeger), evoke the following: Leonardo, Duchamp, de Kooning, Mondrian, Manet, Monet, Ma-tisse, Picasso, Delacroix, Magritte, Demuth, Pollock. In addition, a section of more than twenty paintings and sculptures by a dozen artists includes pictures of the word "ART" in block letters, depictions of art materials, and portraits of earlier artists, contempo-raries, art dealers, and curators. If we count as art the comic strips, lettering, posters, sign paintings, and industrial designs adapted by Pop artists, the Pop movement takes on the character of an exhibition in an art school that combines courses in fine art and ap-plied design. In Pop, America's two cultures, highbrow and popular, meet on the neutral ground of technique. The Pop mode came into prominence around the beginning of the nineteen-sixties, when the American art world had commenced to consolidate itself on a mass-audience basis, and it inaugurated a decade of pedagogy. From the start, the lead-ing Pops declared that their primary interest was in formal qualities and that their repre-sentations of pinups and hamburgers were a diversion to get the crowd moving into the lecture hall. "Artists," said Lichtenstein, "have never worked with the model – just with the painting."

Now, at the close of the decade, the underlying abstractness or formalism of Pop is be-ing passionately urged upon the attention of the art world. In the view of art historians and critics, and some of the artists, too, Lichtenstein, Oldenburg, Warhol, Tom Wessel-mann have been engaged in much the same enterprise as the painters of color areas and bands, such as Ellsworth Kelly and Kenneth Noland. Popeye, Marilyn Monroe (I almost said "Marilyn Mondrian"), and "Red, Blue, Yellow" are equally valid occasions for ad-vanced exercises in line, color, and form. "Our intention," writes Miss Gablik, is to "re-define Pop Art as having a more direct relation to Minimal and hard-edged abstract art than is frequently admitted." Alas, others have got there first; the relationship of Pop to late-sixties abstraction has been most enthusiastically "admitted" by Professor Robert Rosenblum and echoed by Professor Barbara Rose and by Miss Diane Waldman, associate curator of the Guggenheim Museum and director of its current Lichtenstein retrospec-tive, and it is a safe bet that the word has been received in Los Angeles and Pasadena. "Lichtenstein," declares Miss Waldman, "has dematerialized the object and effected a new reconciliation with the picture plane." Comic-strip and advertising-agency artists have done pretty well in dematerializing objects, but it takes an authentic fine-arts artist of the nineteen-sixties to effect reconciliations with the picture plane. What Miss Wald-man is saying (and her observation has been confirmed by Lichtenstein himself) is that, vis-à-vis the original Donald Duck, the function of Lichtenstein is to shift the image from the realm of the Sunday comics to the world of art – a shift comparable to the one carried

The New Yorker, November 8, 1969: 167–76

out by the Navajos when they adopted the dollar bills and soup-can labels of the first Yankees in the Southwest as designs for blankets. With Pop, the tribe of the art galleries and museums "acculturates" the artifacts of the supermarkets, billboards, and women's magazines by passing them through an art-historical filter. The tool is the pedagogy of the picture plane, today in full swing in assimilating, by reinterpretation and trimming, all art into what Professor Rosenblum calls "the formalist experience of our century."

The aestheticism of Pop, its fixation on art-world devices and art-world reputations, has been obscured by the common misconception that, as Miss Gablik has it, Pop is "based upon real things which are part of everybody's world, and not just a private world of the artist's." This roughly describes the aims of Pop in the heroic days of Oldenburg's "Store" on East Second Street and the exhibitions and Happenings at the Reuben Gallery – the period when young artists in New York felt obliged to break out of the grip of art history as represented by Abstract Expressionism. Unfortunately, there is no such thing in art as "everybody's world," just as, despite the easy formulas of art historians, there was no "private world" for Abstract Expressionists. The issue was, and is, style and creative method – and the adoption by some Pop artists of a set of mannerisms that were the opposite of the mannerisms of Abstract Expressionism was insufficient to exorcise art history and gain contact with real things. Bathrooms by Oldenburg, Segal, Lichtenstein, and Wesselmann, reproduced in "Pop Art Redefined," lack the shared characteristics of the products of Kohler or Crane; they are individual restylizations of the art of the designers of plumbing fixtures. Oldenburg messes up a corrugated-paper toilet and washstand with drips of paint and stands his bathtub on end, evoking simultaneously Abstract Expressionist painting and the atmosphere of the slums and loft-building studios. Segal and Wesselmann incorporate sections of brand-new tile walls and chromium-plated fixtures into stage sets that feature nudes reminiscent of Courbet and Matisse; Lichtenstein supplants the physical bathroom with a linear mail-order-catalogue illustration of it.

As for the motif itself, the bathroom comes close to meeting the test of being, at least in America, "part of everybody's world," but a nude stepping out of a bathtub is hardly "everybody's" except in French paintings, and her incompatibility with bathrooms in slums caused Oldenburg to leave her out. In art, "everybody's" world is a style that is opposed to minority styles, and Pop cannibalizes both majority and minority art for its own aesthetic purposes. In the social ambience of the gallery-goer, the "Mona Lisa" is almost as much everybody's as the bathroom, and Duchamp's and Warhol's "Mona Lisa"s are today almost as much public property as Leonardo's. But the "everybody" narrows considerably when it reaches Demuth's "I Saw the Number Figure 5 in Gold" as re-created by Robert Indiana and the drawing by de Kooning that Rauschenberg partly erased. Taking into account such Pop staples as repaintings of Ingres, Delacroix, Rembrandt, and Picasso, a textbook analysis of Cézanne, and a chromium-plated version of Magritte's boots that turn into feet, as well as paintings that refer to art dealers and curators (e.g., Walter Hopps wearing a miniature de Kooning under his coat), one is forced to conclude that in Pop not everybody's world but the enlarged, self-conscious art world of the decade now closing has replaced the Abstract Expressionists' world of artists.

Pop Art reached out not to real things but to pictures of things, and its aesthetic discipline has consisted in seeing objects as pictures or sculptures, so that the Bowery or the suburban kitchen becomes for the Pop artist an art exhibition ready for shipment to the international chain of art showcases. Basically, Pop Art is "found" art; its most potent effect is the hallucination of mistaking the street for a museum or the astonishment of

Molière's character at learning that he has been speaking aloud. In becoming art, objects separate themselves from their functional reality and are changed into thing-like equivalents of themselves – a condition best symbolized by George Segal's solid white plaster ghosts. The inherent detachment of Pop's aestheticized banalities prefigures the "pure" objects of Minimal sculpture and the "reduced" compositions of the color-field painters, misnamed "the art of the real." The extinction of content in Pop Art enabled it to treat in equal fashion a sunset by Turner and a Shell Oil sign, and thus to serve as a bridge between the art of latecomers to Action painting – to whom a de Kooning or a Pollock represented not a new psychic realization but a way of applying paint to a surface – and the varieties of abstract modes that emphasize areas of color disposed on materials of a given size and shape. It might be added that the rising curve of aestheticism in the sixties, with its concept of the world as a museum, represents a withdrawal by the art world from the intensifying politico-social crisis and intellectual confusion in the United States.

The commercial artist or designer who has provided the bulk of "nature" for the Pop artist is an aesthete, too. Like the Pop painter, he converts all styles to his needs, and in illustrating an ad for ice cream he does not forget to shape the drop of chocolate on the sphere of vanilla into the perfect outline of a tear. In appreciating the Lichtensteins now on view (through Sunday, November 9) at the Guggenheim, one is obliged to keep in mind that the comic strips on which they are based were created not by forces of nature, or by children drawing on sidewalks, but by artists who, as Larry Rivers pointed out near the inception of Pop, "went to art schools, traditional & bohemian & . . . admired the Old Masters & still tell you about Picasso or perhaps Klee & they made lots of drawings. . . . When you meet them you are not in the presence of a brute." Craftsmen of the commercial workshops are, one might say, the avant-garde of art among the great public, as Lichtenstein and Warhol are the avant-garde of applied aesthetics in the art world. It is the overlay of "high" and "low" aspects of contemporary art practice that characterizes Pop Art as a movement; "real things" have nothing to do with it. As the embodiment of classroom aesthetic dogmas of the sixties, Pop is, as Miss Gablik and the formalists maintain, linked with Minimalism and color-field painting. But it is linked equally with the commercial-crafts spirit of America's newly expanded art world.

The artist who best represents the basic motives of Pop Art is Roy Lichtenstein, an ex-Abstract Expressionist who has been both a commercial artist and a university art instructor. His more than a hundred paintings, sculptures, drawings, and ceramics at the Guggenheim are dated from 1961 to 1969, and though the works directly based on comic-strip images belong to less than half of this period (roughly, up through 1964) and constitute less than half of the show, they dominate the exhibition. The recomposition of a comic-strip "box" dissociated from the strip – the face of the blonde in the window saying, "I know how you must feel, Brad" – into a large-scale oil painting was Lichtenstein's primordial idea, the discovery that gave birth to him as a painter, and all his works look back to that exciting vision. Many of his paintings of the last five years – landscapes with temples, restyled Mondrians and Picassos, cloud formations that are exercises in spatial ambiguity – seem like random demonstrations of how pictures can be turned into Lichtenstein by the introduction of his comics-derived thick outlines, swimming masses of black, bright colors, and Ben Day dots (a result comparable to the one achieved by Yves Klein through covering canvases and objects with his "International Klein Blue"). Lichtenstein's "Modern Painting with Division" (1967) and "4 Panel Modular 4" (1969) keep abreast of serial pattern painting and Frank Stella's late use of arched elements but retain identification with Lichtenstein through heavy black contours, primary colors, and

fillers of Ben Day dots. His sculptures of the last three years, however, which abandon his cartoon ingredients in favor of thirties-style "modernistic" metal coat hangers and theatre-lobby stanchions in polished brass, glass, and aluminum, seem to be searching helplessly about for art-world references. Perhaps the disc of David Smith will come to the rescue.

In formal terms, Lichtenstein is nothing if not consistent; his aesthetic reprocessing, which homogenizes "vulgar" art with high-art forms and high art with formal derivatives from the mass media, cancels the content of both and leaves only design. Formalist criticism, as represented in this instance by Miss Waldman, finds his work to be all of a piece. Comparing Lichtenstein to Ingres, she writes that "Lichtenstein is able to present us with a new vision, not one based on the comic strip but more probably based on his understanding of modern art. Starting with a specific subject matter, he arrives at a general or ideal image." Miss Waldman seems unaware that in attributing to Lichtenstein an art that is based on understanding art and that achieves the "ideal," she has conceived of him as the typical modernist academician. No doubt Lichtenstein understands modern art, at least as it has been discussed in the United States during the past twenty years, but his aestheticized comics, far from arriving at an ideal image, are extremely uneven in the quality of their design. "Drowning Girl" and "Hopeless" are interesting Art Nouveau rhythmic compositions; "Takka Takka" and "O.K. Hot Shot" are so cluttered that the eye cannot rephrase them into satisfactory patterns; "Preparedness," a huge three-sectioned canvas done this year, is simply dull, in the manner of the poorer government murals of the thirties – the period with which Lichtenstein is at present engaged in his sculpture.

Apart from keeping up with art history and subsuming the comic-strip craftsman under the system of contemporary art ideas, Lichtenstein's paintings tend to reflect a gentle, professorial humor and a sincere liking for corny themes, colors, and postures. "Mr. Bellamy," not at the Guggenheim, is the cartoon of a resolute American naval officer who reflects, in a comic-strip balloon, "I am supposed to report to a Mr. Bellamy. I wonder what he's like." Done in 1961, the year Richard Bellamy assembled a squad of Pop artists at the Green Gallery, the painting is an excellent In joke. The 1965-66 "Brushstroke" paintings, with their traces of drip and exposed (but Ben Day-dotted) canvas, are my favorite Lichtensteins, because of their wit in isolating and reducing to a "thing" the trademark of Action painting, and Lichtenstein's impeccable handling relates the Action brushstroke to Oriental calligraphy. The balloon of "Image Duplicator," a closeup of the eyes of the Mad Scientist, amusingly sums up Lichtenstein's relation to his public: "*What? Why did you ask that?* What do you know about my *image duplicator?*"

The comics are a path back to childhood. A prevailing mood of Lichtenstein, as of Rauschenberg, Oldenburg, and the majority of the Pop artists, is nostalgia; in their scheme, childhood represents reality before it became totally absorbed into art. Lichtenstein's "Composition I," a six-foot-high reproduction of the cover of a schoolboy's copybook, with a rectangular label in the center headed "COMPOSITIONS," and decorated with an all over design of random black-on-white shapes vaguely reminiscent of Pollock, and bordered on the left by a vertical black band à la Newman, is a brilliant synthesis of the artist's past innocence and present professionalism. Parodying the comics enabled Lichtenstein to reintroduce into painting heroic and romantic subjects – air pilots, cops, George Washington, drowning maidens. Though presented under the cover of aestheticism and Camp, the melodrama of such paintings as "Drowning Girl" ("I don't care! I'd rather sink – than call Brad for help!") and "The Kiss" (with an outline of the departing

lover's plane in the background) helps, together with such gags as the "Image Duplicator," to save the Guggenheim exhibition from monotony – contradicting the formalist edict that subject matter is to be played down.

Nominally, Claes Oldenburg is a Pop artist, too – one of the earliest and most forceful, who went through the Pop mill of Happenings, environments, and prop-making. The subjects of his sculptures, constructions, and drawings are taken from the common sources of Pop: packagings (7-Up bottles), art lectures ("Henry [no doubt Geldzahler, now a curator at the Metropolitan Museum] pulls out a rubber lecture"), ready-to-eat items, advertisements, cosmetics, kitchen equipment, tools. With Oldenburg, as with Lichtenstein, stereotypes in and out of art are equalized, and Lichtenstein's coolly conceived brushstroke is matched by Oldenburg's dripping paint pile turned into a plaster mass.

Oldenburg's practice of art and his attitude toward it are, however, radically different from those of Lichtenstein and the typical Pop artist, and to apply the Pop label to him tends to obscure the nature of his work. For Oldenburg, ex-reporter, poet, solitary walker in the city, and introspectionist, art has psychological and social objectives, and the aestheticism of the revisers of clichés is as alien to him as the aestheticism of the Minimalists and color-fielders. If Lichtenstein's accomplishment is confined to nuances of "the formalist experience of our century," Oldenburg has educated himself in the strategies of modernism in order to animate (in the phrase of his "Store Days") "a theatre of action or of things." Oldenburg, too, is absorbed in form – what artist isn't? – but he finds his forms in concrete objects and situations rather than by imposing on art a set of procedures derived from currently acceptable modes. Like de Kooning, though with essential differences, he is a "transformalist" – that is, one who uses the freedom won through modernist experimentation to cut across the history of styles by means of the unique creative act. His opposition to the ersatz Action painting that dominated New York art upon his arrival in it, in the mid-fifties, expressed itself not in submission to a system of antithetical recipes – impersonality, smooth surfaces, preconceived composition – but in slowly unearthing the creative principles of the pioneers. "Lately," he said in "Store Days," "I have begun to understand Action painting that old thing in a new vital and peculiar sense as corny as the scratches on a NY wall and by parodying its corn I have (miracle) come back to its authenticity! I feel as if Pollock is sitting on my shoulder, or rather crouching in my pants!" An artist who has the feeling of being "occupied" by a predecessor is able to extend the past through his imagination and can dispense with the formalists' chain of rational derivations.

The Oldenburg retrospective at the Museum of Modern Art, which, like the Lichtenstein exhibition, covers the current decade (with the addition of a few earlier drawings), is the most inventive – in concept and in use of scale and materials – of any group of works by an American of the post-Abstract Expressionist generation, and its presentation by Miss Alicia Legg, an associate curator at the Museum, is one of the most satisfying installations in recent years. The more than two hundred and twenty items, assembled with the collaboration of the artist, cover every phase of his career except his Happenings, dramas, and environments: the early East Side sculptures of food, clothing, and women's legs, all made out of newspaper soaked in paste, and the latter ones of plaster-saturated muslin painted with enamel; the "flags" concocted in Provincetown out of driftwood and bits of rubbish; the giant "soft" sculptures of toothpaste tubes, telephones, typewriters, electric mixers, fans, and models of the Chrysler Airflow, circa 1935 (the nostalgic element), made of stuffed canvas and vinyl; and a large miscellany, done in the past three years, from the "Giant Soft Drum Set" to the shining 1969 "Giant Saw,"

which flows from the wall on the floor in hinged segments. Most of these pieces are extremely amusing in an eye-opening way; in them the familiar and manmade pass over into the natural, the absurd, and the abstract, as in the assemblage of cylindrical forms that turn out to be simulations of enlarged cigarette butts, and the row of pendulous organs that identify themselves, with some difficulty, as four Dormeyer mixers. Oldenburg has the offside mind and deadpan of the comedian-visionary. (Physically, he reminds me of Arp, who half a century ago unveiled the sculptural possibilities of an eggcup.) His natural attitude is anti-social, his theatre is "a poor man's theatre." His attacks on society are potshots, as befits an artist; the forms he finds inhering in objects may "of themselves" become grotesque or savagely satirical.

That Oldenburg achieves his formal disclosures through a Swiftian isolation and blowup of detail inevitably associates his constructions with fun-house novelties and Hollywood dream carpentry, and this association is encouraged by his lapses into literalism, as in the huge light switches, mammoth shirts, and period-style West Coast motel bedroom. For those who know his work largely through his oversized tea bag and twenty-four-foot lipstick designed as a monument, Oldenburg has probably defined himself as a maker of visual gags. I can think of no better way to correct this impression than to start the tour of his Museum of Modern Art retrospective with the drawings and water-color sketches on the third floor. There the ideas of the artist appear in their inception, when the qualities of his draftsmanship and his thinking contend on equal terms with his subject matter, so that the study of Good Humor as a monument, or a pack of cigarettes as a museum, is no more distracting than the drawing of an obelisk or a figure on horseback. Throughout his career, Oldenburg's object-making, like his experiments with theatre and environments, has been accompanied by tireless sketchbook drawing and writing. The pencil, crayon, and water-color drawings, in their sensitivity of line and compositional clarity, put his poetry and his tactile imagination in first place, and relieve him of debt to either prevailing art concepts or the Pop ace-in-the-hole of aesthetic incongruity.

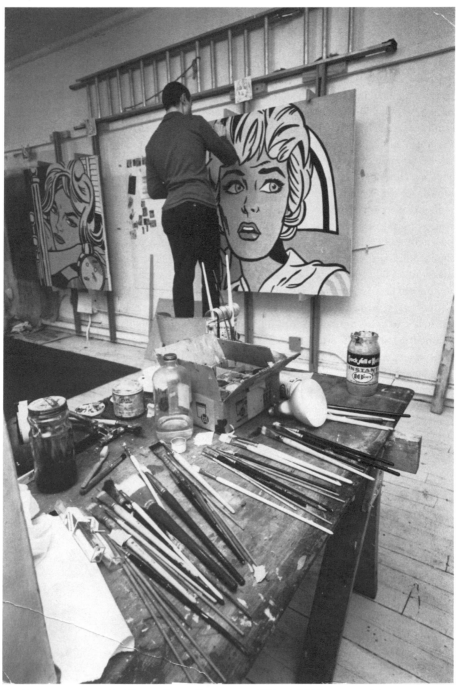

Roy Lichtenstein in his studio. He is working on Nurse, *1964, with* Blonde Waiting, *1964, at left. Photograph by Ken Heyman.*

EVERYTHING CLEAR NOW?

Unsigned

A large picture of a red, white, and black handclasp in the style of Chester Gould, the creator of "Dick Tracy," hangs on the second door of an East Side New York town house, at the head of an elegant, curved staircase. Just beyond, in the main showroom of the Castelli Gallery, there is a picture of a golf ball the size of a medicine ball, a painting of a coiled electrical extension cord, a cartoon kiss reminiscent of Milton Caniff ("Steve Canyon"), an 8-foot by 6-foot hand pushing the button of an Aerosol can.

All this is the art of Roy Lichtenstein, whose show opened there last week.

Owner Leo Castelli glided into the main gallery in soft black loafers and a gray flannel suit and, with a conviction that only a dealer can muster, launched into his Lichtenstein lecture: "To say that Lichtenstein's paintings are like overblown comic strips is oversimplifying the problem. He paints from posters, or from instruction brochures, or advertisements, or the pictures on bleach bottles. He never paints from life. Even if he is painting a beer can, he paints only from a picture of the beer can."

As Castelli talked on, he placed Lichtenstein in the main stream of contemporary esthetic pioneering – somewhere between Robert Rauschenberg (whose assemblages of old shirts, mattresses, and bed sheets Castelli handles) and Jasper Johns (whose painted targets, flags, and calendars Castelli also handles).

"When Lichtenstein first brought these paintings into me, I didn't understand them," he admitted. "He didn't know quite what he was doing, either. The important thing is scale. He did a bathroom but it was not right. At last, I figured it out. The golf ball is huge. But the toilet bowl and the sink in that bathroom are only the size of any toilet bowl or sink. Part of it is scale, and part of it is the plastic quality, a mysterious quality that only experience can show you. Look at that picture! There is not an idea in it! But it is a painting. And Lichtenstein is a painter!"

It is a subtle yarn that Castelli knits, but it is not one of his own making. He has spotted a trend of which Lichtenstein is but one example. There is James Rosenquist, a former poster painter on Times Square, who paints legs, bottle tops, and typewriter keys in the heroic proportions of the Victoria Theater billboards. There is Wayne K. Thibaud [sic], in California, who paints pies – gooey chocolate-cream pies – in rows, just the way they are on bakery shelves. "Art," remarked Castelli, "is what you will it to be. One must rise above one's own taste, sometimes."

IN THE GALLERIES: ROY LICHTENSTEIN

Donald Judd

The funny papers have again caused outrage among the respectable; this time it is not morals but art that is being corrupted. The premises of the status quo, which is multiple, being moribund at stages dating from recently back to the nineteenth century, have been ignored. Respectability comes quickly, is strong and can be shrewd. Lichtenstein's comics and advertisements destroy the necessity to which the usual definitions pretend. In part this social benefaction is aside from the gist of the work. Other than that aggravation there are few reasons for using comics. There may be reasons as to the social meaning of comics and the aesthetic meaning of enlarging them, but these would be minor. It is not so unusual to appreciate the directness of comics; they look like Léger, as do these versions of them. The commercial technique – non-art – is part of the jolt, but the schematic modeling, the black lines and the half-tones of Ben Day dots resemble Léger's localized modeling and black lines around flat colors. Lichtenstein is hardly as good as Léger, but is fairly good and has something on his own. He has added slightly to the ways of being open and raw. Ironically, the composition is expert, and some of it is quite traditional, as in one large panel of a pilot kissing his girl. The two heads, taking up most of the room, are undercut from the right by the ultramarine blue of the runway and the black shadows of the girl's blond hair. The coil of hair, spiral facing outward, concludes the sweep and provides a short, massive, central vertical at the lower edge. The pilot's red-dotted hand, clutching the girl's hair, repeats the vertical in the black. Her hands and his shoulder weave up the left edge. There are other panels and single figures from comics, and details, often single objects, from advertisements. The most unusual range of color is the red-black one, which is somewhat shrill. Perhaps a cadmium red medium is used. The distinctions are definite between red dots within a black line, the canvas or black dots within a black line and areas of red or black. (Castelli, Feb. 10–Mar. 3.)

Arts, April 1962: 52–53; © 1997 Donald Judd Estate / Licensed by VAGA, New York, NY

ROY LICHTENSTEIN AND THE REALIST REVOLT

Robert Rosenblum

In the twentieth century, the tempo of artistic change is frighteningly rapid. In America, what was only recently seen as a triumphant new constellation of major painters (whose styles ranged from the "action painting" of Pollock to the "inaction painting" of Rothko) has suddenly receded into a position of "old master" authority that poses a heavy burden upon the younger generation. Some of these "old masters" themselves have found difficulties in maintaining the superb quality they achieved a decade ago; and for their successors, the problem has been even more acute. To yield to the power of what had quickly become a tradition meant an *a priori* condemnation to a secondary, derivative role. One might be certain of producing beautiful, virtuoso paintings by working within these given premises, but one also risked never creating any truly new ones. To be sure, some recent painters have succeeded against these enormous odds in producing work of extremely high quality and originality (Stella, Louis, and Noland, among them); but in general, most abstract painting of the later 1950's and early 1960's has begun to look increasingly stale and effete. Even in the hands of the most gifted satellites, it has often turned into a kind of academic product in which rapid, calligraphic brushwork – once the vehicle of daring innovation and intensely personal expression – was codified into a mannered, bravura handicraft *à la* Sargent; and large-scaled formal simplifications – once majestic and emotionally overwhelming – have frequently become merely decorative and hollow. Moreover, a commitment to a purely formal realm, untainted by references to things seen outside the confines of the canvas, began to be felt by many as a narrow restriction that prevented commentary on much that was relevant in contemporary American experience.

Some artists responded to this predicament by reintroducing fragments of reality, either in fictive or in actual presence, within a style that remained essentially dependent upon the "old masters" and especially upon de Kooning. A newer and more adventurous path has rejected still more definitively this dominating father-image by espousing, both in style and in frame of reference, exactly what most of the masterful older generation had excluded. The early flags, targets, and numbers of Jasper Johns were decisive signposts in this new direction. Not only did they reintroduce the most unexpectedly prosaic commonplaces in the poetic language of abstraction; but, equally important, they at first used the actual visual qualities of these images as positive pictorial elements. The flat objects Johns originally painted were painted as flat objects, identical with the picture plane, and not as seen through abstract-expressionist lenses that shuffled and fractured colors, contours, and planes. What was rejuvenating about these works was not only the bald confrontation with a familiar object in the arena of a picture frame, but also the bald clarity of the pictorial style which accepted the disarmingly simple visual data of these signs and symbols – total flatness, clean edges, pure colors, rudimentary design. To spectators accustomed to the dominant modes of abstract painting, these pictures were a jolting tonic, like a C-major chord after a concert of Schoenberg disciples. In the same way, Johns's recent sculptures – beer cans, flashlights, light bulbs – challenged the complex spatial lacerations of abstract by accepting wholly the lucid solid geometries of these mundane, uncomplicated forms.

Metro, April 1963: 38–45

In the past few years, Johns's brilliant solutions to the problems of a younger American generation have borne new fruit in the work of an amazing number of artists who have attempted, with varying degrees of success and many failures, to undermine the authority of both the abstract and expressionist components of abstract expressionism. The sheer quantity of these artists amounts virtually to a revolution or, at the very least, a revolt, among whose major manifestoes are the paintings of Roy Lichtenstein.

In a sense, Lichtenstein's position may be compared to Courbet's. To the French master in the 1850's, both sides of the Ingres-Delacroix coin presented an artificial idealism of style and subject which he combatted not only by the intrusion of vulgar content – whether toiling workers or sweating whores – but also by the adaptation of vulgar styles, particularly popular prints, *images d'Epinal,* whose stiff composition and childlike drawing offered an earthy antidote to the weakening stylistic conventions of the Romantic and Neoclassic modes. In the same way, Lichtenstein embraces not only the content, but also the style, of popular imagery in mid-twentieth-century America as a means of invigorating the moribund mannerisms of abstract painting. It is revealing that negative criticism of his art has generally been phrased in the same terms as negative criticism of Courbet's art – the subjects are considered too ridiculously ugly, the style too preposterously coarse for "art." The idealist voice of the mid-nineteenth-century academy has been replaced by the no less idealist voice of the mid-twentieth-century one.

Like Andy Warhol and James Rosenquist, Lichtenstein has chosen the ugliest and most ubiquitous kind of commercial imagery – comic strips, soapbox diagrams, cheap advertising illustrations – as a source for his reformatory art. In place of the aesthetic idealism of recent abstract painting, he substitutes the most vulgar realism of a mass culture's visual environment. The abstract expressionist's veneration of personal brushstroke and private emotion is now opposed by a machine-produced style derived from an industrial, public domain. But just as Stuart Davis and Léger obliged us to realize that twentieth-century urban imagery could be metamorphosed into works of art, so, too, does Lichtenstein force us to examine American commercial illustration in terms of its aesthetic potential. As in the case of Johns's early flags, what is important is not only what is painted, but how it is painted. It is at first most unsettling, of course, to see the humanoid figures of a comic-strip frame blown up to easel-picture size; but the same comic-strip imagery painted in a style borrowed from, say, de Kooning would have far less conviction and force, creating instead a tepid compromise between the true nature of the subject and an alien pictorial manner. What is remarkable about Lichtenstein is that he has absorbed not only the sociological aspects of commercial illustration, but also its pictorial implications. With an irony familiar to the twentieth-century tradition, he has transformed non-art into art. His pictures are not only fascinating as imaginative commentaries on their popular sources, but also as abstract pictorial inventions whose power may initially be concealed by the unfamiliarity of his choice of subject. A case in point is *Little Aloha.* Enlarged to the dimensions of an oil painting and therefore placed in the context of a work of art, this Hawaiian love goddess obliges us to scrutinize her as we never did before. She may first be looked at as a distressing sociological phenomenon, a member of a strange new race bred by the twentieth century. Embodying a popular American erotic fantasy, this vulgarized descendant of Ingres' and Gauguin's odalisques is startlingly ugly, though her monstrous vapidity, alternately grotesque and comical, is consistently hypnotic. Her fascination, however, resides not only in the cultural shock of really examining for the first time a spectacle so common that we have always closed our eyes to it, but also in the visual surprise of perceiving closely the mechanized pictorial

conventions that produce this creature. Much as many nineteenth- and twentieth-century artists were excited by the unfamiliar flatness and simple linear means of styles that ranged from Greek vase-painting and Japanese prints to children's drawings and primitive textiles, Lichtenstein now explores the mass-produced images of the crassest commercial illustration. By magnifying these images, he reveals a vocabulary of uncommon rudeness and strength. Coarse and inky contours, livid primary colors, screens of tiny dots, arid surfaces suddenly emerge as vigorous visual challenges to the precious refinements of color, texture, line, and plane found in the abstract-expressionist vocabulary.

Like all artists, however, Lichtenstein has chosen his visual sources discriminately and has learned to manipulate them in the creation of a style that has become uniquely his. From the multiple possibilities offered by commercial illustration, he has selected those devices which produce a maximum of pictorial flatness – thick black outlines that always cling to a single plane; an opaque, unyielding paint surface that bears no traces of handicraft; insistently two-dimensional decorative patterns – woodcut arabesques and mechanically regimented rows of dots – that symbolize texture and modelling. Thus, the Hawaiian girl is first seen as an illusion of the most voluptuously contoured anatomy, but these sensual swellings are quickly and brutally ironed out by the two-dimensional conventions of Lichtenstein's style. Like the nudes of Ingres, whose anatomies become so monstrous when extracted from their compressed spaces, Lichtenstein's exotic lady offers a compelling tension between the abstract autonomy of sinuous contour and compositional flatness, and the resulting distortions of a jointless arm, a muscleless throat, a boneless face. Throughout the painting this interplay of style and subject commands attention, whether one looks at the rude contrast between a flat black and flat red shape that creates a lipsticked mouth, the rich, curvilinear inventions that indicate shading and texture in the cascades of black, perfumed hair; the totally flat patterns of tiny red dots that alternately become rounded, pink flesh. *Head, Yellow and Black* belongs to the same genetic and pictorial race. The American counterpart of her Hawaiian cousin, she is a pretty girl of the domestic variety; but again, studied closely, the total vacancy of expression and the amphibian physiognomy provide a shocking sociological observation, which, in turn, is supported by an equally startling pictorial invention. The cosmetic complexities of mascaraed eyes, tweezed eyebrows, and permanent waves are transformed into linear abstractions of almost Art Nouveau fantasy. This rich visual incident is then contrasted to the taut and bleak expanses of empty skin surface, monotonously textured background, and mat black dress, so that the whole creates a calculated pictorial intricacy surprising in what seems, to begin with, so crude an image.

In *The Kiss*, the "girl next door" meets her mate, a virile Air Force pilot who seems to have dropped from the clouds in order to provide the total ecstasy that, in a less secularized society, was once experienced by a swooning Santa Teresa. This fervent embrace – a crushing fusion of blonde hair, a military uniform, polished fingernails, deeply closed eyes, and a momentarily grounded airplane – is again masterfully composed in terms of a remarkable variety of linear and textural invention, witness only the sweeping descent of erotic abandon that begins with the pilot's visor and continues downward through the forehead of Miss America, the part in her hair, and finally the knuckles of the clenched male fist.

Lichtenstein's sociological exploration of American mores is further elaborated in the *Eddie Diptych*, which describes the dramatic rupture between teen-age daughter and disapproving parents so common in popular fiction. Ironically reviving the narrative means of a medieval religious painting (a diptych with long verbal description, here both solilo-

quy and dialogue), the *Eddie Diptych* presents a comic-strip crisis in which the ingredients of Western tragedy are bizarrely reflected. Youthful rebellion, parental opposition, omnipotent love are recreated by the *dramatis personae* of this vulgar literary medium with results that are at once funny and disturbing as an accurate mirror of modern popular culture. Pictorially, the diptych is no less intriguing. The colors – the harshest yellow, green, blue, red – produce flat and acid surfaces of unfamiliar visual potency; and the complex lettering is used ingeniously as both a means of asserting the composition's taut flatness and as a delicate decorative pattern of black and white that relieves the assaulting intensity of the opaque colors. The enclosing white frame of the right wing and the structure of the lettering in the left wing – a column arranged around a vertical axis of symmetry – are particularly handsome pictorial devices culled from comic-strip sources but assimilated to Lichtenstein's personal style.

If Lichtenstein has imagined new heights and depths of American comic-strip drama, he has also considered the more prosaic domain of American advertising. The national fetish for domestic cleanliness revealed in ads for everything from soap flakes to bathroom deodorizers is reflected in a number of pictures that extoll the virtues of Good Housekeeping. In *Woman Cleaning*, the gigantic head of a synthetic housewife smiles down at us to register the pleasure and ease of a periodic refrigerator cleaning. In other pictures, these sanitary rituals are further dehumanized. Following the images of mechanization that Léger had explored in the 1920's, Lichtenstein at times shows a disembodied hand performing a simple functional operation. In *Spray*, only the pressure of a housewife's manicured finger is necessary to freshen domestic air; in *Sponge*, the effortless sweep of a lady's left hand works cleansing miracles. Here again, the mass-produced coarseness of Lichtenstein's visual sources – the diagrams on the labels of sanitary products – is unexpectedly transformed by a witty pictorial imagination. In *Sponge,* for instance, the blank, untextured areas vividly convey textures as unlike as skin, sponge, and enamel, just as the familiar screen of dots derived from cheap printing processes is instantly identified with a coat of dust and grime.

Similar hygienic concerns dominate *Step-On Can with Leg*, where the compartmented, sequential arrangement of "how-to-use" diagrams inspires a two-part pictorial demonstration of how a flowered garbage pail is opened by stepping on the pedal. The dainty pressure of a high-heeled shoe, as seen on the left, is apparently sufficient to raise the lid, as seen on the right. Pictorial as well as mechanical rewards are offered in Box Two, where the checkered pattern of a dress, now visible in the upper left-hand corner, and the changed position of the garbage part complicate the simple symmetry of the image in Box One. A diptych is again used in *Like New*, in which the "before-and-after" demonstrations of American advertising are transformed into a painting whose abstract qualities are more explicit than usual in Lichtenstein's work. Here an ad for invisible weaving is surprisingly enlarged in a two-part symmetrical design. What first seems, however, a boxingly tidy regularity of mechanically repeated dots and sawtooth edges is unexpectedly upset by the darkened, irregular aureole in the left panel, which is suddenly recognized as a cigarette burn in a swatch of cloth. There could hardly be a better example of Lichtenstein's ability to recreate the tawdry visual environment of commercial imagery as an extraordinary abstract invention.

Lichtenstein's inventory of American popular culture includes any number of cherished objects that range from ice-cream sodas and new tires to beefsteaks and dishwashers. Like the machine-made creatures who use them, these objects are mass-produced forms of unforgettable ugliness. *Black Flowers* provides the Woolworth's contribution to

the art of flower arrangement – a hideous china vase stuffed with a cornucopian abundance of poppies that must be made of plastic; and, similarly, the art of jewelry descends to the kitsch splendors of an advertised engagement ring whose crowning glories must surely be a glass pearl and two zircons. These 1984 horrors of mass production extend as well to food. *Turkey*, the American dream of a holiday dinner, becomes an inedible, inorganic merchandising product; and Lichtenstein's other selections from supermarket and drugstore displays are no less synthetic and indigestible conclusions to the pleasures and graces of the Western still-life tradition.

Even more startling are Lichtenstein's recent comments on another familiar product of American merchandising – great works of art. Appropriate to a period in which the Sistine Ceiling can be bought together with toothpaste and breakfast food, Lichtenstein focuses the mechanized lens of mass production on these sacrosanct, handmade relics of the Western tradition. *Man with Folded Hands* looks at a great Cézanne portrait through the eye, first, of a reductive compositional analysis in a published study of Cézanne, and then through the eye of Lichtenstein's own style in which wall plane and dado become a screen of printer's dots, infinitely reproducible, and the figure becomes a simplified linear diagram that transforms it into the pictorial equivalent of plastic flowers. This reinterpretation of artistic tradition in the commercial light of the 1960's is even more astonishing in Lichtenstein's version of Picasso's *Femme au chapeau*. Here the horror of a Picasso head of the 1940's – part human, part bull, part dog – becomes still more bizarre when read through Lichtenstein's vocabulary. The flat, opaque colors and vigorous black outlines are consonant enough with Picasso's own style to permit the grotesque force of the original painting to be felt; but this comical ugliness is further compounded by imposing the mass-produced schematization of a comic-strip image upon it. In the realist tradition of the nineteenth and twentieth centuries, Lichtenstein has found his content in a fresh examination of the shocking new commonplaces of modern experience that had previously been censored from the domain of art; and in that tradition, he has suddenly rendered visible what familiarity had prevented us from really seeing, whether comic-strip dramas or Picasso reproductions. More than that, he has succeeded in assimilating the ugliness of his subjects into new works of art, whose force and originality may even help to reconcile us to the horrors of the Brave New World in which we live.

ROY LICHTENSTEIN, FERUS GALLERY

Douglas McClellan

> *Why Brad darling, this painting is a masterpiece! My, soon you'll have all of New York clamoring for your work.*

There is a superb irony in this sentiment when mouthed by the pretty girl to the vapid Troy Donahue type standing next to her in the painting "Masterpiece." Any "in" person can chuckle at the "inness" of the convolutions of meaning, but as paintings "Masterpiece" and its companions scarcely exist. They are tokens like the decay-proof smile on the family that used Crest, or like the ecstasy of the girl who has found underarm safety. As paintings they are important simply because somebody thought to do them, not because they can exist in their own right. Probably they are intended as comment – some hip form of satire – but if they are out to puncture the vapid flim-flam that engulfs us, they only point, they do not comment. They are like an anonymous Letter-to-the-Editor, a default on the part of the author. The signature on the letter – the commitment through form by the artist – that gives substance to what is said is not there. Lichtenstein has seemingly rearranged nothing, he has stayed reverently close to the originals except for greatly enlarging the scale. He has avoided the risks of transformation and he has picked a cripple for a target. The comic page is a ritual art form, it is merely one of the ways we have found to turn absolutely anything into entertainment (possibly art is next in line). In the funnies, the world of human happenings is comfortably simplified by flaccid drawing, the only dimension is conveyed by mechanical dots, and life is represented by triumphant balloons of platitudinous speech rising from the mouths of the characters. It is like shooting fish in a barrel to parody a thing that has so long parodied itself. If his intent is really more sympathetic and not an act of criticism, then Lichtenstein must fall in with others, like the bad movie buffs, the perennial re-readers of Tom Swift, and other kewpie cultists; a man who finds pleasure and security in being the specialist's specialist about nothing in particular. In fairness, his range of subject material also includes sponges and a diagram of a Cézanne out of Erle Loran's book.

Artforum, July 1963: 47

IS HE THE WORST ARTIST IN THE U.S.?

Dorothy Seiberling

For some of America's best known critics and a host of laymen, the answer to the above question is a resounding YES. A critic of the New York *Times*, hedging only a bit, pronounced Roy Lichtenstein "one of the worst artists in America." Others insist that he is no artist at all, that his paintings of blown-up comic strips, cheap ads and reproductions are tedious copies of the banal. But an equally emphatic group of critics, museum officials and collectors find Lichtenstein's pop art "fascinating," "forceful," "starkly beautiful." Provocative though they are, Lichtenstein's paintings have done more than stir up controversy. They have done something significant to art – as discussed on a following page.

The critical stew enveloping his work is gratifying to Lichtenstein. A quiet, affable man of 40, he fully expected to be condemned for the subject matter as well as the style of his paintings. But he little dreamed that within two years of his first pop exhibition, his canvases would be selling out at prices up to $4,000 and he himself would be a *cause célèbre* of the art world.

THIS IS HOW HE BEGAN . . .

AND THIS IS HOW HE DOES IT

In 1951 Lichtenstein translated American artist William Ranney's *Emigrant Train* into Picasso-like shapes. Later he tried out variations on Disney cartoons.

At the outset of his career, Lichtenstein was engrossed in 19th Century Americana. He liked painting cowboys and Indians in modern art styles. Gradually he worked his way into 20th Century Americana like Mickey Mouse and bubble gum wrappers. In 1961 Lichtenstein began to explore comic books. Extracting single scenes, he translated them into paintings, using the techniques shown at right. [Editor's note: The original article included step-by-step photographs of Lichtenstein at work.]

Starting with a scene from a science fiction comic book, Lichtenstein made a small sketch of the composition. Then he used a machine to project the sketch to the size he wanted and traced it onto his canvas. To simulate photoengraver's dots, Lichtenstein laid a metal screen on the canvas, spread oil paint over the screen with a roller and rubbed the paint through the holes with a toothbrush. Undotted parts of the picture were masked with paper. Lichtenstein then painted in the letters and black outlines. The finished picture shows how Lichtenstein altered the cartoon by centering the face and balloon, adding a red helmet and turning the comic strip's question into a joke about his own art.

THE ARTIST HAS SOME ANSWERS

In the debate over pop art and Roy Lichtenstein, three questions keep cropping up.

Why – people start off asking, does Lichtenstein choose subject matter that is so banal, trivial, vulgarly commercial?

Just because it *is* that way, answers Lichtenstein. It is challenging, he says, to try to

make art out of "non-art" *i.e.,* cheap illustrations that are so crude, so slick and so utterly familiar they seem to defy any transformation into art.

There are other answers to this question about subject matter. Like most young artists, Lichtenstein wanted to stake out his own territory. He had dipped into abstract expressionism but found that the masters of that style had already worked out most of its problems. Besides he felt that it was too unrealistic, too inward. Lichtenstein was interested in looking out at the world, at the industrial, hard-sell environment. He gravitated to commercial illustration because "it was an area that hadn't been explored, it was taboo." And inevitably – since new generations of artists are inclined to take off in the opposite direction from their immediate predecessors – Lichtenstein chose an area at the opposite end of the pole from abstract expressionism. It was emphatically representational, depicting love stories, war thrillers, household products; it was impersonal, allowing no evidence of the artist's emotions; it was mechanically mass-produced, eliminating not only all painterly handiwork but originality and uniqueness.

Lichtenstein's paintings so successfully convey the effects of commercial art that they automatically prompt the next question. Does Lichtenstein transform his source material or does he merely copy it?

"The closer my work is to the original," Lichtenstein says in reply, "the more threatening . . . the content." And yet, to make sure that his paintings do "threaten" or otherwise disturb the viewer, he is forced to alter the original cartoon. He tries to make the composition tight, to unify the details so that the image comes across all at once. "I take a cliché and try to organize its forms to make it monumental. . . . The difference is often not great, but it is crucial."

Even if they take Lichtenstein at his word, most viewers wind up with the question: But is it art?

This is the attitude Lichtenstein wants to provoke. By his very act of painting such ignoble images on a giant scale and exhibiting them in an art gallery, he appears to make a mockery of both art and art lovers. He leaves the viewer wondering if his paintings are only parodies, ironic gestures, or if they will outlast their shock and give a new shape to art?

An increasing number of critics already accept Lichtenstein's work as art. They liken his injection of vulgar forms into painting to the equally brutal and controversial breakthroughs of such masters as Caravaggio who introduced an earthy realism into the refined art of 16th Century Italy, or Courbet who jolted 19th Century France with his rude peasants and explicit nudes. The critics further point out that Lichtenstein has not only brought back the figure with a wallop, he has also revitalized abstraction and firmly locked the two together. Between his powerful representational images whether girl or garbage can and his insistent patterns of dots, lines and glaring colors, there is constant competition and tension: flatness versus depth, content versus design.

Eventually, Lichtenstein and his admirers expect, the repulsiveness of his subject matter will wear off and viewers will become more aware, and perhaps appreciative of the esthetic qualities of his paintings. Right now, however, his subject matter dominates. He has magnified, and thus made inescapably visible, the most crassly materialistic and adolescent aspects of modern society. Some opponents of his work contend that he favors what his paintings reflect. Lichtenstein shrugs and refers back to the realistic painters of 50 years ago. "It's the same with me today as it was with the Ash Can painters. I'm in favor of these things as subject matter, but not as a social condition."

POP ARTIST SWITCHES TO AGGRESSIVE NEUTRAL BANALITY

John Ashbery

PARIS, June 14. – Pop Art returns this week in two important exhibitions, one by American Roy Lichtenstein, who started the whole thing, the other by Martial Raysse, a Frenchman.

Lichtenstein's show is his best so far. It will disappoint some admirers, since he has discarded the comic strips which made for much of the impact in his previous shows and now uses images that are almost aggressive in their neutral banality.

One is a conventional rendering of a Greek portico, situated squarely in a two-dimensional space that is the next thing to nowhere. Another is a sunrise of the "If-You-Can-Draw-This-I'll-Make-You-an-Artist-in-6-Months" school. A "Landscape" and a "Seascape With Clouds," done in the artist's usual way with dots from a Ben Day screen, are close to abstraction. He also shows some new abstractions, made of plastic, which look like the work of a sophisticated computer.

MILITANT NEGATIVISM

Thus, Lichtenstein has thrown out anything that could possibly be construed as picturesque or "interesting" in an effort to let his militant negativism shine through unobscured. One can no longer misinterpret his work as a lighthearted spoof of mass media, or make the mistake of the Museum of Modern Art curator who found it Fascist and militaristic because of the comic-strip generals who peopled it.

But, by attempting to block all escapes for the imagination, Lichtenstein actually provides it with new stimuli. The temple and the sunrise are not even conventionalized illustrations, but something even more barren and cheerless. Yet the mystery of what they are subsists and, in the end, becomes the dominant force in the picture.

The Surrealist heritage of Pop Art is more than ever apparent. But it is a kind of reverse Surrealism, obtained by depriving ordinary reality of poetic and imaginative connotations instead of imposing them on it. Lichtenstein's Greek portico is the reverse of Chirico's colonnades. The latter were the concrete expression of metaphysical dreams and obsessions; they incarnated the invisible world. Lichtenstein achieves similar results by stripping physical phenomena of everything but the bare outlines of their physical appearance. (37 Quai des Grands–Augustins; to July 10.)

TALKING WITH ROY LICHTENSTEIN

John Coplans

How do you do your paintings?

I just do them. I do them as directly as possible. If I am working from a cartoon, photograph or whatever, I draw a small picture – the size that will fit into my opaque projector – and project it onto the canvas. I don't draw a picture in order to reproduce it – I do it in order to recompose it. Nor am I trying to change it as much as possible. I try to make the minimum amount of change, although sometimes I work from two or three different original cartoons and combine them. I go all the way from having my drawing almost like the original, to making it up altogether, it depends on what it is. Anyway, I project the drawing onto the canvas and pencil it in and then I play around with the drawing until it satisfies me. For technical reasons I stencil in the dots first. I try to predict how it will come out. Then I start with the lightest colors and work my way down to the black line. It never works out quite the way I plan it because I always end up erasing half of the painting, re-doing it, and redotting it. I work in Magna color because it's soluble in turpentine. This enables me to get the paint off completely whenever I want so there is no record of the changes I have made. Then, using paint which is the same color as the canvas, I re-paint areas to remove any stain marks from the erasures. I want my painting to look as if it had been programmed. I want to hide the record of my hand.

Do you like to do everything by hand in your painting?

Yes. I like to have full control, but I don't care if this control is obvious. For example, I am very happy when the factory takes my painting and makes an edition of enamels on steel. To be explicit, this is what I actually do: I do a full-sized cartoon on paper for the enamel people with acrylic color. They cut stencils from my cartoon and make an edition of perhaps six enamels. I have done it once and I am very happy that the six enamels all came out beautifully in their factory technique. I like the style of industrialization but not necessarily the fact. I am not against industrialization, but it must leave me something to do.

Incidentally, were you a commercial artist at any time in your life?

No. I have done some industrial design, but that had more to do with engineering and drafting.

Did this have any influence on your painting?

Yes. I used to do paintings with drafting and radio symbols in them. Probably the exacting requirements of drafting have had some influence on my work. It helped me to organize and simplify.

What kind of problems did you encounter when you first began working in this style?

I had difficulty in getting into this. The early work was a little "tacky" because I didn't know how to draw in a comic book style.

In your early work, that is in 1961, you seemed to be very aware of what you were up to. There is tremendous diversity of imagery. Were you plugging holes?

Yes. The first show was very diverse. I did the *Roto-Broil;* the *Engagement Ring;* a round picture *The Cat,* which I got from a cat food package; the *Golf Ball,* which was a single object in black and white; *In,* which was just letters; and *Soda,* which is blue and white. I like the idea of blue and white very much because a lot of commercial artists use

Artforum, May 1967: 34-39, © John Coplans

it to get a free color. Blue does for black as well; it is an economic thing. So I liked the idea of an apparent economic reason for making one color work as two colors. Sometimes commercial artists use blue lines with yellow or two colors overlapped in a certain way to look like three colors. Using a configuration which has arisen because of economic expediency – I like that. Of course when these things are done in painting it has another meaning because, obviously, they are not expedient. That has its humor, but it also has other aspects in that a form has been developed that is recognizable to the society. I mean that *this* is a picture of a girl, *that* is a picture of a light cord and it becomes an easily identifiable thing, but this kind of portrayal is so unreal when compared with the actual object. This is something that interests me, plus the fact that these portrayals are taken for *real*. I mean in the same way that a frankfurter looks nothing like the cartoon of it – there are no black lines, dots, or white highlights on the original. In the picture the form becomes a purely decorative abstract object which everyone instantly recognizes as a frankfurter. It becomes a very exaggerated, a very compelling symbol that has almost nothing to do with the original. It has partly to do with the economics of printing, partly to do with the gross vision of the artist. It is very compelling for reasons that have nothing to do with art.

What about the limited range of color you use?

At the beginning I picked out four contrasting colors that would work together in a certain way. I wanted each one as complete in its own way as it could be – a kind of purplish-blue, a lemon-yellow, a green that was between the red and the blue in value (I don't use it too much because it is an intermediate color), a medium-standard red, and, of course, black and white.

You don't vary these colors?

No, and if they have varied it's because different manufacturers' products are varied. I use color in the same way as line. I want it over-simplified – anything that could be vaguely red becomes red. It is mock insensitivity. Actual color adjustment is achieved through manipulation of size, shape, and juxtaposition.

Which of your images are invented from the start?

The explosions, landscapes, and brush strokes. The heads usually come from one or two photographs.

What led you to do the temples?

A Greek restaurant I went to has a wall with repeatedly stenciled Parthenons. The wall was red with the Parthenons sprayed on through a stencil with silver paint. Because of the obviously "hokey" quality of the silver paint, and the very quick method of reproducing the Parthenons by spraying an image through a stencil, it is like a "Modern Times" duplication of a masterpiece. I tried to do that by making a stencil and spraying through it, but somehow it just didn't have the style of the restaurant mural. I think my stencil was too intricate. Anyway, I'm not very sure what it was but the original had a quality that was perfect in its environment. Later, because I had been working in a cartoon style, I decided to do a cartoon of it.

Where did the George Washington image come from?

It is a wood-cut version of one of Gilbert Stuart's portraits of Washington which I saw in a Hungarian national newspaper. I don't read Hungarian so I don't know what it said about Washington.

What about the various common objects you painted, for example, the ball of twine, etc.?

I think that in these objects, the golf ball, the frankfurter, and so on, there is an anti-

Cubist composition. You pick an object and put it on a blank ground. I was interested in non-Cubist composition. The idea is contrary to the major direction of art since the early Renaissance which has more and more symbolized the integration of "figure with ground."

What led you to the landscapes which, incidentally, seem to be very optical?

Well, partly it was a play on Optical Art. But optical materials might be used in commercial art, or in display, you use an optical material to make a sky, because the sky has no actual position – it's best represented by optical effects.

And the sunsets?

Well, there is something humorous about doing a sunset in a solidified way, especially the rays, because a sunset has little or no specific form. It is like the explosions. It's true that they may have some kind of form at any particular moment, but they are never really perceived as defined shape. Cartoonists have developed explosions into specific forms. That's why I also like to do them in three dimensions and in enamels on steel. It makes something ephemeral completely concrete.

Where did you get the image for the engagement ring?

It was actually a box in a comic book. It looked like an explosion.

Did you find or invent the brush stroke image?

Although I had played with the idea before, it started with a comic book image of a mad artist crossing out, with a large brush stroke "X," the face of a fiend who was haunting him. I did a painting of this. The painting included the brush stroke "X," the brush, and the artist's hand. Then I went on to do paintings of brush strokes alone. I was very interested in characterizing or caricaturing a brush stroke. The very nature of a brush stroke is anathema to outlining and filling in as used in cartoons. So I developed a form for it which is what I am trying to do in the explosions, airplanes, and people – that is, to get a standardized thing – a stamp or image. The brush stroke was particularly difficult. I got the idea very early because of the Mondrian and Picasso paintings which inevitably led to the idea of a de Kooning. The brush strokes obviously refer to Abstract Expressionism.

You have never been particularly interested in a sequence of images as in the comics?

No, although I have done a few linked-panel cartoons. There was one five-panel series that got broken up. I thought of it as two diptychs and a single painting in the middle linking them up. It was a five-panel sequence, but a sort of mysterious sequence as though you had walked into the middle of a soap opera. Although you couldn't really figure out what was going on, the story had a cohesiveness.

What gave you the idea of using war imagery?

At that time I was interested in anything I could use as a subject that was emotionally strong. Usually love, war, or something that was highly charged and emotional subject matter. Also, I wanted the subject matter to be opposite to the removed and deliberate painting techniques. Cartooning itself usually consists of very highly charged subject matter carried out in standard, obvious and removed techniques.

Why did you particularly choose a diagram from Erle Loran's book on Cézanne as a basis for a painting?

The Cézanne is such a complex painting. Taking an outline and calling it Madame Cézanne is in itself humorous, particularly the idea of diagramming a Cézanne when Cézanne said, ". . . the outline escaped me." There is nothing wrong with making outlines of paintings. I wasn't trying to berate Erle Loran because when you talk about paintings you have to do something, but it is such an oversimplification trying to explain a painting by A, B, C and *arrows* and so forth. I am equally guilty of this. *The Man With Arms Folded* is still recognizable as a Cézanne in spite of the fact it is a complete oversim-

plification. Cartoons are really meant for communication. You can use the same forms, almost, for a work of art.

How do you relate to the Picasso paintings?

They were intriguing to do for some reason which I think I can talk about to some extent. First of all, a Picasso has become a kind of popular object – one has the feeling there should be a reproduction of Picasso in every home.

You mean he is a popular hero and everyone thinks he represents art today?

Yes. I think Picasso the best artist of this century, but it is interesting to do an oversimplified Picasso – to misconstrue the meaning of his shapes and still produce art. Cézanne's work is really diametrically opposed to something like a diagram, but Picasso's isn't, nor is Mondrian's. Mondrian used primary colors and Picasso used basic kinds of colors – earth colors – although that's not even true most of the time. But there is a kind of emphasis on outline, and a diagrammatic or schematic rendering which related to my work. It's a kind of "plain-pipe-racks Picasso" I want to do – one that looks misunderstood and yet has its own validity. A lot of it is just plain humor.

How much difference is there in the drawing, placement, etc., between the real Picasso and yours?

Quite a bit. Usually I just simplify the whole thing in color as well as in shape. Anything slightly red becomes red, anything slightly yellow becomes yellow, and the shapes become simplified, although in some paintings Picasso simplified to a greater extent than I often do. I don't think simplification is good or bad – it is just what I want to do just now. Picasso made the *Femme D'Algiers* from Delacroix's painting and then I did my painting from his.

Why didn't you ever do a Léger?

It's funny, Léger is someone I didn't understand. I used to think he was just doing clichés. Later I understood the sensibility. I realized that he did it for reasons that have to do with industrialization and "hardness." Recently I have been tempted to do a Léger; it's something I may yet do. I like the idea. He really isn't someone I think I am like, yet everyone else thinks I am like him. I can see a superficial relationship, for obviously there is the same kind of simplification and the same kind of industrial overtones and clichés. My work relates to Léger's, but I admire Picasso more than I do Léger.

What about Stuart Davis?

I like his work. He is as good a precursor of Pop art as anyone. He had the gas station idea, but it was linked to a Cubist esthetic – which mine is to a degree, but not as much. Mine is linked to Cubism to the extent that cartooning is. There is a relationship between cartooning and people like Miró and Picasso which may not be understood by the cartoonist, but it definitely is related even in the early Disney. However, I think what led the American cartoonists into their particular style was much more the economics of the printing process than Cubism. It was much cheaper for the artist to color separately by hand. The reason for the heavy outlines, of course, was partially for visibility and partially because the colors didn't separate very well. You could use the outlines to "fudge" over the incorrect color registration.

What about the very marked difference between your early unsophisticated girls and the later sophisticated ones?

Well, I think that may be because I couldn't draw cartoons very well after years of abstract painting.

You didn't get more interested in sophisticated girls and notice hair styles, makeup and so on?

Yes. In the early ones I was looking for a tawdry type of commercialism as found in the yellow pages of the telephone directory. They were a great source of inspiration. Then another archetypical beauty became more interesting to me.

You mean the highly confectioned woman?

Yes, it's another kind of unreality; but the drawings of them by commercial artists seem to be much more skillful.

It relates to the way women present themselves or the way they would like to be?

Yes. Women draw themselves this way – that is what makeup really is. They put their lips on in a certain shape and do their hair to resemble a certain ideal. There is an interaction that is very intriguing. I've always wanted to make up someone as a cartoon. That's what led to my ceramic sculptures of girls. I was going to do this for some fashion magazine. I was going to make up a model with black lines around her lips, dots on her face, and a yellow dyed wig with black lines drawn on it, and so forth. This developed into the ceramic sculpture heads. I was interested in putting two-dimensional symbols on a three-dimensional object.

In many of your paintings, you make various references to past styles or particular painters.

Yes. I often transfer a cartoon style into an art style. For example, the Art Nouveau flames at the nozzle of the machine gun. It is a stylistic way of presenting the lights and darks. In the *Drowning Girl* the water is not only Art Nouveau, but it can also be seen as Hokusai. I don't do it just because it is another reference. Cartooning itself sometimes resembles other periods in art – perhaps unknowingly.

You mean cartoon artists are not very aware of their stylistic source?

I really don't know. I suppose some are. They do things like the little Hokusai waves in the *Drowning Girl.* But the original wasn't very clear in this regard – why should it be? I saw it and then pushed it a little further until it was a reference that most people will get. I don't think it is terribly significant, but it is a way of crystallizing the style by exaggeration.

ROY LICHTENSTEIN AND THE COMIC STRIP

Albert Boime

The original shock of Lichtenstein's paintings of enlarged details from comic strips has by now faded, and we may perhaps profit by examining more closely their formal characteristics.[1] The controversy initially provoked by these themes – especially in connection with such aesthetic criteria as "transformation" and "legitimacy" – consistently neglected the comic strip from the standpoint of its own expressive features.[2] If, as many critics believe, Lichtenstein's paintings have quality and significance beyond the shock of innovation, we might inquire what the artist discovered in comic strips and how he successfully exploited them for easel painting, especially the manner in which Lichtenstein related pictorial structure to subject matter.

The comic strip shares many features in common with its early forerunners like medieval blockbooks and manuscripts; they are all basically self-contained pictorial units combining both text and illustration on a single leaf or page. However, what distinguishes the type of pictorial narrative known as a "comic strip" from the woodcut and manuscript page (sometimes also employing a sequence of panels) is the particular presentation of written narrative in connection with the illustration. Specifically, it is the "balloon" used as a vehicle for dialogue that distinguishes the comic strip from its forerunners. In earlier illustrations, text and dialogue were generally enclosed in plaques, banners or scrolls bearing little relation to individual characters, or they appeared below the illustrations in the form of legends.[3] As in the *Biblia Pauperum* or Brandt's *Ship of Fools*, each picture was accompanied by a legend expressing a moral or didactic theme. This practice was later adopted by humorous illustrators in the form of "he-she" cartoons, and presently survives in the "gag" cartoons of popular periodicals. Although the balloon device had been used in political cartoons as early as the eighteenth century, it was not considered fashionable for sophisticated illustration. George Cruikshank, in the 1820s, was perhaps the first to employ systematically the balloon in book illustration.[4] But he stands as an isolated example in this respect, and apparently had few successors until the end of the century.

Before the balloon could be adopted by cartoonists the comic strip itself had to be developed for mass newspaper use. A major innovation in this development occurred in the 1840s, when the Swiss artist, Rudolphe Toepffer, employed a sequential narrative based on a series of panels.[5] Later, in this country, F. M. Haworth furthered this development by using the panels in a cumulative sequence, leading up to a dramatic climax.[6] By the last decade of the nineteenth century the distinctive components of the modern comic strip were present except for the balloon – still rejected in favor of the legend device. James Swinnerton, an American pioneer of the comic strip, once stated that at that time the balloon was considered archaic, belonging to a style buried with Cruikshank.[7] But in 1896 the written word moved back into the drawing with the advent of Richard Outcault's Yellow Kid. This strip was indirectly responsible for the revival of the balloon device; for the Yellow Kid's nightshirt, the focal point of the strip, carried written messages. Then in 1897, Rudolph Dirks, the creator of the *Katzenjammer Kids* for the *New York Journal*, began to experiment with balloon lines and found that his visual humor was enhanced by

Art Journal, Winter 1968–69: 155–59; reprinted by permission of the College Art Association, Inc.

this device.[8] Subsequently, with the demand for greater variety the balloon became a permanent addition to all comics.

The use of the balloon in comic strips is crucial to their effectiveness as a communicating medium. This can be seen by comparing present-day comics with the forerunners which made use of the legend below the illustration. In the latter, where a number of characters are present the identity of the speakers is confused and the action circumscribed. The advantage of the balloon lies in its ability to permit action to unfold clearly while directly pointing to each speaking character. It thus distinguishes individuals in any situation, conveys dialogue from figures off-stage and even gives utterance to inanimate objects. And through the clever use of what is known as a "thought" balloon the reader is permitted access to an otherwise hidden level of a character's consciousness. As a result of these advantages, the balloon, once a disquieting device for the cartoonist, is now an intricate part of our visual vocabulary. It is employed to such an extent in comics, advertising and other mass media that it is no longer read merely as a conventional symbol for speech but is identified as speech itself. The present success of the comic strip was in large measure dependent on the balloon device.

In the work of Lichtenstein based on comic strips, the most significant element in his compositional structure is the balloon. The appearance of this feature in every case almost indicates its importance in the mind of the artist as an integral part of the original panel. It is noteworthy also, that the titles of the pictures are invariably derived from the balloon dialogue. For Lichtenstein the effectiveness of the painting requires the presence of the balloon. For example, the adaptation of the Steve Roper panel *I Can See the Whole Room and There's Nobody In It!* employs the balloon as a unifying element in the composition. It extends the breadth of the painting, providing a balance wholly lacking in the original panel. Moreover, the contours of Lichtenstein's balloon form a series of diverging curves which recur throughout the work, and give it a rhythmical unity. This feature is repeated in the overlapping peephole cover, in the speaker's mouth and in the joints of his finger.[9] Perhaps it is most obvious in the parallel arcs found in the extreme right of the balloon and the outer edges of the peephole and its cover. There can be no doubt that these swooping curves, lacking in the original panel, are fundamental to the artist's compositional intent.

In another work, *Engagement Ring*, based on a panel from the *Winnie Winkle* series, the difference from the original is apparent and the balloon is entirely transformed. Lichtenstein has eliminated the right hand section of the panel and extended the width of the window to connect the two figures. The balloon is now larger in proportion to the compositional structure and overlaps both heads, linking them in an indissoluble bond. Significantly, the stem of the balloon is interwoven into the general design; it mirrors the concavity of the wavy hair and is taken up by the undulating S-curves that frame the woman's face. This is not fortuitous. The artist has grasped an understanding of the balloon's flexibility for his art while at the same time sustaining the comic allusion. In a later work, *Hopeless*, the most obvious change from the original panel is to be found in the location and shape of the balloon. As in the preceding work, Lichtenstein has eliminated all dead space from the panel and adjusted a floating balloon to overlap the close-up head. The density of the composition in the painting is due to this adjustment, and the result is a compactness lacking in the original panel. It may be noted that the increased volume of the balloon provides a counterbalance to the large mass represented by the girl's head.

In the *Brattata* the balloon is modified from the original to correspond more closely to

the shape of the pilot's visor. As in the *Engagement Ring* the balloon stem is carefully brought into compositional play with regularly recurring features in the picture. Departing from the straight stem of the original panel Lichtenstein repeats his own crescent shape in the speed lines of the falling plane, in the highlights of the visor and around the knob on the control panel. Its arc parallels the curve of the helmet and recurs in the contours of the pilot's profile. An even more significant change is Lichtenstein's formal emphasis of the cartoonist's visual "sound effect" of machine-gun fire (*Brattata*) not only in size and color but in the increased tilt which counterbalances the mass of the falling plane. A comparison with the original also reveals how Lichtenstein used the balloon in his correction from two to four as the number of downed planes required "to make Ace." The balloon quite effectively becomes the proper vehicle for authenticated fact.

Torpedo-Los! displays again the artist's awareness of the balloon as an essential factor in the comic allusion. Eliminating the ponderous balloons in the original panel, he adopted his own from a subsequent panel in the same sequence. With respect to the general masses of the composition the balloon's exclusion may not have been detrimental. But in this case the dialogue itself is ingeniously interwoven into the general design. The three alphabetic characters comprising the word "LOS" are clues to the composition's organic design. The "L" is mirrored in the angle formed by the captain's hand and the vertical contour of his head and in that of the periscope. The "O" is repeated in the tubing of the periscope. The "O" is repeated in the tubing of the periscope handle and in smaller details throughout the work. The oblique "S" recurs in the highlight of the captain's hat just left of the balloon, in the contours of the hat itself, in the shadow that falls along the left side of the captain's face, in the lines around his nose and in the curvilinear tubing of the periscope. Thus the dialogue enclosed within the balloon is visually exploited in the interests of compositional structure.

Perhaps the outstanding example of Lichtenstein's use of the balloon as a positive pictorial device is found in his presumed "self-portrait" – the *Image Duplicator*. In the original panel the balloon was only partially visible and overlapped the frame lines of the left side. In the painting Lichtenstein carefully centered it and closely correlated its shape with that of the face. The cloud-like configuration of the balloon is picked up by the contours of the face and repeated in the areas of indentation around the bridge of the nose. At the same time, the stem of the balloon is linked to the face through its undulating line which parallels the curve of the right eyebrow. As in the previous work the balloon provides the key to the entire compositional organization, and indeed, is the critical feature uniting all parts of the picture.

In conclusion we may say that the assimilation of comic imagery into Pop Art depended on the cultural saturation of that imagery; and the vitalizing effect of its devices and conventions became the conceptual and structural components of the artist working in the Pop Art mode.

NOTES

1. This study investigates the problem of transformation in Lichtenstein's art within the framework of formal analysis exclusive of technical inventions. The effect of enlargement, the "tightening" of the original comic drawing and the simulated Ben Day process are features that have already been treated effectively in other contexts. The fundamental studies are Robert Rosenblum, "Roy Lichtenstein and the Realist Revolt," *Metro 8*, March 1963, pp. 38 ff.; Lawrence Alloway, "Roy Lichtenstein," *Studio International*, vol. 175, January 1968, pp. 25 ff.

Other articles of note are John Coplans, "An Interview with Roy Lichtenstein," *Artforum*, vol. II, no. 4, October 1963, p. 31; Gene R. Swenson, "What is Pop Art?," *Art News*, vol. 62, November 1963, pp. 25, 62-63; Bruno Alfieri, "The Arts Condition: 'Pop' means 'Not Popular'," *Metro 9*, April 1965, pp. 5 ff.; Ellen H. Johnson, "The Image Duplicators – Lichtenstein, Rauschenberg and Warhol," *Canadian Art*, vol. 23, January 1966, pp. 12 ff.; Bruce Glaser, "Oldenburg, Lichtenstein, Warhol: A Discussion," *Artforum*, vol. IV, no. 6, February 1966, pp. 20 ff.; Richard Hamilton, "Roy Lichtenstein," *Studio International*, op. cit., pp. 20 ff.

2. See Erle Loran, "Pop artists or copy cats?," *Art News*, vol. 62, September 1963, pp. 48 ff.

3. However, there are exceptions in medieval art where text is made to emanate from individual figures. See E. Màle, *Religious Art from the Twelfth to the Eighteenth Century*, New York, 1959, Pl. 32; A. Grabar and C. Nordenfalk, *Early Medieval Painting*, Lausanne, 1957, p. 167. I am grateful to my colleague, Prof. Jacques Guilmain, for these examples.

4. Both Gillray and Rowlandson occasionally used balloons in their political and social satires, but generally their dialogue vehicles retained the vestigial character of banners and scrolls. The balloon contours themselves were often no more than a wispy thread – as if the artists wished to make them as unobtrusive as possible.

5. E. H. Gombrich, *Art and Illusion*, N. Y., 1960, pp. 336 ff.

6. In a sense, the work of Haworth was foreshadowed by Wilhelm Busch, who employed the sequential form in tiny vignettes. But Haworth separated the individual panels and elaborated his themes in the modern format. See W. Hofmann, *Caricature from Leonardo to Picasso*, New York, 1957, p. 121.

7. Cited in W. C. Gaines, "Narrative Illustration," *Print*, Summer 1942, p. 32.

8. C. Waugh, *The Comics*, New York, 1947, p. 11.

9. Curiously, Hogarth's treatise illustrates a comparison between two "kinds" of fingers bearing a remarkable affinity with the fingers in the Roper panel and Lichtenstein picture. Hogarth described the first as "a straight coarse finger," and the other as possessing the qualities of "the taper dimpled one of a fine lady." See William Hogarth, *The Analysis of Beauty*, London, 1753, p. 65 and Pl. II, figs. 82-83. To my mind there is a striking analogy between Lichtenstein's transformation and the Hogarthian concern for "grace" – as if Lichtenstein applied "the line of beauty" to the comic panel. Significant, too, is the fact that Hogarth and Lichtenstein are related to each other and to the tradition they bracket tending to elevate comic imagery to the status of "high" art. See E. H. Gombrich, "Imagery and Art in the Romantic Period," *Burlington Magazine*, vol. 91, June 1949, pp. 152 ff.

ROY LICHTENSTEIN

Diane Waldman

In the confusion attending the birth of a movement, the penchant for group identification is all but predictable. The problem arises after the event has occurred when the identification persists, despite fundamental differences in style among the artists working in a particular idiom. One need only recall the multitude of artists all too easily appropriated to Pop art to realize that the label served to obscure rather than clarify the situation. A label should more properly serve to record a moment, not a movement, or for that matter an individual. What the term provided was a declaration of the bond between these artists based on their use of the banal as subject. While this is a valid approach it offers little more than an interpretation of the most easily apprehended features of a work. At this level it also fails to distinguish between a major artist and the second or third rate practitioner of a style or to evaluate accurately the contribution of the major artist to his time. For the subject matter of any art form, whether comic strip or stripe, cannot be innovating without related formal innovations. One of the advantages of the "abstract" tradition was that it revealed to us, without the distractions of a representational subject matter, the process by which an artist went about making art. This lesson is as applicable to Pop art as it is to recent color abstraction, although the form that it takes is necessarily different. This is not to deny the importance of subject matter but simply to reaffirm that subject matter functions in any significant art form as the bridge by which the artist accomplishes the transition from the idea into art. It is against this framework that the substantive issues must be discussed, a development that has yet to take place. Among the major proponents of Pop to have been subject to this lack of critical perception, Roy Lichtenstein is surely one of the most misunderstood.

In the notorious marriage of a wholly radical subject matter with the methods of fine art, Roy Lichtenstein brought to a level of consciousness, both visual and intellectual, an awareness of the American life style and brilliantly proclaimed the comic strip as a fitting theme for the new American painting of the 1960's. One was forced to confront images of a new "reality" that challenged our accepted values and ways of seeing art. The advent of common household items as objects of pictorial concern is anathema to many, although it is easy enough to make an intellectual accommodation within the long tradition of genre painting. But the use of a cartoon type of imagery has proved an even greater stumbling block to an appreciation of Roy Lichtenstein's painting. Where the objects of Oldenburg or even Warhol's subjects have eventually become palatable. Lichtenstein's subject matter has remained singularly difficult. Both Oldenburg and Warhol, in their different ways, have employed a consistent but relatively limited repertoire of subjects which have been accepted largely by virtue of their familiarity. Lichtenstein, on the other hand, frequently changes his subject matter, using themes as diverse as cartoons and cathedrals, landscapes and the thirties, brushstrokes and pyramids, consequently catching his audience off guard. The need for such a protean subject matter is the stimulation that it provides the artist to extend the range of his formal ideas. This procedure has also allowed him continually to test an essential component of his style, the articulation between a "real" image and an abstract style. By placing optimum pressure on the subject, he

Exhibition catalogue, *Roy Lichtenstein*, Solomon R. Guggenheim Museum, 1969

is able to control the transformation from the original object to the finished image and to integrate convincingly the object with the picture plane. For some critics, however, Lichtenstein is all subject. They have acclaimed him for his iconoclastic subject matter, admiring the social and literary implications of the cartoon, and the possibility of treating any subject in comic strip style. To assume that the power and originality of Lichtenstein's work depends primarily upon its subject is to misunderstand the intent of his work. By its very nature, such an assumption implies that a sensational subject matter must be followed by an ever more outrageous one. This is, of course, not the case, for the landscapes, the brushstrokes, the modern paintings are consistent in their indication of another objective, the exploration of form.

The interest in the object was common to many artists working in the early 1960's. Among them, several artists, notably Kaprow and Oldenburg were experimenting with Happenings and the use of objects as important props for their performances. The use of such an imagery was not exactly new to Lichtenstein (*Ten Dollar Bill,* 1956). His earlier paintings, dating to the mid-fifties, covered such subjects as treaty signing, cowboys and Indians, other vintage Americana. Although he abandoned these paintings for Abstract Expressionism, which occupied him from 1957–1960, he soon began to introduce comic figures into these paintings and, in 1961, to work with the cartoon alone. *Look Mickey* is one of several paintings he did in the spring and summer of 1961 (other subjects were *Donald Duck* and *Popeye*) in which the image is handled in a low comedy manner. He replaced this type of cartoon with another that allowed him a greater flexibility than was possible to achieve with the first ones. He also began to feature ordinary household objects as the subjects of his paintings and it is in the development of a "kitchen" culture that he and Oldenburg are closely related at this time. Both Lichtenstein and Oldenburg tended to emphasize the single object, an emphasis that Oldenburg has for the most part retained while Lichtenstein has alternated between a single object and an allover or multiple focus composition. The objectness of Pop is the direct outcome of the influence of Johns and Rauschenberg. Both artists placed maximum stress on the actual physical attributes of an object. Johns' great contribution was to make a flag or a target both a literal object and a statement about the rectangle. Alone among the Pop painters, Lichtenstein has dematerialized the object and effected a new reconciliation with the picture plane. This is a significant device for it allows an object both its original identity (we retain our sense of the object as a three-dimensional form) and a new one. Oldenburg has pursued the transformation of the object in another way by recreating one three-dimensional object into another fully realized version of the same. Lichtenstein's use of a figure and ground, single image format, based on Picasso, was the means by which he made explicit the integration of the object with the picture plane. For the transformation of the object to be successful it is necessary to maintain an equilibrium between the original object and the translation of that object. In Lichtenstein's paintings the means of achieving this entails the conjoining of a "real" image and an abstract style. The use of such an image brings with it all the data we need to recall the actual object. The abstract style, on the other hand, serves another function, to transcend the literalness of the object. This allows Lichtenstein to reconcile the actual object and the image of the object on the picture plane. This is a crucial departure from Johns who wanted to make the flag or the target a literal object. The less apparent the change from the original source, the more effective the concept of transformation. It is for this reason that the cartoon paintings are Lichtenstein's most extreme and disturbing statement. None of the other Pop artists has approached him in the precarious hair-splitting balance that he creates between the actual

object and the transformed image. The process of transformation brings into focus several of his major propositions: the importance of choice in the selection of subjects and the ability to transform them into works of art. To this he brings his capacity to transcend his subject matter, making it totally his yet preserving the essence of its original nature. This ability to alter reality enables him to confer on the most common of subjects an esthetic orientation entirely foreign to its condition. Then too, the very methods of transformation entail an adjustment of visual images and confirm the subsidiary role of subject matter in relation to formal ideas.

In the single object paintings of 1961-1962, like *Black Flowers,* the relationship between the subject-figure and the benday background is clearly that of a flattened although still somewhat apparent two-plane relationship. The difference in scale between the benday dots, especially small at this time, and the primary figure-shape created a perceptible distinction in the surface plane. This change in scale did not make an immediate impression because the painting had few half-tone references and was basically linear in treatment. The emphasis on the linear rather than on the volumetric quality of a three dimensional object enabled the object to remain stable in relation to the picture plane. In the later single object paintings there is a gradual adjustment of these possibilities and a more thorough articulation of figure and ground. The figure-ground relationship occurs again in the brushstroke series of 1965-1966 with two changes – the substantially enlarged benday dot and the use of a literally two-dimensional image – that replace the earlier linear control of figure and ground and maintain a more convincing relationship with the picture plane. *Golf Ball,* 1962, is composed of a series of black and white arcs that form an abstract pattern reminiscent of Mondrian's plus and minus system. At the same time, by means of their placement, the black and white lines conform to the shape of a three-dimensional object. But the placement of the golf ball on a neutral ground once again neutralizes the object as a volumetric form. This manipulation of the two and three dimensional is one that the artist obviously relishes for he returns to it repeatedly. *Temple of Apollo,* 1964, and *Study for the Great Pyramid,* 1969 are but two examples in which a fully realized form is translated into a purely pictorial two-dimensional image.

An important feature of Lichtenstein's use of the cartoon is the change in scale, the enlargement from the miniscule to easel or wall size, much like the gigantic blow-ups of Oldenburg. Unlike Oldenburg, however, Lichtenstein's enlargements have none of the sense of Olympian abandon or the tactility that we associate with the painterly extravagance of Abstract Expressionism. Lichtenstein's work manifests an elegant refinement and intellectual precision that is both an inherent part of his personality and a decided reaction against Abstract Expressionism. In his use of magnification and distortion, the images are blown up beyond recognition and reassembled into separate units which have an identity apart from the original. In removing a strip from its relationship to the other frames of a cartoon, it becomes both strangely complete and considerably different from its source. This alteration seals the images in time and elevates them to the status of signs. What Lichtenstein creates for us, then, are stereotypes of our culture – a Hollywood sunset, a crying girl, an embracing couple. Although he works with representational images, they can hardly be called naturalistic. He emphasizes this by featuring the urban society, often viewing man by way of his artifacts, and by approaching his subjects indirectly usually through reproductions. This conscious stylization of his motifs may have derived from the comic strip which is itself a highly artificial way of representing reality. Lichtenstein has adapted this method but discarded the approximation to reality of the continuous narrative of the comic strip. There is no doubt, however, that the comic

strip was suited to his needs, not the reverse, as an examination of his work of the mid-fifties will indicate. In heightening this sense of artifice with the use of a realistic imagery, he is strongly reminiscent of Fragonard and Boucher.

Lichtenstein achieved one remarkable effect with the incorporation of the title or legend as a functioning element into the body of a work. Rather than using the title as appendage or accessory to the visual, as a label clue or as a play on illusion, Lichtenstein forced a direct confrontation between the verbal and the visual. Both the verbal and the visual statements exist on a single plane so that the image forms a totally integrated unit. But the spectator response to the set of visual phenomena is quite separate from the reaction to the verbal phenomena. We are encouraged to read, hum, sing, or make other noises, in other words to talk back to the paintings. Other early paintings, like *Fastest Gun*, 1963, convey the impression of a TV camera zooming in for a climactic moment. Somewhat like the response to the "Big Screen," the spectator is drawn into the space of a painting, figuratively speaking, and can frequently become involved with the emotion of the event as he reads: "Okay Hot-Shot! I'm Pouring!" or "I Don't Care! I'd Rather Sink . . . Than Call Brad For Help!" This emotional outpouring is in marked contrast to the coolness of the technique and it is noteworthy that Lichtenstein chooses to utilize this apparent contrast between the style (cool) and the subject (hot). It is apparent that the artist is a master of the complex statement. Cross references abound in a spirit of ironic play and bring with them an undeniable humor.

From around 1963 certain pictorial devices which had appeared occasionally in the paintings of 1961–1962 begin to occur with increasing frequency. These include a kind of curved and at times almost baroque line which could designate anything from clouds to a woman's hair; the sharp zig-zag of the comic strip reappeared in the spiraling cloud formations of a landscape and again in the zooming diagonals of the modern paintings; the dots expanded into fields of modulated color which acted as a ground tied together by his lines and created out of the canvas a taut and rigid screen. Another feature of these paintings is the greater use of a cropped image to suggest the continuation of the image beyond the perimeters of the canvas and to identify the image with the rectangle. This change from the single image to the allover composition is most effective from this time. It undoubtedly derives from the artist's own observation of, and experimentation with, Abstract Expressionism.

Lichtenstein's working method is one that he established with the cartoons: a precision arrived at after a certain trial and error. He selects motifs from illustrations or other second-hand sources and recomposes these images, small in scale, into equally small sketches. The idea of giganticism, whether a 1930's facade, the bravura brushstroke, or an Egyptian pyramid reduced to a minute scale and then enlarged, via the projector, into a facsimile of the original, is nothing if not Dada in the extreme. Once the sketch is enlarged to the scale of the canvas and transferred, it is subject to a series of adjustments – of drawing, shape, and color sequences. When he arrives at a satisfying image the benday dots are filled in by his assistants. He does everything else on the paintings himself. Within the appearance of regularity and impersonality that are a feature of his paintings there is an amazing wealth of detail – a love of contour, of the texture created by the juxtaposition of the benday dots with solid color areas, of the irregular shape playing against the pure geometry of a rectangle, a circle or a square; the thickness or thinness of a line and its placement; or the width of a color stripe. The opposition of verticals and horizontals, a more complex interlocking visual scheme, larger areas of color, and the use of white rather than commercially primed canvas alone to give added intensity to the colors

around it lend the recent paintings a greater sense of compactness than the earlier work.

The comic strip, the landscape, the brushstroke all depended, to varying degrees, on an actuality that the thirties theme does not require. This has, in turn, freed the recent work of some of its purely descriptive function and brought it into an oblique, if unintended, relationship to recent formal abstraction, particularly recent Stella, an affinity that indicates the considerable distance between Lichtenstein and the other Pop artists.

The 1930's series began with a poster that Lichtenstein designed in the fall of 1966 for Lincoln Center. Its subject: the architecture and design of the 1930's: theater marquees, the stepped facades of buildings like Radio City Music Hall or all of Rockefeller Center for that matter, industrial and accessory design, automobile grilles and banisters. He has captured the very feel of the thirties – the clumsy overstuffed forms, the rigid geometry and repetition of forms, the use of ornate details, in short the total ambience of the urban landscape. The paintings have a residual nostalgia – for the past, for a childhood of the thirties, for movie madness – that, like all of his subject matter, never deteriorates into sentimentality. The Pop use of a subject matter of common origins was employed by Lichtenstein in the comic strips, the landscapes, especially the sunsets, and in the use of popular cultural phenomena like *The Temple of Apollo* or *The Great Pyramid.* The brushstrokes were a departure in their reference to a non-popular imagery, Abstract Expressionism, while the current series is a partial return to a more common mode, to a period that has recently become increasingly popular among fashionable taste.

As a theme, the thirties offers innumerable associations other than the formal possibilities that it suggests: reference to an earlier fashion, a comment on the geometric painting of van Doesburg, Vantongerloo, et al that inspired it: to much of current painting – Stella and Noland – which owes something in turn to the earlier art or design. His is an art of reference – to subject matter and to other art styles. An interest in Mondrian's color and structure that was apparent even in the comic strips took even more explicit form in the *Non-Objective I* of 1964, and reappears here in yet another way. Again, it should be considered that his actual Mondrian paintings were not meant to be homages but were used as subject matter solely. This, of course, has created a situation in which an artist who understood and used many of Mondrian's ideas could paint a painting of a Mondrian using it as subject matter which he combined with his knowledge of the artist's ideas and fused with his own unique vision. From his understanding of preceding art forms and his willingness to use anything that suits his needs, he has created an art of strength through many dialogues and ultimately a highly original art.

The forms – circle, square, arc, arranged in a way reminiscent of the thirties, in sets of threes, for example – are cropped in a way that gives enough information for a frame of reference. They are dense and complete within the canvas and cut-off at the edges. Lines of speed appear to converge, or diverge within the canvas; what Lichtenstein creates, in effect, is a center of tension or hub of energy without focus that tapers off at the edges of the canvas. In addition, the thrust is enervated not only by the open-ended forms, a device that first appeared in the landscapes, but by the bulge and swelling of the irregular silhouettes and the closed contours of the geometric forms. Although movement is implied in the use of fast diagonals, it is a movement contained within the usually rectangular dimensions of the canvas. Within the canvas itself the forms are locked in by a black silhouette; the only areas without a contour are certain portions of the benday dots. The dots, as they have increased in size and technical proficiency, have also attained a fascinating sub-form of their own, serving dual roles: as change of scale and as half tone. Because of their prominence as a pattern they serve not only to separate areas

of solid color, along with the black brushstroke, but also to create the illusion of volume. This illusion is contradicted not only by the broad flat areas of color which frame them but also by the appearance of the dots as a flat two-dimensional pattern elsewhere on the same canvas. Lichtenstein uses the half-tone along with overlapping forms, recession lines and points of focus which he transforms, as freely as his subject matter, into a new pictorial scheme, one that calls into question the very premises that it appears to establish. He has determined his own way of confronting the picture plane using both two- and three-dimensional illusion. That this is one of his underlying interests is apparent in his recent sculpture in which he brings line into space.

The earliest work, *Modern Sculpture,* 1967, is a skeletal structure that offers little to the spectator in the way of a concrete form occupying a defined space. Lichtenstein not only disregards the usual conventions for sculpture, he heightens the ambiguity. The lower portion of the sculpture, the part that relates to the floor, bulges out frontally while the upper portion opens out at the rear. A mirror, attached to the top, conveys an illusion of depth similar to the "shaded" benday areas in the thirties paintings. The total structure, with its Picassoesque play on illusion and reality, reflecting brass surfaces and shifting unstable elements, appears to dematerialize and recompose itself of its own volition. In the pieces that follow he has simplified the relationships preferring to keep the sculpture more resolutely linear. As a result the sense of ambiguity, although still a factor in several of the pieces, is a less dominating force. The relationship to floor and wall planes is consequently more straightforward and more consistently linear. The latest work, *Large Sculpture,* 1969, bears an uncanny resemblance to both banisters and to designs like Frank Lloyd Wright's decorative grills for the Guggenheim Museum.

Unlike the sculpture, in which illusion plays such an important role, the color in Lichtenstein's paintings, full strength and brilliant in hue, allows little tolerance for spatial illusionism. It too is secondary source material, deriving from the colors used on commercial packaging. And it also relates to Mondrian's color arrangements to which the artist has added the occasional use of green. Lichtenstein was impressed by the impersonality of advertising color and the fact that one color could be used for different objects. He has adapted not only the strong contrast of advertising color but use of one color for multiple purposes. His color is also a reaction against Abstract Expressionism in which color was often used to convey a specific emotional content.

In effect, Lichtenstein rewards us with a highly complex visual and intellectual statement. It is in the equilibrium established by working part against part, fragment against fragment that he is able to produce a memorable imagery and to discover the psychological reactions we have to a specific subject matter. As Ingres was able to paint the ideal woman, Lichtenstein is able to present us with a new vision, not one based on the comic strip but more probably based on his understanding of modern art. Starting with a specific subject matter, he arrives at a general or ideal image. When an eighteenth century artist chose to render a cloud, we clearly understand that it is fictitious. Lichtenstein is able to spell out the image cloud on his canvas so that the mind and the imagination can envision the real one.

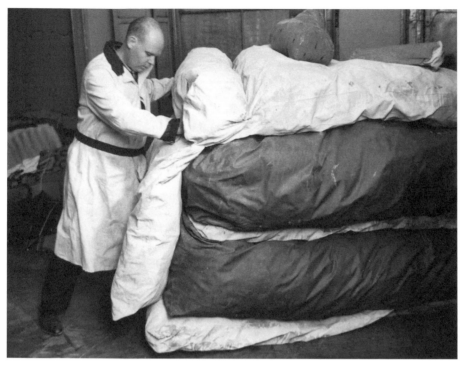

Claes Oldenburg with Floor Cake, *1962. Photograph by Ken Heyman.*

STATEMENT

Claes Oldenburg

I am for an art that is political-erotical-mystical, that does something other than sit on its ass in a museum.

I am for an art that grows up not knowing it is art at all, an art given the chance of having a starting point of zero.

I am for an art that embroils itself with the everyday crap & still comes out on top.

I am for an art that imitates the human, that is comic, if necessary, or violent, or whatever is necessary.

I am for an art that takes its form from the lines of life itself, that twists and extends and accumulates and spits and drips, and is heavy and coarse and blunt and sweet and stupid as life itself.

I am for an artist who vanishes, turning up in a white cap painting signs or hallways.

I am for art that comes out of a chimney like black hair and scatters in the sky.

I am for art that spills out of an old man's purse when he is bounced off a passing fender.

Exhibition catalogue, *Environments, Situations, Spaces,* Martha Jackson Gallery, May-June 1961. Revised for publication in *Store Days: Documents from the Store (1961) and Ray Gun Theater (1962),* New York: Something Else Press, 1967

I am for the art out of a doggy's mouth, falling five stories from the roof.

I am for the art that a kid licks, after peeling away the wrapper.

I am for an art that joggles like everyones knees, when the bus traverses an excavation.

I am for art that is smoked, like a cigarette, smells, like a pair of shoes.

I am for art that flaps like a flag, or helps blow noses, like a handkerchief.

I am for art that is put on and taken off, like pants, which develops holes, like socks, which is eaten, like a piece of pie, or abandoned with great contempt, like a piece of shit.

I am for art covered with bandages. I am for art that limps and rolls and runs and jumps. I am for art that comes in a can or washes up on the shore.

I am for art that coils and grunts like a wrestler. I am for art that sheds hair.

I am for art you can sit on. I am for art you can pick your nose with or stub your toes on.

I am for art from a pocket, from deep channels of the ear, from the edge of a knife, from the corners of the mouth, stuck in the eye or worn on the wrist.

I am for art under the skirts, and the art of pinching cockroaches.

I am for the art of conversation between the sidewalk and a blind mans metal stick.

I am for the art that grows in a pot, that comes down out of the skies at night, like lightning, that hides in the clouds and growls. I am for art that is flipped on and off with a switch.

I am for art that unfolds like a map, that you can squeeze, like your sweetys arm, or kiss, like a pet dog. Which expands and squeaks, like an accordion, which you can spill your dinner on, like an old tablecloth.

I am for an art that you can hammer with, stitch with, sew with, paste with, file with.

I am for an art that tells you the time of day, or where such and such a street is.

I am for an art that helps old ladies across the street.

I am for the art of the washing machine. I am for the art of a government check. I am for the art of last wars raincoat.

I am for the art that comes up in fogs from sewer-holes in winter. I am for the art that splits when you step on a frozen puddle. I am for the worms art inside the apple. I am for the art of sweat that develops between crossed legs.

I am for the art of neck-hair and caked tea-cups, for the art between the tines of restaurant forks, for the odor of boiling dishwater.

I am for the art of sailing on Sunday, and the art of red and white gasoline pumps.

I am for the art of bright blue factory columns and blinking biscuit signs.

I am for the art of cheap plaster and enamel. I am for the art of worn marble and smashed slate. I am for the art of rolling cobblestones and sliding sand. I am for the art of slag and black coal. I am for the art of dead birds.

I am for the art of scratchings in the asphalt, daubing at the walls. I am for the art of bending and kicking metal and breaking glass, and pulling at things to make them fall down.

I am for the art of punching and skinned knees and sat-on bananas. I am for the art of kids' smells. I am for the art of mama-babble.

I am for the art of bar-babble, tooth-picking, beerdrinking, egg-salting, in-sulting. I am for the art of falling off a barstool.

I am for the art of underwear and the art of taxicabs. I am for the art of ice-cream cones dropped on concrete. I am for the majestic art of dog-turds, rising like cathedrals.

I am for the blinking arts, lighting up the night. I am for art falling, splashing, wiggling, jumping, going on and off.

I am for the art of fat truck-tires and black eyes.

I am for Kool-art, 7-UP art, Pepsi-art, Sunshine art, 39 cents art, 15 cents art, Vatronol art, Dro-bomb art, Vam art, Menthol art, L & M art, Ex-lax art, Venida art, Heaven Hill art, Pamryl art, San-o-med art, Rx art, 9.99 art, Now art, New art, How art, Fire sale art, Last Chance art, Only art, Diamond art, Tomorrow art, Franks art, Ducks art, Meat-o-rama art.

I am for the art of bread wet by rain. I am for the rats' dance between floors. I am for the art of flies walking on a slick pear in the electric light. I am for the art of soggy onions and firm green shoots. I am for the art of clicking among the nuts when the roaches come and go. I am for the brown sad art of rotting apples.

I am for the art of meows and clatter of cats and for the art of their dumb electric eyes.

I am for the white art of refrigerators and their muscular openings and closings.

I am for the art of rust and mold. I am for the art of hearts, funeral hearts or sweetheart hearts, full of nougat. I am for the art of worn meathooks and singing barrels of red, white, blue and yellow meat.

I am for the art of things lost or thrown away, coming home from school. I am for the art of cock-and-ball trees and flying cows and the noise of rectangles and squares. I am for the art of crayons and weak grey pencil-lead, and grainy wash and sticky oil paint, and the art of windshield wipers and the art of the finger on a cold window, on dusty steel or in the bubbles on the sides of a bathtub.

I am for the art of teddy-bears and guns and decapitated rabbits, exploded umbrellas, raped beds, chairs with their brown bones broken, burning trees, firecracker ends, chicken bones, pigeon bones and boxes with men sleeping in them.

I am for the art of slightly rotten funeral flowers, hung bloody rabbits and wrinkly yellow chickens, bass drums & tambourines, and plastic phonographs.

I am for the art of abandoned boxes, tied like pharaohs. I am for an art of watertanks and speeding clouds and flapping shades.

I am for U.S. Government Inspected Art, Grade A art, Regular Price art, Yellow Ripe art, Extra Fancy art, Ready-to-eat art, Best-for-less art, Ready-to-cook art, Fully cleaned art, Spend Less art, Eat Better art, Ham art, pork art, chicken art, tomato art, banana art, apple art, turkey art, cake art, cookie art.

add:

I am for an art that is combed down, that is hung from each ear, that is laid on the lips and under the eyes, that is shaved from the legs, that is brushed on the teeth, that is fixed on the thighs, that is slipped on the foot.

square which becomes blobby

NEW YORK LETTER

Michael Fried

The work of Claes Oldenburg, whose hallucinatory, prosaic environment threatens to overflow the Green Gallery this month, seems to exist merely, or chiefly, in order to pose questions of a conceptual nature. Everything depends on what we make of it, on the conceptual framework that, looking at it, we bring to bear. What makes criticism difficult is that Oldenburg seems to be embarked on at least three more or less related projects at the same time. The first has to do with making works of art out of everyday objects, either by fiat or imitation, in the imperious manner of Duchamp. This is not to say that Oldenburg is concerned with the surrealist opposition of signs to things signified, of intellectual categories to protean reality or, as he puts it, illusion to reality. In fact Oldenburg's work suffers next to Duchamp's, say. From the lack of just such firm philosophical purpose: if there is an intellectual principle common to his giant, stuffed-sailcloth hamburger, stuffed calendar, outsized trousers, plaster of paris fried eggs, and plaster cigarettes in a real ashtray, I haven't found it. And I can't shake the conviction that work like Oldenburg's either has got to have such a principle or else be put down as mostly or wholly arbitrary and subjective.

It is here that Oldenburg's second project comes into play, as if to compensate for his philosophical slackness and redeem his work from subjectivity by the sociological, or rather, the *archetypal* significance of the objects chosen for imitation, presentation, fetichism and hyperbole. They are all common items, and so share the trivial passion of the completely mundane. But what is probably more important they are for the most part distinctively American: which I assume is meant to rescue them from merely *personal* subjectivity. This is the familiar melodrama of one kind of American artist, whose naïve esthetic founds itself on the conviction that if only he can involve himself with America profoundly enough the objects he will cathect onto can't fail to have archetypal force and significance. There isn't space to discuss whether in general such aspirations inevitably doom works of art to at best parochial success; though it is hardly surprising that *Patterson* goes unread in England. But I will add that nothing of Oldenburg's forced me to ignore how shaky the thought behind his pieces was, and, often, how slapdash their execution.

Finally, there is in much American painting by young artists today clandestine, or more open, rebellion against the living edge of that dialectic which seems to have governed the recent development of their art: almost a nostalgia for the good old days of drip and drag and cubist space. This is evident, I think, in the work of Johns and Rauschenberg, and I query whether it isn't to be found everywhere in Oldenburg's environment as well – which might account for some of the slapdash painting mentioned above. Moreover, aren't the calendars strikingly like stuffed versions of Johns's number paintings, and don't the popsicles, for example, owe something to Newman and Kelly at the same time? But if this is the case it only serves to add a third kind of sentimentality to the two already cited.

Art International, October 1962: 72–76

Off Off-Broadway: "HAPPENINGS" AT RAY GUN MFG. CO.

Jill Johnston

Claes Oldenburg has been converting his "store" at 107 East 2nd Street, the Ray Gun Mfg. Co., a space of four small narrow rooms, into a theatre for happenings, the Ray Gun Theatre. Some of the coats, cakes, candy, dresses, etc., that he made when it was only a Mfg. Co. still hang heavy and colorful in the front part of the store as you enter, before squashing in at the back where the events take place.

There were four events on four successive weekends to begin with. Then there was a break of four weeks, and now four more are again in progress. On the first two weekends he gave "Store (Version I)" and "Store (Version II)." In the first he laid out a "scene" in each of the three rooms and mobilized only one room at a time, lighting it and darkening the others so the audience was directed to look only at the lighted one. I couldn't see what transpired in one room, but it had something to do with a man on a bed and someone overhead in a drooping black cloud of a hammock. The middle room was a mess. Kitchen scene with man and woman. The larger room contained several people doing different things. I submit a few notes chosen at random, taken during the performance:

> bride with gun . . . thoughtful . . . girl talking on telephone holding fake dog . . . Gloria throws pie Lebel's face . . . bride shoots . . . Gloria wiping dishes . . . girl clipping nails . . . girl on phone tries to give man dog . . . Gloria girl bloody hand laughs . . . man breaks dog with hammer while she keeps talking on phone . . . Billie removes clothes, poses . . . she dumps mud out of pail . . . Pat overhead making love (sound effects) . . . corps . . . Lebel sick on soup . . . man rifles pockets of corpse . . . Lebel shaving . . . chopping wood . . . girl in red removes dress . . . throws wardrobe on floor . . . Lebel chops . . . Gloria sleeps . . . girl, red, cane, exquisite racket.

"Store (Version II)" was overloaded in one room. I didn't enjoy it as much as Version I and was by that time a bit tired of the girls half dressed or undressing.

For the third week Oldenburg rearranged the space and altered the whole presentation. "Nekropolis I." In four parts, each scene a unified incident, "Nekropolis II" was in four parts too, but the parts merged to become one total incident, thus more like a conventional drama.

Yet it remained visual, the handiwork of a painter, a picture set in motion. In "Nekropolis I" Lucas Samaras (Samaras, who has been in almost every happening by everyone thus far, generates remarkable excitement while doing very little) started proceedings with a bit of homicide. After establishing himself as a suspicious character by furtive glances, constrained shuffling, pouring water from a pail in a bathtub, and adding numbers with chalk on a door (the numbers of dead?), he suffocates another depraved figure, Pat Mushinski in crumpled male black, ties her up like a sack (in a slow methodical ritual that has a history), and puts her in the bathtub where she eventually slumps in water up to the chin. The remaining three incidents "War," "Freaks," "Mice" are like an expression of this perversion in simple animal terms, a return to savagery, or direct

The Village Voice, April 26, 1962: 10; reprinted by permission of the author and *The Village Voice*.

self-preservative activities prior to the development of the forebrain. In any case it all seemed pretty healthy to me, and I enjoyed the heavy slow clamor of these bulky creatures crawling and messing around in that bulky "environment" of burlap, paper, paint, and other assembled junk. Oldenburg himself made wonderful nondescript jungle sounds and heaved his considerable weight from mound to mound like a natural denizen.

A MEAL FOR THREE

The central attraction of "Nekropolis II" was a meal for three. The scene started off white and clean. The three customers, faces whitened, all jabbered at once in various languages and did incredible things to the fake food that never stopped arriving. A violinist would stand up now and then to play a nostalgic refrain. A "monster" stumbled in; went to sleep, was kicked out by the proprietor. A "bride" was ushered in; undressed, laid out, carried off. Then a long poetic interlude when the three customers and the waiter donned tinfoil masks ("The Relatives") and rigor mortis set in gradually so that by the time the two "bears" entered they had stopped moving altogether and were knocked over in a slop of food, table, chairs, and masks by the two boxing bears.

Social message? Yes and no. Oldenburg may have social conditions on his mind, who doesn't, but he is primarily making moving pictures, real or fantastic, employing people as chunks of environment as well as themselves in everyday affairs. This is immediate, elemental theatre, the more so perhaps because Oldenburg is an authentic slob.

THE LIVING OBJECT

Ellen H. Johnson

Sophisticated, vulgar, ephemeral, lasting, harsh and tender, Claes Oldenburg's work is poignantly alive. The *Two Girl's Dresses* hanging on the wall of his studio in New York's Lower East Side are as full of movement as the dresses dancing in the wind in front of the dingy shops in his neighborhood; but Oldenburg's creations have a compelling aesthetic and human presence. Unforgettable images, they are as personal, evocative and touching as Van Gogh's *Chair*. Oldenburg's painted sculpture dresses, shirts and shoes, in their subtle undulations and projections, bear traces of the human body; they are still warm with life, a life that is there through his art. While the range of his expressive force extends from gay to ominous, even the most appealing little strawberry tart has something of the blunt power which is so arresting in works like the *Big Standing Shirt*.

To an artist who declares himself "fond of materials which take the quick direct impress of life," restriction to the conventional domain of sculpture or painting would be oppressively limiting and the barriers between the two mediums, increasingly threatened in modern art, are completely dissolved in Oldenburg's work. Of painted sail cloth stuffed with foam rubber, or of enamelled plaster built up with burlap or muslin on a chicken-wire base, Oldenburg's objects are both painting and sculpture. Some are in the round and others, like the dresses, pyjamas and sewing-machine, are wall-pieces, reliefs made to be seen primarily from one side; but with their richly painted humps and hollows they are also like canvases with a curiously mobile irregular substance pushing from the back. When traditional sculpture is colored, the paint is usually "added," rather than given an independent existence as it is in Oldenburg's where the paint flows free and drips and splashes in a moving surface. Color is used as a painter uses it – arbitrarily, to construct and accentuate, or when desirable to reduce volume and space.

Like most artists of his generation (or even since the first scrap of paper was pasted to a cubist canvas) Oldenburg wants to demolish the distinctions between art and reality, at the same time insisting on the aesthetic autonomy of the created object. As he isolates fragments of his experiences and fixes on them obsessively, he creates images of shocking intensity, more powerful than reality. Thus, the deeper the realism the less illusion and the more startling the creation. By his insistence on both – original object and created object – he recharges the age-old dialogue between art and reality. In his words, "Recreating experience is the creation of another reality, a reality according to the human experience, occupying the same space as the other, more hostile, reality of nature. A reality with tears, or as if a piece of pie had attained a state of moral responsibility."

Oldenburg is a deeply sensuous artist, appealing as much to touch, taste and smell as to the loftier sense of sight. The *Slice of Chocolate Cake* with its thick caramel icing is so luscious that one's mouth may well water in contemplating it. He pushes the realism (and the humor) further by pricing the merchandise in his "Store" at $69.95, etc. and by his manner of presenting it: men's shirts and shorts in cardboard boxes, pastries in glass cases and on little serving dishes, a ham and a tray of frankfurters and a kettle of stew on a stove. In one sense, you can't get more realistic than that, and such extreme realism makes more pungent the ironic realization that these are *created* objects: far from being

Art International, January 1963: 42-45, © Ellen H. Johnson

sweet, sticky and melting, the cake is nasty, solid plaster. (Not a new joke, but still a funny one to people who enjoy marble sugar-loaves.) No one would be any more tempted to bite into an Oldenburg pie, even those in natural scale, than into a Cézanne apple.

Always conscious of the evocative power of scale, Oldenburg plays with it, sometimes playing it straight and natural and sometimes putting the objects or fragments of objects in startling, haunting over-size. Something of the effect he wanted to get in installing his 11-foot long ice-cream cone and 4×7-foot hamburger in the Green Gallery was that of big cars displayed in shop-windows uptown. The monumental scale of his new pieces not only affords Oldenburg the challenge, so essential to contemporary artists, to work big, but it also underlines the basic irony in the battle between natural object and created object. As there is a give and take between reality and art, between Oldenburg's experience and his recreation of it, so is there a constant interchange between materials and form, each giving play to the other. (Likewise, his "Happenings" spring from his plastic art as it grows out of them, poetically, spatially and technically.)

Scaled to size or expanded majestically, Oldenburg's pies, sandwiches and cakes are not intended to attack the materialist-centered American in the way in which Hess interprets Thiebaud's dessert-filled canvases as "major social criticism preaching revulsion by isolating the American food habit." Oldenburg is not throwing the pies back in the public's face; he is not so much condemning us or "urging us . . . to leave the new Gomorrah . . . to flee to the desert and eat locusts and pray for faith" as he is sharing with us his personal experience through the vitality of his art. Granted that part of his experience, on which he comments consciously or unconsciously, is the immense, vulgar and wonderful American love of things, that is not the totality of his reference (let alone the reality of his art). "I am for an art that takes its form from the lines of life, that twists and extends impossibly and accumulates and spits and drips, and is sweet and stupid as life itself." (See his complete, poetic statement for the catalogue of *Environments, Situations, Spaces* show, Martha Jackson Gallery, May–June, 1961.) Although one cannot deny that the rough, even violent power of his imagery may harbor a caustic appraisal, as well as open acceptance, of whatever is, still Oldenburg does not preach. He is both too detached and too committed in his art to do that. His subjects and materials are chosen because they are at hand, they are his, and in their cheapness and immediacy they are the most fitting tools for his art in which he celebrates so eloquently the life of the city, dirty, cheap, absurd, ephemeral, always on the move going nowhere. He loves his environment as tenderly and bitterly as Beckett loves Estragon and Vladimir and he takes us with him through the "harsh, sweet poetry" of his work. After seeing Oldenburg's Store, or a performance of his theatre, one feels compelled to walk and linger through the Lower East Side, suddenly aware of the curious, tawdry beauty of store-windows full of stale hors d'oeuvres, hamburgers on Rheingold ads, stockinged legs – of five big old caps standing in a stately row on wooden mounts, of human cast-offs wandering aimlessly or hopefully loitering around the noisy bars. As a poet, Oldenburg does not speak directly of human beings, but their presence inescapably haunts his art. To walk along East Third Street is to walk with Oldenburg – it is somewhat like the sensation when driving around Aix and l'Estaque of driving through a Cézanne canvas. But with Oldenburg the sensation is at once more scattered and more immediate and the young American's transformation of his environment is more shocking and strange.

Immediate and ephemeral as Oldenburg's objects may be in character and material, they fix and hold the warmth of the moment, capturing "the timeless with time." Moreover, his objects are permanent symbols of human life, of simple, essential activities:

bread, shirts, shoes; sewing-machine, iron, cash register. On first impression the cash register and other "machines" in the Store looked surprisingly nostalgic and old-fashioned for a man so committed to the present and the ephemeral, but it soon became apparent that it is not so much a matter of industrial design which separates them from the latest IBM sterility as it is their used, lived-with character, not to mention their formal exuberance and sobriety. And it is not Park Avenue but the ragged, tattered human and paper-filled streets of lower New York whose sights, smell and feel Oldenburg so powerfully evokes.

The emotive content of Oldenburg's work is heightened by the importance which he gives to the feeling of time. In the shirts and shoes there is a quality of the immediate past, of the present in the dresses blowing in the wind or the icing running down the side of a cake, of the immediate future in the expectation contained in a letter, or the tempting promise of the pastries and in the whole idea of a store, with infinite possibilities of finding exciting, desirable things. Oldenburg's time range is close and concentrated; immediate past, present, and immediate future are all elements of an extended present, sustained in his objects (as well as his Happenings). The immediacy, the look of life on the wing, recalls the work of the earlier New York painters as do many other elements of Oldenburg's art (giving the lie to those critics who see him as revolting against de Kooning, etc.): the expansive size of the work, its subjective, autobiographical nature, the search for identity in the act of painting, its dripping, lively physical character and its harsh, impure expressiveness.

It has frequently been pointed out that the older generation's projection of the picture's space out into our world, engulfing the spectator and demolishing the barrier between him and the work of art, finds its natural outcome in the spatial Environments and Happenings of the younger artists. Among Oldenburg's work in these mediums are *Snapshots from the City, The Street,* The Store, and the Ray Gun Theatre which presented five pieces, each in two versions and two performances, during the winter and spring of 1962. (Ray Gun is a name Oldenburg began using in 1960 in a show with Dine at the Judson Gallery. "It's a name I imagined. Spelled backwards it sounds like New York and it's all sorts of things. It's me and it has mystic overtones." He calls his studio the Ray Gun Manufacturing Company.) For each of his 1962 Happenings (he tends to prefer the word "performances"), Oldenburg, his wife and other members of the cast usually spent three evenings talking it over, exchanging ideas, working out the time, the objects and the spatial compositions. One of his problems is to give his performers free rein while still controlling the action and character of the whole production. In his performances, people are the material which Oldenburg's sensibilities work on, people and objects in absurd, touching, strange and commonplace events. Although, in his aesthetic detachment, he treats people as objects and emotions as objects, his work is deeply felt and moving.

In the Ray Gun Theatre there are no professional actors, no dialogue and no script, but no Happening is completely unplanned or lacking in sound and action. There is no audience in the traditional sense, only a small almost exclusively "in" group (limited to about 35) jammed together in a narrow passage so physically involved with the performers that one suddenly feels long hair being brushed in one's face or a leg dangling in front of one's nose or swill splashing on one's ankles. It is messy, vulgar and enchanting. The spectator is transfixed as at a circus, expecting and welcoming the unexpected. It is even more like the ancient mysteries; the spectator's participation is emotional, sensory, mystic. Oldenburg's pieces are performed for a public of initiates, often in tense darkness suddenly broken by startling light as something happens in each of the three sections, but no one can see exactly what is happening because distance and angle obscure two of

the areas and the third is too shockingly close, surrounding, suffocating. What happens cannot be known; it can only be felt by those who are over-sensitive to things, colors, shapes, to darkness and light, to sound and silence, to movement and suspension of time. Far from primitive, Happenings are the mysteries of the sophisticated.

Sensitivity to the absurd is a mark of extreme sophistication and Happenings have obviously some of the same roots as the Theatre of the Absurd, but they are "farther out" and more abstract. In the Theatre of the Absurd persons lose importance, but they are not reduced completely to objects – and both intellect and sentiment somehow still work together in a coherent way; the *Bald Soprano* is a highly polished, inescapable satire. In the Ray Gun repertory some of the pieces have a little plot but most have none at all and things rarely "mean anything"; certainly they never mean the same thing to everyone. Improvised in appearance, impermanent and irrelevant, they are over much too soon, about 30 minutes. One of the performances ended with a girl dressed in a little blue burlesque costume, passing pink ice-cream directly from her fingers to the spectators' mouths. This outrageous act was a pretty little piece of irony, spoofing one of the basic ideas of Happenings – audience participation. Producing a Happening may sound a little like having someone direct The Game, a kind of charade which we used to play, but the Ray Gun Theatre is conceived, directed and presented by an artist who creates living, moving sculpture with people, objects and events as he does with foam rubber, cloth, latex, chicken-wire, plaster and enamel in his no less moving "still life" sculpture. Man is no longer the measure of things, but with Oldenburg things still measure the man because, as Picasso observed, "The artist is a receptacle for emotions, regardless of whether they spring from heaven, from earth, from a scrap of paper, from a passing face, or from a spider's web. That is why he must not distinguish between things. *Quartiers de noblesse* do not exist among objects."

From MARCEL DUCHAMP AND COMMON OBJECT ART

Gerald Nordland

. . . . Claes Oldenburg is holding a very considerable exhibition in the spacious Dwan Gallery in Westwood. His 42 pieces are executed either in plaster or sailcloth and often feature a coating of dripping enamel in a sloppy, vulgar proclamation of kitsch as in pieces of pie, tennis shoes and ice cream sundaes. In other cases Oldenburg works with stuffed sailcloth, making an 8 foot ice cream cone, wall mounted pay telephones, giant ice cream bars on sticks, and bacon and tomato sandwiches. One tour de force is a millinery table with corsets, hose, gloves, bras, complete with mirror and fluorescent light, paint bespattered in a parody of the way in which women's clothing is displayed and sold.

There can be no question that Oldenburg has looked at the impedimenta of American commerce and has found some appalling things to comment upon. He forces the esthete to recognize and remember his vulgar subject matter. One may wonder whether the maker produces these things because he finds them amusing, because they are startlingly similar to the "Mile High Cones," orange juice and hot dog stands of this world, or because this is simply an alley into which he has wandered and now finds himself against the closed end with a reputation for "doing" these things. The only comment one can find in the work is critical. He doesn't tell us that these edibles are good or that these clothes are wearable. He doesn't tell us that they are art objects or that they are intrinsically beautiful or valuable. He criticizes the taste of his time, the valueless, meaningless "kitsch" that sometimes fascinates and always results in revulsion. He seems to enjoy knowing and disliking the subject in equal measure.

Oldenburg's individual pieces have a kind of impressive authority that is undeniable. A prime example of this authority is a "motel modern" chair which occupies a central position in the exhibition. This work has rectangular slab sides which serve as arm rests and a similarly shaped back. Upholstered in an imitation animal skin and absolutely uncushioned, the work is a kind of epic ersatz, conforming to one's worst feelings about mass produced objects of taste. The work goes further however, for it is closely related to the drawing style used in advertisements for furniture stores – it is executed in perspective so that it cannot be photographed except in a kind of three-quarter view. The whole work is thus carpentered at an angle to deceive the camera and fit into this complete Kitsch exposition, which it does very well. Indeed, Claes Oldenburg bows to slob culture with a knowing wit. Unfortunately the comment is so reserved that the work stands only as a record and never as polemic. He too has donned Duchamp's Dadaist disinterest.

Here again the record of Duchamp's researches has proved useful. The anti-art technique, the sanctification of the unthinkable content in a distinguished art gallery, the elevation of the common to a position of importance is the counterpart of the clothing dummies in the *Nine Malic Moulds*. It is another illustration of the way out of a Dada dilemma – self expression in a field where one can maintain the illusion of toughness, criticism and fearless reading of the society's own vulgarity without committment. Apparently the chic find this "fun," entertaining and mildly titilating. I wonder if this doesn't explain Duchamp's retirement from art. Perhaps he found himself tempted to work with materials that were neither ambiguous nor tinged with irony. Perhaps recognizing that

Excerpt, *Art International*, February 1964: 30-32

he could only succumb to esthetic bankruptcy by such a move he elected to stop working. An ironic compliment to the master.

The formality, idealism and dignity of the best of post-war American art has been challenged as effete, and overly refined, uninvolved with the spectacle of life. Perhaps the edge of lyricism and anguish which we found in American painting during the last twenty years has been blunted by familiarity and use by "later generations" of imitators. Even blunted, however, it shows a steel of commitment that reveals emotional content. It was never a safe art and never anonymous. Its banner proclaimed commitment and never ironic withdrawal or even elegant disinterest.

IN THE GALLERIES: CLAES OLDENBURG

Donald Judd

Most of the work in this show is different from Oldenburg's other work and is even better. It is some of the best being done. The show is fairly various: there are several soft objects, a switch, toaster, typewriter, tube of toothpaste, telephone; and some other vinyl things, French fries and string beans; also canvas "ghost" models for the soft objects; a double wall plug and a double wall switch are hard objects. A ping-pong table and the paddles are parallelogrammatic, like the furniture in Oldenburg's bedroom suite, which wasn't praised as it merited. A vacuum cleaner and an ironing board are like those of the thirties. There is a blue cloth shirt with a brown corduroy tie on and the size of a mobile clothing rack. A piece of pie and some small pieces are plaster painted with enamel, probably earlier work. Some of the drawings for the new work are good, and some, most of those on black paper, are comparatively glib, possibly too near a shot at the quality of the swank modern furniture Oldenburg's interested in. The vinyl switch is a softened vermilion, maybe flamingo colored. It sags from its upper corners; it's a swag. The rectangle of the switch is partially stuffed with kapok, and the two switches, set side by side, not above and below, are filled. The switches fit in pockets in the rectangle and can be switched on and off. I think Oldenburg's work is profound. I think it's very hard to explain how. The swag of flamingo vinyl seems to be a switch. It is grossly enlarged and soft, flaccid, changed and changeable. It seems to be like breasts but doesn't resemble them, isn't descriptive, even abstractly. There aren't two breasts, just two nipples. The two switches are too distinct to be breasts. As nipples though, they are too large for the chest. Also they can be directed up or down, on and off. The whole form of the mammarian switch is a basic emotive one, a biopsychological one, an archetypal sense of breasts. Their size is felt as enormous and the nipples seem most important. The switch doesn't suggest this single, profound form, as do the breasts of Lachaise's women, but is it, or nearly it. This sort of basic form occurs in most of Oldenburg's work. The form is single, as it is felt, is single in form, is without discrete parts. It's enough. The emotive form is equated to a man-made object. This show, incidentally, is of things from the home; before that the things were from the store and before from the street. Ordinarily the figures and objects depicted in a painting or sculpture have a shape or contain shapes that are emotive. Oldenburg makes one of those subordinate shapes the whole form. Real anthropomorphism is subverted by the grossly anthropomorphic shapes, man-made, not shapes of natural things or people. The preferences of a person or millions are unavoidably incorporated in the things made, either through choice or acquiescence. Nothing made is completely objective, purely practical or merely present. And of course everything after it's made is variously felt. Part of the switch's anthropomorphism is that it's changing – as if melting and sliding in time. The hard objects are as grossly hard and geometric as these are soft. There are few artists as good as Oldenburg. (Janis, Apr. 7–May 2.)

Arts, September 1964: 63, © 1997 Donald Judd Estate / Licensed by VAGA, New York NY

OBJECT-MAKING

Öyvind Fahlström

Why should it be meaningful to make objects if one is an American artist?

In the U.S.A., as we know, objects (goods) have an ecstatic quality – so that they can be sold, so that new objects can be made, so that more people have the means to buy more objects. If the U.S.A. is half a *warfare state* with a strategic industry "for the good of the nation" (of politicians, the military and industrialists), the remainder is a *market state* "for the good of the individual" (of the industry). To speed up this crazy circle, the Americans are reminded from the time they wake up in the morning until the time when they lose consciousness, that goods are fetiches which make them (better) Americans, mothers, millionaires, filmstars, fighters, mistresses and cowboys.

The tiresome thing about African fetiches is that they can only be (for us) beautiful shapes and a form of exoticism. The engaging thing about Claes Oldenburg's objects is that besides bringing out basic shapes and sign characteristics inherent in universal, everyday objects, he deals with fetich qualities with the glamour which ecstatic objects radiate. (Oldenburg has never made objects which are unpainted, "pure" sculpture.) Furthermore, his objects do not allude to everyday objects and are generally larger than life: they are not intended to be used, only to radiate.

Every hamburger or typewriter by Oldenburg becomes a monument to the ecstatic object. Recently, Oldenburg has also begun to make projects for monuments in New York consisting of colossal objects. (If this is really necessary. In Europe, monuments are erected to Garibaldi or the Unknown Soldier. In the U.S., for example, the puffing "Camel" cigarette in Times Square has become a national triumphal arch erected to the Unknown Consumer – otherwise it would surely have been pulled down, as "Camel" is almost extinct.)

Because Claes Oldenburg conducts experiments into pleasure magic it does not follow that he translates the bourgeois clichés of Madison Avenue. Even though the external quality of his objects differs from that of everyday objects, this does not imply anything expressionistic which introduces an orientation towards the ego. The marked character or personality which his objects possess is rather the result of a perspicacious, friendly and lyrical (crazy) recording of the *milieu* in which the artist lives at the moment he is making them.

In form, material and dimension, or "style," his earlier, papier mâché-like objects and his reliefs tell something about New York's shabby, seething and hectic Slavonic-Puerto-Rican East Side. The big pieces of furniture are concerned with the (white) West Coast Americans, the frank and naïve, grown-up mentality of Los Angeles and Hollywood. His French delicatessen objects are the smallest he has made, like dry, sober, rather finicky Parisian gourmets. The recent medium-sized objects from New York have, with the artist, emerged from the slums; like the new middling jet-set bourgeoisie of parties and private views they are spinelessly blasé or plump and positive.

He can be seen as BIG, SOFT, STRONG. The most striking thing about his objects is that they are SOFT. In earlier years, the content of his objects dealt entirely with softness: clothes, meat, cakes. Since then, most of the objects made by Oldenburg have been soft

Studio International, December 1966: 328–29

(with the principal exception of the French objects) while the subjects have been hard. Why is all art hard? Hard and taut like a canvas, hard and brittle like a sculpture. Is this a tendency towards sublimation and the rigours of the super-ego? Does this perhaps give the impression of changelessness, perfection or eternal life?

But the object which yields is stronger. It is the same with Oldenburg himself; when he directs his performances, it seems as though he is always yielding to circumstances, materials, people. This allows people, material or space to be themselves, but in the end what results is always a characteristically Oldenburg work. But to yield to people does not mean for Oldenburg that he does this out of kindness or with the intention of improving them, as in psychological drama. They are entirely subordinated to Oldenburg's vision, but within it they have life. In the same way, I imagine that nowadays he manages to direct his army of assistants who sew for him: impoverished women artists and dancers, rich housewives, professional seamstresses and, first and foremost, his wife Pat. Without her stitching and her contribution to his performances, Oldenburg, as we know him, would not exist.

Oldenburg's quality of involved detachment means that he can plunge into and grope about in a sea of people just as easily as he can root around in the Salvation Army's boxes of tattered and faded old clothes on Second Avenue. (Pat's and his way of looking through their address book and ringing up candidates for their Happenings was like a virtuoso pianist looking over his music.) It must have been the same when he plunged into the slums of Chicago during his prehistoric years as a crime reporter.

In the same way, he was busy browsing his way through the Lower East Side when my wife Barbo and I first met him in the autumn of '61. For the most part, Puerto-Ricans lived in this area, and every now and then, neighbours threw bricks through the windows in the yard so that Claes had to put up bars.

For us artists the Lower East Side at the time represented a rugged idyll, an inspiring small town. When we had parties we invented new dances, spoke in tongues, cast off our clothes and pelted each other with pats of butter. The owner came and blew us up. In the afternoon, Claes worked setting up books at the Cooper Union. In the evenings sometimes Dick Bellamy (who with the Green Gallery launched pop art) looked in and borrowed Oldenburg's rickety bathtub and lay in it reading *Vogue*. (Translation © Peter and Birgit Bird.)

CLAES OLDENBURG'S SOFT MACHINES

Barbara Rose

Claes Oldenburg is the single Pop artist to have added significantly to the history of form. In order to perceive this, however, one must look beyond the Rabelaisian absurdity of his grotesque imagery to the inventiveness of his shapes, techniques, and materials. These are sufficiently original to identify Oldenburg, not, as he has erroneously been seen, as a *chef d'ecole* of Pop art, but as one of the most vital innovators in the field of contemporary sculpture, whose vision has affected the work of many other young artists of his generation.

Every major artist dreams of reconstructing the world in his own image, but Oldenburg has actually succeeded in translating the external environment into a series of shapes and images that physically resemble the large, mesomorphic frame of Claes Oldenburg. To accomplish this solipsistic goal, he had to invent a vocabulary of forms that would be as vulnerable, as irregular, as eccentric, unique and expressive as the human body itself. Oldenburg began to recreate the human anatomy in his own terms in the late fifties with crude pieces like the papier-maché leg. In 1962 he hit on a way to make forms that were entirely foreign to the traditional concept of sculpture because they were soft rather than hard, as one expects sculpture to be. But this reversal of expectations is important, not because it conflicts with our notion of the nature of solid objects – this would be trivial – but because it challenges our ideas about the nature of sculpture, which we expect to be rigid and resistant like metal or wood, not soft, yielding and pliable like the stuffed and sewn canvas and vinyl world Oldenburg has created in his soft sculpture. By the same token, if Oldenburg were merely involved in a series of ironic puns of a conceptual nature, then his work would hold little interest. Fortunately, he is involved in much more; concept in his art is relatively unimportant when compared with his concern with the sensual and the expressive.[1]

Like many important innovations, soft sculpture was arrived at accidentally. Its origin was the oversize props Oldenburg made for use in his Happenings. According to Oldenburg, sewing as a technique began with the costumes and props for the Ray Gun Theater, a series of Happenings produced in 1962, which called for props like an eighteen-foot airplane and a fifteen-foot man. From these colossal props to the gargantuan stuffed cloth articles of food like the hamburger, ice-cream cone, and slice of cake exhibited in Oldenburg's 1962 Green Gallery exhibition was but a short step. What led to taking this step, however, tells us something important not only about Oldenburg's art, but also about the esthetic of the new sculpture in general, in which his work surely participates.[2]

In his notes, Oldenburg mentions that he began to think of making sculpture when a collector bought a boat and a freighter from Store Days, the store on lower Second Avenue that he filled in 1961 with misshapen replicas of objects sold in general stores. Oldenburg admits he began to think of these objects as independent sculptures because they were treated as sculpture. In other words, the work became sculpture by virtue of the way it was used. Such a view is, of course, to a degree merely an extension of Duchamp's insistence that art is art by virtue of context, but its adoption as a working premise by artists as different from Oldenburg as Morris, Flavin, Judd and Andre demonstrates the degree to

Artforum, June 1967: 30–35

which the concept animates the thinking of the younger generation of sculptors and object-makers.[3]

Oldenburg's first three-dimensional objects were painted plaster like the reliefs that preceded them. Like the splattered and blotched surfaces of the reliefs, the surfaces of these objects recalled the painterly brushwork of Abstract Expressionism. In the soft cloth pieces that followed, however, Oldenburg arrived at a way of translating pictorial concerns, such as chiaroscuro modeling, color, and texture entirely into sculptural concerns. In some works, like the "ghost" models of the typewriter and telephone, or the map of the postal zones of Manhattan, light and dark passages are added directly to simulate, literally, the chiaroscuro of painting. This transferal of painting problems to sculpture is typical not only of Oldenburg, but of many young artists. Like the object makers in general, Oldenburg is a literalist. In this spirit he describes his softening as "not a blurring (like the effect of atmosphere on hard form) but *in fact* a softening." As artists like Bell, Judd, and McCracken make concrete and literal effects formerly used allusively or illusively in painting, so Oldenburg uses softness literally, as a quality that is both actual and specific.

In executing a work, Oldenburg proceeds as follows: first he makes a model of the object he wishes to reproduce, then he makes a pattern with stencils, which is transferred to the material to be used; the stencilled shapes are cut out and sewn together (usually by Oldenburg's wife) and finally stuffed by Oldenburg, who fixes the actual form of the work by "modeling" it from within. Technically, Oldenburg's modeling is the opposite of conventional modeling through building up clay or wax on an armature or cutting away from a solid block. Because the "modeling" is done from the inside, the outside surface is uniform and continuous, and lacks marks of touch. Oldenburg describes choosing the "kind of stuffing and how much and where it will gather – fat or lean" as the crucial moment in the work. In the stiffened canvas sculpture, which tends to stay put as placed to a greater degree than vinyl or soft fabric his degree of control is naturally greater.

Oldenburg's interest in modeling relates him formally to traditional casting and carving just as his material and technique separate him from it technically. In many ways he is closer to Rodin and Matisse than to the Cubists and their heirs. For Oldenburg relies, not on plane, like Cubism, nor on volume, like primary structures, but on undulating mass, the means of expression of pre-Cubist sculpture. Despite the fact that there are no finger marks to remind one of the sculptor's personal touch, Oldenburg's is both an extremely personal and an extremely tactile art. Moreover, his aim is not to reject, but to enhance this tactility, intensifying the urge to touch by "devices which prevent touching, like the silver chain in the door to the Bedroom Ensemble . . . or the glass of the pastry cases." This interest in the tactile once again relates Oldenburg to Abstract Expressionism.

Like the human body, which it resembles in its lumps, bumps, folds, and crevices, soft sculpture is literally subject to the force of gravity to a degree that rigid sculpture is not. Gravity, which Oldenburg calls his "favorite form creator," determines the final form a piece will assume. Thus, one of the reasons Oldenburg prefers the large form is because "on a large scale gravity most wins out completely." Oldenburg's choice of an oversize scale, which again has its origin in a theatrical problem – the necessity for props to be large in order to attract attention – has had many repercussions for the future of sculpture. His 1962 exhibition was, to my recollection, the first one-man show of sculpture in which the pieces, meant to impede circulation and to demand a certain kind of inescapable focus, were executed on the superhuman scale that is so familiar today.

The reliance on gravity to determine the final shape of a work can be viewed as a reliance on chance. The casual manner in which a soft form settles, or even better, relaxes

into place suggests that the work is self-composed, or at least relatively uncomposed. This tendency toward relinquishing total control over composition is something Oldenburg shares with a number of advanced artists. It is part of the legacy of Pollock's drip paintings, and very much part of the current attitude that assigns a lesser role to composition than that assigned to it by Cubism, with its insistence on the internal relationships of discrete parts. This attitude also accounts for Oldenburg's choice of the single image as a format. Again, the preference for the single image is one that relates Oldenburg to many other young artists; it, too, is ultimately traceable back to Pollock's arrival at the single image in the drip paintings.

Like Lichtenstein, Oldenburg shares more with the abstract artists of his generation than he does with the Pop artists, just as Johns and Rauschenberg, despite their Pop imagery, remain essentially second-generation Abstract Expressionists. In its large scale, use of the single image, and lack of internal relationships, Oldenburg's sculpture has far more in common with the advanced art of Morris, Poons, Stella, Judd, *et al.* than it does with any Pop art, which, outside of Oldenburg and Lichtenstein, is indeed as reactionary and academic as most responsible critics have claimed it is. Like many object sculptors, Oldenburg is more interested in creating new shapes and surfaces than in concentrating on the tasteful arrangement or harmonious balancing of analogous forms that has characterized composition in Western art from the Renaissance through Cubism. Composition is treated casually, informally, even arbitrarily, and chance – in the form of the action of gravity – is a determining factor. Of his monuments (immense unrealized and possibly unrealizable projects to be erected in public squares and parks), Oldenburg writes: "The thrown versions of the monuments originated in disgust with the subject, the way one would kick over or throw down a piece of sculpture that hadn't turned out well. Instead of destruction, I accepted as result a variation of form and position . . . " Such an acceptance of chance and the arbitrary as part of the creative process is characteristic in general of post-Abstract Expressionist art. Whether Oldenburg has received it directly through Duchamp and Cage, or indirectly through Abstract Expressionism, which seems more likely, given the extent to which his early reliefs and environments grew out of Abstract Expressionism, is unimportant; what matters is the degree to which it has liberated not only his imagination but that of a generation of young artists.

Because Oldenburg's work is imagistic, one must take into consideration the relationship of the soft forms to the types of images used, since part of the expressiveness of the work arises naturally out of this relationship. Oldenburg selects his range of images from the three environments that constitute his universe: The Home, The Street, and The Store. The identification of the image is crucial; it is necessary in order to establish the active relationship between viewer and object that Oldenburg desires. For this reason, he chooses food or objects of personal use, such as clothing or furniture. Normally these are objects we would pick up, handle, or consume. "The name of the thing tells you how to grab it (camera, gun) or what to do with it (ice cream, chair, jacket)." In each case, active participation is called forth. And the reaction of the viewer to these objects, even when they are re-created on a mammoth scale and eccentrically deformed, is still within the context of the intimate and the personal. In this way, both Oldenburg and the makers of abstract object-sculpture, it seems to me, are working to erode the concept of "psychic distance," the sense of estrangement that we normally bring to the esthetic experience. By choosing to make objects or things, rather than paintings or sculptures that look immediately like "art," they force the viewer to react in terms of his normal environment, not in terms of the specialized reaction we associate only with art. This works to short-circuit

perception in a sense, forcing a more direct, intimate, personal contact with the work.

"Sanding the wooden typewriter keys," Oldenburg writes, "I feel like a manicurist." At another point he speaks of "the perception of mechanical nature as body." Pursuing the concept of anthropomorphizing to its logical extreme, Oldenburg has invested inanimate objects with the breath and pulse of life, and cast them in the irregular, sagging, lumpy forms of the human body. Interestingly enough, this tendency to anthropomorphize the inanimate can be seen in earlier American artists, such as Dove and Burchfield. In some ways Dove's bug-eyed ferryboats and dancing trees and Burchfield's houses in which windows become eyes and doors become mouths are the ancestors of Oldenburg's lewd grinning typewriters and sad-sack telephones.

Because they provide analogies with the human physiognomy and anatomy, one can see Oldenburg's soft machines as a kind of reformulated figurative sculpture. In their humanization, the soft machines are the opposite of the dehumanized, mechanical figures of Cubist sculpture. And indeed they represent an attitude diametrically opposed to that of the earlier 20th century, which viewed industrialism and its concomitant alienation as a cataclysmic threat. Oldenburg makes analogies between the body and the machine, much as cybernetics sees analogies between the brain and the computer. As the distance between man and machine narrows, man does not become more like the machine, as Ortega prophesied, but the machine, which now appears not menacingly strange but reassuringly familiar, becomes more like man – singular, changeable, and, above all, vulnerable.

Softness implies vulnerability. Duchamp was perhaps the first to invest objects with feelings in his "unhappy ready-mades." Oldenburg is pleased with the Airflow as a theme because "the implication of a bent fender or a crushed cab is considerable." There is a certain poignancy in the melancholy exhaustion of the droopy telephones and unkempt tires. But to attribute human qualities and human feelings to inanimate objects is to hold a pathetic fallacy. Such a pathetic fallacy, however, which sees objects as tired and as scarred as people, is central to Oldenburg's content. For it is a particular kind of world Oldenburg is trying to describe, and a particular kind of accommodation between man and his man-made nature that he is prescribing. In a passage reminiscent of the late Wilhelm Reich, Oldenburg writes: "Those who care for the world at this time tend to undress and go naked rather than in armor. I don't find anything metallic suited to this sensibility." If the soft machines are unthreatening, friendly even, in that they are like us, we cannot consider them alien. And it is an end to the alienation of man from his industrial environment that Oldenburg, the post-Marxist and post-Freudian, prescribes. His is the message of the second half of the 20th century, the message of such post-Marxist, post-Freudian thinkers as Norman O. Brown, whose *Life Against Death* was obviously a profound influence on Oldenburg's thought and iconography.[4] Like Brown, Oldenburg sees the possibility of an end to the estrangement between man and the phenomenological world he inhabits.

"An object in the shape of the artist" is Oldenburg's description of his work. Relating sculpture to one's own body image can result in a kind of dislocated expressionism; and in one sense the soft sculptures are really a series of self-portraits. Many, like the gaping faucet-eyed wash basin or the phallic Dormeyer blenders, actually parallel specific features of the human physiognomy or anatomy. Thus, Oldenburg's images act as a surrogate for the human body. Oldenburg admits it is the same to him whether his image is a cathedral or a girdle, since "the contribution of subject matter is almost a side effect since what I see is not the thing itself but – myself – in its form."

As surrogates for the human body, the soft machines serve as totems, "a kind of figure

representation in which the presence of a figure is evoked, as in a seance or hallucination." The image is individualized to the degree that one is convinced that "someone very particular is in the room with you." Like Klee and Dubuffet, Oldenburg seeks to call on the power of the primitive totem which manifests the charisma of submerged psychic forces. Like them, he reveres childhood and the innocent naiveté of the child's eye, as well as the art of the sidewalks and the madhouse. And like their work, Oldenburg's works appear to play host to some primitive force or energy, an energy that often seems to have a specifically sexual charge.[5]

In certain respects Oldenburg's "presences" are like the mysterious, quasi-human personages that peopled Surrealist painting. Other aspects of Oldenburg's imagination also link him with the Surrealists, not in the sense of having been influenced by them, but in the sense of belonging to the same "family of mind." Like the Surrealists, Oldenburg delights in the metamorphosis of one thing into another. The "hard," "soft," and "ghost" models of the typewriter, telephone, light switch, etc., show these objects in different states; the three daffy troll-like Silex juicits reveal the object in different comic attitudes; and the series of melting foods and partially eaten foods represent sequences that suggest the passage of time.

In a series of related objects, Oldenburg may alter the size, shape, form, substance, or state in time of each successive model. The alteration emphasizes the process of change; the state of the object in any of these series is always unstable, transitional, in flux: the objects are always in a process of becoming, rather than in any fixed, resolved, closed state. In the swimming pools, Oldenburg explores different forms of the same object. The interest in mutability is one he shares with a number of young abstract artists, most notably Morris, Stella, and Ron Davis. Oldenburg's investigations of the possibilities for new forms available from each object are often as exhaustive as the permutations of Morris, the spatial rotations of Ron Davis, or the systematic structural exploitations of Stella. At one point, for example, Oldenburg suggests treating the Airflow four different ways: interior, exterior, in sections, and finally whole. The presentation of an exhaustive and equally meaningful set of alternative solutions is common to the methodical thought of the younger generation. Announced in Johns's multiple presentations of the flag, it seems related to the discovery in the physical and social sciences that different types of coexistent models, each adequately accounting for the same data, are possible.

In keeping with his interest in metamorphoses, Oldenburg constantly sees analogies between dissimilar images which may assume, in his imagination, analogous forms.[6] Thus the relationship of Oldenburg's images to their prototypes is not literal nor even logical, but associative. Although Oldenburg claims that his approach is naive imitation, what he does with the objects he imitates is to "charge them more intensively" in order to maximize their power as contemporary totems. These totems, although functional, maintain their "magic" aura through being exalted by the artist's imagination into charismatic personages or presences.

Oldenburg explains the degree to which the image differs from its prototype: "If I alter, which I do usually, I do not alter for 'art' and I do not alter to express *myself*, I alter to unfold the object and to add to it other object qualities, forces. The object remains object, only expanded and less specific." Oldenburg's decision to remain an image-maker in a period when abstract art is ascendent seems based on his conviction that since allusion cannot be eliminated entirely, it must therefore be rendered redundant. He apparently believes that if one cannot eliminate the image, then one can at least render it meaningless or neutral by reducing all images to the common denominator of the body image.

The world, for Oldenburg, is constantly in motion. He is impressed above all by the movement of New York. "Objects previously still begin to move. The Pizza becomes Fan. The Fan chops. Fragments fly." Oldenburg has always conceived in terms of environments – in this, too, he has influenced current abstract sculpture which places so high a value on the relationship of the work to its environment.[7] Oldenburg sees the city as the artist's total environment, and suggests "a series of pieces treating New York . . . as an object sculpture." In fact, one of the most striking things about Oldenburg's imagination is his ability to conceive a complete personal universe and mythology. Oldenburg's objects do not constitute merely a string of related images, but a highly structured iconographical program, as coherent as the iconography of any old master, and as tied to a specific world-view. From the point of departure of the Airflow, for example, Oldenburg generalizes "a place with many different sized objects inside it, like a gallery, a butcher shop, like The Store." Later Airflow becomes a metaphor for the space around objects, a space in which objects can be seen falling, floating, or flying, propped up, lying down, or suspended.

Although at the heart of Oldenburg's effort is a reversal of normal expectations – not as I have pointed out, our expectations about objects, but our expectations about art, specifically sculpture – irony is not a component of his work. In its total lack of irony, Oldenburg's work differs from the rest of Pop art. But in place of the negative and pessimistic sense of irony, Oldenburg has substituted the cathartic force of humor, especially as it manifests itself in the tragi-comic. The sagging, clownish objects are, in their pathos and vulnerability, like the great oafish clown Oldenburg himself often impersonates in his Happenings. Here, as the dead-pan, baggy-pants ring-master, the heir of Chaplin and W.C. Fields, Oldenburg directs the activities of his circus. And the metaphor of the clown is well-taken. From Pagliacci to Pierrot to Picasso's and Fellini's harlequins, the clown assumes the role of the deracinated tragi-comic hero of modern times, as earlier the fool had represented a persona of Everyman. Oldenburg's art belongs to the tradition of the satyr plays, and to that of the fool and the clown; like the other works of this tradition, its message is the fallibility and vulnerability of man.

Oldenburg has claimed that he wishes "to present the geography of the human imagination . . . with real mountains and cities." His content he describes as "always the human imagination . . . both as historically constant and as universal among individuals." Oldenburg's faith in the redemptive power of the imagination is the guarantee that his innocence is genuine, even if it comes clothed in the most extreme sophistication and awareness. From the genuine innocence, vitality and originality of his vision, he has extrapolated a new vocabulary of forms that has already enriched the history of art. This vision is both grandiose and optimistic, it bespeaks the expansiveness and generosity, as well as the generalizing intelligence of the large talent.

NOTES

1. Oldenburg shows an unusual degree of objectivity about his work. For that reason, I have drawn to a great extent on his own notes, which seem to me by far the most intelligent things written about his work. All quotes in the text therefore are from Oldenburg's statements in the following: "Extracts from the Studio Notes," *Artforum*, Jan. 1966, and "Claes Oldenburg Skulpturer och Teckningar" (exhibition catalog, Moderna Museet, Stockholm, Sept. 17–Oct. 30, 1966). With his usual detachment, Oldenburg assesses himself: "My theories are not original, my execution is, and my distinction lies in my sensuality and imagination rather than my intellect."

2. Outside of Oldenburg's own writings, the most intelligent discussion of his work is Donald Judd's "Specific Objects" (*Arts Yearbook* no. 8, 1965) in which Judd places Oldenburg within the general context of object sculpture, to which his work surely relates more closely than to Pop art, the context in which it is normally considered.

3. The extent of Duchamp's influence on current esthetic attitudes can scarcely be overemphasized. What is interesting, however, is that the focus has been shifted from *finding* to *making* in an open situation that affords *abstract* artists the same freedom from restrictive conventions as the original Dadaists claimed. The highly eccentric, non-canonical geometric art of today is as dependent on freedoms won by Dada and Surrealism as Abstract Expressionism was. Not to acknowledge this aspect of current thinking is to falsify history.

4. So in tune with Brown's thinking was Oldenburg that before *Love's Body*, the sequel to *Life Against Death* in which Brown uses the human body as a metaphor for all political, social, and economic organization, Oldenburg had already anticipated this line of thought by using soft sculpture as a body image surrogate.

5. In his interest in the mythic and the totemic, Oldenburg appears to be exhuming the lost Surrealist content of Abstract Expressionism which was active in the early forties, but became submerged after the War when the Surrealists returned to Europe.

6. He notes such analogies as that between the square war monument and the square slab of butter in the baked potato; the giant frankfurter and Ellis Island; and the ironing board monument and the shape of Manhattan.

7. "My work makes a great demand on a collector," Oldenburg states. "I have tried to make it in every way so that anyone who comes into contact with it is greatly inconvenienced. That is to say, made aware of its existence and of my principles." One is struck by how close this statement comes to the intention of primary structures, another suggestion that the meaningful links are between the strongest, most advanced artists of the younger generation, rather than in terms of artificially created "movements" or "schools" such as Pop or Primary.

From CLAES OLDENBURG

Richard Kostelanetz

His first theatrical venture was a short work, *Snapshots from the City,* performed in 1960 in an environment he was showing at the Judson Memorial Church in Greenwich Village. Subsequent performance pieces include *Blackouts* (1961), *Fotodeath/Ironworks* (1961), *Injun* (1962), *Stars* (1963), *Gayety* (1963), *Autobodys* (1963), *Washes* (1965), and *Moviehouse* (1965). In the spring of 1962, he also produced a series of works on ten successive weekends for his Lower East Side storefront studio, which he christened The Ray Gun Theatre – a period remembered in Oldenburg's book *Store Days* (1967). Where the earlier performance pieces occurred in settings especially constructed for artistic occasions, Oldenburg's more recent theatre works explore such "found," yet spatially closed, locations as an indoor swimming pool or the seats of a moviehouse. Although his preparations for a theatrical piece tend to be rather informal, if not haphazard, the resulting work is invariably extremely deft; and through each one runs a distinctly personal style that is consistently achieved. . . .

KOSTELANETZ: What kind of theatrical awareness did you have when you presented your first theatre piece, *Snapshots from the City?*

OLDENBURG: Since that was as late as March, 1960, I had by then seen everyone give performances, except Jimmy Dine, who gave his first at that time too. That is, I had seen pieces by Robert Whitman, Red Grooms, Allan Kaprow, Dick Higgins, and perhaps George Brecht. I was aware of a tradition called "happenings" and also the experiments lumped with happenings although they had a different sort of inspiration, such as Red Grooms's *The Burning Building.* I had also seen the productions at The Living Theatre. I was influenced of course by all these things, but since my purpose was making all this useful to myself, I wasn't trying to be the first one to do anything.

At the time, I made an analysis of what was going on. I felt that there were two possible choices whose differences then looked very clear to me. There were people, both performers and spectators, who would go to one kind of theatre and ignore the other. I remember very well that the late Bob Thompson said he would not see a Kaprow, for example, because he was in the Red Grooms piece. I remember that when a Red Grooms piece and a Kaprow were put on together at the Reuben Gallery, in January of 1960, there was really a lack of communication between the two groups; they divided between an emotional and a rational expression. The latter had come out of Cage's ideas and what Kaprow had done with the *18 Happenings.* . . .

KOSTELANETZ: How did, say, Kaprow's example work upon you?

OLDENBURG: My position, you must understand, has always been on the outside. I didn't live in New Jersey, and I wasn't part of the New Jersey school, of which Kaprow was the leader. I didn't study with Cage. I discovered this whole area when I was looking for a gallery in 1958 and came across Red Grooms, who had started the City Gallery, which was the prototype of the Judson and many other informal artist-run places which also housed performances. Another later stopping-place of Red's perambulating was, for instance, the Delancey Street Museum, a loft which has recently been the home of Peter Schumann's Bread and Puppet Theatre.

Excerpt, "Claes Oldenburg," *The Theatre of Mixed Means*, New York: The Dial Press, 1968: 134 ff.

At the same time, I found Jim Dine, who had also found Red. The City Gallery was a splinter from the Hansa Gallery, and we formed the younger generation. After having my first one-man show at the Judson, I went away for the summer; and when I came back I saw Kaprow open the Reuben Gallery with his *18 Happenings in 6 Parts.* It wasn't until then that I gradually came to realize the existence of this New Jersey group. It included Whitman and Lucas Samaras, who both had been students of Kaprow's and were very much influenced by him, at the same time that they had their own entirely different ideas. Also through Kaprow, I met George Segal and Roy Lichtenstein. That year, of course, I had started the Judson Gallery with Jim Dine, Dick Tyler, and Phyllis Yampolsky. Although I had seen Kaprow at a Hansa picnic at George Segal's farm in 1958, the Reuben performance was my first meaningful point of contact with him. I had earlier read his piece on Jackson Pollock, which impressed me.

KOSTELANETZ: How did you do your first piece?

OLDENBURG: *Snapshots* was done in the beginning of March, 1960. I had created a "street" inside the Judson Gallery; a metamorphic "street" constructed out of paper and street materials; and it had a "floor collage" with all kinds of found objects on it – a "landscape" of the street; and the white walls showing through the construction were to be taken as open space.

KOSTELANETZ: Would you have preferred to have done this on a real street?

OLDENBURG: The original performance was supposed to take place in front of the Judson on Thompson Street. It was called *Post No Bills.* We had planned to block the street at the moment of performance by stalling a car, but the more I thought about the piece, the more I felt it was very closely connected with the construction I had made. I decided that I wanted to show my construction at the same time that I presented a performance. When people eventually came into the Judson Gallery, they saw me on the street as an object. So, from my first performance, my theatre work was linked to my sculpture or my construction. I was literally *in* my construction. Otherwise, I was trying to work from the inanimate situation to an animate one, from no-motion into motion.

KOSTELANETZ: Would you say, then, that the notion of "painter's theatre" is not very useful, because even among the painters exist not only different styles but different artistic traditions and different artistic ancestors?

OLDENBURG: Yet something you could say about my performances to individualize them is that as they are very much connected with my work as a painter and sculptor, they correspond to certain periods of my work. For example, the first three pieces – *Snapshots, Blackouts* [December, 1960], and *Fotodeath/Ironworks* [February, 1961] – are limited in color to black and white, and they have a great deal to do with darkness. This would also describe my work at that time, when I worked entirely with materials from the street and paper, as well as used no color. These three pieces also have a quality of desperation and misery about them; they deal with events of the street and its inhabitants, beggars and cripples. The sculptural pieces from *The Store* [December, 1961] and Ray Gun Theatre [1962], by contrast, are very colorful and warmly lighted – intimate.

After that, starting with *Sports* [October, 1962], which followed The Ray Gun Theatre, you get a group of performances where the place, the actual place, becomes very important. Examples include *Moviehouse* [New York City, December, 1965], the automobile parking lot of *Autobodys* [Los Angeles, December, 1963], and the farmhouse in Dallas for *Injun* [Dallas, 1962], and the swimming pool of *Washes* [New York City, 1965]. *The Store* was a store of course; but it was used very metamorphically – every week the mood and set were changed – whereas the later pieces always take into account a particular place.

Washes deals with what you can do in a swimming pool. There is a limit to how big a thing I can make; but if I go out and find a place like a swimming pool – which was one of the most marvelous settings I've discovered – then I can use it for my own purposes. Now, the difference between *Snapshots* and *Washes* is that in the earlier piece I attempted to construct a street; but as I was unable to construct an actual street, I did an "art" version of the typical street. In *Washes,* I simply went out and found a swimming pool. I had the feeling, while I did the piece, that I had really taken possession of nature for my own purposes. Similarly, my sculpture after *The Store* tends to be rather objective.

In the recent pieces, the biggest object is the place itself, and the people in it tend less to be stereotypes or symbols, but just people moving naturally and doing unaffected things. The parallel in my sculpture is the period I call "The Home," where I made toasters, chairs, ironing boards, plugs. This was the period after the food sculpture, which is connected with *The Store.* In "The Home" period, which started toward the end of 1963, the colors are limited not to drab black and white but to rich textures of those colors with one other color, blue. A washstand, for instance, is black, white, and blue, as is the bedroom. The pieces here are very neat and clear. That expressionist element becomes entirely the action of the material; my choice of soft material, not my manipulation of it, makes the pieces "expressive." . . .

KOSTELANETZ: Why do you create your pieces, both theatrical and sculptural, against a deadline?

OLDENBURG: I have read somewhere, probably in some pop psychology, that if you put in your mind a date for a task and are not afraid then when that date comes all the things will be ready. That's the way I operate in my theatre. Here are these people, my players, and the first thing that happens is that I am overwhelmed by the presence of so many people. As I spend most of my time alone, happenings become a way of meeting people – of getting out into the world. It's like coming back to New York after you've been away for a month; when you take your first ride in the subway, you can hardly get out of the car, because there is so much going on there.

First thing, I have to give my people something to do. After the first rehearsal, or the second rehearsal (if I have an exceptionally large cast), something begins to emerge – and much of it, a great deal, is made by the people themselves. Some of the best parts of a happening occur in the "rehearsals" when the piece takes shape. That thing with the bicycle [one of the last sequences in *Moviehouse*], which really made the whole piece, was a complete improvisation by Domenick Capobianco, who carried the bicycle . . .

KOSTELANETZ: . . . from the front of the theatre to the back, stepping over the rows of seats. Some people thought it stood out too much from the piece – it was so eccentric it was affected.

OLDENBURG: I don't agree with them. I know it stuck out awkwardly, but I liked it for that reason. For me, that was an important thing. It was a kind of ripping of the fabric of the setting.

KOSTELANETZ: In another sense, it was also too climactic a conclusion for a consistently flat structure. After you see several incidents that are faintly odd, then you see something that is really odd or odder; for that reason it is somewhat painful.

OLDENBURG: I am not a purist. However, the fact that Domenick, motivated by who knows what, went down and grabbed the bicycle and started climbing over the seats all by himself is sufficiently factual for me to use it in the piece, to find it irresistible. I think that I was seduced by a visual notion there too; I got so carried away by the correspondence of fans, wheels, and film reels that the bicycle seemed like the proper climax. If the

elements of a happening can be wrenched out and classified, this could be called a "dance." I often hand a person an obstacle and supply him only with a terrain and a direction. The resulting dance creates itself, as a sculpture takes its own shape when I substitute a soft material for a hard one. Domenick took a bike and crossed the terrain of the seats, which was very difficult and likely to hurt him. In one performance his foot stuck in a seat and I had to come along the floor and free him. . . .

KOSTELANETZ: You created certain visual illusions in *Moviehouse*. To convey the illusion of a movie projector flickering, I remember that you put a slow fan in front of the light from the empty projector.

OLDENBURG: I was trying to make the movement of this machine more feelable; to call attention to the character of the machinery.

KOSTELANETZ: It also established a ground bass rhythm for the piece. The second more various bass rhythm came from the usherettes moving back and forth across the rows, even though, as you say, their actions were not precisely timed. The third source of rhythm was, of course, the thumpety-thump of the piano. At the same time that the rhythms of *Moviehouse* were always present and identifiable, its visual sense was at once everywhere and nowhere – there was always something to see, and there was nowhere special to look, except at the end when Domenick carried his bicycle across the rows to the back of the theatre.

OLDENBURG: Everybody looked at him; he riveted attention. The event was unique in the desert of ordinary action – the sort of fantastic event you might find only in a movie, but here it was climbing out into real space. The silhouette of the bicycle moved and got bigger as he got closer to the projector; his image resembled film action in the lighted rectangle. When he got to the end, he put the bicycle down, and once he walked out the door, light came into the theatre. The lighted door in the darkness resembled the screen. As the theatre was drawn inside out, the piece ended.

It's characteristic of all my pieces to want to put the responsibility upon the individual eye. You see whatever you choose to see. People are always saying, "Look over there," while someone else is looking somewhere else. In photos taken of the audience during my performances, everyone is usually looking in different directions.

KOSTELANETZ: Isn't individualized response also an effect of your sculpture?

OLDENBURG: Yes. With the soft sculpture, for instance, the collector must arrange the piece himself.

KOSTELANETZ: In this sense, your work demands perceptions similar to those demanded by life. On Fourteenth Street, there's nowhere special to look. As our individual responses to such unpatterned activity are subjective and various, any meanings we attribute to such perceptions are apt to be personal and ambiguous.

OLDENBURG: Right. You have to make up your own mind.

By the time I had decided that theatre was, from my point of view, as well as that of the performers and the spectators, a choice of what kind of emotion or attitude to feel toward something, my attempt was to make the actions deliberately ambiguous whenever possible; so that you could either get terribly involved with them or you could be rather indifferent to them. . . .

KOSTELANETZ: In some of your pieces there is a clear preoccupation with American history, both the facts and the myth; how would you define your attitude toward the American past?

OLDENBURG: In *The Store* you have a hamburger and baked potato; these are stereo-

typed objects. The equivalent in theatre would be stereotyped figures and stereotyped events. A hamburger would be similar to an "Injun."

I value stereotypes, conventions, because they are "frozen" in time, objectified. All my objects are typical; that is, they are antiques, situated a bit back in time, so that while you observe what I do to them you have a clear idea of the original model. It's not a matter of nostalgia. I am not sentimental about America, or nationalistic. If, in painting, you take a familiar subject, that gives you a certain freedom. Nonetheless, the stereotypes of every nation creep into the minds and imagination of its citizens, but what they mean once they get there may be very personal. They may be masks, externalizations of personal dramas. In the period when I used historical figures, my theatre, I think, was too personal to be considered a conscious play with U.S. history. Though I did refer to the Ray Gun Theatre series as a "history of the U.S. consciousness," I think now it might have been more a history of *my* consciousness. Where I started with an outside idea, as with *Injun,* to represent "man's savagery" in the "pop" conventional way, the contact with actual materials turned the spectacle into an intimate personal account, maybe too much so. . . .

KOSTELANETZ: What were your ideas in, say, *Moviehouse?*

OLDENBURG: I had a clear recollection of a pickpocket working in a theatre late at night in Milwaukee years ago, among the people who were sleeping. I was interested in watching him work. In *Moviehouse,* Domenick, the fellow who carries the bicycle at the end of the piece, is known in the script as "the pickpocket," and his actions consist of going through the rows from back to front, looking under the seats. He's the timer of the piece; when he reaches the front of the theatre and picks up the bicycle, he signals that the piece is entering its last stages. He times the piece by how quickly he moves among the aisles; thus, it is he who actually decides how long the piece will be.

KOSTELANETZ: Speaking of *Moviehouse,* do you ever plan to work film into your pieces?

OLDENBURG: What I've been looking for in film I haven't yet found. All the films I have made have been very unsatisfying. Lately, I have begun to believe that in working with the visual image I started at the wrong end. I feel that sound is comparable to sculpture; it touches me. Sound is an invisible sculpture – think of thunder. It is possible that I'd have better luck if I started a film with the sound.

KOSTELANETZ: How, specifically, would you do that?

OLDENBURG: In my Stockholm performance of *Massage,* the base was a recording I made of myself typing the notes to the catalogue. I became aware of how spatial and physical the sound of a simple thing like that could be, and I used it in the performance, highly amplified. The sound really took possession of the space. That was the first time I ever used tape. Up to now, I've avoided tape-recordings to rely on a phonograph, because the tangibility of putting a record on and taking it off is more of a sculptural feeling.

KOSTELANETZ: How did this sound influence your use of space?

OLDENBURG: The space was a room of the museum; and in that situation, the sound, highly amplified, produced an effect something like that of a battlefield, creating a great deal of expectation about when the next sound would come. You had an almost visual picture of some kind of control of the sound; if you could recognize the sound as a typewriter, you would imagine a man typing. It produced a sense of large scale. I knew it was a typewriter, and I think most people did. One reviewer referred to it as a giant typewriter, which suggested that I was using sound to represent a sculptural object – a visually giant typewriter – I'd previously made. It fascinates me that he felt I was evoking through

sound a giant image. What added to the effect was the fact that the sound was coming from a structure, inside the museum, where I had my studio; so the actual location of the typewriter was precisely where the sound was coming from. Also, this structure in the museum had the appearance of a giant typewriter.

KOSTELANETZ: What kind of structure was it?

OLDENBURG: You would need to see the thing to know exactly what I'm talking about. The structure was placed in one corner of a large room inside the museum, so that it appeared to be a big block inside another room; with a little imagination, you could read this as a typewriter.

What might happen is that I could get so involved with the sound that I might eliminate the film. Or I might wind up using a very weak image and let the thing come through as sound.

KOSTELANETZ: Or, you might make a film about something because you liked the way it sounded.

OLDENBURG: That way the image would be rather inert; yet there would be an image. Or I might let your own eyes provide the images and take over your ears with sound, in a transistor sculpture, say, to be worn around town.

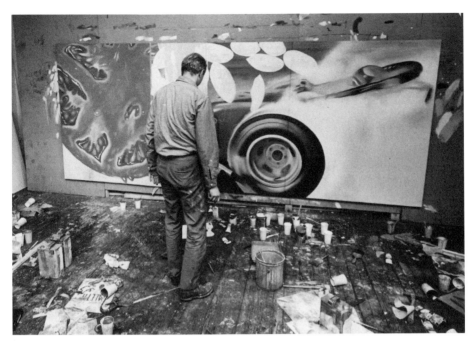

James Rosenquist in his studio, working on Taxi, *1964. Photograph by Ken Heyman.*

REVIEWS AND PREVIEWS: NEW NAMES THIS MONTH
James Rosenquist

Gene R. Swenson

James Rosenquist [Green; to Feb. 17] forces the viewer to recognize the discordant and anonymous elements of an environment which faces him daily. Although Rosenquist's pictures are large, only a part of the image of a shirt cuff or a chin may occupy as much as half of the picture. The viewer's experience is less a sense of disproportion or even over-enlargement (the quality of painting is that of a sign painter) than a sense of violence at seeing fragments of a billboard environment in actual, full-size proportions; we are not permitted distance with its numbing illusion of escape. *Shadows* is divided into three sections: on the inner edge of the dark left section is a faucet with a stream of water flowing out of it; the central part is painted a luminescent red with the glowing profile of a smiling girl and her shadow parallel to the slanting right side of the section; to its right, like a psychological X-ray, the partial curve of a giant, darkened whitewall tire seems to reverberate. As a painting about an annoying sound, a placid but frantically glowing exterior and the mind turning over, it is obvious and even corny. But in pushing the painting to the limits of scale, Rosenquist has pushed to our limits of thought: he forces us to face the mechanical but real size of the world and makes us realize how easily we can become shadows. The elements of this impersonal Brobdingnagian world are pieced together with a ruthless clarity; it is profoundly disturbing and negative.

Art News, February 1962: 20

JAMES ROSENQUIST

Edward F. Fry

> *La vie actuelle, plus fragmentée, plus rapide que les époques précédentes, devait subir comme moyen d'expression un art de divisionnisme dynamique; et le côté sentimental, l'expression populaire, est arrivée à un moment critique . . .*
>
> <div align="right">Fernand Léger, 1913</div>

You are hurrying down a street, thinking perhaps of the words from a song, or a sunny afternoon at the sea shore. You cross an intersection as the light is turning from green to red, and ahead you half-notice a shop with food in the window, advertisements for a coming film. A very shiny new car turns the corner, almost hitting you, and suddenly looking up you see first only a black tire beside your foot, then a chromium bumper, the polished fender, a pair of hands on the steering wheel, the driver's sunglasses. Sudden thoughts of death – a bird at the side of the highway, red, an apple, and the lips of a pretty girl walking by.

Such is the new human reality, the psychic landscape of which we are often only half-aware, in our modern, and therefore inevitably urban, world. It is the stuff of certain kinds of cinema (montage, abrupt sequences) and even sometimes of literature, as in Robbe-Grillet's objectified version of it, or as in the poetry of Cendrars. But only painting can both objectify this reality and present to us simultaneously all its complexities. Such is frequently James Rosenquist's approach to painting, by means of which he creates formal works of art.

James Rosenquist's art is not literary, but like great literature it may be experienced at multiple levels of meaning and of formal structure. His painting is often as much concerned with the nature of art as it is with the nature of reality. *White Bread* for example is first of all a strict composition of closely related colours in planes which indicate space without making use of spatial illusions. The white bread, made with artificial preservatives, is spread with margarine – artificial butter: an objective reflection of industrialized cuisine. The image is painted with a flat anonymous technique, and we suddenly realize that at another level of meaning it is an ironic symbol directed against the heavy impastoes of abstract expressionism.

Rosenquist is not a surrealist. His art is highly self-conscious and intellectually controlled. But when he wishes to do so he can create images that are powerfully hallucinatory, as in *Front Lawn*. This enveloping evocation of suburban landscape is an archetype of a thousand front lawns in any middle-class community, where side by side they run into each other indistinguishably in an endless repetition. Rosenquist's image implies its own repetition. It radiates that hypnotic ennui which has become a pervasive emotion of modern life. The grass and shrubs are painted in colours that stop just short of being metallic. He is asking us the question, how real is nature under such repeated, standardized conditions?

Let us examine at greater length one of Rosenquist's most important paintings. In *Taxi* he has created a powerful psychic collage of almost flawless structure. This complex work can be absorbed visually in a single rapid sweep of the eye across its expanse, even as we

Exhibition catalogue, *James Rosenquist,* Ileana Sonnabend Gallery, Paris, June 1964

comprehend rather more slowly its diverse imagery – a racing driver at speed in a cloud of white smoke, a hand touching the ground, a tomato freshly sliced, the roof of a house, bare tree branches against a blue sky with white clouds, peanuts pouring from a striped cellophane bag, candles on a birthday cake. Gradually these images begin to interact with each other, and then to metamorphose. The mechanical speed of the racing car is momentarily stopped by an illusionistic image, charged with associations, incised with precise sharpness into the amorphous white smoke. It is a hand touching blades of grass. But this hand and the grass, both natural objects whose local colour we know instinctively, have lost all natural reality and are painted in a grey tinted faintly yellow. Beside this image of unnatural nature is the racer's wheel, blurred into grey with also a yellow tint: Nature and Machinery, the one ironically neither more nor less natural than the other. We move with a jump in scale to the left side of the picture, from the wheel to its formal counterpart in the huge disk of a tomato, which may or may not be artificially ripened but whose redness is more intense than that of the racing car itself, just as the clouds are perhaps less real in appearance than the white smoke of the racing engine. The peanuts that pour from a bag are at times lime-like abstractions blending with the candle flames, whose presence evokes the memory of countless anonymous celebrations marking the passage of time. But these very peanuts, which are small in relation to the tomato, become possibly huge footballs when beside the racing car, and finally once even a perfectly abstract form that is more intensely blue than the sky itself.

Thus in a world of simple anonymous objects and actions nothing is always itself but is always changing in relation to everything else. The only fixed point of reference is our subjective capacity to comprehend simultaneously all the complexities of such a continually changing and totally relativistic world; and ultimately through this capacity we participate as well in the aesthetic reordering of such a world on a flat surface.

In these few examples of Rosenquist's work, as in others, there are always two or more levels of artistic thought functioning concurrently. It is this richness and subtlety of structure, of formal invention, of transformation and poetic allusion, that places Rosenquist at the most advanced position in contemporary painting. In him is fulfilled Léger's prophetic call for a painter of modern life.

(Based on conversations with the artist in his studio, New York, 2 May 1964.)

LOS ANGELES: JAMES ROSENQUIST

William Wilson

As slippery, agreeable and conventional as an ad man at a client's party, Rosenquist nevertheless makes us aware of his attitudes in his big chopped-up ads and billboard sections. He persistently presents a picture of harebrained noninvolvement, sneaking in his comment so quietly that we are never certain we have not made it up for ourselves. His is a world of inescapable superficiality.

He necessarily comments upon a dead idea . . . Shaw said that was the fate of those who comment. He talks of a world created by vulgar advertising. But after all there is another world of advertising that is tenaciously tasteful and art-oriented. Rosenquist is not interested because he pretends not to be interested in art. His comments become current by association. Two large panels that derive from old "T-zone" ads become current by their association with the lung cancer fuss. They are about a big pretty lie from a day for which we might long, a day when the simple pleasure of smoking was not accompanied by a reasonable certainty that we are committing suicide in the process. Nobody can say for sure that this is Rosenquist's idea. He doesn't force it.

Any estimate slips maddeningly off the mark. More clearly than any of his deadpan soulmates, Lichtenstein or Warhol or Rauschenberg, Rosenquist is a purist of denial who only affirms that things are, or were, bright, phony and impersonal. If we cannot be sure he is concerned with cancer, we can be sure he is with consumption. Mass consumption of artificial goods. Every work is of artificial stuff (he delights in the obviously heightened color of canned fruit salad) made even more artificial by use of a technique as rigid as that of the Egyptians; the ad technique whose basic tenet is "Thou shalt not offend." The purity that is his necessarily reminds us of other artistic purists, but Rosenquist will not be cornered. A painting showing a hand holding a piece of Swiss cheese might make one think he was interested in spatial play, but he cuts the whole thing up like a jigsaw puzzle and reaffirms the flat. What holds him about the head of Joan Crawford in a cigarette-ad fragment is not the roundness of the orbs or the sculptural quality of her cheekbones, but the machine-like phoniness of its split lids and its mouth of plastic smoothness.

Rosenquist accepts esthetics as snobbery and anger as absurd. If his energetic color reminds you of Stuart Davis, he makes it clear that these bright things are not of his making, they are the result of one impression of a colorplate in a set of progressive proofs.

Do we see a snide reference to his view of Abstract Expressionism in certain backgrounds and in a carelessly left paint rag? Rosenquist will not cop out. Is he interested in a refined shape? He makes spaghetti and Crawford's hair out of the same stuff. Finally we begin to sink into the mood. Finally we are assured that we can be carefree because everything is made of plastic . . . even plastic we can eat. Then we begin to get a little sick. We think Rosenquist has prodded us to it with that menacing chromium fork of his. Prodded us where we are no longer capable of being shocked. That's pretty good.

Artforum, December 1964: 12

JAMES ROSENQUIST: ASPECTS OF A MULTIPLE ART

Lucy R. Lippard

When some of the lights on the Forty-Second Street movie marquees were turned out in order to attract attention in that neon jungle, we reached a significant saturation point. Rosenquist departs from the resulting half-lit world of contrasts rather than from the all-out Fun Fair that preceded it. His references are oblique, his images obscured, his aims complex; his is a multiple, rather than a single-minded art, made up of a unique combination of sassy Pop realism, mysterious irrationality and an essentially non-objective sensibility. The key to Rosenquist's work is not its commercial vocabulary, nor its detachment, but its scale. "For me things have to be life size or larger. I believe it is possible to bring something so close that you can see through it, so it comes to you right off the wall. I like to bring things into unexpected immediacy – as if someone thrust something right next to your face – a beer bottle or his shirt cuff – and said 'how do you like it?'"[1]

If a beer bottle is painted six feet tall, it radiates suggestively beyond the painting. (If the bottle is that big, what about the people?) Many paintings executed in conventional scale will diminish and lose their impact in the ordinary room or exhibition space. A Rosenquist retains its vigor in much the same way that a Rothko or a Newman holds its own in any space and in fact remakes the space in its own image. Their single images and Pollock's all-over compositions also reject the static relationship between objects imposed by conventional, consistent scale. The Cubists brought the objects portrayed forward to the picture plane; the Futurists attempted, with little success, to go beyond it. The Surrealists, who made full use of juxtaposition and arbitrary scale, did so only within the limits of conventional space, depending on the recognizable framework – a room or a landscape – to define the size of an object. They still saw the rearrangement of scale in literary, nineteenth-century terms, and were involved in a limited alteration of scale, changing the way certain objects or places were seen, rather than in re-scaling a new immediate environment.

Rosenquist's work is often compared to that of René Magritte. Although he admires the Belgian Surrealist, the similarity is superficial. They share a knowledge of the mystery inherent in common images. Yet Magritte's remote and deadpan approach is closer to that of the other Pop artists than to Rosenquist's. His questions about illusion and resemblance are posed in an earlier, and static, spatial language; his picture-within-a-picture motifs are concerned with dislocation rather than re-integration. Magritte plays devil's advocate rather than God with reality. He challenges known nomenclature but rarely renames anything. To Rosenquist it makes no difference what things are called. What they look like counts. He employs artifice as a formal tool and surface reality to rob objects and people of their identities. More important, and this is the crux of the visual difference between Pop and Surrealism, Rosenquist's disparities of scale are not intended to reflect upon neighboring images, but to act directly upon the spectator.

Traditional implications of illusionism are reversed. The disproportionate scale of Rosenquist's images forces them out rather than back into the painted distance, envelops the spectator in an elephantine trompe l'oeil. Where other Pop artists have used scale to overpower but not to attack, holding the image on the picture plane in an arrogant with-

Artforum, December 1965: 41-44

drawal, Rosenquist uses his gigantism as an assault on normality: this is the first aspect of his work. In the process of the attack, the object loses its identity and becomes form. This is the second experience – a more subtle and less recognized one. Lichtenstein and Rosenquist are the two non-objective painters involved in Pop. That is, they share basic intentions with their wholly abstract contemporaries. "One thing, the subject isn't popular images," Rosenquist has insisted. "It isn't that at all."

At one time there was a popular misconception that this "former sign painter named James Rosenquist" (*Newsweek*) was a kind of updated "peintre naif," hauled off his scaffolding by some inspired entrepreneur. In fact, he has been painting seriously for fourteen years. From 1952 to 1955 he studied art with Cameron Booth at the University of Minnesota, then came to New York for a year's scholarship at the Art Students League. After various odd jobs he was hired by the General Outdoor Advertising Company, having learned sign-painting as a trade at the age of twenty. By 1960 he had developed a distinctive all-over style, predominantly grey, a heavily painted "grid of many colors, like an old rug." The one transitional painting, still non-objective, superimposed a huge red arabesque derived from billboards. The fresh, lurid color of his present work was the final break with early influences.

In winter 1959–60, Rosenquist made a series of window display murals for Bonwit Teller and Bloomingdale's based on billboard techniques, and he has often spoken of his experiences painting signs and of the possibilities of working seriously in that manner. It was not, however, until the fall of 1960 that he first applied commercial techniques and subject matter to his own painting. "Zone," the first canvas in his present style, still exists, though greatly changed. Aside from a huge face, it originally included some cows, a hand shaking salt on a lapel, a naked man committing suicide. A flood in the studio washed off some of the paint and it was reworked. The colors were too bright and too many. The little man was too small. "He fell into the old pictorial space," and Rosenquist was primarily concerned with getting away from conventional pictorial traditions, especially those of scale and space. He began (as Andy Warhol did at roughly the same time) by rendering his new images in Abstract Expressionistic techniques and "drips." Even after abandoning this to make a clean break, he retained for a few years a freedom of execution that went generally unnoticed. At a normally chosen vantage point an image would look almost stenciled; on closer inspection, loose, relaxed strokes could be discerned, though this derived more from the distance factor of billboards than from any Expressionist tendency.

Rosenquist still prefers to paint the individual images "so well that they might sell something, as though it had to be done by noon on contract. By painting fast and directly, even if it's just to sell snake oil or stockings, more goes into it than you realize." Most of his paintings go through myriad transformations, sometimes as many as five major changes a day, each decided and executed at almost breakneck speed. No matter how large or how finished or how close to the deadline a canvas may be (The World's Fair mural, for example) he will begin from scratch on an entire section, or rearrange the whole composition the day before it is to be installed. While the basic principles of Rosenquist's fragmentation are those of collage, he completely eschews ready-made pictorial materials, and is equally opposed (for his own art) to mechanical aids and reproductive processes, finding them too limiting. "Change is what makes art. Collage is too divorced from materials. Painting goes into more depth. The work changes all the time no matter how careful you are to stay close to what you are copying." On the other hand, some of his preliminary studies are impermanent collages, bearing no strict resemblance

to the completed canvas. He begins by making numerous composition sketches in the form of scribbled "ideagrams," pastel or pencil drawings with color and conception notes, and apparently non-objective oil-on-paper studies. Color areas stand for the images, which, when chosen from magazines, newspapers or other commercial sources, are stapled onto a piece of paper, in approximately their final shape or order. But between these work sheets and the finished product, the scale and color of everything may be completely revised. Change of scale gives the artist complete flexibility and provokes new ideas even after the original decisions have been made. In the work sheet a man's trouser leg and a candy bar may be about the same size, while on the final canvas one is ten times larger than the other.

Even if Rosenquist wants to "avoid the romantic quality of paint and keep the stamp of the manmade thing," his approach is fundamentally romantic, which again sets him apart from the rest of the major Pop artists, except for Oldenburg. He is also a "wholesome" painter (though this word has been relegated to the level of bread and bad movies), a moral artist in the sense of Robert Motherwell's statement:

> I think a great deal of what's happening between America and Europe now – I'm speaking of younger artists – is our implacable insistence here on moral values, which I think is slowly disappearing among younger artists in Europe, who paint mainly with taste. And I don't mean this in a superior way, but almost primitively, as a kind of animal thirst for something solidly real. It's directed to what one really feels, and not to what one prefers to feel, or thinks one feels.[2]

The idealism of today is irony. Satire and social protest are not major elements in Rosenquist's art. In fact, the only painting which is conspicuously "political" is a large triptych entitled "Homage to the American Negro." Here a headless "white" man (posed, but unintentionally, like the Lincoln Monument) sits on a Negro's head. Through and around a pair of dark glasses the sky and rectangular background are subtly varied by color and value switches. A white mother whispering advice to her children is placed before a camera aperture reading "darken, normal, lighten," and her nose is decorated with IBM machine perforations. The only brown thing in the painting is the delicious looking chocolate frosting on a huge piece of vanilla cake that takes up the entire right side. Elsewhere the "colored people" are literally colored – green, blue, orange, etc. The painting is about color, but not the color of skin. "It is about the colors in a colorful person, the colors you do not see through glasses."

Rosenquist's last one-man show (April 1965), which consisted solely of the 23-foot mural, "F-111," was entirely devoted to a social theme, that of the artist's position in today's society, the insignificance of the easel painting in an era of immensity, of jet war machines and "noveaux collectionneurs" buying wholesale. He has used scale here to force acknowledgment of the importance of art, as a "visual antidote to the power and pressure of the other side of our society." Nevertheless, this message is far from apparent to the casual or even to the concentrating viewer, and serves as further indication of the determinedly iceberg quality of Rosenquist's art and aims. The same is true of the specific images in the majority of his works. They have no "story to tell," but they often do have a personal significance to the artist, a significance which he refuses to make obvious because it is personal, and because the painting is to be seen first and foremost as a painting, as a "visual boomerang." He constantly avoids clever, witty, poetic, easily absorbed or humorous imagery in his use of juxtaposition. While the idea for a painting and

its title usually occur to him simultaneously, neither is literal. "A Lot to Like," 1962, seems to demand a generalized interpretation pertaining to the mad rush of the consumer to consume, but it was intended as a comment on the flaunting of masculinity. (The football player throws his "pass" through the hole in the razor blade and into the bottomless woman.) Blandly round and smooth forms are contrasted with sharp edges and associations, such as the blade (deceptively painted a soft grey), the point of the umbrella, and the hard green rain ("like Hiroshige, but radioactive, Hiroshima too"). Here, as elsewhere, there is a distinct abstract eroticism emphasized by the unidentified and consequently suggestive anatomical areas, and by the sinuous arabesques that join and transform the ragged, quick-flash image compartments. The irony of Rosenquist's work is pervasive, not specific. He refers to the '50s by hair styles, cars or clothes from the recent past, images that "people haven't started to look at yet, that have the least value of anything I could use and still be an image, because recent history seems unremembered and anonymous while current events are bloody and passionate and older history is categorized and nostalgic."

Rosenquist's experience as a billboard painter sharpened his reactions to the non-representational aspects of outwardly representational forms. This might not have been the case had he not had the eye of a non-objective painter. Being hoisted up Kirk Douglas' cheek to paint a four-foot eyelash, he became aware that Kirk Douglas had disappeared, the cheek was no longer a cheek, nor the eyelash an eyelash; that he was enveloped in a sea of purely plastic form and color defined by immense arabesques. In turn, it is this familiarity with the monstrous that allows Rosenquist to understate his enlargement. Most of us will get no closer to such an experience than seeing Jayne Mansfield's ten-foot high monotone breast emerging from the movie screen. There is something of the old 3-D films or even of stereoscopic images in Rosenquist's protruding forms, and parallels are suggested with advanced film technique such as the love-making scenes from "Hiroshima, mon amour," where specific parts of the body are seen in such close-up detail that they become the anonymous essence of union. In this sense he is again in opposition to Lichtenstein and Wesselmann, who have gone to great lengths to flatten and remove their images from spectator space in order to achieve that other ambiguity between two and three dimensions. Less rigorous and more experimental than the other Pop artists, Rosenquist is also more uneven. His methods demand an intuitive control and at times the images float uneasily on the surface in a spatial no-man's land, or are landlocked in crowded incoherence when the formal idea is not fully resolved. His mastery of these complexities is grounded in a highly developed and still expanding vocabulary of spatial devices.

These devices are, for the most part, based on minutely varied color changes. The eye unaccustomed to such refinements misses a good deal in his work. Rosenquist acquired a heightened awareness of monotone nuance from the grisaille billboards. (In "Silver Skies," for instance, each grey is tinted a different color.) The white-lead base of practically all of his colors (except for the day-glo tones, which he was perhaps the first to use extensively) gives them a fresh and ingenuous air (also saccharine and pungently repellent when so desired). White is particularly important in the pale "unfinished" colors, like those of printers' color-separation proofs. In other contexts, white is used to segment and imperceptibly alter forms which are in other respects "whole." An all but invisible line, a psychological rather than visual division, is obtained by the addition of an infinitesimal amount of white; the result is like a shadow across the surface, almost unnoticeable, providing a quieter dimension to the excitement of an art which first seems

implacably resistant to a subtle reading. Similar effects hold one image in front of another or signal sharp divisions within a single image, or set up dissimilar spaces. A pictured object, moving from one subtly defined compartment to another, may change abruptly in value but not in color, or vice versa. A brilliant cadmium may be juxtaposed against a still more brilliant day-glo red on one side, a cool grey on the other, forcing a change of identity in midform and, radically, but again nearly imperceptibly, distorting its role in the overall design.

Such subtleties are employed in a clearer and more formal manner in the use of a painted or separate and slightly projecting rectangle that repeats or modifies its ground. This stresses the non-objective character of the work as well as reinforcing certain effects of scale. In "Noon," a sky panel set in another sky enlarges an infinite and virtually unenlargeable area by making it relative (an eminently Magrittean idea, but used for different ends). A more extensive exploration of the relief panels occurred in "Capillary Action I," 1962, a large painting of a tree in a park landscape where green and greenish, photographic greys and "natural" tones are played against each other to expose the artificiality and banality of Nature. A grisaille foreground implies "Please Don't Step on the Grass," a kelly green panel stuck over a swatch of paint-smeared newspaper and tape implies "Wet Paint." Rosenquist says it is about "seeing abstraction everywhere, looking at a landscape and seeing abstraction," in contrast to the usual spectator sport of finding the figure or landscape in abstractions. The implications of this theme were followed up in a construction – "Capillary Action II," 1963, where the tree is real, about eight feet high and neither painted nor refurbished. Here too a piece of torn newspaper hints at the artifice of reality itself. The space is animated by three stretched plastic panels and a square drawn in wiggly red neon, all set at different distances from the surface of a larger, inset panel. "A painter searches for a brutality that hasn't been assimilated by nature. I believe there is a heavy hand of nature on the artist," Rosenquist has said. This second piece proved him right in an extra-art manner. It was the result of a wild day and night search through Westchester for the "right tree," which never turned up. "Nature couldn't provide it."

When he began to add extraneous materials to his canvases consistently in 1962-63, Rosenquist chose carefully, concentrating on "abstract" substances, such as mirror, tin, clear plastic, glass, aluminum and rainbow streaked bars of wood. One of the most effective was sections of limp plastic drop sheet, either transparent or vertically dripped with paint, which acted upon the canvas below and combined visually to make new colors, providing a shifting chromatic screen through which that area of the painting changed continually, and adding a capricious dimension subject to the breeze or light in the room. In 1964 he made several free-standing constructions, most of which employed light. These were environmental in that they were more concerned with extending sensuous experience than with pure form. Light and clear plastics share with Rosenquist's iconography a quiescent immateriality, the ability to destroy conventional space and define further levels or "vantage points" from or through which an object might be seen. A chrome-plated barbed wire extravaganza with a flourish of blue neon streaking through it used light as abstract fantasy; a luridly multicolored ramp set over a sheet of brightly painted plexiglass, with colored light flashing beneath it was illusionistic; a ceiling panel of a floor plan with bare bulbs suspended from it was paradoxically "realistic." All of this was part of a burgeoning interest in irregularity, manifested in various non-rectangular or centrally pierced works and two small paintings hung "off kilter" to stress the expendability of background and show that "a painting shouldn't be perfect. Perfection makes a pun. I'm tired of the Mondrian kind of relationship."

For most of 1965, however, Rosenquist abandoned these experimental pieces and returned to a stricter and more highly polished evolution of his straight painting style, which culminated in "F-111." Partially responsible for this switchback was a summer (1964) in Europe, where everything was so graciously "artistic and beautiful" that on his return he felt forced to revert to a raw, brash and "non-artistic" idiom to get started again. During the past summer (1965), spent in Aspen, Colorado, Rosenquist became vitally interested in Oriental thought and also embarked on an extremely personal project to experiment with the effects of peripheral vision. Not painting, nor construction, and only ambiguously environmental, this series of tentlike arches of painted canvas may constitute the breakthrough into the non-objective which has been imminent for at least two years. The climactic summing-up of "F-111" would seem to necessitate it, were it not that the unexpected and wide-open character of the man and the work defies prediction.

NOTES

1. All unsourced quotations are from the artist, primarily in conversation with the author, and also from G. R. Swenson's interview "What Is Pop Art?" *Art News*, February, 1964, and Dorothy Seckler's "Folklore of the Banal," *Art in America*, Winter 1962.
2. *Metro*, no. 7, 1962, p.95.

THE MAN IN THE PAPER SUIT

Doon Arbus

James Rosenquist and I were sitting at a table in a corner of the dimly-lit coffee house. He is all one color: a pale yellowish brown.

Rosenquist is one of the pioneer pop artists, a former sign painter who went on to greater things, including a very successful major exhibition of his works at the Venice Biennale this past summer. He was just about to leave for Tokyo, at the invitation of the Japanese government, to be present along with several other big names in American art at the opening of a comprehensive exhibit of American art since the end of World War II.

He wore the suit that has been causing so much excitement, the one he wore to a recent exhibition, the one that is made out of brown paper.

I kept looking at him, trying to think of something to say about the suit. After all, that's the whole point of our meeting: Why does James Rosenquist have a paper suit and how does it feel to wear one? I know how *I'm* feeling. Intimidated. There isn't anything to say about it that doesn't seem terribly obvious. I guess that's what makes it a Pop suit.

"Don't you get cold?"

"Oh no. It's like if you're walking down a windy street in the winter time and you hold a newspaper against your chest, you know, inside your coat, it'll keep you warm."

I had never tried, but it seemed to make sense. Isn't paper less porous than cloth? "Is it just a single layer of paper?"

"I don't know. I think maybe there's a layer of cloth in here somewhere." He opens the jacket and examines the inside where the lining might have been, but there seems to be nothing there but paper. "You know," he says thoughtfully, "I really like the way it's made. The way it's cut and put together." He runs his finger approvingly along the lapel. "Yes, it's very well tailored, don't you think?"

I reach across the table and hesitantly finger the edge of his sleeve. I had been wanting to touch it since the first moment I saw it, but I just hadn't dared. The paper has a light, dusty brown color and it's vertically striped with narrow ridges. It feels thicker and spongier than ordinary paper. In fact it really doesn't seem much like paper at all, except for the soft, crackley sound it makes when it creases.

"Nice, huh?" says Rosenquist. "Isn't it light? And it's so comfortable to move around in." Rosenquist is squirming luxuriously, as if to prove it is comfortable.

The waitress is standing beside him with the liverwurst and onion sandwich he ordered. Rosenquist opens his napkin and places it on his lap, eyeing the sandwich with relish as the waitress places it in front of him.

"I'm hungry." He picks up a sandwich half, holds it up in front of him and gazes steadily at it. "There have been times in my life . . . it happened when I was 26 and last year, too . . ." He takes a bite of the sandwich. ". . . I'll be working on something. Plugging along, you know. Sort of in the dark. And suddenly way out there, I see a little pin of light. So far away. All I know is that's where I have to go. And I think, 'It's going to take *so much work*.' But I have to do it. So I work and I work and I work and after a long long time, when I am almost there . . . POW . . . I see another tiny light way off in another

New York / The World Journal Tribune Magazine, November 6, 1966: 7-9

direction. And I've got to pull up and start going toward that light. That is where I have to go . . . " Rosenquist shakes his head in mock dismay. He smiles vacantly at me.

"Tell me why you had the suit made."

He nods. "Well, whenever I go to the galleries or to an opening or something like that, you know, like going to Tokyo, I have to decide what to wear. I have clothes in my closet, you know, suits. But I go up to visit friends of mine all the time, painters or sculptors maybe, in their studios. I wander around. Look at the things they're doing. Well, there's got to be a nail sticking out of the wall somewhere and wet canvases lying all over the place, you know?" He shrugs. "I'm always walking into things. All my suits have big gashes in the sleeves."

"It's like a great, old tintype photograph I once saw. I guess it was taken at an artists' colony. You know, the formal group portrait. Everybody very stiff, with their chins sticking out." He puffs up his chest. "They all look so dignified, and then you look up close and this one guy has a rip in his lapel. It's like a big flaw that changes everything."

"So you know, I've been trying to decide what to do. I mean I don't want to go around in a blue serge suit with a torn pants-leg or something, so I asked this guy, Horst, who is a designer, 'Would you make me a suit out of brown paper?' He was funny about it. I don't know. He didn't like the idea of making it out of brown paper. So he kept suggesting other things, like silver paper with sequined stripes. But I sort of *feel* like a paper bag. Something that might end up in the garbage tomorrow. I mean sometimes it's like a neon sign keeps flashing at me and it's saying, 'JAMES ROSENQUIST, IT'S ALL OVER!' I mean you're through! Dead. Finished. But anyway, so that's the kind of paper I wanted. Finally I told Horst to think about it this way. No one would be noticing the material because it would just be plain brown paper, like a garbage bag or something, so his tailoring will be bound to stand out better. It would be like having pure tailoring without a suit. You always have to give people some other reason for doing things."

Poor Horst! If he really agreed to make the suit in brown paper because he thought the material would be inconspicuous, he couldn't have been more deceived. In fact, the only comment about the paper suit that avoids the obvious is probably something like, "Well, Mr. Rosenquist, I certainly admire the cut of your suit!" But the material seems to be such a surprise to everyone who sees it that I can't imagine such a remark being made. People's curiosity about it seems insatiable. There is so much they want to know. "How much did it cost?" "Why doesn't it tear?" "What happens if you get caught in the rain?" "How many times have you worn it?" "Isn't it going to be hard for you to throw it away?" "Where can I get one of my own?" Some are more inclined to make witticisms like "Have you a scrap of paper on you?" or "Do you send it to the eraser's once a week?" But *everyone* notices the material.

Rosenquist has only worn the suit three times and it is not unscathed. There are no gashes or holes in it, but it has begun to pucker a bit at the knees and elbows and seems in danger of losing its shape. He also admitted that the seat of the pants was growing dangerously thin, but none of this seemed to bother him. In fact, he is even considering whether to get Horst to make him a paper tuxedo for formal occasions. Later Jasper Johns, a fellow pop artist who went to Japan with Rosenquist, reported that Rosenquist was somewhat embarrassed there when he was caught out in a rain that was laden with industrial poisons which caused a suit to disintegrate on him.

Rosenquist glances at his watch and says he has to go. He pushes his chair back from the table, crumples his napkin into a ball and seems about to put it on the empty plate in front of him. But he stops with his arm poised grotesquely in mid-air. He looks like a

wind-up doll that has just run down. He slowly relaxes his fist and looks intently at the wadded napkin, then down at his own chest and back at the napkin again. The corners of his mouth curl quizzically in a sort of smile. He appears at once melodramatic and ingenuous. "Wow," he says.

ART: A NEW HANGAR FOR ROSENQUIST'S JET-POP "F-111"

Hilton Kramer

James Rosenquist's immense pop painting entitled "F-111," which dominated the American exhibition at the 1967 São Paulo Bienal and has been widely exhibited in European museums since it was first shown here at the Leo Castelli Gallery in 1965, went on view yesterday at the Metropolitan Museum of Art.

The painting is executed as a series of panels, and measures 86 feet long and 10 feet high when completely assembled. At the Metropolitan, it occupies three walls of a large gallery. Accompanying the Rosenquist work, which is on loan from the collection of Mr. and Mrs. Robert C. Scull, are three paintings from the Metropolitan's permanent collection: "The Rape of the Sabine Women" by Nicholas Poussin, "The Death of Socrates" by Jacques Louis David and "Washington Crossing the Delaware" by Emanuel Gottlieb Leutze. The museum has mounted this motley assemblage under the rubric of "History Painting – Various Aspects."

"F-111" takes its title, of course, from the fighter-bomber of that name, and juxtaposes images of this military aircraft with a variety of commonplace motifs from the realm of consumer advertising and photojournalism. These motifs include, among other disparate images, an angel food cake, an oversize Firestone tire, a child's head under a hair-dryer and a mushroom cloud from a nuclear explosion under an umbrella. The picture is organized as a giant montage, with each section designed to be "read" separately and, at the same time, as part of the over-all image. Pictorially, the style might best be described as buckeye cubism.

A museum spokesman has described "F-111" as a "painted comment on the industrial-military aspect of the American scene." The director of the Metropolitan, Thomas P. F. Hoving, has declared that, in his opinion, the work "makes an important and timely statement," not only because of its form and expression "but sociologically as well." Mr. Scull, the present owner of the painting, has contributed an article to the March number of the museum's Bulletin in which he offers the view that the work is "a milestone in the visual literature of what is perhaps art's greatest theme: the struggle between life and death."

To descend from these dizzying altitudes of rhetoric, where the wish is father to every thought, to the humbler, more terrestial realm where Mr. Rosenquist's creation actually exists, is to find oneself confronting a slick, cheerful, overblown piece of work that is, expressively, on a level with the commercial art from which its visual materials are drawn. Far from prompting any deep emotions about the fate of civilization, this is the kind of

The New York Times, February 17, 1968: 25

visual spectacle – gay, extrovert, technically adept, but irredeemably superficial – that leaves the spectator feeling as if he ought to be sucking on a popsicle.

If there is an important sociological phenomenon here, it will be found in the way the Metropolitan has mounted the painting, not in the painting itself. The notion of employing Poussin and David as some sort of support for the Rosenquist work is itself an idea of stunning vulgarity and insensitivity, and thus not without significance in the realm of museum standards and responsibilities. Indeed, it betrays a total indifference to esthetic standards to include the Leutze painting in a class – no matter how defined – with Poussin and David, but I suppose it was necessary to come up with a work of high kitsch that would provide a transition from the high art of these French masters to the high camp of "F-111."

All in all, this showing of Mr. Rosenquist's painting is a lamentable event. True, the picture is famous, and Mr. Rosenquist enjoys an international renown because of it. But no one at the Metropolitan is willing to claim greatness for the work – even Henry Geldzahler, the curator of contemporary arts, avows that the "question of quality seems irrelevant" – and only greatness could justify still another mounting of the painting under these prestigious auspices.

Still, there are aspects of the occasion that one will long remember. Mr. Scull's contribution to the museum's Bulletin, for example is a classic of its kind. After recounting his personal adventures in and out of the artist's studio, Mr. Scull offers us his personal response to the picture in question. "For me, the F-111 is tremendous. I am not referring to its size, although it is certainly a tour de force in this respect, with some 850 square feet of real excitement. . . . It presents the essence of the United States' relationship to the world, displaying the equation of the good life of peace, with its luxuries and aspirations, and our involvement with the potential for instant war and final annihilation. . . . It speaks to all mankind, employing the plain language of everyday men, not the secret signs of the specialist."

I wonder if it was art historical contributions of this quality that Mr. Hoving had in mind when he announced some months ago his ambition to make the Metropolitan "the Harvard of museums"?

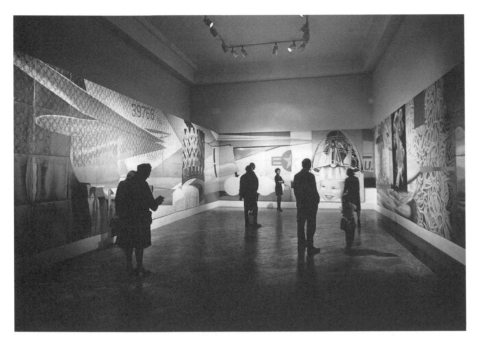

James Rosenquist, F-111, *oil on canvas with aluminum, 10 × 86 feet, 1965. Metropolitan Museum of Art, New York. Photograph by William E. Sauro / NYT Pictures.*

RE THE F-111: A COLLECTOR'S NOTES

Robert C. Scull

In 1961 I heard about an artist who was working in a manner different from that of the then prevailing abstract expressionism. He was not represented by a gallery, and one had to visit his studio to see his work. My guide was Richard Bellamy, director of the Green Gallery. One Sunday we rendezvoused in front of a building on Coenties Slip, in lower Manhattan, and after the usual shout-from-the-street-instead-of-doorbell, we made our way upstairs.

To this point, the preceding could describe many of my loft and studio visits. Meeting James Rosenquist was another experience. I encountered an ill-at-ease ex-North Dakotan of about twenty-eight who spoke in a painfully abstract manner. He had been in New York some six years, I learned, and till recently he had made his living as a billboard painter. I had to ask to be shown his paintings. The first ones, his older work, evidenced the influence of the abstract expressionists. This was not surprising, considering the impact of the great works that had recently come from Pollock, de Kooning, Still, Rothko, and Kline. After this slightly historical display Rosenquist brought out three canvases he had just completed. They were figurative works, but their images were unlike any I had ever seen. They seemed to me as disconnected and puzzling as Rosenquist's way of speaking.

The one that interested me the most was a large canvas in acid-bright colors. It was not

Metropolitan Museum of Art *Bulletin*, March 1968: 282–83

the color that aroused my curiosity, but rather the madness of the imagery. Entitled *The Light That Won't Fail*, the painting was divided into three sections. The largest was given over to a large part of a television screen; one of the smaller sections revealed part of a Spam sandwich, the other, the profile of a girl's mouth, chin, and neck.

I asked why the objects were not centered – why only fragments of them were used. No answer. I pressed for some explanation. The artist finally came out with, "Man, this is our new religion – the cathode-ray tube – and the painting *is* the explanation."

I liked that. It focused on what I came to see was at the heart of Rosenquist's work: his immediate concern with the forces playing on all of us.

I judge art, not by history, but by the measure of my response and personal involvement in the art experience. *The Light That Won't Fail* almost annoyed me and at the same time it charmed me, for I could see that Rosenquist was looking at things in a new, contemporary manner. I bought the painting then and there (incidentally giving the artist his first sale). It seems to me as strong today as it did in 1961.

By 1964 the extraordinary movement that came to be known as pop art was a generally accepted fact. New works by Rosenquist, Oldenburg, Dine, Wesselmann, Warhol, Indiana, and Lichtenstein were being bought by collectors and museums, and the new art had even triumphed over the name given to it, half in fun, half in condescension. During the winter of 1964-1965 the art world heard that Rosenquist was working on a mammoth canvas. I asked Jim if I might see it. No, I was told. Even he had not seen it all together, he said, since he was painting it in sections and his studio, big as it was, could not accommodate the whole thing. Disappointed in that, I inquired if he had other new work to show. No, he said, because the "big one" was taking all his time.

As the weeks went by, about the only solid news from the studio was that the new work included a gigantic rendering of a fighter-bomber and that the painting itself was more than eighty feet long. Jim gave his friends the impression that his task was perhaps too great. He would mumble that he "had to get on with it," that "there was no turning back." I sensed obsession. His attitude may have had romantic overtones, but what it meant, practically speaking, was that for over half a year there were no canvases for sale and the artist's obligations were piling up.

In the spring of 1965 I left the city on a vacation. After attending four of Jim's openings in a row, I was going to miss the unveiling of the "big one," since his schedule and mine could not be made to coincide. However, I counted on returning while the canvas was still in the gallery.

The exhibition opened and the *F-111* was an immediate success – if that word also means instant controversy. As usual, Rosenquist's work was applauded by those who understood its significance. Those who disliked pop art could not dismiss the painting and were astonished by what they deemed the arrogance of such a huge undertaking.

My vacation ended. When I returned to New York and went to 4 East 77 Street, I was surprised to see trucks at the entrance and moving men on the stairs leading to the gallery. Somehow I had arrived a day late and the painting was being taken down. Worse news was in store. Leo Castelli, Jim's dealer, was in the act of dispatching forty-one of its fifty-one panels to individual buyers all over the United States. The role of this remarkable dealer must be noted. Although he had sold the majority of the panels, he had had the foresight to stipulate that all sales were subject to cancellation if a purchaser could be found for the entire painting before it left the gallery. I informed Mr. Castelli that I would buy the painting and keep it together.

For me, the *F-111* is tremendous. I am not referring to its size, although it is certainly

a tour de force in this respect, with some 850 square feet of real excitement. First of all, it is a great painting in the traditional sense of orderliness, integrity, and execution. But I have encountered these qualities in many paintings I did not care to own. Two things drew me to this one: its authority – every bit of it was done with the dexterity of a master – and its content. Most art historians seem to agree that one of the specifics for greatness in a work of art is that it seriously mirror or comment on its own time. The *F-111* does this overwhelmingly. It presents the essence of the United States' relationship to the world, displaying the equation of the good life of peace, with its luxuries and aspirations, and our involvement with the potential for instant war and final annihilation. I regard the painting as a milestone in the visual literature of what is perhaps art's greatest theme: the struggle between life and death. It speaks to all mankind, employing the plain language of everyday men, not the secret signs of the specialist.

The history of the *F-111* since I bought it is a story in itself. Like a true flying machine, it has traveled to other countries, touching down wherever a large enough wall space was available. I am happy indeed to welcome it home again and to have it seen by visitors to the Metropolitan.

ROSENQUIST AT THE MET: AVANT-GARDE OR RED GUARD?

Sidney Tillim

Doubtlessly my reaction – acute dismay – at the news of a loan exhibition of James Rosenquist's 10 by 86-foot Pop art mural, *F-111,* at one of the great museums of the world, the Metropolitan Museum of Art, was somewhat paranoid. But even within the prominently and professionally "advanced" crowd there were gasps of horror, though for entirely different reasons. Whereas I simply felt threatened, *they* felt shame, the shame of an avant-garde chicken coming home to roost in a way they had neither imagined nor desired. No one imagined the apotheosis of modernism in this form. Whether it was illusion or rationalization that had been shattered was immaterial. It was still possible to believe that modernism was still resisted, was still engaged in a holy war as recently as when Alan Solomon miscalculated the masochism of his bourgeois patrons at the Jewish Museum, for his exhibitions aroused considerable protest, their publicity value notwithstanding. It was even possible to keep the faith when the new Whitney became just another camp follower, because if the subject of its newest retrospective is Don Judd, the Whitney is also showing the ratified Adolph Gottlieb and even has John Heliker on tap. But Pop art at the Met? Sire, this is no longer the revolution, it is the Terror.

The appearance of the Rosenquist opus at the Metropolitan dramatizes, perhaps more than a first-rate modernist work might have done, the extent to which modernism has become a complex Establishment, involving certain dealers, critics and curators who function as a kind of interlocking directorate which definitively affects taste and the marketplace. There is, of course, no literal governing caste as such, as there was in the days of the old Academy, but the effect is the same. Some art is decreed fashionable, some is not. Power breeds imitation because it always functions the same way. Thus, despite recurrent internecine ideological disputes, modernism inevitably has slipped from the role of liberator into the role of tyrant. True, as an Establishment it is still premised on radical imperatives, but the result is an elitist radicalism whose questionable nobility (questionable because it still believes itself to be radical) is confirmed by an act of artistic transgression at a once powerful institution that, apparently no longer sure of its own values or too bewildered to care, has become a party to its own desecration. As the Louvre was once a book in which artists learned to read, the Metropolitan had for some of us become a house in which we sharpened our memories and learned not to forget. I mourn the passing of the old order at the Met; the collection is inviolate, of course, but the old ambience has been destroyed.

What makes it so difficult to accept the presence of the *F-111* at the august Metropolitan is the fact that it is both unnecessary and inevitable. Some reform was perhaps needed at the Metropolitan. Its collection of relatively recent modernist art, notoriously limited, acknowledges mainly an obligation rather than serious historical interest, or even the respect it once showed paintings like *September Morn.* But whatever ailed it, so drastic a cure was hardly required. Rape is not the most satisfactory form of accommodation. In fact, since no one expects and many do not desire the Met to contain a self-sufficient museum of modern art, its shortcomings were but a pretext for a dramatic gesture, the motivation for which exists partly in the gesture itself. That is, it represents an estimation

Artforum, April 1968: 46–49, © Sidney Tillim

of the "life style" of the art world today and is, in fact, a concession, if it does not actually pander, to its pretenses. It is, in other words, a symptom of the taste it serves, a taste in which a spurious progressivism combines with a desire for celebrity. This alone marks the rejection of the Bohemian ethic of alienation. In effect, then, the Metropolitan's new, young and obviously ambitious director, Thomas P. F. Hoving, morally supported by his *eminence grise,* Curator of Contemporary American Art Henry Geldzahler, has compelled the institution he directs to act as a backdrop for a rhetorical gesture that is simultaneously a statement of policy and something of an advertisement for himself.

The presence of the *F-111* in the Met is the climax and the ultimate symbol of everything that has happened to and in the avant-garde since the late fifties and early sixties. And if one, at first, tolerated the excesses of the Pop generation because it broke down the monolithic structure of a vanguard sired by Abstract Expressionism and welcomed the liberation from crisis esthetics, one has now to recognize a new tyranny that is worse than the old. I have elsewhere described this as a new philistinism, by which I mean a sensibility crippled by being forced to live in a state of constant anticipation and, finally, expectation, of the "new," until it becomes self-fulfilling, consuming history rather than creating it. There is then a profound irony to what many will take as a "breakthrough" at the Met, and it is all that permits us to hope that it will not mature into a tragedy of spoilation. Personally, I'm not optimistic.

There is meanwhile an artistic side to all this. The presence of the *F-111* in the Metropolitan raises questions of function and quality that are especially relevant to the intentions of recent art.

The question of function is raised by the fact that the *F-111* is a mural, yet it was not designed for a specific structure, and was even sold piecemeal until Collector Robert Scull bought it, by special arrangement, outright. Consequently the work makes no physical sense in the Metropolitan at all. The room in which Rosenquist's melange of a vast aircraft fusilage punctuated by such *kitscherei* as a small universe of spaghetti, a large slice of a huge tire, and a gigantic vignette of a banal moppet under a hair-dryer, all in lurid billboard color, in no way coincides, in shape and in architectural detail, with either the concept, size or scale of the mural. The room is both too narrow and too high. The enormous painting, which consists of 51 panels, sits at the bottom of a veritable well. There is some twelve feet or more of air between the top of the work and the ceiling. This presses down on the picture, all but minimizing its scale. Then, too, the painting is made to range unequally around three walls of a narrowish gallery. About two-thirds of it is on a single wall. The rest just continues across a narrow wall and onto the wall opposite the largest section where it ends without any architectural relation. This destroys the decorative possibilities of the mural. Rather, the general effect is of an arbitrariness that is heightened by the fact that the wall on which the major portion rests is a false one, built out some four feet from the actual supporting wall, apparently to lessen the wall space so that the ensemble would seem to cover more. This not only corrupts the architectural integrity of a room which is admittedly nothing more than a plain chamber, but it does not produce the desired effect. Instead, the mural looks like a blanket that is too short for its bed.

On the other hand, however, the Metropolitan, or a like institution, is the only place where the ritualistic meaning of such a homeless mural can be grasped. For while it is physically inadequate, the museum as a public institution provides the proper psychological ambience in which to relate to the work as a cultural symbol rather than merely as art or expression. A mural is also a decoration; that is, it is an ideal representation in which the visual splendor is equivalent to the morality implicit in ideal representation. It is be-

cause of this idealizing function of heroic scale that the *F-111* is not the sociopolitical polemic that many, including the artist, suppose it to be, but rather a glorification, at least partially, of the ethos of the culture of which as a mural it becomes a symbol. True, there is banality in the work and it has not been transcended, but this flaw is part of the formal inconsistencies of the work which I shall discuss shortly. Here I want to point out mainly that the *F-111* is a neo-aristocratic emblem and that to the degree that the Metropolitan liberates its "pretenses," it (the Metropolitan) assumes the role of patron and the sort of patron that made the fresco cycles of the old masters possible.

The presence, then, of the *F-111* in a setting that is a surrogate for "high" patronage, dramatizes a new sense of art or a new sense of the uses of art for public purposes for which existing forms of patronage and, by extension, architecture, are no longer adequate. The *F-111* is not the only uncommissioned work of immense size and muralesque ambitions to have been created lately. There is Al Held's 56-foot *Greek Garden,* not to mention the interest in public projects by a number of sculptors and the emergence of agents who specialize in soliciting large public projects for artists. What system of patronage can most sensibly absorb these ambitions, and are these ambitions viable in art as it is presently constituted?

Obviously, government and industry would seem the most likely successors to the autocratic patrons, princes and popes; but their participation in modernist art so far savors more of politics and public relations than of cultural enrichment. Now the propaganda element of high art is always an important aspect of its *raison d'etre.* It only becomes reprehensible when the patron chooses bad art to do the job. So far neither government nor industry can command the finest art. The recent city-wide exhibition of abstractionist sculpture in New York was a travesty of taste because the city was interested only in propaganda and was not very particular about the work that fulfilled the purpose. But the real significance of this act of patronage (with private funds, it should be added) was that the city of New York had to call in "experts" to organize the show. That is, it had to call in representatives of the dealer-critic system to organize an exhibition sponsored by the very sort of patronage that the critic-dealer system overthrew during the 19th century (as Harrison and Cynthia White have shown in their study of "institutional change in the French painting world," *Canvases and Careers*). Similarly, the presence of private dealers in a new market for public monuments swarms with the same contradictions. The old agent served the prince, not the artist. Thus, there is a conflict of artistic and economic systems.

The importance of these contradictions is that they relate to the quality, or lack of it, of recent muralesque and otherwise monumental art. That is, none of it that I know of has been particularly successful as painting. Sociological contradictions seem to translate themselves into formal ones, becoming manifest as a conflict between mural and easel conventions, the history of which I shall outline shortly. In the *F-111* this results in a total lack of monumental lines in the composition due to the failure of shape and detail to engage in an organic way. The picture fails to develop real breadth of effect because its structure is essentially that of the montage rather than something fundamentally abstract. Held's *Greek Garden* similarly has big shapes but no dominant pattern.

Perhaps it is only logical then that the vocal partisans of Pop art tend to stress its propaganda value rather than quality. Citing the *F-111* as "symbol of the industrial-military complex of our times, a paranoic subject worthy of Dali," Henry Geldzahler also has declared in the *Bulletin* of the Metropolitan Museum for March that "the question of quality is irrelevant when one is confronted with the *F-111*." Lawrence Alloway, who coined the

term "Pop art" in the late fifties as a description of mass communications which was subsequently applied to certain art works, is almost irrationally hostile to what he regards as "academic formal art criticism" which is predicated on traditional notions of "quality."

Rosenquist himself was so unclear as to the formal status of his work that he permitted it to be sold, panel by panel, until, as I have said, Robert Scull bought the entire work by special arrangement, which was that dealer Leo Castelli reserved the right to cancel the sale of the individual panels – which were no more than souvenirs of the original anyway – if a buyer for the entire painting appeared.

Finally, both Mr. Hoving and Mr. Geldzahler confirm the general confusion by identifying the *F-111* with history painting and attempting to substantiate their claim by installing with the *F-111* Poussin's *Rape of the Sabines,* David's *The Death of Socrates* and a small version of Leutze's *Washington Crossing the Delaware.* The attempt at historical association was a valid one, and the history genre is also plausible. But the works chosen are easel paintings with none of the decorative significance and architectural implications of the *F-111*. A far better choice would have been any one of the three huge Tiepolos which the Metropolitan now owns and which, by the way, are also partly giant easel paintings that do not fully satisfy the decorative function of a completely realized mural. In fact their decorative idealism is compromised by an imbalance of realism and design similar to that of the *F-111*.

Considering the issues raised by the *F-111*, especially by its installation in a heretofore ideologically neutral museum, the issue of quality, I have to concede, is somewhat secondary, though I am not making excuses for the painting. I mean simply that momentarily the conceptual problem is paramount. The point is that Rosenquist and others are experiencing the impulse to work on a scale and size unprecedented in modernist art, and that either the historical moment or their historical understanding seems to make realization very difficult. Or to put it another way, an integrated sense of style embodying both plastic art and architecture is inconceivable without historical ratification. It does not make sense that there should be a meaningful mural style without an architectural complement. My feeling about the matter is that the fault lies with modernism itself and that a fully organic decorative style that would represent an entire culture once more is not possible without some fundamental changes. And for these to take place, there has to be a better understanding of the modernist past. Specifically it has to be recognized that whereas modernism generally may be historically "inevitable," it is constantly making counter-proposals to itself. It is important to understand *that the revolution of modernism probably centers around the issue of scale.*

Modernism achieved its early modernity as an easel style. The 19th century saw an abrupt decline in mural art with the exception of that of Puvis de Chavannes, an all but forgotten artist whose star may soon rise again. But the later modernity of modernism includes a reaction against the purely easel tradition. This was post-Impressionism. Gauguin expressed a desire to do Puvis in color, but just as importantly Cézanne chose Poussin, a painter in the grand manner, to repaint after nature. (There is some justification, then, for Mr. Hoving's and Mr. Geldzahler's historical confusion.) In other words, the heroes of both of the modernists were conceptual painters. This provides at least a formal explanation of the internal stress modernism has always felt, the stress, that is, between an art of sensory immediacy and conceptual deportment, between what has been very erroneously misunderstood as "feeling" and the power of a grand idea. We know the climax of this great internal disorder as Abstract Expressionism, which nonetheless broke through to the first culturally reflexive sense of monumental scale since the end of

the 18th century. Still, the conflict between feeling and idea has persisted if only because the sensory bias of modernism has remained dominant. In color painting, the most grandiloquent of modernist styles, art as Idea is preempted by a metaphor of sense experience so *extreme,* so absolute, one is tempted to say, that it has atomized all of the traditional components of a picture. Line, shape, movement, pattern and space are assimilated to the single effect of intense chromatic sensation. Thus what appears to be the apotheosis of modernist sensibility is simultaneously self-limiting to the extent that further reduction of depicted shapes, further *complex simplicity* (neé reductiveness) seems precluded.

All other art since the late 1950s, art, that is, that has regarded traditional modernism with conceptual esteem while seeking to reformulate it, has been art that in some way anticipated the crisis of reductiveness. It is art that has operated to a disadvantage to the extent that the decorative splendor attained with abstractionist techniques cannot be successfully challenged by any less abstract style. Therefore, art which has not been abstract has had to be something else. At the same time, the greater its distance from the abstract, the greater its disadvantage in rephrasing modernist sensibility. Consequently, the shaped canvas has met the crisis of reductiveness in terms most resembling traditional abstractionist ones while the almost criminally misunderstood figurative art has the least similarity.

But Pop art has tried to have it both ways and has been obliged to camouflage what is basically an old-fashioned conflict between form and content with its now characteristic and sometimes corrosive irony. The subject matter employed by an artist like Rosenquist is deliberately ignoble because the artist cannot formally live up to the idealism implicit in his will to monumental scale. His subject matter therefore implies the lack of meaningful narrative which he cannot begin to imagine because the structure he employs – a variant of synthetic Cubism – precludes those illustrative values which are a prerequisite to the expression of sentiment. Picasso's *Guernica* fails to generate emotional power for the same reason. Thus despite the artist's denial, according to Mr. Geldzahler, that it was his intention to paint heroically, the fact is that he has tried to and failed. The fact also is that he has painted better pictures on a smaller scale, and that much of his work since the completion of the *F-111* seems uncertain in scale and therefore fragmentary.

On the other hand, militant abstractionism, obsessed with its own "inevitability" seems more involved with a desire for apotheosis than the intrinsic limits of its formal concept.

In sum, the appearance of a Pop mural at the Metropolitan Museum is part farce, part high drama, evoking as it does the crisis of high art in our time. The final irony, and truth, may be that perhaps the right thing has occurred but for all the wrong reasons.

ART

Lawrence Alloway

James Rosenquist has done another giant painting in sections: the first, in 1965, was "F-111"; the second, painted last year, was "Horse Blinders," recently on view at Leo Castelli's Gallery. The size of both paintings, about 10 feet high and something more than 80 feet long, is dictated by the dimensions of the gallery. The spectator, stepping into Castelli's second-floor front room, was walled in with huge images. The "F-111" had fifty-one sections and Rosenquist told G. R. Swenson that originally he expected it to be sold a piece at a time: each bit would be incomplete, a souvenir of the original. In the end the painting stayed together so that the radical idea of atomistic dispersal was lost. "Horse Blinders" has fewer sections (I counted fourteen vertical ones) and it looks as if Rosenquist has withdrawn from his distribution-by-fragmentation idea. These canvases are interspersed with aluminum sheets, which always occur at the corners of the rooms so that they reflect, in reverse and somewhat blurred, the painting at right angles to them. Breaking up the sequence, or even hanging "Horse Blinders" in another space, would reduce the changing reflections which are, I think, a part of its success.

Rosenquist's earlier work tends to fall short as color; his tonal handling of form (he was trained in the sky above Times Square) was expert and convincing, but his color was subservient to tonal values, that is to say to colors used one at a time. He established color zones: one would be all pink, another all gun-metal gray, another the orange of spaghetti. These zones have been intensifying in color lately but not until now has his color really become active, the equal, as a pictorial factor, of his tonal definition of form. The aluminum sheets, which in "F-111" were used to give what the artist called "a brittle feeling," in contrast to the canvas, contribute to his new vivid color. There is a full range over the spectrum: flaring orange, cloudy purple, pale blue, brilliant yellow, livid red. And the colors fuse with one another, overlap and infiltrate, with a coloristic resource not found in the earlier paintings.

What is the subject of "Horse Blinders"? The title refers to the apparatus worn by horses to block peripheral vision and thus reduce sources of sudden alarm, horses being nervous creatures. The connection of this to the painting isn't clear, though presumably the artist is either (1) freeing us of *our* blinders so we can see more widely, or (2) implying that the objects in his painting act like horse blinders on us, their users. In terms of object recognition, the picture is about kitchen technology. Reading from right to left, which is the way attention moved in the gallery, the following items are legible: a finger (like an image from an ad for touch control); an ATT cable, its color-coded wires opening out like a bouquet; a motion study of a spoon beating food in a bowl, followed by energy patterns in wave form; a block of butter melting in a pan over a glowing burner; finally a telephone cord (motion study again) and a blurred mass (flesh?).

Rosenquist's method of composition is that of montage, the photographic and figurative extension of collage. Whereas in Cubist collage separate bits of material are assembled in a mainly flat space, montage unites imagery from separate sources in a *scenic* way. It is the method of Soviet movies of the twenties, and of iconographically ambitious WPA murals in which allegorical figures, representative American types, and pylons mingle

The Nation, May 5, 1969: 581–82

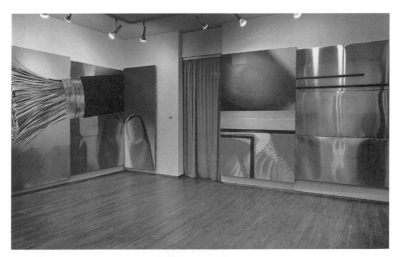

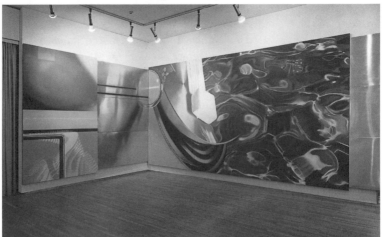

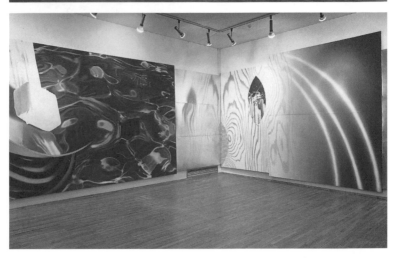

James Rosenquist, Horse Blinders, *oil on canvas with aluminum, 10 × 84½ feet; 1968–69. Museum Ludwig, Cologne. © 1997 James Rosenquist / Licensed by VAGA, New York, NY.*

and interpenetrate. In Rosenquist's pictures slices of images, each one highly naturalistic in detail, are taken from half-legible sources. Forms are defined as obscure bosses of advancing detail or as amorphous surfaces that expand into what the artist once called "immediate infinity." The effect is of objects slipping out of focus, losing their boundaries. Enlargement and identity loss reinforce each other: the result of his giantism is doubt, not clarity. Often the transitions from one zone of a painting to another are more emphatic in their color change than in the objects defined internally in each zone.

Rosenquist explained the significance of a detail in the earlier big picture, which included an A-bomb mushroom, by saying: "Then next, that's an underwater swimmer wearing a helmet with an air bubble above his head, an exhaust air bubble that's related to the breath of the atomic bomb. His 'gulp' of breath is like the 'gulp' of the explosion. It's an unnatural force, man made." There is no doubt that the objects in their order in "Horse Blinders" could also be annotated in this way. However, just as his objects are painted in a way that makes them simultaneously explicit yet evasive, so the interjection of allegory is felt by the spectator, but without his becoming dependent on the artist's explanation. There is, I think, an inherent obscurity in Rosenquist's work, though I do not mean this in a derogatory sense. Indeed, the function of obscurity in his work is to protect him from the banal. The "F-111" is, in format, like a WPA mural; "Horse Blinders," except for its obscurity, could be a "Wonders of the Technical Age" mural or a fold-out in an encyclopedia. Undoubtedly, Rosenquist thinks in terms of objects with symbolic meanings and in terms of allegories about man's place in society, but his moralism, though articulate, is secretive.

Rosenquist's forms are all derived from recognizable objects split off from their familiar context. In this respect his practice resembles that of the Pop artists with whom he used to be associated. Pop art made a great play in the recontextualizing of common materials and unprocessed objects within the traditional field of art. Though highly aware of the sign systems they were using, Pop artists to a man refrained from assigning symbolic function to their forms. Rosenquist, though equally sensitive to the manmade landscape, seems always to have thought about it allegorically, in terms of what was good for man or what machines were doing to people. He has failed to materialize these Great Thoughts, but he has done something else infinitely more interesting.

Dutch artists of the 17th century could assign symbolic meaning to their realistic subjects without weakening the illusion of things seen, but Rosenquist cannot communicate with society in unshared symbols. What we can do, as spectators, however, is to view his art in relation to our common experience of objects, even if the system by which they are ordered is out of reach. Then we can see the brilliance of his achievement as, by means of a naturalistic technique, he presents us with de-realized objects. Rosenquist is the painter of the objects and spaces of our world, but as they slip out of focus, enormous but lost. It has been said that Pop art has shown us the art and objects of the city, bringing neglected aspects of life back into view. Rosenquist, who more than anybody else was responsible for realizing a realistic potential within Pop art, does the reverse. He paints the world in all those episodes in which we lose our grip on it.

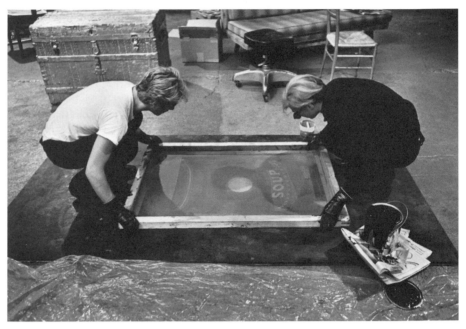

Gerard Malanga and Warhol silkscreen a Campbell's soup can, mid-1960s. Photograph by Ugo Mulas.

ANDY WARHOL, FERUS GALLERY

Henry T. Hopkins

To those of us who grew up during the cream-colored thirties with "Big-Little Books," "Comic Books," and a "Johnson and Smith Catalogue" as constant companions; when "good, hot soup" sustained us between digging caves in the vacant lot and having "clod" fights without fear of being tabbed as juvenile delinquents; when the Campbell Soup Kids romped gaily in four colors on the overleaf from the Post Script page in "The Saturday Evening Post," this show has peculiar significance. Though, as many have said, it may make a neat, negative point about standardization it also has a positive point to make. In a tenderloin-oriented society it is a nostalgic call for a return to nature. Warhol obviously doesn't want to give us much to cling to in the way of sweet handling, preferring instead the hard commercial surface of his philosophical cronies. But then house fetishes rarely compete with Rembrandt in esthetic significance. However, based on formal arrangements, intellectual and emotional response, one finds favorites. Mine is "Onion."

Artforum, September 1962: 15

From NEW YORK LETTER

Michael Fried

Of all the painters working today in the service – or thrall – of a popular iconography Andy Warhol is probably the most single-minded and the most spectacular. His current show at the Stable appears to have been done in a combination paint and silk-screen technique; I'm not sure about this, but it seems as if he laid down areas of bright colour first, then printed the silk-screen pattern in black over them and finally used paint again to put in details. The technical result is brilliant, and there are passages of fine, sharp painting as well, though in this latter respect Warhol is inconsistent: he can handle paint well but it is not his chief, nor perhaps even a major concern, and he is capable of showing things that are quite badly painted for the sake of the image they embody. And in fact the success of individual paintings depends only partly (though possibly more than Warhol might like) on the quality of paint-handling. Even more it has to do with the choice of subject matter, with the particular image selected for reproduction – which lays him open to the danger of an evanescence he can do nothing about. An art like Warhol's is necessarily parasitic upon the myths of its time, and indirectly therefore upon the machinery of fame and publicity that market these myths; and it is not at all unlikely that the myths that move us will be unintelligible (or at best starkly dated) to generations that follow. This is said not to denigrate Warhol's work but to characterize it and the risks it runs – and, I admit, to register an advance protest against the advent of a generation that will not be as moved by Warhol's beautiful, vulgar, heart-breaking icons of Marilyn Monroe as I am. These, I think, are the most successful pieces in the show, far more successful than, for example, the comparable heads of Troy Donahue – because the fact remains that Marilyn is one of the overriding myths of our time while Donahue is not, and there is a consequent element of subjectivity that enters into the choice of the latter and mars the effect. (Epic poets and pop artists have to work with the mythic material as it is given: their art is necessarily impersonal, and there is barely any room for personal predilection.) Warhol's large canvas of Elvis Presley heads fell somewhere between the other two.

Another painting I thought especially successful was the large match-book cover reading "Drink Coca-Cola"; though I thought the even larger canvas with rows of Coke bottles rather cluttered and fussy and without the clarity of the match-book, in which Warhol's handling of paint was its sharpest and his eye for effective design at its most telling. At his strongest – and I take this to be in the Marilyn Monroe paintings – Warhol has a painterly competence, a sure instinct for vulgarity (as in his choice of colours) and a feeling for what is truly human and pathetic in one of the exemplary myths of our time that I for one find moving; but I am not at all sure that even the best of Warhol's work can much outlast the journalism on which it is forced to depend.

Excerpt, *Art International*, December 20, 1962: 57

IN THE GALLERIES: ANDY WARHOL

Donald Judd

It seems that the salient metaphysical question lately is "Why does Andy Warhol paint Campbell Soup cans?" The only available answer is "Why not?" The subject matter is a cause for both blame and excessive praise. Actually it is not very interesting to think about the reasons, since it is easy to imagine Warhol's paintings without such subject matter, simply as "over-all" paintings of repeated elements. The novelty and the absurdity of the repeated images of Marilyn Monroe, Troy Donahue and Coca-Cola bottles is not great. Although Warhol thought of using these subjects, he certainly did not think of the format. The mildest aspect of the work is the descriptive sensitivity which is mingled with the stenciled elements. Unlike Lichtenstein, the only person with whom Warhol can be directly compared, Warhol does not strictly maintain the commercial scheme, or any other unillusionistic scheme. Also his sensitivity extends to the format: in one painting some bottles are empty, some full and some are half empty; one of Elvis Presley is "over-all" within a rectangle set up and to one side, leaving a border of canvas; the photographs, probably repeated with a silk-screen, often lighten in value toward one side or are deleted. The repetition should be made more insistent and the variation, if it is necessary, rapid and also insistent. Troy Donahue's head and shoulders are within an oval, which cuts his coat to two red prongs repeating downward. That is pretty clear but could be emphasized. The variation between four small paintings of single heads of M. M. show what might be done with emphatic variations. The best thing about Warhol's work is the color. The colors are often stained; they look like colored inks, and often black is stenciled over them, which produces a peculiar quality. The stained alizarin and the black of some repeated Martinson Coffee cans is interesting, for example. The painting with repeated heads of M. M. has an orange ground. The hair is yellow, the face is a purplish pink and the eye-shadow is a greenish cerulean. The black image is stenciled over the flat areas. M. M. is lurid. The gist of this is that Warhol's work is able but general. It certainly has possibilities, but it is so far not exceptional. It should be considered as it is, as should anyone's, and not be harmed or aided by being part of a supposed movement, "pop," "O. K.," neo-Dada, or New Realist or whatever it is. The various artists are too diverse to be given one label anyway.

Arts, January 1963: 49, © 1997 Donald Judd Estate / Licensed by VAGA, New York NY

THE ARTWORLD

Arthur Danto

Hamlet: Do you see nothing there? The Queen: Nothing at all; yet all that is I see.
<div align="right">Shakespeare: Hamlet, Act III, Scene IV</div>

Hamlet and Socrates, though in praise and deprecation respectively, spoke of art as a mirror held up to nature. As with many disagreements in attitude, this one has a factual basis. Socrates saw mirrors as but reflecting what we can already see; so art, insofar as mirrorlike, yields idle accurate duplications of the appearances of things, and is of no cognitive benefit whatever. Hamlet, more acutely, recognized a remarkable feature of reflecting surfaces, namely that they show us what we could not otherwise perceive – our own face and form – and so art, insofar as it is mirrorlike, reveals us to ourselves, and is, even by socratic criteria, of some cognitive utility after all. As a philosopher, however, I find Socrates' discussion defective on other, perhaps less profound grounds than these. If a mirror-image of *o* is indeed an imitation of *o,* then, if art is imitation, mirror-images are art. But in fact mirroring objects no more is art than returning weapons to a madman is justice; and reference to mirrorings would be just the sly sort of counterinstance we would expect Socrates to bring forward in rebuttal of the theory he instead uses them to illustrate. If that theory requires us to class *these* as art, it thereby shows its inadequacy: "is an imitation" will not do as a sufficient condition for "is art." Yet, perhaps because artists *were* engaged in imitation, in Socrates' time and after, the insufficiency of the theory was not noticed until the invention of photography. Once rejected as a sufficient condition, mimesis was quickly discarded as even a necessary one; and since the achievement of Kandinsky, mimetic features have been relegated to the periphery of critical concern, so much so that some works survive in spite of possessing those virtues, excellence in which was once celebrated as the essence of art, narrowly escaping demotion to mere illustrations.

It is, of course, indispensable in socratic discussion that all participants be masters of the concept up for analysis, since the aim is to match a real defining expression to a term in active use, and the test for adequacy presumably consists in showing that the former analyzes and applies to all and only those things of which the latter is true. The popular disclaimer notwithstanding, then, Socrates' auditors purportedly knew what art was as well as what they liked; and a theory of art, regarded here as a real definition of "Art," is accordingly not to be of great use in helping men to recognize instances of its application. Their antecedent ability to do this is precisely what the adequacy of the theory is to be tested against, the problem being only to make explicit what they already know. It is *our* use of the term that the theory allegedly means to capture, but we are supposed able, in the words of a recent writer, "to separate those objects which are works of art from those which are not, because . . . we know how correctly to use the word 'art' and to apply the phrase 'work of art.' " Theories, on this account, are somewhat like mirror-images on Socrates' account, showing forth what we already know, wordy reflections of the actual linguistic practice we are masters in.

But telling artworks from other things is not so simple a matter, even for native

The Journal of Philosophy, October 15, 1964: 571-84

speakers, and these days one might not be aware he was on artistic terrain without an artistic theory to tell him so. And part of the reason for this lies in the fact that terrain is constituted artistic in virtue of artistic theories, so that one use of theories, in addition to helping us discriminate art from the rest, consists in making art possible. Glaucon and the others could hardly have known what was art and what not: otherwise they would never have been taken in by mirror-images.

<div align="center">I</div>

Suppose one thinks of the discovery of a whole new class of artworks as something analogous to the discovery of a whole new class of facts anywhere, viz., as something for theoreticians to explain. In science, as elsewhere, we often accommodate new facts to old theories via auxiliary hypotheses, a pardonable enough conservatism when the theory in question is deemed too valuable to be jettisoned all at once. Now the Imitation Theory of Art (IT) is, if one but thinks it through, an exceedingly powerful theory, explaining a great many phenomena connected with the causation and evaluation of artworks, bringing a surprising unity into a complex domain. Moreover, it is a simple matter to shore it up against many purported counterinstances by such auxiliary hypotheses as that the artist who deviates from mimeticity is perverse, inept, or mad. Ineptitude, chicanery, or folly are, in fact, testable predications. Suppose, then, tests reveal that these hypotheses fail to hold, that the theory, now beyond repair, must be replaced. And a new theory is worked out, capturing what it can of the old theory's competence, together with the heretofore recalcitrant facts. One might, thinking along these lines, represent certain episodes in the history of art as not dissimilar to certain episodes in the history of science, where a conceptual revolution is being effected and where refusal to countenance certain facts, while in part due to prejudice, inertia, and self-interest, is due also to the fact that a well-established, or at least widely credited, theory is being threatened in such a way that all coherence goes.

Some such episode transpired with the advent of post-impressionist paintings. In terms of the prevailing artistic theory (IT), it was impossible to accept these as art unless inept art: otherwise they could be discounted as hoaxes, self-advertisements, or the visual counterparts of madmen's ravings. So to get them accepted *as* art, on a footing with the *Transfiguration* (not to speak of a Landseer stag), required not so much a revolution in taste as a theoretical revision of rather considerable proportions, involving not only the artistic enfranchisement of these objects, but an emphasis upon newly significant features of accepted artworks, so that quite different accounts of their status as artworks would now have to be given. As a result of the new theory's acceptance, not only were post-impressionist paintings taken up as art, but numbers of objects (masks, weapons, etc.) were transferred from anthropological museums (and heterogeneous other places) to *musées des beaux arts,* though, as we would expect from the fact that a criterion for the acceptance of a new theory is that it account for whatever the older one did, nothing had to be transferred out of the *musée des beaux arts* – even if there were internal rearrangements as between storage rooms and exhibition space. Countless native speakers hung upon suburban mantelpieces innumerable replicas of paradigm cases for teaching the expression "work of art" that would have sent their Edwardian forebears into linguistic apoplexy.

To be sure, I distort by speaking of a theory: historically, there were several, all, interestingly enough, more or less defined in terms of the IT. Art-historical complexities must yield before the exigencies of logical exposition, and I shall speak as though there were one replacing theory, partially compensating for historical falsity by choosing one which

was actually enunciated. According to it, the artists in question were to be understood not as unsuccessfully imitating real forms but as successfully creating new ones, quite as real as the forms which the older art had been thought, in its best examples, to be creditably imitating. Art, after all, had long since been thought of as creative (Vasari says that God was the first artist), and the post-impressionists were to be explained as genuinely creative, aiming, in Roger Fry's words, "not at illusion but reality." This theory (RT) furnished a whole new mode of looking at painting, old and new. Indeed, one might almost interpret the crude drawing in Van Gogh and Cézanne, the dislocation of form from contour in Rouault and Dufy, the arbitrary use of color planes in Gauguin and the Fauves, as so many ways of drawing attention to the fact that these were *non-imitations*, specifically intended not to deceive. Logically, this would be roughly like printing "Not Legal Tender" across a brilliantly counterfeited dollar bill, the resulting object (counterfeit *cum* inscription) rendered incapable of deceiving anyone. It is not an illusory dollar bill, but then, just because it is non-illusory it does not automatically become a real dollar bill either. It rather occupies a freshly opened area between real objects and real facsimiles of real objects: it is a non-facsimile, if one requires a word, and a new contribution to the world. Thus, Van Gogh's *Potato Eaters*, as a consequence of certain unmistakable distortions, turns out to be a non-facsimile of real-life potato eaters; and inasmuch as these are not facsimiles of potato eaters, Van Gogh's picture, as a non-imitation, had as much right to be called a real object as did its putative subjects. By means of this theory (RT), artworks re-entered the thick of things from which Socratic theory (IT) had sought to evict them: if no *more* real than what carpenters wrought, they were at least no *less* real. The Post-Impressionist won a victory in ontology.

It is in terms of RT that we must understand the artworks around us today. Thus Roy Lichtenstein paints comic-strip panels, though ten or twelve feet high. These are reasonably faithful projections onto a gigantesque scale of the homely frames from the daily tabloid, but it is precisely the scale that counts. A skilled engraver might incise *The Virgin and the Chancellor Rollin* on a pinhead, and it would be recognizable as such to the keen of sight, but an engraving of a Barnett Newman on a similar scale would be a blob, disappearing in the reduction. A *photograph* of a Lichtenstein is indiscernible from a photograph of a counterpart panel from *Steve Canyon;* but the photograph fails to capture the scale, and hence is as inaccurate a reproduction as a black-and-white engraving of Botticelli, scale being essential here as color there. Lichtensteins, then, are not imitations but *new entities,* as giant whelks would be. Jasper Johns, by contrast, paints objects with respect to which questions of scale are irrelevant. Yet his objects cannot be imitations, for they have the remarkable property that any intended copy of a member of this class of objects is automatically a member of the class itself, so that these objects are logically inimitable. Thus, a copy of a numeral just *is* that numeral: a painting of 3 is a 3 made of paint. Johns, in addition, paints targets, flags, and maps. Finally, in what I hope are not unwitting footnotes to Plato, two of our pioneers – Robert Rauschenberg and Claes Oldenburg – have made genuine beds.

Rauschenberg's bed hangs on a wall, and is streaked with some desultory housepaint. Oldenburg's bed is a rhomboid, narrower at one end than the other, with what one might speak of as a built-in perspective: ideal for small bedrooms. As beds, these sell at singularly inflated prices, but one *could* sleep in either of them: Rauschenberg has expressed the fear that someone might just climb into his bed and fall asleep. Imagine, now, a certain Testadura – a plain speaker and noted philistine – who is not aware that these are art, and who takes them to be reality simple and pure. He attributes the paintstreaks on

Rauschenberg's bed to the slovenliness of the owner, and the bias in the Oldenburg bed to the ineptitude of the builder or the whimsy, perhaps, of whoever had it "custom-made." These would be mistakes, but mistakes of rather an odd kind, and not terribly different from that made by the stunned birds who pecked the sham grapes of Zeuxis. They mistook art for reality, and so has Testadura. But it was meant to *be* reality, according to RT. Can one have mistaken reality for reality? How shall we describe Testadura's error? What, after all, prevents Oldenburg's creation from being a misshapen bed? This is equivalent to asking what makes it art, and with this query we enter a domain of conceptual inquiry where native speakers are poor guides: *they* are lost themselves.

<center>II</center>

To mistake an artwork for a real object is no great feat when an artwork is the real object one mistakes it for. The problem is how to avoid such errors, or to remove them once they are made. The artwork is a bed, and not a bed-illusion; so there is nothing like the traumatic encounter against a flat surface that brought it home to the birds of Zeuxis that they had been duped. Except for the guard cautioning Testadura not to sleep on the artworks, he might never have discovered that this was an artwork and not a bed; and since, after all, one cannot discover that a bed is not a bed, how is Testadura to realize that he has made an error? A certain sort of explanation is required, for the error here is a curiously philosophical one, rather like, if we may assume as correct some well-known views of P. F. Strawson, mistaking a person for a material body when the truth is that a person *is* a material body in the sense that a whole class of predicates, sensibly applicable to material bodies, are sensibly, and by appeal to no different criteria, applicable to persons. So you cannot *discover* that a person is not a material body.

We begin by explaining, perhaps, that the paintstreaks are not to be explained away, that they are *part* of the object, so the object is not a mere bed with – as it happens – streaks of paint spilled over it, but a complex object fabricated out of a bed and some paintstreaks: a paint-bed. Similarly, a person is not a material body with – as it happens – some thoughts superadded, but is a complex entity made up of a body and some conscious states: a conscious-body. Persons, like artworks, must then be taken as irreducible to *parts* of themselves, and are in that sense primitive. Or, more accurately, the paintstreaks are not part of the real object – the bed – which happens to be part of the artwork, but are, *like* the bed, part of the artwork as such. And this might be generalized into a rough characterization of artworks that happen to contain real objects as parts of themselves: not every part of an artwork A is part of a real object R when R is part of A and can, moreover, be detached from A and seen *merely* as R. The mistake thus far will have been to mistake A for *part* of itself, namely R, even though it would not be incorrect to say that A is R, that the artwork is a bed. It is the "is" which requires clarification here.

There is an *is* that figures prominently in statements concerning artworks which is not the *is* of either identity or predication; nor is it the *is* of existence, of identification, or some special *is* made up to serve a philosophic end. Nevertheless, it is in common usage, and is readily mastered by children. It is the sense of *is* in accordance with which a child, shown a circle and a triangle and asked which is him and which his sister, will point to the triangle saying "That is me"; or, in response to my question, the person next to me points to the man in purple and says "That one is Lear"; or in the gallery I point, for my companion's benefit, to a spot in the painting before us and say "That white dab is Icarus." We do not mean, in these instances, that whatever is pointed to stands for, or represents, what it is said to be, for the *word* "Icarus" stands for or represents Icarus: yet

I would not in the same sense of *is* point to the word and say "That is Icarus." The sentence "That *a* is *b*" is perfectly compatible with "That *a* is not *b*" when the first employs this sense of *is* and the second employs some other, though *a* and *b* are used nonambiguously throughout. Often, indeed, the truth of the first *requires* the truth of the second. The first, in fact, is incompatible with "That *a* is not *b*" only when the *is* is used nonambiguously throughout. For want of a word I shall designate this the *is of artistic identification;* in each case in which it is used, the *a* stands for some specific physical property of, or physical part of, an object; and, finally, it is a necessary condition for something to be an artwork that some part or property of it be designable by the subject of a sentence that employs this special *is.* It is an *is,* incidentally, which has near-relatives in marginal and mythical pronouncements. (Thus, one *is* Quetzalcoatl; those *are* the Pillars of Hercules.)

Let me illustrate. Two painters are asked to decorate the east and west walls of a science library with frescoes to be respectively called *Newton's First Law* and *Newton's Third Law.* These paintings, when finally unveiled, look, scale apart, as follows:

As objects I shall suppose the works to be indiscernible: a black, horizontal line on a white ground, equally large in each dimension and element. *B* explains his work as follows: a mass, pressing downward, is met by a mass pressing upward: the lower mass reacts equally and oppositely to the upper one. *A* explains his work as follows: the line through the space is the path of an isolated particle. The path goes from edge to edge, to give the sense of its *going beyond.* If it ended or began within the space, the line would be curved: and it is parallel to the top and bottom edges, for if it were closer to one than to another, there would have to be a force accounting for it, and this is inconsistent with its being the path of an *isolated* particle.

Much follows from these artistic identifications. To regard the middle line as an edge (mass meeting mass) imposes the need to identify the top and bottom half of the picture as rectangles, and as two distinct parts (not necessarily as two masses, for the line could be the edge of *one* mass jutting up – or down – into empty space). If it is an edge, we cannot thus take the entire area of the painting as a single space: it is rather composed of two forms, or one form and a non-form. We could take the entire area as a single space only by taking the middle horizontal as a *line* which is not an edge. But this almost requires a three-dimensional identification of the whole picture: the area can be a flat surface which the line is *above* (*Jet-flight*), or *below* (*Submarine-path*), or *on* (*Line*), or *in* (*Fissure*), or *through* (*Newton's First Law*) – though in this last case the area is not a flat surface but a transparent cross section of absolute space. We could make all these prepositional qualifications clear by imagining perpendicular cross sections to the picture plane. Then, depending upon the applicable prepositional clause, the area is (artistically) interrupted or not by the horizontal element. If we take the line as *through* space, the edges of the picture are not really the edges of the space: the space goes beyond the picture if the line itself does; and we are in the same space as the line is. As *B,* the edges of the picture can be

part of the picture in case the masses go right to the edges, so that the edges of the picture are *their* edges. In that case, the vertices of the picture would be the vertices of the masses, except that the masses have four vertices more than the picture itself does: here four vertices would be part of the art work which were not part of the real object. Again, the faces of the masses could be the face of the picture, and in looking at the picture, we are looking at these faces: but *space* has no face, and on the reading of *A* the work has to be read as faceless, and the face of the physical object would not be part of the artwork. Notice here how one artistic identification engenders another artistic identification, and how, consistently with a given identification, we are *required* to give others and *precluded* from still others: indeed, a given identification determines how many elements the work is to contain. These different identifications are incompatible with one another, or generally so, and each might be said to make a different artwork, even though each artwork contains the identical real object as part of itself – or at least parts of the identical real object as parts of itself. There are, of course, senseless identifications: no one could, I think, sensibly read the middle horizontal as *Love's Labour's Lost* or *The Ascendency of St. Erasmus.* Finally, notice how acceptance of one identification rather than another is in effect to exchange one *world* for another. We could, indeed, enter a quiet poetic world by identifying the upper area with a clear and cloudless sky, reflected in the still surface of the water below, whiteness kept from whiteness only by the unreal boundary of the horizon.

And now Testadura, having hovered in the wings throughout this discussion, protests that *all he sees is paint:* a white painted oblong with a black line painted across it. And how right he really is: that is all he sees or that anybody can, we aesthetes included. So, if he asks us to show him what there is further to see, to demonstrate through pointing that this is an artwork (*Sea and Sky*), we cannot comply, for he has overlooked nothing (and it would be absurd to suppose he had, that there was something tiny we could point to and he, peering closely, say "So it is! A work of art after all!"). We cannot help him until he has mastered the *is of artistic identification* and so *constitutes* it a work of art. If he cannot achieve this, he will never look upon artworks: he will be like a child who sees sticks as sticks.

But what about pure abstractions, say something that looks just like *A* but is entitled *No. 7*? The 10th Street abstractionist blankly insists that there is nothing here but white paint and black, and none of our literary identifications need apply. What then distinguishes him from Testadura, whose philistine utterances are indiscernible from his? And how can it be an artwork for him and not for Testadura, when they agree that there is nothing that does not meet the eye? The answer, unpopular as it is likely to be to purists of every variety, lies in the fact that this artist has returned to the physicality of paint through an atmosphere compounded of artistic theories and the history of recent and remote painting, elements of which he is trying to refine out of his own work; and as a consequence of this his work belongs in this atmosphere and is part of this history. He has achieved abstraction through rejection of artistic identifications, returning to the real world from which such identifications remove us (he thinks), somewhat in the mode of Ch'ing Yuan, who wrote:

> Before I had studied Zen for thirty years, I saw mountains as mountains and waters as waters. When I arrived at a more intimate knowledge, I came to the point where I saw that mountains are not mountains, and waters are not waters. But now that I have got the very substance I am at rest. For it is just that I see mountains once again as mountains, and waters once again as waters.

His identification of what he has made is logically dependent upon the theories and history he rejects. The difference between his utterance and Testadura's "This is black paint and white paint and nothing more" lies in the fact that he is still using the *is* of artistic identification, so that his use of "That black paint is black paint" is not a tautology. Testadura is not at that stage. To see something as art requires something the eye cannot decry – an atmosphere of artistic theory, a knowledge of the history of art: an artworld.

<div align="center">III</div>

Mr. Andy Warhol, the Pop artist, displays facsimiles of Brillo cartons, piled high, in neat stacks, as in the stockroom of the supermarket. They happen to be of wood, painted to look like cardboard, and why not? To paraphrase the critic of the *Times,* if one may make the facsimile of a human being out of bronze, why not the facsimile of a Brillo carton out of plywood? The cost of these boxes happens to be 2×10^3 that of their homely counterparts in real life – a differential hardly ascribable to their advantage in durability. In fact the Brillo people might, at some slight increase in cost, make their boxes out of plywood without these becoming artworks, and Warhol might make *his* out of cardboard without their ceasing to be art. So we may forget questions of intrinsic value, and ask why the Brillo people cannot manufacture art and why Warhol cannot *but* make artworks. Well, his are made by hand, to be sure. Which is like an insane reversal of Picasso's strategy in pasting the label from a bottle of Suze onto a drawing, saying as it were that the academic artist, concerned with exact imitation, must always fall short of the real thing: so why not just *use* the real thing? The Pop artist laboriously reproduces machine-made objects by hand, e.g., painting the labels on coffee cans (one can hear the familiar commendation "Entirely made by hand" falling painfully out of the guide's vocabulary when confronted by these objects). But the difference cannot consist in craft: a man who carved pebbles out of stones and carefully constructed a work called *Gravel Pile* might invoke the labor theory of value to account for the price he demands; but the question is, What makes it art? And why need Warhol *make* these things anyway? Why not just scrawl his signature across one? Or crush one up and display it as *Crushed Brillo Box* ("A protest against mechanization . . .") or simply display a Brillo carton as *Uncrushed Brillo Box* ("A bold affirmation of the plastic authenticity of industrial . . .")? Is this man a kind of Midas, turning whatever he touches into the gold of pure art? And the whole world consisting of latent artworks waiting, like the bread and wine of reality, to be transfigured, through some dark mystery, into the indiscernible flesh and blood of the sacrament? Never mind that the Brillo box may not be good, much less great art. The impressive thing is that it is art at all. But if it is, why are not the indiscernible Brillo boxes that are in the stockroom? Or *has* the whole distinction between art and reality broken down?

Suppose a man collects objects (ready-mades), including a Brillo carton; we praise the exhibit for variety, ingenuity, what you will. Next he exhibits nothing but Brillo cartons, and we criticize it as dull, repetitive, self-plagiarizing – or (more profoundly) claim that he is obsessed by regularity and repetition, as in *Marienbad.* Or he piles them high, leaving a narrow path; we tread our way through the smooth opaque stacks and find it an unsettling experience, and write it up as the closing in of consumer products, confining us as prisoners: or we say he is a modern pyramid builder. True, we don't say these things about the stockboy. But then a stockroom is not an art gallery, and we cannot readily separate the Brillo cartons from the gallery they are in, any more than we can separate the Rauschenberg bed from the paint upon it. Outside the gallery, they are pasteboard cartons. But then, scoured clean of paint, Rauschenberg's bed is a bed, just what it was be-

fore it was transformed into art. But then if we think this matter through, we discover that the artist has failed, really and of necessity, to produce a mere real object. He has produced an artwork, his use of real Brillo cartons being but an expansion of the resources available to artists, a contribution to *artists' materials,* as oil paint was, or *tuche.*

What in the end makes the difference between a Brillo box and a work of art consisting of a Brillo Box is a certain theory of art. It is the theory that takes it up into the world of art, and keeps it from collapsing into the real object which it is (in a sense of *is* other than that of artistic identification). Of course, without the theory, one is unlikely to see it as art, and in order to see it as part of the artworld, one must have mastered a good deal of artistic theory as well as a considerable amount of the history of recent New York painting. It could not have been art fifty years ago. But then there could not have been, everything being equal, flight insurance in the Middle Ages, or Etruscan typewriter erasers. The world has to be ready for certain things, the artworld no less than the real one. It is the role of artistic theories, these days as always, to make the artworld, and art, possible. It would, I should think, never have occurred to the painters of Lascaux that they were producing *art* on those walls. Not unless there were neolithic aestheticians.

The artworld stands to the real world in something like the relationship in which the City of God stands to the Earthly City. Certain objects, like certain individuals, enjoy a double citizenship, but there remains, the RT notwithstanding, a fundamental contrast between artworks and real objects. Perhaps this was already dimly sensed by the early framers of the IT who, inchoately realizing the nonreality of art, were perhaps limited only in supposing that the sole way objects had of being other than real is to be sham, so that artworks necessarily had to be imitations of real objects. This was too narrow. So Yeats saw in writing "Once out of nature I shall never take/My bodily form from any natural thing." It is but a matter of choice: and the Brillo box of the artworld may be just the Brillo box of the real one, separated and united by the *is* of artistic identification. But I should like to say some final words about the theories that make artworks possible, and their relationship to one another. In so doing, I shall beg some of the hardest philosophical questions I know.

I shall now think of pairs of predicates related to each other as "opposites," conceding straight off the vagueness of this *demodé* term. Contradictory predicates are not opposites, since one of each of them must apply to every object in the universe, and neither of a pair of opposites need apply to some objects in the universe. An object must first be of a certain kind before either of a pair of opposites applies to it, and then at most and at least one of the opposites must apply to it. So opposites are not contraries, for contraries may both be false of some objects in the universe, but opposites cannot both be false; for of some objects, neither of a pair of opposites *sensibly* applies, unless the object is of the right sort. Then, if the object is of the required kind, the opposites behave as contradictories. If F and non-F are opposites, an object o must be of a certain kind K before either of these sensibly applies; but if o is a member of K, then o either is F or non-F, to the exclusion of the other. The class of pairs of opposites that sensibly apply to the $(\acute{o})Ko$ I shall designate as the class of *K-relevant predicates.* And a necessary condition for an object to be of a kind K is that at least one pair of K-relevant opposites be sensibly applicable to it. But, in fact, if an object is of kind K, at least and at most one of each K-relevant pair of opposites applies to it.

I am now interested in the K-relevant predicates for the class K of artworks. And let F and non-F be an opposite pair of such predicates. Now it might happen that, throughout an entire period of time, every artwork is non-F. But since nothing thus far is both an art-

work and F, it might never occur to anyone that non-F is an artistically relevant predicate. The non-F-ness of artworks goes unmarked. By contrast, all works up to a given time might be G, it never occurring to anyone until that time that something might both be an artwork and non-G; indeed, it might have been thought that G was a *defining trait* of artworks when in fact something might first have to be an artwork before G is sensibly predicable of it – in which case non-G might also be predicable of artworks, and G itself then could not have been a defining trait of this class.

Let G be "is representational" and let F be "is expressionist." At a given time, these and their opposites are perhaps the only art-relevant predicates in critical use. Now letting " $+$ " stand for a given predicate P and " $-$ " for its opposite non-P, we may construct a style matrix more or less as follows:

F	G
$+$	$+$
$+$	$-$
$-$	$+$
$-$	$-$

The rows determine available styles, given the active critical vocabulary: representational expressionistic (e.g., Fauvism); representational nonexpressionistic (Ingres); nonrepresentational expressionistic (Abstract Expressionism); nonrepresentational nonexpressionist (hard-edge abstraction). Plainly, as we add art-relevant predicates, we increase the number of available styles at the rate of 2^n. It is, of course, not easy to see in advance which predicates are going to be added or replaced by their opposites, but suppose an artist determines that H shall henceforth be artistically relevant for his paintings. Then, in fact, both H and non-H become artistically relevant for *all* painting, and if his is the first and only painting that is H, every other painting in existence becomes non-H, and the entire community of paintings is enriched, together with a doubling of the available style opportunities. It is this retroactive enrichment of the entities in the artworld that makes it possible to discuss Raphael and de Kooning together, or Lichtenstein and Michelangelo. The greater the variety of artistically relevant predicates, the more complex the individual members of the artworld become; and the more one knows of the entire population of the artworld, the richer one's experience with any of its members.

In this regard, notice that, if there are m artistically relevant predicates, there is always a bottom row with m minuses. This row is apt to be occupied by purists. Having scoured their canvases clear of what they regard as inessential, they credit themselves with having distilled out the essence of art. But this is just their fallacy: exactly as many artistically relevant predicates stand true of their square monochromes as stand true of any member of the Artworld, and they can *exist* as artworks only insofar as "impure" paintings exist. Strictly speaking, a black square by Reinhardt is artistically as rich as Titian's *Sacred and Profane Love*. This explains how less is more.

Fashion, as it happens, favors certain rows of the style matrix: museums, connoisseurs, and others are makeweights in the Artworld. To insist, or seek to, that all artists become representational, perhaps to gain entry into a specially prestigious exhibition, cuts the available style matrix in half: there are then $2^n/2$ ways of satisfying the requirement, and museums then can exhibit all these "approaches" to the topic they have set. But this is a matter of almost purely sociological interest: one row in the matrix is as legitimate as another. An artistic breakthrough consists, I suppose, in adding the possibility of a column to the matrix. Artists then, with greater or less alacrity, occupy the positions

thus opened up: this is a remarkable feature of contemporary art, and for those unfamiliar with the matrix, it is hard, and perhaps impossible, to recognize certain positions as occupied by artworks. Nor would these things be artworks without the theories and the histories of the Artworld.

Brillo boxes enter the artworld with that same tonic incongruity the *commedia dell'arte* characters bring into *Ariadne auf Naxos.* Whatever is the artistically relevant predicate in virtue of which they gain their entry, the rest of the Artworld becomes that much the richer in having the opposite predicate available and applicable to its members. And, to return to the views of Hamlet with which we began this discussion, Brillo boxes may reveal us to ourselves as well as anything might: as a mirror held up to nature, they might serve to catch the conscience of our kings.

SAINT ANDREW

Unsigned

"Terrific!" said the smiling young man, backed up against the wall by a mounting crush of people. The young man was artist Andy Warhol, and the crush was a tidal wave of guests at a party given to celebrate the opening of his latest show in New York last week. The wave grew to fantastic proportions. The dancing guests, jammed together in the big West Side apartment, frugged in place, like a mob of bears back-scratching against the trees of a thick forest. A *New York Times* photographer retrieved the wrong coat from a gigantic pile of overwear. The pile grew so surrealistically high that Norman Mailer, who arrived late, was led solicitously aside by the host to park his vestments in private. Such is success in New York's Babel of art.

There in the midst of the Beatle-rocking bedlam was the 32-year-old artist, listening to the twanging anthems of triumph with his elfin smile, dancing only with his pale blue eyes, looking, with his mysterious white hair and happy nose, like the offspring of a union between Peter Pan and W. C. Fields.

Warhol is in truth the Peter Pan of the current art scene. He is already a legend of pop art with his world-famous paintings of Campbell's Soup cans, Marilyn Monroe, tabloid front pages and American ways of dying. He paints the gamy glamour of mass society with the lobotomized glee that characterizes the cooled-off generation. Now his theme is flowers, but the garish, neon-colored flowers of cafeteria window boxes – Broadway blooms for Broadway glooms.

Before his opening at the Leo Castelli Gallery last week, Warhol looked happily at the fields of painted flora in his vast studio, a glittering arena covered entirely in aluminum foil and silver paint. "I waited till after the election," he said. "I was going to make the show all Goldwater if he won, because then everything would go, art would go . . . But now it's going to be flowers – they're the fashion this year. They look like a cheap awning. They're terrific!"

And flowers it was, done in Warhol's new system in which he has a blown-up photo-

graph converted into a silk screen. Warhol then forces varying thicknesses of paint through the screens onto canvas and adds color. This process produces a series of images that are the same but different, like the inky smudges of newspaper photos rubbed by millions of hands that carry them around the city.

Henry Geldzahler, the brilliant young assistant curator of American art at the Metropolitan Museum, calls Warhol "a sensibility as sweet and tough, as childish and commercial, as innocent and chic, as anything in our culture." He is the true primitive of pop art, possessing the kind of traumatized naïveté that seems to be the closest thing to innocence our hip age can provide. He lives in a three-story house on Lexington Avenue, a house crammed with the eccentrically elegant artifacts of a bizarre civilization – old carrousel horses, a carnival punching-bag machine, a giant wooden Coke bottle, a crushed-car sculpture by John Chamberlain.

"Everything is art," says Warhol. "You go to a museum, and they say this is art and the little squares are hanging on the wall. But everything is art, and nothing is art. Because I think everything is beautiful – if it's right." For Warhol, "right" means "not faking it" – being what you are, and the difference between right and not right is "style." "Style – like in de Kooning or Kline. It comes out in their brush stroke – the energy, the character, not just a painting technique."

But the intensely personal style that is the mark of a de Kooning or Kline is not for Warhol. He is the most blatant of the new personalities of pop – the "anti-sensibility" man who reacts in a euphoric monotone that is half ecstasy, half hibernation. That is why he turned to the mass-production techniques of silk screen. "I think everybody should be a machine. I think everybody should be like everybody. That seems to be what is happening now."

So Warhol's weapon against the loneliness of differentiation is a kind of happy regression, back to the undifferentiated childhood world of giant images and soothing repetition. But, because he is a man, not a child, the big image and the repeating image are a sort of fetish, just like the huge Carmen Miranda wedgie he has on a table at home, or like the giant shoe ad which won him the Art Director's Club Medal in 1957, when he was still a commercial artist.

From the fetishes of commercial art to the super-fetishes of painting was a logical step for Warhol. Like all pop artists, he saw the pathos and charm of the obsolescent images of mass culture, from a comic strip to an overwhelmingly unattainable movie beauty. Like all artists, the content of his life dictated the obsessions of his art. "I used to have the same soup lunch every day for twenty years. So I painted soup cans." But it is the final fillip of an absurd elegance that makes pop art, and Warhol adds: "I used to want to live at the Waldorf Towers and have soup and a sandwich."

The elegance of his soup cans, his silk-screened serried ranks of Marilyn pouts or Troy Donahue smirks – even the elegance of his stark, silvery electric chairs and joltingly smudged car crashes, all have brought Warhol success (his bigger pictures sell for about $5,000) and easy entry to that new hip world of blurred genders and sharp characters, the polyestered successors to Scott Fitzgerald's golden youth. These violently groomed, perversely beautiful people want art, fun, ease, and unimpeded momentum in every conceivable direction. Pop art is their art.

Warhol has recently turned to filmmaking. After only a year behind the camera he has already been called by one critic "the most important experimental filmmaker now working." He is a star of the Film-Makers' Co-operative and several of his short films were shown as a kind of added attraction at the recent New York Film Festival. Warhol's films

are the logical extension, one might say the reductio ad absurdum, of his deadpan cele-
brations of everyday phenomena. His first film, "Sleep," was six hours of a camera watch-
ing a sleeping man. The movie's only action was the twitches, tics, and heavings of his
Morphean movements.

Other Warhol films are called "Eat," a study of a masticating countenance, "Kiss," a
close look at nonstop osculation, and "Empire," an eight-hour zoological study of the
Empire State Building. "It's terrific!" says Warhol of "Empire." "It's blurry because the
building moves in the wind. You see the lights come on, and the stars – it's fantastic,
beautiful."

Jonas Mekas, the guiding force in the Film-Makers' Co-op, calls Warhol's films "med-
itations on life . . . almost religious . . . a looking at daily activities like sleeping or eat-
ing. It's a saying Yes to life." Last week Warhol was saying Yes in his latest opus. It is his
contribution to the current Jean Harlow craze, except that Harlow is played by a man –
Mario Montez, a leading "superstar" in the "underground" movies. On a couch in his
studio the dark Montez, transformed into a chalky-white "Gene" Harlow, delicately
chomped a banana next to a real blonde superstarlet, Carol Koshinskie, while a super-
loud record of "Swan Lake" blasted away in the background.

The next night Warhol was back, this time in front of another Co-op director's cam-
era. Gregory Markopoulos was making a mythological epic in which Warhol played the
Greek god Oceanus. Dressed in black jeans, skindiver's black tunic, streamers of silver
paper, and a sea-shell codpiece, Warhol pedaled majestically on an Exercycle for fifteen
minutes. "He's a happy person," said Markopoulos. "The kind of character Aeschylus
had in mind for the god of the sea." The next night Warhol, togged out in soup and fish –
the same black jeans, plus white shirt and tuxedo jacket – attended a movie-watching
party at the home of Jane Holzer, the *Vogue* cover girl. "Baby Jane," called by *Vogue* edi-
tor Diana Vreeland "the most contemporary girl I know," is a Warhol superstar. With her
mane of blond hair, her hyperthyroid drive and buckshot hedonism, she epitomizes the
pants-wearing young set who feed on the hybrid world of pop, flick, and hip.

At the party, Jane as usual ate nothing but candy. Warhol circulated among young
wraiths from the worlds of fashion and frolic. Jane's real-estate-broker husband watched
impassively, like a character in a Mailer story, while on the screen Baby Jane's face in gigan-
tic close-up chewed gum and brushed her teeth. A hypnotic pop tension built up, broken by
Hollywood producer Sam Spiegel's wife shouting, "We're all turned on to you, baby."

Such are the orgiastic climaxes of Warhol's world. It is a strange world; a chaos styl-
ized against chaos. "Andy's so nice," says Jane Holzer. "There's no hang-up or anything;
he makes you feel good." In an age structured for spectators, Warhol is the supreme ac-
cepting spectator. "He's been called a voyeur," says writer-art dealer Ivan Karp. "While
the other pop artists depict common things, Andy is in a sense a victim of common
things: he genuinely admires them. How can you describe him – he's like a saint – Saint
Andrew."

At his studio last week, Warhol was finishing a series of silk screens of Jacqueline
Kennedy after the assassination – the only non-flower picture in his show. He kneeled
on the floor in green rubber gloves spreading paint through the screen with a wooden bar
– a craftsman absorbed in his work. "That picture of her at the swearing in of President
Johnson was so good," he said. "Maybe I should have made the whole show just Jackie.
It's terrific."

REVIEWS AND PREVIEWS: NEW NAMES THIS MONTH
Andy Warhol

Thomas B. Hess

Andy Warhol [Castelli] is the brightest of Pop artists. Underneath his turtleneck disguises – white wig, black glasses, deprecating shrugs in frugging bashes – you sense a diamond-sharp mind with a flair for doctrinaire theatrics. "I think everybody should be a machine," he wrote [A.N., NOV. '63] and his latest pictures do look as numb, banal and modern as the latest suds-free washer. These are works for the mantlepiece of a T.V.-commercial hero – say, the Jolly Green Giant. Warhol's subject matter used to lean on the sadistic and erotic – death and pinups. Now four illustrations (from a Kodak journal) of what seem to be four pansies (The *Herald-Tribune* called them anemones) have been screened, photo-mechanically enlarged and squeegeed onto batches of stretched canvas. Color the backgrounds bitter grass. Color the petals Op-Pop fluorescent: Crash-helmet orange, Joseph E. Levine gold, Zap-gun ultra-maroon. They are successfully drained of any interest beyond the conceptual apparatus a spectator chooses to poke at them. It is as if Warhol got hung up on the cliché that attacks "modern art" for being like "wallpaper," and decided that wallpaper is a pretty good idea, too. He empties the image of everything except a rudimentary decision for voids. The rest is up to the art-gallery audience – and a livelier bunch of swinging humanoids won't be found this side of Vegas. Most of the works in the show had little gold stars pasted to the wall beneath them – meaning they had been sold – filling the gallery atmosphere with a glamor-smell of cash. The profound anti-style achievement of Warhol's show is that it embodies what's "In." He follows close to the trail of the divine Salvador Dali – of whom Arshile Gorky once said (addressing a group of integrity-soaked cold-water-loft abstractionists): "I profoundly admire Dali, for his immense financial success." In other words, Warhol makes empty metaphysical vessels that are continually being filled with real money, which is an undeniable triumph, sociologically. He faltered only once: in a back room was a rectangle made of 42 identical closeups of Jacqueline Kennedy, bereft and aghast, screened from the famous news photo where she watches Lyndon Johnson being sworn in. Here Warhol blurts a certain tenderness and respect, in his choice of image, in the ghastly lilac colors. There is sentiment – of the Atlantic City souvenir-shop variety perhaps, but would it have occurred to Univac? Warhol had better keep these lapses into 18th-century impulse under control, or he might turn into a human artist.

Art News, January 1965: 11

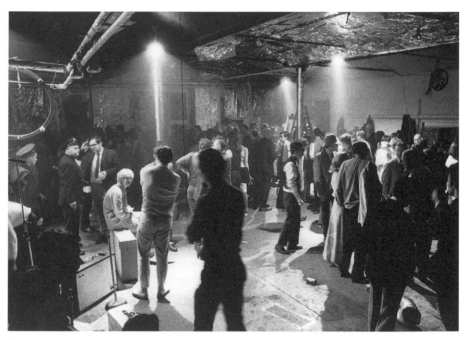

Police stop by Warhol's Factory, mid-1960s. Photograph by Ugo Mulas.

SUPERPOP OR A NIGHT AT THE FACTORY

Roger Vaughan

Reynolds wrap is what hits you. The whole place is Reynolds wrap, the ceiling, the pipes, the walls. They said it was like this, but until you walk in and actually see that it is true, until you stand and look all around and stare at all that foil and wonder how many rolls of the stuff was used and how many man hours it took to pin it to the walls and crinkle it around the pipes and paste it to the ceiling, you don't believe it. And that isn't all.

The floor has been painted silver. All the cabinets stuffed with paint and film and records have been painted silver. The hi-fi components have been painted silver, and speakers are in silver boxes. The sound is incessant. The tape recorder is silver, and the thermofax machine is silver. There is a silver exercycle, two silver fire extinguishers, four cases of coke bottles painted silver, and an old, silver vacuum cleaner. There is a huge trunk like the one Judy Garland says she was born in, painted silver. The TV set has been sprayed silver, and beside it are the upended legs of a store mannequin, silver, of course. The pay telephone on the wall is silver. The odd assortment of stools and chairs are silver. And the bathroom is silver-lined and painted, including the toilet bowl and flushing mechanism.

Andy Warhol's long, straight hair is silver. At first you think it has been sprayed, like the telephone, because there is some black underneath the top layer. It is not real, but

The Sunday Herald Tribune, August 8, 1965: 7–9

Andy Warhol is real. He is stretched out on a red hairy couch, and when people come in he gets up and is very polite and says, "How do you do," when introduced. He has the roundish horn-rimmed sunglasses on like he always does, a dirty pink shirt, black sweat-shirt and jeans, and black cuffed zipper boots with medium heels. He is very relaxed, al-most sagging. His mouth is sullen. His hand is loose when you shake it. He is skinny, not too tall, and has an anemic look about him.

Two of Warhol's assistants are in the studio with him. One of them, Gerard, with a Beethoven haircut and a weight-lifter's build, is asleep on another couch. The other, tall, thin and shy, is thermofaxing the liner notes of an opera album.

A photographer is there, and he sets up a few lights and prepares a remote camera, the idea being to let Warhol press the button and take self-portraits. This appeals to Andy. "Oh great! Wow, oh yes, marvelous!" He fiddles with the button, clicking off a few frames, and becomes more enthusiastic. He looks up from studying the button and says in his soft, fluid voice, "Why this is really marvelous. I could do my paintings this way, I mean if a person were dying he could photograph his own death." He looks a bit wide-eyed as he contemplates this, and his mouth twists ever so slightly into a pleased smile.

Warhol sits on the couch, looks directly at the camera, and presses the remote button. His expression never changes as the camera whirs through 36 exposures. He shoots 10 rolls this way. Then there is a break, and he goes out and buys some bananas and shoots two more rolls of himself eating the bananas because he has made a banana movie called *Harlot* in which the star of the film eats six bananas in one hour. While the camera is be-ing reloaded, Warhol talks about a recent film he's done, *Suicide.*

"I found this person, my star, who has 13 scars on one wrist and 15 scars on the other wrist from suicide attempts. He has marvelous wrists. The scars are all different shades of purple. This was my first color movie. We just focused the camera on his wrists and he pointed to each scar and told its history, like when he did it, and why, and what happened afterward."

Someone suggests filming a real suicide, and Warhol brightens. "Ohh, wouldn't that be something," he says. "One of my friends committed suicide recently, but he didn't call me." Warhol's left hand goes to his lips in a habitual gesture. "He was so high he didn't think, I guess. He was a dancer and had been in a couple of my films. He got high and just danced right out the window." Warhol chews lightly on a fingernail and looks thoughtful, pondering with popartistic detachment what sort of film a real suicide would have made. He gets up and moves in a quiet, gliding way across the room to a table stacked with paint cans, and begins trying to match a certain shade of purple.

On the floor, on one side of the room, 17 silkscreen paintings of the electric chair at Sing Sing Prison cover about 20 square feet, drying. There are three orange ones, five bright green, three yellow, one purple, four red, and one brown. Among them also is a bright blue Jackie Kennedy, a seven-foot Elvis Presley pulling a six gun, and one pink, black, green and red Liz Taylor on a pale green background. They were all news photos originally, Associated Press, UPI, *The Daily News.* Warhol clipped them, sent them out for silk screens to be made, and ran off prints by the numbers in the studio. Mass produc-tion art.

Warhol calls his place "the factory." The street entrance is a small green door sand-wiched between an antique shop and a parking garage. The elevator is for freight, and the studio itself, pre tin-foil days, was dingy and functional, with dark brick walls and steel beams in the ceiling. But more than that, "the factory" is a good name for Warhol's place because of the way art is produced there. You half expect a ruddy-cheeked salesman with

a sample case on wheels to come bursting in from a successful road trip, waving order forms, yelling, "They want 100 more electric chairs in Denver, and St. Louis wants 500 of the flowers, 500! Imagine."

The flowers, Warhol explains with a smile, came from a fabric that was in a Kodak ad on how to print color in your home darkroom. He gets up from his knees where he has been working on the purple color matching problem, the background of a three-foot square Liz Taylor head, and walks to a cardboard box sitting on a table. He motions to several large different colored flower prints along the way. "These are for my Paris show," he says, opening the cardboard box. He pulls out a handful of tiny canvases, five-by-five inches, covered with the same flower print. "They come six to a package, and you get six different colors. Each set costs $30." He sounded like he was selling Christmas wrappings, and he must have thought so too, because he suddenly looked up and almost laughed. Someone asks how many he had made, and he says about a hundred. "When should I stop? I don't know how many to make. Should I stop making them?" He shrugs and goes back to Liz Taylor.

Besides the Liz Taylor on the floor is a white canvas on stretchers, the same size as the painted one. Warhol has finally matched the purple to his satisfaction, and begins to paint the white canvas, *with a brush!* Andy Warhol painting with a brush! The photographer moves in, then stops at Warhol's upraised hand. "No no, please, we don't use a brush anymore. It's just that a blank has been lost, and I have to do an odd one to replace it." Warhol seems embarrassed to be caught with a brush, and blushes faintly. But a blank? "You see, for every large painting I do, I paint a blank canvas the same background color. The two are designed to hang together however the owner wants. He can hang it right beside the painting, or across the room, or above or below it." What does this really add to the art work? "Nothing, really," he says with the same small smile. "It just makes them bigger, and mainly, it makes them cost more." Liz Taylor, for instance, three feet by three feet, in any color you like, with the blank, costs $1600. Signed, of course.

They wouldn't have been signed, Warhol claims, unless the Leo Castelli Gallery, his dealer, which gets a substantial percentage of the take for that privilege, hadn't ordered it. "People just won't buy things that are unsigned," Warhol complains. "It's so silly. I really don't believe in signing my work. Anyone could do the things I am doing, and I don't feel they should be signed." He was asked why he spent a few hours recently signing Campbell's Soup cans in a supermarket if he felt so strange about signing things. He smiled, "That was a big joke. Gerard really signed the cans." Warhol turned toward Gerard who had awakened and was preparing a projector for the evening's film screenings. Tennessee Williams was expected along with some other guests. "Didn't you, Gerard?" Gerard nodded, a curl dropping over his right eye. "We just thought it would be funny to have a bunch of cans signed by me that people would take home and actually open and eat. Gerard didn't copy my signature, even. He just signed my name. It really doesn't matter."

"The Gallery thinks it does, though. Look at these." Warhol goes over to a shopping bag on the floor and pulls something from it neatly wrapped in tissue paper. It is a can of Campbell's Chicken Noodle Soup weighing nearly 10 pounds. "The studio had these made for me to sign. They are beautiful, aren't they? Aluminum, I guess, solid. They cost about $50 a can, I guess. What do you think? They want me to sign them all, but I don't think I should. Do you think so? What should I do? I really can't decide whether to sign them or not." His hand goes to his lips again. "I don't think I will."

Someone tells a story of how he once watched Picasso sitting in the square of some village in Spain, drawing on plates with a marking pen, signing each one in less than a

minute and charging $100 apiece for them. There was a long line of purchasers, and a cashier had been set up to collect the money. "Really?" Warhol asks. "No kidding, he really did that?" And he may have been reconsidering those soup cans.

Since returning from Paris this summer, where, Warhol said, people "seemed to like the flowers," he hasn't done anything to sign. It's all movies now, at the rate of one a week. As one of his assistants put it, "Andy has been, well, kind of doing 'paint-think' since he got back." "If I do start painting again," Warhol says, "someone else will do it all, I won't touch anything." Except maybe affix his signature for Mr. Castelli. Of course there are also the pillows, various cloud-shaped hunks of silver plastic inflated with helium – the ultimate in mobiles – that Warhol contracted to have made some time ago. But they too are past.

Naomi Levine interrupts Warhol's reverie. She is one of the stars of Andy's silver screen. She came in early to use the phone, and was still there at midnight. She is short, with long black hair and watery brown eyes that plead. She is small-waisted, bosomy and eager. She is the star of one of the many *Kiss* movies by Andy Warhol, an hour of kissing between Naomi and a guy in front of a camera that never moves. She is also the star of *The Couch*, an experimental film in which all of Naomi's charms are revealed as she passionately and nakedly squirms on a couch. Her efforts are for naught. The male co-star is more fascinated by his motorcycle, parked next to the couch, which he works on during the entire film. She has been in eight other of his movies. She has made three movies herself, one of which she breathily says is called *Yes!* and involves people playing with flowers in a country setting, and playing with each other, and just "having fun."

When she gets off the phone it rings for Andy, and while he talked she blew in his free ear and giggled naughtily.

Then the people start arriving. One of Andy's film stars comes in and kisses him on the back of the neck while he is still on the phone. Two girls come in, one a photography stylist around town, with her friend, the dress designer from the Coast, who is wearing a V-neck pull-over mink-toe sweater.

There is a tired-looking, pregnant ex-model, bulging out the front of her white plastic Correges suit, striking poses here and there for a gawky kid with a camera who someone says is her husband. A little 14-year-old girl with long blonde hair ("she runs her own rock and roll group") is doing the jerk with this conformist, long-haired kid ("he blows guitar in her group"). There is the ex-head of a 97th Street and Columbus Avenue girl gang who explains that she has been saved by "urban renewal and Andy Warhol." Instead of bopping heads, she now appears in his films. Three little boys, ages three, four, and five, are wandering around, little bugs, playing spooky games among the silver props, oblivious to the rest of the world, underground people in their own small right. More stars come in, male, quiet and morose, along with blonde Edie Sedgwick, the new superstar, in five-inch earrings, net stockings and a leotard.

Gerard and another assistant sweep the floor. Couches and chairs are arranged in front of the silver screen. More people. Someone changes the record and the Supremes are singing again, "Baby, baby, where did our love go . . . ?" and some fellow in an Ivy League suit, with a rubber snake around his neck, is frugging with Naomi, who is paralyzing everyone with the way she is moving and jiggling. The fellow with the snake turns the volume up.

"The secret is, it's got to be livable," this copiously sweating Beach-Boys type shouted over the noise. He says he is Chuck Wein, Harvard '60, Warhol's new writer-director. "We have a lot of parties and a good time, but it's what happens between the dancing. . . ."

– and he goes back to the workout he has been having with the ex-girls-gang queen of 97th Street and Columbus Avenue.

Tennessee Williams comes in, small, tweed-sport jacketed, with brown suede brass buckle shoes, a mustache and big sunglasses. Tennessee doesn't say much, he just says, "Hello," and walks around. He looks intrigued by the electric chairs and by one big silk screen of an auto wreck picture Warhol has pulled from a newspaper. The wrecked car is upside down, and people are spilling out of smashed windows. There is some discussion about whether the woman hanging out of the back window is dead or alive. Tennessee says he thinks she is alive, then decides she is definitely dead. Definitely.

Tennessee digs all the Liz Taylors, the red one and the green one and the purple one, then says he likes the red one best. But he is more interested in Naomi and the guy with the snake. They are going hard, arms jerking, hips bumping, and Tennessee Williams doesn't take his eyes off them. Tennessee shuffles his feet in time to the music.

Lights go out and people make for the orchestra seats as Mr. Beethoven flips a switch, and *Screen Test,* by Andy Warhol the film maker, starts to roll.

The enormous, out of focus head of a sultry, attractive girl flashes on the screen. She is brushing her hair. She brushes and brushes. Then sound. The kind of sound you expect from a very old, used-up army training film, unintelligible, garbled, filled with static. An occasional word filters through. An off-screen voice (Warhol's) is telling the girl that if she wants to become a movie star, she must master the art of saying certain words with the right inflection. The off-screen voice starts drilling her on a word, over and over and over again. The word was "diarrhea." "Die – ahhhh – riiiiii – aaaaaa," the off-screen voice coaches, and her lips form the syllables lovingly and obscenely, her eyes darkened under lowered lids. Tennessee Williams roars. Then someone tells us the girl on the screen is really a guy.

Chuck Wein, Harvard '60, hastens to explain that things are changing. "Andy does more with the camera now. Sometimes he zooms it, and he even turns it on and off occasionally during the action. That creates unusual effects. He still won't cut or edit, but he has agreed to let me put together all these hour and a half segments we have been doing with Edie, things like *Your Children They Will Burn, Not Just Another Pretty Face, Beauty #2,* and *Isn't It Pretty to Think So,* which is the last line of Hemingway's *The Sun Also Rises* into a long feature film. We also plan to make a technicolor film called *Black and White,* about an interracial romance. We call what we are doing *Synscintima.* 'Syn,' for synthetic, 'scin' for scintillating, and 'intima' for the personal or intimate nature of the films. We have dubbed the whole thing 'reel-real,' or the idea of the reel of film creating the reality."

The lights go out on Wein's discourse, and reel-real number two of *Screen Test* by synscintimatographer Andy Warhol dances on the screen. Going down in the freight elevator someone jokingly wonders aloud if Naomi is really a guy.

WARHOL: THE SILVER TENEMENT

David Antin

Wittgenstein once pointed out that "A proposition is an image of reality." It almost seems as if the most curious aspects of Warhol's work grew out of an examination of the converse statement "An image is a proposition about reality." This conviction certainly underlies the cliché that "one picture means more than a thousand words," which suggests that somewhere embedded in the image there is a proposition that cannot be stated in a thousand words. That is to say, there is such a proposition and it is unclear.

This touching faith in the meaningfulness and intelligibility of the seen gives a certain portentousness to almost any of the images surrounding us, provided they happen to dominate our attention. Who has not been tricked into regarding intensely some isolated numeral or enigmatic fragment of a label blocking the view from a doorway. I know a poet who wrote a poem on the sign . . . ZEN FOODS. Consider the News of the Day. A man in a chesterfield, carrying a briefcase, is seen descending the steps of a building. A reporter holding a microphone walks up to him and says, "Have you anything to say about your meeting with the President, sir?" The man answers, "No comment," and walks out of the picture. Still, we are left with the disturbing impression that there is something that we have seen. It is this disturbing sense that Warhol can count on.

In his most recent show, the back room at Castelli's was plastered with citron colored wallpaper onto which had been silk-screened 73 fluorescent pink cows (somebody counted them). Not whole cows, cow heads. The large trapezoidal face magnified to the point of incipient disappearance did not have sufficient dots to fill out the nose or the horns and stared blankly out of the wall. They were nevertheless recognizable, and recognizability is the only indispensable characteristic of an image. (If it is not recognizable it is not an image at all.) Pushed one step further, it is Elsie the Borden Cow. It is POP ART. It is BANAL. It is funny or vicious, depending on your taste. But change the effect slightly.

The foolish trapezoidal faces, enlarged to a painful scale — the point of incipient disappearance — did not have sufficient dots to fill out the nose or the softly rounded horns and stared mournfully out of the wall. They are sorrowing clowns. "They are all of Us."

Warhol is the master of a communication game that elicits the false response. The image is presented and the effect flickers back and forth, enigmatically back and forth in the case of the cows.

Take the early comic strips. A blow-up of Nancy is incredible. (This is generally what makes it so impossible to reproduce the work of Pop artists, for unlike the work of fine artists theirs has to be seen in the original.) On the small scale of the comic strip *Nancy*, it is acceptable because it reads in the logic of its convention. It translates into its message so fast it is scarcely an image at all, i.e. it dissolves into Mr. Bushmiller's conception of the comic. Taken at the scale of the Warhol blow-up the drawing convention becomes insane. There is all that empty space between the contours marking the legs, the eyes are black holes, there is no nose, the hair is a crenelated football helmet, and that ribbon – it is monstrous. But it is still Mr. Bushmiller's *Nancy*, which does not threaten us like the fleas under Robert Hooke's microscope or disgust us like the excreta under Swift's. In the end it is enigmatic.

Art News, Summer 1966: 47 ff.

It is enigmatic because there is no apparent context to which it can be related, and yet the scale, the centrality suggest that there is *some* context. It can be taken as axiomatic that an image always seeks a context. In fact, images are habitually so dominated by their contexts that removal effects an astonishing change, as seen in collage. It is also very strikingly apparent in details of large paintings. In his early essay on Mannerism, Walter Friedländer describes in the following manner a female figure in Rosso Fiorentino's *Moses Defending the Daughters of Jethro:* "She is surrounded by frightened lambs, her arm outstretched in fright, a light cloak around her otherwise exposed body, sheer astonishment on her pretty face." The violent action of the painting appears to have conditioned Dr. Friedländer's response to the detail, because the face of the girl, viewed in isolation, is as impassive as a Greek mask, which it strongly resembles, and the animals, if they are in fact lambs, are as deadpan as Warhol's cows. What is more, the face of Moses himself, who is striking some fallen assailant, could if transposed be seen yawning in sleep instead of contorted with effort or anger. The context is what is all-determining.

But this drive to seek mood behind the image of the face is what Warhol works with in *Presley,* in *Cagney,* in the *Marilyns.* Absurdly in the case of the *Presleys.* Two canvases, four images, of the star as gunfighter at the point of the "showdown." What is shown? The blankfaced star faces the spectator, the drawn pistol in one hand, the other held near the hip. The four images are the same, but they are not alike. They have all been printed with different degrees of clarity, at faintly different heights on the canvas. An arbitrary change of color from one canvas to the next shifts everything. From left to right you read out "purposeful rage," "affronted innocence," "murderous sullenness," "terror." Nonsense! You go back and read it out again. It is indisputable that there is a subtle shift from image to image as the eye traverses the two canvases. But is it in the images themselves? From one canvas to the next there is a sharp jump as the color shifts. Everyone knows color affects mood. How? But the whole thing is ridiculous. It is a staged promotion shot. There *is* no mood. And yet . . .

In the *Marilyns* the sense of hidden meaning is enhanced by public tragedy. There is the gay, familiar, open-mouthed face. Surely lurking somewhere behind it is some cue, some information communicating a private agony. This is the conviction that spewed up columns of drivel in the papers, reams of poems, learned dissections by psychiatrists and sociologists. It was also this that led Mishkin in the *Idiot* to say that if he had been a painter he would have painted nothing but the faces of men about to be executed, the faces of the condemned. The belief in the moment of truth made visible. This conviction also compels subway riders to stare into the faces of the British Heath Killers or the untroubled features of the strangled bride in the pages of the *Daily News.* Consider Warhol's *10 Most Wanted Men.* So captioned they are a sinister crew and we can all detect the marks of depravity on their ravaged faces. But change the caption. They are: *Founders of the Little League, Board of Directors of a Soft Drink Company, Worker Priests, Members of New Evangelical Religious Sect.* In each case we can read the marks of their lives back into the photographed faces. Take the *Golden Deaths,* a centered, empty electric chair in an empty room, the straps loose, the leader cable visible in the grain of the newsphoto overcolored yellow. I once worked with a man who told me he had written away to see if he could get tickets for himself and his wife to attend Lepke's execution because he thought it would be an experience to remember.

This impulse to touch tragedy, or, more broadly, meaning, is the basis also of the *Jackies.* The face of Jacqueline Kennedy, as familiar as royalty, caught in a public disaster, seen over and over again on the television screen, in the newsreels, the newspapers. The

individual shots of her are now as familiar as the Stations of the Cross. This is where she gets out of the car, her skirt covered with blood; here she watches Lyndon Johnson being sworn in; here she attends the funeral. The images are so well known that they are recognizable even when only the barest cues to the image remain. And in the Warhol canvases, the image can be said to barely exist. On the one hand this is part of his overriding interest in the "deteriorated image," the consequence of a series of regressions from some initial image of the real world. Here there is actually a series of images of images, beginning from the translation of the light reflectivity of a human face into the precipitation of silver from a photosensitive emulsion, this negative image developed, re-photographed into a positive image with reversal of light and shadow, and consequent blurring, further translated by telegraphy, engraved on a plate and printed through a crude screen with low-grade ink on newsprint, and this final blurring becoming the initial stage for the artist's blow-up and silkscreening in an imposed lilac color on canvas. What is left? The sense that there is something out there one recognizes and yet can't see. Before the Warhol canvases we are trapped in a ghastly embarrassment. This sense of the arbitrary coloring, the nearly obliterated image and the persistently intrusive feeling. Somewhere in the image there is a proposition. It is unclear.

The *Flowers* are somewhat different. Here a photograph of flowers from a Kodak journal has been interfered with. The greys are removed and what emerges are floppy-shaped petals and signified grass in decisively unnatural color: fluorescent blackish greens, orange, gold, purple. I have heard the *Flowers* described as funny, as a put-on. And they are absurd. The pathetically limp shapes in contrasting brilliant and absurdly somber color. They resemble those photomurals that interior decorators used to put on office walls, particularly the large 4-foot canvas. But the flowers are shaped like baggy-pants comedians (no interior decorator's touch) and somehow they resemble more closely Watteau's traveling players. It is practically impossible to say what the object of the pathos in *Flowers* is. Warhol manipulates an almost impossible pathos. It is, in a sense, the images themselves, their awkwardness, their insubstantiality, their unnaturalness. Watteau's comedians are also awkward, insubstantial and unnatural. At the same time Warhol insists on, and we are always aware of the unjustifiable nature of, the feeling. If this is a put-on, it is a good thing to remember that all of Zen is a kind of put-on and that a Zen master is nothing other than a master of the spiritual put-down.

This doubleness of effect is especially peculiar to the films. A remarkable thing about *Blowjob* was that when Allen Ginsberg saw it he was reported to have said, "The whole theater lit up when he came." While Paul Blackburn told me, "The thing never came off at all; he was like hungup, man." This is clear-cut contradiction, and again it was a case of reading out the proposition from the image of a face. The *10 Most Wanted Men* or *Founders of the Little League?* How do we know anything was going on at all in *Blowjob?* All we saw was the image of a face, peculiarly blank. Perhaps what we recognize is that enigmatic, introspective smile of one turned back upon himself. We recognize the same smile in *Haircut,* in *Eat,* in Leonardo's angels. Does this suggest a new interpretation for *La Gioconda?*

More impassive than the flowers but very similar are the Elizabeth Taylors. In this work the image lies in a very narrow space slightly in front of the canvas, and it is in this narrow field that the "ideal," expressionless face separates into a series of floating superimposed colors (Clement Greenberg, take note) – the eye shadow, the lips, the hair. The ideal face is transformed into a curious mask. It is not to be doubted that this is an "ideal" face despite the terrifying flesh tones out of Woolworth portraits, the mad eye-

shadow and the wig-like hair. This is, after all, *Liz.* Warhol specializes in the Beautiful People and is probably the last significant "ideal" painter since Ingres (I call him a painter since he generally uses canvas and colors it). The ideal is to a great extent determined by its situation (pose) more than by its intrinsic appearance, and Warhol favors extreme frontality for the face, the chin slightly elevated and shadowed underneath (for men). This is the position taken for his own "ideal" portrait and for the multiple prints of Rauschenberg as the "Beautiful Youth." The main requisites for the beautiful face are traditional; youth and blankness, which almost amounts to the same thing. But under the spell of the hieratic pose (to which we have long been acculturated and whose significance we instantly recognize) we forget Warhol's age and Rauschenberg's pear-shaped body. There is only the curious seediness of the printed photographs. In the case of the Rauschenberg it at times almost obliterates the image entirely. The mechanical defects in the process are preserved and magnified and give a sense of wear and tear, of aging, to an ageless image of romanticized youth.

It is not an accident. In the *Jackies,* the magnification of the image and the suppression of grey values give her a remarkably ugly nose. Rauschenberg is almost consumed by underdevelopment; Warhol menaced by shadows spreading from under his jaw and threatening to engulf him, the same shadow spreading from the cleft in the chin of some unidentified actor in one of the films shown at Warhol's new discotheque. This seediness is a shadow hanging over all his images of the beautiful. Eye-shadow in the macabre face of his astonishing singer Nico, who so beautifully resembles a *memento mori,* as the marvelous deathlike voice coming from the lovely blond head sings, "Let me be your mirruh! Let me be your mirruh! Let me be your mirruh!" repeated each time with the precision of a cracked record; five o'clock shadow in the case of the beautiful Gerard. For who is seedier than Gerard Malanga? (Henry Geldzahler). After prolonged exposure to Warhol's work, seediness emerges as almost a spiritual category. As a kind of inevitable consequence of the beautiful and its lesser and more pathetic forms, the chic and the fashionable. Everything Warhol touches becomes intricately seedy, and maybe even unsuccessful (beautifully though). The discotheque is a case in point.

The Exploding Plastic Inevitable on a Wednesday night – set in the barnlike upstairs hall of the Polsky Dom Narodny. With few people present, three films are projected simultaneously toward the front stage. In a panel on the left, *Eat.* Robert Indiana eats his mushroom silently and self-consciously. Center, *Vinyl.* In an endless juvenile delinquent routine Gerard Malanga keeps lighting cigarettes meaningfully until he becomes the victim of some obscure and ludicrous torture arrangement, which, correctly, is all preparation. On the right, *Banana.* The banana has been eaten many frames ago and a beautiful female impersonator in full dress lies on a couch while Malanga, this time well-dressed in 19th-century Viennese gentility, with another actor, looks on significantly (Freud and Breuer? An abortion?). The movies, all homemade and showing it, have a consistently attractive, ratty look. Rotary mosaic mirrors and stroboscopes flash light through the rather windy depths of Polsky Dom Narodny's upstairs hall. There is intermittent high decibel rock-and-roll and a few dancers. A little man walks around quietly emptying ashtrays. Fragments of a film sound-track mix with the music. Gradually more people come and dance. Robert Indiana changes colors and seems to be looking at the scene. After a while there are no more films and there is much more dancing. Finally The Velvet Underground itself, with Nico singing. Dancing are Ingrid Superstar, Gerard Malanga and Mary Woronow. Nico, perfect as a cadaver, sings "Let me be your mirruh! Let me be your mirruh! Let me be your mirruh!" Warhol, this precise moralist, has moved right into the

teeth of the discotheque world brilliantly, but the most remarkable effects of his *Exploding Plastic Inevitable* seem to depend on the hall being half-empty for quite some time, i.e. on his not doing good business. Otherwise you never get to hear the films (*Hedy:* "Do you know who I am? I have fourteen thousand dollars in uncashed checks right here in my bag!"), the slow build-up, more typical of Judson Church than a discotheque. Otherwise it turns into just another discotheque. Warhol's success depends upon his failure, on being a magnificently cracked "mirruh" with the silver chipping off. But with the natural confidence of a Renaissance man, he has moved from medium to medium creating his priceless and beautifully shoddy works. (They are priceless because there is no way to set a price on them.) He has moved from painting to film, to the taped novel, soap opera, the discotheque, all sharing the same precisely pinpointed defectiveness that gives his work its brilliant accuracy. I have heard that his next move will be into architecture and that he is now planning a silver tenement. But the Sculls will move in, and he will have failed again (beautifully).

"PRINCE OF BOREDOM" THE REPETITIONS AND PASSIVITIES OF ANDY WARHOL

William Wilson

The paintings of Andy Warhol present repeated or magnified images: flower-flower-flower; car-crash-car-crash-car-crash; FLOWER-FLOWER-FLOWER. The images are applied through a silk-screen, and can be repeated with a number of variations. The silk-screens are made from photographs taken by someone else, and the screening is often done by someone else in Warhol's factory, so that the artist's part can be isolated as the choice of images and the decision to repeat the image and perhaps to magnify it.

Silk-screening makes repetition part of the meaning of the image. Even one silk-screened print is felt as a repetition, and Warhol repeats these images until repetition is magnified into a theme of variance and invariance, and of the successes and failures of identicalness. The silk-screening is a technique allowing precise delineations, but it is used sloppily by Warhol, allowing sentiment and lack of sentiment, care and carelessness, to jostle together.

Since the medium could easily be used with more precision, and is not, the purpose must be to call attention to the fact of repetition by not repeating precisely. So Warhol succeeds at failing to repeat, and this failure suggests that successful repetition is to be pitied, while the failure to repeat is to be feared.

Warhol approaches repetition in another way, through stereotypes. The word refers to a technique of printing from solid metal plates and once suggested improved repetition of an image. Troy Donohue, Elvis Presley, Elizabeth Taylor: the characters have the lustre of assembly-line products with custom trim, of things manufactured for sale. They would combine quite nicely with the repetition of endlessly unchanging assembly-lines of soup cans, ketchup bottles, green stamps. Miss Taylor is portrayed after her tabloid sick-

Art and Artists, March 1968: 12–15

ness, and there are portraits of Marilyn Monroe who died, and more portraits of Mrs. Kennedy, cruel before-and-after the assassination portraits. What these images have in common with the 13 most-wanted men, the electric chair, the body jumping or falling from the bridge, the automobile accidents, is *passivity:* people and things acted upon by machines, events, circumstances. In *Kulchur* 16 Gerard Malanga asks Andy Warhol, "Are you allowed to do what you should by circumstances?" Warhol: "No." Malanga: "What is beyond your control?" Warhol: "What's that mean?"

The pictures of these people and these things reflect the process of being acted upon by cameraman, camera, and a continuing chain of impersonal operations, here described by the poet, David Antin, for the portrait of Mrs. Kennedy: ". . . there is actually a series of images of images, beginning from the translation of the light reflectivity of a human face into the precipitation of silver from a photosensitive emulsion, this negative image developed, re-photographed into a positive image with reversal of light and shadow and consequent blurring, further translated by telegraphy, engraved on a plate and printed through a crude screen with low-grade ink on newsprint, and this final blurring, becoming the initial stage for the artist's blow-up and silk-screening in an imposed lilac colour on canvas" ("Warhol: The Silver Tenement," *Art News,* Summer, 1966, p. 58). Through these processes, the blurring, the repetition, and the passivity become more clearly focused.

These images are of people or of things which have received the action, or who have been constructed by other people, machines, or events, more than they have constructed themselves (even Mrs. Scull is portrayed in the construction put upon her by a subway photobooth). The people may be actors, but they have been acted upon. When there is such passivity in the images, and such repetition of the images – when repetition is the style, and passivity is the content – then the result is the mutual implication of repetition and passivity: an instance of one is an instance of the other. Passivity is seen as the suffering of repetition. Suffering (in the other sense) seems not to be in the particular pain or unique horrible action, but in the repetition of it. The suggestion is that pain is not suffering until it is repeated, that suffering is pain in retrospect and in duplicate, and that there is passivity in suffering the repetition. But sufficient repetition passes beyond any suffering into blankness, numbness, and a repeated pain becomes an anaesthetic.

In some paintings the images are not repeated by addition but by multiplication: that is, the image is magnified (not 100 cans of soup, but one can magnified 100 times). This magnification of an image out of all proportion to the rest of experience, rendering it unmanageable and a trifle overbearing, is a variation on a theme of passivity, even as multiplication is a variation of addition.

Warhol's movies thrive on passivity, magnification, and repetition. *Sleep* shows a man sleeping for six hours, and repeats one reel in an endless loop, which removes the variety of actual sleep. *Blow Job* shows only the man being acted upon, the one who enjoys or suffers the action – the patient, as it were, not the agent. *Eat* presents a painter chewing, chewing, chewing, and the camera passively records the non-action. Sleep, sex, and nutrition are parts of life that make repeated demands on a person, and that demand repetition in their satisfaction. These early movies are in Warhol's lyric and pastoral mode, his Barbizon School period, and could be introduced into any life-studies course.

The Chelsea Girls magnifies the problems of understanding Warhol, but it also shows some things more clearly than shorter films. Since the movie is shown two reels at a time, no two performances can be repeated identically (this point has been brilliantly developed by Gregory Battcock, "Four Films by Andy Warhol," *The New American Cinema,* pp. 233–52). The obstacles to mechanical repetition call attention to repetition as such,

and the ideal of repetition haunts the movie even as the movie depicts people haunted by repetitions something less than ideal. Within the movies are shown people, not quite actors, in the grip of gestures, habits, speeches, which they have not rehearsed the way actors rehearse, but which they have rehearsed because they have been repeating them and repeating them. Whatever chance, spontaneity, or the accidents of unrehearsed filming might provoke, the characters are held firmly in the grip of their own repeatings; the movie shows that for them life has been one long rehearsal, and they can be depended upon, when placed before the jaded eye of the camera, to yield their down-at-heel universality, their hand-me-down timelessness. The people emerge not as sinners, but as repeaters, as patient martyrs to repetition: trimming hair, washing dishes, complaining, torturing, failing. Appropriately enough the movie opens with a mock Holy Family (mother, child, and man who is too short to be the husband, and who doesn't seem to be the father), and closes with a mock confession to a Pope who says so beautifully that it isn't easy being a Pope, but that it isn't hard either, it's just something you are. The efficacy of confession, even to Pope Ondine, depends upon the promise that the sin will not be repeated. Clearly no one in the movies is in a position to make such a promise. Their punishment for repetition of their sins seems to be in the repetition itself, however. Sinning turns out to be another form of penance, and Warhol repeats the pattern of the immoralist who burns through to his own hard-core morality.

Warhol has announced his ambition to be a machine: "The reason I'm painting this way is because I want to be a machine. Whatever I do, and do machine-like, is because it is what I want to do." Since a machine is capable of endless and perfect repetitions (see Masters and Johnson, *Human Sexual Response,* for descriptions of machines no one could hope to emulate), and since Warhol is not, we can say that he can only succeed in failing to fulfil this ambition, succeed in showing that when repetition is an ideal, it is unattainable. But this failed machine is destined to succeed as a flower, as Dennis Hopper's photograph on the cover of December 1964 *Artforum* suggests. The early paint-by-number flower paintings, and the silk-screened flowers from a magazine photograph, present flowers as an object of thought or feeling by means of flower-like methods of thought: passivity, repetition. This identity of method and object gives the flower paintings their special authority: petal repeats petal, blossom repeats blossom, picture repeats picture. Warhol stood one day in the gallery, languidly surrounded by silver pillows drifting around the room and colourlessly reflecting colours and lights. Occasionally someone transplanted him to another spot, and as he turned in the lights he seemed not so much photogenic as phototropic. At the opening, a guard made people wait downstairs, and Warhol waited patiently until someone pushed him forward. Upstairs, a gallery director explained that Andy was supposed to tell the paperhanger how to hang the room full of cows, but when he found the man so capable, he told him to do it his way, and left. The paperhanger covered even the light switches with those pale purple cows whose repetitiveness and passivity, however bucolic, are an elaboration of a theme evident in the earlier electric chairs. It is as if Marie Antoinette at Petite Trianon, and Marie Antoinette in the Place de la Concorde, were the same thing.

These works of Andy Warhol seem to omit happiness or joy, even pleasure, as out of the question, perhaps because such emotions do not lend themselves to repetition, and do not follow from passivity. But the melancholy in these works is offset by the daylight to be found in the perfect expression of a feeling: there's a joy in seeing sadness perfectly portrayed. When Warhol shows repetition as an ideal of mindlessness, like an ideal it re-

cedes from the grasp of man, who is condemned to variety, novelty, and precarious margins. But even as Warhol shows that repetition cannot be achieved, he shows that it cannot be avoided. He shows repetition as a glory, as a jest, and as a riddle, and he shows the sufferance in suffering. No wonder that in the *Exploding Plastic Inevitable,* that epiphenomenon, he has Nico sing, "Let me be your mirror! Let me be your mirror! Let me be your mirror!"

EARLY WARHOL: THE SYSTEMATIC EVOLUTION OF THE IMPERSONAL STYLE

John Coplans

Of the several artists who were to emerge as the leading proponents of Pop art in the sixties nearly all were professionally trained painters; many had years of serious endeavor behind them, even if in other styles. Some may have worked from time to time in jobs outside of their chosen career to support themselves, but their knowledge of art was extremely sophisticated. Warhol is possibly the only exception. Yet once he made the decision to switch from commercial art to painting, the rapidity of his transformation was startling. From the beginning of his painting career (sometime toward the end of 1960) Warhol employed a banal and common imagery. His ability to intuit his entry into the art world with an imagery that shortly afterward was to prove extremely critical within the development of American painting was the first token of his uncanny knack of incisively and speedily touching the heart of critical issues.

It is impossible, however, to discuss the origins and development of Pop art – and especially the use of banal imagery so central to the style – without first remarking the influence of Jasper Johns and Robert Rauschenberg. Both painters unleashed into the art ambience various alternative proposals to Abstract Expressionism, chiefly by opening up painting (once again) to a greater range of imagistic content. Rauschenberg and Johns employed a type of imagery that evoked the ordinary, the commonplace of everyday life, and thus jointly freed banal imagery for use by a later generation of artists. Warhol was undoubtedly aware of Johns's and Rauschenberg's art (as were many other painters) but his direct use of comic-strip imagery, as in *Dick Tracy* (1960), *Nancy* and *Popeye* (both 1961) was an unexpected extension of their vocabulary.

Warhol's first works are clearly exploratory and derive as much from Abstract Expressionism as they connect to Pop. Though the cartoon imagery and the style of drawing obviously refers to the original models, the paint is loosely applied and dribbles in the "approved" Abstract Expressionist manner. In *Del Monte Peach Halves* (c. 1960-61) – a harbinger of the forthcoming Campbell's soup cans – the fruit can is more or less centrally positioned, with the image and subdivided background very loosely painted. In contrast, *Nancy* appears to be a literal blowup from a frame of the well-known cartoon. In short, these paintings veer between reworked images and absolute duplications.

Artforum, March 1970: 52–59, © John Coplans

The most decisive move apparent in the body of paintings that follow (between 1961 and 1962) is the rejection of paint handling. This decision sharply connects his work to Roy Lichtenstein's. It is astonishing that the two should simultaneously have struck this notion, especially since they were the only artists to do so among the many involved with Pop imagery at that time. But, while Lichtenstein persistently and unwaveringly narrowed down his style, Warhol at this time worked his way through many ideas with great rapidity, dropping each idea immediately once it was dealt with. If Lichtenstein proceeded with greater clarity and apparent purpose, it is for obvious reasons. He was a much more experienced painter than Warhol (his first one-man exhibition was held in New York in 1952) and he had a greater theoretical grasp of his aims. Characteristically, once Lichtenstein narrows down a range of imagery suitable to his esthetic purpose he systematically plugs the gaps. However, both artists during this period selected images which, though different, nevertheless reflected corresponding ideas. In addition, they sometimes lifted their images from similar sources, especially newspaper or yellow-page phone book advertisements. For instance, Warhol's 1962 painting, *Before and After,* is subdivided into two side-by-side images that sequentially reveal the silhouetted head of a woman, identical except for the reshaping of her prominent aquiline nose to a pert *retroussé* by cosmetic surgery. Lichtenstein's *Like New* (painted about the same time) is a hinged diptych that also uses a sequential image. On the left panel is a piece of woven cloth with a large cigarette burn in the center; on the right is the same piece of cloth in impeccable condition after reweaving. Obvious, too, at this time is a shared vein of humor – both relish thumbing a nose at the art world by choosing an outrageously subesthetic range of subject matter.

Warhol's body of painting clearly underwent three principal stages of development: 1) he would select an image and rework it informally; 2) he then began hand-painting selected images to simulate mass production; and 3) he finally dealt with mass production directly through the use of various reproductive processes. The transition from one stage to another is not always clear, for there are occasional lapses.

Within the second category are the paintings derived from newspaper pages, match covers, dance step diagrams, painting-by-number sets; multiple images of glass labels, money, S&H stamps; single and multiple images of airmail stamps and Coke bottles; and, most famous of all, single, multiple and serial images of Campbell's soup cans. With the exception of the Campbell's soup cans, which came last, the sequence and order of these works are difficult to establish.[1] Throughout this period Warhol made numerous drawings either related as preparatory to the many images enumerated above or as proposals that were never painted: a record cover, a baseball and others.

In these works there is a heavy amount of lettering, which he later abjured. (Lichtenstein also gave it up, but he initially did a lot more with it than Warhol.) Warhol dropped lettering entirely after the Campbell's soup cans, concentrating instead on the punch of his visual imagery. Also missing in much of this early work is the sense of brutality and morbidity common in the later work. In short, in the earlier subject matter the possibility of the imagery being charged is there, but the temperature is low. The "charge" at this point is still below the surface. Nor is it a question of these works being painted by hand, though this is partially a factor; due simply to choice of imagery and inertness of handling, they lack the grotesqueness and sense of horror transmitted throughout the later work.

Within this group of paintings the highly varied "Do It Yourself" images are the most offbeat. Taken from hobby shop color-keyed painting sets, these banal images are transformed by Warhol into strange paintings that are themselves supremely banal metaphors

for paintings. Though the color is literal, its lyricism is sharply at odds with the banality of the image. The "Do It Yourself" paintings pose the question: can a painting be made that looks mechanical but is not? The numerous numbers (that, in the hobby sets, indicated which areas were to be painted which colors) are of mechanical origin, printed onto transfer paper and pasted to the canvas surface by the application of heat. They mark the first suggestion of Warhol's finding means to expunge entirely the use of the artist's hand from his painting.

Some of the most important paintings from this second period, at least as far as Warhol's esthetic evolution is concerned, are the images of complete front or back pages from the *New York Mirror, Post* or *Daily News.* Newspapers inherently suggest the use of printing processes. They also deal with the ideas of mass production and reproductive processes, especially the photograph, which liberally appears in large scale on the cover pages of these newspapers. Implicit in these paintings are Warhol's later charged images of disasters and public personalities who make news.

The newspaper image presents, in a very forthright way, the issue of duplication, which is never quite raised in the work of Lichtenstein, who deals only with the reproductive process itself through the use of Ben Day dots. With Warhol one senses the use of the chosen image as a whole, as an entity, especially in the later photographic images. The imagery that Warhol finally selects is in the range of charged, tough notions that in Rauschenberg's work, for example, become transformed by painterly handling. Warhol's imagery is transformed in much the same manner that Lichtenstein transforms the comic strips, but the crucial issue is that the transformation is not immediately apparent. More immediate to the viewer is that the painting looks as disposable as the original it is modeled from: something to be thrown away, or the cheapest kind of advertising, of no value except as a message to sell. (This is exactly what infuriated Erle Loran as well as many others of the art audience. What these viewers failed to sufficiently consider was the power and ironic efficiency of the various concealed formal devices operating in the paintings: critical alteration of the contexts of the images, changes of scale, suppression of paint handling, compositional inertness, etc.)

The money, Coke, airmail and S&H stamps, glass label and Campbell's soup can paintings enforce the issue of multiplicity of the image itself, which as a motif is endlessly repeated. Two important formal innovations edge into these paintings. First, the actual as against the simulated use of an anonymous and mechanical technique, and second, the use of serial forms. Several of the money paintings were silk-screened, as were the modulated rows of images imprinted on the surface of the Whitney Museum's *Green Coca-Cola Bottles.* (However, though Warhol even much later never entirely removed hand touches from his paintings, it was not until he used the blown-up photographic image taken from newspapers or other sources that he became crucially involved in photomechanical and silk-screen printing processes.) And with the Campbell's soup cans, which are the last of the hand-painted images, he shifts very decisively into the use of serial forms.[2]

Central to serial imagery is redundancy. The traditional concept of the masterpiece as a consummate example of inspired skill that sets out to compress a peak of human endeavor into one painting is abandoned in preference to repetition and abundance. Serial forms also differ from the traditional concept of theme and variation. In the latter, the structure may be the same, but the composition is sufficiently varied so that each painting, though belonging to a set, can be recognized as unique. In serial imagery, uniqueness is not the issue; the structure and composition are sufficiently inert so that all the paintings, even though they can be differentiated, *appear* to be similar. Basically, it is a

question of a shift in emphasis. Theme and variation are concerned with uniqueness and serial imagery is not. Serial forms are visually boring; there is very often a low threshold of change from painting to painting. But each painting can exist very fully alone. Obviously, when serial paintings are seen together within the context of a set, the serial structure is more apparent. Serial paintings or sculptures, however, are all equal in the sense of being without any hierarchy of rank, position or meaning. They also may be added to indefinitely, at any time. This, of course, depends upon the approach of each individual artist and the manner in which he sets up (or alters) the parameters of his particular system.

Including the Campbell's soup cans, Warhol's most serial paintings are those which thematically concentrate on a single image; for example, the various portraits as well as the Brillo and other boxes, the aluminum pillows, some of the disasters, and all the flowers. The power of these images derives from their seriality: that there are not only many more than a few in any given series, but that it seems to the viewer there are many more than can possibly be counted. This has partially to do with choice of imagery. Warhol invariably selects an image that pre-exists in endless multiples. Thus his series give the appearance of being boundless, never finished and without wholeness. Moreover, the larger the actual number of paintings in any one series, the greater the sense of inertia or input. Warhol's series, then (like the work of many other serial artists), speak of a continuum.

It is difficult to ascertain exactly what combination of circumstances led Warhol to change his imagery and technique so rapidly, radically and simultaneously toward the end of 1962 and in early 1963. Warhol's first New York exhibition in late 1962 included a very diverse range of paintings – Campbell's soup cans, Coca-Cola match covers, modular rows of Coke bottles, modular Martinson Coffee tins, at least one of the newspaper images (*129 Die*) and various portraits, in particular the modular heads of Troy Donahue, Elvis Presley and Marilyn Monroe. In this exhibition, including at least one painting of rows of Coke bottles, all the portraits employ the silk-screen technique. The impersonal method of hand-painting the images hitherto employed is subjected to a powerful transformation.

Rauschenberg and Warhol seem to have developed an interest in the silk-screen technique at about the same time (though Warhol may have anticipated Rauschenberg somewhat in the money paintings of 1962). Rauschenberg's purpose was to find a means to alter the scale of the photographic material which he had formerly affixed to his paintings as elements of collage. Silk-screening allowed him to adhere the blown-up image as an integral element of the canvas surface. Warhol, on the other hand, used the technique as a device to control the overall surface of the painting. Warhol first lays down a flat but often brilliant ground color and then unifies the surface and image by repetition of the module of the screen. The final image, however, is very arbitrary and quite unlike the impersonal handling of the serial Campbell's soup cans, from which all trace of paint handling has been suppressed. In employing the silk-screen technique, which is used in commercial art to give evenness of surface and crispness of outline, Warhol reverses the effect. In his hands the technique becomes as arbitrary, unpredictable and random as the paint surface appears to be in an Abstract Expressionist painting.

In essence, silk-screen is a sophisticated stencil process. Onto the bottom of a box frame several inches deep and considerably larger than the image to be printed, a suitable porous material is affixed (silk in the hand process and fine metal mesh in the mechanized process). The image can be affixed onto the material by a variety of means, either by hand or photomechanically. Warhol uses the latter method. All areas other than those parts of the image to be printed are occluded and made impervious to the print medium,

be it ink, oil paint or a water-soluble dye. The frame is then placed on top of and in close contact to the surface to be printed. The liquid printing medium is poured in at one end of the frame. It is then stroked across the image with a rubber squeegee and forced through the mesh to print on the surface of the material beneath. Though the silk-screen process is simple, many things can go wrong. For instance, if the medium is stroked across the image unevenly, if the density of the medium varies, if the squeegee is worn or dirty, or if there is insufficient medium to complete a stroke, the image will not print evenly. Parts of the image will become occluded or the dirt will print tracks, etc. The sharpness of the image will also vary according to the pressure exerted on the squeegee, or the angle at which it is held. Many of these deficiencies will often work their way into the mesh and, unless the screen is cleaned, will show up in subsequent images.

These normally accidental effects are often deliberately sought by Warhol. At other times, his images are printed more evenly. In many of the latter, especially some of the Marilyn Monroes, the nearly identical images are heightened by touches of color applied with a brush. A compelling aspect of Warhol's silk-screen images is that the transformation of the images is effected in the technique; thus it is embedded in the various processes.

The silk-screen process is capable of breeding a tremendous number of paintings. Yet not only are Warhol's images very few, but by the time the identical images are either printed many times on a single canvas, or alternatively, printed on small single canvases and then assembled into one serial painting, the number of his paintings shrinks considerably. In fact, his overall *ouevre* is surprisingly small. Since a major part of the decisions in the silk-screen process are made outside the painting itself (even the screens for color can be mechanically prepared in advance), making the painting is then a question of screening the image or varying the color. These decisions can be communicated to an assistant. Perhaps this is one reason why Warhol doesn't count how many works he has made, or care. Those he doesn't like he can throw or give away. It is not so much that he is uninterested in his own history (though that may well be a factor); his indifference arises partly because of the processes involved. It is always possible to make more, and what obviously interests Warhol are the decisions, not the acts of making.

Neither Lichtenstein's nor Warhol's painting (nor Johns's nor Rauschenberg's, for that matter) is involved in edge-tension in the same manner as the field painters (Stella, Noland, Kelly). Lichtenstein's method of organizing the painting has more to do with Cubism, particularly his method of cropping the image. The actual borders of Warhol's paintings, on the other hand, are arbitrary and not at all critical. In fact, Warhol's paintings lack edge-tension. To him the edge is merely a convenient way to finish the painting. Like Lichtenstein, Warhol crops, but the final edge of the painting is determined by the repetition of the module of the screen, or the size of a single image contained on the screen. In Warhol's paintings of Elvis Presley, which reproduce the whole figure, the background is a flat silver. Either single, double or treble repeats of the figure are centered on the canvas. The top edge of the canvas cuts the head and the bottom edge cuts the feet. Because of the nature of the silk-screen process, which necessitates the unmounted canvas being placed in the press in order to be printed upon, the edges of these paintings are determined afterwards, though obviously their general location may be known in advance. Very often the single images printed on one canvas are united to form a larger unit of several canvases. In any event, the edge is always positioned as an outgrowth of the margins of the image on the screen. At times Warhol will add to a screened canvas another, blank canvas of the same size painted the identical ground color – as for

instance in some of the Liz Taylor paintings or the very large, dun-colored *Race Riot.* But unlike photographs or movies, which localize space by delineating subject, surroundings, background, etc., Warhol's paintings present images in a surrounding space that is felt or perceived as a continuum. This is enhanced by the fact that his portraits are without a literal background. His heads or figures are positioned on a flat-painted surface.

What Warhol's painting lacks in edge-tension is compensated for by other tensions he induces in his pictorial structure, notably that of slippage. This is introduced in various ways – by the under-inked directional vector of the squeegee, or the printed overlap of the margins of the screen, or a lack of taut registration when several colors are used. Many of the large flower paintings involve this form of color slippage. In addition, Warhol deliberately ensures that the color areas are larger than the natural forms they are designed to denote. For example, the red of the lips in the Liz Taylor portraits is very much larger than the lips themselves.

A strong feeling of time is also induced by the silk-screen printing method. It arises from the apparent variation of light in the modulated or serialized images. In fact, there is no actual change of light. Warhol takes the same image, repeats it, and creates in the viewer a sense of seeing a whole series of light changes by varying the quantity of black from image to image. Thus the same image runs the gamut of blacks or greys, apparently indicating different times or amounts of daylight, when in fact the viewer is perceiving a single photo printed with a variety of screening effects. No other Pop artist is involved in the ideas of time, sequence, duration, repetition, and seriality to the extent that Warhol is. These aspects of formal innovation are what make his work unique.

In at least one painting, *Robert Rauschenberg* (1963), time is used by Warhol in a straightforwardly literal or narrative manner. The painting was made by screening old photographs of Rauschenberg, first as a child with his family, then as a growing boy, and finally, as the artist Warhol knows. The time sequence of the images, which are repeated on the canvas in modulated rows, runs from top to bottom, the images at the bottom (of Rauschenberg the artist) being much larger in size. Apart from this painting, Warhol's usage of the time element is generally more abstract. Warhol seems to realize that his work is less sentimental or journalistic – hence of greater impact – if the painting suggests time without actually using it.

Because of the oblique time-element that Warhol introduces into the paintings, each repetition of the same image seems to be unique rather than a duplicate of the others. Thus the internal variations and the slippage that arise as consequences of the printing techniques give life to what was originally a static image, in particular by making the viewer think that time is moving. This, of course, is enhanced in the serial paintings by the linear qualities of the sequence of the images from left to right and top to bottom. One reason why Warhol was readily able to drop words or written images is that his serial or modular images act in very much the same orderly sequence of parts that the structure of words evokes. The idea of movies, of course, is also inherent in the silk-screen paintings, the sequential presentation of images with slight changes first occurring in the money and Campbell's soup paintings, and particularly in the painting of tiered rows of Coke bottles that are in various stages of fullness or emptiness. Still other aspects of his painting lead toward movies – the silver backgrounds of many paintings, as well as the blank silver canvases often adjoining, which are like movie screens.[3]

Warhol's instinct for color is not so much vulgar as theatrical. He often suffuses the whole surface of a canvas with a single color to gain an effect of what might be termed colored light. It is difficult to use any of the traditional categories in discussing Warhol's

use of color, which bends toward "non-art" color. His color lacks any sense of pigmentation. Like the silver surfaces of the Liz Taylor or Marlon Brando paintings, it is sometimes inert, always amorphous, and pervades the surface. Though often high-keyed, his colors are at times earthy, as in one of the race riot paintings, which is covered in a flat, sickly-looking, ocherish tinge reminding the viewer of a worn, stained and decaying surface. In other paintings Warhol moves into what may best be described as a range of psychedelic coloration. For the most part his color is bodiless and flat and is invariably acted on by black, which gives it a shrill tension. Further, the color is often too high-keyed to be realistic, yet it fits into a naturalistic image. This heightens the unreality of the image, though the blacks he so often uses roughen the color and drain it of sweetness. However in a number of other works Warhol successfully counterpoises two or more brilliant hues without the use of black.

Warhol uses public pictures of people. With rare exceptions (Ethel Scull) he avoids candid snapshots that reveal private or idiosyncratic information about the persons concerned. His portraits are forthright, but of people wearing composed faces. The pictures are neither reworked nor touched up. What one finally must confront is the paradox that however correct its likeness, a picture never tells the truth. Photographs of faces are supposed to be revealing of more than the physical structure of the face. However they rarely reveal inner truths about the person concerned. That is why the Jackie paintings are so powerful (and touch us so deeply). Mrs. Kennedy may have been photographed during a terrible experience or ritual, but in the Warhol paintings she looks normal even in her anguish. It is only in the car crashes, when people are caught imminently facing their own death, that they wear masks frozen in terror; otherwise Warhol's portraits transmit nothing of the inner psychic tensions of the persons portrayed. They are always dehumanized by never reflecting what they feel. Thus Warhol dehumanizes people and humanizes soup cans.

The flowers were first shown in 1964. They consist of many series of different sizes within two main series, one of which has green in the background, and the other, black and white. What is incredible about the best of the flower paintings (especially the very large ones) is that they present a distillation of much of the strength of Warhol's art – the flash of beauty that suddenly becomes tragic under the viewer's gaze. The garish and brilliantly colored flowers always gravitate toward the surrounding blackness and finally end up in a sea of morbidity. No matter how much one wishes these flowers to remain beautiful they perish under one's gaze, as if haunted by death.

Warhol is open to everything. And everything these days seems to consist of violence and death. Both are central to his art and his life. He doesn't censor, nor does he moralize – at least not directly in the work, though in a paradoxical manner, by choice of material. When he presents his imagery he does so without any hierarchical or extra-symbolic devices. He can be related to the Absurdist playwrights and writers, in vision if not in style. He does not share the underlying dramatic structure apparent in their work. He also has no Surreal, metaphorical or symbolic edge. His work is literal throughout: those are Campbell's soup cans, that is an atomic explosion, here is a car crash, and the accident that can happen to anyone. The car crashes are as anonymous as the movie stars; they are portraits of death without even the ritual that attends the convicted killer executed in the electric chair.

It seems at first that Warhol's imagery is catholic, but this is not so; his choices are very deliberately limited. On the rare occasions when a painting fails, it fails foremost

because his sense of choice has let him down. But his sensitivity to exactly the right amount of charged imagery is singular.

Warhol's career as a painter or even a movie-maker may or may not be over. Only the future will answer this. One thing we are certain of. Whatever the ambition that motivated Warhol to become an artist, art itself – it seems – has had as much effect on Warhol as Warhol has had on art. Finally, like Duchamp, whom he so ardently admires, here is a man who now only speaks when he has something to say.

NOTES

1. In addition, there exist photographs of a series of representations of automobiles, some of details (front, or wheel and mud-guards) and others of repetitive side views of the whole. These works were made as illustrations for a magazine article and should not be confused with Warhol's exhibited works.
2. For a more extended discussion of the usage of serial forms see my *Serial Imagery* (exhibition catalogue, Pasadena Art Museum, 1968: book, the New York Graphic Society, 1968).
3. Though Warhol's interest in movies – to whatever degree – was very likely longstanding, apparently the crucial event that directed him into film-making was his 1963 exhibition of Liz Taylor and Elvis Presley paintings at the Ferus Gallery in Los Angeles. The attraction of Hollywood was too powerful to resist. Before making the journey for the opening of the exhibition Warhol obtained a hand movie camera and on arrival in Los Angeles with some of the Factory crew he began shooting *Tarzan*. The opening shots of this movie begin on the L.A. freeways and the subject is introduced by an approach shot of a "Tarzana" off-ramp freeway sign.

IN THE GALLERIES: ALLAN D'ARCANGELO

Vivien Raynor

This approach to the contemporary scene is familiar, but D'Arcangelo is a shade less self-conscious than most of his Newly Realistic colleagues. He concentrates on superhighways, their signs, white lines and billboards, using a flat, hard-edge formula related to poster art of thirty years ago. A "quadruptych" shows an orange moon rising over a brown and black landscape to reveal, by stages, a Gulf sign. In others there are route signs phosphorescent white against blue and black: a Pegasus jumps across the highway; a blonde looms huge over the horizon, all pink and blue and smoking a cigarette. D'Arcangelo's visual sense leads him to project some of the beauty of a road at night – which disqualifies him from an honors degree in Pop. Moreover, he hasn't completely grasped the official wit. On the other hand, awareness of the party line causes him to water down his visual experience with too elementary a stylization. (Thibaut, Apr. 30–May 25.)

HIGHWAYS & BY-WAYS

Nicolas Calas

Before Allan D'Arcangelo there was Chirico to whom we should be everlastingly grateful for having made the landscape look as artificial as an African mask. Reality is not enough! Playing with distance, Chirico evoked a Palladian past. But he was not granted the prescience to foresee that some half-century later his biscuits would acquire a Pop taste. Is Pop Art actually two-dimensional, as has sometimes been claimed? With D'Arcangelo's highways Pop Art must seriously consider the problem of tri-dimensionality. D'Arcangelo's use of distance neither serves to take us back into a past of which Chirico was fond, nor to isolate us in the present as does Dali. D'Arcangelo's highways are as much in the *now* as Kafka's labyrinth. Unlike the Futurist's view of speed which is spectator-oriented, D'Arcangelo's is driver-oriented. One is aware of having either to speed up or slow down.

The highway is today the significant form of the American architectural landscape. Unlike Chirico, who shifts the position of the vanishing point to create the sense of loss

Arts, September 1963: 57
Art and Artists, October 1967: 12–14

of position between the now and the historical past, D'Arcangelo makes of the vanishing point the polar star of the speeding driver. When caught in the straits of obsession, how is one to escape from fixations? In his series of paintings called *US 1*, D'Arcangelo approaches the dilemma by transcribing perspective into the vocabulary of diagram: on either side of the highway, trees fall within a triangle; with the parallels of the road, they meet the triangular skyline at a point we call vanishing.

Theoretically, these paintings should be too abstract to arouse emotion. But D'Arcangelo tunes his paintings: the skyline is supported by jetting tree-tops, the road is taunted by road signs which strain toward the hyphenated center line; nevertheless, the distant sky is precipitated into the foreground because of the exaggerated clarity of the farthest road markings and trees. By omitting details which would distract attention from forms, D'Arcangelo takes sides in the struggle between the abstract and its opponents: road signs bear down starkly; daytime trees flatten into chrome-green areas, after dusk night-green, while black roads turn brown from the reflection of greens, turned black. These defy the mirror of color.

D'Arcangelo breaks the hold of perspective by a strict adherence to the driver's code. In a recent series of works called *Barriers,* he weights his pictures with constructions, whether beams of bridges coated in primer-orange or warning signs striped white and black or white and red, superimposing an irregular H or a zebraic net over the pictorial space. Cadmium orange or stripes brightened with white lift the monochrome sky out of the background.

The painter-driver exploits his dual personality for the benefit of the observer. In some instances the view of the highway vanishing is isolated and boxed in a single flat square of the picture plane. Geometry is no longer the handmaiden of images; images are the raiments of tectonics. Tuned to speed, geometry of the barriers set crosswise over the view divides the picture into "musical" sections. (This optical illusion is actually due to the pull exerted by the vivid oblique red stripes.) D'Arcangelo's shift of emphasis from distance to plane is an escape from the narrowing speed. Relief from significant forms is in forms upset.

D'Arcangelo goes on to upset the order of images. In a recent painting, *Map,* which takes precedence, the image of the road or the map? The curve of the East Coast or the curve of the highway? The division of the painting into four equal squares or the content of the squares? In the beginning was the printed image. Then came the painting created in the image of its maker.

Another, more recent, series of highways are seen perpendicular. They confront the driver with his phobia: the road before him, climbing steeply over the next hill, suddenly rises and becomes a wall. Motion is paralyzed, feelings turn cold. What but anxiety can be expressed by the highway's white divide tapering toward the narrowest of skies in the bluest of nights? Barnett Newman was the first to have presented our world with a linear view of the ego. The exchange of ideas among artists is pursued in vivid dialogue that fearlessly transcends the great divide between the figurative and the abstract. What could be less nonabstract than the landscape of speed? Highways are not for pedestrians. Every mile of paved surface, with its lawn embankments, its framing trees, must be swiftly by-passed. Velocity subtracts. Painters reinterpret cutups into the new abstract-like compositions. The unreality of a glossy postcard's view is collaged to the schematic design of the highway; the green of the lawn is reappraised in terms of a vertical rectangle, the texture of grass is represented by a drawing on a ground rectangle; the sky, reduced to a tiny blue square substituting for the postcard's embellished view of dirt. The

faint clouds of a heavenly summer day emerge from the Kodachrome blue of the card to roll in thick circles over parts of the unpainted canvas. In yet another work, the black surface of the highway is treated as a cutout and appears to be standing on its side when conjoined to the schematic drawing of an unfinished highway. In the distance the incomplete section of the road runs into a finished one, this time a ready-made ten-cent shiny reproduction of a curved road.

With the mechanization of the landscape, the real and artificial blend and clash their respective colors, lights, and shapes. D'Arcangelo excels in the cross-fertilization of the abstract and the vernacular, the blueprint and the chromatic, the crowded postcard and the spacious canvas. The effects can be stunning.

In a recent series of "roads," D'Arcangelo increased the distance between reality and its abstract rendition by reducing the highway landscape to a broad central green band placed between two narrow bands, a blue one above and the other below forming a geometric black-and-white pattern. At times the sky itself forms a "road" dividing the green plane in two, at others a road sign set against the green makes the work appear particularly "abstract." These paintings are remarkably attractive; they fascinate the viewer much the way the road stretching before him fascinates the driver. It would seem relevant here to distinguish between "attractive abstraction" and "bland abstraction." With the former we are reminded of the Quattrocento true perspective which charms us with its compressed distance between foreground and background, of Chirico's false projects of cubes which heighten the illusion of mystery, of Mondrian's subtraction of the image from a divinely divided space. With D'Arcangelo, the narrow space encasing the driver has been banished from the roadway, the omission compensated by the vastness of green.

Some critics have denied that D'Arcangelo's highroads are genuine Pop Art because they are not two-dimensional. Confound the wise! How much longer are we to be told that more is less? Painting is more than the eye can see.

D'Arcangelo, in paintings of 1967, got off the highway by making a left turn. Yet he remains in the driver's seat: what he sees on his left differs from what lies on his right. What the viewer sees is an abstract painting supported by a highway vocabulary. In the oversize *Landscape,* 1967 (38 inches by 42 inches), and in the small *American Landscape* (9 inches by 19 inches), stripes have been lifted off the ground to rise and curve a path into the sky while a road sign stops a quatrefoil cloud. The landscape has been exploded, its parts swiftly reassembled; precarious compositions are firmly balanced by a vibrant curve, forcing the road's vanishing point to boomerang into a low summit. Arrows pointing skyward guide the driver in the direction of two-dimensionality.

With these paintings D'Arcangelo makes a most lively contribution to Expressionist geometry. This is a style, mannerist and centrifugal, that at present challenges systematic abstraction.

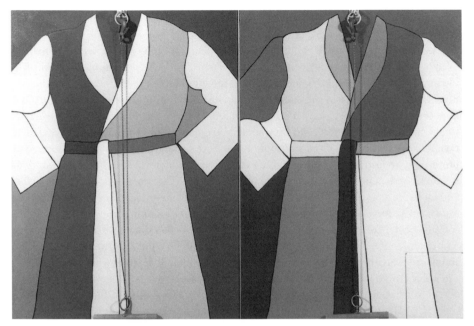

Jim Dine, Double Isometric Self-Portrait (Serape), *oil with objects on canvas, 56⅞ × 84½ inches, 1964. Whitney Museum of American Art, New York. Photograph by Geoffrey Clements.*

JIM DINE AND THE PSYCHOLOGY OF THE NEW ART

Alan R. Solomon

The recent hubbub about pop art has produced a regrettable distortion of the real nature of this new art. Pop has enjoyed a *succès de scandale* because of the strangeness of its images, and it has been misinterpreted as an art of protest and a reflection of discontent in the modern world. A series of exhibitions in Europe during the past twelve months, first in London and Stockholm, and then in Copenhagen, Amsterdam, The Hague, and elsewhere, has only succeeded in extending the confusion abroad, since European critics have consistently misunderstood the work. The American exhibition at the Venice Biennale has been described in the European press as an invasion of Pop, and Rauschenberg, the International Prize winner, has been crowned King of Pop Art, despite the fact that none of the artists in the exhibition regards himself, or should be regarded, as a Pop Artist.

The confusion, as I have pointed out before, begins with the term itself, imported into America by its inventor, Lawrence Alloway, who used it to describe an earlier British phenomenon which has some, but only some, elements in common with the new American art. These parallels, as the name itself implies, have to do with the use of images from the popular and commercial culture. The Americans who use such motifs include, among the original innovators, Lichtenstein, Warhol, Rosenquist, Wesselmann, and perhaps one or two others. However, all of the members of this group have certain additional charac-

Art International, October 1964: 52–56

teristics, just as important as their images, and informing their choice of such "distasteful" subjects.

The style of each of these painters depends in one way or another on a kind of neutral or mechanical execution, derived from comic strips, billboards, photomechanical techniques, or whatever. While each of them had individual stylistic characteristics, this approach to the execution of the painting eliminates the traditional issue of handling, and imposes a certain detachment and impersonality on their art. Their attitude is what we would call nowadays "cool," and they actually tell us very little about themselves, their real personal feelings, and their attitude toward the situation in the painting. Instead of protesting, or satirizing, they are telling us that anything goes, and that the mystery of art does not depend on *any* imaginable preconception. This openness, so much a determinant in the attitude of the new American generation, comes not from indifference, but from a desire for a new esthetic and a new morality. Such a point of view is absolutely incomprehensible to Europeans, except for a few who have had some taste of contemporary American life. Oriented toward Cartesian rationalism by a long and rich tradition, the ambiguity of attitude and the apparent absence of familiar disciplines (there is, of course, a new discipline) annoy and distract them. These qualities are more compatible with the northern mentality, and it is perhaps no accident that the exhibitions mentioned at the beginning all took place in northern cities; however, northern Europeans too still try to relate the new American art to accustomed values.

Other artists of the new generation, operating in reponse to the same spirit of openness and freedom of inquiry, have also turned to the contemporary environment for their material, but their preoccupations center on objects and images from the modern world and the potential behavior of these, rather than on "found" modes of representation of objects detached from behavior.

For these artists, particularly Dine and Oldenburg, among the original group (Rauschenberg and Johns, the precursors of all the artists mentioned here, anticipate the various attitudes, and are excluded from the present discussion), the response to objects in the world is intensely personal, and they are deeply involved in communicating their private feelings through their art. Their styles depend upon expressive means to communicate these feelings, and in fact they hark back, like Rauschenberg and Johns, to the abstract expressionists in their modes of execution, unlike the first group, who have repudiated the older concern with animated surface and active execution.

The familiar world of reality is a secret and mysterious place for an artist like Jim Dine (much of what is said here also applies to Oldenburg), and the objects and images which people it operate on strange and unrevealed levels, beyond our ordinary comprehension. This point of view also determines the ambiguous flavor of the work of the Pop Artists, but in their "coolness" they do not go beyond the point of confronting us with the bizarre or the enigmatic concealed in banality; they leave us to our own resources, since they do not disclose their own.

Unlike the others, Dine sees objects symbolically, not in a conventional or historical sense, but in a new way which is psychologically tuned. Familiar forms become vehicles of anxiety or of sexual feelings, for example, and he systematically explores the unconscious pressures generated by objects. In this sense he has been conditioned by Freud, not as a student of psychoanalytical theory, but as an exponent of that modern temperament which has been touched in certain ways by the complexities of modern existence and which has acquired new insight into the patterns of human response. His symbolism resembles Freud's in that it is based on transformation, formal analogy, and association

with human forms and conditions, but it remains an intuitive vocabulary, derived through the special quality of the artist's eye and mind. Objects acquire a new power and intensity for him; things become organic, or more specifically, anthropomorphic, with a potential of action and behavior which lifts them out of their familiar inert and passive identity. I have pointed out before that "happenings," to which Dine and Oldenburg were probably the most important early contributors, not only involved the audience more directly than conventional theater, but also gave to objects, which always played an important part in these events, a new importance, with the result, actually, that objects often became members of the cast, as important as the human actors.

Apart from the new behavior of objects, the work of Dine echoes an intense commitment to life, its process, to human feeling as the measure of experience, and to art as its vehicle. In one of his "happenings," *The Smiling Workman,* of 1959, Dine appeared as a painter, the happy craftsman of the title, before a large surface on which he began to paint from three buckets of color with extravagant gestures, splashing and slopping the pigment on the "canvas." In an enormous outburst of enthusiasm he printed on his "picture," "I like what I'm doing," picked up the bucket of red paint, and, as the audience gasped, poured it over himself (actually it was tomato juice), and then jumped through the paper on which his "picture" was painted.

In another happening called *Vaudeville,* 1960, in a set decorated with fresh vegetables, Dine did a kind of comic turn, extravagantly made up and dressed in the straw hat and striped shirt of the old vaudevillian. The girl in the piece was a cardboard cutout, lifesize, which he wore on one arm. This time a bucket of paint was poured down the back of the set, and an uncanny *esprit* pervaded the whole occasion. It is difficult to evoke in such a description the intensity of the audience's response, which was electrifying. Dine on stage had a charismatic effect which depended on the intensity of his projection of himself and the activities he was involved in.

Most important, however, and this is the key to the impact made by the "happenings," we were individually confronted by situations which seemed very personal, so that we always felt like *voyeurs*. The problems raised by unaccustomed confrontations of objects and actions were always unpredictable and psychologically disquieting. We were always afraid of what might happen next; yet the happening remained in a certain sense tactful and decorous, never becoming painfully explicit or embarrassing. The point was that we were threatened emotionally and esthetically in a direct and unavoidable way. We went because we were compelled to, and we stayed, one might say, because it felt so good when it was over and the tension had been dispelled.

Dine gave up "happenings" before they began to be fashionable and widely imitated. He did so because he felt that they took him away from his central involvements as a painter, but at the same time they had clarified several critical issues which already preoccupied him in his paintings of the year or so preceding. One of these was the question of the function of the work of art as psychological catharsis, not in a specifically subjective sense, but in terms of what is common and general in all of our responses to art. In this regard, painting has always involved an exploration of attitudes for Dine, and each new work moves farther along this path. As a result, his most recent pictures always raise new difficulties and seem totally unacceptable at first.

The other issues in his paintings result in one way or another from this initial preoccupation. Every picture mocks our preconceptions about beauty, acceptability, taste, the laws of painting, propriety, or whatever. His pictures might be called ugly, but only with respect to existing ideas about the opposition of beauty and ugliness. He is committed to

psychological truth, not to ugliness, and he lifts a great variety of tabus which we have only begun to understand in recent times. The confrontation with our intimate thoughts and feelings, with the things we really "enjoy" deep within us but have always prudishly regarded as unacceptable (in the face of our secret pleasure in such things), brings up conflicts which are rather difficult for most of us to face, burdened as we are with conventional inhibitions. These complexities not only have to do with the variety and richness of sexual feelings, but also with "messiness," disagreeable textures or objects, and a general notion that some kinds of feelings about such things are "bad" or "wrong." On every plane, Dine forces us into the uneasy position of worrying about the way we have spent our lives in contention between our natural impulses and "what mother taught us was right." I cannot avoid the assertion that our response to Dine's art depends on the manner in which we have personally resolved these conflicts. One either hates his work, or derives an unconscionable pleasure from it; we find it simply impossible to be indifferent to his paintings, since their probing strikes so deep. The thrill of comprehension or the shudder of distaste disjoint our emotional composure to such a degree that many earlier involvements with subject matter in art seem superficial, arbitrary, and often dishonest.

To all of this Dine brings a sense of humor and of irony which moderates the insistence of his probing and allows it to be tolerable. Otherwise, the psychodramatic aspect of his work would render it egocentric and bathetic, a kind of permissive self-indulgence. In other words, he sees these fundamental human problems with a certain objectivity; his detachment, operating at the same time as his commitment, raises the issues to a more general level.

In this respect, his art deals not only with human feelings but with painting itself; his exploration also embraces an ironical examination of the resources and the attitudes of the painter. He intimates that a facile acceptance of given ideas about painting dissembles as much as easy assumptions about experience. His drawing and his execution seem clumsy and inept because he cultivates an expressive awkwardness and a naive vision. (This places a terrible burden on the knowing viewer who recognizes a "bad" painting when he sees one.)

Only in his most personal drawings, those he does for his children, for example, does he display his natural skill.

Dine's handling varies enormously from picture to picture and often within the same painting, ranging from a juicy curvilinear impasto which painfully reveals the bombastic overindulgence of van Gogh's expressionism to excruciatingly delicate wishy washes of color which become almost obscene in their attenuation. Some of his most beautiful (please remember how relative these words must be!) passages result from the offhand slap-dash introduction of apparent accidents which he calculatedly exploits, as a kind of pervading messiness, not as "found" effects of inherent beauty in the way that some of his predecessors used them, but set deliberately in opposition to the idea of refinement, whether it results from accident *or* design. It must be understood how antithetical suave strokes and elegant textures are to his way of thinking about surfaces. And as if his clumsy, impulsive, erratic marks were not enough, he often presses unpleasant stamped textures of metal, cardboard or wood into thick wet paint, or uses them as stencils, as in the *Four Rooms,* or the *Red Bathroom,* or else uses unpleasant metal or cloth surfaces as sources of texture. In other words, he purposely avoids the conventional and accepted ways of producing beautiful surfaces in search of new, more complex sources of interest which depend on visual or tactile irritation – on effects which open up a new vocabulary of response for the viewer. The discomfort stirred by these irritants inevitably results in

kinds of response which suggest a scatological preoccupation on the part of the artist; I have explained earlier why we are affected in this way by such experiences.

Dine's colors usually raise the same problem, since most of the time they are quite disagreeable and "tasteless," nasty browns, outrageous pinks, sickly greens and blues, or cold metallic silvers. In our annoyance at his unpleasantness, we might easily reject his colors, like his textures, because art "should be pleasing," but to reject them leaves unanswered some very important questions about our conscious or unconscious choices in such matters, particularly when so many of us choose precisely these colors for our kitchens, bathrooms, bedrooms, or institutional spaces. Dine simply wants to know why; for that matter an even more important unanswered question remains, about why we perhaps feel the need to escape from reality into art, into "pleasant" or "beautiful" colors and textures. We might well ask whether this involves some kind of evasion, and if so why it is necessary.

The earlier work by Dine tended to be more conventional in execution, simpler, with a single image. It was the concept or the image which was new and unfamiliar, and from the beginning, the choice of color and objects. As I remarked earlier, all of his work is based on autobiographical considerations, and his pictures should always be regarded as projections of himself, and vice versa. For example, his own clothes somehow continually get into his pictures, from an early tattered green corduroy suit splashed with paint, through *Shoe* and *Hat,* the various Tie and Coat paintings and *An Animal* (made from a bearskin coat he acquired that winter) of 1961, and the recent self-portraits in a red bathrobe, the *White Suit,* etc.

Shoe and *Hat,* like most of his earlier pieces, are seen with a poignant crudeness, a calculated naiveté of vision, which forces our attention on the character of the object, usually isolated in a field. The effect becomes bizarre and strangely intense, so that we see the objects with an unfamiliar wonder, as a child might see new things. Dine often incorporated the titles into these paintings, as in the case of *Shoe, An Animal, Hair,* etc., and the lettering reveals the same kind of awkward crudeness. The word becomes as important as the objects in several cases; the graphic symbol for the object somehow becomes another of its attributes which additionally alters the ambiguity imposed by the formal intensification.

This kind of attitude reminds us, of course, of Jasper Johns and his similar use of isolated objects, with which he often included words, usually the title of the picture (*Tango, Tennyson, Device Circle,* etc.). Without a doubt, Johns was an important source for Dine, as he was for all of the other members of Dine's generation; it was he who first brought up the original problems about objects and their behavior. Even though Dine's early work obviously demonstrates his obligation to Johns, his attitude from the beginning was different and he has moved along another path, as I will explain in a moment. There has been a certain tendency to consider Dine a follower of Johns, and to cite the similarity of pieces like Dine's *Shovel* to pieces like *Fool's House* by Johns, including the presence of the single hanging object (a shovel in one case, a broom in the other), and the writing on the painting, with arrows pointing to objects. I have pointed out before that Johns, Rauschenberg, and Dine all saw a good deal of one another in 1961-62, that there was much discussion of ideas of mutual interest, and that the influence exerted was by no means all in the direction of Dine. Granting Dine's obligation to Johns and Rauschenberg (whose *Charlene,* of 1954, with its flashing light and movable parasol, set the *original* precedent for all these ideas), the fact remains that the suspended objects and written labels with arrows in Dine's *Shovel* and *Job No. 1* predate Johns' *Fool's House.*

The aloofness and commanding imperturbability of Johns' paintings make his objects function ambiguously because their passivity and inertness calls into question his reasons for attaching so much importance to them. Dine, on the other hand, from the very beginning imposed a fierce intensity on his objects, in contrast to Johns' coolness; for him objects make terrible demands, equivocal, and full of overtones of suggestive sentiment.

Things for Dine assume a new kind of identity, they acquire human attributes, personality of sorts; they become agents of human interplay, of anguish, of sexuality, of threatened violence, and most of all, they become the instruments of a pervasive irony. The hardware and tools with which he has continued to be obsessed since they first appeared in his work in 1962 have perhaps been the most crucial objects for him. ("I use only new things that are familiar, such as hammers, pliers, etc., so that there will be no confusion about the mystery the viewer brings to the picture. I am also able to milk the urge to be quiet (sometimes pure) in this manner, since a hammer with a blond handle and a silver head needs very little (nothing) to be a pretty thing. I also love the anonymity of tools because they cross more visual boundaries in their real state than all the various forms of romance around us.")

Most of his paintings up to that point had functioned in a specific way, as kinds of icons. The simplicity and the central placement of the image, as well as the concentration on static forms, gave these pictures a contemplative quality, which, however, in each case usually projected a strong sexual image, by deliberate intention, according to a private symbolism derived from associations with the shapes and characters of the forms. *Hat* of 1961, is a good example of this kind of painting.

However, in a painting like *Job No. 1,* from somewhat later, 1962, the iconic monumentality gives way to a kinetic complexity which is new in his work, and which really has to do with a new kind of factual literalism. The painting becomes directly involved in a series of actions, its existence in fact depending on these actions, the tools for which are at hand, together with the written instructions: "After you're through painting the walls paint this board black and white." There are no symbolic overtones here. Rather, that irony of which I have spoken repeatedly comes to bear upon the idea of the painting. One of the key motifs in Dine is the elaboration of the painting in unconventional ways, so that it might become a job, part of the artist's life (with the tracks of his motions on the canvas), still incomplete since we have not carried out the instructions. He constantly confounds the identity of the picture: It may become part of our space, like *Vise,* 1962, part of our environment, like *Four Rooms,* 1962, with an armchair on which gallerygoers never know whether to sit or not, or part of our landscape, like *Lawnmower,* 1962. The fact that the summery landscape of *Lawnmower* bleeds out onto the mower, or that the paint of one panel covers the armchair in *Four Rooms,* or that the texture of the chair appears on the panel, all have to do with Dine's wry reflections on the mutability of the conditions of painting in relation to reality.

In his more recent work, objects which come within a certain distance of the canvas run the risk of being magnetically drawn into it, or at least leaving their mark upon it in some way. Lately, Dine's paintings have been full of shadows or ghosts, beginning with the silhouettes of arms in *Job No. 1* and including the shadows of the hatchet in *Hatchet with Two Palettes,* 1963, and the illusionistic cloth in *My Long Island Studio,* 1963, which replaces a real paint rag hung there at some point: a whole series from 1962 with plumbing leaves a trail of painted water droplets or rays of light on the surface. Dine's restless exploration in these later paintings tends to remove him from the iconic symbolic preoccupations of which I spoke earlier. Yet his habit of finding analogs persists: the sexual

meaning of *Vise* is clear enough, once it has been pointed out. A certain overtone of violence in it becomes explosive in *Hatchet with Two Palettes;* at the same time, however, this last picture also contains a clearly personal image, the palette, which Dine compulsively repeated through a whole series of paintings in 1963–64.

One of these, *A 1935 Palette* has that central emblematic character which I remarked as a feature of his earlier work, and which continues to recur at frequent moments. At the same time, this picture might be taken as a literal rendering of a palette, with oleaginous smears of thick pigment on its surface. Yet the date in the title happens to be the year of Dine's birth, and he obviously has something more complex going here. The palette shape also appears in a series of self-portraits, paintings about himself like the *Red Self-Portrait,* 1963. The flavor of the palette changes constantly in its suggestive overtones, now becoming oppressive, now erotically female. Above all, it reminds us without exception that Dine's paintings are always about painting, no matter what else they may be concerned with.

The huge *My Long Island Studio* in a way typifies this preoccupation with the facts of painting. Essentially it is a gigantic color chart, that is, a replica of one of those color cards with chips of the most popular (!) shades. However, in contrast with the unyielding rigidity of the scheme of such a card, the squares of color are unevenly painted, hastily and intensively worked, so that the effect becomes curiously inert. This flat, passive regularity has been complicated in a number of ways. At the left another color chart has been superimposed, altering the original plane, the original scheme, the relation to the margin, etc. At the right a transparent palette fills the whole panel, creating further spatial ambiguity. These confusions have nothing to do with familiar cubist manipulations of form and space. Rather, they produce a discontinuity of meaning which confounds all the issues of spatial coherence, formal unity, temporal relationships, and once again, the rock-bottom issue of identity, of the identity of the things in the painting, as well as the painting itself. The picture contains an inventory of different manners of handling. The fussy flatness of the color squares contrasts with passages of impasto, scumbling, transparent washes, drips, and shadings. The way of making a painting constantly intrudes, so that the illusionism of the rag, so smugly settled in space over the apparent surface, cannot overcome the denial of illusion he forces on us by leaving the lines with which the squares were ruled, or the computations of dimensions on the left margin, or the reality of the paint-dipped sticks on the right edge, which compromises the illusionism of the rag.

I find an extraordinary boldness, and a real virtuosity, in the way Dine trifles with conventional principles of "good" design, "coherent" organization, "consistent" handling, "plastic" space, etc., not because these manipulations are permissively destructive, but because they challenge our attitudes so effectively. They do this not in a polemical way, but simply because he brings through such practices an extraordinary new sense of mystery to the painting, and a new sense of ambiguity.

He is one of the most interesting exponents of this new ambiguity, which is so much a part of the contemporary spirit. The evocative indeterminacy of his work depends on two things, his obsessive impulse toward reiteration and variation, and a distinctly polar ambivalence. He unequivocally acknowledges that oscillation between attraction and repulsion, which he tends to think about in terms already familiar here: "I have always gone from one pole to the other of scatology . . . too clean . . . too dirty; this compulsion, along with the fear that the paintings may go away, are the reasons for making the things I do, probably." Or again, "I like the idea of making things that look like they are useful, i.e., *Job No. 1.* This invites some to touch and others not to want to. Always the two

poles of scatology. The frustrating thing is that they'd better not . . . but that sometimes I'd like them to." At one exhibition opening, another artist literally accepted the implicit injunction in *Hatchet with Two Palettes,* and chopped three or four holes in the canvas.

The special psychological openness of Dine's art springs first from a kind of creative generosity which verges on prodigality, both in the performance and in his feeling about the beholder. Thus, he is drawn to invite the destruction of his pieces, on the one hand, and on the other, he speaks of those who "run scared at the hint of favors, as they know nothing anyway, and hence one wants to make objects of objects to give to any eye (the generosity of big ideas is the frightening thing). This is what upsets them."

His openness leaves him anywhere in the world to go, unlike some of his contemporaries. Paradoxically, his work has been closed to many people, simply because it is so intimately tied to the new sensibility; in this sense his paintings are more demanding than anyone else's. Since we are still somewhat remote from a common level of awareness of these issues, what is enduring and meaningful generally in the new art, and specifically in the work of Jim Dine, will take a little while to be understood.

NEW YORK: JIM DINE

Robert Pincus-Witten

Pop art soured after 1963. By the mid-'60s it became evident that the movement could no longer sustain itself, hold together out of sheer stylistic glue, so to speak, and those figures who were to occupy positions of second and third rank began to identify themselves one by one – or fall away to nothingness. The artists of the movement sought out other modes of expression – some achieving a production of equal vigor, others, not. Rauschenberg, whose contributions were and are immense, opted for intermedia "technology" – a production often of a staggering dullness. Jasper Johns confirmed what had been hinted at all along – that his many strengths were those of a major graphic artist. Andy Warhol made emphatic his role as intermedia entrepreneur and filmmaker. George Segal continued to produce as before – cast relics of human desolation. Roy Lichtenstein stayed abreast of current taste for *Art Déco* and Depression ephemera, intensifying the fad as he was in turn affected by it. James Rosenquist made serious contributions toward pictorialized sculpture. Oldenburg also contributed to this evolution, preempting at the same time a lion's share of esteem. Wesselmann, Indiana, Marisol, Ray Johnson, so many others – evaporations. And JIM DINE? No longer bolstered by a broad-based style or public approbation, Dine emerges as an engaging, talented painter whose popularizations follow so closely upon authentic achievements as to make it appear that they had been his all along.

The early work demonstrates to what degree Dine had been indentured to Rauschenberg and Johns and his sharing of aspirations with Oldenburg in terms of street art in the late 1950s and early '60s. These earliest works, with their sordid and touching surfaces,

Artforum, May 1970: 74–75

are Dine's strongest and most lyrical efforts. From Rauschenberg came the "real" industrially fabricated element affixed to an "art" surface of pigment and canvas. From Johns, a feel for rich word and image interchanges and the confirmation too that seeming painterliness could be predicated on traditional drawing values. Oldenburg also had been confirmed by Johns in this respect. And the grimy, *matèrielle*-at-hand collage and Happening contributed a frank transitional note from Abstract Expressionism. My heart goes to the works of the early 1960s – *Hair, Shoes* and *Green Ties in a Landscape* – a richly impastoed monochromism after Johns. Like early Cézanne repainting his way through Monet, Dine is a touchingly awkward Johns. By 1963, the tangible object is out in full flourish – garden implements, bathroom fixtures – and from here on all becomes stylish permutation. The fortyish surrogate persona – the bathrobe – emerges and the heart motif, too – love, his wife, hairy snatch, as indicated by several studies and prints.

What is so curious about these thematic symbols are not that they devolve about Rauschenberg, Johns or Oldenburg, but that Magritte has been shaken down – particularly in those Dines which incorporate the symbol of the axe or hatchet, mostly the arresting aluminum sculptures of 1965, *The Red Axe* and *The Hammer Doorway*.

Between 1962 and 1966, Dine had been psychoanalyzed; in 1968, expatriated. These biographical tantalizers are hurriedly given in a brief autobiographical paragraph. They raise vital questions concerning the focus of the psychoanalysis – as well as the effects of the displacement. Did he work with a Freudian, a Jungian, a Sullivanian, a Rogerian? This experience demands long discussion if only to get at the meaning of the symbol to the artist – that is, their functioning in his neurotic pattern and, in this way, to divulge their inspirational sense, if any. Expatriation seems important because it is accompanied by such Etruscan decline. What was jejune in New York still passed muster in London. Emerge the monumental straw and chicken wire hearts, the free assemblages of studio configuration. That they are knock-offs of Sonnier, Saret and company, and possibly, too, of the tactile assemblages of Samaras, bespeaks the acuteness of the artist's transatlantic antennae.

A broad view of a focused theme in Dine's recent work was facilitated by a companion exhibition at the Sonnabend Gallery. The theme is the Studio, as realized in several large canvases and various accumulations. The canvases were smudged freely with purple patches of various colors. In front of them, on the floor, were arranged selections of carpenter's, plumber's and electrical tools, ribbons and rags, and studio implements. These studio theme pictures, like the earlier palette series of 1963, are in the debt of Johns's studio pictures. Interspersed are ubiquitous hearts as carefree as Warhol flowers. The motif underscores Dine's conflict between the emotional association of the motif and the abstract "meaning" of the substance out of which it is made – straw, wire, cloth, paint, wood. In Dine's work the symbol is all flux and spontaneity, the substance all turgid and fixed, in its concentration more "literary" than the symbol. This, despite its *dernier cri* all-over floor distribution, anti-verticality, aleatory structure and support, "new materials" and impulsivity. The combines never become "objectified," "factual," "empirical data." They remain a confessional window display – a stage setting which continues to represent the heroic first years of the Reuben Gallery and the Happening.

ÖYVIND FAHLSTRÖM:
MODELS OF SHATTERED REALITY

Torsten Ekbom

Öyvind Fahlström's art has undergone a slow but continuous development from the non-figurative to the figurative. This change in style expresses more than an aesthetic reorientation; it is primarily psychological and expresses a new attitude to life. The first phase, in the 1950's, was meditative, introspective, uncommunicative: an abstract art using signs as characters, inspired in part by Capogrossi. The most recent phase, in the 1960's, is open, responsive to life, involved: a political, social pictorial art related to American pop art. There is a simple explanation for this radical change: the first phase occurred in Europe, the other in America, in close contact with painters such as Robert Rauschenberg, Jasper Johns, Claes Oldenburg. But this change does not involve any radical break with what he produced earlier. In what he has produced in America, Fahlström follows up tendencies that can be traced back to the earliest of his works, both where subjects and technique are concerned.

Fahlström has never completely abandoned his earliest sign-shapes: in his picture-scroll *Opera* (1952) there is, for example, a sign that can be read as the beak of an eagle; the same beak occurs twelve years later in the variable painting *Sylvie* (1964). In *Opera* there is a section in which a number of shapes are gradually transformed within squares; from this it is not a long step to the strip cartoon form used in *Krazy Kat* (1964). Fahlström's way of using comic strip cartoon squares is only superficially reminiscent of such an artist as Roy Lichtenstein; instead this form emphasizes the continuity of his own production, the logical development of a personal conception of art.

Before his first visit to America, he produced two works that show this relationship with the past and which anticipated his work in America: *Första och andra kalaset på Mad* (*Gorging on Mad*, nos. 1 and 2 – the second is also called *Dr. Livingstone, I presume*). Previously Fahlström had either invented his signs or character-forms himself or taken them from esoteric sources, Mexican picture scrolls, enlargements of clinical microscopic preparations, etc. In the two *Kalas på Mad* paintings, the forms are taken from popular culture, comic strips. But Fahlström is still not interested in the figurative aspect of the cartoons; the pictures are built up of hundreds of fragments which insulate the shape from meaning and create a completely new form-world, at the same time teeming, chaotic, impossible to take in at one glance and yet exact in detail. (His method of working can make one think of John Cage's way of combining things in *Fontana Mix*, in which tape with recorded sound is cut up into millimetre-long fragments and then stuck together again at random to form new sound-structures.) But the shapes can never be completely cut off; behind each fragment one can divine the meaning, the context, and in some places it suddenly becomes clear, almost like when one suddenly recognizes a face in a crowd of anonymous people. The effect is surprising and mysterious: the teeming mass of apparently abstract shapes is suddenly transformed into a fantastic, undulating world of shadows in which contorted shapes struggle to escape from the labyrinth into the light, into reality.

The first big painting from his time in America is *Sitting* . . . (1962). This work still

Art International, Summer 1966: 49–52

has the teeming profusion of forms from the two *Kalas på Mad* paintings but the forms are no longer divorced from their meaning. The abstract, ambiguous signs have been transformed into unambiguous, figurative forms whose meaning gives the picture a new element of drama, development, coherence. (A circular shape is "interpreted" as the range of vision of the periscope of a submarine.) *Sitting* . . . is built up in squares like a page of comic strips and can consequently be "read" in a certain sequence, the squares indicating different levels of time and space. The repetition of a sign in another square can thus be interpreted as a movement of the original sign. The sign has become a role in a dramatic sequence of events and the new position, in conjunction with new signs, indicates a new context and a new meaning, like a character in a comic strip that occurs in every square looking the same but changed by the development of the story. Roy Lichtenstein achieves an ironic effect by isolating one individual square of a comic strip, divorcing it from the story so that it becomes absurd, without context. Fahlström is more literary, more philosophic. The strip-cartoon technique provides a unique opportunity to present the action in a combination of picture and text, an open form that is not tied to the fixed time-space structure of literary presentation or the "closed, figure-like" compositions of conventional realism. If one can further imagine that the forms are movable and may be placed in new positions (like actors on a stage) instead of being mechanically repeated on the canvas in, for example, nine different combinations, a complicated "game structure" arises that cannot be described by means of any conventional or established approach, a game structure that in Fahlström words "does not involve either the one-sidedness of realism, nor the formalism of abstract art, nor the symbolic relationships in surrealistic pictures, nor the balanced unrelationship in 'neodadaist' works." Fahlström achieved this aim in his first "variable game painting," *Sitting . . . Six months later* (1962). In it, the signs and the figurative shapes are cut out of vinyl plastic and can be fastened anywhere on the picture by means of magnets.

It is this literary and dramatic technique of presentation that distinguishes Fahlström from neo-dadaists and pop artists. Anyone who wants to trace what has influenced him had better look outside pictorial art. Fahlström's most recent pictures, these strange, lyric visions that resemble science-fiction landscapes with elements of "Mad" humour, obscenities and hallucinations in them, recall most of all the novels of William Burroughs (*The Ticket that Exploded, The Soft Machine, Nova Express*). In both artists, the same lyrical, ecstatic high-tension is to be found, the same combination of the pleasurable and the nauseating, the cold light from neon strips and instrument panels, the horrified fascination induced by science and the insane terror-balance of the armaments race. And in both of them, the same mysteriousness, the sudden vacant spaces that open towards dark, unfamiliar rooms. In *Sitting . . . Six months later,* someone has leapt right through a wall; only the silhouette is outlined in the brickwork, the opening is black, a hole into the night. (The detail is taken, for that matter, from Bill Elder's strip about Frank N. Stein. When the monster became conscious, it hurled itself right through the wall.)

One advantage of using the "game structure" is that it compels the artist to penetrate past the formal conventions. If a form is movable, it is a matter of indifference whether one position is better or worse than another. Interest is concentrated on the meaning, the interaction, the combinations. The difficulty in making an analysis is that the forms are capable of being interpreted in so many ways (they are non-symbolic) that all attempts to find an intrigue (an unambiguous causal connection) fail. Nor has Fahlström any such intentions. His method is more lyrical and visionary. He speaks of the "electric arc" or the spark that can occur between two forms that come in contact with each other.

A cloud crosses the silhouette of the two lovers, in another version they are sitting high up on the spool-shaped form of the (French) atom bomb. Thus Fahlström's pictures are not games in the real sense of the word. The rules of the game are generally so vague that no conflict situations as defined by the theory of the game ever arise. (An exception is *Checklist for Dr. Schweitzer's Last Mission* which is in the form of a regular parlour game.) One can say rather that the paintings are "pseudo games," puzzles that can never be solved because in theory the possible combinations are infinite. Fahlström himself emphasizes the hybrid character of his creations: "The finished paintings are somewhere at the point of intersection between paintings, games (of the same type as Monopoly and war games) and puppet shows."

In *The Planetarium* (1964), the game element is very obvious. Like all of Fahlström's big compositions, it is a complicated picture whose effect is perhaps achieved more through its intellectual content than through its visual effect. His starting point was some sentences from Nathalie Sarraute's novel *The Planetarium*. Thus, once again, the background is a literary one. *The Planetarium* is an attempt to give pictorial form to the conception of man that is to be found in the new French novel. The result is best described with Fahlström's own term: puppet theatre psycho-drama.

Nathalie Sarraute takes as the starting point for her novel a special psychological concept, "tropisms," which can best be described as the Joycean inner monologue seen through a microscope. *The Planetarium* is a kind of sociological model of the relationships between people; like fixed stars, encompassed in their isolation, people move round each other, seeking a contact that remains an illusion, while space echoes with phrases, fragments of conversations, dead words: a meaningless, empty attempt at communication. Fahlström's *Planetarium* is a quite faithful transposition of this pessimistic conception. Forty-two silhouette-like figures stand out against a background of empty space. At the bottom stands a smaller figure and the rest of the painting is contained in a speech-bubble coming out of its mouth. In this way the figures are part of an inner monologue, a projection of all the roles and relationships that give identity to the socially adapted person. The role aspect is emphasized by the procedure of dressing the figures. This is done by the spectator. There are ninety-four magnetized costumes (taken from the comic strips) that can be put on the figures, who thus change identity and even sex as the "conversation" proceeds. On a smaller picture at the side of the big one, every figure is represented by words from the conversation, words that change in accordance with what clothes are put on. It is our role that determines what we say but in the long run the differences cancel each other out. The conversation remains just as fragmentary and meaningless however one moves the figures in the "game." The figures are puppets, hanging on invisible strings.

Nevertheless the picture of the world presented in Fahlström's *Planetarium* is not so consistently pessimistic as the one Sarraute presents. Fahlström's picture is a "model" of reality and as such, it is morally neutral. The valuations, the conflicts do not exist until the spectator takes part in the game. American neo-dadism has developed this approach so far that the boundary between art and life is in the process of disappearing. Fahlström does not go so far, at least not in his paintings. He, too, is trying to "step over into life" and is working with what he calls "the material of life": comic strips, photographs from newspapers and magazines, complete objects that are used ready-made. But his personal vision is always in the foreground. The choice of the pieces in the puzzle is never accidental as it is, for example, with John Cage; the pieces are meticulously selected, "difficult, rare finds, they are more than anything else what Koestler in his new book calls 'bisocia-

tions' – when one has a piece of A and finds a piece of B and a terrific conflagration occurs when A is rubbed against B! In other words, the result is quite different and much bigger than the sum of the two."

The most magnificent result of this open-game method is the variable painting *The Cold War* (1964-65). If *The Planetarium* was a model of a sociological reality, *The Cold War* is a political model, a visionary projection of the terror balance. The picture is divided into two outer fields, East and West, that are balanced by a neutral zone in between. East and West contain figurative shapes, the neutral zone has signs (unambiguity versus ambiguity). Of the twenty or more pieces of which the painting is built up, only a few can be unambiguously associated with actual political reality. (Fahlström is never banal, there are no easily recognizable politicians, launching ramps, missiles that can be moved in intercontinental courses, in the painting.) But there is a banquet table that can be folded up like a measuring stick . . . "with different kinds of food, bottles of wine, red and white, champagne in silver goblets, joints of meat, fish, salmon, salads, cakes, fruit . . . everyone is to unite in the cold war and sit down at a great banquet table and carouse and stuff themselves and bicker in the United Nations. . . ." There are also a dozen experimental mice and a giant tidal wave (the result of an atomic test detonation?), and a yes-and-no shape, an indicator that can be moved on a board and which makes one think of a military, strategic manoeuvre board. The other elements are independent, disconnected, absurd – a gorilla on a shining tiled floor, big red footballs, a growing "tree" of trousers (human mutations?), tableaux on hinges that can be unfolded: a little man standing in front of a hole in the earth in a desolate, moon-lit landscape with shadows on the ground. The intensity of this painting is largely achieved by the way in which the pieces are combined: "the individual pieces are not pictures, they are the machinery of which to make pictures – a picture organ." Tension arises when the spectator constantly experiences a symbolic function in the isolated elements, a function that at the same time feels very strong and yet is illusive, uncertain, ambiguous. The spectator gazes into a strange theatre-machinery in which everything seems familiar but all the functions are put out of action. The scenery (a broken gate on hinges) is suspended in a vacuum like the figures in *The Planetarium*. Reality is shattered, reduced to fragments. All the same, it does not feel right to interpret the picture as an apocalyptic bogey-picture. *The Cold War* is also a world in itself, a work of art with its own laws and rules of play, that first and foremost function within the work of art (as a political analysis *The Cold War* is all too vague to be able to function as a concrete model). The pieces on a chess-board can also seem to lack connection with each other to the uninitiated, but he who has penetrated the secrets of the game sees invisible links between the pieces. The same invisible "electric arc" unites the elements in *The Cold War* into a coherent vision, perhaps frightening and mysterious, but also filled with poetry and a strange combination of warmth and coldness, humour and melancholy.

For me, *The Cold War* is one of the most important works in Fahlström's production. Other game-paintings – *Young Dr. Benway, Sylvie, Eddy* (Sylvie's brother) *in the Desert* are a further development along this line, but perhaps they lack the visual striking-power and the complicated structure and pattern of relations of *The Cold War.*

A development of the game technique, yet another step away from art, nearer to life, can already be discerned in Fahlström's production. In *Dr. Schweitzer's Last Mission* (which is not yet completed) the pieces are enlarged (the largest piece is a six-metre-long puppet representing a Swedish film star) and the work will be an exhibition in itself, will fill a whole gallery. Fahlström has published a "check-list" to go with this painting in the

form of a game in which four players represent the USA, Soviet Russia, the neutral states and China. *Dr. Schweitzer's Last Mission* is without doubt Fahlström's biggest undertaking so far, a "word picture" that, with its intellectual and artistically creative intentions, puts most contemporary painting in the shade.

That Öyvind Fahlström has not been recognized earlier is perhaps due to the fact that we find it more difficult to accept an artist who does not keep to his own genre – who is at one and the same time dramatist, poet, philosopher and pictorial artist – than we do to accept an artist who is only concerned with problems connected with painting. But just this crossing of the boundaries, this nullifying of traditional genres, is one of the most important things an artist can do today, when a constantly increasing specialization threatens definitely and irretrievably to isolate art from the community. Öyvind Fahlström's paintings can help to break this isolation. What he has to say concerns us all because his art is not specialized, nor is it "art for art's sake," nor does it aim to please. His paintings are rather commentaries on life than "art" and it is for just this reason that they have an effect.

THE HORIZONS OF ROBERT INDIANA

G. R. Swenson

Robert Indiana's paintings have something of the plains in them, the country with its flat speech, matter-of-fact and sure; and there is something of the edge of the city, warehouses and artists' lofts, proximity to the center of the world's activities; and a touch of the sea.

The painter is a little like that himself. He doesn't say much, and usually doesn't discuss himself. If asked, "How are you?" he is likely to answer, "I'm finishing the edges of the words in *American Dream Number 6*." His art is his subject, and talking with him at times is like sitting on the courthouse steps talking about the weather – as casual as life and death. He comes from the country and until recently has lived in the city at the edge of the sea.

As much American literature testifies, the land can be trusted, but nature is different. She is both a physical and a spiritual threat. The pioneer struggle was against her. "Eat" was the beckoning signpost on the frontier, the promise of the land; "die" was the concomitant threat of nature. Even in the romances of Willa Cather the threat of both physical and spiritual death hangs over the landscape.

These dangers are perhaps not so much found in Robert Indiana's paintings as remembered – "presences." The American plains and its settlers are unique; and art inevitably displays the by-products of place. In these paintings one finds not the immediate physical threat which the pioneers faced, but people (some of whom remember), the look of houses isolated against the sky, the country with its solid fields of color and open spaces. They have modified and expanded Indiana's esthetic outlook. To a Midwesterner it is important that there will be throughout his life "a plain so wide that the rim of the

Art News, May 1966: 48–49 ff.

heavens cut down on it around the entire horizon." (Ole Rolvaag's *Giants in the Earth.*)

Indiana's "Confederacy" paintings – Alabama, Mississippi and Louisiana are finished and included in his current one-man show [Stable Gallery, New York; May 3-28] – are not echoes of those places, but they are moral cries of an American against the dangers of unrecognized narrowness and willful refusal to change. The words ("Just as in the anatomy of man, every nation must have its hind part") are not demagogical, but in the spirit of America's fathers; Indiana finds an analogy between the state and the individual (the words are Indiana's own, not a quotation), and he recognizes the vulnerability and weakness of the individual human being. The stars, from the design of the Confederate flag, are like a stain; the central star in these three paintings falls on, respectively, Selma, Philadelphia and Bogalusa.

The "political" paintings tend more to seek goodness and personal reform than to seek power and group effectiveness. His series of *YIELD* paintings (the first was given to Bertrand Russell's peace foundation, another to CORE) have such a theme. "A Divorced Man Has Never Been President" is a lament (it refers as much to Rockefeller as to Stevenson). In his *American Dream* paintings, ERR has an equal place with EAT and DIE.

The exhortations from Melville and Whitman which appear in Indiana's paintings do not urge us to seek the White Whale or the Open Road. The new frontier is no longer a beckoning danger out there, but beside us here, even in the city. Indiana frequently uses symbols of commerce and road designs, the compass-rose shape in *Year of Meteors,* cartographic descriptions of the places named in the *Melville Triptych;* but Indiana refers to Whitman's sight of the ship, *The Great Eastern,* on the same bay he saw for many years out a hole in the east wall of his studio, and he takes from *Moby Dick* a few phrases about the then bustling area where he lived – Whitehall, Corlears Hook, Coenties Slip. (Recently his building was demolished.)

Nevertheless Indiana's romance does urge us to that part which is still important in Melville's sea voyage and Whitman's open road. In the first chapter of *Moby Dick,* Ishmael says, "But that same image, we ourselves see in all rivers and oceans. It is the image of the ungraspable phantom of life; and this is the key to it all." *The Great Eastern* swam up the bay in the Year of Meteors; in his painting Indiana makes Whitman's words ring out: "Nor forget I to sing of the wonder."

Robert Indiana was born in New Castle in the state which he chose as his name. He spent his first four years after the army in Chicago. There, he says, he got a sense of an urban life more peculiarly American than New York's. Chicago, like Kansas City and Denver and Los Angeles, does not keep its processes hidden; in full view there are stockyards and railroad tracks and even at that time an airport, in the middle of the city. Only in New York would a stranger have to ask how you find a filling station.

He spent his last year at school in Scotland (the last year before he came to New York), in Edinburgh, one of the darkest cities in the northern hemisphere, the city of black buildings and overcast, darkened skies, the home of great empiricists. "My first year in New York (1956-57) was just floundering, trying to find myself, until I came to the Slip. Then it was a matter of settling into essentially what I am."

His loft, in that fringe of derelict warehouses on Coenties Slip, overlooked the sycamores and ginkgoes of the small park called Jeannette.

There were words painted over the building in which he lived and its neighbors, on their flat sides and in the spaces between the windows in front as well. In the room that became his studio he found a circular copper stencil of The American Hay Company; and, to paraphrase William Carlos Williams, he saw the word in gold.

A chief characteristic of Robert Indiana's painting is words. In 1960 and 1961 many of us had begun to think everything but abstraction was an aberration. But on Coenties Slip, where one also found Ellsworth Kelly, Jack Youngerman, Ann Wilson and James Rosenquist, something new was happening. Dick Smith, Agnes Martin, Robert Rauschenberg and Jasper Johns, among others, lived nearby. Except for the last two, it was a little known and diverse colony of painters.

It was soon dispersed, however. In 1962 a "movement" was suddenly discovered. Galleries and publicists – hostile but opportunistic young critics, indifferent reporters for big-audience mediums, sympathetic but near-sighted curators – all found aspects of what had happened with quiet daring on the Slip useful. The good gray deans of Abstract-Expressionism found themselves threatened, or at least unconsulted. (According to their version, the new art had practically been invented by publicists and galleries.)

The simple fact of words in a painting – but not their meaning – took on an exaggerated importance. Called Pop Art and New Super-Realism and Sign Painting, it used aspects of the world of advertising and road signs and of the American Dream; therefore, both its friends and enemies mistakenly concluded, it must be about vulgarity and immorality. Indiana's "American Dream" series of paintings (with TILT and JILT, JUKE and JACK, EAT and DIE written over them) have a different, more subtle and larger intent. That intent was obscured by impatient observers at the time, in part by the simple fact of words. The content of the words was ignored in favor of analyzing their formal use in the composition.

Some, indeed many, of the words he uses come from Melville and Whitman, Hart Crane and Longfellow. After their facts as words, the next most important thing about them at the time seemed to be that they are American words. Yet somehow that adjective "American" still carried for many critics, pro and con, those defensive overtones which so corrupted the criticism of the '50s. Paris was constantly contrasted with New York during those years, unfavorably and gratuitously; New York critics often rather pointlessly (at least so far as the painting was concerned) beat the drum for abstract internationalism, sometimes against the Surrealists, even more against American "provincial" art (as if it were a threat).

An artist can worry about being provincial (it is said that Arshile Gorky did), but neither worldliness nor provinciality is a necessary partner to the great or the good in art. In the case of some artists – Indiana is one – these two elements can exist together, in a strange and moody tension. Paris is no longer a threat in the '60s, it's as simple as that; younger "native Americans" are more sure of themselves.

Midwesterners have to deal with boredom, monotony, simplicity – call it what you will. Day after day on the plains a man is faced with the same landscape, the same flatness, the same sky; yet one thing that can deeply puzzle him is if the light and atmosphere and temperature and season and colors seem for a moment exactly the same as at another time. The sameness has an almost kaleidoscopic effect for someone sensitive to its nuances; it is far removed from the exalted "Zen" boredom (often boredom for its own sake) of some of the new art.

Indiana did the number 6 first in a series of numbers painted early in 1965 (they were recently shown in Germany on a tour of four European museums). When he did the number 5 there was no question that it would be different from Demuth's *I Saw the Figure 5 in Gold,* which Indiana had previously quoted.

Jasper Johns also did a number 5. In a time when "influence" unfortunately (and often inaccurately) means "derivative," it is difficult to relate the words, numbers or circles

of Indiana to Johns objectively, without seeming to lessen the stature of one or the other. The artist himself initially resisted using words because he was aware of this prejudice. His intention as a whole, however, is removed from the sensitively and subjectively formalistic esthetic of Johns; the "influence," where it exists, is that peculiar modern variety, perhaps better called "creative misunderstanding."

Numbers need not threaten men any more than nature has threatened men in the past. Indiana entwines between the staples of art – lyricism, form and color, a new beauty – lessons of life and persistently fresh worlds. We live surrounded by a luxuriant growth of numbers. Numbers proliferate. From time to time a postal zone improvement plan or all-digit dialing will seem to strangle us in an undergrowth of numbers, and some of us will hack away against it. But more and more this growth becomes the natural state of man.

Robert Indiana's series of number paintings are about things that surround us and galvanize us. Numbers have been a subordinate element in his work from the first version of *Marine Works* (1960) through his several celebrations of Demuth's *Figure 5* up to the sixth *American Dream* (finished as this article goes to print). At the time he started the *Dream*, in the winter of 1964-5, he seemed stymied, whereupon he decided simply to paint the number 6 – not as a comment (as the number was in his earlier series of polygons) but a "6" in colors, in one of its infinite shapes, alone.

The shapes he has chosen, like the stencil shapes in his other works, are not the most elegant in the world. Indiana's paintings certainly have an erectness, a stateliness, a deliberate quality not unlike Midwestern pride and Jeffersonian morality; but part of their stateliness is their plain honesty, inelegant in parts, perhaps even vulgar, and straight as a shot.

His is not a vulgarity of the city. (Often exponents of the new art seem to think mere vulgarity is a positive virtue, and then proceed to find it even where it does not exist, in Rosenquist and Wesselmann, for example.) But there is also the city in these paintings, sometimes as obvious as it is in *The American Gasworks,* and sometimes as curiously compromised as the city is in the Brooklyn Bridge paintings.

Early in 1964 Robert Indiana began to paint a double portrait of "mother" and "father" which, he says, are still incomplete. They are strange, compulsive, mythic, the only true "images" which have occurred in his painting. Everything else is a sign, like numbers, complete in itself although it may also refer to something else. Indeed, a "presence" always seems to stand near his paintings, modifying and enlarging the sense of sight, an "ungraspable phantom."

The Jeffersonian farmer has disappeared from American life. Men no longer grow stern and moral in struggle and contact with the land, or, rather, nature. The city provides the farmer with machines and subsidies. (The rural vote, in a sense, was lost before the court took it away.) Robert Indiana has been uprooted from the country; he has been transplanted, but his recognition of the ways of nature has not been lost. Nature has changed her face, but in the struggle with her, men still become moral.

FOREWORD

Jan van der Marck

Direct as a road marker, "hip" as a folk song, flat as a corn field and colorful as a county fair, Robert Indiana's emblematic paintings, for all their detached elegance of execution, express a vigilant concern with what unites and separates Americans today. The artist is compassionately involved with the plight of the defenseless individual in a pluralistic society and with the survival of this society in a disaster-bound world. He speaks in a language borrowed, almost tongue-in-cheek, from our contemporary communications network. This is the "Pop" aspect of Indiana's work. Its equally intentional autobiographic tinge facilitates our "reading" it in "Pop" terms. Beyond that, we should consider its formal honesty, bold but balanced use of color and flawless surface. In the artist's opinion this technical perfection, however basic and important, remains meaningless unless it buttresses an imagery that has symbolic significance on more than one level.

The X-shaped *USA 666* in this exhibition is the "danger colors" black and yellow variant of the *Sixth American Dream.* The latter painting is also called the *Indianapolis Dream* and the artist likes to refer to it as his father's dream, for his father, who was born in Indianapolis, died at the time the painting reached its completion. The color pattern is derived, as Indiana explains, from the red and green of the original Phillips 66 sign against the blue of the Indianapolis sky. This company emblem that preceded the present one was the one dominant sign of Indiana's youth with, perhaps, the EAT sign of his mother's restaurant as a second. His father, as an employee of Phillips 66, wore a miniature version of the company emblem in his lapel. While commemorating the year his father did not live to see, the *Sixth American Dream,* on another level, refers to U.S. route #66, much travelled by the artist during his days in the Air Force. [Editor's note: Indiana was, in fact, in the Army Air Corps.]

The theme of racial injustice, first hinted at in *Rebecca* (American Slave Company) of 1962, was brought into focus in the 1963 *Yield Brother* (one version the artist presented to the Bertrand Russell Peace Foundation, another to CORE) and since 1964 given a serial treatment in the "Confederacy" paintings, *Mississippi, Alabama, Louisiana* and *Florida.* The first three are painted in an "integrated" color sequence, ranging from black to brown to tan; in the last one Indiana uses his *Sixth American Dream* colors – red, blue and green. Their legend ("just as in the anatomy of man, every nation must have its hind part") has the spirited ring of Jeffersonian practicality. In it Indiana registers a Yankee protest against the dangers of bigotry and prejudice slanted toward an understanding of the incorrigibility of human nature.

Love is as dominant a theme in Indiana's philosophy as it is in his 1965-66 production, wherein he treats it as a four letter word, split in two with the VE forming the base and the L and tumbling O on the top, one variation of which became a Museum of Modern Art Christmas card. Since that time the instantly successful image, with its eye-catching colors derived from the *Sixth American Dream,* has been used straight, inversed, reflected and reversed as though Indiana wanted to develop symbolic parallels to love given and love withheld, the illusion and the delusion of love.

The lettering in *LOVE,* not a component but the very subject of the printing, is more

Exhibition catalogue, *Robert Indiana*, Dayton's Gallery, Minneapolis, September 1966

complex and coherent than in any of Indiana's works so far. In the earlier compositions letters were arranged in simple linear or circular formation, never touching one another, or merging into one "Gestalt." The degree to which the total configuration is perceived as solid rather than flat form – and therefore, quite naturally, could develop into sculpture – is proportional to its asymmetry, e.g. different sizes of angle, different length of line and different thickness of shape. Here the flatness of Indiana's painting has given way to an illusory depth dimension, based not on perspective but on color contrast and on optical reversibility of image and ground. The high-keyed and close-valued red, blue and green force the eye to shift for comfort from positive to negative and from actual to complementary form calling attention to the latter's cigar, clamp and arrowhead shapes. Thus, as no doubt will please Indiana, the elusiveness of love carries from idea to form and vice versa.

Numbers are an important part of Indiana's recent production – the "Cardinal" numbers from 1 through 9, plus the zero, and the "exploding" numbers in which size is stepped up in a regular progression. Their broad, over-blown shapes do not conform to the modish standards of contemporary design and are curiously reminiscent of those old-fashioned but eminently readable general store and government office calendars. The use of numbers in Indiana's work goes back to the 1960 marine assemblages. They were a happy accident; he found a stack of used copper stencils when he moved into his loft on Coenties Slip. Numbers became compositional rather than incidental and Indiana relied on them more and more for form and subject-matter. This may explain why the artist, concurrent with and in the margin of his larger and more important compositions, would treat numbers as stylistic exercises. Once these numbers are freed from their context and role to inform, they revert back to their previous "found object" state. A subject-matter that can be instantly recognized and readily accepted, it allows the artist to concentrate on color and form. In his "cardinal" numbers Indiana introduces an intentional ambiguity based on the principle of redundancy, by identifying each number with its letter equivalent.

With today's proliferation of numbers – on calendars, time tables, clocks, meters, dials, and road signs, to mention just a few – our senses have become so numbed that it takes a strong number-turned-image to hold the viewer's attention. It is a measure of Indiana's effectiveness that he enables us to abstract from the obvious and to concentrate on formal intentions. By exploiting the interdependency of form and color and of positive and negative volume in both his "love" and "number" paintings, Indiana convincingly restates a never flagging interest in the premise of hard-edge painting.

IN THE GALLERIES: MEL RAMOS

Jay Jacobs

Mr. Ramos giveth and Mr. Ramos taketh away. He presents us with a bevy of luscious broads, starkers all, whose denture-like artificiality becomes apparent even as we begin to salivate. Flushes of metallic nail-polish colors suffuse the turns from *chiaro* to *scuro,* while an icy blue line with hockey-rink overtones delineates the ins and outs of the female form divoon. Mr. Ramos' dimpled nudes, nobly-nippled and hard as nails, burst forth from candy wrappers, cuddle up to ketchup bottles, perch upon burgers and wedges of Gruyère and emerge uncontaminated from oil cans, their neon-bright boobs flashing "Come hither, drop dead, come hither, drop dead." And if their message and indictment is, at this late date, somewhat platitudinous, they are executed with considerable elegance – an elegance that is lost, unfortunately, in black and white reproduction. Mr. Ramos does not paint ketchup bottles very well, but, after all, who does?

THE ART OF MEL RAMOS

Robin Skelton

Much so-called "Pop Art," while using the pictorial vocabulary of advertisements, newspapers, pin-ups, and street signs, does not do much more than enlarge and reproduce familiar images. Tom Wesselmann's American Nudes are "blow-ups" of pictorial cliches. Allen Jones produces variations upon the leg-magazine cartoon. Andy Warhol's early work involved gigantic Campbell's Soup tins and reproductions of newspics, and Roy Lichtenstein gained a measure of notoriety by his enlargements of comic-book heroines. John Wesley has ventured closer to surrealism, and further away from dadaism with his juxtapositions of rhinoceri and bathing belles, and with his use of Gauginesque females placed in a context of decorative symbols. His *Bird Lady,* for example, shows one of these girls together with a bird in whose beak is an egg, the upper margin of the print being decorated with a frieze of down-hanging birds' heads. Others, like Allan D'Arcangelo and James Rosenquist use familiar forms of highways and industrial machinery to create beautifully modulated near-abstract compositions. Gerald Laing's work only alludes in general terms to "Pop" imagery, though its colouring is usually what we associate with the vivid commercial hoarding rather than with the more muted tones of other realities.

Mel Ramos is unlike many of these artists in that his work is almost always based upon a carefully controlled dialogue of forms, and is presented with a subtle awareness of textures that reminds one more of the brushwork of Dali or Tanguy than of the photo-

Arts, January 1966: 56
The Malahat Review, October 1969: 60–67

EDWARD RUSCHA, FERUS GALLERY

Nancy Marmer

There is a remarkable tension about this show. No room here for amateurs; sybarites keep out. These are coldly brilliant canvases whose perfection of technique proclaims a hermetic self-sufficiency, an almost depersonalized aloofness. The tension comes in at that "almost." Personality, not through painterly gesture or expressionistic distortion, asserts itself in the surreal clamps and torn western magazine that Ruscha aggressively and ironically adds to his obsessive order, intrudes via the defascinated, the unconnected, the literally conceived object.

The paintings divide into two groups. First, and most impressive, are the two large landscapes which mythologize the heart of peregrinating America – the filling station. "Standard Station, 10¢ Western Being Torn in Half" presents a surgically sterile image in red, white, and vivid light blue. The vacant station is painted as a lunar architect's plan might be, using hard edged forms, clean lines, sharply delineated perspectives into airless flat space, and brilliantly stifling color. In the upper right hand corner is a torn western magazine, illusionistically portrayed so as to seem attached to, rather than painted on, the canvas. The placement is surrealistic, the notion poetic; but the ontological gap between magazine and painting is finally impossible to bridge. "Standard Station, Amarillo, Texas" has no such literary devices; the colors, red, white and dark blue, are perhaps less satisfying in their heavy-handed reliance on value contrasts for dramatic effect, but the total image is nevertheless austerely compelling.

The second group contains four small paintings more nearly surreal in their mood, sign paintings. Two, appropriately in this highly professional context, announce the word "BOSS" in orange letters on a dark blue ground. In one, titled "Securing The Last Letter," the clamp which wrenches the final "S" out of shape is a fink. In the second, "Not Only Securing The Last Letter But Damaging It As Well," the "S" is distorted by two clamps, whose hostile intent is no longer a secret. "Hurting The Word Radio #1" and "#2" are variations on the same theme; the yellow letters of the word "RADIO" are now set apart from an electrically light blue ground by the shadows they cast, and once again single letters fall victim to the minatory clamps. The effect of all this clutching is not significantly different from that of the superimposed magazine. The distorted letters, rubbery and agonized, are in direct conflict with the icy formality of stencilled sign on flat ground; they signal impurity in an ambience of mechanical formal means and suggest artistic anxieties about the hegemony of technique. (One thinks of Leger, who said, "Technique must be more and more exact, the execution must be perfect . . . I prefer a mediocre painting perfectly executed to a picture, beautiful in intention, but not executed. Nowadays a work of art must bear comparison with any manufactured object. Only the picture which is an object can sustain that comparison and challenge time.") That an intrusion of some sort, however, seems necessary to Ruscha's oeuvre at this time is proven by the poverty of "Dimple," a sign that just lies there.

In short, if some of Ruscha's paintings are unresolved, the best convey the possibility of an iconographic power of a high order.

Artforum, December 1964: 12

mind, a restraint and a discipline, that more than counters this. When can we discard the erotic as "pornographic"? My own answer is that the erotic becomes pornographic when there is not the slightest doubt that the sole intention and effect of the piece is sexual stimulation and titillation. Whether or not the pornographic, thus defined, should be condemned, is another matter entirely. It is hard for me, personally, to believe that it is more vicious to excite sexual passions than it is to excite passions of hatred and bigotry. It is far better, as the button tells us, to make love than to make war.

Censorship is, therefore, if only by the way, another implied theme of these new works, as it is the theme of any work dealing with subject matter that many people find offensive. The drawings are, from one point of view, a bait for bigots. From another point of view, however, they are archetypal, showing us a commerce between the animal appetite and the idealizing imagination, admiring both and seeing them in relationship of mutual, even symbiotic dependence. Can we, perhaps, envisage from these drawings, a world in which people have come completely to terms with their instincts and appetites and can exist in mutual affection? Can we envisage an Eden where, as the lion may lie down with the lamb, so the woman may lie down with the beast that, in another world, she might well choose to have hunted for her food or shot for her protection?

The world of Mel Ramos's work is much more than a distorted reflection of the popular images of our culture. It is not social comment in the way that Warhol's soup cans and newspics are social comment. It is not the simple recognition of popular mythology as are the comic-book blow-ups of Lichtenstein. It is a world of clear vision, clear questioning, and moral candour. That the drawings and paintings themselves are beautifully made and superbly composed is almost too evident to require comment. That they are, however, intellectually as well as visually pleasing, does require some argument, for Ramos has chosen, with wit and with cunning, to present his dialogues to us in such a way as to both imitate and undermine the hedonistic fantasies of our culture.

When Ramos moved on from his "Hamburger Bun" period, he did not change his basic strategy, but he did change his symbolism. The new paintings and drawings of 1967-68 present a different dialogue. Now, instead of consumer goods, the Ramos nude confronts and is confronted by animals. In some cases the girl dominates the animal. She straddles the walrus and the zebra, for example. In others, however, she is possessed by the animals, and, while retaining her poise, is involved in sexual acts with them. She lies back, her legs elegantly afloat in air, experiencing the oral ministrations of the leopard; she reclines at ease, the nose of the deer in her groin. Or she is being straightforwardly embraced by an ape or a panda.

The drawings of these events are as meticulously crafted as ever. Indeed, the delicacy and sharpness of the pencil lines is such as to remind one of the most meticulous drawings of the past. Of recent artists only the engraver, Stephen Gooden, comes to my mind as having the same extraordinarily precise control of the smallest hairline. Several of these drawings have already led to paintings in which the girl and beast are placed against a flat decorative background that adds to the impression of other-worldliness which the encounter itself provides. Moreover, the detailed handling of the animals is now so impressive as to add to the hallucinatory intensity of the whole. The walrus displays his every wrinkle, and the ape his every hair.

This new set of dialogues differs from the earlier in that the beast-image is, itself, as archetypal as that of the naked goddess. The activities of Zeus in his various disguises must be remembered, and the story of Beauty and the Beast has many versions before Perrault. To suggest an interpretation of this new series of symbols would involve us in a good deal of complexity. It is, however, worth noting that Ramos is not alone in his use of animal imagery these days. Graham Sutherland's most recent exhibition was entitled a "bestiary." I commented in the last issue of this review upon the animal imagery of Jack Coughlin. Poets are also turning their attention to the symbolic possibilities of animals. Sometimes, as in Robert Lowell's *Skunk Hour,* the animals are only briefly alluded to, though central to the poem. Sometimes, as in several poems in Ted Hughes's recent collection *Wodwo,* the animals are the main subject and appear to dominate mankind. It is interesting to note that Hughes, in a recent issue of *The Listener,* published three poems under the general heading *Crow Lore* in which he made use of the animal fable, and that of recent years the increased interest in folklore has resulted in the publication of many animal fables from the native folklore of Africa and North America.

This may seem a digression, but it is my conviction that, although Ramos may appear to have diverged from true "Pop," by using imagery which is no longer immediately recognizable as related to that of the magazines and hoardings, he has, in fact, now latched on to equally pervasive imagery, though not equally brash. One must remember that our television screen, the image-maker for so much of our culture, is not exactly averse to using animal themes. After *Lassie,* and *Gentle Ben,* we can turn not only to *Daktari,* but to *Cowboy in Africa,* which, in effect, fuses the safari-myth with the western-myth, and thus provides a popular parallel to Ramos's fusion of the Vargas world with that of the forest and jungle.

The beast-woman conjunction is, however, just as ambiguous as the earlier juxtapositions. These erotic subjects are handled with so delicate and ironic a control that they are about as pornographic as an Elgin marble; therefore we find ourselves noting yet again a "dialogue" not only between the related forms, but between the imagery and its handling. The imagery may suggest a gross lasciviousness only appropriate to the pages of Krafft-Ebbing or "hardcore" pornography; the artistry, however, indicates a delicacy of

graphic screens of advertisements. He deals in total clarity. Every element is in sharp focus, and thus he suggests a supernormal precision of vision, and a hallucinatory intensity of regard. His nudes are posed with the elegance and nonchalance of a Vargas drawing in *Playboy,* and, while there is no verbal accompaniment to underline the ideal (and, in one sense of the term, idyllic) sexual candour of the display, the textures used are themselves so decorously smooth and the limbs so pristine, that one is immediately aware that one is surveying the houri of fantasy, the perpetual virgin of the Mohammedan Paradise, the contemporary emanation of Paphian Aphrodite, rather than the girl next door.

This image is, in most of Mel Ramos's work, placed in close juxtaposition with another which is handled with precisely the same clarity and elegance, and given the same pristine appearance. In the work which first brought Ramos international recognition this second image was most usually one from the world of consumer goods. The girl would appear emerging, not, like Aphrodite, from the foam, but from a pack of cigarettes or a container of candy. She would be poised, not upon the cushions of oriental fantasy, but upon a hamburger bun or the cap of a Coca-Cola bottle. At first sight these pictures simply suggest a sardonic reference to the decadence of goddess-worship in our times. We no longer think of our ideal woman in a context of eternity, but in a context of perishable appetites. We no longer associate her with the archetypal images of heroic poetry, but with the ephemeral glorifications and hyperboles of the ad-man.

Such an interpretation would, however, be far too much of a simplification. The two images are given precisely the same amount of loving attention; their appearance emphasizes the vast amount of laborious care that has been lavished upon them. If there is here a dialogue between the "Sacred and the Profane" as Ramos himself has suggested, it is left to the spectator to decide which is which. Are we to gather that the "sacred" goddess of love, inspiration, beauty, and ideal sexuality is to be found, nowadays, in decadent agreement with the profane materialism of commercially exploited appetites? Are we to think that the toothpaste tube or the Cola bottle are, equally with the goddess, objects of our desire and reverence? Are we, indeed, required to see this juxtaposition as an act of social criticism, or as an act of life-acceptance? Is it not, perhaps, true that the ideal cigarette packet is as much an aesthetic achievement as ideal human beauty? If we delight in our appetites, should we not find the candy bar as admirable as Candy? If we answer "yes" to this question we are, of course, immediately faced with discussing whether or not there can be (outside that Mohammedan Paradise or the spaces between the lines in *Playboy*) purely sexual satisfaction without the smallest admixture of other emotional experiences, and without any awareness of the richness and complexity of the human personality.

These questions do clearly arise both from Mel Ramos's paintings and from any survey of television commercials, glamour magazines, and Hollywood charm schools. Ramos would earn our gratitude for posing these questions for us so delicately and wittily, had he done nothing else at all. Ramos, however, has chosen to bring the question of scale into his dialogue also. Looking at the girl on the Coca-Cola bottle-cap, are we to think the cap to be gigantic or the girl minute? It is interesting to note that most observers assume the cap to be large; they have been conditioned to do so by the human habit of judging scale entirely in human terms, and by many gigantic images upon hoardings. Nevertheless, if we are here in a world of ideal fantasy, we must remember that in Alice-land there are two sides to the mushroom. Is the tube of toothpaste five foot three, or is the girl eleven inches tall? Has humanity dwindled, or have the new gods of Hamburger, Detergent, and King-Size Cigarette simply grown to dominate the old anthropomorphic deities?

For those impure and tentacular minds of this day, all the extra-esthetic resemblances perceived in the canvases of Pollock, draw together into paintings very much about those appearances of nature modern artists professed to ignore. Far from having a life of their own, they also refer us to Pollock the man, you, me, America and life in general.

Abstract-Expressionism "had" to come to something like "New Realism"; it "had" to arouse a preoccupation with literal things, if for no other reason than to keep the potential need for abstraction alive. Taking place in the circles of advanced art, the change was at once a hidden form of respect for the immediate past, as much as the form of the reaction was unpredictable. Realism at present is not very much like the Realisms of before.

George Segal's "presences" (I do not know whether I should call his assemblings of plaster people and real objects "sculptures" or "environments") emerge precisely when Abstract-Expressionism has lost the sharp focus of its issues. Their somber and massive corporeality affects us doubly because they confront us against an artistic background of violent gestures and intangible veils of colored light. Directly, they cause us to question once again the nature of art (is it an abstraction or a resemblance?) and, since these figures with their ready-mades are impressions or objects taken from life, they force us to ask further whether life is more real than art.

The answer to this is by no means clear. Leaving aside for the moment the ready-mades, Segal's figures are direct molds from people he knows. We are reminded of the scandal of Rodin's *Age of Bronze,* which was accused of being nothing more than a cast, though apparently it was not. At the same time there is the great interest artists have shown in the casts of suffocated Pompeians whose forms were preserved by the volcanic ash of Vesuvius. On the one hand a man is denounced because his work seems too true to life, as if he tampered with the exclusive rights of God; and on the other, an act of God is praised because it feels like a work of art. This is not simply an esthetic dilemma. It is a metaphysical irony.

But perhaps the irony is beginning to evaporate. It is a fact that there are many professional artists (including this writer) who respond as powerfully to some aspect of nature or civilization outside of a literal art product (a craggy landscape, or an iron foundry in full blast, for instance) as they do to an acknowledged masterpiece in a museum. The assumed difference between emotion and esthetic emotion seems impossible to determine and tiresomely academic. A remark like, "the New Jersey Turnpike, as it passes through the industrial complex around Newark, is better than art," is frequent among some of us, and it is not at all cynical. One is not faced here with a rejection of art, but with an amplification of its domain and a blurring of its limits, because, far from stopping at that point, these artists go on to *make works of their own.*

Segal is not simply pointing to an impressive scene nor is he cutting out a slice of life. If anything is obvious in what he does, it is the sense of its having been fashioned by selectivity and thought. Still, his work occupies that borderline area so compelling to younger artists today, between what we have called fine art and what we have been sure was, at the very best, only material for fine art. His groups recall the mood of the Old Kingdom Egyptian statuary and the detached grandeur of fifteenth-century Italian portraiture, as much as they juxtapose to this faint hint of art history a means and appearance that is patently untraditional and "true to life."

Whatever we wish to name his activity, Segal's results impress with their high seriousness. It is clear, too, that for all their closeness to the actual, they are also removed, cut off from life, with a sad and sometimes terrifying ominousness. Even the ready-mades which accompany the figures have this quality of presentiment, not felt before in their

No, what I am after is a kind of polish. Once I have decided all the detail – photos, lay-out, etc. – what I really want is a professional polish, a clearcut machine finish. This book is printed by the best book printer west of New York. Look how well made and crisp it is. I am not trying to create a precious limited edition book, but a mass-produced product of high order. All my books are identical. They have none of the nuances of the hand-made and crafted limited edition book. It is almost worth the money to have the thrill of seeing 400 exactly identical books stacked in front of you.

SEGAL'S VITAL MUMMIES

Allan Kaprow

A new attack on the line that divides art from life is launched by this artist who makes plaster replicas of his friends.

George Segal, native New Yorker, lives in South Brunswick, N.J., where he farmed and then taught high school. He is 38 years old, married, has two children. He holds a B.S. de-gree from N.Y.U. and an M.A. from Rutgers. Since 1955, he has shown regularly at the Hansa Gallery, until its demise, and thereafter at the Green Gallery. In this circle of Hans Hofmann alumni, he became familiar with that great teacher's principles, and Segal's in-novations must be credited in part to their liberating effects. In 1962, he was included in the U.S. participation at the São Paulo biennial. He shows this month at Green and, later, at Sonnabend, Paris.

Modern art has come to mean a variety of painting and sculpture radically dissociated from natural appearance and, therefore, from common thought and feeling. In certain extreme examples of abstraction, art and what we usually take for life seem to be ab-solutely and finally separated. Indeed, because of these examples, which by their high quality have influenced our thinking in general, the definition of art might be: that which appears like nothing else except art.

But if Jackson Pollock wanted his paintings of the over-all period to have "a life of their own," it soon was apparent that they also reminded us of microscopic blowups of living tissue, macrocosms photographed through telescopes and the very commonplace textures of rocks and tangles of bramble bushes we have always had around us.

It is possible, even allowing for social and political influences, to suppose that at rela-tively unstable moments such as ours, when the best art has been consistently non-natu-ralistic and professionally exclusive (at least on the surface), a stage will be reached where an inevitable reversal will take place and the extremity of the initial position taken will precipitate a new form of that which was rejected. The idea proposes a design in the change, a sense of complementariness in all activity which gives to it a necessary rhythm and pulse. Thus, a sensation of red produces an after-image of green; angels rejoice when a sinner is received into heaven; the son who hates his father most violently, acknowl-edges him by relating every act to the elder man; clowns know that vulgarity pushed far enough can become eloquence; tragedy at its most unbearable becomes tragi-comedy.

Art News, February 1964: 30–33

books. I was testing – at that time – that each copy a person might buy would have an individual place in the edition. I don't want that now.

To come back to the photos – you deliberately chose each subject and specially photographed them?

Yes, the whole thing was contrived.

To what end? Why fires and why the last shot, of milk?

My painting of a gas station with a magazine has a similar idea. The magazine is irrelevant, tacked onto the end of it. In a like manner, milk seemed to make the book more interesting and gave it cohesion.

Was it necessary for you, personally, to take the photographs?

No, anyone could. In fact, one of them was taken by someone else. I went to a stock photograph place and looked for pictures of fires, there were none. It is not important who took the photos, it is a matter of convenience, purely.

What about the layout?

That is important, the pictures have to be in the correct sequence, one without a mood taking over.

This one – I don't quite know what it is – some kind of fire, looks rather arty.

Only because it is a kind of subject matter that is not immediately recognizable.

Do you expect people to buy the book, or did you make it just for the pleasure?

There is a very thin line as to whether this book is worthless or has any value – to most people it is probably worthless. Reactions are very varied; for example, some people are outraged. I showed the first book to a gasoline station attendant. He was amused. Some think it is great, others are at a loss.

What kind of people say it is great – those familiar with modern art?

No, not at all. Many people buy the books because they are curiosities. For example, one girl bought three copies, one for each of her boy friends. She said it would be a great gift for them, since they had everything already.

Do you think your books are better made than most books that are marketed today?

There are not many books that would fit into this style of production. Considered as a pocket book, it is definitely better than most. My books are as perfectly made as possible.

Would you regard the book as an exercise in the exploration of the possibilities of technical production?

No. I use standard and well-known processes; it can be done quite easily, there is no difficulty. But as a normal, commercial project most people couldn't afford to print books like this. It is purely a question of cost.

Do you know a book called "Nonverbal Communication" by Ruesch and Kees?

Yes, it is a good book, but it has a text that explains the pictures. It has something to say on a rational level that my books evade. The material is not collated with the same intent at all. Of course, the photographs used are not art photographs, but it is for people who want to know about the psychology of pictures or images. This ("Various Small Fires") IS the psychology of pictures. Although we both use the same kind of snapshots, they are put to different use. "Nonverbal Communication" has a functional purpose, it is a book to learn things from – you don't necessarily learn anything from my books. The pictures in that book are only an aid to verbal content. That is why I have eliminated all text from my books – I want absolutely neutral material. My pictures are not that interesting, nor the subject matter. They are simply a collection of "facts"; my book is more like a collection of "readymades."

You are interested in some notion of the readymade?

CONCERNING "VARIOUS SMALL FIRES":
EDWARD RUSCHA DISCUSSES HIS PERPLEXING PUBLICATIONS

John Coplans

This is the second book of this character you have published?
Yes, the first, in 1962, was "Twenty-Six Gasoline Stations."
What is your purpose in publishing these books?
To begin with – when I am planning a book, I have a blind faith in what I am doing. I am not inferring I don't have doubts, or that I haven't made mistakes. Nor am I really interested in books as such, but I am interested in unusual kinds of publications. The first book came out of a play with words. The title came before I even thought about the pictures. I like the word "gasoline" and I like the specific quality of "twenty-six." If you look at the book you will see how well the typography works – I worked on all that before I took the photographs. Not that I had an important message about photographs or gasoline, or anything like that – I merely wanted a cohesive thing. Above all, the photographs I use are not "arty" in any sense of the word. I think photography is dead as a fine art; its only place is in the commercial world, for technical or information purposes. I don't mean cinema photography, but still photography, that is, limited edition, individual, hand-processed photos. Mine are simply reproductions of photos. Thus, it is not a book to house a collection of art photographs – they are technical data like industrial photography. To me, they are nothing more than snapshots.
You mean there is no design play within the photographic frame?
No.
But haven't they been cropped?
Yes, but that arises from the consciousness of layout in the book.
Did you collect these photos as an aid to painting, in any way?
No, although I did subsequently paint one of the gasoline stations reproduced in the first book – I had no idea at the time I would eventually make a painting based on it.
But isn't the subject matter of these photos common to your paintings?
Only two paintings. However, they were done very much the same way I did the first book. I did the title and layout on the paintings before I put the gasoline stations in.
Is there a correlation between the way you paint and the books?
It's not important as far as the books are concerned.
I once referred to "Twenty-Six Gasoline Stations" and said "it should be regarded as a small painting" – was this correct?
The only reason would be the relationship between the way I handle typography in my paintings. For example, I sometimes title the sides of my paintings in the same manner as the spine of a book. The similarity is only one of style. The purpose behind the books and my paintings is entirely different. I don't quite know how my books fit in. There is a whole recognized scene paintings fit into. One of the purposes of my book has to do with making a mass-produced object. The final product has a very commercial, professional feel to it. I am not in sympathy with the whole area of hand-printed publications, however sincere. One mistake I made in "Twenty-Six Gasoline Stations" was in numbering the

Artforum, February 1965: 24–25, © John Coplans

everyday situation. Whether they are art or only artifacts, they exude a strange quality of common experience transformed, intensified and yet muffled.

Compare their state with Marcel Duchamp's "ready-made" *Bottle-Rack*. That astonishing moment in modern art, as decisive and bold an act as it was, did more to clarify and tighten the lines being drawn between art and life than it did to relax them. Duchamp's ready-made was declared in italics to a public unprepared for it; it was a *preferred* object in conflict with the "creative" modes of art current then. While the inherent possibilities of a wider range of artistic means, and an awareness of the value of everyday objects, must have been obvious enough to Duchamp, the fact remains that the rest of the art world only entrenched deeper into the idea of art as Mind and Abstraction. Segal's objects – tables, chairs, bathtubs, pin-ball machines, coffee cups – are accepted for what they are and what they may become in a meditative vision of the universe, while Duchamp's ready-mades are first of all *weapons*.

This change in attitude, which is shared by other Americans and a few Europeans today, is in good measure an American phenomenon. In a country lacking long cultural traditions and with little interest in the classical distinctions important to European philosophy, it is quite possible to see a gradual emergence of an art which is independent of those traditions, even while utilizing some of their tools and content for other purposes.

In the United States it has become nearly possible to act as though art is what you decide it is, and to see in it not a betterment of life, but a testimonial to it and a penetration into it. Characteristic of American thought is that peculiar intelligence that believes it can accomplish anything because it can make up the rules as it goes along. "Pay-as-you-go," installment-plan living, continuous social and economic mobility, has generated attitudes in which "anything goes" because "everything's got to go." The ambiguity of these expressions is intended. Segal records in plaster the image of a woman, seated with a real coffee cup in a common cafeteria booth he has picked up in a junk yard, and finds no irony in this combination. The ensemble is moving because he has paid profound attention to it. He could do so because he was unencumbered by an esthetic which asserts the value of art over artifact over life.

Yet Segal's works are not at all lacking in differentiated sequences of attention. First is the life-sized image of a human being, man in general. Second is the specific portrait of a friend. Third are the attributes of the personality, his environment, the things which define his private world and which locate him in a particular space. Fourth, often the smallest objects will have the greatest concentration of detail, for instance the nail polish and brush held by *Girl Painting Her Fingernails*. Here there is an unstressed schema, remotely traditional, in which one passes from relative abstraction to relative specificity, but, I think, without evident hierarchy. It is not that a figure's attributes are finally less real or of less worth than himself, but that they have become consubstantial with him. They share in his isolation. He needs them to root him in concrete existence, and they need him to transcend time and place.

These several moments are, however, each the result of an effort to precipitate as concrete and tangible a world as possible, according to their particular functions. Segal does not start with *a priori* metaphysics or rules. The differences stem from an intuited grasp of how this or that individual fits into his world. His works are, foremost, involvements with his friends with whom he has a specific relationship. By wrapping bandages dipped in wet plaster around the parts of their bodies, cutting off the hardened sections, then later reassembling them into the whole body, he "touches" them and possesses them physically and psychically with a contact that would be possible in no other way. Both for

him and for us, he evokes their presence; they are almost real because they have sub-stance and a name.

Yet at the same time, he embalms them. These stark, motionless figures, nearly mum-mies, frozen in some ordinary hour of their day, remain in an endless trance, blanched of color, communicating with no one. Like mummies (and unlike Mme. Toussaud's wax-works), the inside of Segal's figures remain true to life in reverse, a fairly exact impres-sion of the skin and clothing of the model, while their outsides tend to be built up, transposed and impersonal, revealing the marks of the artist's hand.

If we think that reality is verisimilitude, then here the inner man is more real than the outer man: a familiar twentieth-century idea, but in this case stated covertly (one should know this fact, I think). But if we believe that the real is that which is apperceived and re-vealed by a transformed raw matter, then the outer view of the plaster is reality. In point of fact, Segal does not choose one or the other. By taking an exact impression of the form of a friend, he is not truly taking a casting because he does not make an additional posi-tive mold of the negative. He clothes his model, as it were, locking him inside forever, forcing him, almost, into his unique and individual loneliness, as though until that time the friend was uncertain about himself. The result is that though we may recognize the friend from his features, gestures and personal objects, he has become a universal man.

The attributes and environments of these beings, however, are conceived from the op-posite pole. One finds a chair, a table, a razor, a window, all unaltered, aside from their careful selection and placement in the composition. Only the last (a composing method which is *not* for the purpose of emphasizing formal relations) allows them to partake of the vast somnolence of the figures. Otherwise, they appear exactly as always. Their skin is their identity, their first and final cause. Inside they are without distinguishing fea-tures, are simply raw material, fundamental being. Their magic lies in their existential necessity, their blunt actuality and their sense of belonging, both to each other and to the silent personages among them.

George Segal's reality is a tragic one, in which the human and the artifact are alone and immobile, but as though *consecrated* to this state by some interior directive, to en-dure forever. Yet in conveying it, his strength is to have avoided the prevailing (and by now worn-out and merely chic) preoccupation with the analysis of, and comparison be-tween, art and life, i.e., *the witty pun.* For Segal (and a growing group of Americans) the world on all its levels is real enough; one does not doubt it, any more than one doubts the creative process. Nature and mankind are equally in operation, constantly and inevitably. It is conceivable that Segal's figures might be exhibited one day, this time quite alive, sit-ting together, their *objects* now in plaster. The effect would be the same and the vision would be as profound. Perhaps, at last, we have arrived at a point where anything at all is available for an artist, where "abstract" and "concrete" are interchangeable. We may be on the verge of a new era. Segal is one artist of stature who is making this possible.

PLASTER CASTE

John Perreault

George Segal's plaster people, caught in poignant gestures of loneliness and surrounded by the furniture of their life, will be seen next month at Janis

Now that Pop Art *per se* is no longer an issue, now that this constellation of styles has been assimilated and its shock value neutralized – Campbell's soup-can waste-paper baskets are a glut on the market and Camp, by its very nature a super cliché, has become an ordinary cliché – it is significant, nevertheless, that several of the artists labeled, extolled and sometimes, unfortunately, dismissed as Pop have continued to develop and to produce new works of high quality.

One such artist is George Segal; his December show (at Janis) will do much to establish his position as, surprisingly enough, a major artist who, along with three or four of the other Pop Popes, proves his art is artful enough to survive the labels that served as handy introductions but not as adequate definitions. The shock of seeing Segal's plaster molds of real people located within pristine arrangements of found objects has been mitigated by familiarity; we are now able to perceive just how judicious and significant are the multiple choices that go into the creation of one of Segal's poignant and yet strictly unsentimental "slice-of-life" evocations.

Segal has the distinction of being a New York artist who lives in New Jersey. He lives outside of North Brunswick with his wife and two children on what was formerly a chicken farm. Indeed, he was once a chicken farmer himself and his neighbors, either unimpressed or uninformed about his more recent achievements, still think of him as this, even though his abandoned "coop," which is several city blocks long, houses a workshop and numerous, incongruous, plaster inhabitants.

Segal began as a painter. In the late '50s, his friendship with Allan Kaprow, who was then teaching nearby at Rutgers University (Robert Whitman and Lucas Samaras were students and Roy Lichtenstein was teaching at Douglass College), played an important role in his development. Segal later became acquainted with Claes Oldenburg, Red Grooms and other artists centered around the Hansa Gallery, and had his first show at the Green Gallery, like Hansa under the direction of Dick Bellamy. From the beginning plaster people were his trademark.

In his recent works, after a venturesome but unprofitable side-trip into painted figures and allegory, Segal achieves a balance that is post-Pop, post-painterly and pre-apocalyptic. In short, by combining aspects of several different categories – painting vs. sculpture, presentation vs. representation, art vs. life – he has managed a significant statement that is about both art and life.

One can find much to praise in his careful contrasts between real (presented) objects and made (represented) figures: plaster bodies in contrast to wood, rattan, glass and even daylight. His media-mix is canny. *Subway* uses moving lights to suggest the motion of a subway car between stops. The blinking PARK sign in *Parking Garage,* a major piece in the Janis show, is perfect. His sense of composition, although arrived at through an anti-compositional stance, is classic without being rigid or cold.

In his new works, Segal re-introduces the self-portrait. *Self-Portrait with Head and*

Art News, November 1968: 54-55

Body depicts Segal himself in the act of placing a plaster head upon a plaster body. The figure is the same one employed in a finished state in *Girl Sitting against Wall,* notable for its almost Supremist severity of composition. *Artist in Studio* shows Segal or the plaster ghost of Segal in the act of drawing two models (also plaster). The tableau is backed up by a wall on which a series of large drawings are displayed. With these two pieces Segal manages to create works of art that are about themselves in a new and very complicated way.

Artist in Studio is illuminating because it reveals the central formal issue of Segal's work – until now disguised by the shock of his commonplace subject matter. For Segal, the concept of "boundary" is crucial. He not only makes choices involving model (mold), pose and suggestive environmental fragments, but also major decisions about boundaries. Where will a piece end? How much is just enough? Should the linoleum beneath the plaster figures be discarded? The open bag of plaster? The rafters of his studio?

On the other hand, the most obvious characteristic of Segal's work is his consistent use of isolated figures within contexts that are widened by his skill in selecting evocative props (the perfect motel bed in *The Motel Room,* the shower stall of *Shower Stall,* the metal corner-guard affixed to *The Parking Garage*). This characteristic suggests the paintings of Edward Hopper. The mood is somewhat the same, as is the mode. And, like Hopper, Segal is not an American Social-Realist, but a poetic-realist. This phrase seems to be an unnatural conjunction of polarities. Reality, however – if we mean by "reality" total rather than exclusively cerebral or visual experience – is unavoidably poetic and not, contrary to certain therapeutic but false philosophies, composed of mere facts. Facts when inspected with even a minimum degree of attention dissolve into ephemeral sense data or, on the other hand, into vague subjective states. Segal is able to transform facts – shoes, drinking glasses, subway cars – into emotions.

In regards to the plaster figures themselves, these hollow men and women are a cast of characters that achieves a kind of blue-collar universality. They indicate the American yoga of physical and psychological exhaustion. The bodies, or the imprints of these bodies, exist in three-dimensional space, but their thoughts or their souls are elsewhere, outside the workaday world. Segal is a poet. But he is never oppressive, didactic or "literary." He celebrates acceptance. Acceptance, however, must not be read as resignation. Wisdom is contained in the location of the differences between these apparent similarities.

Segal exploits the language of the body. He does not use the heroic poses of traditional representational sculpture, but the every-day postures that communicate unconsciously. (Indeed, in some systems or anti-systems of thought, the physical manifestation of a psychological state *is* the psychological state.) Facial expressions, because they are created by muscles too subtle to be captured by Segal's techniques of "mummification" (cloth soaked in wet plaster is applied directly to the live model), are automatically eliminated, and the body itself, as in dance, bears the burden of expression. The body, however, even when immobile, is capable of sending messages of great complexity. The way a man sits, lounges, slumps or arranges himself in a chair contains more history and more truth than all the personality profiles in the world. The body does not lie. The language of the body – relationships between limbs and torso, muscle tensions, posture and carriage – offers a rich vocabulary of signs.

The "working-class," un-Mod tonality of Segal's iconography is satisfying, not because it approaches certain Marxian or Ash-Can clichés, but because his blue-collar prototypes – a parking-lot attendant, a girl putting on a pair of shoes – represent a-literate personalities (as opposed to fashionably normative "post-literate" ones) who have not

ritualized their body language into "manners" that determine "correct" ways of sitting, standing, moving. Segal brilliantly exposes this forbidden vocabulary of gestures. The bodies of Segal's faceless (wordless) people become all face.

What Segal captures with almost infallible grace is the moment of stasis, the significant pose. His figures are poised between the physical and the spiritual and can be read either way, just as certain Gestalt illustrations can be read as ladies or rabbits, lovers or pottery. He rarely descends into bathos or social commentary. At his best and most "poetic" he succeeds in expressing the universal in terms of the particular. What more can we ask?

REVIEWS AND PREVIEWS: NEW NAMES THIS MONTH
Peter Saul

Jack Kroll

Peter Saul [Frumkin; Jan. 8–Feb. 3] is a young Chicagoan who has picked up on the "astonished Muse" of kitschy-kulchy, like Claes Oldenburg and others. These artists are inspired by the adhesive regressions of comic-strip art and its polymorphous-perverse mythography, the groinless potency of Superman, the iconological Sargasso Sea of Smoky Stover, the idiot schemas of upholstery and showerstall ads. Their Lascaux is the primordial mesa of Covina County and their apocalypse is a *Katzenjammerung* of stuffed toilets, choked garbage disposal units and bayonetted boxes of Kleenex. Saul paints the Obstructed Universe of consumption of culture, using color like a Matisse lobotomized by Dr. Mabuse and worrying the swill of his imagery with a good deal of young but promisingly malleable voracity. His *Master Room* is awash with cuspidorsfull of *chazerei,* from the lorn wraith of a coke bottle to a bathtub defiled with a swastika and a stymied game of tic-tac-toe, all captained by an Ionesco chair emptied of its hide-a-bed husband. Prices unquoted.

PETER SAUL

Ellen H. Johnson

Peter Saul may be Polemical in his subject matter, but not in the way he presents it. Not for him experiments in new techniques and hybrid mediums; he regards traditional oil painting as a satisfactory vehicle for what he urgently wants to say and it is more than satisfactory exactly because it is so at odds with the content of his work. The conflict between Saul's ideas and the language in which he puts them makes his message more drastic at the same time that it gives the viewer a reassuring loophole in the thought that anyone who paints such intriguing forms and vivid colors can not really be serious about those outrageous things. Saul's painting, like that of Bosch, looks cheerful until one sees what the weirdly metamorphic creatures are up to and even then it is fairly easy to make the picture "Go Abstract." At least, that is the way it will work for some viewers, while others may be stuck with the subject matter. To let the one exclude the other is to miss the pungent flavor of the mixture: Saul wants to offend and please at the same time, because he is a painter and because he is a young man who finds much that is rotten in the state of the world, particularly in his own country which he has looked at from Europe for the past eight years. He is not at war with painting, but he is with many other things: crime, brutality, commercialism, prudery, greed, among others. And he is especially troubled, I think, by the adolescent mentality of the pulp-magazine and TV public, which is fascinated by lurid corruption and violence and which is willing to settle for a second-hand experience of what it secretly craves. Saul is not advocating a first-hand experience of perversion and murder (as the narrative of so many of his pictures testifies, he firmly believes that crime does not pay), but he does urge an honest awareness of their presence and of their dangerous appeal which makes the subject of crime such a commercial success in the entertainment field. A similar aim motivates the sexual and scatological character of his imagery. Anyone who looks at TV commercials, advertising cigarettes languidly inhaled across soulful glances and celestial kisses, or stomach tablets travelling along a dainty intestinal tract accompanied by nauseating music, should at least be grateful to Saul for stripping things of their insipid packaging and putting them bluntly as they are. He strikes back at advertising with its own weapons: exaggeration, scale distortion, quick contrast, emphatic colors, visual directives (arrows, etc.), repetition of brand names and emblems. With e.e. cummings he is protesting "The Unspontaneous and Otherwise Scented Merde which Greets One" – except that Saul does not put merde in a foreign language. When he paints toilets, viscera, excrement, sexual organs, it is not that he loves dirt like a naughty boy but, like Aldous Huxley, he appreciates that "It's difficult . . . not to be vulgar, when one isn't dead." In his best paintings Saul achieves what must be one of the basic aims of his work – a natural radiant vulgarity.

While Saul's subjects may suggest parallels with such contemporary writers as Beckett, that resemblance is only on the surface. Saul may have something of Beckett's humor and poignant sense of the absurd but little of his wit or his profound pity and love (if Saul does feel those emotions, he has no way of conveying them in the idiom he has chosen). Even his humor is different from Beckett's; Saul's characters and their antics are amusing, rarely ironical or touching. However, it is obvious that he has a more ambitious ideo-

Exhibition catalogue, *Peter Saul*, Allan Frumkin Gallery, New York, October 1964

logical program than just to make us laugh (although most of us would be grateful enough for that). One suspects that he does have sympathy for his poor little creatures running futilely here and there; Donald Duck is apparently everyman who pathetically but eagerly bucks all the odds of commercialism, apathy, mechanization, money, crime, etc.; our soldiers are ducks fighting with baseball bats and boxing gloves; Superman is nothing more than his insignia. Man is a mindless thing – a bottle, a toilet, a phallus on legs – nothing but his bodily functions. These are some of the messages Saul may have intended; but usually his paintings do not arouse terror so much as uneasiness and, most of all, amusement. The ludicrous and lovable expressions of his characters (the face of the duck as he squashes a Japanese can), the ridiculous situations (a football-helmeted man and flower-pot-headed woman smoking an enormous dual cigarette) and his fantastic inventions (a yellow sex-monster with twenty-three phalluses attacking a green mattress-clad woman whose distant head emits a comic "ugh") are all just plain funny. One delights in his zany combinations and the richness of his fantasy; but these are fantasies, Rube Goldberg machines for sex and crime. They are daydreams, not nightmares. That effect comes not only from his irrepressible humor but from the quality of innocence that pervades the work. This quality is not just something put on with the childish primitive drawing, but the very ideas themselves, the fresh imagination, the uninhibited forms. The awkwardness and boldness of the shapes all have an appealing childlike flavor reminiscent of Klee, although far less sophisticated. However, Saul's work is closer to Miro and Gorky in other elements: The predominantly sexual imagery, the humanization of objects, the interchangeability of living and inanimate forms and the way forms flow into and grow out of each other in a wild but natural association of ideas. The foot of an electric chair becomes a human leg; a breast becomes a coffee-stand; a dagger is a murder weapon, a phallus, a missile, a pointed breast and a man with a black hat. One is reminded of Gorky's multiple morphology of sexual, visceral and floral forms wandering in and out in a constantly varied chain of life, but Saul's explicit images are far less abstracted and on a different plane of being than Gorky's. Their playfulness is closer to Miro and so is the way Saul intensifies the brightly colored shapes by setting them in an airless environment. On the other hand, the variety of color and disposition of forms more often suggest Gorky. (Compare "Scream" with the blue and gold version of "The Plough and the Song.")

In spite of their possible relation to surrealism, Saul's creatures are the invention of his own peculiar imagination, and his strangely childlike scale distortions are more related to our disjointed, swollen and threatening world of advertising than to surrealism. Cigarettes are as big as a table, glasses larger than heads, people smaller than telephones. Saul pulls together objects. Figures, landscapes, interiors and exteriors (a tree stump with a saw in it in "Living Room"), kitchens, bedrooms, and bathrooms into compact single compositions which are often astonishingly similar to late cubist still lifes in their basic design. They sometimes evoke Picasso's compositions, especially some of his protosurrealist pieces, as the "Nude with a Guitar Player" of 1914. Although Saul's work is in a new generation's "Cruder" style, there are analogies to those Picassos in the physiological and sexual imagery and the violent shifting in size implying distance in time – as one leg miles away from the other. Besides the general cubist and surrealist tone of his work, there are more direct influences which Saul himself acknowledges: Beckmann (whose painting he must have become familiar with as a student in St. Louis), Diebenkorn, Orozco and Bacon. These are all highly expressive figurative painters whose attraction for Saul is understandable.

It will be interesting to see what happens to Saul's work now that he is returning to the

States and can take his position in the midst of what he has been looking at from a distance, socially and aesthetically. Like several of his contemporary Americans, he has found much of his imagery in second-hand sources, things already once removed from actuality: comics, popular science and thriller magazines, TV programs and advertising. But he has never taken those images whole, only fragments and ideas, symbols and a cartoon style. Moreover, not only what he selects from those sources and what he does with them but also his attitude toward them is different. Where Lichtenstein appears to be amused and Warhol indifferent, Saul is angry – and wants to do something about it. He does not paint the banal because it has no meaning but because its meaning provokes him. He strikes reality through a medium which is supremely non-real; through the falsity of ads and comics Saul aims at what he considers to be "big truths." "I will show people that what they want most to look at is not the kind of thing that they will enjoy seeing."

In his allegories for today, as in Hogarth's "Modern Moral Subjects," satire is the major weapon, combined in Saul's case with a wildly humorous power to invent images and to say things through color. The painful antics of "society" take place on a terraced structure of lollipop colors; we feel the orange waves of electricity approaching the acid green flesh of the slick "Sex Criminal Being Executed." Saul pounds our senses with color: garish, vibrant, smoldering, brassy, tender, commercial, shrill, bizarre. There are passages of particularly outlandish appeal as the coral, orchid, Venetian red and yellow-green on blue in "Scream" or the two reds and Pepto-Bismol pink in the upper right corner of "Crime Boy's Secret Bathroom." That inset section is not only what the title indicates but it can likewise be taken as a think balloon or a cartoon within a cartoon; and it also suggests an image on a screen with Mickey Mouse looking out at the real world and panting in terror at what he sees. One of the intriguing, and generally modern, aspects of Saul's "iconography" is that unlike earlier art, such as Hogarth's, it is private and open to many different readings. Even after one "gets onto" Saul's symbolism and cast of characters, it is difficult to unravel the complex narrative or situation and to extract the moral which he has in mind. Also characteristically contemporary is the great attention and vitality Saul gives to objects by isolating, exaggerating, distorting them in a flat world of color with none of the cast shadows of the natural world. But, even for contemporary art, Saul's objects are unique in their terrible power of mobility. They run, slide, push, bend, drip, pour, tumble and spin in an orgy of action.

In his recent paintings things tend to be somewhat calmer than they used to be. There is less aimless rushing around, a greater concentration of forces. Bigger, more simplified forms, sharper edges, braver and clearer colors and a surer sense of scale. Although now more complex, the total compositions are more assured. This represents a gradual development in Saul's art over the past two or three years. His earlier work, as "Murder in the Kitchen" of 1961, was still abstract expressionist in style but more like a happening in the rambunctious subject matter. In fact the whole wonderful mess might be a moment in the kitchen scene of Oldenburg's "Store Days" of 1962 (the parallel with happenings is, of course, completely coincidental). Saul's origins in abstract expressionism, most particularly in de Kooning, are even more apparent in the untitled drawing of 1960 with its eruptive shapes and lines and its turbulent space. This early work of Saul's is an excellent example of his drawings which deserve to be discussed separately, not peripherally. They are almost never studies for pictures; but, independent and complete, they are smaller paintings in crayon, gouache and pastel.

By 1962, Saul had freed himself sufficiently to paint such individual pictures as "Mad Ducks" and "Superman's Mightiest Task." These two, like many others of the 1962 paint-

ings, have a considerable amount of white ground left bare. But later in the year, and throughout 1963, color gets fuller and bolder and forms move toward the more monumental character of the 1964 work. He has tidied up the ice-box, so to speak, putting things on the shelves in a more compact and orderly fashion. Instead of the former tendency to rotate movement across the surface like a swastika perpetually pushing itself around, there is now a coherent movement of large blocks in and out of space. Some passages of the recent pictures, for example the interweaving arms in "Japanese Versus Americans," make one think of the complex design of tubes bridging space in Duchamp and Picabia (that the erotic machines of both are recalled in Saul's inventions is almost too obvious to mention). Where previously floating, the forms are now more securely anchored in a space which is three-dimensionally occupied, approaching a sculptural concept. And he no longer roughs up the paint – he never did very much – instead he uses it straight and clean so it will not say anything in itself. Deeply concerned as he is with his parodies and parables for our time, the last thing Saul is interested in doing is to paint pictures about his way of painting pictures.

REVIEWS AND PREVIEWS: NEW NAMES THIS MONTH
Wayne Thiebaud

Thomas B. Hess

Wayne Thiebaud [Stone; to May 5] shows, for the first time in New York, paintings of American food on which he has been working in California for a number of years. He relates to San Francisco School painting, to Park, Diebenkorn and Bischoff in the fat consistency of his pigments and in the rancid contrasts of hues that are like commercial dye colors. Shadows tend to a particular Eastman Kodak blue; the background (refrigerator white) is stroked up to the picture plane. But Thiebaud's deadpan observations of supermarket delights surpass other San Francisco efforts in the exactness with which he has adjusted a given style to a new image. His better-known colleagues are pantheistic Romantics; they hail blithe spirits or probe at aching losses. Thiebaud paints straight social realism. He reveals what the richest country in the world has developed for the affluent, middle-class, split-level orgy – aerated chocolate cream fillers, dense nut jellies, horrible soft drinks brewed from tasteless giant fruits, chemical vitamins forced into neon-vegetable coloring. It is as bland as Limbo. Looking at these pounds of slabby New Taste Sensation, one hears the artist screaming at us from behind the paintings, urging us to become hermits: to leave the new Gomorrah where layer cakes troop down air-conditioned shelving like chloresterol angels, to flee to the desert and eat locusts and pray for faith. He preaches revulsion by isolating the American food habit. It is the irony of Daumier (Thiebaud's lollipops point to the belly as Daumier's lawyers point to the Crucifix) – controlled, elegant, tender, savage. Henry James wrote that his America never could produce great cartoonists because the culture was insufficiently established, there were no distinctions. Thiebaud's pictures are in the best sense caricatural; they show that we have reached the level of James's Paris. This is major social criticism made visual.

Art News, May 1962: 17

THIEBAUD: EROS IN CAFETERIA

Diane Waldman

The West Coast's leading Pop artist differs from most of his colleagues in his frank relish for paint; he exhibits new work this month at Allan Stone, New York.

To his iconography of the still-life-as-object, Thiebaud has added the human figure – the American consumer replacing the American super-product. As we were once faced with row upon row of layer cakes, ice-cream cones, bowls of soup or hot dogs parading in regimented grandeur across the canvas, we now have the Common Man stepping down from his billboard. Gumball machines are removed from the candy store, lipsticks from the five-and-dime, the football player from the locker-room; time stops, and his objects – stripped of their environment – stare back at us, alone and waiting.

Thiebaud's art follows a cyclic pattern revolving around landscapes, still-lifes (he has been working with cigar-store counters and vending machines since 1953) and the figure in changing patterns of emphasis. He says:

"The figure is the finest and most intricate measuring device of what we know about art. Through it we can best check our awareness of space, weight, balance, illusion, as they are inculcated in the conventions of visual responses . . . Painting problems are like problems in other fields. A question or problem is made increasingly complex when over-laden with varieties of first-rate hypotheses or solutions relating to it. The heritage of figure painting presents signposts and fences, avenues and terminal points, limitations and horizons. These challenges seem to continue to interest me centrally."

To his current series on show at the Stone Gallery [April 5–30] he brings his considerable technical gifts: a fondness for paint and its handling, deriving ultimately from Abstract-Expressionism and San Francisco figurative painting (mainly Diebenkorn) and his extraordinary knowledge of halation. The tactile materiality of his paint surface, at once sensual and vulgar, whether approximating meringue or flesh, invests each object with a heightened sense of reality. Simultaneously, by its own very real presence, it calls into question the nature of that reality. Contradictions abound: his volumetric figures stand away from the two dimensionality of the painted void which surrounds them, attached to the canvas only by the indication of a cast shadow; or by a sudden unexplained change of perspective, or none at all where some indication is called for, the head of the *Woman in Tub* becomes an isolated object within a series of shallow, lightly-tinted planes which read across or up the canvas rather than in depth. It is in the very skillful use of these contradictions that his irony exists as he comments upon the essence of the real.

His men and women are usually just short of life-size – a scale which heightens their impact, but still allows the spectator to dominate. Thrust against refrigerator-white backgrounds, the figures are framed by double outlines: by a nimbus of neon reds turning into oranges, yellows, greens and blues as it traces the silhouette and then again by the creamy impasto of the background edging up to the figure and contouring it. Using white as the equivalent of light, he arranges his colors in close-hue juxtapositions, working shadows together with the figures. What he achieves is a language of color which brings the vocabulary of the Impressionists back into focus. In the catalogue for his exhibition of figures at Stanford University, in the fall of 1965, Thiebaud noted:

Art News, April 1966: 39–41 ff.

After an initial over-all drawing (with diluted lemon-yellow paint) I make another drawing in a different color. I try to draw the entire thing each time and to make corrections and changes as I go along. As many as eight to twelve drawings of this kind are made in as many colors, i.e., golden yellow, cadmium red, alizarin crimson, cerulean blue, ultramarine blue, lime green, rose pink and others. When this is well along, I start to paint, allowing some of the original drawing lines to remain and become part of the painting.

The painted void around the figures acquires greater size than in the earlier still-lifes, heightening the visual tension between subject and ground. Whether in pairs or in larger groups, his people face away from each other, preoccupied and self-contained. The marked absence of articulation between his figures or between his figures and their "non-environment" recalls the earlier array of foodstuffs in assembly-line order or the faceless gumball machines silently standing side by side. In speaking of this Thiebaud cites:

> Concentrating on a single figure centers our eyes and suggests critical focus. When figures are placed together our interest tends to divide . . . Two or more figures suggest possibilities for external interactions. At present I am attempting to suspend any specific interaction. By placing figures together without an obvious relationship I hope to develop a quiet air of expectancy . . . an anxious pause charged with a visual question.

Time and motion are arrested; each of his figures is caught and fixed on the canvas with its own precisely shaped shadows, each inferring its own given moment in time without necessary relationship to any other. In this there is something more than a hint of the Surreal – a suggestion of arbitrarily juxtaposed time sequences which heightens the sense of dislocation and the moment of anticipation.

Although his people and still-lifes are isolated from their immediate ambience, they retain the warmth and intimacy of the commonplace events which shaped them. Without their frame of reference they become virtual abstractions, without relatedness or context; this also bestows upon them a certain pathos and an ironic grandeur. If, to *Girl with Mirror,* one applies the label "Vanitas," it quickly becomes apparent that she is denied the allegorical trademarks associated with such a symbol. There is no clue of Death nor any sign of age and decay; instead we are given an ordinary woman frozen before her mirror at one particular instant of her life. Thiebaud is also careful to erase any personal idiosyncrasies of his models or those traits which endow a portrait with specific personality. This depersonalization has necessitated restricting the vocabulary of poses to rather deadpan, profile, straight-on or three-quarter views. He wishes to eliminate his own subjective feelings in his portraits, believing that it interferes with what he calls the one-to-one relationship between the spectator and the sitter. By isolating and depersonalizing his figures he emphasizes their habits, dress and social modes; it is his way of questioning contemporary man – as earlier he questioned the mass-produced staples of cafeteria society.

A Thiebaud nude acts somewhere in the distance between the naked and the nude. A lush paint surface, fraught with sensuality, combines with a sometimes surprising awkwardness of form or, conversely, a voluptuously modeled figure is thrust into an unseductive posture. These are by no means the ideal forms we have associated with the concept of the nude as exemplified by a Venus or an abstracted odalisque. As in Ingres, although

Thiebaud employs color rather than line, eroticism occurs at the edges of the figures, in the rainbow-hued colors tracing the curves and hollows of the body.

"Our bodies," he says, "are tender especially in folds and fascination with detailing. These folds and sensitive points indicate our concern for ourselves. We love ourselves and others like ourselves in order to extend ourselves . . . Painting a picture is a way of stretching out and suspending a highly savored piece of time by visual means. This is one reason why artists seem to fall in love with things. They stroke and caress the same objects over and over again, slowly getting to know a little more about the forms each time. Most artists paint pictures again and again because each painting is another attempt to extend their passions. Erotic art results from a preoccupation with heightened anticipation of sensual events about to happen. If the desired event is to be put off temporarily the preview must be exquisite . . . Erotic paintings are pictures of vulnerability, for when we are in love with anything or anyone, we are exposed. In order for us to feel that exposure is worthwhile, the object of our love must seem available. We tend away from deep-freeze ice-cream cones and chilling nudes. The ice-cream must be in a state of softness so that we may taste the flavor and the body must be exposed and ready for love."

IN THE GALLERIES: JOHN WESLEY

Donald Judd

If pop art is defined as the apparent duplication of a picture or a pattern popularly used, Wesley's paintings are pop art. Roy Lichtenstein's paintings, by that definition, are the only others consistently pop. Outside of the method of concealing the formal and inventive elements within schematic depictions normally without such things, Wesley's paintings do not resemble Lichtenstein's or anyone's. The number of the paintings, the time necessary to paint them, makes it unlikely that the method was taken from Lichtenstein. Wesley's paintings, if they are pop art, are retroactive pop. Most of the paintings are like or are copies of the pictures and patterns of blue and white china. Most of the forms are nineteenth-century. The forms selected, the shapes to which they are unobtrusively altered, the order used and the small details are humorous and goofy. This becomes a cool, psychological oddness. A blue escutcheon fills *Cheep*. This blue, which is always the same, is slightly bluer and darker than cerulean. At the top there are two identical birds statant, nearly white silhouettes, each holding a worm like a banner. Their eyes are just double circles. They are the parents of the fifteen smaller birds in the nest or bowl at the bottom. Their eyes are just empty rings, like Orphan Annie's. Together they make a complicated white silhouette inflamed. There are two rows of them, all identical, all with their bills wide open. The heads and the spaces between them make oval vertical shapes, and the touching bills make two horizontal zig-zags. There are blue ovals between the top row of birds; the white of their bodies fills the spaces between the lower birds. Their bodies and the intervening spaces are outlined by the same lines. The vertical shapes are as positive as the shapes of the birds, yet are obviously different spatially. This ambiguity is one of Wesley's main devices. The blank eyes are also an instance. Two of the paintings have colored flowers on vines encircling pictures, one of which is the *Radcliffe Tennis Team,* obviously not this year's. The five girls are schematized and are in black and white. The outlines are always awkward and funny. The girls have no bones, and their empty, awry racquets and outlined clothing form other blank, unlocatable spaces. All of Wesley's paintings are well done. The only objection is theoretical, not critical. Wesley's method, and Lichtenstein's, is somewhat the same as that of traditional painting; the form is relatively hidden. The guise here is not appearances though, but what some bumpkin made of appearances for some unartistic reason. This is a big difference and is interesting – it is sort of a meta-representation – but (and this unreasonably denies the paintings as they are) the curious quality of Wesley's work would be better unconcealed, unadjusted and unscaled to anything else.

Arts, April 1963: 51

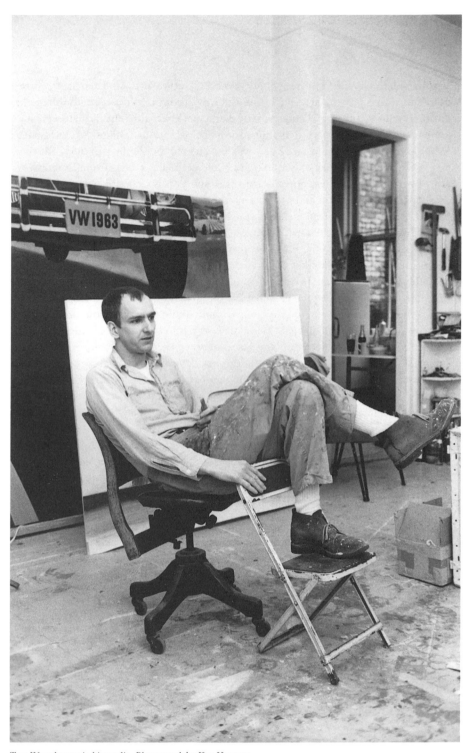

Tom Wesselmann in his studio. Photograph by Ken Heyman.

ART: "POP" SHOW BY TOM WESSELMANN IS REVISITED

Brian O'Doherty

How do you criticize an exhibition? In other words, how do you tell the truth about it? For frontline work (which this is) I think you take the implicit standard in the picture and take it from there. Does the work do what it sets out to do? And of course, is what it sets out to do clear?

At first and second glance, Tom Wesselmann's exhibition at the Green Gallery, 15 West 57th Street, is a "pop" art show – the best one-man pop I've seen, and I've seen about seven. The work is bright and brash, shuffling together magazine blow-ups and cut-outs, fine art reproductions, a bit of hand-painting, and incorporating things such as a television set (in excellent working order), a radio (tuned in too), and a sink unit (un-connected to a water source). All are put together with a blank, dead-pan air, and all of them traffic in double-takes in that everyman's land between illusion and reality.

Mr. Wesselmann was among those represented at the big pop orgy that closed at Janis recently. After being complimented in this column on a "higher sense of esthetic respon-sibility" for his pop performances there, Mr. Wesselmann wrote saying he had no interest in social comment or pop art, a label he detested. The esthetic aspect of his work was pri-mary and he wished to be judged by that.

That makes things difficult. Since Mr. Wesselmann's raw materials run from svelte magazine nudes to canned goods, his subject matter cannot be unconsidered – it is the petty coinage of our daily lives. Mr. Wesselmann seems to be asking the critic to perform a highly interesting trick – to consider the forms of transposed banality, but not their content; to concentrate on a soup can in a new esthetic environment, but not to read the label.

At this stage a critic in New York begins to feel a little like Alice in Wonderland. For the artist's intention is often at variance with his performance. Many artists seem to think the critic should play the game by their mysterious rules, not by the rules his eye tells him – the eye that separates the successful from the unsuccessful, good from bad.

This brings one to something else that needs saying, and has nothing to do with Mr. Wesselmann. The divisions of "good art" and "bad art" are considered in some quarters (what a murky phrase!) as not being what is called "valid." If you say you are for "good art" you are merely avoiding the great division of our time between abstract and nonab-stract art – as wide a gulf, the implication goes, as that between East and West at this po-litical moment. Fundamentally both divisions are artificial; one forsakes the common estate of the artist, the other forsakes the common estate of humankind.

Such sophistry is compounded by accusations of "conservative" or "reactionary" di-rected at the critic, in a sort of esthetic McCarthyism. But these names are so debased that they are now entirely relative terms. Reactionary compared to what? To the name-callers? If so a critic can feel justified in calling himself a liberal, which is I suppose what most critics who like labels would like to be called. But then giving names to people and things is a form of swift dismissal that removes the necessity for thought, and the New York art scene is above all the locus of the no-think.

Thus when Mr. Wesselmann intelligently objects to the label pop he deserves the com-

The New York Times, November 28, 1968: 36

pliment of being re-examined on his own terms. Removing the pop label and taking another look, he turns out to be a fine Buster Keaton type of entertainer, who takes the produce of his society and turns it into blankly empty, fascinating non-statements. At the same time he smartly pulls all sorts of switches between the real and the illusory. And his visual methods show a good understanding of shallow pictorial space.

But judged from the highest standard, this would be a one-word column composed mostly of "no." His ambitions for consideration on the same basis as, say, Matisse, are contradicted by his highly literary content. His work, which I still find wildly witty and madly hip, has, if I understand him correctly, no witty intent, which tends to put the joke on him. Although he has the last laugh, 18 out of 20 are sold.

TOM WESSELMANN AND THE GATES OF HORN

J. A. Abramson

It appears that the furor, recriminations and repatriation among the critics and public of 1961–62 are over; we seem to be approaching a condition of general amnesty where Pop art is concerned. The transition from the "Pop sensationalism" and "neo-Dada" labels of that period to the present easy acceptance of Pop as bona fide art is to the painters themselves no more than the attainment of an equilibrium corresponding to their own personal and constant refining of style. The point which is often overlooked is that these styles of Pop as we see them today are not in the main the results of a sudden realization of satori in 1960 or 1961, but rather the consequences of a continuing and fairly steady process of stylistic evolution in the work of most of the "first generation" Pop artists. As the current show (May 11–June 4) at the Sidney Janis Gallery indicates, this quality of steady and, in a sense, logical progression is especially evident in the work of Wesselmann.

By now, most of us agree that Pop is art. But is it *Pop?* This question is a pertinent one where Wesselmann is concerned, particularly when we confront numerous statements by the artist that reject the label. Whether we attempt to consider Pop as a style or as a movement, at this date we still seem to lack a clear understanding of the unifying factors in this art. I think it is a mistake to label anything that happens to use "common-object" or "pop" subject matter as Pop art. There is certainly a difference, if only one of intent, between the utilization of this type of subject matter by Duchamp in the early decades of this century, by such artists as Wallace Berman, Bruce Conner and Boris Lurie at the present time, and its use by such as Wesselmann, Warhol and Lichtenstein. Pop as conceived by the last three artists is not Dada. It lacks the polemical content and program of Dada and has an entirely distinct interest in formal manipulations. Pop would seem, contrary to Dada, to be a uniquely and purposefully passive kind of art, not in its choice or handling of subject matter, but rather in its attitude toward subject matter and, by extension, toward art itself. In this sense, Pop is more closely allied to urban beatnikism and its aesthetic of "the immediacy and unrelatedness of everything" than it is to Dada. The conception of man as a free-floating and passive perceiver, traveling by Brownian movement from experience to experience, is in many ways parallel to the Pop artist's "acceptance" of objects, be they artifacts of mass culture, natural objects or art objects. This is subtly different from just a broadening of the categories of subject-matter choice, as the choice of subject matter is still predicated on factors of artistic impact. It is rather a different conception of subject matter, concerned much more with the integrity and meaning of the *image* than that of the painting as an aesthetic entity.

The choice of "pop" subjects is, of course, to be expected when we consider the new attitude expressed in these paintings. In a way, the painting now is often no more than an excuse or a pretext for an exploration of images – not images which might or might not make a good painting, but images that are *encountered.*

This does not mean that Pop paintings are necessarily "passive" paintings. (Some of them, the good ones, have a power and presence that is anything but passive – because they happen, coincidentally, to be good paintings as well as Pop paintings.) What it does mean is that the artist has not only broadened his subject matter, but that he regards sub-

Arts, May 1966: 43-48

ject matter *at one level,* no matter what its nature might be. He does not approach things; they approach him. This is a "bridging of art and life" in a way, but even more it is a use of art as a *means* to document the results of an approach to life. In this sense, Henry Geldzahler is correct when he refers to Pop as being the "new landscape painting," and Andy Warhol's "Pop art is knowing how to live" begins to make a sort of sense.

An interest in cartooning marked Wesselmann's initial contact with art (he studied this for a year at Cincinnati Art Academy before transferring, on the advice of a professor, to Cooper Union in New York), and the essentially emblematic nature of the feet, mouths and nipples of his present work could possibly be thought of as a return to "pure" cartoon. Whether or not this is the case, the artist has arrived at his present style by way of a rigorously single-minded and oddly hermetic path. The *Nude with Parrot No. 1* of 1960 mirrors an involvement with Pollock and de Kooning which was not restricted to Wesselmann alone, but seems to be a common factor in the background of most of the present Pop artists. Many of Wesselmann's works of this period show forward projection and illustrate the artist's attempt to cope with the problems posed by de Kooning and Pollock. Wesselmann has stated that "de Kooning was an immense obstacle for me . . . I almost gave up painting because he'd done it already. I couldn't conceive of any other way of painting than de Kooning's." Pollock represented a similar obstacle, though less central. Thus we see this nude disintegrated, spread out, over and through the canvas, with her arm and leg thrown back to become involved with the rear areas and edges of the painting. This lateral compression and attempted all-over patternization relate in an obvious way to Pollock and de Kooning (as does the uniting of the positive and negative shapes), but also spring from an interest in collage that was present from the beginnings of the artist's career: "The fact is, I began with an interest in collage, which I first used in 1959 in art school." The development from an art-school de Kooningesque style to a translation of this into collage format can readily be seen in some of the works of late 1959 and early 1960, such as *The Lousy Haircut* and another collage which uses a cut-out Matisse nude. At this time Wesselmann made his decision that he was by nature a figurative painter, a painter of objects.

The *Great American Nude* series begins in the middle of 1961. According to the artist, the theme came to mind first and the concurrent palette restriction (to red, white and blue) of the early GAN's was primarily an excuse to justify the use of the theme. A sudden interest in size of the works also occurs at this time. Earlier, Wesselmann had been convinced that he was an "intimate" painter, and had restricted himself to works that could conveniently be held on his lap. The *Nude with Parrot No. 1* of 1960 is no bigger than a sheet of typing paper, but the *GAN No. 6* of late 1960 and the *GAN No. 12* of 1961 are both four feet square; the *GAN No. 30* of 1963 is four by five feet, and the *Still Life No. 36* of 1963 is over ten feet high. This trend has continued up to the present; most of the figures in the current show are life-size – or much larger, in the case of the body fragments.

As can be seen from the *GAN No. 12,* by 1961 Wesselmann had arrived at the basic elements of his style, but was still searching for technique and conception. The influence of Nicholas Marsicano, under whom he studied at Cooper Union, can be seen in many of the nudes of this period, especially in the limiting of the female to a thick flowing outline with the sensuousness of the body occurring within. The artist was pursuing a program of conscious eclecticism at this time, doing intensive studies of Matisse's and Mondrian's styles. However, it is a misconception to think that Wesselmann turned to Mondrian and consciously adopted elements of that painter's technique in an effort to "get around de Kooning." Wesselmann had long admired the freedom and sloppy elegance of de Kooning,

but felt that this quality was just not a part of his nature. Mondrian represented "another kind of wildness" and thus served as an inspirational example rather than a possible format to be followed and extended.

Since early 1960, Wesselmann has progressed along a path of constant simplification of images, but this was inherent in his attitude toward objects as "emblems." This simplification is also characteristic of his early palettes. The paintings were not so much dominated by one color as they were predicated on an arbitrary, "emblematic" conception of color. Grass was green, sky was blue, the body pink, etc.: a pure, bright palette with no nuances and with a conscious avoidance of the "poetic." This palette persisted, with some broadening, until late 1965, when modeling, as in the foot in *Seascape No. 1,* began to creep into the figures. It was this simplification to a "nucleus of style" coupled with the constant figurative intrusion of collage and assemblage elements that formed the basis of his style as seen today. Wesselmann has recently, however, made what seems to be an effort toward a more clear-cut statement of non-poetic color; the blues and greens of his seascapes are deliberately artificial and "commercial" in appearance, their obvious spuriousness reinforcing the artist's conception of painted objects as signs or abbreviations. The yellow beach and green ocean of *Seascape No. 7,* in the current show, are of this genus and demonstrate this shift from a use of the basic characteristic color of objects to a more sophisticated concept of color itself as an emblem or sign.

The "conscious eclecticism" mentioned above is most centrally related to the artist's deliberate restriction of format to the classical categories of painting: still life, landscape (or seascape), interior, portrait, nude. Of these, the only one untouched to date is the portrait category, and this, so far as particularized renderings of people are concerned, will probably remain so. The majority of his works fall into three originally separate themes: the GAN's (some of which can be considered as interiors as well as nudes), the landscape-seascapes, and the still lifes. These have recently been tending to merge, as in the nude-seascapes and the still-life insertions in the GAN's.

At first glance, one would be tempted to label the subject matter completely "pop," but, according to the artist, this is a superficial comment. It has been said that Warhol very carefully selects the images that somehow seem most pertinent, compellingly pertinent, to all of us. This does not occur with Wesselmann and has nothing to do with his choices. The sentiments of Warhol – "I love Campbell's Soup; I used to have it for lunch every day" – are not to be found in Wesselmann's paintings or behind his choices. He has no "love" (or hate) for anything until it is *in* a painting or subjugated to a painterly situation: "I use 'pop' subject matter because I recognize in it opportunistic situations." Wesselmann's progressively increasing cropping of the female image to some degree exemplifies this attitude toward subjects, painting and images. He has gone from almost full figures, as in *GAN No. 51* (1963) and *GAN No. 58* (1965), to torsos as in *GAN No. 74* (October 1965), and to today's anatomical fragments consisting of legs, feet, mouths and breasts.

The artist states that he is not painting any specific woman or mouth, or any specific type of woman, but just woman. However, it is a fact that most of these works are done from a specific model, the artist's wife, and the figures as seen relate directly to the conformations of her body. But, to Wesselmann, she is Woman; and the paintings begin, in an unspecific, non-portrait fashion, with her and are immediately extended to representations of generalized Woman. The simplification and cropping are results of this pursuit of the essence, in an emblematic sense, of this object-idea. The nipples, the "real" pubic hair, of earlier works and the gigantic cut-out mouths (which are derived from collage-

movie mouths) are not meant to be real; rather they are emblems of the complex of ideas and associations engendered by encounters with the real. They are, and I hesitate to use the term, almost complete symbols. Of course, Wesselmann has played with the opposite side of this coin; "I began with a simple enough idea . . . I was interested in collage, applying it to strictly realistic situations; so, a figurative piece of collage became a tree, a piece of wallpaper became a wall, and so on." But, ". . . two years ago, painting was king. Then I did the plastic piece with apples and radio [*Still Life No. 46*] . . . , then less and less of the paintings as an entity and more and more of the image . . . the integrity of the painting didn't matter anymore; now it is the integrity of the image."

To date, the elements of Wesselmann's evolution seem to center around an increasing size of the total composition, a broadening of palette, an increasingly tight and unified composition, a greater use of *trompe-l'oeil* effects (such as the use of landscape photographs, real space and objects), an increasing simplicity of image, more fragmentation and "close-up" views and an increase in specifically sexual imagery. The increased compositional tightness can easily be seen in a comparison between the *GAN No. 12* of 1961, the *GAN No. 58* of 1965 and the *Seascape No. 7* of late 1965. It is accomplished through a reduction in the number of elements, a more rigorous compartmentalization of space and a more diagrammatic rendering of masses. The increasing simplicity I've mentioned is functional to this, and certainly a logical progression because related to the desired intensity of image.

As was noted earlier, formally Wesselmann's work is not passive. The increase in sexual imagery is a direct result of a definite and increasingly powerful commitment to pornographic subject matter. Of course, if an artist is deliberately seeking a generalized, pictorial "essence" of woman, the pornographic, in the form of rather specific renderings of genitalia, is bound to figure in the proceedings at some time or another. But this is only part of the story where Wesselmann is concerned. He is actively in favor of the abolition of the term and the concept "pornography":

> I am interested in pornography and certain aspects of my work are pornographic . . . and certain aspects of my intentions are pornographic. But pornography is one part of life, and that's one part of my work. To say that that characterizes my work would be going much too far . . . but, first of all, I don't agree with pornography. I don't really mean anything when I say "pornographic," but there are things I want to say, in paintings, about the validity of doing it, the fact that these things are suppressed and they shouldn't be . . .

This not only implies that, for Wesselmann, pornography is in the eye of the beholder, but hints at a further and broader attitude: that the viewer of the painting should and can bring a great deal of the subject matter of the work of art with him *to* the painting. Any semantic entity, whether it be a word, a "standard" emblem such as a Campbell's Soup can or a more generalized sign such as a wet, spongy, Hollywood mouth, requires the perceiver or viewer of the sign to make the necessary connection from sign to what is signified. The use of a taped sound track of wine being poured into a glass in *Still Life No. 21* of 1962 and the ringing phone in *GAN No. 44* of 1963 are other examples of this playing in the half-world between the object or situation and its depiction. On another level, with particular reference to Wesselmann's nudes, it is perhaps the opposite of Boris Lurie's adept transformations of female figures into graffiti. The sexuality of Wesselmann's nudes is a remarkably abstract, pristine phenomenon despite, or possibly because of, the meticulously generalized renderings of carnal attributes and trappings. We see the re-

clining nudes with flamboyant silk stockings and garters; ordinarily, all that these would need would be a whip and a pair of boots to become the Spider-Women of a Jersey torture house. But instead the soft colors and blank faces make us think of "creatures met on Malibu Beach." It is as if the *Great American Nude* series represents the results of a fractional distillation of all the femininity in the world, with an end product, tightly stoppered, of pure essence of Woman. A clinical specimen.

Even as specimens, these new paintings have considerable blasting power. Part of this is due to a further progression in the evolution of the artist's concept of the form as mass on a flat surface. In 1962, a noticeable characteristic of many of Wesselmann's nudes (see *GAN No. 21, 30* and *39*) is an interior line just within the edge where the body meets the other areas of the painting. This interior line is present in most of the works of 1962, but then drops out and is not to be seen again until late 1965. However, in this later series of works, the line is not within the figure, but is represented by a series of lines, graded in value, belonging to the color plane as it meets the body edge. For example, if the body meets a dark blue plane (as in *Seascape No. 7*), the line of junction is approached by blue lines which get progressively lighter in value as they near the body edge. In the works of 1962 mentioned above, this seems to be a perfunctory modeling of the body area, or perhaps a hang-over of the heavy outline of the earlier, Marsicano-influenced works. In the present works it also functions to model the fragments of the body around which it appears, but has an intense, vibratory effect completely unlike anything in Wesselmann's earlier work.

The diagrammatic, ambiguous area which comprises the nude body in its entirety or in part in the pre-1965 works sometimes shows a tendency, because of the hard edge and because of the intense value and color contrasts, to break away from its spatial position and float above or jump around the surface of the picture plane. The hard edge begins to break down, because of the thinness of the collision. With this new handling of edges, Wesselmann blunts these hard, thin collisions and manages to make the body part appear more rounded, ruling out any floating of the image that would cause it to lose solidity. This reinforcement of solidity naturally causes the image to project outward more strongly, and the effect is a particularly powerful one. A certain amount of the vibratory effect seems to come from a mixing of hue as the lines lighten in value, so that the blue lines, as they become lighter and approach the body, begin to show some intrusion of pink within them. I feel, however, that the effect of round mass, which is evident even in black and white, is a function of value manipulation almost entirely. The inclination, when one first sees this, is to say "Aha, Op!" but I would imagine that this technique is the result, again, of Wesselmann's experience with collage. A collage inclusion, even if only thin tissue paper, has a definite edge, and the holding power of an edge-with-substance in Wesselmann's paintings establishes an extremely effective artificial collage.

"Extremely effective" is perhaps the key phrase for Wesselmann's current show. The cutouts, of the full nudes and of the mouths and feet, are almost hypnotic in their intensity, though deceptively close, when first seen, to some of Rosenquist's devices. The difference would seem to be that while Rosenquist is painting real (although billboard-size) objects, the Wesselmann fragments are schemata. The appearance of these parts on the earlier whole nudes or torsos must be kept in mind, as the new isolated ones are their progeny. The present paintings are huge, rich and heavy, but at the same time their economy of means lends them a strange quality of timelessness and lightness. Both as images and as deliberately generalized associational triggers, the works have immense power.

REVISING POP:
LATER CRITICAL REFLECTIONS

AMERICAN PAINTING DURING THE COLD WAR

Max Kozloff

More celebrated than its counterparts in letters, architecture, and music, American post-war art has become a success story that begs, not to be retold, but told freshly for this decade. The most recent as well as most exhaustive book on Abstract Expressionism is Irving Sandler's *The Triumph of American Painting,* a title that sums up the self-congratulatory mood of many who participated in its career. Three years ago, the Metropolitan Museum enshrined 43 artists of the New York School, 1940–1970, as one pageant in the chapter of its own centennial. Though elevated as a cultural monument of an unassailable but also a fatiguing grandeur, the virtues of this painting and sculpture will survive the present period in which they are taken too much for granted. Yet, if we seem to have explored everything about this art technically, we have not yet asked sufficiently well what past interests have made it so official.

The reputation of the objects themselves has been taken out of the art world's hands by money and media. But this accolade reflects rather than explains a social allure that has been far more seductive overall than even the marvelous formal achievements of the work. I am convinced that this allure stems from an equivocal yet profound glorifying of American civilization. We are not so careless as to assume that such an ideal was consciously articulated by artists, or, always directly perceived by their audiences. Still, that the art in question has been eloquent in surmising our most cherished public myths and values would be hard, on examination, to deny. Their international reputations should not preclude our acknowledgment that a Clyfford Still or a Kenneth Noland, an Andy Warhol or a Roy Lichtenstein, among many others, are quintessentially American artists, more meaningful here than anywhere else. It is less evident, though reasonable that they have acquired their present blue-chip status partly through elements in their work that affirm our most recognizable norms and mores. For all the comment on the "triumph of American painting," this aspect of it has been the one least studied, a fact that in itself has historical interest.

If we are to account for this omission, and correct it, we are inevitably led to ask what, after all, can be said of American painting since 1945 in the context of American political ideology, national self-images, and even the history of the country? Such a question has not been seriously raised by our criticism, I think, for two reasons. One is the respectable but unproven suspicion that such an outlying context is too porous and nonexclusive for anything meaningful to be said. The other is the simplistic assumption that avant-garde art is in deep conflict with its social, predominantly middle-class setting. The liberal esthete, otherwise variably critical of American attitudes, has been loathe to witness them

Artforum, May 1973: 43–54

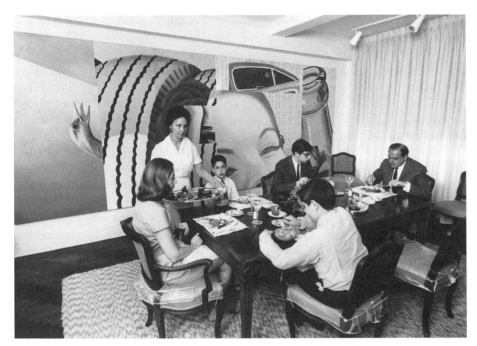

Dining room, Robert C. Scull home, circa 1964–65. Painting on wall: James Rosenquist, Silver Skies, *1962. Photograph by Ken Heyman.*

celebrated in the art he admires, even though this is to subtract from its humanity as art. (The radical philistine correctly senses systems support in American art, but reads its coded signals far too crassly as direct statement.) Professional avant-garde ideology exhibits a great distaste for the mixing of political evaluations with artistic "purity." Yet however convenient, they dam up the continuing psychological resonance of American art and reinforce the outdated piety with which it is regarded.

Two facts immediately distinguish ambitious American painting from all predecessors in modern art. Before the Second World War, this country had exerted no earlier genuine leadership nor had it any significant cultural prestige in visual art. Distinguished painters were active – Georgia O'Keeffe, Mark Tobey, Edward Hopper, and Stuart Davis – but their example was considered too parochial in coloration, and thus too "unmodern" to provide models for mainstream work. The complete transformation of this state of affairs, the switching of the art capital of the West from Paris to New York, coincided with the recognition that the United States was the most powerful country in the world. In 25 years, no one could doubt that this society was determined from the first to use that power, economic and military, to extend it everywhere so that there would be no corner of the earth free from its influence. The most concerted accomplishments of American art occurred during precisely the same period as the burgeoning claims of American world hegemony. It is impossible to imagine the esthetic advent without, among several internal factors, this political expansion. The two phenomena offer parallels we are forced to admit, but may find hard to specify. Just as the nations of Western Europe were reduced to the level of dependent client and colonized states, so too was their art understood here to be adjunct, at best, to our own. Everywhere in the New York art world there were such easy assumptions of self-importance and natural superiority as not to find

their match in any of the noncommunist democracies. Never for one moment did American art become a conscious mouthpiece for any agency as was, say, the Voice of America. But it did lend itself to be treated as a form of benevolent propaganda for foreign intelligentsia. Many critics, including this one, had a significant hand in that treatment. How fresh in memory even now is the belief that American art is the sole trustee of the avant-garde "spirit," a belief so reminiscent of the U.S. government's notion of itself as the lone guarantor of capitalist liberty. In these phenomena above all, our record ascribes to itself an incontrovertible "modernity."

To find historical precedents, I rather imagine, one has to go as far back as the France of the Revolution, Directory, and Napoleon, and imperial Britain of the 19th century. But though the Abstract Expressionists produced a magisterial imagery, it never became a court art under centralized patronage. And though their successor, the Pop artists, tackled everyday themes and presented the most banal icons, no one would judge their work genuinely demotic or sentimental. These pictorial modes were projections toward fantasy audiences by artists who felt themselves estranged from any audience, regardless of the level of their eventual commercial success.

In 1945, the United States emerged intact and unbombed from a devastating world war that had left its allies traumatized and its enemies prostrate. We were a country, according to Dean Acheson, still at an adolescent stage of emotional development, yet burdened with vast adult responsibilities of global reconstruction and leadership.[1] Compared to Soviet Russia's overwhelming armed might on the ground, America possessed a terrifyingly counterweighted superweapon, the atomic bomb. We had also a heavy war industry whose reconversion to peacetime needs was being urged by public opinion and economic good sense.

In the worldview of the untried president, Truman, the European civil war had removed a buffer that had hitherto stood against the eruptive forces of Euro-Asiatic communism. Comparable to Axis enslavement, these forces clearly had no legitimate aim in establishing for themselves a security zone in Eastern Europe. Here was a situation that called for the stepping up rather than the relaxation of the American militancy that had just proved itself with such effectiveness in actual combat. It was necessary to alert the idealist spirit of the Americans to a new danger when they were feeling their first relief from war weariness and pleading for widespread demobilization. At Truman's disposal, significantly, were two important psychological levers: the recent illusion of national omnipotence, and the conviction, no less illusory, that all the world's peoples wanted to be, indeed had a right to be, like Americans. "We will lift Shanghai up and up, ever up, until it is just like Kansas City," a U.S. Senator once remarked.[2]

To galvanize such attitudes, and to justify the allocation of funds that would contain the communist menace, Truman dramatized world politics as a series of perpetual crises instigated by a tightly coordinated, monolithic Red conspiracy. He made his point graphically in Iran, Greece, Berlin, and eventually Korea. "It must be," he said, "the policy of the United States to support free peoples who are resisting subjugation by armed minorities or by outside pressures."[3] The Marshall Plan, Truman Doctrine, the Atlantic Alliance and Point Four, and above all, National Security Council paper 68 were measures, infused sometimes with extraordinary generosity and always with extreme boldness, to strengthen economies whose weakness made them vulnerable to "subjugation," and not incidentally to invest in their resources and to improve their position to buy American products, the better to ensure our political dominance. Thus, when these activities were countered by the Russians, was initiated the era of mounting interventions, "atomic diplomacy,"

the arms race, and increasing international scares – the era known to us as the Cold War.

The generation of painters that first came of age during this period – whose tension, in retrospect, was so favorable to the development of all the American arts – felt united on two issues. They knew what they had to reject in terms of past idioms and mentality. At the same time, they were aware that achievement depended on a new and pervasive creative principle. Pollock, Still, Rothko, de Kooning, Newman, Gottlieb, and Gorky were prideful, enormously knowledgeable men who had passed through the government-sponsored WPA phase of their careers and now knew themselves, no longer charity cases, to be cast out on their own. During and shortly after the war, they were still semi-underground personalities with first one-man shows ahead of them, although they were on the average forty years old. For them, regionalist painting, rigid geometric abstraction, and politically activist art were very infertile breeding grounds for new, breakthrough ideas. On the hostile American scene in general, they counted not at all.

In 1943 some of them contributed to a statement which, in part, reads:

> As a nation we are now being forced to outgrow our narrow political isolationism. Now that America is recognized as the center where art and artists of all the world meet, it is time for us to accept cultural values on a global scale.[4]

No doubt the remark reflects the personal and quite natural impact of the leaders of modern European art, temporarily present in New York as emigres from the war. That their tradition had been blasted apart does not seem so much to have depressed as excited the Americans. Jealous understudies were preparing to take over the roles of those whom they considered failing stars. Above all, there was to be no convergence of immediate aims or repeating of European "mistakes," such as Surrealist illusionism or Neoplastic abstraction. Where artists like Leger and Mondrian deeply sympathized with the urban vitality of America, this was precisely the motif – especially in its accent on machined rhythms – that the Abstract Expressionists thought deadening to the human soul and had to escape.

It is remarkable that art searching to give form to emotional experience immediately after the most cataclysmic war in history should have been completely lacking in overt reference to the hopes or the absurdities of modern industrial power. These Americans were neither enthusiasts of the modern age nor nihilist victims of it. None of them had been physically involved in the great bloodletting. The violence and exalted, tragic spirit of their work internalized consciousness of the war and found a striking synthesis in expressive brushwork contained by increasingly generalized and reductive masses. Theirs came also to be a most spacious, enveloping art, its spontaneity or sheer willfulness writ large and innocent of the mockery and despair, the charnel elements in such Europeans of their own generation as Francis Bacon and Jean Dubuffet, whose works flared with atrocious memories.

The native rhetoric, rather, was an imperious toughness, a hardboiled aristocracy. In 1949, William Baziotes wrote: "when the demagogues of art call on you to make the social art, the intelligible art, the good art – spit on them and go back to your dreams. . . ."[5] All the ideas of the New York School were colored by antagonism to the practical mind, not as to some disembodied attitude, but as an inimically lowbrow and literalist obstacle to an authentic understanding of their work in America. Nothing was more irrelevant and foreign to their conception of terror in the world than American "knowhow," exactly at the moment when that "knowhow" was to provide a backup in concerted U.S. tactics of saber-rattling.

On the contrary, in choosing primitive icons from many cultures, Southwest Indian or Imperial Roman, for example, they attempted to find "universal" symbols for their own alienation. Their art was suffused with totems of atavistic faith raised in protection of man against unknowable, afflicting nature.

Yet, it was as if their relish for the absolute inextricably blended with the demands of the single ego, claiming solidarity with the pioneering modernism of European art, and compensating for the inability to establish contact with social experience. Robert Motherwell was the only one among them to express written regrets on this score. The modern artists "value personal liberty because they do not find positive liberties in the concrete character of the modern state."[6] Not being able to identify with debased social values, they paint only for their colleagues, even if this is to condemn them to formalism remote from

> a social expression in all its public fullness . . . Modern art is related to the prob-
> lem of the modern individual's freedom. For this reason the history of modern art
> tends at certain moments to become the history of modern freedom.[7]

In a very curious backhanded way, Motherwell was by implication honoring his own country. Here, at least, the artist was allowed, if only through indifference, to be at liberty and to pursue the inspired vagaries of his own conscience. Elsewhere in the world, where fascist or communist totalitarianism ruled, or where every energy had been spent in fighting them, the situation was otherwise. Modern American art, abandoning its erstwhile support for left-wing agitation during the '30s, now self-propagandized itself as champion of eternal humanist freedom. It added to the conviction, if not the logic, of the artists' stand that they couched such sentiment in the fancied morality of archaic religion. Prior to the late '60s the only iconographical link, and a wistful one at that, with the activism of their youth, was Motherwell's endless series on black bulls' testicles, titled "Elegy to the Spanish Republic."

It is impossible to escape the impression that the simple latitude they enjoyed as artists became for this first generation, part of the necessary content of their work, a theme they reiterated with more intensity, purpose, and at greater length than in any other prior movement. Where Dadaism, a postwar art 30 years earlier, had utilized license for hilarious disdain, the New Yorkers charged "freedom" with a new, sober responsibility, even with a grave sense of mission. Each of their creative decisions had to be supremely exemplary in the context of a spiritual privilege denied at present to most of their fellow men. "The lone artist did not want the world to be different, he wanted his canvas to be a world."[8] Here were radical artists who, at the very inception of their movement, purged themselves of the radical politics in their own background. They did this not because they perceived less domestic need for protest in the late '40s (on the contrary), but because serious politics would drain too much from the courage needed for their own artistic tasks. That they heroicized these tasks in a way suggestive of American Cold War rhetoric was a coincidence that must surely have gone unnoticed by rulers and ruled alike.

Information about these preceptors of American painting would be incomplete without dealing with their understanding of themselves as practitioners of the "sublime." "The large format, at one blow, destroyed the century-long tendency of the French to domesticize modern painting, to make it intimate. We replaced the nude girl and the French door with a modern Stonehenge, with a sense of the sublime and the tragic that had not existed since Goya and Turner."[9] Going further than even Motherwell here,

stressing the need for an unqualified and boundless art, beyond beauty and myth, Newman, personally a very thoughtful anarchist, wrote "We are reasserting men's natural desire for the exalted, for a concern with our relationship to the absolute emotions."[10] Hence was revealed the positive value, an inevitably doomed quest for unlimited power, to which painters of high resources bent their backs. Nothing less would satisfy them than the imposition of a roughhewn grand manner. Avant-gardes are not strangers to self-righteousness. And the unusual feature here was not the assertion of sovereignty over the French tradition, the claim that art history was now definitively being made on these shores – correct, as it turned out. It was, rather, the declaration of total moral monopoly, the separation of the tiny minority in possession of the absolute from the unwashed materialist multitudes.

To be sure, the question for sublimity invariably emerged as a call *against institutional authoritarianism and was always considered to be a meaningful gesture of defiance against repression.* "There," said Clyfford Still, speaking of his role in the '40s, "I had made it clear that a single stroke of paint, backed by work and a mind that understood its potency and implications, could restore to man the freedom lost in twenty centuries of apologies and devices for subjugation."[11] How one might relate such an overwrought mood to the prevailing fear of atomic destruction is a baffling and disturbing question.

Looking back on this issue, the art historian Robert Rosenblum saw it characteristically in art historical terms:

> . . . a quartet of the largest canvases by Newman, Still, Rothko, and Pollock might well be interpreted as a post-World War II myth of genesis. During the Romantic era, the sublimities of nature gave proof of the divine; today, such supernatural experiences are conveyed through the abstract medium of paint alone.[12]

Their affinity with, one would hesitate to call it a historical derivation from, the deserted, magniloquent, and awesome landscapes of Romantic painting obviously furthered nationalist overtones for these artists as well. By 1950, in none of the recently occupied and worn-out countries could there be painting of such naked, prepossessing self-confidence, such a metaphoric equation of the grandeur of one's homeland with religious veneration.

Still, it would misrepresent this art to call it internally assured. As the '50s wore on, it became evident that however original in pictorial style, American painters had emotional ties with the anxieties and dreads of French existentialism. It is true that they disengaged themselves from the typical Sartrean problem of the translation of personal to political liberty, but they showed great concern for his notion that one is condemned to freedom, that the very necessity to create oneself, to give oneself a distinguishable existence, was a desperate, fateful plight.

> The tension of the private myth is the content of every painting of this vanguard. The act on the canvas springs from an attempt to resurrect the saving moment in his "story" when the painter first felt himself released from Value – myth of past self-recognition. Or it attempts to initiate a new moment in which the painter will realize his total personality – myth of future self-recognition.[13]

From a quite famous essay, "The American Action Painters," Harold Rosenberg's sonorous remarks were designed to reveal the heights to which the gestural side of our art as-

pired by indicating the precipices off which the psychology of gesture might easily fall. One false step, one divergence from the "real act," and you produced merely "apocalyptic wallpaper."

> In terms of American tradition, the new painters stand somewhere between Christian Science and Whitman's "gangs of cosmos." That is, between a discipline of vagueness by which one protects oneself from disturbance while keeping one's eyes open for benefits; and the discipline of the Open Road of risk that leads to the farther side of the object and the outer spaces of the consciousness.[14]

It is certain that however much they may have disagreed with these dialectics, painting, for the American vanguardists, was often an uncertain and obstacle-prone activity, rife with internal challenges to authentic feeling, in which, "As you paint, changing and destroying, nothing can be assumed."[15] Behind their bravado and machismo, a more authentically insecure note is sounded, a tingle of fear in the muscle, acknowledging the very real possibility of sudden failure, and with that, something far more serious indeed, loss of identity. False consciousness was a not so secret enemy within the artist's organism. Rosenberg's article itself ended with an attack on the taste bureaucracy, the enemy without, which was witlessly drawn to modern art for reasons of status, and could not grasp the morality of the quivering strokes for which his whole piece was a singular promotion.

During the '50s the world-policing United States experienced a series of checks and frustrations that made it both a more sobering and uneasy place in which to live. Washington launched policies on the basic assumption that a loss of face and U.S. backdown in any area of the globe, no matter how remote, would bring about an adverse shift in the balance of power. Even a local defeat would amplify our weakness, shake faith in our resolve, and leave countless nations exposed to our communist enemies. One tends to forget that the domino theory, with its paranoid vision, budded over 20 years ago. It was an era of confrontation. To meet trial and crisis, American bases hemmed in the Iron Curtain on every front, radar nets were extended at ever further remove from our boundaries, the nuclear arsenal was expanded, SAC B-52's flew stepped-up patrol missions, and the defense budget and the armaments industry grew at an accelerated pace. But American influence could not match American power, despite its offensive and defensive potential.

Events proved that we could no more cross the Yalu River with impunity than we could aid the Hungarians when they revolted against Soviet manipulation. Eisenhower's "New Look" depended on the deterrence of "massive retaliation," consistent with the idea that the presence of hyperdestructive weaponry could resolve issues beyond the reach of inadequate manpower in the field. But this concept did not lend itself to flexibility. The discrepancy between commanding rhetoric and the control of actual affairs proved so evident that a noxious climate of suspicion, jingoism, apathy, and megalomania envenomed the American atmosphere. "There are many depressing examples," writes Charles Yost,

> of international conflicts in which leaders have first aroused their own people against a neighbor and then discovered to their chagrin that even when they judged the time had come to move toward peace, they were prisoners of the popular passions they had stimulated.[16]

Such was the situation that set the scattered American left in retreat and brought forth the full ire of right-wing criticism of government policy in the American '50s. This mani-

fested itself in a fusillade of civil-rights suppressions, and quickly became exemplified by the choke of McCarthyism.

Liberal personalities in sensitive or influential positions were purged in an ever more promiscuous campaign to root out the cancer of supposed disloyalty. Superpatriots, in their intimidating cry, "Twenty years of treason," conceived that there was as much an internal danger to their ideal America as the foreign threat. A superiority complex began to impose upon American civilization a form of demagogic thought control, ever more sterile, rigid, and unreal, with particular animus against intellectuals of the Eastern variety, stigmatized as "eggheads." Ironically, Stevenson, the chief egghead, felt obliged when campaigning against Eisenhower, to accuse him of not doing enough to stop the communists.

It was in the interest of federal government to ward off the accusations that would undermine its credibility as a bona fide cold warrior.

> You have to take chances for peace, just as you must take chances in war. Of course we were brought to the verge of war. The ability to get to the verge without getting into war is the necessary art . . . If you try to run away from it, if you are scared to go to the brink, you are lost. We've had to look it square in the face. We took strong action.[17]

Thus, John Foster Dulles explaining his policy of brinksmanship. In this unwitting mockery of existential realism, such cliff-hanging willingness to gamble the fate of millions (as at Quemoy and Matsu), was naturally accompanied by a persistent negative pattern of action: the refusal to negotiate or instrument test-ban treaties and disarmament proceedings. Moreover, Dulles' ideology of risk, really a form of international "chicken," was steeped in the pieties of Christian faith, whose application, just the same, required "the necessary art." However, the atmosphere eventually became so nightmarish that the conservative Republican, Eisenhower, went to the summit with Krushchev, in tacit admission that a stalemate had been reached.

The "haunted fifties," as I. F. Stone called the decade, acted as a psychological depressant on the national consciousness. At Little Rock, the desperation of blacks became once more visible and stayed just as unrectified. Under the gospel of anticolonialism and defense of freedom, the United States was supporting a multitude of corrupt and petty dictators. For all our energy, growth, affluence, and progressiveness, the Pax Americana emerged as the chief banner of counter-revolution. Under the stupefying, stale impact of these contradictions, a whole college generation earned the title "silent," while others, no less conformist in their way, dropped out among the beats. Separated by only a very few years, there appeared William Whyte's *The Organization Man* and Paul Goodman's *Growing Up Absurd*. Mort Sahl could quip that the federal government lived in mortal fear of being cut off without a penny by General Motors, a mild enough acknowledgement, during the plethora of sick jokes, of who was really in charge.

> In 1958, Dwight Macdonald submitted an article to *Encounter* – 'America! America!' – in which he wondered whether the intellectuals' rush to rediscover their native land (one of the obsessive concerns of the fifties, at almost every level of cultural life) had not produced a somewhat uncritical acquiescence in the American imperium.[18]

Encounter magazine, which rejected Macdonald's piece, was sponsored by the Congress for Cultural Freedom, all of whose branches were discovered, by the '60s, to be sup-

ported secretly by dummy foundations set up by the CIA. Here was a group of prominent Cold War intellectuals who

> had achieved both autonomy and affluence, as the social value of their services became apparent to the government, to corporations, and to foundationsThe modern state, among other things, is an engine of propaganda, alternately manufacturing crises and claiming to be the only instrument which can effectively deal with them. This propaganda, in order to be successful, demands the cooperation of writers, teachers, and artists not as paid propagandists or as state censored timeservers but as free intellectuals.[19]

It signifies a new sophistication in bureaucratic circles that even dense and technical work of the intelligentsia, as long as it was self-censoring in its professional detachment from values, could be used ambassadorially as a commodity in the struggle for American dominance.

If this country was unrivaled in industrial capacity and military might, it must follow that we had a culture of our own, too. One ought not, therefore, be surprised to see the fading away during the late '50s of the official conviction that modern art, however incomprehensible, was subversive. While conquering all worthwhile critics and curators on its home territory, in the process being imitated a hundredfold in every art department in the country, Abstract Expressionism had also acquired fame in the media and riches in the support of culturally mobile middle-class collectors. A second and even third generation of followers, many of them trained on the G.I. Bill or on Fulbright scholarships, had testified to the virility of its original principles. But this onslaught of acceptance, that so vitiated its proud alienation and so undermined its concept of inhospitable life in America, went far to traumatize the movement. It was at the point of a stylistic hesitation that the work of the Abstract Expressionists was sent abroad by official agencies as evidence of America's coming of creative age. Where the USIA had earlier capitulated to furious reaction from right-wing groups when attempting exhibitions of nonrepresentational art or work by "communist tinged" painters, it was now able to mount, without interference, a number of successful programs abetted and amplified by the International Council of The Museum of Modern Art. While the Museum played a pivotal role in making our painting accessible across the seas, private dealers had already initiated the export process as early as 1950. But now it was to be the austere and eruptive canvases of the early masters, those lordly things, that came to European attention through well organized and publicized traveling shows. This occurred during one of the repeated dips in America's image on the continent. Making much headway in England and Germany, less in France and Italy, the *New American Painting,* as it was called in an important show of 1959, furnished out-of-date and over-simplified metaphors of the actual complexity of American experience.

At the risk of considerable schematization, I would say that the torments of the '50s had enervated and ground down the ideological faculty of the American artist. Never comfortable with manifestoes, he embarked now into an ironic, twisted, and absurdist "Neo-Dada," as it was at first known, or a distinctly impersonal, highly engineered chromatic abstraction. Significantly, neither of these modes pretended any philosophical or moral claims at all – the better, as it turned out, to *specify* sensations and appearances in the immediate environment. Technology had shown, with dazzling conviction, that means were more important than ends, and that in the vacuum of a society that was losing a sense of its goals, professionalism and specialization had utmost value. Now that

their mentors had shown that American art could be "mainstream," members of the younger generation could release their pent-up fascination for their surroundings without fear of being taken – or sometimes even delighting in being taken – for regionalists. In this flattened ethical landscape, public information, often of the most trivial, alarming, or contradictory character, held almost cabalistic sway for a huge percentage of artists. Reciprocally, this meant that there would be greater intensity but also shorter attention spans in the popular regard for what they did. Art thinking, that had been yoked to one field theory for several years, now gave evidence of breaking into many differing spheres of ephemeral, specialized interest. Public conditions stimulated an extreme acceleration of artistic change.

Whether they expanded or restricted the flow of available information, the younger artists tended to adopt a morally neutral stand except to the absorbing studio tasks at hand. Discredited for them were the he-man clichés that once magnified the would-be potentials of art and that bespoke of thorough refusal to accommodate the artistic enterprise to the tastes of the bourgeois audience. In place of Olympian but self-pitying humanism, they insisted on functional attitudes and a cool tone. No longer, for instance, was there any agonizing over personal identity or spiritual resources, the bugbears of crisis-oriented Action painters. Without undue pangs of conscience, work got done almost on a production-line basis.

To speed this mythless art, the '60s provided the tempi of enthusiasm. McNamara's "cost effectiveness" and Kennedy's Youth Corps and Alliance for Progress seemed at the time a heady combination of objectives that would leave behind the embarrassment of Sputnik and the U-2 incident. A "can-do" mentality promised momentum away from the stagnation of the Republican years. Pledging to end a fictional missile gap, the new president also engendered plans for flexible counterinsurgency, created the Green Berets, and masterminded the Bay of Pigs fiasco. Politics became a theater of charismatic hard-sell. Science in the universities became a colony of the defense industry. Contingency plans, doomsday scenarios, think tanks, the Velvet Underground, Cape Canaveral, the drug culture: all this hard- and software, to use terms coined during the period, bobbled together in that indigestible stew of sinister, campy, solid-state effluvia with which the American '60s inundated the world. In retrospect, there is a moment when we can see that Herman Kahn, "thinking the unthinkable," and Andy Warhol, wishing that everyone were like a machine, participate in the same sensibility.

In the beginning, there was Jasper Johns and Robert Rauschenberg. The interest both these men had in the work of Marcel Duchamp and the composer John Cage, from the late '50s on, indicates a deflationary impulse, as far at least as serious, grand manner abstraction was concerned. But it is still a moot point whether the American flags of the one, or the images of Kennedy in the art of the other, were derisory in any social sense. These two artists took from Dada neither its scornful theater nor its lightsome subversions, but rather its malleability, even its ambivalence. The absence in their work of any hierarchical scheme, either of subject or formal relation, was, in any event, far less malign than in Dada. Part of the difference may be explained by the fact that the American polity, unlike the sprawling chaos of the early European interregnum, maintained a high ratio of stability to prosperity. The possibilities of the sardonic were limited in a country whose youth, more and more during these years, was oriented to scientific careerism.

"What does he love, what does he hate?" asked Fairfield Porter of Johns. "He manipulates paint strokes like cards in a patience game."[20] Time and again, the note struck in his work, and that of Rauschenberg, is of a fascinated passivity. It fell to these brilliant

Southerners to materialize the slippage of facts from one context to another, the possibilities inherent in the blurring of all definitions, the mutually enhancing collision of programmed chance and standard measurement. And all this was understood in the larger mental simulacrum of a game structure in which, not the potentials, but the deceits of form became the main issue. Theirs was an intellectual response that acknowledged pointlessness by making a subject out of it. They found in the numbness that afflicted any sensitive citizen agog before the disjunctive media stimuli of his world, a source of iconic energy. Instead of an arena of subjective human reflexes and editorialized sentiment, dominated with allusions to man and his space, they conjured a plane laden with neutralized objects or images of objects.

The commercial success of the Pop artists, legatees of Johns and Rauschenberg, is bound up for us, at its inception in 1962 as it is now, with their commercial subjects and styles. There was repeated all over again the controversy that Realist incursions into high art, like Courbet's, had originally provoked. The greatest heat was generated by the question: "Is any of this material esthetically transformed?" However, this time there was no socialist creed to add fuel to the debate – only an objectivity that seemed a mask for the celebration of what everyone, even the artists themselves, admitted to be the most abrasive images in the American urbanscape. Pop symptomized, more than it contributed to, an age noted for visual diarrhea. In that charged atmosphere around the time of the Cuban missile crisis of 1962, the "New Realist" show at the Sidney Janis Gallery deceived some into thinking that a political statement, in accord with their views or not, had been decreed in American art. If anything, however, its omission of any political *parti pris,* in contrast to its highly flagrant themes of crimes, sex, food, and violence gave Pop art the most insurrectionary value. Few people could speak coolly about it at all.

One of the exceptions over a long period, Lawrence Alloway, later wrote:

> As an alternative to an aesthetic that isolated visual art from life and from the other arts, there emerged a new willingness to treat our whole culture as if it were art . . . It was recognized in London for what it was ten years ago, a move towards an anthropological view of our society . . . the mass media were entering the work of art and the whole environment was being regarded, reciprocally, by the artists as art, too.[21]

In contrast, Ivan Karp, who dealt in their works, pleaded the case of Warhol, Rosenquist, and Lichtenstein under the banner "Sensitivity is a bore." "Common Image Art," as he called it,

> is downright hostile. Its characters and objects are unabashedly egotistical and self-reliant. They do not invite contemplation. The style is happily retrograde and thrillingly insensitive . . . It is too much to endure, like a steel first pressing in the face.[22]

The worship of brutality and the sociology of popular media as legitimate art folklore, both these attitudes, early and recent, add to rather than distort the record of the movement. For Pop art was simultaneously a tension-building and relieving phenomenon. It processed many of the most encroaching, extreme, and harsh experiences of American civilization into a mesh of grainy rotogravure or a phantasm taken from the dotted pulsations on the face of a cathode tube. Lichtenstein's *Torpedo Los,* cribbed from a comic about a Nazi sub commander, was placed with jokey topicality in the era of Polaris sub-

marines. Here was an art that could shrewdly feed on the Second World War while keeping present, and yet assuaging, the fears of the Cold War.

On the national level, during those early years of the '60s, events were most confused. Under Kennedy the social scene had become relatively enlightened, style conscious, and permissive, with chic and fey undergrounds rivaling the White House court. Without extending himself very much toward the arts, the President made headway among intellectuals by inviting Malraux and Stravinsky to sup at his table. (The composer thought the presidential pair "a couple of nice kids.") Meanwhile, Harvard professors were industriously planning strategy that would inaugurate ten years of mayhem in Vietnam. Culturally there ensued a kind of literate bad faith, the camp attitude, which was never so bitter as cynicism nor so unsophisticated as to allow for moral judgments. It became a necessary emotional veneer for audiences to feel removed from, yet assimilate with full indulgence of their typed, insolent glamorly impulses, events and objects they knew to be hideous and depraved. For having discovered this formula in art, Pop was instantly acculturated and coopted by the mass media upon which it preyed.

The immense publicity and patronage these artists enjoyed was surely no put-on. The masses at large had at last found an avant-garde sensation which they could appreciate quite justifiably on extraesthetic grounds, while its esoteric origins lent piquancy to its appeal. If it had not already had rock music, a whole younger generation could have learned the disciplines of mod cool from Pop art alone. As could never be with Abstract Expressionism, Pop artists and their clients mutually manipulated each other. There were high dividends of communications feedback and product promotion that were difficult to overlook, especially during the epoch when consumership was based almost entirely on style, and packaging had tacitly nothing to do with the value of goods received. Yet the upper bourgeois collectors who boosted Pop art with such adventurism were genuine enthusiasts.

The stereotype that they were parvenu vulgarians, on a taste level with the images they so vocally adored, has to be modified under analysis. It is true that some of them were self-made men of nouveau-riche status, but this does not distinguish them at all from the field of the postwar monied in America. Professional or in business, most of them had seriously collected the Abstract Expressionists a few short years before. Pop art, oddly enough, given its exaltation of the standardized, but also explainably, considering its glorification of success, flattered their sense of individualism. Moreover, "Now middle-aged or older, they identify the pop movement with their children's generation. To own these works, they feel, is to stay young."[23] Perhaps an even more telling consideration was the excitement this art suffused in them as an absolutely up-to-the minute visual phenomenon, a condition they often interpreted by crowding out even their furniture with a plethora of Pop works that could no longer be looked at singly, but had to be taken in montage fashion, with that nonlinear, noncontemplative élan of the trendy Marshall McLuhan.

The Pop artist behaved with aplomb as a celebrity in the New York art world. Such an elevation to stardom, the while he was compelled to behave as a rising businessman, gave to the artist a recognizably new psychology. It was in a spirit of realism that Allan Kaprow, speaking generally of many different studio types, described what he thought were their relevant traits in a much-read article of 1964, "Should the Artist Become a Man of the World?" Kaprow had discerned not only the collapse of Bohemia, and that "the artist could no longer succeed by failing," but that he was a college trained, white collar bourgeois himself, who resembled the "personnel in other specialized disciplines and industries in America."[24] Best then, to make a moral adjustment and engage in the

politics of *culture,* for avoiding it is never to know whether one has proven oneself in "the presence of temptation or simply run away."[25] Kaprow managed to make accommodation to the prevailing cultural powers sound still a heroic task (a very clever insinuation), though it was probably an involuntary *fait accompli.* An echo of Abstract Expressionist high-mindedness lurked in this argument. He admonished the new artists that "Political awareness may be all men's duty, but political expertise belongs to the politician. As with art, only the full-time career can yield results" – a separatist line strikingly reminiscent of one taken by Rosenberg and Motherwell in 1948! And yet, as against this, Claes Oldenburg could draw very opposite conclusions three years later: "You must realize cops are just you and I in uniform . . . Art as life is murder . . . Vulgar USA civilization now beginning to interfere my art."[26]

The Kaprow article was published close in time to the Gulf of Tonkin resolution. In that same year, the dealer Leo Castelli printed an ad in *Art International* showing a map of Europe with little flags indicating shows by his artists in various cities, an unsubtle anticipation of victory at that summer's Venice Biennale. Earlier, Kennedy had come to see that domestic and third world liberties might not exactly flourish under a United States garrison mentality. He gave signs of lessening Cold War pressures, of curbing the CIA, and of ending racial discrimination in jobs. The August 1963 March on Washington, at which Martin Luther King spoke – "I have a dream" – symbolized the unappeased punishing inequity of the blacks. It was to herald, along with the Free Speech movement and student rebellion at Berkeley, the eruptions of the gathering New Left, all the protest, war sit-ins, strikes, guerrilla politics and peace vigils to come. After Kennedy had been killed, the nostalgic flavor of Pop art and the entertainment media in general became particularly evident, as if depiction of the present had all the heart go out of it.

The Pop artists became sporadically active on the fringe of dissent. Sometimes supported by their elders, they contributed to CORE, to many peace causes and moratoria against the Vietnam war. Rosenquist's extraordinary *F-111* could be read (few did so), as an indictment of United States militarism. (On the contrary, the big furor elicited by this work was caused by the relatively minor issue of its exhibition at the Metropolitan.) Rauschenberg secretly financed much of the Artists' Peace Tower against the war in Los Angeles in 1965. But he also celebrated the triumph of American space flight technology, the trip to the moon, for NASA in 1969.

The truth was that Pop art, whatever the angered political sentiments of its creators, was a mode captured by its own ambiguities, and cranked up willy-nilly to express benign sentiments. It could not have been Pop art, that beguiling invention, if its latencies of critique had not been sapped by its endorsement of business. Abroad, this flirtatious product of the "Great Society" was framed with maximum panache. At our lavish installation at the 1967 São Paulo Biennial, Hilton Kramer reported that "such a display of power cannot avoid carrying political implications in an international show . . . Some observers here, including the commissioners of the other national sections, have been quite vocal in condemning what they regard as an excessive display of wealth and chauvinism."[27] Under the tutelage of the National Collection of Fine Arts, Pop art could symbolize a continuing American freedom, but one whose supermarkets and synthetics had roosted in a score of different economies, and had come to speak above all of glut and complacency.

An entirely different kind of freedom was prefigured by the ultracompetitive colorfield and systemic abstractionists of the '60s. One sees in the art of Stella, late Louis, Noland, Kelly, Irwin, Poons, and Olitski, an institutionalized counterpart of Pop, polarized with regard to it more in idiom than the mechanized style they both shared. But

where Pop was timely and expansive, these artists upheld the timeless and the reductive. The symbolic values latent in such abstraction aspired to a vision of limitless control and ultimate, inhuman perfectibility (which was also a particular aspect of '60s America). The computer and transistorized age of corporate technology achieved in its striped and serialized emblems, its blocks or spreads of radiant hues, an acrylic metaphor of unsettling power.

Never, in modern art, had such a "purist" enterprise been deployed without recourse to utopian or "futurist" justifications, and it was perhaps because of its very muteness on this point that color-field abstraction now seems to us, in terms of American self-imagery on the world scene, the stick behind the carrot.

The antiseptic surfacing, the compressed, two-dimensional designing, the optical brilliance, and the gigantism of this art's scale, invoke a far more mundane awe than the sublime. And yet, no one can categorize the sources that stimulated this openness of space, or say of such painting that it refers to a concrete experience. Nothing interferes with the efficient plotting of its structure – in fact, efficiency itself becomes its pervasive ideal. The strength, sometimes even the passion of this ideal, rescues the best of this work from the stigma of the decorative, but only to cause it all the more to seem the heraldry of managerial self-respect.

It would not be irrelevant that during this time, the conglomerate executives with their lobbyists and bankers, through the efforts of their technical elites, had achieved an unprecedented hold on the economy. "While in the realm of pure logic, a Federal Power Commission in Washington might tell Standard Oil of California what it might or might not do, in actual fact such an agency is less powerful than the corporation . . . This is the politics of capitalism."[28] It is fruitful to suppose that this diffused, invisible, but immensely consequential reality, with its subtle manipulations, would find some correspondence in the sensitized zone of capitalist art. As Pop art spoke best to the entrepreneurial collector, so expensive-looking color-field abstraction blazoned the walls of banks, boardrooms, and those corporate fiefs, the museums. Never as literally readable or cosmetic as Pop, this art had more appropriately chaste and hierarchical overtones whose stripped functioning materialized a code that was more intuitively grasped than rationally comprehended. No deciphering of the conventions of art was necessary for the corporate homage of this art to come across to its patrons. In that sense, though without subject in a strict iconographical sense, it was self-sufficient expressively, and by 1964, no later, immediately meaningful as a consumed signifier.

There is another, larger dimension in which it made itself felt, as well. America had become ugly, fouled with industrial wastes, and split with divisive forces. As Norman Mailer put it:

> America was torn by the specter of civil war, and many a patriot and many a big industrialist – they were so often the same – saw the cities and the universities as a collective pit of Black heathen, Jewish revolutionaries, a minority polyglot hirsute scum of nihilists, hippies, sex maniacs, drug addicts, liberal apologists and freaks. Crime pushed the American public to give birth to dreams of order. Fantasies of order had to give way to lusts for new order. Order was restraint, but new order would call for a mighty vault, an exceptional effort, a unifying dream.[29]

Without so intending, American abstraction of the '60s strikes us as the visual anagram of these "lusts for new order." There is something understandable, very contemporary, and also chilling in the spectacle this new art offered. As a psychedelic poster for a whiz-

bang at Fillmore East had its definite constituency, so chromatic abstraction would solace those in upper echelons who could not abide the inertial tugs and the irate spasms in the overheated ghettos of our national life.

None of this, however, can be assumed to have occupied the artists' conscious minds while at work. The gap between their own technical motives, the demiurge of form pursued for its own sake, and the rarefied prestige their art conferred upon its backers, does not seem to have occasioned any comment among them – nor did it have to. On the contrary, they had been socially insulated by a critical framework – an explanation of purpose and a means of analysis – called formalism. The ineffable criterion of this doctrine, the word "quality," was sparingly applied to those works which were considered to have advanced the possibilities of radical innovation in painting while maintaining vital contact with its tradition. The artists had to contend with professional standards – none outside formalism were allowable – that were at once more ambitious and yet more conservative than those in the business world. These standards were also nakedly authoritarian, but if nervous-making on that score, they at least assured a seemingly objective superiority to those that had met them.

It is curious that the word "quality," though more abstract in connotation than, say, "risk," is more onerous and arrogant in implication. One went through a rite of passage, a rigorously imposed set of limitations that took the place of any moral stance, and yet arrogated to itself a historical mission. The enemy here was not the defunct School of Paris, but upstart "far-out" American competitors. Clement Greenberg, critic emeritus of formalism, was an intellectual Cold Warrior who traveled during the '60s under government sponsorship to foreign countries with the good news of color-field's ascendance. This message, however, proved to be less noteworthy abroad than in our university art departments, where the styles of Noland and Olitski were perpetuated with a less than becoming innocence.

Meanwhile, if political agitation on the left failed to stir these masters (Stella excepted), the more attenuated, parodistic elements of late Pop sidled into their work. There had been finally less antagonism between them than hitherto supposed. But then, the determination of American art in general to draw nourishment from its environment has been one of its most natural yet underestimated features. Long after the war, our artists were still participating in the vitality of American experience, but they also had a taste of something darker and more demonic within it, the pathology of oppression. This was an awareness that has come increasingly to motivate their social unrest. Toward the end of this development, the time and space of the art of the '60s having run their course, as had the work of the two preceding decades, the Metropolitan Museum accorded it a giant retrospective, with all the honor that venerable establishment is capable of giving. But compared to the projections of fear and desire which underlie our art, that honor, a kind of imperial bearing in state, now looks insignificant indeed.

NOTES

1. Dean Acheson, in a conversation with the author at the Aspen Institute for Humanistic Studies, Aspen, Colorado, Summer, 1966.
2. Quoted in Stephen Ambrose, *Rise to Globalism*, Baltimore, 1971, p. 118.
3. Quoted by Barton Bernstein, "The Limitations of Pluck," *The Nation*, January 8, 1973, p. 40.
4. Quoted by Edward Alden Jewell, *The New York Times*, June 6, 1943, in Irving Sandler, *The Triumph of American Painting*, New York, 1970, p. 33.

5. Quoted in *New York School, The First Generation*, Los Angeles County Museum of Art, 1965, p. 11.
6. Robert Motherwell, "The Modern Painter's World," *Dyn VI*, 1944, quoted in Barbara Rose, *Readings in American Art Since 1900*, New York, 1968, pp. 130-131.
7. Motherwell, *ibid*.
8. Harold Rosenberg, "The American Action Painters," *Art News*, September, 1952, p. 37.
9. Max Kozloff, "An Interview with Robert Motherwell," *Artforum*, September 1965, p. 37.
10. Barnett Newman, "The Ideas of Art," *Tiger's Eye*, December 15, 1948, p. 53.
11. Clyfford Still, "An Open Letter to an Art Critic," *Artforum*, December, 1963, p. 32.
12. Robert Rosenblum, "The Abstract Sublime," *Art News*, February, 1961, p. 56.
13. Rosenberg, p. 48.
14. Rosenberg, *ibid*.
15. Philip Guston in "Philadelphia Panel," *It Is*, Spring, 1960, p. 34.
16. Charles Yost, *The Conduct and Misconduct of Foreign Affairs*, New York, 1972, quoted by James Reston in *The New York Times*, January 14, 1973.
17. John Foster Dulles, *Look* magazine, January, 1956, quoted in Ambrose, p. 225.
18. Christopher Lasch, "The Cultural Cold War," *Towards A New Past: Dissenting Essays in American History*, ed. Barton Bernstein, New York, 1969, p. 331.
19. Lasch, pp. 344-345.
20. Fairfield Porter, "The Education of Jasper Johns," *Art News*, February, 1964, p. 44.
21. Lawrence Alloway, "Popular Culture and Pop Art," *Studies in Popular Communication*, Panthe Record 7, 1969, p. 52.
22. Ivan Karp, "Anti-Sensibility Painting," *Artforum*, September, 1963, p. 26.
23. William Zinsser, *Pop Goes America*, New York, 1969, p. 24.
24. Allan Kaprow, "Should the Artist Become a Man of the World," *Art News*, October, 1964.
25. Kaprow, *ibid*.
26. Claes Oldenburg, "America: War & Sex, Etc.," *Arts Magazine*, Summer, 1967.
27. Hilton Kramer, "Art: United States' Exhibition Dominates Sao Paulo's 9th Biennial," *The New York Times*, September 20, 1967.
28. Andrew Hacker, *The End of the American Era*, New York, 1970, p. 68.
29. Norman Mailer, *Of a Fire on the Moon*, New York, 1971, p. 65.

THAT OLD THING, ART . . .

Roland Barthes

As all the encyclopedias remind us, during the fifties certain artists at the London Institute of Contemporary Arts became advocates of the popular culture of the period: comic strips, films, advertising, science fiction, pop music. These various manifestations did not derive from what is generally called an Aesthetic but were entirely produced by Mass Culture and did not participate in art at all; simply, certain artists, architects, and writers were interested in them. Crossing the Atlantic, these products forced the barrier of art; accommodated by certain American artists, they became works of art, of which culture no longer constituted the being, merely the reference: origin was displaced by citation. Pop art as we know it is the permanent theater of this tension: on one hand, the mass culture of the period is present in it as a revolutionary force which contests art; and on the other, art is present in it as a very old force which irresistibly returns in the economy of societies. There are two voices, as in a fugue – one says: "This is not Art"; the other says, at the same time: "I am Art."

Art is something which must be destroyed – a proposition common to many experiments of Modernity.

Pop art reverses values. "What characterizes pop is mainly its use of what is despised" (Lichtenstein). Images from mass culture, regarded as vulgar, unworthy of an aesthetic consecration, return virtually unaltered as materials of the artist's activity. I should like to call this reversal the "Clovis Complex": like Saint Remi addressing the Frankish king, the god of pop art says to the artist: "Burn what you have worshipped, worship what you have burned." For instance: photography has long been fascinated by painting, of which it still passes as a poor relation; pop art overturns this prejudice: the photograph often becomes the origin of the images pop art presents: neither "art painting" nor "art photograph," but a nameless mixture. Another example of reversal: nothing more contrary to art than the notion of being the mere reflection of the things represented; even photography does not support this destiny; pop art, on the contrary, accepts being an *imagery*, a collection of reflections, constituted by the banal reverberation of the American environment: reviled by high art, the copy returns. This reversal is not capricious, it does not proceed from a simple denial of value, from a simple rejection of the past; it obeys a regular historical impulse; as Paul Valéry noted (in *Pièces sur l'Art*), the appearance of new technical means (here, photography, serigraphy) modifies not only art's forms but its very concept.

Repetition is a feature of culture. I mean that we can make use of repetition in order to propose a certain typology of cultures. Popular or extra-European cultures (deriving from an ethnography) acknowledge as much, and derive meaning and pleasure from the fact (we need merely instance today's minimal music and disco); Occidental high culture does not (even if it has resorted to repetition more than we suppose, in the baroque period). Pop art, on the other hand, repeats – spectacularly. Warhol proposes a series of identical images (*White Burning Car Twice*) or of images which differ only by some slight

From the catalogue of the exhibition *Pop Art* at the Palazzo Grassi, Venice, first published by Electa, 1980; in France in the collection *L'obvie et l'obtus*, Edition du Seuil, Paris, 1982; and in the English translation by Richard Howard in *The Responsibility of Forms*. Translation © 1985 by Farrar, Straus & Giroux, Inc.

variation of color (*Flowers, Marilyn*). The stake of these repetitions (or of Repetition as a method) is not only the destruction of art but also (moreover, they go together) another conception of the human subject: repetition affords access, in effect, to a different temporality: where the Occidental subject experiences the ingratitude of a world from which the New – i.e., ultimately, Adventure – is excluded, the Warholian subject (since Warhol is a practitioner of these repetitions) abolishes the pathos of time in himself, because this pathos is always linked to the feeling that something has appeared, will die, and that one's death is opposed only by being transformed into a second something which does not resemble the first. For pop art, it is important that things be "finite" (outlined: no evanescence), but it is not important that they be finished, that work (is there a work?) be given the internal organization of a destiny (birth, life, death). Hence we must unlearn the boredom of the "endless" (one of Warhol's first films, *Four Stars*, lasted twenty-five hours; *Chelsea Girls* lasts three and a half). Repetition disturbs the person (that classical entity) in another fashion: by multiplying the same image, pop art rediscovers the theme of the Double, of the Doppelgänger; this is a mythic theme (the Shadow, the Man or the Woman without a Shadow); but in the productions of pop art, the Double is harmless – has lost all maleficent or moral power, neither threatens nor haunts: the Double is a Copy, not a Shadow: *beside,* not *behind:* a flat, insignificant, hence irreligious Double.

Repetition of the portrait induces an adulteration of the person (a notion simultaneously civic, moral, psychological, and of course historical). Pop art, it has also been said, takes the place of a machine; it prefers to utilize mechanical processes of reproduction; for example, it freezes the star (Marilyn, Liz) in her image *as star:* no more soul, nothing but a strictly imaginary status, since the star's being is the icon. The object itself, which in everyday life we incessantly personalize by incorporating into our individual world – the object is, according to pop art, no longer anything but the residue of a subtraction: everything left over from a tin can once we have mentally amputated all its possible themes, all its possible uses. Pop art is well aware that the fundamental expression of the person is style. As Buffon said (a celebrated remark, once known to every French schoolboy): "Style is the man." Take away style and there is no longer any (individual) man. The notion of style, in all the arts, has therefore been linked, historically, to a humanism of the person. Consider an unlikely example, that of "graphism": manual writing, long impersonal (during Antiquity and the Middle Ages), began to be individualized in the Renaissance, dawn of the modern period; but today, when the person is a moribund idea, or at least a menaced one, under the pressure of the gregarious forces which animate mass culture, the personality of writing is fading out. There is, as I see it, a certain relation between pop art and what is called "script," that anonymous writing sometimes taught to dysgraphic children because it is inspired by the neutral and, so to speak, elementary features of typography. Further, we must realize that if pop art depersonalizes, it does not make anonymous: nothing is more identifiable than Marilyn, the electric chair, a telegram, or a dress, as seen by pop art; they are in fact *nothing but that:* immediately and exhaustively identifiable, thereby teaching us that identity is not the person: the future world risks being a world of identities (by the computerized proliferation of police files), but not of persons.

A final feature which attaches pop art to the experiments of Modernity: the banal conformity of representation to the thing represented. "I don't want a canvas," Rauschenberg says, "to look like what it isn't. I want it to look like what it is." The proposition is aggressive in that art has always regarded itself as an inevitable detour that must be taken

in order to "render" the truth of the thing. What pop art wants is to desymbolize the object, to give it the obtuse and matte stubbornness of a fact (John Cage: "The object is a fact, not a symbol"). To say the object is asymbolic is to deny it possesses a profound or proximate space through which its appearance can propagate vibrations of meaning: pop art's object (this is a true revolution of language) is neither metaphoric nor metonymic; it presents itself cut off from its source and its surroundings; in particular, the Pop artist does not stand *behind* his work, and he himself has no depth: he is merely the surface of his pictures: no signified, no intention, anywhere. Now the fact, in mass culture, is no longer an element of the natural world; what appears as fact is the stereotype: what everyone sees and consumes. Pop art finds the unity of its representations in the radical conjunction of these two forms, each carried to extremes: the stereotype and the image. Tahiti is a fact, insofar as a unanimous and persistent public opinion designates this site as a collection of palm trees, of flowers worn over one ear, of long hair, sarongs, and languorous, enticing glances (Lichtenstein's *Little Aloha*). In this way, pop art produces certain *radical images:* by dint of being an image, the thing is stripped of any symbol. This is an audacious movement of mind (or of society): it is no longer the fact which is transformed into an image (which is, strictly speaking, the movement of metaphor, out of which humanity has made poetry for centuries), it is the image which becomes a fact. Pop art thus features a philosophical quality of things, which we may call *facticity:* the *factitious* is the character of what exists as fact and appears stripped of any justification: not only are the objects represented by pop art factitious, but they incarnate the very concept of facticity – that by which, in spite of themselves, they begin to signify again: they signify that they signify nothing.

For meaning is cunning: drive it away and it gallops back. Pop art seeks to destroy art (or at least to do without it), but art rejoins it: art is the counter-subject of our fugue.

The attempt has been made to abolish the signified, and thereby the sign; but the signifier subsists, persists, even if it does not refer, apparently, to anything. What is the signifier? Let us say, to be quick about it: the thing perceived, augmented by a certain thought. Now, in pop art, this supplement exists – as it exists in all the world's arts.

First of all, quite frequently, pop art changes the level of our perception; it diminishes, enlarges, withdraws, advances, extends the multiplied object to the dimensions of a signboard, or magnifies it as if it were seen under a jeweler's *loupe.* Now, once proportions are changed, art appears (it suffices to think of architecture, which is an art of *the size of things*): it is not by accident that Lichtenstein reproduces a *loupe* and what it enlarges: *Magnifying Glass* is in a sense the emblem of pop art.

And then, in many works of pop art, the background against which the object is silhouetted, or even out of which it is made, has a powerful existence (rather of the kind clouds had in classical painting): there is an importance of the grid. This comes, perhaps, from Warhol's first experiments: serigraphs depend on textile (textile and grid are the same thing); it is as if our latest modernity enjoys this manifestation of the grid, at once consecrating the raw material (grain of the paper in Twombly's work) and the mechanization of reproduction (micro-pattern of the computer portraits). Grid is a kind of obsession (a thematics, criticism would have said not long ago); it participates in various exchanges: its perceptual role is inverted (in Lichtenstein's aquarium, water consists of polka dots); it is enlarged in a deliberately infantile fashion (Lichtenstein's sponge consists of holes, like a piece of Gruyère); the mechanical texture is exemplarily imitated (again, Lichtenstein's *Large Spool*). Here art appears in the emphasis on what should be insignificant.

Another emphasis (and consequently another return of art): color. Of course, everything found in nature and a fortiori in the social world is colored; but if it is to remain a factitious object, as a true destruction of art would have it, its color itself must remain *indeterminate*. Now, this is not the case: pop art's colors are intentional and, we might even say (a real denial), subject to a *style:* they are intentional first of all because they are always the same ones and hence have a thematic value; then because this theme has a value as meaning: pop color is openly chemical; it aggressively refers to the artifice of chemistry, in its opposition to Nature. And if we admit that, in the plastic domain, color is ordinarily the site of pulsion, these acrylics, these flat primaries, these lacquers, in short these colors which are never shades, since nuance is banished from them, seek to cut short desire, emotion: we might say, at the limit, that they have a moral meaning, or at least that they systematically rely on a certain frustration. Color and even substance (lacquer, plaster) give pop art a meaning and consequently make it an art; we will be convinced of this by noticing that pop artists readily define their canvases by the color of the objects represented: *Black Girl, Blue Wall, Red Door* (Segal), *Two Blackish Robes* (Dine).

Pop is an art because, just when it seems to renounce all meaning, consenting only to reproduce things in their platitude, it stages, according to certain methods proper to it and forming a style, an object which is neither the thing nor its meaning, but which is: its signifier, or rather: the Signifier. Art – any art, from poetry to comic strips – exists the moment our glance has the Signifier as its object. Of course, in the productions of art, there is usually a signified (here, mass culture), but this signified, finally, appears in an *indirect* position: obliquely, one might say; so true is it that meaning, the play of meaning, its abolition, its return, is never anything but a *question of place.* Moreover, it is not only because the pop artist stages the Signifier that his work derives from and relates to art; it is also because this work is *looked at* (and not only seen); however much pop art has depersonalized the world, platitudinized objects, dehumanized images, replaced traditional craftsmanship of the canvas by machinery, some "subject" remains. What subject? The one who looks, in the absence of the one who makes. We can fabricate a machine, but someone who looks at it is not a machine – he desires, he fears, he delights, he is bored, etc. This is what happens with pop art.

I add: pop is an art of the essence of things, it is an "ontological" art. Look how Warhol proceeds with his repetitions – initially conceived as a method meant to destroy art: he repeats the image so as to suggest that the object trembles before the lens or the gaze; and if it trembles, one might say, it is because it seeks itself: it seeks its essence, it seeks to put this essence before you; in other words, the trembling of the thing acts (this is its effect-as-meaning) as a pose: in the past, was not the pose – before the easel or the lens – the affirmation of an individual's essence? Marilyn, Liz, Elvis, Troy Donahue are not presented, strictly speaking, according to their contingency, but according to their eternal identity: they have an "eidos," which it is the task of pop art to represent. Now look at Lichtenstein: he does not repeat, but his task is the same: he reduces, he purifies the image in order to intercept (and offer) what? its rhetorical essence: here art's entire labor consists not, as in the past, in streamlining the stylistic artifices of discourse, but, on the contrary, in cleansing the image of everything in it which is not rhetoric: what must be expelled, like a vital nucleus, is the code essence. The philosophical meaning of this labor is that modern things have no essence other than the social code which manifests them – so that ultimately they are no longer even "produced" (by Nature), but immediately "reproduced": reproduction is the very being of Modernity.

We come full circle: not only is pop art an art, not only is this art ontological, but even

its reference is finally – as in the highest periods of classical art – Nature; not of course the vegetal, scenic, or human (psychological) Nature: Nature today is the social absolute, or better still (for we are not directly concerned with politics) the Gregarious. This new Nature is accommodated by pop art, and moreover, whether it likes it or not, or rather whether it admits it or not, pop art criticizes this Nature. How? By imposing a *distance* upon its gaze (and hence upon our own). Even if all pop artists have not had a privileged relation with Brecht (as was Warhol's case during the sixties), all of them practice, with regard to the object, that repository of the social relation, a kind of "distancing" which has a critical value. However, less naïve or less optimistic than Brecht, pop art neither formulates nor resolves its criticism: to pose the object "flat out" is to pose the object at a distance, but it is also to refuse to say how this distance might be corrected. A cold confusion is imparted to the consistency of the gregarious world (a "mass" world); the disturbance of our gaze is as "matte" as the thing represented – and perhaps all the more terrible for that. In all the (re-)productions of pop art, one question threatens, challenges: "*What do you mean?*" (title of a poster by Allen Jones). This is the millennial question of that very old thing: Art.

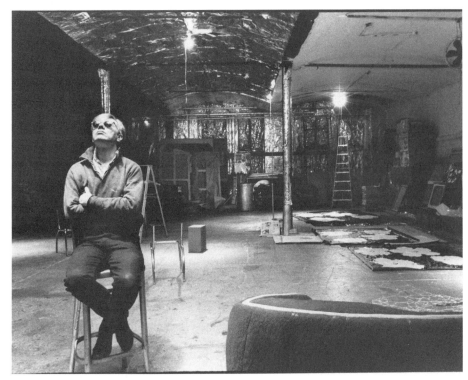

Andy Warhol portrait in the Factory, circa 1964–65. Photograph by Ugo Mulas.

THE RISE OF ANDY WARHOL

Robert Hughes

To say that Andy Warhol is a famous artist is to utter the merest commonplace. But what kind of fame does he enjoy? If the most famous artist in America is Andrew Wyeth, and the second most famous is LeRoy Neiman (Hugh Hefner's court painter, inventor of the Playboy femlin, and drawer of football stars for CBS), then Warhol is the third. Wyeth, because his work suggests a frugal, bare-bones rectitude, glazed by nostalgia but incarnated in real objects, which millions of people look back upon as the lost marrow of American history. Neiman, because millions of people watch sports programs, read *Playboy,* and will take any amount of glib abstract-expressionist slather as long as it adorns a recognizable and pert pair of jugs. But Warhol? What size of public likes his work, or even knows it at first hand? Not as big as Wyeth's or Neiman's.

To most of the people who have heard of him, he is a name handed down from a distant museum-culture, stuck to a memorable face: a cashiered Latin teacher in a pale fiber wig, the guy who paints soup cans and knows all the movie stars. To a smaller but international public, he is the last of the truly successful social portraitists, climbing from face to face in a silent delirium of snobbery, a man so interested in elites that he has his own

The New York Review of Books, February 18, 1982: 6-10

society magazine. But Warhol has never been a *popular* artist in the sense that Andrew Wyeth is or Sir Edwin Landseer was. That kind of popularity entails being seen as a normal (and hence, exemplary) person from whom extraordinary things emerge.

Warhol's public character for the last twenty years has been the opposite: an abnormal figure (silent, withdrawn, eminently visible but opaque, and a bit malevolent) who praises banality. He fulfills Stuart Davis' definition of the new American artist, "a cool Spectator-Reporter at an Arena of Hot Events." But no mass public has ever felt at ease with Warhol's work. Surely, people feel, there must be something empty about a man who expresses no strong leanings, who greets everything with the same "uh, gee, great." Art's other Andy, the Wyeth, would not do that. Nor would the midcult heroes of *The Agony and the Ecstasy* and *Lust for Life.* They would discriminate between experiences, which is what artists are meant to do for us.

Warhol has long seemed to hanker after the immediate visibility and popularity that "real" stars like Liz Taylor have, and sometimes he is induced to behave as though he really had it. When he did ads endorsing Puerto Rican rum or Pioneer radios, the art world groaned with secret envy: what artist would not like to be in a position to be offered big money for endorsements, if only for the higher pleasure of refusing it? But his image sold little rum and few radios. After two decades as voyeur-in-chief to the marginal and then the rich, Warhol was still unloved by the world at large; all people saw was that weird, remote guy in the wig. Meanwhile, the gesture of actually being in an ad contradicted the base of Warhol's fame within the art world. To the extent that his work was subversive at all (and in the sixties it was, slightly), it became so through its harsh, cold parody of ad-mass appeal – the repetition of brand images like Campbell's soup or Brillo or Marilyn Monroe (a star being a human brand image) to the point where a void is seen to yawn beneath the discourse of promotion.

The tension this set up depended on the assumption, still in force in the sixties, that there was a qualitative difference between the perceptions of high art and the million daily instructions issued by popular culture. Since then, Warhol has probably done more than any other living artist to wear that distinction down; but while doing so, he has worn away the edge of his work. At the same time, he has difficulty moving it toward that empyrean of absolute popularity, where LeRoy Neiman sits, robed in sky-blue polyester. To do that, he must make himself accessible. But to be accessible is to lose magic.

The depth of this quandary, or perhaps its lack of relative shallowness, may be gauged from a peculiar exhibition mounted in November 1981 by the Los Angeles Institute of Contemporary Art: a show of portraits of sports stars, half by Neiman and half by Warhol, underwritten by Playboy Enterprises. It was a promotional stunt (LAICA needed money, and exhibitions of West Coast conceptualists do not make the turnstiles rattle), but to give it a veneer of respectability the Institute felt obliged to present it as a critique of art world pecking orders. Look, it said in effect: Neiman is an arbitrarily rejected artist, whose work has much to recommend it to the serious eye (though *what,* exactly, was left vague); we will show he is up there with Warhol.

This effort backfired, raising the unintended possibility that Warhol was down there with Neiman. The Warhol of yore would not have let himself in for a fiasco like the LAICA show. But then he was not so ostentatiously interested in being liked by a mass public. This may be why his output for the last decade or so has floundered – he had no real subjects left; why *Interview,* his magazine, is less a periodical than a public relations sheet; and why books like *Exposures* and *POPism* get written.[1]

Between them *POPism: The Warhol '60s* and *Exposures* give a fairly good picture of

Warhol's concerns before and after 1968, the year he was shot. Neither book has any literary merit, and the writing is chatty with occasional flecks of *diminuendo* irony – just what the package promises. *POPism* is mostly surface chat, *Exposures* entirely so. For a man whose life is subtended by gossip, Warhol comes across as peculiarly impervious to character. "I never know what to think of Eric," he says of one of his circle in the sixties, a scatterbrained lad with blond ringlets whose body, a postscript tells us, was found in the middle of Hudson Street, unceremoniously dumped there, according to "rumors," after he overdosed on heroin. "He could come out with comments that were so insightful and creative, and then the next thing out of his mouth would be something *so* dumb. A lot of the kids were that way, but Eric was the most fascinating to me because he was the most extreme case – you absolutely couldn't tell if he was a genius or a retard."[2]

Of course, poor Eric Emerson – like nearly everyone else around the Factory, as Warhol's studio came to be known – was neither. They were all cultural space-debris, drifting fragments from a variety of sixties-subcultures (transvestite, drug, S&M, rock, Poor Little Rich, criminal, street, and all the permutations) orbiting in smeary ellipses around their unmoved mover. Real talent was thin and scattered in this tiny universe. It surfaced in music, with figures like Lou Reed and John Cale; various punk groups in the seventies were, wittingly or not, the offspring of Warhol's Velvet Underground. But people who wanted to get on with their own work avoided the Factory, while the freaks and groupies and curiosity-seekers who filled it left nothing behind them.

Its silver-papered walls were a toy theater in which one aspect of the sixties in America, the infantile hope of imposing oneself on the world by terminal self-revelation, was played out. It had a nasty edge, which forced the paranoia of marginal souls into some semblance of style; a reminiscence of art. If Warhol's "Superstars," as he called them, had possessed talent, discipline, or stamina, they would not have needed him. But then, he would not have needed them. They gave him his ghostly aura of power. If he withdrew his gaze, his carefully allotted permissions and recognitions, they would cease to exist: the poor ones would melt back into the sludgy undifferentiated chaos of the street, the rich ones end up in McLean's. Valerie Solanas, who shot him, said Warhol had too much control over her life.

Those whose parents accused them of being out of their tree, who had unfulfilled desires and undesirable ambitions, and who felt guilty about it all, therefore gravitated to Warhol. He offered them absolution, the gaze of the blank mirror that refuses all judgment. In this, the camera (when he made his films) deputized for him, collecting hour upon hour of tantrum, misery, sexual spasm, campery, and nose-picking trivia. It too was an instrument of power – not over the audience, for which Warhol's films were usually boring and alienating, but over the actors. In this way the Factory resembled a sect, a parody of Catholicism enacted (not accidentally) by people who were or had been Catholic, from Warhol and Gerard Malanga on down. In it, the rituals of dandyism could speed up to gibberish and show what they had become – a hunger for approval and forgiveness. These came in a familiar form, perhaps the only form American capitalism knows how to offer: publicity.

Warhol was the first American artist to whose career publicity was truly intrinsic. Publicity had not been an issue with artists in the forties and fifties. It might come as a bolt from the philistine blue, as when *Life* made Jackson Pollock famous; but such events were rare enough to be freakish, not merely unusual. By today's standards, the art world was virginally naive about the mass media and what they could do. Television and the press, in return, were indifferent to what could still be called the avant-garde. "Publicity"

meant a notice in *The New York Times,* a paragraph or two long, followed eventually by an article in *Art News* which perhaps five thousand people would read. Anything else was regarded as extrinsic to the work – something to view with suspicion, at best an accident, at worst a gratuitous distraction. One might woo a critic, but not a fashion correspondent, a TV producer, or the editor of *Vogue.* To be one's own PR outfit was, in the eyes of the New York artists of the forties or fifties, nearly unthinkable – hence the contempt they felt for Salvador Dali. But in the 1960s all that began to change, as the art world gradually shed its idealist premises and its sense of outsidership and began to turn into the Art Business.

Warhol became the emblem and thus, to no small extent, the instrument of this change. Inspired by the example of Truman Capote, he went after publicity with the voracious single-mindedness of a feeding bluefish. And he got it in abundance, because the sixties in New York reshuffled and stacked the social deck: the press and television, in their pervasiveness, constructed a kind of parallel universe in which the hierarchical orders of American society – vestiges, it was thought, but strong ones, and based on inherited wealth – were replaced by the new tyranny of the "interesting." Its rule had to do with the rapid shift of style and image, the assumption that all civilized life was discontinuous and worth only a short attention span: better to be Baby Jane Holzer than the Duchesse de Guermantes.

To enter this turbulence, one might only need to be born – a fact noted by Warhol in his one lasting quip, "In the future, *everyone* will be famous for fifteen minutes." But to remain in it, to stay drenched in the glittering spray of promotional culture, one needed other qualities. One was an air of detachment: the dandy must not look into the lens. Another was an acute sense of nuance, an eye for the eddies and trends of fashion, which would regulate the other senses and appetites and so give detachment its point.

Diligent and frigid, Warhol had both to a striking degree. He was not a "hot" artist, a man mastered by a particular vision and anxious to impose it on the world. Jackson Pollock had declared that he wanted to be Nature. Warhol, by contrast, wished to be Culture and Culture only: "I want to be a machine." Many of the American artists who rose to fame after abstract expressionism, beginning with Jasper Johns and Robert Rauschenberg, had worked in commercial art to stay alive, and other pop artists besides Warhol, of course, drew freely on the vast reservoir of American ad-mass imagery. But Warhol was the only one who embodied a culture of promotion as such. He had enjoyed a striking success as a commercial artist, doing everything from shoe ads to recipe illustrations in a blotted, perky line derived from Saul Steinberg. He understood the tough little world, not yet an "aristocracy" but trying to become one, where the machinery of fashion, gossip, image-bending, and narcissistic chic tapped out its agile pizzicato. He knew packaging, and could teach it to others.

Warhol's social visibility thus bloomed in an art world which, during the sixties, became more and more concerned with the desire for and pursuit of publicity. Not surprisingly, many of its figures in those days – crass social climbers like the Sculls, popinjays like Henry Geldzahler, and the legion of insubstantial careerists who leave nothing but press cuttings to mark their passage – tended to get their strategies from Warhol's example.

Above all, the working-class kid who had spent so many thousands of hours gazing into the blue, anesthetizing glare of the TV screen, like Narcissus into his pool, realized that the cultural moment of the mid-sixties favored a walking void. Television was producing an affectless culture. Warhol set out to become one of its affectless heroes. It was no longer necessary for an artist to act crazy, like Salvador Dali. Other people could act

crazy for you: that was what Warhol's Factory was all about. By the end of the sixties craziness was becoming normal, and half of America seemed to be immersed in some tedious and noisy form of self-expression. Craziness no longer suggested uniqueness. Warhol's bland translucency, as of frosted glass, was much more intriguing.

Like Chauncey Gardiner, the hero of Jerzy Kosinski's *Being There,* he came to be credited with sibylline wisdom because he was an absence, conspicuous by its presence – intangible, like a TV set whose switch nobody could find. Disjointed public images – the Campbell's soup cans, the Elvises and Lizzes and Marilyns, the electric chairs and car crashes, and the jerky, shapeless pornography of his movies – would stutter across this screen; would pour from it in a gratuitous flood.

But the circuitry behind it, the works, remained mysterious. (Had he made a point of going to the shrink, like other New York artists, he would have seemed rather less interesting to his public.) "If you want to know all about Andy Warhol," he told an interviewer in those days, "just look at the surface of my paintings and films and me, and there I am. There's nothing behind it."[3] This kind of coyness looked, at the time, faintly threatening. For without doubt, there was something strange about so firm an adherence to the surface. It went against the grain of high art as such. What had become of the belief, dear to modernism, that the power and cathartic necessity of art flowed from the unconscious, through the knotwork of dream, memory, and desire, into the realized image? No trace of it; the paintings were all superficies, no symbol. Their blankness seemed eerie.

They did not share the reforming hopes of modernism. Neither dada's caustic anxiety, nor the utopian dreams of the constructivists; no politics, no transcendentalism. Occasionally there would be a slender, learned spoof, as when Warhol did black-and-white paintings of dance-step diagrams in parody of Mondrian's black-and-white *Fox Trot* (1930). But in general, his only subject was detachment: the condition of being a spectator, dealing hands-off with the world through the filter of photography.

Thus his paintings, roughly silkscreened, full of slips, mimicked the dissociation of gaze and empathy induced by the mass media: the banal punch of tabloid newsprint, the visual jabber and bright sleazy color of TV, the sense of glut and anesthesia caused by both. Three dozen Elvises are better than one; and one Marilyn, patched like a gaudy stamp on a ground of gold leaf (the favorite color of Byzantium, but of drag queens too) could become a sly and grotesque parody of the Madonna-fixations of Warhol's own Catholic childhood, of the pretentious enlargement of media stars by a secular culture, and of the similarities between both. The rapid negligence of Warhol's images parodied the way mass media replace the act of reading with that of scanning, a state of affairs anticipated by Ronald Firbank's line in *The Flower Beneath the Foot:* "She reads at such a pace . . . and when I asked her *where* she had learnt to read so quickly, she replied, 'On the screens at Cinemas.' "[4]

Certainly, Warhol had one piercing insight about mass media. He would not have had it without his background in commercial art and his obsession with the stylish. But it was not an *aperçu* that could be developed: lacking the prehensile relationship to experience of Claes Oldenburg (let alone Picasso), Warhol was left without much material. It is as though, after his near death in 1968, Warhol's lines of feeling were finally cut: he could not appropriate the world in such a way that the results meant much as art, although they became a focus of ever-increasing gossip, speculation, and promotional hoo-ha. However, his shooting reflected back on his earlier paintings – the prole death in the car crashes, the electric chair with the sign enjoining SILENCE on the nearby door, the taxidermic portraits of the dead Marilyn – lending them a fictive glamour as emblems of

fate. Much breathless prose was therefore expended on Andy, the Silver Angel of Death, and similar conceits. (That all these images were suggested by friends, rather than chosen by Warhol himself, was not stressed.)

Partly because of this gratuitous aura, the idea that Warhol was a major interpreter of the American scene dies hard – at least in some quarters of the art world. "Has there ever been an artist," asked Peter Schjeldahl at the end of a panegyric on Warhol's fatuous show of society portraits at the Whitney in 1979, "who so coolly and faithfully, with such awful intimacy and candor, registered important changes in a society?"[5] (Well, maybe a couple, starting with Goya.) Critics bring forth such borborygms when they are hypnotized by old radical credentials. Barbara Rose once compared his portraits, quite favorably, to Goya's. John Coplans, the former editor of *Artforum,* wrote that his work "almost by choice of imagery alone, it seems, forces us to squarely face the existential edge of our existence."[6]

In 1971 an American Marxist named Peter Gidal, later to make films as numbing as Warhol's own, declared that "unlike Chagall, Picasso, Rauschenberg, Hamilton, Stella, most of the Cubists, Impressionists, Expressionists, Warhol never gets negatively boring"[7] – only, it was implied, *positively* so, and in a morally bracing way. If the idea that Warhol could be the most interesting artist in modern history, as Gidal seemed to be saying, now looks a trifle *voulu,* it has regularly been echoed on the left – especially in Germany, where, by one of those exquisite contortions of social logic in which the *Bundesrepublik* seems to specialize, Warhol's status as a blue chip was largely underwritten by Marxists praising his "radical" and "subversive" credentials.

Thus the critic Rainer Crone, in 1970, claimed that Warhol was "the first to create something more than traditional 'fine art' for the edification of a few."[8] By mass producing his images of mass production, to the point where the question of who actually made most of his output in the sixties has had to be diplomatically skirted by dealers ever since (probably half of it was run off by assistants and merely signed by Warhol), the pallid maestro had entered a permanent state of "anaesthetic revolutionary practice" – delicious phrase! In this way the "elitist" forms of middle-class idealism, so obstructive to art experience yet so necessary to the art market, had been short-circuited. Here, apparently, was something akin to the "art of five kopeks" Lunacharsky had called on the Russian avant-garde to produce after 1917. Not only that: the People could immediately see and grasp what Warhol was painting. They were used to soup cans, movie stars, and Coke bottles. To make such bottles in a factory in the South and sell them in Abu Dhabi was a capitalist evil; to paint them in a factory in New York and sell them in Düsseldorf, an act of cultural criticism.

These efforts to assimilate Warhol to a "revolutionary" aesthetic now have a musty air. The question is no longer whether such utterances were true or false – Warhol's later career made them absurd anyway. The real question is: how could otherwise informed people in the sixties and seventies imagine that the man who would end up running a gossip magazine and cranking out portraits of Sao Schlumberger for a living was really a cultural subversive? The answer probably lies in the change that was coming over their own milieu, the art world itself.

Warhol did his best work at a time (1962–1968) when the avant-garde, as an idea and a cultural reality, still seemed to be alive, if not well. In fact it was collapsing from within, undermined by the encroaching art market and by the total conversion of the middle-class audience; but few people could see this at the time. The ideal of the radical, "outsider" art of wide social effect had not yet been acknowledged as fantasy. The death of the

avant-garde has since become such a commonplace that the very word has an embarrass-ing aura. In the late seventies, only dealers used it; today, not even they do, except in Soho. But in the late sixties and early seventies, avant-garde status was still thought to be a necessary part of a new work's credentials. And given the political atmosphere of the time, it was mandatory to claim some degree of "radical" political power for any nomi-nally avant-garde work.

Thus Warhol's silence became a Rorschach blot, onto which critics who admired the idea of political art – but would not have been seen dead within a hundred paces of a real-ist painting – could project their expectations. As the work of someone like Agam is ab-stract art for those who hate abstraction, so Warhol became realist art for those who loathed representation as "retrograde." If the artist, blinking and candid, denies that he was in any way a "revolutionary" artist, his admirers knew better; the white mole of Union Square was just dissimulating. If he declared that he was only interested in getting rich and famous, like everyone else, he could not be telling the truth; instead, he was par-odying America's obsession with celebrity, the better to deflate it. From the recesses of this exegetical knot, anything Warhol did could be taken seriously. In a review of *Expo-sures,* the critic Carter Ratcliff solemnly asserted that "he is secretly the vehicle of artis-tic intentions so complex that he would probably cease to function if he didn't dilute them with nightly doses of the inane."[9] But for the safety valve of Studio 54, he would pre-sumably blow off like the plant at Three Mile Island, scattering the culture with unimag-ined radiations.

One wonders what these "artistic intentions" may be, since Warhol's output for the last decade has been concerned more with the smooth development of product than with any discernible insights. As Harold Rosenberg remarked, "In demonstrating that art to-day is a commodity of the art market, comparable to the commodities of other specialized markets, Warhol has liquidated the century-old tension between the serious artist and the majority culture."[10] It scarcely matters what Warhol paints: for his clientele, only the signature is fully visible. The factory runs, its stream of products is not interrupted, the market dictates its logic. What the clients want is *a* Warhol, a recognizable product bear-ing his stamp. Hence any marked deviation from the norm, such as an imaginative con-nection with the world might produce, would in fact seem freakish and unpleasant: a renunciation of earlier products. Warhol's sales pitch is to soothe the client by repetition while preserving the fiction of uniqueness. Style, considered as the authentic residue of experience, becomes its commercial-art cousin, styling.

Warhol has never deceived himself about this: "It's so boring painting the same pic-ture over and over," he complained in the late sixties. So he must introduce small varia-tions into the package, to render the last product a little obsolete (and to limit its proliferation, thus assuring its rarity), for if all Warhols were exactly the same there would be no market for new ones. Such is his parody of invention, which now looks nor-mal in a market-dominated art world. Its industrial nature requires an equally industrial kind of *facture:* this consists of making silkscreens from photos, usually Polaroids, bleed-ing out a good deal of the information from the image by reducing it to monochrome, and then printing it over a fudgy background of decorative color, applied with a wide, loaded brush to give the impression of verve. Only rarely is there even the least formal relation-ship between the image and its background.

This formula gave Warhol several advantages, particularly as a portraitist. He could always flatter the client by selecting the nicest photo. The lady in Texas or Paris would not be subjected to the fatigue of long scrutiny; in fact she would feel rather like a *Vogue*

model, whether she looked like one or not, while Andy did his stuff with the Polaroid. As social amenity, it was an adroit solution; and it still left room for people who should know better, like the art historian Robert Rosenblum in his catalogue essay to Warhol's portrait show at the Whitney in 1979, to embrace it: "If it is instantly clear that Warhol has revived the visual crackle, glitter, and chic of older traditions of society portraiture, it may be less obvious that despite his legendary indifference to human facts, he has also captured an incredible range of psychological insights among his sitters."[11] Legendary, incredible, glitter, insight: stuffing to match the turkey.

The perfunctory and industrial nature of Warhol's peculiar talent and the robotic character of the praise awarded it, appears most baldly of all around his prints, which were given a retrospective at Castelli Graphics in New York and a *catalogue raisonné* by Hermann Wünsche. "More than any other artist of our age," one of its texts declares, "Andy Warhol is intensively preoccupied with concepts of time"; quite the little Proust, in fact. "His prints above all reveal Andy Warhol as a universal artist whose works show him to be thoroughly aware of the great European traditions and who is a particular admirer of the glorious French *Dixneuvième*, which inspired him to experience and to apply the immanent qualities of 'pure' *peinture*."[12] No doubt something was lost in translation, but it is difficult to believe that Hans Gerd Tuchel, the author, has looked at the prints he speaks of. Nothing could be flatter or more perfunctory, or have less to do with those "immanent qualities of pure *peinture*," than Warhol's recent prints. Their most discernible quality is their transparent cynicism and their Franklin Mint approach to subject matter. What other "serious" artist, for instance, would contemplate doing a series called "Ten Portraits of Jews of the Twentieth Century,"[13] featuring Kafka, Buber, Einstein, Gertrude Stein, and Sarah Bernhardt? But then, in the moral climate of today's art world, why not treat Jews as a special-interest subject like any other? There is a big market for bird prints, dog prints, racing prints, hunting prints, yachting prints; why not Jew prints?

Yet whatever merits these mementos may lack, nobody could rebuke their author for inconsistency. The Jew as Celebrity: it is of a piece with the ruling passion of Warhol's career, the object of his fixated attention – the state of being well known for well-knownness. This is all *Exposures* was about – a photograph album of film stars, rock idols, politicians' wives, cocottes, catamites, and assorted bits of International White Trash baring their teeth to the socially emulgent glare of the flashbulb: I am flashed, therefore I am. It is also the sole subject of Warhol's house organ, *Interview*.

Interview began as a poor relative of *Photoplay*, subtitled "Andy Warhol's Movie Magazine." But by the mid-seventies it had purged itself of the residue of the "old" Factory and become a punkish *feuilleton* aimed largely at the fashion trade – a natural step, considering Warhol's background. With the opening of Studio 54 in 1977, the magazine found its "new" Factory, its spiritual home. It then became a kind of marionette theater in print: the same figures, month after month, would cavort in its tiny proscenium, do a few twirls, suck or snort something, and tittup off again – Marisa, Bianca, Margaret Trudeau, and the rest of the fictive stars who replaced the discarded Superstars of the Factory days.

Because the magazine is primarily a social-climbing device for its owner and staff, its actual gossip content is quite bland. Many stones lie unturned, but no breech is left unkissed. As a rule the interviews, taped and transcribed, sound as though a valet were asking the questions, especially when the subject is a regular advertiser in the magazine. Sometimes the level of gush exceeds the wildest inventions of S. J. Perelman. "I have felt

since I first met you," one interviewer exclaims to Diane von Furstenberg, "that there was something extraordinary about you, that you have the mystic sense and quality of a pagan soul. And here you are about to introduce a new perfume, calling it by an instinctive, but perfect name." And later:

> Q. *I have always known of your wonderful relationship with your children. By this,*
> *I think you symbolize a kind of fidelity. Why did you bring back these geese*
> *from Bali*
> A. *I don't know.*
> Q. *You did it instinctively.*
> A. *Yes, it just seemed right. One thing after the other. . . . It's wild.*
> Q. *There's something about you that reminds me of Aphrodite.*
> A. *Well, she had a good time.*

Later, Aphrodite declares that "I don't want to be pretentious," but that "I was just in Java and it has about 350 active volcanoes. I'll end up throwing myself into one. I think that would be very glamorous."[14]

In politics, *Interview* has one main object of veneration: the Reagans, around whose elderly flame the magazine flutters like a moth, waggling its little thorax at Jerry Zipkin, hoping for invitations to White House dinners or, even better, an official portrait commission for Warhol. Moving toward that day, it is careful to run flattering exchanges with White House functionaries like Muffie Brandon. It even went so far as to appoint Doria Reagan, the daughter-in-law, as a "contributing editor." To its editor, Reagan is *Caesar Augustus Americanus* and Nancy a blend of Evita and the Virgin Mary, though in red. Warhol seems to share this view, though he did not always do so. For most of the seventies he was in some nominal way a liberal Democrat, like the rest of the art world – doing campaign posters for McGovern, trying to get near Teddy Kennedy. Nixon, who thought culture was for Jews, would never have let him near the White House. When Warhol declared that Gerald Ford's son Jack was the only Republican he knew, he was telling some kind of truth. However, two things changed this in the seventies: the Shah, and the Carter administration.

One of the odder aspects of the late Shah's regime was its wish to buy modern Western art, so as to seem "liberal" and "advanced." Seurat in the parlor, SAVAK in the basement. The former Shahbanou, Farah Diba, spent millions of dollars exercising this fantasy. Nothing pulls the art world into line faster than the sight of an imperial checkbook, and the conversion of the remnants of the American avant-garde into ardent fans of the Pahlavis was one of the richer social absurdities of the period. Dealers started learning Farsi, Iranian fine-arts exchange students acquired a sudden cachet as research assistants, and invitations to the Iranian embassy – not the hottest tickets in town before 1972 – were now much coveted.

The main beneficiary of this was Warhol, who became the semi-official portraitist to the Peacock Throne. When the *Interview* crowd were not at the tub of caviar in the consulate like pigeons around a birdbath, they were on an Air Iran jet somewhere between Kennedy Airport and Tehran. All power is delightful, as Kenneth Tynan once observed, and absolute power is absolutely delightful. The fall of the Shah left a hole in *Interview*'s world: to whom could it toady now? Certainly the Carter administration was no substitute. Those southern Baptists in polycotton suits lacked the finesse to know when they were being flattered. They had the social grace of car salesmen, drinking Amaretto and

making coarse jests about pyramids. They gave dull parties and talked about human rights. The landslide election of Reagan was therefore providential. The familiar combination of private opulence and public squalor was back in the saddle; there would be no end of parties and patrons and portraits. The Wounded Horseman might allot $90 million for brass bands while slashing the cultural endowments of the nation to ribbons and threads; who cared? Not Warhol, certainly, whose work never ceases to prove its merits in the only place where merit really shows, the market.

Great leaders, it is said, bring forth the praise of great artists. How can one doubt that Warhol was delivered by Fate to be the Rubens of this administration, to play Bernini to Reagan's Urban VIII? On the one hand, the shrewd old movie actor, void of ideas but expert at manipulation, projected into high office by the insuperable power of mass imagery and secondhand perception. On the other, the shallow painter who understood more about the mechanisms of celebrity than any of his colleagues, whose entire sense of reality was shaped, like Reagan's sense of power, by the television tube. Each, in his way, coming on like Huck Finn; both obsessed with serving the interests of privilege. Together, they signify a new moment: the age of supply-side aesthetics.

NOTES

1. Andy Warhol, *Andy Warhol's Exposures* (New York: Grosset and Dunlap, 1979), and Andy Warhol and Pat Hackett, *POPism: The Warhol '60s* (New York: Harcourt Brace Jovanovich, 1980).
2. Warhol and Hacket, *POPism*, p. 212. – Ed. note
3. Andy Warhol, quoted in Kasper König, Pontus Hultén, Olle Granath, eds., *Andy Warhol;* exhibition catalogue, Moderna Museet, Stockholm (New York: Worldwide Books, 1969), n.p. – Ed. note.
4. Ronald Firbank, *The Flower Beneath the Foot* (New York: Brentano's, 1924), pp. 5-6. – Ed. note.
5. Peter Schjeldahl, "Warhol and Class Content," *Art in America* 68, no. 5 (May 1980): 112. – Ed. note.
6. John Coplans, "Andy Warhol: The Art," in *Andy Warhol*, ed. Coplans, with Jonas Mekas and Calvin Tompkins; exhibition catalogue, Pasadena Art Museum (Greenwich, Conn.: New York Graphic Society, 1970), p. 49. – Ed. note.
7. Peter Gidal, *Andy Warhol: Films and Paintings* (New York: E. P. Dutton; London: Studio Vista, 1971), p. 76. – Ed. note.
8. Rainer Crone, *Andy Warhol*, trans. John William Gabriel (New York: Praeger Publishers, 1970), p. 23. See also Crone and Wilfried Wiegand, *Die revolutionaire Asthetik Andy Warhol's* (Darmstadt: Melzer Verlag, 1972). – Ed. note.
9. Carter Ratcliff, "Starlust: Andy's Photos," *Art in America* 68, no. 5 (May 1980): 120. – Ed. note.
10. Harold Rosenberg, "Warhol: Art's Other Self," in *Art on the Edge: Creators and Situations* (Chicago: The University of Chicago Press, 1975). pp. 105-106. – Ed. note.
11. Robert Rosenblum, "Andy Warhol: Court Painter to the 70s," in *Andy Warhol: Portraits of the 70s*, ed. David Whitney; exhibition catalogue, Whitney Museum of American Art (New York: Random House, 1979), p. 18. – Ed. note.
12. Hans Gerd Tuchel, "Andy Warhol als Graphiker / Andy Warhol as Graphic Artist," trans. Dennis S. Clarke, in Herman Wünsche, *Andy Warhol: Das Graphische Werk 1962–1980* (Bonn: Bonner Universitat Buchdruckerai, 1980), n.p. – Ed. note.
13. "Ten Portraits of Jews of the Twentieth Century," The Jewish Museum. September 17, 1980-January 4, 1981.
14. Iris Love, "Diane von Furstenberg," *Interview* 11, no. 11 (November 1981): 26-29. – Ed. note.

From THE INDEPENDENT GROUP: BRITISH AND AMERICAN POP ART, A "PALIMPCESTUOUS" LEGACY

Lynne Cooke

In 1956 This is Tomorrow took place – a show generally considered the culmination of those activities, exhibitions, and discussions that had preoccupied the Independent Group during the previous four years.[1] It was also the year of another landmark exhibition in British art history. Entitled Modern Art in the United States, and containing examples of the much discussed but hitherto unseen (in England) Abstract Expressionist painting, this show was held at the Tate Gallery, the national museum for the collection of both historical British and modern international art.[2] The two exhibitions could hardly have been more different. The first, staged at the Whitechapel Gallery, a noted venue for contemporary art in London's then impoverished East End, contained a dozen installations, which had the effect of turning the whole gallery into a vast environment. These had been devised by twelve separate groups, each of which notionally contained at least one artist and one architect among its three or four members. That each acted quite independently of the other enhanced the very different areas of concern they represented, so that, alongside much Constructivist-related work, references to popular culture of diverse kinds, as well as to primitivism, archeology, and anthropology could be discerned, especially in the two most memorable and prophetic installations. Both of these were by members of the Independent Group: one by the Richard Hamilton-John McHale-John Voelcker trio, and the other by the quartet comprising Eduardo Paolozzi, Nigel Henderson, and Alison and Peter Smithson.[3]

Near the entrance to the exhibition the visitor encountered the Hamilton-McHale-Voelcker construction with its perspectively distorted architectural spaces crammed with contemporary visual material of the most diverse kinds and scales, culled from movies, astronomy, comics, food and consumer-goods advertisements. All of this intermingled with sounds from a juke box competing with the highly amplified recordings of the voices of previous visitors, as well as with different smells. The effect sought was something close to multisensory disorientation. The other historically significant installation, by contrast, comprised a kind of minimal living space, a rude lean-to patio-cum-pavilion containing a variety of battered homely objects – a bicycle wheel, a trumpet, a TV set – symbols of a devastated past and/or future life lain out as an archeologist might display the material culture that had been unearthed during an excavation of some lost society.[4]

The Tate show was a far more conventional affair, in part because it was a straightforward survey of twentieth-century American painting and sculpture and in part because it contained few echoes of that avowedly populist and participatory spirit that animated most of the This is Tomorrow participants for whom, according to the press release, "The doors of the Ivory Tower are wide open."[5] The key to the excitement it generated lay in the fact that it provided local artists with their first direct exposure to Abstract Expressionist painting.

If both exhibitions attracted considerable public attention and media coverage, it may

Excerpt, *Modern Art and Popular Culture: Readings in High and Low*, edited by Kirk Varnedoe and Adam Gopnik, New York: Museum of Modern Art / Harry N. Abrams, 1990: 193 ff.

be supposed that in large part the audiences for the two were, notwithstanding some overlap from the younger art community, distinctively different. Certainly, the legacies attributed to each are quite separate – separate rather than conflicting.

The American show was followed three years later by another exhibition, held again at the Tate Gallery, this time devoted exclusively to Abstract Expressionism, loosely defined.[6] Stimulated by this example, a number of British artists began to make large-format color-field paintings, which they perceived to be radically abstract in configuration. Banding together, they presented their work in 1960 at the RBA Galleries in a polemical exhibition entitled Situation. A follow-up show was held the next year. The debt of these painters, who included John Hoyland, Robyn Denny, and Bernard Cohen among their number, to their American forebears was openly acknowledged. No ambiguity attends the transition of influence and inspiration from the most recent American works in the 1956 show to those that herald the debut of these British abstract artists coming to maturity in the early sixties, nor to their belief that the central strands of high modernism, as defined in the writings of critics like Clement Greenberg, were being actively carried forward in their art.[7]

The legacy of This is Tomorrow is altogether more complex and problematic. First, it is important to note that, although the most discussed sections of the show were provided by erstwhile members of the Independent Group, the group itself had by then formally disbanded. Nevertheless, in hindsight this show, rather than any of their other multifarious activities, has been deemed the inception of Pop Art and hence has been considered their most significant contribution to the history of art. . . .

In 1961 a number of young painters, most of whom had trained at the Royal College of Art in London, were included together in an anthology exhibition at the I.C.A., called Young Contemporaries: notable among the participants were David Hockney, Derek Boshier, Patrick Caulfield, and Peter Phillips. They, too, were soon to become celebrated as Pop artists. The connections between the members of the Independent Group and the younger sixties Pop painters, are, however, difficult to determine precisely, being more circuitous than direct, more circumstantial than causal. At most, the former seem to have contributed to a cultural climate conducive to the development of a figurative art that drew for its imagery and spirit – in a free-wheeling, hedonistic, subjective way – on contemporary youth and media culture.

It is important to remember, too, that it was only in 1957 that Richard Hamilton executed the first of his paintings to incorporate motifs, techniques, and styles derived from the mass media. This was *Hommage à Chrysler Corps,* a painting he later described as

> a compilation of themes derived from the glossies. The main motif, the vehicle, breaks down into an anthology of presentation techniques. One passage, for example, runs from a prim emulation of in-focus photographed gloss to out-of-focus gloss to an artist's representation of chrome to an ad-man's sign meaning "chrome." Pieces are taken from Chrysler's Plymouth and Imperial ads, there is some General Motors material and a bit of a Pontiac. . . . The sex-symbol is, as so often happens in the ads, engaged in a display of affection for the vehicle.[8]

(Nonetheless, as Lawrence Alloway soon pointed out, there are significant traces in Hamilton's mode of composing, as well as in his manner of layering meaning, of Duchamp's art, and of *The Bride Stripped Bare by Her Bachelors, Even* in particular.)[9]

Equally telling is the fact the other leading artist to have been connected with the In-

dependent Group, Eduardo Paolozzi was at that moment better termed a New Brutalist than a Pop artist, if any labeling is required.[10] Although since the 1940s he had made numerous small collages in which he incorporated barely modified material drawn from comics and down-market pin-ups, Paolozzi's main activity as an artist at this point was the creation of bronze sculptures of anthropomorphic hybrids. Closer to primeval monsters than to futuristic robots – given their fractured carapaces constructed by embedding into wax sheets myriad small objects of various kinds, and imbued with a quasiexistentialist angst – these battered figures were more redolent of Surrealist grotesquerie than of any contemporary fascination with the new ethos of the mass media and consumer consumption. In addition, most of the other key artists associated with the Independent Group, notably Nigel Henderson, John McHale and William Turnbull, were closer in their interests and concerns to Paolozzi than to Hamilton, whose painting up to then had principally involved questions relating to perception and in ways that, ultimately, could be traced back through Duchamp to Cézanne.[11]

While the proliferation of elements often associated with particularly low-grade forms of mass culture caused many to see in Hamilton and Co.'s installation for This is Tomorrow a Dadaist effect if not intent, the focus of their thought was very different. As demonstrated both by the catalogue (in the layout of Hamilton's collage opposite a black-and-white image that ambiguously hovered between positive and negative figure-ground readings), and by their juxtaposition in the show of admass imagery with effects generated by devices frequently used in the realm of fine art, such as perspectival distortions, they sought to render sensory, and especially visual, perception ambiguous. However, the lessons enshrined in this multimedia "high/low" cultural interplay were not presented didactically; what was understood by most participants was apprehended intuitively and experientially.[12]

Since Paolozzi's debts, by contrast, were more to Surrealism, which he had studied in Paris in the forties and to which thereafter he remained aligned, at least in his own eyes, his approach to mass culture was significantly different.[13] While in his sculpture this involved the metamorphosis of popular-culture items into high art, in his contributions to Independent Group activities he betrayed a more ethnographic slant.[14] However, over the course of the fifties his fascination with low-grade mass culture gradually was overlain with a pessimistic, existentially inflected view of the contemporary world, a view that later drew him to the science-fiction writer J. G. Ballard, with whom he shares a mistrust of technology, or at least of modern man's responses to technology.[15]

Yet this New Brutalist ethos – as it manifested itself within the framework of the Independent Group – was perhaps best expressed not in This is Tomorrow but in the exhibition that that same quartet of Paolozzi, Henderson, and the Smithsons, together with Ronald Jenkins, had organized for the I.C.A. in London in 1953. Entitled Parallel of Life and Art, it comprised over one hundred images garnered from a wide variety of visual sources, rephotographed and then printed, often enlarged, on grainy paper. Divested of labels and captions, and thus often defying easy identification, these photographs were arranged in a labyrinthine installation that created a seamless, encompassing, heterarchical mélange. Among the few fine-art images included alongside reproductions of children's drawings, hieroglyphs, and "primitive" art were photographs of works by Dubuffet, Pollock, and Klee; the majority, however, were images taken from other fields, especially from the sciences, technology, and photo-journalism – images that often resulted from the latest developments in the particular fields, such as microscopic photography, aerial photography, photo-finish cameras, and high-speed flash. Photography was seen to play

a key role in this egalitarian view of the recently expanded visual world, in which, according to the catalogue statement, scientific and artistic information ought to be regarded as aspects of a single whole.[16] Yet for many critics the overall impression given by the show, which they deemed more attentive to the ugliness or horrors of everyday life than to its ostensible beauties, was disquieting – testimony to the effectiveness of what Reyner Banham, another member of the Independent Group and a leading writer on architecture and design, described as its subversive innovation, the flouting of "humanistic conventions of beauty in order to emphasize violence, distortion, obscurity, and a certain amount of 'humeur noir.'"[17]

The principal goals of this exhibition were therefore very similar to those that later underpinned This is Tomorrow, at least as outlined by Lawrence Alloway (the leading art critic within the Independent Group) in his catalogue introduction to that show: "A result of this exhibition is to oppose the specialization of the arts. . . . An exhibition like this . . . is a lesson in spectatorship, which cuts across the learned responses of conventional reception."[18] Yet such goals were but the baseline of the Independent Group's endeavors: the implications they foresaw from a radical shift in cultural values were as important to them. In anticipation of the extensive social reconstruction they hoped would result from that shift, it was necessary, they believed, to begin to devise ways of studying the new phenomena that were rapidly overtaking and redefining the field of popular culture, both the novel technologies and the proliferating mass media.

Fundamental to any assessment of the legacy of the Independent Group as a whole (as well as to the problem of connecting the artists belonging to it with the Royal College Pop painters) is the fact that the Independent Group was not primarily engaged in making artworks. Discussion was its first concern, manifested most importantly in the series of seminars convened exclusively for its closely selected membership but also in certain public lectures devised for the I.C.A., its parent organization. Supplementary to that was the curating, designing, and installing of exhibitions.[19] Whether in debates or in exhibition making, the activities of the Independent Group were always collaborative. Both its vitality and the source of its historical significance lay in the flexibility and openness with which it accommodated the amiably competing, interdisciplinary interests of its leading protagonists. At no point, however, did it issue either joint statements or manifestoes, though many of its leading figures did publish articles on topics that had proved the focus of much discussion among the group. The artworks that a number of them made while members were, consequently, ancillary to its existence, no more influential on nor determined by the group activity than, say, the academic research on the pioneers of the early modern movement in architecture that concurrently preoccupied Reyner Banham as a postgraduate student at the Courtauld Institute, or the lectures Lawrence Alloway prepared on aspects of the historical collection as a temporary employee of the Tate Gallery.

The young artists emerging from the Royal College in the early sixties, by contrast, were painters *tout court*. They incorporated into their art imagery culled from the latest, most up-to-date aspects of their visual environment, its sites of leisure, pleasure, and desire. Theirs was an enthusiastic, personal, and uncritical response to an England in the first full flush of a newly won economic prosperity, a prosperity that, by the end of the fifties, had transformed the incipient consumerism of the mid-decade into an unprecedented boom in spending. But not only did these young sixties artists not share their predecessors' critical distance from the immediate environment, they did not engage in theoretical or cultural studies of the kind that were the hallmark of the Independent Group. . . .

While the Pop Art that emerged in Britain in the sixties was widely, enthusiastically, and rapidly embraced, in the United States it was bitterly contested.[20] However, its various advocates and denunciators cannot be divided along the lines of radical and conservative, academic and avant-garde, for what Pop Art initially seemed to propose was a far greater challenge than that which was normally implied in the shift from one art movement to another, that is, by a change in subject and/or style. The situation in England was not comparable: neither the art objects made by members of the Independent Group nor the paintings of the sixties Pop artists offer equivalent challenges to those notions of originality, authorship, and innovation that lie at the heart of modernism, even to the very category of art qua art, that American Pop Art at its most rigorous and trenchant was believed to posit. In aesthetic terms, the British strains could be condemned, or celebrated, for being vulgar, tasteless, and jejeune; but in no sense did they present more fundamental assaults on normative categories.[21] And similarly in social terms: the Independent Group was expansionist and accumulative in its targets and only incidentally confrontational and contestatory, while British Pop of the sixties offered far less threat to the status quo than did either pop music or fashion. In fact, its ready acceptance at a general level could be ascribed in part to the ease with which it was assimilated into the new manifestations then sweeping the field of music, fashion, and design, manifestations that cumulatively became promoted as Pop culture, and hence as key elements in the scene soon known as "Swinging London."

The emergence of American Pop Art in 1962 aroused enormous controversy among the defenders of high culture, following as it did at least a decade of anxious defensiveness by those mandarins.[22] In their determination to safeguard high culture, certain strategies had been adopted to present Abstract Expressionism as a pinnacle of high-art achievement, one which had to be segregated from the incursions of all forms of kitsch. To this end, the degree to which de Kooning, for example, drew on both mass-cultural imagery and its themes was ignored or heavily underplayed.[23] Robert Rauschenberg's combines, which preserved unaltered the factuality, the "given" quality, of their pre-formed mass-cultural elements were, at least at first, able to be marginalized by being considered a form of Neo-Dada. Thus it was Jasper Johns's paintings that, in the late fifties, came to represent a major threat to the hegemony of Abstract Expressionism: for notwithstanding his virtuosity in handling paint, his overtly banal subject matter appeared highly provocative in the face of those transcendental ideals purportedly manifest in Abstract Expressionism.

The question of the relationship between high and low culture grew increasingly explosive with the steadily expanding proliferation of mass culture into all areas of daily life, a fact demonstrated first by the furor that surrounded the earliest show to bring together many of the American Pop protagonists, Sidney Janis's 1962 New Realists exhibition, and second, by the way that the greatest controversy centered around Andy Warhol and Roy Lichtenstein, painters whose work not only drew on advertising and media imagery for its subject matter but which, more importantly, utilized the conventions and techniques of mass reproduction in representing it.[24] Moreover, in addition to their seeming not to transform admass material, both artists presented it on a scale and in a format that directly challenged serious painting on its own ground. Unlike such patently avant-garde activity as "happenings," which adopted means, materials, and techniques, and even operated in venues, that were regarded as in some way alternative – nonart or antiart – American Pop Art sought to locate itself at the very heart of the mainstream. This was undoubtedly done highly consciously, for all its chief protagonists had, in their

youth, flirted with or grown through phases of Abstract Expressionist painting. Moreover, since all had backgrounds in commercial art, they were thoroughly conversant with the normative distinctions that separated the two realms, their different codes, conventions, and values.[25] They therefore offered a challenge to prevailing concerns and larger cultural values of an order that the more conventional British artists emerging from the Royal College could not match. It was a kind of challenge that the Independent Group, operating in a quite different cultural matrix, did not seek to posit.

It is not surprising that no sustained parallels or significant connections can be drawn between the emergence of Pop Art in Britain and the United States. This involves more than the likelihood of local differences obscuring or modifying related impulses; rather it depends on the substantially different socio-cultural contexts in which each burgeoned. Such connections have nonetheless frequently been drawn largely because of the ways in which the history of Pop Art was first written. Were it not for the personal circumstances of Lawrence Alloway's life, the Independent Group might never have become a component integral to any discussion of Pop Art, nor might such weight have been given, at least in the early accounts, to its manifestations in Britain in the sixties.[26]

Alloway coined the term "Pop" initially to refer to the widespread interest in popular culture as it was expressed by the members of the Independent Group in their discussions, lectures, and other group activities. A particular interest of his, he fostered it wherever he was most active and influential, such as in the seminar series held at the I.C.A. during the winter of 1953-54. He was then, almost predictably, attracted by the arrival of certain younger British artists, mostly from the Royal College, who used it as the source of imagery in their paintings; and he subsequently modified the meaning of the term to accommodate them, dubbing their work, collectively, Pop Art. In 1962 he moved to the United States, where he quickly became an influential curator of pioneering exhibitions devoted to the work of key participants in what had emerged there under several rubrics before it finally became definitively known as Pop Art.

In later writing a history of the postwar art in Britain that drew on popular culture for its imagery and, sometimes, style, Alloway cojoined Pop and Pop Art in a quasilinear unfolding, which conformed to the progressivist evolutionary models then prevailing in art history – and the Independent Group became the progenitors of Pop Art.[27] It is worth noting, however, that although Alloway had written extensively on various art and popular culture topics during the years of the Independent Group, and although at that time he also reviewed the work of its key artists Paolozzi and Hamilton in highly favorable terms, he never mentioned, let alone discussed, the group during its existence.[28] If it was in large part due to Alloway that the Independent Group came to have a recognized place in those histories of Pop Art written in the sixties, thereafter its stature waned as the preeminence of certain of its American principals grew and the careers of others elsewhere declined. By the beginning of the eighties, in general histories of twentieth-century art it was often reduced to little more than a cursory citation, a singular prefiguration, an obligatory footnote.[29]

British Pop Art of the sixties has with time suffered a similar eclipse, being increasingly seen as but one, local, manifestation among many, and arguably not a crucial one at that. The prodigious spread of the mass media and consumer culture throughout the Western world from the mid-fifties onward was rarely separable in most places from the infiltration of American influence – in the guise of both high and low cultural forms. This generated a range of reactions throughout Europe in which response to the former was inextricably linked to a response to the latter, and the results were deemed, collec-

tively, manifestations of Pop Art. Overlooked then, and so never commandeered under that rubric, the works made during the 1960s by the German Capitalist Realists Gerhard Richter and Sigmar Polke now appear both more substantial and more significant, in the ways that they address the challenges offered by this proliferating mass culture than do those of any other non–New York "Pop" artists – the British included – with the singular exception of Richard Hamilton.[30] Only recently, however, has due attention begun to be accorded them in the English-speaking world: this will doubtless in turn contribute significantly to the rewriting of the standard histories of Pop Art, which to date are still largely determined by the perspectives taken by certain British and American authors of the sixties.

If by the later part of that decade (American) Pop Art seemed to have swept all before it, having been assimilated into mainstream accounts of the development of modern art as a parallel and counterpoint to contemporary abstraction,[31] developments in the seventies led to its being reconsidered in very different terms. In the wake of the Conceptualists' institutional critique and deconstruction of the art object, its languages and forms, Pop Art came under increasing attack, especially from the Left.[32] Far from offering a critique or even exposure of the dominant values of late capitalist consumer society as had formerly been argued, most notably in continental Europe, it was now seen to be thoroughly implicated in them, collusive and complicit.[33] Most historical accounts attempting, with the benefits of hindsight, to assess its contribution to modernism have henceforth concentrated on little else.

By contrast, those artists and writers who came to maturity in the late seventies had grown up in a media-saturated world and were therefore attuned, it is argued, to the dominating effects of the electronics media and information technologies not only on the current visual landscape and its languages but on all conscious thoughts and unconscious desires. To them there seems no possibility of offering any critique from outside this context, that is, of providing a critique that is not itself marked by some degree of complicity with the prevailing ideology. Framed by the new theoretical writing emerging from poststructuralist authors, most recent investigations of Pop Art have therefore taken a different course, and a somewhat more positive reading has ensued – or at least one that may be construed as positive within an increasingly negative overview of Western culture at large. Media-literate in new ways, interpretations of this kind have been particularly forthcoming from those influenced by the writing of Jean Baudrillard, who has played a seminal role in the United States throughout the eighties in the thinking and development of many younger artists and writers.[34]

Most of the advocates of American Pop in the later sixties sought to argue for its high quality in orthodox terms, that is, for its formal affinities with concurrent modes of vanguard abstraction, and thus for its place in the mainstream of modernist expression. In so doing, they masked or suppressed, at least for a time, consideration of what has recently, once again, been considered essential to the radicality of its challenge, namely, its fundamental assault on certain central tenets of modernism: originality, authenticity, and innovation. Congruent with this has been the realization, admittedly more dependent on the example of Warhol than of Pop Art as a whole, that it is inextricably caught within the operations of the culture industry at large and yet at best not fully subservient to them. As Benjamin Buchloh argues:

> the contradictions evidenced in the work's consistently ambivalent relationship to
> both mass culture and high art . . . [were crucial to] the way in which Warhol un-

derlined at all times that the governing formal determination of his work was the distribution form of the commodity object and that the work obeyed the same principles that determine the objects of the cultural industry at large.[35]

This and related interpretations have given Warhol's art immense potency in the eighties, since even more than the issues pertaining to simulation and appropriation, the question of the commodification of the artwork has come to the fore. But the centrality of these questions to the postmodernist debate is such that Pop Art as a whole has gained renewed significance – so much so, in fact, that Paul Taylor was recently able to claim quite persuasively, in the introduction to an anthology of theoretical writings devoted to this subject: "Two and a half decades after the event, Pop Art has reemerged as the most influential movement in the contemporary art world."[36]

NOTES

1 The exhibition was not organized by the Independent Group (hereafter referred to as IG) but by Theo Crosby, editor of *Architectural Design.* For a detailed study of the origin and form of the show, see Graham Whitham, "This is Tomorrow: Genesis of an Exhibition," in *Modern Dreams,* pp. 35-39.
2. Modern Art in the United States contained the work of Arshile Gorky, Willem de Kooning, Jackson Pollock, Mark Rothko, and Clyfford Still; about 110 artists were represented in all. Pollock's work had in fact already been shown in London, in a group exhibition entitled Opposing Forces held at the I.C.A. in 1953. Thomas Hess gave a lecture entitled "New Abstract Painters in America" at the I.C.A. in November 1951; at a series of lectures at the I.C.A. in the winter of 1953-54, Toni del Renzio, a member of the IG, discussed Action Painting under the title "Non-Formal Painting." Reyner Banham argues that to the Smithsons, who first encountered Pollock's work at the Venice Biennale of 1950, "he became a sort of patron saint even before his sensational and much publicized death"; Reyner Banham, *The New Brutalism: Ethic or Aesthetic?* (New York, 1966), p. 61. One of Hans Namuth's pictures of Pollock in his studio was included in Parallel of Life and Art (an exhibition at the I.C.A. in 1953); for the organizers he represented something that was very much in concert with the prevailing impulse of the show, a flouting of humanistic conventions of beauty in lieu of violence, distortion and obscurity.
3. For a detailed study of the formation and activities of the IG, see Anne Massey, "The Independent Group: Towards a Redefinition," *Burlington Magazine,* no. 1,009, April 1987, pp. 232-42 (hereafter referred to as "Towards a Redefinition").
4. Kenneth Frampton described it acutely as a "symbolic temenos – a metaphorical backyard, an ironic interpretation of Laugier's primitive hut of 1753 in terms of the backyard reality of Bethnal Green"; Kenneth Frampton, "New Brutalism and the Welfare State: 1949-59," in *Modern Dreams,* p. 48. Paolozzi had stayed with the Nigel Hendersons, who lived in Bethnal Green; an anthropologist, Nigel's wife, Judy, was working on a project that involved a study of backyards in that community.
5. Lawrence Alloway, introduction to *This is Tomorrow,* catalogue of an exhibition at the Whitechapel Gallery, London, 1956, n.pag.
6. Entitled The New American Painting, this exhibition contained the work of James Brooks, Sam Francis, Philip Guston, and Grace Hartigan, in addition to that of Pollock, de Kooning, and other "First Generation" Abstract Expressionists.
7. The continuity of this initial impetus was maintained especially through the figure of Anthony Caro, the sole sculptor invited to participate. Greenberg's advocacy of his sculpture and the continuing influence of Greenberg's theories in Britain are well documented.
8. Hamilton, quoted in Richard Morphet, introduction to *Richard Hamilton,* catalogue of an exhibition at the Tate Gallery, London, 1971, pp. 32-33.
9. Of the related Pop Art *$he,* which grew out of an investigation Hamilton undertook into consumer goods for an IG lecture, Lawrence Alloway wrote: "*$he* extends the most elliptical sign

language of the art world (minted by Marcel Duchamp) to consumer goods. The painting is characterised by the cool, clean hygienic surface of kitchen equipment and the detailing has the crisp, fine points of ads or explanatory booklets on the products that Hamilton is painting"; "Artists as Consumers," *Image,* no. 3. c. February 1961, pp. 14-19. Later he added, equally validly. "The twentieth century experience of overlapping and clustered sign systems is Hamilton's organising principle"; Lawrence Alloway, "Pop Culture and Pop Art," *Art International,* July 1969, p. 19.

10. "New Brutalism" is a term that was applied more often to the architecture of the Smithsons. For further discussion, see Frampton, "New Brutalism," pp. 47-51. Some years later, Paolozzi and the Smithsons attempted to disassociate themselves from the IG.

11. For a detailed examination of Hamilton's early work, see Morphet, Introduction to *Richard Hamilton.* Certain of these differences should also be attributed to the markedly contrasting temperaments and sensibilities of Paolozzi and Hamilton. Whereas the former is prolix, the latter is terse; whereas the former is anti-academic, the latter demonstrates a spare intellectualism; whereas the former mined tawdry pulp publications – often cheap and nasty, violent and sexist – the latter admired industrial design, the glossies, and other sophisticated products essential to the manufacturing of consumer dreams; and whereas the former found an element of fantasy and horror inherent in actuality, the latter regarded its latest forms of expression with what has been aptly termed "an irony of affirmation." Their differences in attitude could perhaps be compared to the difference between perceiving something receptively and thinking critically about it.

12. Lawrence Alloway later summarized their collective approach: "Any lessons in consumption or in style must occur inside the patterns of entertainment . . . and not weigh it down like a pigeon with *The Naked and the Dead* tied to its leg"; Lawrence Alloway, "The Long Front of Culture" (1959), reprinted in John Russell and Suzi Gablik, *Pop Art Redefined* (London, 1969), p. 42 (hereafter referred to as *Pop Art Redefined*).

13. See "Speculative Illustrations: Eduardo Paolozzi in Conversation with J.G. Ballard and Frank Whitford," *Studio International,* vol. 183, no. 937 (October 1971), p. 136.

14. Paolozzi has had a greater interest than most of the IG members in the products of indigenous cultures and preindustrial societies. Whereas in his art of the fifties his aim was to metamorphose his found material into bronzes (rather than leave it in a preformed state, as occurs in assemblage work), in the activities he undertook as a member of the IG – such as his famous lecture of 1952), Paolozzi's attitude to his sources was what might be called ethnographic surrealism. In that pioneering lecture, Paolozzi presented under an epidiascope a large number of tear sheets without recognizable order, logical connection, or commentary; the material included painted covers from *Amazing Science Fiction,* advertisements for Cadillac and Chevrolet cars, a page of drawings from the Disney film *Mother Goose Goes to Hollywood,* and sheets of United States Army aircraft insignia as well as robots performing various tasks, usually with the help of humans. It was not until a decade later that he incorporated some of this material into his art, in the graphic suite *Bunk.*

15. For a more detailed discussion of the relation between Ballard and Paolozzi, see Eugenie Tsai, "The Sci-Fi Connection: The IG, J.G. Ballard, and Robert Smithson," in *Modern Dreams,* pp. 71-75.

16. Note should be taken of the influential role played by certain celebrated photo books, including László Moholy-Nagy's *Vision in Motion* (1947), D'Arcy Wentworth Thompson's *Growth and Form* (1916; 1st American edn. 1942), Amédée Ozenfant's *Foundations of Modern Art* (1931), and Sigfried Giedion's *Mechanization Takes Command* (1948), on the thinking of the IG. According to Diane Kirkpatrick (*Eduardo Paolozzi* [London, 1970], p. 19), these books, together with "Gutkind's *Our World From The Air,* and Kepes's *The New Landscape* each presented different aspects of the new visual frontiers which Kepes described as 'magnification of optical data, expansion and compression of events in time, expansion of the eye's sensitivity range, and modulations of signals.'"

17. Banham, *New Brutalism,* p. 62.

18. Alloway, Introduction to *This is Tomorrow,* n.pag.

19. For a detailed discussion of the exhibitions organized by members of the IG, see Judith Barry, "Designed Aesthetic: Exhibition Design and the Independent Group," in *Modern Dreams,* pp. 41-45.

20. For a fuller discussion of the critics of American Pop Art, see Carol Anne Mahsun, *Pop Art and the Critics* (1981), dissertation, Ann Arbor, Mich., and London, 1987.

21. The British 1960s Pop artists, whose effect upon the aesthetic status quo was little more than stylistic, were so rapidly assimilated that comparisons have been drawn with the Pre-Raphaelite Brotherhood. These are apt in a number of respects: as regards the speed with which each group became celebrated; as regards their mutual interest in what might be called exotic subject matter; and as regards the fundamentally provincial character of their concerns, at least as realized in their art.

22. Opponents ranged from those on (or formerly on) the Left, such as Clement Greenberg, Irving Howe, and Dwight MacDonald, to conservatives such as José Ortega y Gasset and T.S. Eliot. Greenberg's most notable essay on the subject of "high/low" was "Avant-Garde and Kitsch," first published in 1939, and reprinted many times. But see also Greenberg's "The Present Prospects of American Painting and Sculpture," *Horizon,* nos. 93-94, October 1947. See also Dwight MacDonald, "A Theory of Mass Culture," *Diogenes,* vol. 3 (1953). Typical of these defenders of high culture (though he tended to overstate his arguments) was Erle Loran, who castigated the Pop artists (especially Roy Lichtenstein, who borrowed from his Cézanne compositional diagrams), while viewing Abstract Expressionism as a demonstration of the "true meaning of free democracy . . . in America." For Loran, the New York School paintings were the "most advanced products of the human mind, comparable in some ways to achievements in physics and chemistry." For Erle Loran, see "Cézanne and Lichtenstein: Problems of Transformation," *Artforum,* vol. 2 (September 1963), pp. 34-35; "Pop Artists or Copy Cats," *Art News,* September 1963, pp. 48-49, 61. The statements by Loran quoted in this note are from "Cézanne and Lichtenstein," p. 35. There was a general difference in approach to much mass culture between writers in the United States and the IG. Among the first American books to survey the subject in any detail was an anthology entitled *Mass Culture: The Popular Arts in America,* edited by Bernard Rosenberg and David Manning White and published in 1957. It contained the work of fifty-one writers concerned with the social effects of the media on American life. In their introduction to the texts, the editors commented that when they were seeking representative viewpoints they found many more excoriators than defenders of mass culture. Moreover, most of the defenders, including White himself, argued in favor of mass culture on the grounds it spread high culture to new audiences, instancing the presentation of Shakespeare, ballet, and opera on TV and the boom in paperback publishing, which had led to the reprinting of Dostoevsky as well as pulp writers. Unlike the IG, they did not value it in itself, on its own account. That the IG was aware of at least some of these debates is indicated by the fact that in a 1958 article, "The Arts and the Mass Media," Lawrence Alloway attacked Greenberg's essay "Avant-Garde and Kitsch," objecting to his reduction of the mass media to "ersatz culture . . . destined for those who are insensible to the value of genuine culture"; reprinted in Michael Compton, *Pop Art,* London, New York, Sydney, and Toronto, 1970, p. 154. Marshall McLuhan's *The Mechanical Bride,* published in 1951, was also discussed at IG meetings. More than half the book was given over to reproductions of advertisements and other manifestations of popular culture; the other half was devoted to a commentary on their significance.

23. De Kooning's interest in, say, the pinup and Mom-ism was only first studied in 1972, in Thomas B. Hess's "Pinup and Icon," *Art News Annual,* vol. 38 (1972), pp. 223-37. Note that de Kooning had been trained in commercial-art techniques in Rotterdam, had worked in that field in New York in the interwar years, and maintained a lifelong interest in popular art forms – an interest expressed in his art in diverse ways.

24. The New Realists show at the Sidney Janis Gallery, New York, contained the works of Warhol, Lichtenstein, Oldenburg, and Rosenquist, among the fourteen artists exhibited. For a range of early responses to (American) Pop Art, see the symposium held at the Museum of Modern Art, New York, on December 13, 1962, in which the participants included Peter Selz, Henry Geldzahler, Hilton Kramer, Dore Ashton, Leo Steinberg, and Stanley Kunitz. This was later published in *Arts Magazine,* April 1963, pp. 36-45.

25. Because they were graphic in nature, Lichtenstein's sources at this moment did not even have the degree of respectability that certain types of photographic reproduction had. They were consequently considered that much more shocking at first. Similarly, in his paintings Andy Warhol simulated a style of advertising copy very different from the chic high-style advertisements he made as an award-winning designer for such up-market clients as I. Miller and *Vogue.*

26. Among the more substantial early publications on Pop Art, a considerable number were by English authors. See, in addition to Alloway, for example, "The Development of British Pop," in Lucy Lippard, ed., *Pop Art* (New York, 1966), pp. 27-68; John Russell, "British Art," in *Pop Art Redefined;* and Compton, *Pop Art.* One of the first and most important shows curated by Alloway was Six Painters and the Object, which included work by Jim Dine, Lichtenstein, Jasper Johns, Robert Rauschenberg, James Rosenquist, and Warhol. It opened at the Solomon R. Guggenheim Museum in New York in 1963 and then traveled to the Los Angeles County Museum of Art, where Alloway added a companion, West-Coast-based show, Six More.

27. Alloway published his history on several occasions; the most influential account appeared in Lippard, ed., *Pop Art.*

28. See Anne Massey and Penny Sparke, "The Myth of the Independent Group," *Block,* no. 10, 1985, p. 48. They point out that Banham, whose writing was also being published widely at this time, did not mention the IG in print until the winter of 1962–63, in an article published in *Motif,* entitled "Who Is This Pop?" in which he argued that all subsequent manifestations of Pop sensibility were indebted to the IG.

29. See, for example, Robert Hughes, *The Shock of the New* (New York, 1980). Norbert Lynton, in his *The Story of Modern Art* (Oxford, 1980), mentions briefly the This is Tomorrow exhibition without, however, naming the IG. John Russell omitted all mention of the IG, Pop, and British Pop from his account of twentieth-century art, *The Meanings of Modern Art* (New York, 1981).

30. Gerhard Richter and Richard Hamilton, in particular, would repay closer comparison, given that both are modernist artists committed to bringing a critical, articulate, contestatory address to painting. Although their interests in the usage of various types of popular-culture imagery and styles converge, neither has confined himself to a conventional Pop Art approach. For example, during the 1960s, Hamilton executed a series of works inspired by the "classical Braun products" designed by Dieter Rams, which, according to the artist, "attempted to introduce a contradiction into the lexicon of source material of Pop. They posed the question: does the subject-matter in most American Pop Art significantly exclude those products of mass culture which might be the choice of a New York Museum of Modern Art 'Good Design' committee from our scrutiny?" ("concept/technology > artwork," in *Richard Hamilton,* catalogue of an exhibition at the Moderna Museet, Stockholm, 1989, p. 22). Recently Richter has drawn on news photographs from the popular press for his series of works based on the Baader-Meinhof gang, a series that raises the possibility of a contemporary history painting.

31. Robert Rosenblum, for example ("Pop Art and Non-Pop Art," *Art and Literature,* vol. 5 [Summer 1964], reprinted in *Pop Art Redefined,* pp. 53-56), argued that "the initially unsettling imagery of Pop Art will quickly be dispelled by the numbing effects of iconographic familiarity and ephemeral or enduring pictorial values will become explicit . . . this boundary between Pop and abstract art is an illusory one," an argument that John Russell and Suzi Gablik sought to second in *Pop Art Redefined.* In doing so, they reinforced statements that many of the artists, most notably Lichtenstein, were then making about their work. But, as Lisa Tickner has pointed out in a discussion of Allen Jones's art ("Allen Jones in Retrospect: A Serpentine Review," *Block,* no. 1 (1979), the problem with trying to focus on form and formal issues alone is that images are not nonhierarchical, interchangeable, and equitable. She continues (p. 41), "It has seemed crudely philistine to talk about the social and psychological relevance of the material – but any understanding of art as a signifying practice must break with the form/content distinction (with the accompanying implication that the 'art' lies in the 'form'), and must attempt to comprehend both the specificities of art as a particular kind of activity, and the way in which this activity transforms or endorses meanings that lie both within and beyond it." It is just this which certain of the more doctrinaire analysts of Pop signally fail to do; see, for example, Donald Kuspit, "Pop Art: A Reactionary Realism," *Art Journal,* Fall 1976, pp. 31-38.

32. Typical of these analyses, which focus on the commodity character of art in capitalist societies, is the argument advanced by Donald Kuspit, in "Pop Art: A Reactionary Realism."

33. Andreas Huyssen has analysed the reasons why in West Germany Pop was taken to be a subcultural, indigenous underground statement, at once critical of capitalist consumer society and yet emancipatory in its effects; see Andreas Huyssen, "The Cultural Politics of Pop" (1975), reprinted in Taylor, *Post-Pop Art* (MIT Press, Cambridge, Mass.: 1989), pp. 45-78.

34. The most prolific and well known of the theorists who, informed by Marxist and linguistic theories, have examined late capitalism as a society of consumption, Jean Baudrillard ("Pop: An

Art of Consumption?" [1970], reprinted in Taylor) argues that the (American) Pop artists cannot be "reproached for their commercial success, and for accepting it without shame. . . . It is logical for an art that does not oppose the world of objects but explores its system, to enter itself into the system. It is even the end of a certain hypocrisy and radical illogically. . . . Yet it is difficult to accuse either Warhol or the Pop artists of bad faith: their exacting logic collides with a certain sociological and cultural status of art, about which they can do nothing. It is this powerlessness which their ideology conveys. When they try to desacrilize their practice, society sacrilizes them all the more. Added to which is the fact that their attempt – however radical it might be – to secularize art, in its themes and its practice, leads to an exaltation and an unprecedented manifestation of the sacred in art. . . . [T]he author's content or intentions are not enough: it is the structures of culture production which are decisive . . . in Pop Art. . . . [I]ts smile epitomizes its whole ambiguity: it is not the smile of critical distance, it is the smile of *collusion.*" (Taylor, pp. 36, 40-41, 44.) For recent exhibitions that feature art indebted to Baudrillard's and related ideas, see *A Forest of Signs,* catalogue of an exhibition at the Museum of Contemporary Art, Los Angeles, 1989; and *Image World: Art and Media Culture,* catalogue of an exhibition at the Whitney Museum of American Art, New York, 1989.

35. Benjamin H.D. Buchloh, "The Andy Warhol Line," in *The Work of Andy Warhol,* ed. Gary Garrels (Seattle, 1989), p. 55.
36. Introduction to Paul Taylor, op.cit., p. 11.

From POP TRIUMPHANT: A NEW REALISM

Bruce Altshuler

. . . . The rise of Pop can be emblemized in Oldenburg's transition from The Street to The Store, from the site of debris to the site of commerce. From the junk aesthetic Oldenburg moved to present art and its objects as destined for the consumer market, where "Museum in b[ourgeois] concept equals store in mine."[1] First embodied as brightly painted reliefs in the stairwell and front gallery of Martha Jackson's large exhibition early in the summer of 1961 – Environments, Situations, Spaces – the concept demanded a place all its own. And when Oldenburg moved his studio to an old storefront at 107 East 2nd Street, he decided to instantiate it right there. On Friday, December 1, from seven to ten P.M., he opened his own store, just in time for the Christmas shopping season.

Incorporated as The Raygun Manufacturing Company, The Store originally was to close at the end of December, conducting business Fridays through Sundays from one to six o'clock and by appointment. Due to popular demand Oldenburg extended it through January, followed by a series of happenings – for an audience of thirty-five crowded amidst his lively works – that lasted until the end of May. Eighty feet long and ten feet wide, The Store was filled with 107 objects, ranging in price from $21.79 for a painted plaster oval mirror to $899.95 for the large figure of a bride. The reliefs from the Martha Jackson show were supplemented by all sorts of free-standing objects, everything messily painted in bright commercial enamel right out of the can. There were shoes, doughnuts, sneakers, candy bars, pants, shirts, letters, hats, sandwiches, ties, dresses, fried eggs, girdles, disembodied legs and jacketed torsos, cakes and pies in glass cases.[2] As Sidney Tillim wrote in *Arts*, "It was the very simulacrum of the ultimate in American variety stores, a combination of neighborhood free enterprise and Sears and Roebuck."[3] For Tillim, The Store exemplified artists' recent discovery that the American Dream could be avant-garde, too. Here he had subject matter in mind, images of consumer goods and media imagery that were proliferating in vanguard galleries. But soon the financial aspect of the connection would become more apparent, and more controversial.

The Store was presented in conjunction with the Green Gallery, which had agreed to pay half of the expenses and take a commission of one-third after sales had reached $200. With total sales of $1,655 and expenses of about $400, Oldenburg ended his two months of business owing the gallery $285.[4] This debt readily would be made good, however, as 1962 turned into a boom year for the art that would become known as Pop. The year began with Jim Dine at Martha Jackson in January, moved in February to the Pop introductions of James Rosenquist at the Green Gallery and Roy Lichtenstein at Castelli, George Segal's plaster figures at the Green Gallery in May, Andy Warhol's thirty-two paintings of Campbell's Soup cans at the Ferus Gallery in Los Angeles in July, Oldenburg's huge soft sculptures at the Green Gallery in September – October leading into Sidney Janis's New Realists, Andy Warhol's silkscreen paintings at the Stable Gallery and Tom Wesselmann's *Great American Nudes* at the Green Gallery in November. The year of Pop ended in Los Angeles at the Dwan Gallery, with a group show of thirteen artists, *My Country 'Tis of Thee*. There, with eerie foreboding, a vandal shot the figure of JFK in Marisol's sculpture *The Kennedys*.[5]

Excerpt, *The Avant-Garde in Exhibition: New Art in the 20th Century*, New York: Harry N. Abrams, 1994: 212-19

Oldenburg himself spent the summer of 1962 working in the lofty 57th Street space of the Green Gallery, preparing for his opening-of-the-season exhibition. Here he had room to enlarge the kind of objects that he had shown at The Store, creating the gigantic stuffed canvas hamburger, ice cream cone, and slice of cake that so impressed the collectors a month before the Janis show. Run by the former director of the Hansa Gallery, Richard Bellamy, the Green Gallery was backed anonymously by the first major collector of Pop Art, Robert Scull. Wealthy owners of a taxi fleet, Scull and his wife, Ethel, epitomized the collectors who would become art-world celebrities during the sixties. In fact, the first book on Pop, by John Rublowsky, featured photographs of the new collectors living on Park Avenue and in the suburbs with their Rosenquists, Lichtensteins, and Warhols.[6] On those walls images from comic books, advertisements, and packaging looked back with nostalgia to the America of their youth, with facture clean enough to enter, the suburban world into which postwar prosperity had moved them, along with about a third of the American population. And these new buyers would be purchasing their art with a new attitude. As *Life* happily quoted Leon Kraushar, one collector whose home was shown in Rublowsky: "[T]hese pictures are like IBM stock . . . and this is the time to buy."[7]

That the first group show of the new artists was held at the establishment Sidney Janis Gallery was a matter for much critical comment when the exhibition New Realists opened on the last day of October.[8] In *The New Yorker*, Harold Rosenberg said that the show "hit the New York art world with the force of an earthquake," attributing the "sense of art history being made" to the prestigious venue. Tom Hess in *Art News* remarked that it was "the reputation of the gallery which added a certain adrenaline quality to the manifestation," since Janis had "assumed a status for living painting that resembles the old Duveen's of the Master trade." Most emphatic was Sidney Tillim in *Arts*, who noted that "dealer Sidney Janis has moved in on the 'pop' craze at harvest time," and that, as the preeminent dealer of Abstract Expressionism, he "is capable of certifying a trend." For Tillim the European work, which all critics considered less innovative than the American, had been included to certify the existence of "a new International Style" now led by the New York artists.[9]

Because the exhibition was to include at least two works from each of fifty-four artists, and the American paintings were so large, the gallery at 15 East 57th Street was much too small. Janis therefore rented an empty store across Fifth Avenue at 19 West 57th Street, through whose glass front the public could survey the installation. In the window he placed Oldenburg's array of brightly painted women's underwear, an ironic transposition of The Store from the Lower East Side to classy 57th Street, via the aesthetics of 14th Street shop display.

Although the show was called New Realists, the translated French appellation coming from Restany, there was much discussion of what these artists should be called. In his own catalogue essay Sidney Janis seemed to prefer Factual Artists, also mentioning the use of Pop Artist in England and Polymaterialist in Italy, and in a footnote he refers to Commonists as another alternative. Eventually, of course, Pop triumphed, a term first used by English critic Lawrence Alloway to refer to the culture rather than to the art derived from it. Brian O'Doherty's second *New York Times* review of the show was entitled "'Pop' Goes the New Art," and the term soon would appear in headlines in *Time*: "Pop Art – Cult of the Commonplace," "Art: Pop Pop."[10]

While some critics, such as Dore Ashton, tended to view the exhibition as just more Neo-Dada of the sort seen at Martha Jackson, the recent work of Lichtenstein, Warhol,

Indiana, Wesselmann, and Rosenquist clearly pointed in a new direction. As Tom Hess reported: "The point of the Janis show . . . was an implicit proclamation that the New had arrived and that it was time for the old fogies to pack. . . . the New Realists were eyeing the old abstractionists like Khrushchev used to eye Disneyland – 'We will bury you' was their motto." And Janis's stable of Abstract Expressionist masters did not take the challenge lightly. After the exhibition, as the gallery continued to take on Pop artists, a protest meeting was held and Guston, Motherwell, Gottlieb, and Rothko left the gallery. Only de Kooning remained.[11]

In the catalogue Janis identified three themes exemplified by work in the exhibition – the everyday object, the mass media, and repetitive imagery evoking mass production – but the two installations made little attempt to group the pieces by these categories. The sense of an international movement was emphasized through the intermingling of European and American work, and most artists appeared in both gallery spaces. Certainly there were some telling juxtapositions of a thematic kind. Just past the Oldenburg underwear display in the window of the storefront space, Arman's rows of faucets hung next to Warhol's painting of 200 Campbell's Soup cans, the antiquated look of the European hardware contrasting with the slick reproduction of American packaging. Further along, past James Rosenquist's huge painting of a car grill over a mass of spaghetti, *I Love You with My Ford*, the EAT of Robert Indiana's *Black Diamond American Dream #2* – which would be acquired by the president of MOMA for his personal collection – sat behind Oldenburg's luscious pastry display case, across the room from the enlarged sliced white bread, Lipton soup mix, Del Monte catsup and canned fruit, and Schmidt's beer of Tom Wesselmann's *Still Life #19*. Toward the end of the space sat George Segal's eerie group of six plaster figures around the dinner table, life casts encasing interior likenesses of their models. Positioned next to a refrigerator by Jean Tinguely, they bore mute witness to the shock of those who opened the fridge door to a screaming siren. Appropriately enough, the theme was introduced at the front door, as one passed Lichtenstein's comic book close-up of a woman cleaning the inside of her refrigerator, below Spoerri's funky *Le Parc de Marcelle*, a "snare-picture" comprised of a chair and folding table, to which were glued beer bottles, a coffee cup, and a full ashtray.

The display was more elegant in the Sidney Janis Gallery at 15 East 57th, without the ad hoc lighting and exposed sprinkler pipes of the temporary space down the street. In the smaller rooms of the gallery the large American paintings were even more striking, completely overwhelming the intimately scaled work of most of the European artists. Here such clean and bright paintings as Lichtenstein's *Blam*, Rosenquist's *Silver Skies*, Wayne Thiebaud's *Salads, Sandwiches, and Desserts*, and Warhol's paint-by-numbers daffodils and irises, *Do It Yourself*, took all attention away from works like Tinguely's relief of radio parts, Christo's wrapped burlap package, Yves Klein's pink and blue sponge sculptures, and the Italian Gianfranco Baruchello's mounted pile of newspapers, *Awareness II*. Of course, some European pieces acquitted themselves well in terms of scale and power, with Arman's accumulation of sabres more than holding its own across a doorway from Jim Dine's painting with attached lawnmower, and the Swede Öyvind Fahlström's surreal-psychedelic cartoon imagery bearing up across from Warhol's unfinished flowers.

In both spaces the overall impression was that the European work was old-fashioned, akin to earlier New York Neo-Dada in its use of discarded and rough materials, and in painterly feel closer to the legacy of Abstract Expressionism than to the clean lines of American media images. The Italian Mario Schifano might paint the Coca-Cola logo, but his messy drips looked dated alongside Warhol's soup cans. Mimmo Rotella and Ray-

mond Hains used actual advertising posters, but their ripped patterns were more like *Tachiste* gesture than the pristine ads in Wesselmann's collages or than Rosenquist's billboard fantasies. As for the English artists, certainly John Latham's reliefs of abused books seemed much like late fifties assemblage. And while Peter Blake's large *Love Wall* of postcards, pin-ups, and Pop image of a heart looked neat and new between the Klein sponge sculptures and Christo's package, and Peter Phillips's *Wall Machine* used comic book panels, their visual restraint was obvious when compared with the boisterous American way of recycling media imagery. As Hess remarked in *Art News*, the Europeans "look feeble in this line-up. Some Englishmen do comic strips that try to say 'WOW' but can only manage the equivalent of 'Coo, matey.'"[12]

The other critics concurred that the Americans dominated the exhibition, and even Restany in retrospect agreed that his *Nouveaux Réalistes* "look[ed] like venerable ancestors" of the New York artists.[13] The shock was especially great for the three French artists who came to New York for the exhibition – Martial Raysse, Jean Tinguely, and Niki de Saint-Phalle, who was showing concurrently at the Iolas Gallery. Although he had been taken on by Janis the previous summer, Arman was unable to leave Paris, but he received an outraged letter from his friends: Their pieces looked small, dusty, and antique next to the aggressive American work. The exhibition had been designed to make them look bad, and they had been unfairly vanquished. Raysse, whose displays of pristine plastic commodities looked especially fresh compared to the work of his fellows, nonetheless was very upset. He wrote to Arman about Warhol, even including sketches of particular pieces, and told his friend to begin painting groups of brightly colored French objects so as to reclaim his position.[14] In retrospect, the French were to feel that they had been used by Janis to give his establishment gallery an avant-garde air, making it more attractive to the younger American artists.[15]

Restany himself responded to the exhibition with an article in the January 1963 *Art International*, an issue devoted to the Janis show and to the new Pop artists. There he criticized the Americans for developing the *Nouveau Réaliste* investigation of "the expressive autonomy of the object" into a monotonous "modern fetishism of the object." For him most of the Pop painters just worked in another trompe-l'oeil style, modern in look but retrograde in substance. In addition to displeasure over the way that his artists had been shown up, he could not have been happy about the treatment of his catalogue essay. Only a small portion of the long piece was printed, for Janis had found the wordy tract virtually untranslatable and largely irrelevant to the content of his exhibition.[16] The only long critical text to be included was that of John Ashbery. He, ironically, had written it in Paris.

Naturally, there was a great deal of press surrounding the show. Critics such as Hilton Kramer, Dore Ashton, Irving Sandler, and Thomas Hess, closely associated with the ethos of Abstract Expressionism, were largely negative, especially concerning the painting of Warhol, Lichtenstein, and Rosenquist. While in various ways supportive of such work as that of Oldenburg and Segal, who, in Sandler's words, "infuse commonplace objects with new imaginative meanings," for them the general movement seemed to repudiate any search for transcendence or higher significance. What some viewed as social commentary Kramer saw as feigned, a vision "too tame and accommodating[,] . . . the usual attempt to disguise an essentially conformist and Philistine response to modern experience under a banner of audacity and innovation." In spirit if not in tone, many critics echoed Max Kozloff's view in the first article discussing the new art as a whole, "Pop Culture, Metaphysical Disgust and The New Vulgarians": "The truth is, the art galleries are

being invaded by the pin-headed and contemptible style of gum chewers, bobby soxers, and worse, delinquents." Even Brian O'Doherty, whose enthusiasm for the exhibition seemed to know few bounds, found much there to be throwaway art, expendable once its clever journalistic work was done.[17]

On December 13, just after the Janis show and culminating the year of Pop, a symposium on the subject was organized by curator Peter Selz at the Museum of Modern Art.[18] A major issue was the speed with which Pop art had appeared and become commercially successful. Henry Geldzahler, a young curator at the Metropolitan Museum of Art and a firm Pop supporter, noted that a year and a half ago he had visited the studios of Lichtenstein, Warhol, Wesselmann, and Rosenquist to find them all working in the new mode unaware of one another, and that now there was a symposium on their "movement" at MOMA. To resent such rapid success, he thought, was to subscribe to an outmoded myth of the alienated artist, a notion obsolete since a significant class of collectors had appeared seeking to patronize advanced art. This "instant art history," and the participation of museums in the process, was decried by Kramer and Stanley Kunitz, and Kramer attributed much of Pop's success to the ease with which the work could be spoken about. For him, it marked "a kind of emancipation proclamation for the art critic[,] . . . the conversation piece par excellence."

Yet both Geldzahler and Leo Steinberg thought that the triumph of the Pop artists reflected more than ease of verbal and imagistic reference. Rather, the Pop phenomenon signaled a shift in the nature of the avant-garde. Steinberg saw it as a change in strategy, a move from attacking the bourgeoisie to embracing its values with a vengeance. For Geldzahler the point was that advanced art now had its own establishment, one that had been educated to expect and to desire the new, and thus one that no longer could be shocked. The avant-garde had triumphed, and in its success it had eliminated the ground of its own existence.

A few months later, *Time* reported that "Collectors, uncertain of their own taste, find pop art paintings ideal for their chalk-walled, low-ceilinged, $125,000 co-op apartments in new buildings on Park Avenue. . . . [S]ince the avant-garde public is so hungry for more and more avant, the pop artists are in the chips."[19] And certainly it was these chips that inspired much of the resentment toward the Pop artists. Members of the Club had slaved for years before selling a painting, and here young artists were finding financial success with their first shows. The grapevine and the journals reported "wild buying," and Pop artists socialized with wealthy collectors who, the critic Barbara Rose remarked, were "as frequently collecting artists as art."[20] The fifties had brought America into a different world, and the sixties had brought it a different kind of art world.

As Allan Kaprow would note in 1964, "If the artist was in hell in 1946, now he is in business."[21] The growing university system had hired artists trained on the G.I. Bill, and for the first time large numbers of artists could expect to earn a decent living. Widespread university education had expanded general cultural awareness, and an enlarged middle class was able to support what they were being taught to value. Museum activity grew, popular media gave more coverage to the new art scene, gallery sales and prices of successful artists increased. With Pop the pattern that would recur throughout the seventies and eighties was formed – new art providing new status to those of new wealth. Not only had Pop packaged the imagery of the American dream, it had wrapped itself up in the same bundle. For the rest of the decade advanced art would attempt to untie the twine.

1. Barbara Rose, *Claes Oldenburg* (New York: The Museum of Modern Art, 1969). Also see the artist's 1961 notebook remarks in Claes Oldenburg and Emmett Williams, *Store Days* (New York: Something Else Press, 1967), pp. 8, 49, 81.

2. For the full inventory of The Store, with prices, see Oldenburg and Williams, pp. 31-34.

3. Sidney Tillim, "Month in Review," *Arts*, February 1962, p. 36.

4. Oldenburg and Williams, p. 150.

5. John W. McCoubrey, *Robert Indiana* (Philadelphia: University of Pennsylvania, Institute of Contemporary Art, 1968), p. 54.

6. John Rublowsky, *Pop Art*. Photography by Ken Heyman (New York: Basic Books, 1965). In addition to photographs of the Sculls, the book showed the home of Leon Kraushar, whose widow would sell his Pop works through Munich dealer Heiner Friedrich in 1968 to German collector Hans Stroher, who would circulate them throughout Germany before their installation in the Hessischen Landesmuseum in Darmstadt. Phyllis Tuchman, "American Art in Germany: The History of a Phenomenon," *Artforum*, November 1970, p. 59.

7. "You Bought It – Now Live with It," *Life*, July 16, 1965, p. 59.

8. Actually, this was the first group show in *New York* to feature the newly emerged form of Pop. The previous April and May, the Dallas Museum for Contemporary Art had presented the exhibition 1961, whose 36 artists included Dine, Lichtenstein, Oldenburg, and Rosenquist. There The Store was partially re-created, and Oldenburg presented a second version of his Happening, *Injun*.

9. Harold Rosenberg, "The Art Galleries: The Game of Illusion," *The New Yorker*, November 24, 1962, p. 162. Thomas B. Hess, "New Realists," *Art News*, December 1962, p. 12. Sidney Tillim, "The New Realists," *Arts*, December 1962, pp. 43-44. Four years later the show was cited in these terms by Lucy Lippard in her early overview of the movement, where she noted that at Janis "Pop was consecrated as fashionable. . . ." Lucy Lippard, "New York Pop," in Lucy Lippard, *Pop Art* (New York: Praeger, 1966), p. 84.

10. Sidney Janis, "On the Theme of the Exhibition," in *New Realists* (New York: Sidney Janis Gallery, 1962). On Alloway's use of the term *Pop*, see Lawrence Alloway, "The Development of British Pop," in Lippard, p. 27. Alloway's misleading use of the Independent Group activities in England as a precursor of American Pop is discussed in Lynn Cooke, "The Independent Group: British and American Pop Art, A 'Palimpcestuous' Legacy," in Kirk Varnedoe and Adam Gopnik, eds., *Modern Art and Popular Culture: Readings in High and Low* (New York: Museum of Modern Art, 1990), especially pp. 197-202. For the four exhibitions of the Independent Group, which include the important This Is Tomorrow of 1956, see Graham Whitham, "Exhibitions," in David Robbins, *The Independent Group: Postwar Britain and the Aesthetics of Plenty* (Cambridge, MA: MIT Press, 1990), pp. 123-161. The cited articles appeared in the *New York Times* on November 4, 1962, Section 2, p. 23, and in *Time* on May 3, 1963, pp. 69 ff. and August 30, 1963, p. 40.

11. Dore Ashton, "New York Report," *Das Kunstwerk* (16), November–December 1962, pp. 69. Hess, p. 12. "Sidney Janis," in Laura de Coppet and Alan Jones, *The Art Dealers* (New York: Clarkson N. Potter, 1984), pp. 39-40.

12. Hess, p. 13.

13. Restany, "Modern Nature," p. 44.

14. Interview with Arman, October 11, 1991.

15. According to unpublished interviews conducted by Susan Hapgood in Paris in April 1992, both Pierre Restany and Daniel Spoerri hold this view. I thank Hapgood for the use of her transcripts, in which Restany also suggests that it was Leo Castelli who convinced Janis to focus on the new Pop artists instead of Neo-Dada.

16. Pierre Restany, "Le Nouveau Réalisme à la Conquête de New York," *Art International*, January 25, 1963, pp. 33-36. Janis cabled the Galerie J about Restany's text being largely "irrelevant" on September 25, explaining in a letter the same day that they had been unable to get an "intelligible translation" of the whole essay, but that Georges Marci (who worked with Jean Larcade, and had introduced Arman to Janis) had managed to render part of it into understandable English. Janis felt that to print the whole piece would damage the reputations of both Restany and the *Nouveaux Réalistes*. Sidney Janis Gallery Archives, New York.

17. Dore Ashton, "New York Report," *Das Kunstwerk*, November–December 1962, pp. 69–70. Irving Sandler, "In the Galleries," *New York Post*, November 18, 1962, magazine, p. 12. Hilton Kramer, "Art," *Nation*, November 17, 1962, p. 335. Max Kozloff, "Pop Culture, Metaphysical Disgust and the New Vulgarians," *Art International*, February 1962, p. 38. Brian O'Doherty, "Art: Avant-Garde Revolt: 'New Realists' Mock U.S. Mass Culture in Exhibition at Sidney Janis Gallery" and "'Pop' Goes the New Art," *New York Times*, October 31, 1962, p. 41 and November 4, 1962, section 2, p. 23. Much of the published criticism of Pop is reprinted in Carol Anne Mahsun, ed., *Pop Art: The Critical Dialogue* (Ann Arbor: UMI, 1989), and discussed in Carol Anne Mahsun, *Pop Art and the Critics* (Ann Arbor: UMI, 1987).

18. The proceedings were published a few months later in "A Symposium on Pop Art," *Arts*, April 1963, pp. 36–45. The participants were Henry Geldzahler, Hilton Kramer, Dore Ashton, Leo Steinberg, Stanley Kunitz, and Peter Selz, and at the symposium slides were shown of the artists' work. Jill Johnston reported that Marcel Duchamp was in the audience, and that after Kramer called him "the most overrated figure in modern art," Duchamp remarked to his neighbor that the critic seemed "insufficiently light-hearted." Jill Johnston, "The Artist in a Coca-Cola World," *The Village Voice*, January 31, 1963, p. 24.

19. "Pop Art – Cult of the Commonplace," *Time*, May 3, 1963, pp. 60–70. The article was occasioned by Lawrence Alloway's exhibition at the Guggenheim Museum, "Six Painters and the Object." (The artists were Dine, Johns, Lichtenstein, Rauschenberg, Rosenquist, and Warhol.) *Time* goes on to quote Philip Johnson calling Pop "the most important art movement in the world today," and Max Ernst derisively remarking, "It is just some feeble bubbles of that Coca-Cola, which I consider less than interesting and rather sad."

20. Both remarks are from the *Art International* number of January 25, 1963, devoted to the Janis exhibition. The sales situation is reported by Sonya Rudikoff, "New Realists in New York," p. 41, and the comment on the collectors is from Barbara Rose, "Dada Then and Now," p. 27.

21. Allan Kaprow, "Should the Artist Become a Man of the World?" *Art News*, October 1964, p. 34. Summarizing the New York art scene a few years later, Alan Solomon, who had mounted the early retrospectives of Johns and Rauschenberg at the Jewish Museum, remarked that with the "analysts' bills, sports cars, Barcelona chairs, summer houses, travel abroad, [and] custom clothes . . . i[t] has become ever more difficult to tell the artists from the collectors." Alan Solomon, text, and Ugo Mulas, photographs, *New York: The Art Scene* (New York: Holt Rinehart Winston, 1967), p. 67.

RAY-GUN MFG. CO.

DICIEMBRE 1 AL 31

THE
STORE
BY
CLAES OLDENBURG

107 E. 2ND ST.

HOURS: FRI., SAT., SUN. 1 TO 6 P.M.
AND BY APPOINTMENT
IN COOPERATION WITH
THE GREEN GALLERY

MANHATTAN PRESS 1662 PARK AVE. LE 4-7977

CHRONOLOGY

1958

January–February	Leo Castelli Gallery, New York. "Jasper Johns."
March	Leo Castelli Gallery, New York. "Robert Rauschenberg."
October–November	Leo Castelli Gallery, New York. Group exhibition includes Johns, Marisol, and Rauschenberg.

1959

February–March	Judson Gallery, Judson Memorial Church, New York. "Jim Dine, Marc Ratliff, Tom Wesselmann."
May–June	Judson Gallery, Judson Memorial Church, New York. "Drawings, Sculptures, Poems by Claes Oldenburg."
October	Art Directions Gallery, New York. "Dick Artschwager and Richard Rutkowski."
October	Judson Gallery, Judson Memorial Church, New York. "Judson Group." Exhibition includes Dine, Oldenburg, and Tom Wesselmann.
November–December	Judson Gallery, Judson Memorial Church, New York. "Oldenburg-Dine."
December–January 1960	Reuben Gallery, New York. "Below Zero." Show includes Dine, Grooms, Oldenburg, Rauschenberg, and George Segal.
December–February 1960	Museum of Modern Art, New York. "Sixteen Americans." Exhibition includes Johns and Rauschenberg.

1960

January–February	Reuben Gallery, New York. "Paintings." Show includes Dine, Oldenburg, and Segal.
January–March	Judson Gallery, Judson Memorial Church, New York. Exhibition of *The House* by Dine and *The Street* by Oldenburg.
February–March	Judson Gallery, Judson Memorial Church, New York. "Ray Gun and Spex." Oldenburg's first Happening, *Snapshots from the City,* in the environment of *The Street.* Dine presents *The Smiling Workman in the House.*
May	Reuben Gallery, New York. "Claes Oldenburg." His first solo show, with a variation of *The Street.*
May	Judson Gallery, Judson Memorial Church, New York. "Tom Wesselmann and Marc Ratliff."
June	Martha Jackson Gallery, New York. "New Media – New Forms." Show includes Dine, Robert Indiana, and Oldenburg.
September–October	Martha Jackson Gallery, New York. "New Media – New Forms II." Show includes Dine and Oldenburg.

1961

May	Dance Studio, New York. "Contemporary American Art: Stephen Durkee, Robert Indiana, and Richard Smith."
May–June	Martha Jackson Gallery, New York. "Environments, Situations, Spaces." Features objects from Oldenburg's *The Store* and Dine's *Spring Cabinet.*
June	Oldenburg moves studio to storefront at 107 East 2nd Street, New York.
October–November	Allan Stone Gallery, New York. "Stephen Durkee."
October–December	Museum of Modern Art, New York. "Art of Assemblage." Exhibition includes Indiana, Johns, Marisol, and Rauschenberg.
November–December	Everett Ellin Gallery, Los Angeles. "Jasper Johns Retrospective."

December	Tanager Gallery, New York. "Tom Wesselmann, Great American Nude."
December–January 1962	Second version of *The Store* created in conjunction with Green Gallery at Oldenburg's studio.

1962

January–February	Martha Jackson Gallery, New York. "Jim Dine."
January–February	Green Gallery, New York. "James Rosenquist."
January–February	Allan Frumkin Gallery, New York. "Peter Saul."
February–March	Leo Castelli Gallery, New York. "Roy Lichtenstein." His first show at Castelli. Consists of new cartoon images.
February–May	"The Store," New York. Oldenburg presents performances.
April–May	Allan Stone Gallery, New York. "Wayne Thiebaud."
April–May	Dallas Museum for Contemporary Arts, Dallas. "1961." Group exhibition includes objects from Dine, Roy Lichtenstein's *The Kiss*, and Oldenburg's *The Store*. Also includes Johns, Rauschenberg, and Rosenquist.
May–June	Green Gallery, New York. "George Segal."
July–August	Ferus Gallery, Los Angeles. "Andy Warhol." One-person show of Campbell's soup cans.
August	Mi Chou Gallery, New York. "Art of Two Ages: The Hudson River School and Roy Lichtenstein."
September–October	Green Gallery, New York. "Claes Oldenburg." First display of large-scale "soft" sculptures.
September–October	Pasadena Art Museum, Pasadena. "New Paintings of Common Objects," including Dine, Lichtenstein, Ruscha, Thiebaud, and Warhol.
October–November	Stable Gallery, New York. "Robert Indiana."
November–December	Sidney Janis Gallery, New York. "International Exhibition of the New Realists." Exhibition of European New Realists and American Pop artists, including Dine, Öyvind Fahlström, Indiana, Lichtenstein, Oldenburg, Rosenquist, Segal, Warhol, and Wesselmann.
November	Stable Gallery, New York. "Andy Warhol."
November–December	Green Gallery, New York. "Tom Wesselmann: Collages/Great American Nude & Still Life."
November–December	Dwan Gallery, Los Angeles. "My Country 'Tis of Thee." Show includes Indiana, Johns, Lichtenstein, Oldenburg, Rauschenberg, Rivers, Rosenquist, Warhol, Wesley, and Wesselmann.
December	Pace Gallery, Boston. "Stock Up for the Holidays." Show includes Dine, Indiana, Marisol, Oldenburg, Rosenquist, Warhol, and Wesselmann.
December 13	Museum of Modern Art, New York. Symposium on Pop Art including Dore Ashton, Henry Geldzahler, Hilton Kramer, Stanley Kunitz, Peter Selz and Leo Steinberg. Transcript published in *Arts*, April 1963.

1963

January–February	Art Institute of Chicago, Chicago. "66th American Annual Exhibition." Rosenquist is the only Pop artist to win a prize. Indiana, Lichtenstein, Marisol, Oldenburg, Rauschenberg, and Segal participate as well.
February	Sidney Janis Gallery, New York. "Jim Dine."
February	Allan Frumkin Gallery, New York. "Peter Saul."
February–March	Robert Elkon Gallery, New York. "John Wesley."
March–April	Contemporary Arts Museum, Houston. "Pop Goes the Easel." Exhibition includes Dine, Lichtenstein, Mel Ramos, Warhol, and Wesselmann.
March–May	The Jewish Museum, New York. "Robert Rauschenberg." Retrospective.

March–June	Solomon R. Guggenheim Museum, New York. "Six Painters and the Object." Exhibition includes Dine, Johns, Lichtenstein, Rauschenberg, Rosenquist, and Warhol. Show travels to Los Angeles County Museum of Art; Minneapolis Institute of Arts; University of Michigan Museum of Art; Rose Art Museum, Brandeis University; Museum of Art, Carnegie Institute; Columbus Gallery of Fine Arts; and the Art Center in La Jolla.
April	Ferus Gallery, Los Angeles. "Roy Lichtenstein."
April–May	Gallery of Modern Art, Washington, D.C. "The Popular Image Exhibition." Dine, Johns, Lichtenstein, Oldenburg, Rauschenberg, Rosenquist, Warhol, Wesley, and Wesselmann.
April–May	Nelson Gallery-Atkins Museum, Kansas City. "Popular Art: Artistic Projection of Common American Symbols." Exhibition includes Dine, Lichtenstein, Oldenburg, Rosenquist, Thiebaud, Warhol, and Wesselmann.
April–May	Thibaut Gallery, New York. "Allan D'Arcangelo."
May	Ferus Gallery, Los Angeles. "Edward Ruscha."
May–August	Museum of Modern Art, New York. "Americans 1963." Exhibition includes Indiana, Marisol, Oldenburg, and Rosenquist.
September	Oakland Art Museum, Oakland. "Pop-Art USA." Exhibition includes D'Arcangelo, Dine, Johns, Indiana, Lichtenstein, Oldenburg, Ramos, Rauschenberg, Rivers, Rosenquist, Ruscha, Saul, Thiebaud, Warhol, Wesley, and Wesselmann.
September–October	Ferus Gallery, Los Angeles. "Andy Warhol."
September–October	Leo Castelli Gallery, New York. "Roy Lichtenstein."
October	Dwan Gallery, Los Angeles. "Claes Oldenburg."
October	Nelson Gallery-Atkins Museum, Kansas City. "Mixed Media and Pop Art." Exhibition includes D'Arcangelo, Dine, Indiana, Johns, Lichtenstein, Marisol, Oldenburg, Ramos, Rauschenberg, Rosenquist, Segal, Thiebaud, Warhol, Wesley, and Wesselmann. It travels to the Albright-Knox Art Gallery, Buffalo.
November	Warhol opens the Factory at 231 East 47th Street, New York.
December–January 1964	Des Moines Art Center, Des Moines. "Signs of the Times III: Paintings by 12 Contemporary Pop Artists." Exhibition includes D'Arcangelo, Durkee, Indiana, Lichtenstein, Ramos, Rosenquist, Thiebaud, Warhol, and Wesselmann.
December–January 1964	Munson-Williams-Proctor Institute, Utica, New York. "New Directions in American Painting." Organized by the Poses Institute of the Arts, Brandeis University. Show includes Dine, Indiana, Johns, Lichtenstein, Oldenburg, Rauschenberg, Rivers, Rosenquist, Thiebaud, Warhol, and Wesselmann.

1964

January	Ferus Gallery, Los Angeles. "A View of New York Painting." Show includes Lichtenstein and Warhol.
January–February	Green Gallery, New York. "James Rosenquist." After the show, he moves to Leo Castelli Gallery.
January–February	Sidney Janis Gallery, New York. "Four Environments by Four New Realists." Including Dine, Oldenburg, Rosenquist, and Segal.
January–February	Art Institute of Chicago, Chicago. "67th Annual Exhibition." Includes Dine, Grooms, Saul, and Wesselmann. Dine wins Norman Wait Harris Silver Medal.
February	Cordier & Ekstrom, Inc., New York. "Öyvind Fahlström."
February–March	Fischbach Gallery, New York. "Allan D'Arcangelo."

February–March	Green Gallery, New York. "Tom Wesselmann."
February–April	The Jewish Museum, New York. "Jasper Johns." Retrospective.
March	Davidson Art Center, Wesleyan University, Middletown, Connecticut. "The New Art." Show includes Artschwager, Dine, Durkee, Indiana, Lichtenstein, Marisol, Oldenburg, Ramos, Rosenquist, Thiebaud, Warhol, and Wesselmann.
March–April	Green Gallery, New York. "George Segal."
April–May	Sidney Janis Gallery, New York. "Claes Oldenburg."
April–May	Stable Gallery, New York. "Andy Warhol."
April–October 1965	World's Fair, New York. Lichtenstein exhibits mural in Theaterama building of New York State Pavilion. Warhol's piece, also commissioned for the New York State Pavilion, *Thirteen Most Wanted Men*, is hung on the facade of building but is then painted over (with the artist's permission) by fair officials who find it too politically charged. Indiana is also included.
May	Stable Gallery, New York. "Robert Indiana."
May	Pace Gallery, New York. "Claes Oldenburg."
May	Allan Stone Gallery, New York. "Wayne Thiebaud."
May–September	32nd Venice Biennale, Venice, Italy. Americans include Dine, Johns, Oldenburg, Rauschenberg. Rauschenberg wins international painting prize.
September–October	Leo Castelli Gallery, New York. "Group Exhibition." Show includes Artschwager, Lichtenstein, Rosenquist, and Warhol.
October	Paul Bianchini Gallery, New York. "American Supermarket." Exhibition includes Artschwager, Johns, Lichtenstein, Oldenburg, Rosenquist, Warhol, and Wesselmann.
October	Allan Frumkin Gallery, New York. "Peter Saul."
October–November	Leo Castelli Gallery, New York. "Roy Lichtenstein: Landscapes."
October–November	Sidney Janis Gallery, New York. "Jim Dine."
October–November	Dwan Gallery, Los Angeles. "James Rosenquist."
October–November	Ferus Gallery, Los Angeles. "Edward Ruscha."
October–January 1965	Museum of Art, Carnegie Institute, Pittsburgh. "The 1964 Pittsburgh International Exhibition of Contemporary Painting and Sculpture." Show includes Dine, Marisol, Oldenburg, Rauschenberg, Rivers, and Wesselmann.
November	Paul Bianchini Gallery, New York. "Mel Ramos."
November	Ferus Gallery, Los Angeles. "Roy Lichtenstein."
November–December	Leo Castelli Gallery, New York. "Andy Warhol: Flower Paintings."

1965

January	Dwan Gallery, Los Angeles. "Arena of Love." Group show based on the theme of "Love." Includes D'Arcangelo, Fahlström, Lichtenstein, Ramos, Thiebaud, and Warhol.
January–February	Green Gallery, New York. "Tom Wesselmann."
February–April	Worcester Art Museum, Worchester, Massachusetts. "The New American Realism." Exhibition includes D'Arcangelo, Dine, Grooms, Indiana, Johns, Lichtenstein, Marisol, Oldenburg, Rauschenberg, Rivers, Rosenquist, Segal, Thiebaud, Warhol, and Wesselmann.
February–April	Corcoran Gallery of Art, Washington. "The 29th Corcoran Biennial." Includes Indiana, Lichtenstein, and Rauschenberg. Rauschenberg wins first prize.
April	Paul Bianchini Gallery, New York. "Warhol, Oldenburg, Lichtenstein."

April–May	Leo Castelli Gallery, New York. "James Rosenquist: *F-111*."
April–May	Milwaukee Art Center, Milwaukee, Wisconsin. "Pop Art and the American Tradition." Exhibition includes D'Arcangelo, Dine, Indiana, Lichtenstein, Oldenburg, Ramos, Rosenquist, Ruscha, Segal, Warhol, Wesley, and Wesselmann.
April–May	Rose Art Museum, Brandeis University, Waltham, Massachusetts. "Larry Rivers Retrospective."
April–May	Fischbach Gallery, New York. "Allan D'Arcangelo."
June–September	The Jewish Museum, New York. Rosenquist's *F-111*.
October	Sidney Janis Gallery, New York. "George Segal."
October–November	David Stuart Galleries, Los Angeles. "Mel Ramos."
October–November	Institute of Contemporary Art, University of Pennsylvania, Philadelphia. "Andy Warhol." Retrospective.
November	Paul Bianchini Gallery, New York. "Mel Ramos."
November–December	Ferus Gallery, Los Angeles. "Edward Ruscha."
November–December	Leo Castelli Gallery, New York. "Ceramics and Pop – Roy Lichtenstein." Exhibition of "Brushstroke" paintings and ceramic works.
December	Sidney Janis Gallery, New York. "Pop and Op." Exhibition includes Dine, Lichtenstein, Marisol, Rosenquist, Warhol, and Wesselmann.
December–January 1966	Solomon R. Guggenheim Museum, New York. "Word and Image." Exhibition includes Dine, Indiana, Johns, Lichtenstein, and Ruscha.
December–January 1966	Virginia Museum of Fine Arts, Richmond. "Pop and Op, an Exhibition of Graphic Works." Show includes D'Arcangelo, Dine, Lichtenstein, Ramos, Rosenquist, Warhol, and Wesley. Travels to American Federation of Arts Gallery, New York; Baltimore Museum of Art; Nelson Gallery-Atkins Museum, Kansas City; Columbus Museum of Arts and Crafts; High Gallery of Art, Atlanta.

1966

February	Paul Bianchini Gallery, New York. "Pissaro to Lichtenstein." Exhibition includes Dine, Indiana, Oldenburg, Segal, Warhol, and Wesselmann. It travels to the Contemporary Art Center, Cincinnati.
March	Allan Frumkin Gallery, New York. "Peter Saul."
March–April	Sidney Janis Gallery, New York. "New Work by Claes Oldenburg."
April	Leo Castelli Gallery, New York. "Andy Warhol: Wallpaper and Clouds."
April–May	Leo Castelli Gallery, New York. "James Rosenquist."
April–May	Sidney Janis Gallery, New York. "Marisol." Exhibition of *The Party*.
May	Stable Gallery, New York. "Robert Indiana."
May	Sidney Janis Gallery, New York. "Tom Wesselmann: Great American Nudes."
May	Contemporary Arts Center, Cincinnati. "Andy Warhol: Holy Cow! Silver Clouds!"
May–September	33rd Venice Biennale, Venice, Italy. Americans include Helen Frankenthaler, Ellsworth Kelly, Roy Lichtenstein, and Jules Olitski.
July	Sidney Janis Gallery, New York. "Tom Wesselmann."
September–October	Stable Gallery, New York. "Robert Indiana."
September–November	Whitney Museum of American Art, New York. "Art of the United States: 1670-1966." Exhibition includes Dine, Indiana, Johns, Lichtenstein, Marisol, Oldenburg, Rauschenberg, Rivers, Rosenquist, Segal, Warhol, and Wesselmann. Inaugural show for the opening of the new Whitney on 75th Street and Madison Avenue.
October	Sidney Janis Gallery, New York. "Erotic Art '66." Exhibition includes

	Dine, Fahlström, Marisol, Rivers, Rosenquist, Segal, Warhol, and Wesselmann.
October–November	Institute of Contemporary Art, Boston. "Andy Warhol."
November–December	The Cleveland Museum of Art, Cleveland. "Works by Roy Lichtenstein."
November–February 1967	Museum of Modern Art, New York. "Art in the Mirror." Includes Dine, Indiana, Johns, Lichtenstein, Rauschenberg, Rivers, Rosenquist, Warhol, and Wesselmann.

1967

January–February	Sidney Janis Gallery, New York. "Tom Wesselmann."
January–February	Paul Bianchini Gallery, New York. "Richard Artschwager/Joe Goode/Claes Oldenburg/Robert Watts/H. C. Westermann."
January–February	Robert Elkon Gallery, New York. "John Wesley."
February	Leo Castelli Gallery, New York. "Tenth Anniversary Exhibition." Show includes Artschwager, Johns, Lichtenstein, Rauschenberg, Rosenquist, and Warhol.
February–March	Sidney Janis Gallery, New York. "Öyvind Fahlström."
February–March	Albright-Knox Art Gallery, Buffalo. "Dine/Oldenburg/Segal: Painting/Sculpture."
March–April	Sidney Janis Gallery, New York. "New Work by George Segal."
April–May	Sidney Janis Gallery, New York. "Claes Oldenburg."
April–May	Pasadena Art Museum, Pasadena. "Roy Lichtenstein." First traveling retrospective of Lichtenstein's work. Organized in conjunction with and travels to the Walker Art Center, Minneapolis.
April–June	"The Store," New York. Claes Oldenburg show in his studio at 404 East 14th Street.
June–September	Museum of Modern Art, New York. "The 1960's: Paintings and Sculpture from the Museum's Collection." Exhibition includes Artschwager, D'Arcangelo, Dine, Indiana, Johns, Lichtenstein, Marisol, Oldenburg, Rauschenberg, Rivers, Rosenquist, Segal, Warhol, and Wesselmann.
October	Central Park, New York. "Sculpture in Environment." Oldenburg digs a hole behind the Metropolitan Museum of Art.
October–November	Leo Castelli Gallery, New York. "Roy Lichtenstein."
October–January 1968	Museum of Art, Carnegie Institute, Pittsburgh. "Pittsburgh International Exhibition of Contemporary Painting and Sculpture." Includes Dine, Indiana, Lichtenstein, Oldenburg, Saul, Warhol, and Wesselmann.
December	Sidney Janis Gallery, New York. "Homage to Marilyn Monroe." Oldenburg's first fabricated metal sculpture, *Lipstick*, included. Also work by Fahlström and Wesselmann.
December–January 1968	Alexandre Iolas Gallery, New York. "Gun-powder Drawings – Edward Ruscha."
December–January 1968	Contemporary Art Center, Cincinnati. "Roy Lichtenstein: An Exhibition of Paintings and Sculpture."
December–February 1968	Whitney Museum of American Art, New York. "Annual Exhibition of Contemporary Painting." Show includes D'Arcangelo, Dine, Indiana, Lichtenstein, Rosenquist, Ruscha, Warhol, Wesley, and Wesselmann.

1968

January–February	Irving Blum Gallery, Los Angeles. "Edward Ruscha: L.A. County Museum on Fire."
February–March	Rose Art Museum, Brandeis University, Waltham, Massachusetts.

"American Exhibition from the IX Bienal, São Paulo." Show includes D'Arcangelo, Indiana, Lichtenstein, Oldenburg, Rosenquist, Ruscha, Segal, Thiebaud, Warhol, and Wesselmann.

February–May	Metropolitan Museum of Art, New York. "*F-111*." Rosenquist's mammoth painting is exhibited, with much controversy.
April	Irving Blum Gallery, Los Angeles. "Roy Lichtenstein."
April–May	Museum of Contemporary Art, Chicago. "George Segal: 12 Human Situations."
April–May	Institute of Contemporary Art, University of Pennsylvania, Philadelphia. "Robert Indiana."
June	Irving Blum Gallery, Los Angeles. "Claes Oldenburg."
October–November	Richard Feigen Gallery, Chicago. "Richard J. Daley." An exhibition by fifty artists protesting violence and repression during the Democratic National Convention that occurred in August. Lichtenstein, Oldenburg, and Rosenquist participate.

1969

January	Irving Blum Gallery, Los Angeles. "Andy Warhol."
February	Irving Blum Gallery, Los Angeles. "Roy Lichtenstein."
March	Sidney Janis Gallery, New York. "Öyvind Fahlström."
March–April	Castelli Graphics, New York. "Andy Warhol."
March–April	Leo Castelli Gallery, New York. "James Rosenquist: Horse Blinders."
March–April	Art Gallery, University of California, Irvine. "New York: The Second Breakthrough: 1959-1964." Show includes Dine, Johns, Lichtenstein, Oldenburg, Rauschenberg, Rosenquist, and Warhol.
April–May	Richard Feigen Gallery, Chicago. "Claes Oldenburg – Constructions, Models, and Drawings." Exhibition of Chicago-related sites and themes.
April–June	The Jewish Museum, New York. "Superlimited: Books, Boxes and Things." Group show of multiple and editioned 3-D objects of the past decade. D'Arcangelo, Dine, Indiana, Lichtenstein, Oldenburg, Rivers, Rosenquist, Ruscha, Warhol, and Wesselmann included.
May	Yale University, New Haven. Oldenburg's first "feasible" monument, *Lipstick (Ascending) on Caterpillar Tracks*, is installed on the campus.
May	Irving Blum Gallery, Los Angeles. "Edward Ruscha."
June–July	Moreau Gallery, St. Mary's College, Notre Dame. "Robert Indiana: Graphic Works."
September	New Gallery of Contemporary Art, Cleveland. "Roy Lichtenstein: Rouen Cathedrals and Haystacks."
September–November	Guggenheim Museum, New York. "Roy Lichtenstein." First New York retrospective of Lichtenstein's painting and sculpture. Guggenheim buys its first painting by him, *Preparedness*. Exhibition travels to Nelson Gallery-Atkins Museum, Kansas City; Museum of Contemporary Art, Chicago; Seattle Art Museum; and Columbus Gallery of Arts.
September–November	Museum of Modern Art, New York. "Claes Oldenburg." Comprehensive survey of objects and drawings, 1954-1969.
October–November	Institute of Contemporary Art, University of Pennsylvania, Philadelphia. "The Spirit of the Comics." Includes Fahlström, Grooms, Lichtenstein, Oldenburg, Ramos, Saul, and Warhol.
October–December	Metropolitan Museum of Art, New York. "Prints by Five New York Painters." Exhibition of works by Dine, Lichtenstein, Rauschenberg, Rivers, and Rosenquist.
October–February 1970	Metropolitan Museum of Art, New York. "New York Painting and

	Sculpture: 1940-1970." Organized by Henry Geldzahler, the show includes Lichtenstein, Oldenburg, Segal, Rosenquist, and Warhol.
November–December	Robert Elkon Gallery, New York. "John Wesley."
December–January 1970	Nelson Gallery–Atkins Museum, Kansas City. "Roy Lichtenstein."

1970

January–February	Alexandre Iolas Gallery, New York. "Edward Ruscha."
February–March	Whitney Museum of American Art, New York. "Jim Dine." Retrospective.
February–March	Hopkins Center, Dartmouth College, Hanover, New Hampshire. "Robert Indiana."
April–May	Sidney Janis Gallery, New York. "New Work by Wesselmann."
May	Leo Castelli Gallery, New York. "James Rosenquist."
May–June	Pasadena Art Museum. "Andy Warhol." Exhibition travels to Museum of Contemporary Art, Chicago, and Whitney Museum of American Art.
October–November	Leo Castelli Gallery, New York. "James Rosenquist."
November	Sidney Janis Gallery, New York. "New Work by Claes Oldenburg."
December–January 1971	Newport Harbor Art Museum, Newport Harbor, Rhode Island. "Tom Wesselmann, Early Still Lifes: 1962-1964." Exhibition travels to Nelson Gallery–Atkins Museum, Kansas City.

THE DOCUMENTS OF TWENTIETH-CENTURY ART series was founded in 1944 by Robert Motherwell as The Documents of Modern Art. Between 1944 and 1995, the following titles were published in the series under the imprints of Wittenborn & Schultz, Viking Press, and G. K. Hall:

Guillaume Apollinaire, *The Cubist Painters*

Piet Mondrian, *Plastic Art and Pure Plastic Art*

Lazló Moholy-Nagy, *The New Vision*

Louis H. Sullivan, *Kindergarten Chats and Other Writings*

Wassily Kandinsky, *Concerning the Spiritual in Art and Painting in Particular*

Jean (Hans) Arp, *On My Way: Poetry and Essays 1912–1947*

Max Ernst, *Max Ernst: Beyond Painting and Other Writings by the Artist and His Friends*

Daniel-Henry Kahnweiler, *The Rise of Cubism*

Marcel Raymond, *From Baudelaire to Surrealism*

Georges Duthuit, *The Fauvist Painters*

Robert Motherwell, ed., *The Dada Painters and Poets*

Carola Giedion-Welcker, *Contemporary Sculpture*

Marcel Duchamp, *The Bride Stripped Bare by Her Bachelors, Even*

Pierre Cabanne, *Dialogues with Marcel Duchamp*

Daniel-Henry Kahnweiler, with Francis Cremieux, *My Galleries and Painters*

LeRoy C. Breunig, ed., *Apollinaire on Art*

Philip James, ed., *Henry Moore on Sculpture*

Marcel Jean, ed., *Arp on Arp: Essays, Memories*

Jacques Lipschitz, with H. Harvard Arnason, *My Life in Sculpture*

Dore Ashton, ed., *Picasso on Art: A Selection of Views*

Fernand Léger, *Functions of Painting*, Edward R. Fry, ed.

Umbro Apollonio, ed., *Futurist Manifestos*

Wassily Kandinsky and Franz Marc, *The Blaue Reiter Almanac,* ed. Klaus Lankheit

Stephen Bann, ed., *The Tradition of Constructivism*

Hugo Ball, *Flight Out of Time: A Dada Diary*, ed., John Elderfield

Richard Huelsenbeck, *Memoirs of a Dada Drummer*, ed. Hans J. Kleinschmidt

Ad Reinhardt, *Art as Art: Selected Writings of Ad Reinhardt*, ed. Barbara Rose

John Bowlt, ed., *Russian Art of the Avant-Garde: Theory and Criticism 1902–1934*

Arthur A. Cohen, ed., *The New Art of Color: The Writings of Robert and Sonia Delaunay*

Marcel Jean, ed., *The Autobiography of Surrealism*

Kenneth C. Lindsay and Peter Vergo, eds., *Kandinsky: Complete Writings on Art*

Paul Matisse, ed., *Marcel Duchamp, Notes*

Harry Holtzman and Martin James, eds., *The New Art – the New Life: The Collected Writings of Piet Mondrian*

Joan Miró, *Joan Miró: Selected Writings and Interviews*, ed. Margit Rowell

Rose-Carol Washton Long, ed., *German Expressionism: Documents from the End of the Wilhelmine Empire to the Rise of National Socialism*

INDEX

Illustrations are referenced by *italic* page numbers.
Bold page numbers reference writing selections by authors in this anthology.

Designer: Star Type, Berkeley
Compositor: Star Type, Berkeley
Text: 9.25 /12.25 ITC Bodoni Twelve
Display: Akzidenz Grotesk
Printer: Malloy Lithographing
Binder: Malloy Lithographing